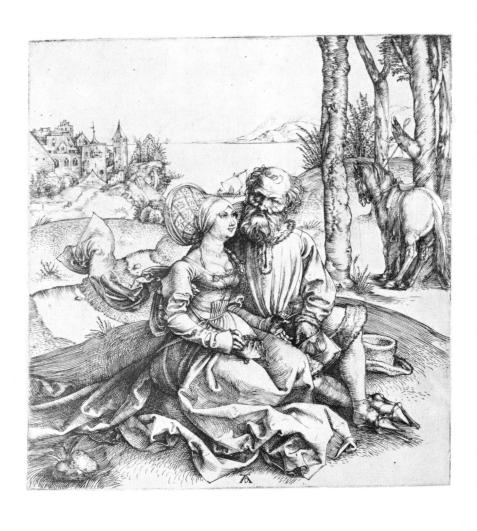

A HISTORY OF
ENGRAVING & ETCHING

FROM THE 15TH CENTURY TO THE YEAR 1914

BEING THE THIRD AND FULLY REVISED EDITION OF
"A SHORT HISTORY OF ENGRAVING AND ETCHING"

BY

ARTHUR M. HIND

Late Keeper of Prints and Drawings in the British Museum

WITH FRONTISPIECE
AND 110 ILLUSTRATIONS IN THE TEXT

DOVER PUBLICATIONS, INC.
NEW YORK

Published in Canada by General Publishing Company, Ltd., 30 Lesmill Road, Don Mills, Toronto, Ontario.

Published in the United Kingdom by Constable and Company, Ltd.

This new Dover edition, first published in 1963, is an unabridged and unaltered republication of the third, fully revised edition, as published by Houghton Mifflin Company in 1923. The frontispiece was reproduced in photogravure in the 1923 edition.

International Standard Book Number: 0-486-20954-7

Library of Congress Catalog Card Number: 63-5658

Manufactured in the United States of America

Dover Publications, Inc.
180 Varick Street
New York 14, N. Y.

*This Dover Edition is dedicated
to the memory of*
ARTHUR MAYGER HIND
(1880–1957)

PREFACE

I OWE a word of apology for augmenting the already extensive bibliography of engraving, and some explanation of the scope of my work may serve to supply it.

It aims, in the first place, at presenting a descriptive survey of the history of engraving on metal throughout the various centuries and schools, considerable space being devoted to the more important engravers, the names of lesser account being cited just so far as they contribute towards a connected view of the whole development, and a balanced estimate of relative artistic values. It is especially in this relation that I feel the importance of the inclusion of a chapter on modern etchers and engravers, who, in books of this kind, have seldom been treated in their natural place beside the older masters. While recognising the greater dangers of personal bias in expressing opinion on the work of living artists, I am strongly opposed to the idea that modern art demands a different and separate treatment.

I have attempted throughout to give references to original sources and best authorities, so that, both for lesser and greater artists, the student may find a sign-post when space precludes direct information.

The General Bibliography, and the Individual Bibliography attached to the Index of Engravers, present a much larger collection of authorities than has been attempted in any similar publication. The technical introduction merely aims at describing the various processes in sufficient detail to help the student, who has made no practice of the art, to a clear comprehension of cause and effect.

A somewhat new feature is formed by the Classified List of Engravers, which has gradually assumed its present shape during the course of my work. Many names of second-rate engravers appear in this section, which would have merely overburdened the text. It is the common fate of compendious lists to be both cryptic and complicated. I cannot think that mine will form an

exception, and I am convinced that they will need from time to time both correction and augmentation ; but I trust that the system, which has been a gradual development into the simplest form I could devise, may serve as a scientific basis, and find sufficient uses to justify the labour entailed. I have considerable hopes that amateurs and students in many fields of research beside that of engraving may find here the names without which they have no key to the illustration of their particular subject or period. Moreover, a list of engravers, carefully placed in their natural groups, will often lead to the solution of problems of authorship when a dictionary would offer no starting-point. I have included various countries in the Classified List (*e.g.* America, Sweden, Norway, and Russia) which have hitherto received scant attention in general works on the subject.

In comparison with painting and sculpture, engraving is a cosmopolitan art, the immediate inter-relation of different countries being facilitated by the portable nature of its creations. This consideration is perhaps the strongest argument for the adoption of the great epochs and phases of development as the most logical order for the descriptive survey, though it occasionally entails slight recapitulations. The Classified List of Engravers, being arranged to give a continuous survey under the headings of the different countries, forms in this respect a natural supplement to the order of the historical section.

The Index, which includes over 2500 names, covering all the engravers and etchers cited in the text and classified list, presents, in the most condensed form, dates, places of activity, and individual bibliography, wherever such are known. This section may seem to encroach somewhat on the domain of a dictionary of engravers, but the student who knows the multitude of sources from which reliable information is to be culled, and the difficulty of computing a balance of authority, even after his sources have been consulted, may find some practical utility in the collection. Moreover, many names of living artists are included which are not to be found in any of the dictionaries, the biographical details having been obtained, in many instances, at first hand from the etchers themselves.

The bibliography will show that my indebtedness to the literature of the subject almost precludes specification. Two books, however, I would mention as most nearly allied in scope to the historical portion of my work, *i.e.* Lippmann's *Kupferstich*, and Kristeller's *Kupferstich und Holzschnitt in vier Jahrhunderten*. My debt to

the former may be unconsciously even greater than I suppose, as it formed my earliest introduction to a subject on which it is one of the soundest guides. On the technical side I would merely cite Singer and Strang's *Etching, Engraving, and the other Methods of Printing Pictures*, which, with its excellent bibliography of processes,[1] was of great assistance to me in my introductory chapter. Books such as these have naturally been my constant guides, but a continued study of the original prints, in which detailed research on one or two schools has been seconded by a systematic examination of masses of work of every period, forms the real basis both for my Classified List of Engravers and for the opinions expressed in the text.

In respect of personal help, my greatest debt of gratitude is to Mr. Campbell Dodgson. He most kindly read through the text in manuscript, and the classified lists in proof, giving me numerous suggestions, which his deep and minute knowledge of the subject renders an invaluable service. I would also record the invariable sympathy and suggestion which have been afforded a new member of his own department by Mr. Sidney Colvin. My sincere thanks are also due to Mr. Laurence Binyon for having suggested to me the inception of a most congenial task, and for frequent counsel during the work's progress ; to Mr. Alfred Whitman for constant assistance in the field of mezzotint, on which he is an acknowledged authority ; to Mr. Frank Short for very kindly reading and criticising my technical introduction in manuscript ; and to my brother for reading the proofs of the text.

I am indebted to many other friends and acquaintances in England and abroad, both for personal help in study in other print collections, and for much correspondence in answer to repeated queries : among others, to Geheimrath Lehrs of Berlin and Dresden, to Prof. Singer of Dresden (to both of whom I owe a personal debt for something of my initiation in the subject, while studying in Germany some six years ago), to Drs. Weixlgärtner and Dörnhöffer of Vienna, to Graf. Pückler-Limpurg and Dr. Pallmann of Munich, to Dr. Kristeller of Berlin, to Dr. John Kruse of Stockholm (for many details on Scandinavian engravers), to Monsieur François Courboin of Paris, to Professor Henri Hymans of Brussels, to Mr. A. W. Pollard and Mr. Arundell Esdaile (for repeated assistance on matters of bibliography), to Mr. F. M. O'Donoghue

[1] To which Professor Singer has for years been making additions, intending at some future date to publish a comprehensive bibliography.

(particularly in relation to portrait), to Mr. Basil Soulsby, to Mr. R. Nisbet Bain (for advice on the orthography of Russian names), to Mr. Barclay Squire and Mr. Alfred H. Littleton (for matters connected with the engraving of music), to Mr. Martin Hardie, to Mr. T. W. Jackson of Oxford, and to Mr. Charles Sayle of Cambridge.

The illustrations have been made, for the most part, from impressions in the British Museum, one being from Amsterdam (Fig. 4), another from South Kensington (Fig. 110), and the two examples of Legros being taken from Mr. Dodgson's collection. Three alone were taken from other reproductions—*i.e.* Fig. 2 from the Chalcographical Society's publication of 1887; Fig. 3 from Lehrs, *Die ältesten deutschen Spielkarten*; and Fig. 13 from G. W. Reid, *Reproduction of the Salamanca Collection*, London, 1869. The facsimile plate used for the frontispiece has been kindly lent me by the Dürer Society. The plate of engravers' tools was designed by Mr. S. W. Littlejohn, who has also given me constant and ready help on many technical matters.

It is my intention, if the reception of the present work is at all favourable, and if my leisure during the next five or six years can compass an even more laborious task than the present, to attempt a companion book on Woodcut, Lithography, and Relief-cuts and Plane-prints in general.

A. M. H.

June, 1908.

———

NOTE TO THE SECOND EDITION

The corrections and additions are for the most part limited to details of date and bibliography. The pages in which they occur are the following :—5, 8, 13, 14, 42, 46, 48, 51, 52, 66, 70, 80, 141, 145, 148, 165, 169, 172, 177, 181, 201, 213, 217, 222, 223, 230, 255, 282, 287, 295, 316, 357, 360, 382, 386, 391, 393, 394, 395, 396, 397, 398, 399, 400, 404, 407, 408, 409, 410, 411, 412, 413, 414, 415, 416, 417, 418, 419, 420, 421, 422, 423, 424, 425, 426, 430, 431, 432, 433, 434, 435, 436, 437, 438, 439, 440, 441, 442, 444, 445, 449, 450, 451, 452, 454, 455, 456, 457, 458, 459, 460, 461, 462, 464, 465, 466, 467, 468, 470, 471, 472, 473.

These references are the best indication I can give of the character of the revision.

A. M. H.

September 1911.

NOTE TO THE THIRD EDITION

IN the text the most considerable revisions and additions have been made in the chapter on Modern Etching. I have fixed the year 1914 as a limit to my history, and if future editions are called for it is my intention to confine revisions or additions within this date. It may happen that certain artists are included both younger and of no more distinction than others who do not appear. This should be explained, apart from errors of judgement and gaps in my knowledge, by the fact that their work in etching and engraving only began after the year 1914.

Outside this chapter the more important revisions in the text have been made at the following places according to the pagination of the second edition :—5, 8, 23, 27, 90. 99, 105, 119, 132, 133, 135, 169, 175, 177, 190, 212, 214, 220, 229, 230, 235, 240, 242, 244, 255, 267, 268, 284, 287, 288, 289, 300, 303, 304, 305, 306, 307, and 309.

The chief alterations in the Classified List of Engravers occur at pages (second edition) 360, 366, 368, 371, 373, 374, 375, 378, 379, 381. 383, 384, 385, 386, 387, 388, 389, 390, 391, 392, and 394.

The General Bibliography has been considerably enlarged throughout its various sections, books and articles being cited up to the current year.

I have added many new names to the Index of Engravers, chiefly of contemporary artists, but here and there I have judged it well to add to my selection of the earlier masters. The individual bibliographies in the Index have also been brought up to date.

I owe my readers some apology for not having fulfilled the intention expressed in the last paragraph of my Preface of 1908. Material has indeed been collected, but years have not brought the leisure that I should require for this particular task I am less sanguine than in those early years, but a History of Woodcut is one of the works I still hope to complete, and I look forward to a space of years when opportunity may permit of its accomplishment.

A. M H.

October 1922.

CONTENTS

APPENDIX III

LIST OF ILLUSTRATIONS

GIVING THE DIMENSIONS OF THE ORIGINALS (IN MILLIMETRES) IN ALL
CASES WHERE THE REDUCTION IS CONSIDERABLE.

The following abbreviations to the various catalogues are most frequently used in the text :—

 B = Bartsch, Le Peintre-graveur.
 P = Passavant, Le Peintre-graveur.
 R-D = Robert-Dumesnil, Le Peintre-graveur Français.
 A = Andresen, Der deutsche Peintre-graveur.
 D = Dutuit, Manuel de l'Amateur d'Estampes.
 C.S. = Chaloner Smith, British Mezzotinto Portraits.

For others, reference to the Index and Individual Bibliography will give the solution.

INTRODUCTION

PROCESSES AND MATERIALS

ENGRAVING may be broadly defined as the art of drawing or writing on any substance by means of an incised line. By a natural transference from the abstract to the concrete, the term may be referred to the work so performed, and by a further transference, illogical, but stereotyped by usage, it is applied to an impression taken on paper or some allied material, from the original engraved work. Engraving
a definition.

Engraving in
the sense of
impression
or print.

The present historical study is almost exclusively concerned with engraving in the last signification, and with the engraved work itself only in so far as it serves as a basis for impressions or prints. The work of the goldsmith, and in fact all engraving pursued as an end in itself, fall outside its scope.

Engraving may be divided into two main classes :—

<div style="text-align:center">

I. *Engraving in intaglio.*

II. *Engraving in relief.*

</div>

Two main classes of engraving : I. Intaglio. II. Relief.

In I. the line or space engraved possesses a positive value, and stands for the design itself. In II. the lines or spaces are engraved merely as negatives to leave the design in relief. A different method of taking impressions is needed for each class, which, by illogical transference, may be termed respectively *intaglio* and *relief printing*. In the latter method, which is called more accurately *surface printing*, the ink is merely transferred from the part left in relief (as in printing from type), while in the former the ink is extracted by dint of great pressure from the engraved lines themselves.

Two methods of printing.

Class II. is chiefly concerned with work on wood, which in its early history is more strictly called wood-cutting than wood-engraving. With this our study has nothing to do. Metal cuts are also omitted as belonging essentially to the same category as wood-cuts. Then the branch of engraving on metal where the lines are incised merely to print as white on a black ground, which is called in French the *manière criblée*,[1] intermixed as it generally is with dotted work (*geschrotene Arbeit*), is also left out of our study, on

Class II. omitted in this book.

[1] For a sound exposition of the principles of this process see S. R. Koehler, "White Line Engraving for Relief Printing in the 15th and 16th Centuries," *Report of the National Museum*, 1890, pp. 385-94. Washington, 1892.

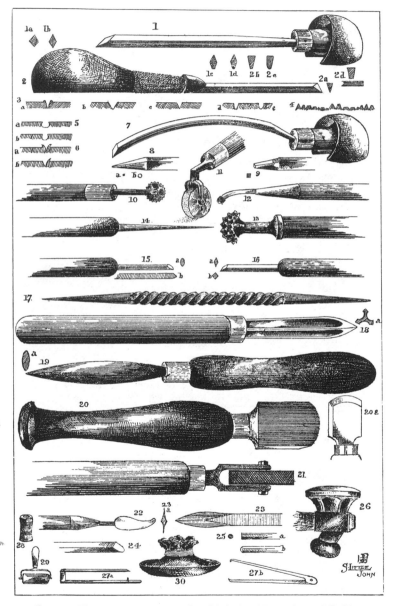

FIG. 1.—The Tools used in the various Methods of Engraving and Etching.
(Key on p. 18.)

the ground that the method of printing these engravings in relief brings the art nearer in principle to wood-cut than to line engraving.[1]

Our subject then is limited to the type of engraving on metal in intaglio, where the lines or spaces engraved serve as the design, which, except in occasional instances,[2] figures as black on white, or at least as a darker on a lighter tone. *Gravure en taille-douce* it is called in French, a term perhaps implying the joy of the craftsman in engraving the line which is to be the design in itself, rather than a mere negative value to be laboriously removed.

The subject limited to intaglio engravings on metal.

For a true appreciation of prints, which form the chief material for our study, it is essential to understand the main principles of the various processes by which plates may be engraved. A description of these processes, in just sufficient detail to enable the student of the history of engraving to obtain a proper comprehension of cause and effect, is the aim of the present chapter.

The essential element of the *graver* or *burin* (1),[3] the chief instrument of the line-engraver, is a small steel rod some four or five inches long, the shape of whose section is either square or lozenge (1, *a* and *b*), with cutting point and edges gained by sharpening the head in an oblique section. The most usual form of handle is as in 1, but it is not infrequently shaped as in 2. The plates used in engraving are generally of copper, well beaten and of highly polished surface. Zinc, iron,[4] silver,[5] steel,[6] brass,[7] and even pewter[8] plates have occasionally been used, iron and zinc less frequently for line-engraving than for etching, where the artist may choose these materials to achieve a rougher result. Steel was largely used in the second quarter of the last century for line-engraving, etching, and mezzotint. The more recently applied method of steel-facing by

Line-engraving. The graver (or burin).

The plate.

Steel-facing.

[1] Blake's etchings in relief form an exception to this principle of exclusion.

[2] *E.g.* an impression of *The Virgin and Child with a Bird*, by E. S., reproduced F. Lippmann, *Kupferstiche und Holzschnitte alter Meister*, Berlin, x. (1900), 1. Cf. M. Lehrs, *Repertorium*, xii. 273.

[3] The numbers in brackets throughout this chapter refer to the plate illustrating tools used in engraving (Fig. 1).

[4] See Dürer, pp. 80, 106-7 ; Hopfer, etc., p. 109.

[5] See Nielli, p. 42 ; Goltzius (footnote, p. 120).

[6] See Chap. V. p. 150, note 2 ; Chap. VII. pp. 211, 223 ; Chap. IX. p. 284.

[7] There are two or three original brass plates in the British Museum : an undescribed Italian plate of the fifteenth century (a *Nativity*), and two good early copies after J. Matham (B 157 and 158). The use of the word "brass" by Harington in the introduction to his edition of Ariosto's *Orlando Furioso* (1591) is perhaps merely a vague use of the term, which would include copper.

[8] In an inventory of Alessandro Rosselli (1528) plates are described as of *rame* (copper), *ottone* (brass), and *stagno* (pewter, or tin). This at least shows that pewter, or a similar alloy, was used for engraving at this period. Cf. Meldolla, p. 112, and note. W. Blake is known to have used pewter plates. The chief application of pewter in engraving has been for the printing of music, one of the earliest examples of a practice common in the eighteenth century being Handel's *Giulio Cesare*, published by Cluer, London, 1724. Some of the pewter plates used by Cluer's contemporary, Walsh, are still in the possession of Messrs. Novello. For the general history of music printing and engraving see F. Chrysander, *Musical Times*, 1877.

electrolysis, which imparts an equal durability to the copper, has almost entirely superseded the use of plates of a metal whose toughness presents greater difficulties to the engraver. Steel-facing is now frequently used when a large number of impressions are to be taken for some commercial purpose, but most artist-engravers and etchers prefer to limit their editions to the number that can be taken from the copper. Whether the purity of the line is more than microscopically impaired by the process is a matter on which opinions are divided.

Method of engraving.

The engraver grasps the blade of the graver between the thumb and first or second finger (in the latter case letting the first finger fall along the top of blade, as shown in the illustrations in Bosse's treatise [1]), holding the round part of the handle against the palm. He then presses the point of the graver into the surface of the plate, which is laid on a pad to facilitate its turning, being careful to keep the two under sides of the graver at equal angles to the plate's surface.

Burr.

The resultant incised line will exhibit a curl at either side (if regularly engraved) as in 3a, but this will be very slight if the graver is perfectly sharpened. This roughness, called *burr*, is

The scraper.

removed by the *scraper* (18: an instrument with triple and fluted blade, very finely sharpened), leaving a clean furrow as in 3b or 3c according to the shape of graver used (1a or 1b). Another tool similar to the ordinary graver, but with a triangular section (though

Tint-tool.

sometimes slightly curved on the upper side) called the *tint-tool* (2, 2a), is more especially a wood-engraver's instrument, used for cutting series of fine lines so as to get the tone or "tint" from which it

Scorper (scauper or scooper).

derives its name. Sharpened with a square or round belly (2b and 2c), after the manner of what is termed a *scorper* (*scauper* or *scooper*), it may serve the metal engraver for his broader lines. The ordinary lozenge graver is also sometimes sharpened in a similar way (1c and 1d). Except in its flattest shape, that of the gouge, which is used to scoop out parts of the plate to be erased, these "scorper" forms are much less used by the artist-engraver than by the heraldic and letter engraver. More particularly a craftsman's instrument again

Threading-tool.

is the *threading-tool* (2d). A shape similar to the tint-tool, with broad flat belly, is threaded on its lower surface to facilitate the engraving of a series of parallel lines.

Throughout our description of the various tools it must be remembered that while, as far as possible, the conventional forms are given, many other variations of shape may occur according to the discretion of each engraver.

To make a line of thickness varying in its own length, the engraver either deepens his cutting, or leans the graver on one side; the latter only if the swelling required be slight, as otherwise the irregular furrow with a sloping side thus formed would fail to hold the ink adequately. If greater variation in breadth is required,

[1] See General Bibliography, II. Processes, 1645.

he must cut further lines alongside his original furrow. In close Dot and flick
shading dots made by the point of the graver and short lines, called work.
flicks,[1] are often used, either by themselves for the lighter portions of
the shading, or within the interstices of the cross-hatchings. The
flicks are frequently made with the curved graver such as is used
in stipple work (7).

For the correction of work on the plate the method is as follows : Corrections
The part of the surface wrongly engraved is removed by means of on the plate
the scraper, or, if the lines are shallow, rubbed down with the
burnisher, an instrument having an oval section and a rounded and Burnisher.
highly polished edge (19). By means of the *callipers* (shaped as in Callipers.
27a or 27b) the exactly corresponding part of the other side of the
plate is located, and the indentation caused by the erasure is then
knocked up from behind with a *hammer* (26), or if only a very Hammer.
limited space is to be corrected, with an ordinary *flat punch* (25a) Flat- and
and hammer. Occasionally, more particularly in the case of thick cocking-
steel plates, a punch with a rounded head (called the *cocking-punch*) punches.
is used in conjunction with the hammer on the face of the plate, in
such a manner as to beat down the sides of the engraved lines and
close the cavity. The surface, being levelled with charcoal and
polished with the burnisher, can be engraved as before. Light lines
can also be worn down by rubbing with the *oil-rubber* (a roll of Oil-rubber.
woollen cloth bound with string, which is generally used merely with
oil to clean and polish the plates, see 28) in conjunction with the
finest emery (commonly called flour emery) or other polishing
powder (*e.g.* fine crocus, or rotten stone), emery being more suit-
able for steel, the two latter powders for copper.

In ETCHING, as the name implies, the line is obtained by corrod- Etching.
ing or "eating" the plate with some acid or mordant.

The plate, after being polished with the oil-rubber and sedulously
cleaned with chalk or whitening, is covered with a thin layer of
etching-ground, made by the mixture, in varying quantities, of different
waxes, gums, and resins. A harder ground,[2] used largely by earlier
etchers, but now quite discarded, contained similar ingredients (with
the important exception of the virgin wax), combined with nut-oil.

The most common way of *laying the ground* is as follows :—a Laying the
ball of solid ground, brought into contact with the heated plate, ground
melts and oozes through the porous silk in which it is kept wrapped.
The substance thus melted is spread evenly over the plate by a

[1] Called *stipps* by Vertue in his description of the elements of line-engraving
(see Vertue MSS., B. M. Add. 23081, f. 40 b).

[2] The *hard etching-ground* (*vernis dur*) would offer sufficient resistance to the
needle or échoppe to militate against the true flexibility of etching. The *soft
etching-ground* (*vernis mol*), as used by Rembrandt and nearly all later etchers,
offers practically no resistance to the needle, permitting the same freedom of hand
as in drawing. Cf. note on p. 105. This *soft etching-ground* should not be
confused with the later process called *soft-ground etching*. Confusion might be
avoided by adopting the term *wax-ground* for the ordinary *soft etching-ground*,
where the distinction should be required.

by the dabber, succession of short sharp blows with the *dabber* (30), a pad of some two or three inches in diameter covered with silk or kid. The grounded plate is then held over some lighted tapers, whose smoke is absorbed by the melted ground, making it black, a practice merely to aid the etcher to see the lines he is opening. With the idea of avoiding the negative nature of the design, which would thus appear as bright copper red on a black ground, some etchers use means to cover the ground with white, so that their design will resemble red chalk on white paper.

by the roller, Two other methods of laying the ground may be mentioned. First by means of the *roller* (29). A mixture, of the consistency of a paste, of ordinary ground with oil of spike, is laid on a piece of plate glass. Over this the roller is passed, and covered with a uniform coating of the paste, which is then evenly rolled over the plate. The application of heat soon drives away most of the oil, but for complete evaporation several days are necessary.

by solution in chloroform. By a third method the ground is dissolved in chloroform. The solution is poured over the plate, and the superfluous liquid run off The chloroform dries very quickly, leaving the solid ground.

Transferring the design. The artist-etcher will often work without the aid of any design laid on the surface of the ground. But if design is needed it can easily be transferred by covering the back of the thin paper, which contains the drawing, with red or other chalk, and pressing the design through on to the blackened ground. There are, of course, various other means, a pencil drawing on thin paper laid against the grounded plate and passed through the press being an expeditious method.

Etching-needle. To open up the lines the instrument used is what is called the *etching-needle*, which is generally set in a simple holder as in 14. The needles, of course, vary in thickness, and are more or less

The oval point (or *échoppe*). sharply pointed according to need. Sometimes for thicker lines a broader needle, sharpened in an oval section (15) is used, though much less now than at the time of Callot and Bosse, and variation in width in the course of the line could be made by holding the point at varying angles, or by cutting more or less into the surface of the plate through the ground.[1] Even the square and lozenge graver shapes (16) are also occasionally used by the etcher. The modern artist-etcher keeps, however, almost entirely to the simple form of needles, regarding the swelling and diminishing line, achieved by the oval point, as more suited to the less fluent art of line engraving.

Mordants. There are three mordants in general use: *dilute Nitric or Nitrous*[2] *acid, dilute Hydrochloric acid mixed with Chlorate of Potash, i.e.*, what is called the *Dutch Bath*, and a *solution of Perchloride of Iron*. The last is least used by the artist-engraver, partly,

[1] This, of course, being a *mixed method*, for which see below, p. 9. In this mixture of cutting with etching the lines would show tapering ends as in burin work, not the square ends of pure etching.

[2] This unstable acid is only occasionally used for delicate bitings.

no doubt, because of the difficulty of gauging its strength and action. It has been recently much employed for making process plates.

Nitric acid, which is the oldest mordant, works quickly and strongly, and has a tendency (which may be moderated by the admixture of sal-ammoniac) to attack each side of the line, forming a rounded cavity as in 5*a*. The presence of bubbles facilitates the calculation of the time to be allowed for biting. The *Dutch Bath* (which is often used in conjunction with the preceding mordant to bite the more delicate lines) acts slowly and more directly downwards (biting a cavity as in 5*b*). No bubbles are visible in the action, so that its effect can only be judged by careful timing according to known strength of acid.

Perhaps the oldest method of applying the mordant was to build up a little wall of wax round the edge of the plate within which the acid could be poured as in a bath. This " damming " process must have been long in use among the goldsmiths. The biting.

Another early method described by Bosse (1645) is the arrangement of a large dish banked on three sides, and set at an angle so that the acid which is poured over the plate (previously protected at the back and edges by a coating of varnish) would constantly drain into a receptacle below. Except in a modified form introducing a spray, recently applied to the etching of process plates, this mode has quite fallen out of use. The process now generally adopted does not seem to have been introduced until the end of the 17th century,[1] and probably found little favour until the beginning of the last century. The plate is protected at the back and edges with a coating of Brunswick black (or some other stopping-out varnish), and then put into a bath of acid.

When the lightest lines are sufficiently bitten (the time required may vary from a few minutes to a few hours), the plate is taken out. If certain lines need to be etched more deeply, the others must now be covered with stopping-out varnish and the plate again immersed, a process which can be repeated any number of times according to the gradations required. Biting in certain portions of the plate can also be effected by means of placing some drops of acid with feather or brush on the part to be bitten. Stopping-out. Feathering.

A method of attaining the required gradations without stopping-out is as follows. The lines which are to be darkest are first opened with the needle, and the plate exposed to the acid. Then, after a certain length of biting the plate is removed from the bath, and other lines, which are to be lighter, uncovered, and the plate returned to the bath. The same process is repeated as many times as needed, the lines first opened getting, of course, most bitings. In its most expeditious form this method can be carried out by etching the whole design beneath the acid, beginning with the darkest lines.

If the ground is removed from the plate before the work is

[1] Possibly by Sebastien Leclerc. See Bosse, *Gravure*, ed. 1701.

Rebiting.

complete, for the sake of taking proof impressions, the second ground must be transparent, and is best laid with the roller. The ground thus laid will leave uncovered all but the very faintest lines, and the work can thus be rebitten without further use of the etching-needle. For the equality of the work, which often suffers in a careless rebiting, it may be necessary to use the needle to uncover the lighter lines as well.

Further lines can also, of course, be added, and in this case the ground is driven well into the old lines to prevent their rebiting. It is found that the nearer the lines are laid together the greater the heat engendered by the acid and the quicker the biting. This fact, on which Lalanne[1] laid great emphasis, makes it essential for the etcher to lay his darker lines at a comparatively greater distance from each other than the lighter ones, or confusion would result.

Distinguishing characteristics of etched and engraved lines.

The distinction between an etched and an engraved line in a print seldom presents difficulty. Apart from the greater freedom of character, consequent on the ease with which the needle is directed, the etched line nearly always has rectangular extremities, while the line cut with the graver tapers to a point. An engraved line with blunt extremities is, however, sometimes needed, and is achieved by " cutting back."

Glass prints.

Before passing on I may just refer to another method of obtaining prints, which to the cursory observer look deceivingly like etchings. I mean the *glass prints* produced by some modern etchers,[2] which in reality are not etchings or engravings at all. The process is one of obtaining a print on sensitised paper exposed to the light behind a glass plate which has been prepared by the artist to play the part of a photographic negative, transparencies being left where lines are needed in the print. The essential character of the process puts it quite out of the range of our subject.[3]

Soft-ground etching.

The aim of soft-ground etching[4] is the imitation of the texture of a pencil or chalk drawing. Ordinary ground is mixed with about an equal proportion of tallow, and laid on the plate. Thin paper is stretched evenly over the surface of the ground, and the design firmly drawn upon this with a lead-pencil. The paper being removed, the ground is found to adhere where the lines have been drawn in a manner corresponding to the grain of the paper and to the quality of the pencil. The biting is effected by the same method as in ordinary etching.

J. H. Tischbein, the younger, invented another method similar in its results to soft-ground. Powdered crystalline tartaric acid

[1] See General Bibliography, II. 1866.
[2] More particularly Daubigny, Millet, Rousseau, and Corot, about 1855-60.
[3] For a discussion of the process see G. Hédiard, *Gazette des Beaux-Arts*, Nov. 1903.
[4] Not to be confused with soft etching-ground, see p. 5. My own reference to Dietrich Meyer in the 1st and 2nd editions of this work was due to this confusion, as it is the soft etching-ground that he is reported to have been the first to use. See p. 288 for references to the history of soft-ground etching.

was dusted over the grounded plate before the ground, to which it was to adhere, was hardened. The lines were drawn with a blunt point, which forced the particles through the ground on to the plate. The acid being applied these particles would be dissolved, and so leave way for the biting of an irregular grain. The process has apparently been little used.

Generally regarded as a part of etching, but essentially more Dry-point. allied to line engraving, is the method called *dry-point*. A tapering point (often a solid piece of steel sharpened at either end, as in 17, and of much greater strength than the etching-needle) is drawn firmly across the copper, scratching its line, and causing a burr (as in 6*a* or 6*b* according to the inclination of the point), which is much more distinct than that raised by a properly sharpened graver. If, as is generally the case, the burr is left untouched, each line will print with a half-luminous ridge of tone at one or both sides, giving a richness of effect quite foreign to the pure etched line. Very few printings suffice to wear away the burr, which seldom lasts out more than fifteen to twenty-five good impressions. Some- times, though this is seldom done, the burr is scraped away. There is still something in the delicate sensitiveness of the dry-pointed line which is quite characteristic apart from the tone given by the burr.

The three processes of line-engraving, etching, and dry-point Mixed are frequently intermingled on one plate. Dry-point is constantly methods. used in combination with etching, to complete a lightly bitten plate, or add tone to an etched design. Then both etching and dry-point serve as aids to the line-engraver, and the etcher[1] likewise has occa- sional recourse to the graver. It is still possible strictly to define an etching from a line-engraving according as the one method subserves or dominates the other.[2] The earliest line-engravers used the one method alone, but in the eighteenth century it was the convention of the line-engraver to start his plate by a light etching of the general features of the design.[3] He then finished with the graver, often alternating engraved lines with the lighter ones first etched. Dry-point[4] has also been used by other line-engravers in place of the preliminary etching.

By *tone-processes* we mean those methods whose aim is the Tone- attainment of surfaces of tone comparable to a wash of colour. processes. Sometimes the engraver may wish to display the analysed elements of his work, but more generally he aims at an accomplishment which almost hides his method from the casual observer.

We will first describe the *crayon* (or *chalk*) *manner*, taking, as it The crayon does, a place midway between the line and tone processes. Its manner. aim is the imitation of the surface texture of the strokes of a chalk

[1] See *e.g.* Dorigny, Callot, Bosse, J. and E. van de Velde, etc., Chap. VI. pp. 160, 163, 168.
[2] See Chap. VII. pp. 197, 213, 221-2.
[3] See Strange, Sharp, Woollett, etc., Chap. VII. pp. 204-6 ; Hogarth, p. 234.
[4] *E.g.* Morghen, see Chap. VII. p. 209.

drawing. The plate is covered with the etching ground, and this is perforated with various kinds of needles (with one or more points) with the *roulette*, and other tools of the same genus, and with the *mace-head* (*mattoir*), an instrument with a butt-end provided with irregular points (13).[1] The roulette genus includes tools of various forms with a common feature in a revolving circular head. In its simplest form it presents a single serrated edge (10); or the cutting surface of the wheel may be broader, and dotted or lined in a variety of manners (the form, with an irregular grain, being sometimes called the *chalk-roll* (11), because of its common use in this process); while in a third type, called the *matting-wheel* (12), the head revolves at right angles to the handle.

After etching, the work is often strengthened with the graver, the dry-point, or with the same tools that were used in the etching (roulette, etc.), directly on to the plate. The oval-point is often used for the broader lines. The process is sometimes applied in combination with soft-ground etching, whose aim is analogous.

The Pastel manner. What is termed the *pastel manner* is essentially the same process as crayon, only a succession of plates[2] is used to print the various colours in imitation of pastel.

Stipple. The *stipple* method is closely allied to the crayon manner, but its imitation of broad surfaces of tone denotes a tone process without qualification. The essential element of stippling is the rendering of tone by a conglomeration of dots and short strokes (or flicks). As in the crayon method, both etching and engraving are brought into play, but a new element in stipple is the use of a graver curved as in 7.

The conventional method is to lightly etch the outline and chief contours, piercing the ground in small holes with the etching-needle (sometimes with two bound together), or with the simple roulette (10). Then the main part of the work is achieved by dotting or flicking with the point of the curved stipple graver, or the dry-point. The simple roulette may also be used directly on the plate, without intervention of the etching ground, as may also the other instruments of the roulette genus which have been already described. Line, is of course, frequently mixed with the dotted work.

Work with the punch (*gravure au maillet*). With less claim to a separate entity as a branch of engraving than the two preceding, but used in conjunction with others, is the method of *dotting*, directly on the plate, by means of the *hand-punch*, or the *punch* and *hammer*. It was a traditional method of the goldsmith long before the birth of engraving in our sense, and a considerable number of impressions exist taken at later periods from early goldsmiths' plates engraved in the dotted manner,

[1] See plates 14 and 15 in "1758" ed. of Bosse's *Gravure*.
[2] For further discussion cf. Chap. IX. pp. 288, 299, 307.

originally intended only for ornament and not for printing.[1] The *dotting-punch* with the single point (8*a*), or with a second point merely used as a gauge, is usually set in a handle and worked by the hand alone (it is the traditional tool of the map and chart engraver). Sometimes the head is flattened, and lined and hatched in the manner of a file (*matting-punch*, 9); this form, and other shapes with two or more heads, are always used with the hammer. The *ring-punch* (8*b*), with a hollow circular head, is a common goldsmith's tool, and was often used by the niellists. The punch-method is seldom used alone by the engraver, but is not infrequently found in conjunction with "crayon" or "stipple."

By *mezzotint* results are obtained in exactly the reverse direction Mezzotint. to that of all the other processes of engraving. The artist, having prepared a plate which would print quite dark, proceeds in a negative manner to work out his lighter portions.

The instrument most generally used to prepare the plate is The rocker. called the *rocker* (20). Its main element is a curved serrated edge with thread smaller or larger (some 50-100 teeth to the inch), according to the quality of texture required. The rocker is held with its blade at right angles to the plate, and the curved edge rocked regularly over the whole surface at many angles, causing a uniformly indented surface with a burr to each indentation. A proof taken from this would print black, much of the rich quality of the tone coming from the burr. Then with the *scraper* (23, with two cutting edges, a different shape from the ordinary scraper) the engraver removes those portions of the burr where the lights are to appear, working from dark to light. The more of the surface of the grain that is scraped away, the less will the ink be retained by what remains, and if the scraping and burnishing be continued quite to the bottom of the indentations, a smooth surface will be left, which will hold no ink, and print white. During the last century mezzotint engravers have lessened the arduous labour of preparing the ground by attaching the rocker to a long pole- The pole. handle, which can oscillate freely from a moving pivot in any direction. Indications are not wanting, however, to show that some such contrivance of pole and pivot had been known from the very beginning of the art.[2]

An earlier method of preparing the plate seems to have been by means of the *roulette*, and other tools of the same genus, especially the large barrel form with rim, lined and hatched, called the *engine* (21). The method of the earliest mezzotinters differed very essentially in the fact that it was largely a positive process. They roughened the plate where they required their darks, left the parts

[1] The *opus interrasile* and *opus punctile* used by mediæval goldsmiths are described by Theophilus, *Div. Art. Schedula*, Bk. III. capp. 72, 73 (ed. Hendrie). Cf. Chap. IX. p. 290.
[2] See Chap. IX. on Prince Rupert, p. 263.

which were to appear white untouched by the roulette or " engine,"
and so scarcely needed to use the scraper at all.

Mixed mezzotint. Engraving,[1] etching,[2] and dry-point[3] are sometimes used in
combination with mezzotint, and stipple[4] and aquatint[5] are also
occasionally added to vary the grain. Such combinations with
other processes, and with other aids, like that of machine ruling,[6]
constitute a *mixed mezzotint*.

Aquatint. Tone effects, similar to those obtained by mezzotint, but of even
more regular though less rich texture, are achieved by the *aquatint*
process. Its essential principle is etching through a porous ground
formed of sand or of some powdered resinous substance.

Laying the ground. There are various methods of laying the ground. The earliest
and perhaps the most usually employed is this. Some powdered

The dust ground. asphaltum, or resin, is put in a box; this is blown into a cloud with
the bellows (or with a fly-wheel worked from without), the plate
placed on the floor of the box, and the door shut. The dust settles
evenly over the surface, and is fixed to the plate for the biting by
the application of heat. Another " dust " method is to shake the

The spirit ground. powder over the plate from a muslin bag. A very different process
is to dissolve the resin in spirits of wine. If this solution is spread
over the plate the spirit will evaporate, leaving the dry grain on the
plate.

Another method of obtaining a perforated ground was invented
and described by Stapart (Paris, 1773), but it has been little used.[7]
He sifted sea salt on to a thin coating of ordinary etching ground,
which was kept fluid by heat. The grains of salt sink on to the
surface of the plate, and, when the ground is hardened, these
may be dissolved by application of water, leaving a porous ground
ready for the etching.

Biting. If any part of the plate is to be completely white this must be
protected with the stopping-out varnish. The plate is then put in
the acid and left to bite just as deeply as is required for the lightest
portions. It is then removed; the parts which are now bitten to
the required depth, are covered with varnish, and the plate is returned
to the bath. The process is repeated as often as needed, the por-
tions that are to print darkest naturally having most bitings.

Sand-grain. Similar effects to ordinary aquatint can be obtained by various
other methods, such as that of passing the grounded plate through
the press in conjunction with sand-paper.[8] This causes a slight burr
on the plate, but the main effect is attained by biting through the
etching ground which has been pierced in the process. In work
with these methods the scraper may have to be brought into play.

[1] *E.g.* Prince Rupert.
[2] *E.g.* Jan Thomas, George White, R. Earlom, J. M. W. Turner, S. W.
Reynolds. [3] *E.g.* Fürstenberg, John Dixon, etc.
[4] *E.g.* S. Cousins, W. Walker. [5] *E.g.* Charles Turner.
[6] Cf. p. 13. [7] I have not identified any print by Stapart.
[8] *E.g.* Legros, *La Mort du Vagabond*.

Analogous effects of great variety may also be achieved by pressing Textile-grain. textiles through the ground.[1]

The grain on the plate may also be corroded by means of Sulphur tint. sulphur. The plate is spread with oil, and powdered sulphur is dusted on to this. The particles will slowly eat away a very delicate grain. Then a delicate grain may be achieved by merely leaving Acid tint. the acid on the surface, or on parts of the surface of the plate, where required, either by means of feathering or by immersion. Examples of this may be noted quite early in our history, *e.g.* in two plates of Daniel Hopfer (B. 16 and 90), and recent etchers have not infrequently applied the same practice.

Since the end of the eighteenth century *machine ruling* has been Mechanical very largely used in one form or another by commercial engravers. methods. Many of the line engravers[2] of the latter part of the eighteenth and beginning of the last century used it largely for their skies, and for other regular surfaces in the shading. By complicated ruling machines the grains of mezzotint,[3] of aquatint, and of the various tone processes can be closely imitated.

A common practice, or fad, which dates from the end of the Glass coloured seventeenth century may just be mentioned. I mean that of laying prints. specially treated paper impressions (of either mezzotint, stipple, or what not) on glass, rubbing away the paper behind, leaving just the slightest film with the print, and then colouring at the back by hand. Seen in frames and in a bad light, *glass coloured prints* of this description often belie their real nature and pass as paintings.[4]

Edward Orme[5] had a special method of using varnishes which rendered the paper transparent wherever applied, avoiding the delicate process of rubbing away the paper. Charles Turner produced many prints to be treated in this manner.

Some recent engravers have used a process by which a print Monotypes. taken from a metal plate has something of the appearance of a mezzotint or aquatint, though the plate has not in reality been engraved at all. The method involves painting the subject in oils on the surface of the plate, either directly or by the reverse process of first covering completely, and then rubbing out the light by finger or brushes, etc. An impression is pulled from this either by hand pressure or in the printing press, and as only one impression can be taken they have been called *monotypes*.[6] The process chiefly belongs to the last twenty years, but its essential element, that of

[1] See p. 330, Lee Hankey. A note on textile grounds is appearing in a catalogue of Lee Hankey's prints by Martin Hardie.

[2] See Chap. VII. p. 211.

[3] See Unterberger, p. 273.

[4] For an early description of the process see J. Barrow, *Dictionarium Poly-graphicum*, 1735 (under "Mezzotint"). Cf. a "transparency" method of "back painting" described in J. Smith, *Art of Painting in Oyl*, 1687.

[5] See his *Essay on Transparent Prints*, 1807.

[6] For further information see S. R. Koehler, *Chronik* iv. (1891); E. Ertz, *Studio*, Aug. 1902; A. H. Fullwood, *Studio*, July 1904.

painting transferred in the press, had been occasionally used by earlier engravers, e.g. by Castiglione and William Blake. Sir Hubert von Herkomer[1] has developed the same idea further, making a metallic mould or electrotype from a plate similarly painted and dusted with powder to add a certain granulation to the surface. Impressions can be taken from this electrotype just as from an ordinary engraving. It is a method of re .oducing what is really a painting without the aid of photography, as in photogravure and the other mechanical processes.

Printing. As the artist-engraver is quite often his own printer, we will briefly state the elements of a process which can be finessed into a real art, and one on which the successful realisation of the engraver's idea depends in a large degree.

Some printer's ink is first laid on the plate and pressed into the lines by means of a dabber, similar in principle to that used for laying the etching ground. The superfluous ink is then rubbed from the surface of the plate by printing muslin, and the rubbing generally finished with the palm of the hand (coated with a thin layer of whitening). The plate is either rubbed quite clean, or more or less ink may be left on the surface, just where the engraver wishes to add a tint. A certain softness of effect is gained by what is **Retroussage.** called *retroussage*. Some fine muslin is passed lightly over the plate, just touching the surface. In this motion the stuff catches a portion of the ink, and, drawing it slightly upwards, leaves a certain quantity on the edges of the lines, which consequently lose the harshness of definition in the printing. By the same means ink may be drawn out of the lines, and spread as an even tint over the whole plate.

The copper-plate press. A sliding board which passes between two rollers is the essential feature of the *copper-plate press*. The paper is placed damp against the plate, and pulled through the press underneath layers of special blankets. In the case of wood-cuts and all relief-blocks the ink is merely taken from the surface, and the ordinary printing press with its perpendicular motion is sufficient for the comparatively small pressure required. In copper-plate printing, on the other hand, the pressure must be strong enough to force the paper into the hollows, and so pull out the ink.

From the presence of hole marks in impressions of not a few early prints—more especially Italian—it seems that at the earliest period of engraving, before the full development of the copper-plate press, the plate may have been sometimes pinned to a block, just as we know was done in the case of metal cuts.[2] In other cases, when early impressions are known without the holes, we may assume that these were made at some period to fix the plate to some article of furniture or decoration to serve as ornament.

Printing by hand-pressure. It must be remembered that it is the common practice of the

[1] See his *Etching and Mezzotint Engraving*, 1892.
[2] Cf. Chap. I. p. 37.

goldsmith to obtain test impressions by hand. These would be best taken by rubbing with the burnisher, or with some similarly shaped instrument,[1] a layer of smooth paper being generally sufficient cover to protect the damp paper on the plate. The thin and unequal quality of certain of the earliest prints may perhaps be sometimes explained by the assumption of printing by hand pressure.

The plate has to be refilled with ink between each impression. Sometimes the last vestiges of ink are pulled out by taking another impression, of course perfectly valueless in itself, which goes by the name of *maculature*. Maculature.

Occasionally a proof is taken, not from the plate itself, but from an impression on paper while the ink is still damp. Such *counterproofs*, which of necessity look weak and thin, and have no artistic value, are taken with the idea of having a print where the work appears in the same direction as on the plate itself, either for the sake of mere comparison with the latter, or as an aid to the engraver in making corrections or additions on the copper. Counterproof.

For the various methods of printing in colour we would reserve our remarks to a special section in Chapter IX.

It goes without saying that the work on the plate is gradually worn down through the printing. The number of good impressions which can be taken is a very uncertain quantity, varying in accordance with the quality of the engraving. Both dry-point and mezzotint, depending as they do for their quality on the delicate burr yield few brilliant impressions, often not more than some fifteen to twenty-five. We have noticed the fact that steel-facing is frequently used to-day to harden the surface. But even with this protection, in the case of delicate work like mezzotint, good impressions would still be limited to a hundred or so. From a line-plate, however, under the same condition, two or three thousand might be taken without great apparent deterioration. Without steel-facing, copper-plates of line-engravings and pure etchings might be made to yield one, two, or even three thousand impressions, but the deterioration is constant, and the last prints would be mere ghosts of the original composition. Number of impressions.

The amateur should bear in mind that an impression on which the *plate-mark* (*i.e.* the limit of the impress caused by the printing) has been cut away (what is called " clipped ") does not possess the value which attaches to a perfect print. One must remember, however, before branding a print as a *clipped impression*, that paper of a certain quality never retains the marks of the impress. The presence of the plate-mark is also a sure test to distinguish an engraving from a woodcut or a lithograph, a matter which in occasional instances is not without difficulty. Plate-mark.

The word *state* [2] is applied to the separate stages through which States.

[1] The term "hand-roller" sometimes occurs in books on engraving, but this would scarcely give the pressure required in intaglio printing.

[2] See A. M. Hind, "Engravings and their States," *Burlington Mag.* xv. 25, and 271.

a print passes when new work is added on the plate itself. The immense differences which can be made by printing with more or less ink on the surface never constitute a state, merely a variant impression. Besides definite changes in the work on the plate, the addition of the engraver's or designer's signature, address of publisher, and of the title (either scratched, or in clear engraved lettering), are all regarded as elements constituting states. The practice of *remarque* proofs, constituted by the presence of the "remarque" (as the subsidiary sketch in the margin is termed), largely emanates from the printseller of reproductive engravings and etchings of the last century, and is as inartistic in idea as it is commercial in spirit. A late impression need not be even a second state if no change has been made on the copper itself, while a comparatively early impression might quite well be a late state (say fifth or sixth) if the engraver has taken only one or two proofs from the plate in its earlier states, to guide him towards the development of his idea. Thus later states may be just as good from an æsthetic standpoint as early proofs, which from their very rarity command much higher prices.

<div style="margin-left:2em">Forms of inscription used by engraver, etcher, designer, publisher, and printer.</div>

The work of the engraver is generally indicated by one of the Latin words *sculp(sit)*, *caelavit* or *incidit*; and of the etcher by *f[ec(it)]* [*aqua forti*]. The student must be wary, however, in his inferences, as there are examples, more particularly in the sixteenth and seventeenth centuries, where the line-engraver uses *fecit* and the etcher *sculpsit*. The confusing mixture of processes in the line work of artists such as Callot, Bosse, J. van de Velde, etc., may account in some instances for the looseness of application. *Pinx(it)* and *delin(eavit)* are the usual predicatives of the painter and draughtsman respectively, *inven(it)* and *composuit* being also used in reference to the author of the design. *Figuravit* generally refers to a drawing having been made as the immediate basis for the print (often by the engraver himself), after the original composition of another artist. If the publisher's or printseller's name is given, it is generally followed by *exc(udit)*,[1] *divulgavit*, or *formis*, the printer's by *imp.*, though this seldom occurs except in manuscript.

<div style="margin-left:2em">Paper.</div>

In estimating the age of an impression, some knowledge of the various qualities of paper is of service, but it must be combined with the qualifying recognition that old hand-made paper (possibly as much as two or three centuries old) has always been much sought after and used for its quality by many modern engravers and etchers. The earliest engravers most commonly used ordinary linen-rag paper with a regular grain, not too opaque in quality.

Towards the beginning of the seventeenth century Indian and Japanese papers were beginning to be imported into Europe. The

[1] For a contemporary explanation of the term in the school of Wierix, see a letter of B. Moretus quoted by Max Rooses in his *Christophe Plantin*, 2nd ed., Antwerp, 1896, p. 279. Literally, both *exc.* and *formis* would imply the printer.

Indian

former, usually thin in texture, is of a white though dull surface, and prints much more cleanly than the latter. The Japanese paper is far more absorbent, and needs in consequence to be printed from a plate not too fully charged with ink. With its rich yellow tone and silky surface, it is an excellent paper where a delicate surface tint without sharp definition of line is required. Rembrandt used it largely, as have most etchers since his day. The paper used in the first half of the nineteenth century is generally the worst of all: it frequently displays its bad quality by turning colour in spots. This spotty discoloration of the paper—"foxing," as it is called— is as varied in its character as in its causes. It may be of animal or of vegetable growth, or even of mineral origin, arising from the composition of the paper, the nature of the ink, the dampness and impurities of the surrounding atmosphere, and a host of other causes. While the commoner forms may be removed by the simplest remedies, great care, as well as considerable scientific knowledge, is required by the restorer who is effectively to check each kind of growth. A thick card-like paper was also first used at the beginning of the nineteenth century, often a good sign of a more modern impression from an eighteenth century mezzotint. Vellum, whose manufacture goes back many centuries before that of paper, has been occasionally used at all periods. For large prints its rich quality is extremely powerful and effective. The manner in which it shrinks sometimes renders the identity of a vellum impression a puzzling matter. Even the great iconographer Bartsch did not avoid the pitfall, giving a separate description in his catalogue of Rembrandt to a shrunk vellum impression of a plate described in another number.[1]

Paper-marks, indicating a standard quality, or less often a particular factory, may be of occasional service in locating the origin and limiting the date of early prints, but the manner in which paper must have been transferred from one country to another, and the uncertainty of interval between manufacture and use, necessitate many reservations and qualifications in accepting this type of evidence. *Water-marks*

It may be added that impressions are sometimes taken on other materials besides paper and vellum, *e.g.* on satin or silk. In the eighteenth century this is by no means uncommon,[2] but it is difficult to set any limits to the period of the practice of printing on textiles, which, in the case of wood-blocks, was undoubtedly in use in Europe as early as the twelfth century.[3] *Impressions on silk and stuff.*

[1] B. 301, being described from a contracted impression (Amsterdam) of B. 300 (part of B. 366).

[2] One might instance Worlidge's *Gems*, 1768, of which some copies of the earliest edition were printed on satin. Of earlier work a satin impression of Dürer's *Frederick the Wise* (B. 104) in the British Museum may be noted. It is not likely, however, that it was printed before the seventeenth century.

[3] Cf. Chap. I. p. 19, note 1.

KEY TO THE PLATE ILLUSTRATING THE TOOLS USED IN THE VARIOUS METHODS OF ENGRAVING AND ETCHING

1. The graver or burin, set in the handle of most usual shape. *a* and *b*, sections of the same ; *a*, square ; *b*, lozenge ; and *c* and *d*, sections of the same sharpened with a flat (*c*), or round (*d*) lower edge, to act as a scorper (scauper or scooper).

2. Showing another shape of graver handle. The blade is here sharpened in a triangular section (the two cutting edges forming a smaller angle than in the lozenge), in the form called the tint tool. On the basis of this shape are sharpened scorpers (scaupers or scoopers) as in *b* and *c*, the threading tool (*d*).

3. Sections of the plate, showing the line as cut by the graver : *a*, with the burr ; *b* and *c*, the line as cut by square (*b*), or lozenge graver (*c*), with the burr scraped away ; *d* and *e*, the line as cut by a scorper (flat and round).

4. Section of a scraped mezzotinted plate.

5. Sections of the plate, showing the etched line : *a*, bitten with nitric acid ; *b*, bitten in the Dutch bath (hydrochloric acid).

6. Sections of the plate as cut by the dry-point, with the burr on one, or both sides, according as the point is held.

7. Stipple graver.

8. *a*, Dotting-punch ; *b*, ring-punch.

9. Matting-punch.

10, 11, 12. Various forms of roulettes—

 10. The simple roulette.

 11. The chalk-roll.

 12. The matting-wheel.

13. The mace-head (mattoir).

14. Etching needle.

15. The oval point (*échoppe*), and its sections, *a* and *b*.

16. The square and lozenge graver shapes (occasionally used in etching).

17. The dry-point.

18. The scraper, and section (*a*).

19. The burnisher, and section (*a*).

20. The mezzotint rocker. *20a*. Another view of the same.

21. The engine (a large type of roulette used by the early mezzotinters).

22. Mezzotint burnisher.

23. Mezzotint scraper, and section (*a*).

24. The gouge (or scooper).

25. *a*, Ordinary flat punch ; *b*, cocking punch.

26. Engraver's hammer.

27. Callipers, two types (*a* and *b*).

28. Oil rubber.

29. The roller (for laying the ground in etching).

30. The dabber (also for laying the ground).

CHAPTER I

THE EARLIEST ENGRAVERS

(THE FIFTEENTH CENTURY)

ENGRAVING, in its broadest signification, is no discovery of the modern world. Goldsmith and metal-chaser have flourished amongst almost every cultured people of antiquity of whom we have any knowledge, and the engraved line is one of the simplest and most universal modes of ornamentation in their craft. But there is no evidence that the art was used as a basis for taking impressions on paper before the fifteenth century of the present era, and our study has little to do with engraving apart from its application to this end. *Origin and antiquity of engraving.*

Printing from relief-blocks had already been practised for several centuries for impressing patterns on textiles,[1] but no paper impressions of wood-cuts are preserved which can be dated before the latter part of the fourteenth century. In fact paper itself can hardly have been procurable in sufficient quantity much before about 1400. It is by no means astonishing that the idea of printing from a plate engraved in intaglio should have been devised later than the sister process, where the transference of the ink from the surface of the block would entail comparatively little pressure.

The two processes of printing are so entirely different that one can hardly say that the line engraver owed more to the wood-cutter than the mere suggestion of the possibility of duplicating his designs through the medium of the press. The popularity of religious cuts and pictures of saints, produced in the convents, and sold at the various shrines to the pilgrims in which the age abounded, must have opened the eyes of the goldsmith to the chance of profit, which hitherto had been largely in the hands of the monks and scribes turned wood-cutters. Another incentive to the reproductive arts, of *The comparative position of wood-cut and intaglio engraving.*

[1] The known examples of such impressions on stuff (*Zeugdrucke*) seem all to belong to the period between the twelfth and fifteenth centuries. The method of printing is described by Cennino Cennini in his *Trattato della Pittura* (probably written before 1437), ch. 173 (Ed. Milanesi, Florence, 1859 ; tr. Mrs. Merrifield, London, 1844 ; A. Ilg, Vienna, 1871). For the development of early wood-cut printing, which the student of the origins of intaglio engraving cannot afford to forget, I would merely refer to two most valuable essays—(i.) F. Lippmann, *Ueber die Anfänge der Form-schneidekunst und des Bilddruckes*, Repertorium, i. 215 ; (ii.) C. Dodgson, *Introduction to Catalogue of Early German and Flemish Wood-cuts in the British Museum*. vol. i. (1903).

which the wood-cutter must have early taken advantage,[1] was the introduction of playing cards in Europe.

From their very beginnings the two arts were widely separated, that of line engraving having all the advantage in respect of artistic entourage. The cutter of pattern-blocks (*Formenschneider*) would be ranked in a class with the wood-carvers and joiners; the monk, duplicating his missionary pamphlets in the most popular form, might have been a brilliant scribe, but not often beyond a mere amateur in art; and, finally, the professional cutter, who was called into being by the increased demand towards the second half of the fifteenth century, was seldom more than a designer's shadow or a publisher's drudge. The goldsmith, on the other hand, generally started with a more thorough artistic training, and from the very nature of his material was more able than the cutter to preserve his independence in face of the publishers, who could not so easily apply his work to book illustration in conjunction with type.[2] Moreover, the individual value of the process would appeal to the painter and to the more cultured exponent of art more directly than the other medium, which often does no more than merely duplicate the quality of the original design. So quite early in the history of our art we meet the *painter-engraver*, i.e., as Bartsch understood the title of his monumental work, the painter who himself engraves his original designs, in contradistinction to the *reproductive engraver* who merely translates the designs of others. "Artist-engraver" has been recently suggested as an English rendering of *peintre-graveur*, but the term is hardly more happy than painter-engraver, for what reproductive engraver will not also claim to come beneath its cloak? As a term at once most comprehensive and exclusive, we would prefer to use *original engraver* (or *etcher*), for we have to deal with an artist like Meryon, who from natural deficiency (colour blindness) could not be a painter at all.

The earliest date known on any intaglio engraving is 1446, and occurs on the *Flagellation* of a Passion series in the Berlin Print Room (for another of the series see Fig. 2). There is direct evidence that others preceded this at least by a few years, and the priority of one master may reasonably be extended to a decade, or even more. Copies in illuminated manuscripts point to the existence of prints by the engraver, called from his most extensive work the MASTER OF THE PLAYING CARDS, as early as 1446.[3] This engraver forms the chief centre of influence on the technical character of the first decade of engraving in the North. From stylistic connexion with Stephan Lochner, he has been generally localised near Cologne, but recent recognition of Hans Multscher

Side notes:

The original engraver (*peintre-graveur*) as opposed to the reproductive engraver.

GERMANY: earliest group. The Master of the Year 1446.

The Master of the Playing Cards.

[1] In 1441 the Signoria of Venice forbade the importation of foreign printed pictures and cards (*carte e figure stampide*), which points to wood-cut cards being in existence at this period, though no extant pack can be dated with any certainty before 1460 (*i.e.* later than the earliest known cards in line-engraving).

[2] Cf. Chap. IV. p. 119, and note 1. [3] See Lehrs, *Jahrbuch*, ix. 239, xi. 53.

and Conrad Witz inclines Lehrs to place him in the neighbourhood
of Basle, citing the South German origin of Lochner as an apology
for the older position. His manner of shading, which suggests the
painter rather than the goldsmith, is of a simple order, consisting
of parallel lines laid generally in a vertical direction, and seldom
elaborated with cross-hatching. His playing cards (most of which

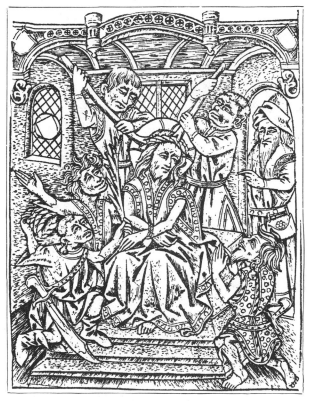

FIG. 2.—The Master of the Year 1446. Christ crowned with Thorns.

are in Paris or Dresden) present an example of the branch of
activity which, alongside with the making of small devotional prints,
formed one of the chief uses to which early wood-cutting and
engraving were applied (see Fig. 3). As a draughtsman he possesses
an incisive and individual manner, and, in his representations of
animals, he is no unworthy contemporary of Pisanello. The flat and
decorative convention of his drawing of bird and beast shows a
certain kinship with the genius of Japanese art.

Among the craftsmen who show the clearest evidence of his in-
fluence is the MASTER OF THE YEAR 1446, which gives considerable

weight to the assumption that the Master of the Playing Cards was
working some years before this date. With less artistic power and a

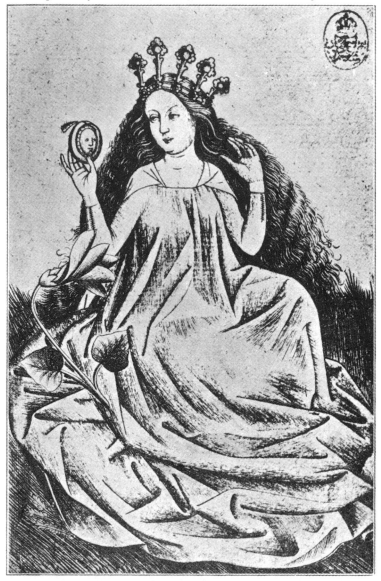

FIG. 3.—The Master of the Playing Cards. Cyclamen Queen.

more timid execution, the same scheme of parallel shading is followed,
though varied with a more liberal admixture of short strokes and flicks.

Another engraver, who emanates from the same school—of small original power, but of some interest as a copyist on account of compositions preserved us by his plagiarisms—is the MASTER OF THE BANDEROLES, so called from the recurrence of ribbon scrolls with inscriptions on his prints. He has also been called the Master of the Year 1464, but as he merely repeated the date from a wood-cut series which he copied (a grotesque alphabet now in Basle), the title is hardly apt. In certain instances, *e.g.* the *Alphabet*, and a *Fight for the Hose* (Munich), the latter from a print of the Finiguerra School (Berlin),[1] the sources of his plagiarisms have been identified. Others, like the *Judgment of Paris* (Munich), possess greater value as probable copies from lost Italian originals. As an artist he is of little account. Clumsy draughtsmanship is combined with slender powers of modelling, often still further enfeebled by the weak printing commoner in Italian than in German work of this period. It is not unlikely that he may have worked at some period of his life in Italy itself.

The Master of 1462 is another of the fictitious personalities whose name should be ruled out. The most recent criticism attributes the *Holy Trinity* at Munich (with the MS. date of 1462 on which the original name was based) to the Master of the Banderoles, and other prints formerly assigned to him are now attributed to the Master of the Playing Cards (*e.g. St. Bernardino*, Lehrs, i. 239, 11), or ranged under a newly christened MASTER OF THE WEIBEMACHT, so called from a print in Munich representing a *Woman on an ass leading four monkeys in her train* (Lehrs, i., Tafel, xi. No. 30).

Most of the earliest German engravers are now thought to belong to the Upper Rhine. Quite contemporary with these is another group which bears undoubted signs of Flemish or Burgundian origin.

The MASTER OF THE DEATH OF MARY (so named from P. II. 227, 117, and of great interest for a large *Battle* piece) is perhaps only one among other slightly older contemporaries of the engraver called from his most important plates the MASTER OF THE GARDENS OF LOVE.

In this engraver, some of whose prints must have been in existence in 1448, by reason of copies in a manuscript of that year, the Netherlands exhibit an earlier development of a certain grade of technical excellence than Germany, a fact which possibly points to the earlier introduction of the art in the former region. Besides the two *Gardens of Love* (Berlin and Brussels), which are of such importance for the view they give of the Burgundian gallant society of the middle of the century, considerable interest attaches to a *St. Eligius*, the patron saint of goldsmiths (P. II. 253, 2, Amsterdam). It is one of the earliest pictures of a workshop of the craft from which the art of engraving was emanating (Fig. 4).

Of about the same period, and either belonging to the Nether- lands or to the neighbouring region of Burgundy and France, is the

[1] See Lippmann, *Jahrbuch*, vii. 73. Dr. Warburg, on the other hand, holds that the original source from which both were taken was Northern (see *Sitzungsberichte der Kunstgeschichtlichen Gesellschaft*, Berlin, Feb. 1905).

engraver known by a print in Dresden (P. II. 32, 54) as the MASTER OF THE MOUNT OF CALVARY. His *St. George and the Dragon* (British Museum), with its strong outline and with its figures put sharply in relief, is almost certainly the work of a goldsmith. Still keeping to the simple scheme of parallel shading, he exhibits a sense of style in the dignity of his design uncommon among the engravers of the time. His *Knight in Armour* (Willshire, vol. ii. p. 483, G. 131*), of which the British Museum possesses a unique impression (Fig. 5),[1] is noteworthy for the curious type of armour and accoutrement, which seems to be nearer that in use in the region of Burgundy or the Jura than anything in Germany or the Netherlands.[2]

GERMANY :
second group.
E. S.

The Master, known by his initials, E. S. (or sometimes by the dates 1466 and 1467 which appear on certain of his plates), un-

FIG. 4.—The Master of the Gardens of Love. St. Eligius, Patron of Goldsmiths.

questionably owes much to the Master of the Playing Cards in the formation of his style.[3] It is a fact easily forgotten, considering the distance which separates the bulk of his work from the earlier efforts which were once regarded as the product of a different engraver, christened from the most important plate in this manner the " Master of the Sibyl." The plate of *Augustus and the Sibyl* (P. II. 68, 1) has all the timidity of youth, and is executed with less cross-hatching and a more liberal use of short flicks than most of the signed work of E. S. ; yet it already possesses the salient

[1] In a volume of costume prints in the King's Library, 140. i. 10 (fol. 80).

[2] Cf. H. Bouchot, *Un ancêtre de la gravure sur bois*, Paris, 1902, p. 96.

[3] Cf. *e.g.* the *Virgin with the Snake* (Padua, Bibl. del Seminario), the master-piece of the engraver of the Playing Cards, with E. S.'s small *Virgin on a Crescent* (P. II. 55, 142).

characteristics of form which mark the latter, the most prominent feature being the heavy nose. The master may have only begun to date his prints in quite the last years of his life, and this early work may reasonably be placed as far back as 1450.

The Master E. S. seems to have been a native of Strassburg, or some neighbouring town, and nothing is more likely than that he served his apprenticeship at Basle, or at whatever place on the Upper Rhine the Master of the Playing Cards had his school. The influence of Van Eyck has often been emphasised, but increasing knowledge of the indigenous schools of early German painting tends to diminish the probability of any definite point of contact with Flanders. E. S. does not rank high as an artist, but on the technical side he was one of the greatest influences in the progress of the art of engraving. Starting no doubt as a goldsmith, he gradually freed himself from the limitations of the craft, and developed a solid system of engraving, with a regular scheme of cross-hatching, which laid the foundation for the perfection of the art in Albrecht Dürer. As one would expect from a goldsmith, the secondary parts of composition, the ornaments, and conventional plants, etc., are de-

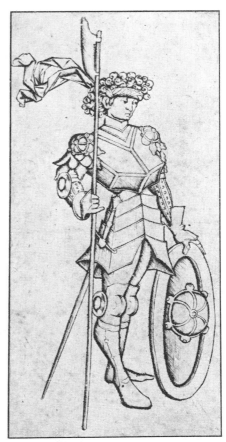

FIG. 5.—The Master of the Mount of Calvary. Knight in Armour.

signed with exceeding care. And if one regards separate faces and figures alone, he shows considerable power of expression, but in the larger problems of composition he is seldom quite successful. His most ambitious attempt in a composition of many figures is his large *Madonna of Einsiedeln*, dated 1466 (B. 35). In that year the Feast of the Consecration of the Swiss cloister by angels was celebrated

with considerable pomp, and the print was no doubt sold as a memorial to the pilgrims who attended the commemoration. Apart

FIG. 6.—The Master E. S. Virgin and Child with St. Margaret and St. Catherine in a Garden.

from its subject the plate itself has a historical interest. It passed into Italy, and with the original lines erased and the surface burnished, but still showing some traces of the old composition,

served an anonymous Umbrian engraver before the end of the
century for a figure of the famous warrior *Guerino Meschino*. This
would hardly have been done unless the plate in its original state
had been quite worn out, so we may assume that the number of
impressions taken from the plate must have been considerable.

Although E. S. is a constant interpreter of the forms of Gothic
architecture, he nevertheless seldom fails to commit the most
evident errors in perspective. An egregious example is the *Annun-
ciation with the Round Arch* (P. II. 69, 3), which Israhel van
Meckenem easily corrects in his copy, just as the author of the
wood-cuts in the Blockbook of the " Ars Moriendi " corrected other
similar errors in the originals of E. S. from which he borrowed.

E. S. is a perfect representative of the Gothic elements in the art
of design which pervaded nearly all German work of the fifteenth
century, elements that were gradually transfigured by the more
universal art of Dürer, and finally ejected before the middle of the
next century by the overwhelming stream of the Renaissance from
Italy. Apart from the predominance of Gothic forms of architecture
in the prints of this early German school, there is a responsive note
in all the other elements of its drawing. It is, as it were, a trans-
ference of the spirit that inspires the lofty pointed arch and sinuous
tracery, which is the basis of the long forms, the thin fingers, and
the angular folds, that so generally characterise the work of this
school. A noteworthy characteristic of the old Gothic architects
and sculptors was their affection for the grotesque. It is one of
those elements of design in which the German engraver of the
fifteenth century remains supreme. The *Grotesque Alphabet* of the
Master E. S. (B. 98, etc.) with its incisive humour is an excellent
example of this quality.

The technical advance from the simple scheme of the Master of
the Playing Cards which was chiefly promoted by E. S. and his
prolific work, was carried even further, and united with much higher
artistic endowments in MARTIN SCHONGAUER. He is the first of the
German engravers whom we definitely know to have been more a
painter than a goldsmith, and this fact will largely account for the
character of the advance which he achieved in the art. Living
almost all his life in Colmar, where he was probably born about 1445
(or somewhat earlier), nothing is more likely than that he learnt his
engraving in the workshop of E. S., which, as has been remarked,
was probably somewhere in the neighbourhood of Strassburg.

Both the technical manner and the types used in his early work,
such as the *Virgin and Child on the Crescent Moon* (B. 31), betray
a close affinity to that master. There is still small capacity for
modelling in perspective ; the child is as it were silhouetted against
the Virgin's breast with little attempt at foreshortening. Moreover,
in this early period all the essential features of the Gothic pervade
Schongauer's style. There are the long figures, the sharp folds, the

slender fingers with exaggerated knuckles, the lined and knotted faces. It is the spirit which is seen to perfection in one of his best and largest prints of this period, the *Death of Mary* (B. 33). Another comparatively early plate, the *March to Calvary* (B. 21), is again one of the largest, as so often happens with the young and ambitious artist. The strength of his genius for composition is here fully developed, but there is still a certain provincialism of characteristic both in types and technique which he almost completely loses later. The *St. Michael and the Dragon* (B. 53) is another plate essentially in the early style, but almost at its turning point, so fine and skilful is its engraving. His power of fantasy, akin to the grotesque in Gothic, is wonderfully exemplified in the *St. Anthony tempted by Devils* (B. 47), which Vasari tells us the

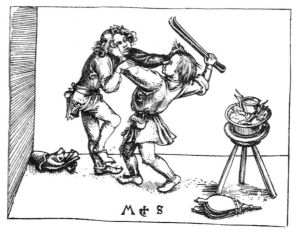

FIG. 7.—Martin Schongauer. Goldsmith Prentices fighting.

young Michelangelo was inspired to copy. Combined with his imaginative power, are a sense of humour and powers of observation which place his *Goldsmith Prentices fighting* (B. 91, Fig. 7), and the *Peasants going to Market* (B. 88) among the best pieces of genre produced in the fifteenth century.

Little by little Schongauer rises above the Gothic limitations both of setting and of type. Ornament and architecture are simplified, and everything is concentrated on the expression of the central idea. For the nobler characters he represents, he comes to discard the ill-favoured, one might say provincial types from which E. S., and in fact most German engravers of the fifteenth century, never swerved, and actualises an idea of beauty which in its nearer approach to more absolute ideals appeals to a far more universal appreciation. In the *Christ appearing to Mary Magdalene* (B. 26, Fig. 8), and *Christ and Mary on a Throne* (B. 71) the full blossom of

his art is seen. The concentration of interest on the central theme is noteworthy. In the former the distant landscape is mere outline, the tree is bare, the grass is without the varied and distracting collection of goldsmiths' plants, while in the latter there is no ornament to divert the attention in the simple architecture whose graceful lines merely serve to balance a beautiful composition.

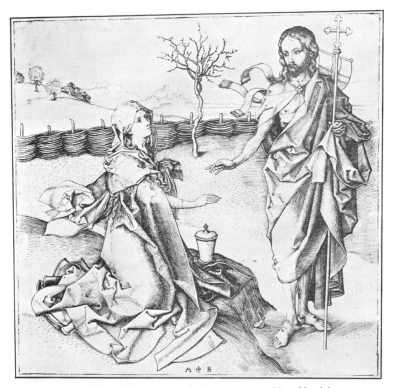

FIG. 8.—Martin Schongauer. Christ appearing to Mary Magdalene.

If our suppositions are correct, the chain of development from the beginning of the art in Germany passed from the Master of the Playing Cards to E. S., and from the latter to Schongauer. And the last of these, whose talent only just fell short of the height of a master great in the universal sense, was the link to join the former to Dürer, who in 1491, the year of Schongauer's death, was just beginning his work.

Until the end of the century Schongauer's influence remained paramount among German engravers, and, like that of E. S., was felt in no inconsiderable degree as far abroad as Italy.

Chain of development in German engraving.

L&8.

At least one other member of Schongauer's family, Martin's brother Ludwig, was an engraver, if, as is most likely, this is the right interpretation of the monogram L&8. Tradition has also identified a certain Barthel Schongauer with the engraver who uses the signature bα8, but it is probable the monogram is rightly read BG, and not BS. He copied several of Schongauer's plates, but his original work is in reality more closely allied to that of the Master of the Amsterdam Cabinet (see below).

bα8.

B M.

A master whose style was closely formed on that of Schongauer is the monogrammist B M. His engraving is somewhat crude and his drawing irregular, but his large plate of the *Judgment of Solomon* shows no lack of dramatic force.

LCℨ.

An engraver of much greater originality, who also to some extent shows the influence of Schongauer, is the master known by his signature LCℨ. There are elements in his work, *e.g.* the landscape and architecture, which point to the Netherlands, and it seems attractive to regard the z of his monogram as the Dutch ending -zoon, but on the whole evidence inclines to locate him in Upper Germany. His *Temptation of Christ* exhibits a likeness to Schongauer in the type of face, but the composition as a whole is quite original and full of fantasy, and the manner of engraving, if somewhat thin in line, has no little charm.

A. G.

The more delicate elements of Schongauer's style were perhaps most aptly continued in the master of the monogram A. G. (who on insufficient grounds has been called Albrecht Glockenton, one of a family of Nuremberg miniature painters). His work and that of another anonymous master, WᴧH (who has been called Wolf Hammer) possess a special interest as being found printed directly on the page of text in certain missals and breviaries published by Georg Reyser at Würzburg and Eichstädt between 1479 and 1491. They are among the rare examples during the fifteenth century in the North[1] of a practice which was hardly used at all until a hundred years later.

WᴧH.

B�osR.
PM.

In Lower Germany, Schongauer finds his closest followers in the engravers with the monograms B☦R and PM. The latter has hardly a rival among these early masters in the power of modelling the nude, which is notably good in his *Crucifixion with the two Thieves* (Frankfurt).

The Master of the Amsterdam Cabinet.

The only other engraver before Dürer besides E. S., who can claim a place at all comparable to that of Schongauer, is the anonymous artist called from the Print Room which contains the largest collection of his works (amounting in all to some eighty pieces) the MASTER OF THE AMSTERDAM CABINET. From a book of drawings by the same hand preserved at Wolfegg, somewhat vaguely called the *Hausbuch*, which illustrates the Planets and their influences, and the various arts and occupations of men, he has

[1] Cf. pp. 33, 47, 65, 70, 96, 119.

also been called the MASTER OF THE HAUSBUCH, while a date which
Duchesne asserted to have been written on one of the prints (though
this is not at present known) gave him the further title of the MASTER
OF 1480. As yet none of the many suggestions as to his personality,
one of which identified him with Holbein the Elder, has been con-
vincing. It is now generally assumed, however, that he must be
looked for somewhere on the middle Rhine, perhaps near Frankfurt
or Mayence.

He is an artist with a freedom of draughtsmanship quite remark-
able at this epoch. If his manner of engraving has something of
the irregularity of an amateur, his power of expression is vigorous
and masterly. With certain brilliant characteristics, which by their
very modernity may attract us even more than Schongauer, he never-
theless stands well behind the latter in artistic conscience and power
of composition. His plate of *Solomon's Idolatry* (Lehrs 7) is a
wonderful example of the meaning he can put into his faces, while it
is characteristic in another particular, the presence of a little curly
dog who is looking on with an interested expression, a piece of side-
play which almost foreshadows Rembrandt. His plate of a *Dog
scratching his Neck* (Lehrs 78) shows how directly he studied nature.
He is one of the first of the German engravers to attempt unaffected
portrait directly from the life, *e.g.* in his *Study of two Heads* (Lehrs
77). It has generally been asserted that hardly any outside influence
makes itself felt in this engraver's work. But his *St. Martin and
the Beggar* (Lehrs 38) and *St. Michael and the Dragon* (Lehrs 39,
cf. Schongauer, B. 53) could hardly have originated without some
suggestion from the corresponding subjects in Schongauer's work,
while his *Woman with the Escutcheon* (Lehrs 86, Fig. 9) recalls
analogous compositions of the same master (*e.g.* B. 97), at least in
the type of face. But these, and a single reminiscence of F. S. (in
the *St. Mary Magdalene*, Lehrs 50), are isolated instances, and his
achievement is almost perplexing in its originality. His technical
manner also stands quite apart from other work of the period.
With its burr the result is like that of dry-point, which was so
little used before the seventeenth century. Whether he scratched
the plate with a proper dry-point, or with the graver, matters little.
The burr was not scraped away, and the essential virtue of the dry-
point process was already realised.

Allied in style to the Master of the Amsterdam Cabinet, at W⚥B.
least in his irregularity of manner as an engraver, and in a natural
power of rendering facial expression, is the master of the monogram
W.⚥B. Only some four prints of his are known, but they are re-
markable among the earliest attempts at lifelike portrait engraving
in Germany.

It was not long before the achievement of the Master E. S., which NETHER-
technically so far outstripped that of any of his contemporaries, made LANDS :
itself felt as a most potent influence beyond the German borders. second group

The second generation of engravers in the Low Countries profited far more from the advance made by the German master than from the work of immediate predecessors of their own nationality.

Master of the Boccaccio Illustrations. Of dated work at this time there is little besides that of the

FIG. 9.—The Master of the Amsterdam Cabinet. Woman with the Escutcheon.

MASTER OF THE BOCCACCIO ILLUSTRATIONS, *i.e.* the author of a series of prints which appeared in a French translation of Boccaccio's *De Casibus virorum et foeminarum illustrium*, published by Colard Mansion at Bruges in 1476. The drawing is crude and ungainly, but there is considerable vivacity in the figure composition, and a refreshing truth in the simple architectural backgrounds of some of the plates. With this engraver shading is quite secondary to

outline. In one of the very rare copies of the book (belonging
to the Marquis of Lothian, Newbattle) the plates [1] are coloured by a
miniature painter of the time, and the engraver probably fashioned
his style with a view to this possibility. There are many other
examples, notably among such work as the numerous small devotional
plates of the German MASTER OF THE ST. ERASMUS, where prints
have served as an outline basis for the illuminators of manuscripts.

We may mention in this place another print which has particular
interest as being found in the Chatsworth copy of the earliest book
printed in English, i.e. Caxton's *Recuyell of the Histories of Troye*.
It represents *Caxton presenting a Copy of his Work to Margaret of
York* (the wife of Charles the Bold), and though not known in
any other copy, and here only inlaid in the first blank leaf and
perhaps inserted at a much later date than the first publication,
must nevertheless have been originally designed to illustrate the
book.[2] The *Recuyell* was printed in Bruges some two years before
the Boccaccio, and the plate is certainly by an engraver of the same
school as the Boccaccio illustrator, if not by the same hand.

A sounder and more prolific craftsman than the Boccaccio W⚹
master was the engraver who used the signature W⚹. In his case
the dependence on E. S. is sufficient to support the assumption,
that he may at some time have studied under the German master.
This may account for his possession of some of the plates of E. S.,
which were reworked in his studio, and provided with his signature.
It has been recently suggested that the rework was really due to
Israhel van Meckenem, who on this hypothesis must have served an
apprenticeship with the Netherlandish master.[3] By far the most
interesting work of W⚹ consists in his engravings of Gothic
architecture and reliquaries. His system of shading is sound, and
by a good command of light and shade he succeeds well in giving
the idea of depth to his constructions. His understanding of
perspective is quite remarkable among the engravers of the fifteenth
century.

An early Dutch engraver of pronounced individuality is the I A M of
master who uses the monogram I A M, sometimes adding the sign of Zwolle.
a weaver's shuttle, and the word ZWOLL (which was no doubt the
place of his activity). In style he is a close follower of the contem-
porary school of painting in Holland, of whom Albert Ouwater and
Geertgen tot St. Jans are the best known representatives. Such prints
as the *Christ in the Garden* (B. 3) and the *Taking of Christ* (B. 4)
are characteristic of the realism of his manner and the exaggerated

[1] Pasted in. The only other copy known with plates is at Göttingen. Cf. pp.
30, 47, 96, 119 for the practice of printing directly on the page of text. See also
pp. 65, 70.

[2] See S. M. Peartree, *Burl. Mag.* August 1905, and A. W. Pollard, *The Library*,
Oct. 1905.

[3] See M. Geisberg, *Meister der Berliner Passion und I. v. Meckenem*, 1903, p. 91.

expression he gives to his coarse and heavy-featured types. His most successful plate, both in the avoidance of exaggeration, and in the engraving, which is less crude and harsh than usual, is the *Adoration of the Kings* (B. 1).

Allart du Hameel.

Working quite near the end of the fifteenth, if not at the beginning of the sixteenth century, is the architect and engraver ALLART DU HAMEEL, who interests us chiefly as preserving the designs of that master of fantastic satire, Jerome Bosch. The word "Bosche" which occurs on several of his plates may refer to the painter, or perhaps merely to the town which was common to both painter and engraver. Allart du Hameel uses the simplest technical means. His shading, which is fine and delicate, is little in evidence, and he relies almost wholly on an outline which, in his *Battle-piece* (B. 4) and the *Last Judgment* (B. 2), must very closely reproduce the delicate and incisive line of his model.

F V B.

Another engraver whose work betrays the influence of the Dutch school, and of Dierick Bouts in particular, is known merely by his monogram F V B. In spirit he comes nearer than any engraver of the time to the Master of the Amsterdam Cabinet and to Schongauer. His *Samson and the Lion* has much of the vivacity of the former master, while technical analogies in the use of dry-point, though more sparingly applied, may be noted in his greatest plate the *Judgment of Solomon* (B. 2). Like both the engravers with whom we have compared him, he is an excellent engraver of genre, and his *Two Peasants quarrelling* (B. 35) is one of the most entertaining plates in this field produced in the fifteenth century. Old tradition calls him FRANZ VON BOCHOLT, but as yet no foundation has been found for the identification.

LOWER GERMANY: the close of the century. Israhel van Meckenem.

In Israhel van Meckenem we meet an engraver who is known to have worked towards the end of the century at Bocholt, where he died in 1503. As we have noted in relation to $\mathbb{W}\, \lambda$, there is evidence that Israhel's stylistic connexion with the Netherlands may be referred in a particular degree to a possible apprenticeship with this master. Like most of the early engravers he was a goldsmith, and never in fact much more than a clever craftsman. He was a prolific producer: his work amounts in all to some 570 plates, but a large proportion are copies from E. S., Schongauer, the young Dürer, and others. He was one of the first engravers to apply to any extent the idea of reworking his plates after they were worn with many printings. Nor did he limit this practice to his own engravings, but reworked numerous plates of others, *e.g.* of E. S. and F V B, and more than all of the MASTER OF THE BERLIN PASSION, who has been recently identified with Meckenem's father.[1] One of the faculties of the goldsmith, that of ornament, he possessed in a high degree,

[1] See Individual Bibliography (Geisberg). The student should beware of confusing him with the Master of the Year 1446, who is also known from his Passion Series in Berlin.

and his prints of Gothic grotesque and scroll work are among the most excellent of their kind (see Fig. 10).

Another engraver of the Lower Rhine (probably of Cologne), the P. W. master of the monogram P. W., produced one of the most ambitious series of prints of the time, six large illustrations of the Swiss War of 1499. There is considerable freedom and vigour in his figures, not unlike that of the Master of the Amsterdam Cabinet, but the landscape, seen almost as a bird's eye view, is quite elementary in character. His most pleasing work is a set of small round playing-cards of extremely delicate engraving.

Among the engravings produced in Upper Germany at the close UPPER of the century, a small group signed F. S. possesses added interest GERMANY. from the attribution to the Nuremberg sculptor VEIT STOSS. They Veit Stoss. are evidently the work of an artist unpractised in the process, but

FIG. 10.—Israhel van Meckenem. Ornament with grotesque figures.

his *Madonna with the Apple* (B. 3), *Raising of Lazarus* (B. 1), and *Pietà* (B. 2), despite some exaggeration in the treatment of the minutiæ of form, *e.g.* the veins of the leg in the *Pietà*, possess a distinct charm of their own.

One engraving, a design for a baptismal font, has been attributed Jörg Syrlin. to another sculptor, JÖRG SYRLIN of Ulm. The elder sculptor of that name, who seems to have died in 1491, has generally been reputed its author, but the evidence is so slight that it might almost as well be by the son, who lived well into the sixteenth century.

The group of engravings signed *Mair*, if rightly assigned to Mair of NICOLAUS ALEXANDER MAIR, a painter who was working at Land- Landshut. shut between 1492 and 1514, are distinctly archaic in stamp for the time of their execution. The line-work is simple, the shading is in broad surfaces with little detail, the architecture is that of doll's-houses. In one respect he seems to have anticipated the idea of the chiaroscuro cuts which Cranach and Burgkmair made popular in Germany. He often printed on grey or green prepared

paper, and heightened the ground with white (*e.g.* the *Nativity*, signed and dated 1499 in the British Museum), so that his system of light shading was no doubt followed with this purpose in view.

M. Z.

Another engraver, also probably belonging to Bavaria, is the master of the monogram M. Z., who has been generally called MATTHÄUS ZASINGER, though on little foundation. His largest works are two prints, dated 1500, illustrating festivities—a tourna-ment and a court-ball—at Munich. But his special charm as an engraver of genre, who has mastered the finer elements of his process, is better seen in a print like the *Youth and Girl embracing in a Room* (B. 15), which, though poor in draughtsmanship, displays an extremely delicate handling of the medium. Working, like Mair, at a time of transition, he stands in sharp contrast to the latter as already betraying the influence of Dürer, and anticipating, more particularly in his landscape, the freer style of the etchers of the Regensburg school.

ITALY.

Many words have been wasted by the belligerent critics who have championed the respective claims of Germany, the Nether-lands, or Italy for the award of priority in the practice of the art of engraving. Vasari's story that its invention was due to the Florentine niellist and goldsmith, Maso Finiguerra, about 1460, must, of course, be discarded in view of our present knowledge of the origins of the art in the North, if not also by the existence in Italy itself of engravings which must precede any that can be attributed to Finiguerra by a decade, or even more.

But without entering any profitless discussion on a matter whose aspect may at any time be changed by new discoveries, it must be confessed that the relatively higher technical development of the art in the North by about the year 1460 inclines one to regard Germany or the Netherlands as the first home of engraving, as it was of printing. But unlike printing, which was pioneered in Italy about 1465 almost entirely by the immigrant Northerners, the art of engrav-ing, even if in some degree suggested by foreign work, developed quite as a native plant, and was practically untouched by the influ-ence of the Northern engraver until several decades after its inception.

Italian and Northern schools of engraving contrasted.

The early Italian engravers may not possess the technical proficiency of their Northern contemporaries, but they have a much finer feeling for the beautiful, if not an absolutely higher artistic sense. The output of the century was much smaller in the South, but in some respects far wider in its scope. In the North we have found the art largely used for little devotional prints, for whose artistic worth those who scattered them cared little. In Italy, on the other hand, the tide of the Renaissance had opened up broader channels of thought, and in a country with an awakened sense of beauty, where art was already recognised as having self-contained ideals apart from the matter it dealt with, the artist commanded a

more liberal range of subject combined with a greater reluctance to let out his work cheaply to merely missionary uses. If engraving in Italy had a practical cause to serve, it was essentially an artist's motive, the desire to multiply designs which might serve as models in the workshops of sculptor, goldsmith, potter, and craftsmen of every type.

One of the signs which point to the later introduction of engraving in Italy than in the North is the later development of the art of good printing of copper-plates. Quite the majority of the contemporary impressions of Italian prints up till about 1470 are printed so poorly (not to take into account the common light greyish green colour of the ink used), that one is led to surmise that many must have been taken either by hand (with burnisher or some similar instrument), or by a printing-press with none of the equality of pressure provided by the double roller. A lack of definition, and a line of broken or dotted character are often good signs of an early impression of a print of this school.

A problem of some difficulty in relation to early plate-printing is the presence of rivet-holes in many of the fifteenth century Italian engravings, which, as they occur in many instances on even the earliest impressions, cannot always merely indicate the application of the plate itself, like a niello, to decorative purposes. Such rivet-holes are found to occur in many examples of the early prints in the *manière criblée*, white line metal-cuts which would be printed like wood-cuts, and so would have to be fixed on to a block for the press. It is not unlikely that the early Italian printer of copper-plates, for some reasons dependent on the type of press in use, found a similar convenience necessary in the case of ordinary intaglio engravings.

As a craft, engraving in Italy tended more quickly than in the North to yield itself to the service of some great painter or school of painting, and so developed earlier a style which the more independent German goldsmith engraver was longer in seeking. For the average artistic quality of work in the beginnings this tendency was no doubt a benefit, and the readiness of the engraver to sink his personality probably explains why the Italian painter, with pliable interpreters to hand, took to engraving less often than the German. In the end the blessing proved a bane, and produced a host of secondary engravers, while in Germany the best artists were still devoting their personal energies to original engraving.

Although there is no certain evidence as in the case of The early Germany, the earliest Italian engravings seem by reason of style to group. date at least a few years before the middle of the fifteenth century. They are probably for the most part the production of Florence, which was then, as it remains to-day, the centre of the goldsmiths' craft in Italy. An important place in this early group is taken by two series of plates in the Albertina, Vienna, the *Larger Passion*

The Master
of the larger
Vienna
Passion.

(B. xiii. p. 77, 16-25) and the *Triumphs of Petrarch* (B. xiii. p. 116, 12-17). They are rough and crude in cutting, and suffer from an exaggeration both in the delineation of bulging muscles and in the

FIG. 11.—Anon. early Florentine Engraver. The Resurrection.

overladen ornament which is the mark of the goldsmith engraver. Another plate, probably by the engraver who is responsible for the above series, is a *Resurrection* in the British Museum (Fig. 11),

which shows the Medici badge [1] on the shield of one of the soldiers. Here the predominant influences seem to be those of Masaccio and Fra Angelico, though it is somewhat closely reminiscent of a relief by Luca della Robbia over one of the Sacristy doors in the Duomo at Florence, which was commissioned in 1443. Of other prints of the period which amount in all to a very small number, *Virgil the Enchanter* (Dresden) shows close relations to the style of cassone painting common in Florence about the middle of the century, and the *St. Peter Martyr* (British Museum and Rome) something of the realism of Castagno, but the greater part point to the sculptors like Brunelleschi, Ghiberti, and Luca della Robbia as the strongest factors in Florentine art at this time.

A *Profile Portrait of a young Woman* (Berlin)[2] is one of the finest examples of the early period, owing its success in no small measure to the avoidance of problems of light and shade which the Italian engraver had not yet learnt to cope with. It is a mere outline, the head-dress and bust richly bedizened in embroidery and jewels, of a type seen in a group of pictures which has been variously attributed to Domenico Veneziano, Piero della Francesca, Verrocchio, and Pollaiuolo. It is not altogether impossible that such a work as this head might have emanated from the workshop of the young goldsmith-painter Pollaiuolo.

Some sort of limit to the work of this early period is furnished by the *Resurrection with the Table for finding Easter* (British Museum) which must have been executed by 1461, as this is the first year cited. As an engraving it is of a secondary order, corresponding to a *Smaller Passion Series* (B. xiii. p. 74, 2-15), and a copy on one plate of the six *Triumphs* mentioned above (B. xiii. 423, 60) (both in the Albertina), but it is of the greatest importance, giving, as it does, the earliest date found on any Italian print.

The distinct advance made in the art between about 1455 and 1480, which we may call the second period of Italian engraving, is perhaps due in large measure to MASO FINIGUERRA, who by no means deserves the glamour of unreality which modern critics, in the heat of their reaction against Vasari's exaggerated claims, have allowed to gather round him. The main facts of his life are well attested. Born in 1426, the son of a goldsmith, and brought up in his father's craft, Maso Finiguerra is known to have been working in niello in 1449. In 1452 he received payment for a niellated pax[3] done for the Baptistery of St. John; five years later he is found in partnership with Piero di Bartolommeo di Salì, and in the early sixties, if not before, he is closely associated with Pollaiuolo, who is also known to have worked with Salì. In 1463 there is

The second period. Maso Finiguerra.

[1] Three feathers encircled by a ring. [2] *Jahrb.* I. p. 11.

[3] Probably a *Crucifixion with the City Walls in the Background*, and not the *Coronation of the Virgin* (a work of the school of Filippo Lippi, perhaps by Matteo Dei), which Gori (*Thesaurus Diptychorum*, 1759) was the first to christen Finiguerra. Both are in the Bargello, Florence.

evidence that he supplied designs for some of the intarsia panels in the Sacristy of the Duomo (the subjects certainly by his hand being *St. Zenobio between two Deacons*,[1] and the *Annunciation*). His burial is recorded in 1464.

Besides these designs for intarsia, which are his best authenticated works, there is every reason to accept the old attribution of a series of drawings in the Uffizi, which was admitted by Vasari and Baldinucci, and is supported by the presence of the master's name in a contemporary hand on several of the series. With these may be ranged a set of drawings in the British Museum, forming a sort of Chronicle of the World, which, if showing more than one hand, must emanate from the same workshop as the above. Then there is an important group of nielli (of which Baron Edmond de Rothschild has the largest collection[2]), and their correspondence in style with the intarsia panels and the drawings points to the same author, leading to the very reasonable conclusion that they are by the most famous Florentine niellist of the period.

Finally, we have a group of engravings, closely agreeing in style with all the above, which Mr. Sidney Colvin has reclaimed to the master's honour. Vasari's reference in his life of Pollaiuolo to Finiguerra as a "master of engraving and niello[3] unsurpassed in the number of figures he could efficiently group together whether in small or large spaces" (a passage in which he seems not to have thought of the claims which he makes later in the chapter devoted to Marcantonio and other engravers for Finiguerra as the inventor of the art) added to the evidence which we have summarised above, seems to raise the attribution of some at least of these engravings to the famous niellist out of the realm of conjecture into the certainty of an established fact.

The engravings to which we refer, as most certainly by the hand of Finiguerra, are the *Planets* (a series of seven plates), the *Road to Calvary and the Crucifixion*, the *Fight for the Hose*, and the *Judgment Hall of Pilate*. It is a likely assumption that Finiguerra only turned to the new art during the last few years of his life, and possibly none of these prints date before about 1460. The *Planets* series, with its summary of astrological lore, must have been very popular at the time, if we may judge by the existence of a set of copies which appeared very soon after the original publication (in conjunction with a calendar starting with the year 1465). The *Mercury* is of special interest to the student of engraving, as it depicts the shop of a goldsmith such as we may picture Finiguerra's to have been (Fig. 12). In all these engravings there is a considerable technical advance upon the coarse cutting of the earlier group, but the line still lacks clearness of definition, though this may be due in part

[1] Now in the Opera del Duomo. Baldovinetti also supplied designs for the panels.
[2] Formerly the Salamanca Collection. Reproduced : G. W. Reid, London, 1869.
[3] *Per lavorare di bulino e fare di niello.*

to imperfect printing. The main characteristics of style in dress
are still the long trailing skirt, and the two-peaked hat with heavy
veil borrowed from the costume of Burgundian society,[1] which figures

FIG. 12.—Maso Finiguerra. The Planet Mercury (part).

so prominently in Florentine cassone paintings between about 1440
and 1460.

In Italy for half a century or more after 1450 the art of niello
was a popular branch of the goldsmith's craft (far more so than in

[1] Cf. in Northern art the work of the Master of the Gardens of Love.

the North), and its close connexion with the development of engraving will warrant a slight digression.

Niello may be described as the method of treating an engraved silver (or gold) plate by filling the furrows with a black substance (*nigellum*) formed by the fusion of copper, silver, lead, and sulphur, which gives the art its name. Powdered niello was laid on the surface of the plate, melted by the application of heat, and so run into the lines. The substance being allowed to cool and harden, the surface of the plate was burnished, and the design would appear in black on a bright ground. The art was no doubt known to goldsmiths several centuries before the introduction of engraving,[1] but it was little practised until quite the middle of the fifteenth century, when it suddenly became popular, only to fall almost completely out of use some sixty or seventy years later. Outside Italy it never greatly flourished. The mark of a good niello-plate in general is distinctness and clearness of cutting, but there is large variation in different schools in the depth of the engraving, in the intervals between the lines, and in the greater or lesser use of cross-hatching. Thus in the Florentine school the background is generally cut in clear lines, laid in two parallel series crossing nearly at right angles, while the delicate modelling is done by a system of much more lightly engraved lines carefully cross-hatched. Of this the niello-print which we reproduce in Fig. 13 (which is one

The Two Schools : the Florentine;

FIG. 13.—Maso Finiguerra, or a Niellist of his School. Two Cupids blowing Trumpets.

the Bolognese.

of the group attributed to Finiguerra) is an excellent example. The Bolognese school, on the other hand, of which FRANCESCO RAIBOLINI (FRANCIA) was the head, aimed at a velvety tone, both in modelling and background, which was achieved by the closest cross-hatchings, in which the effect of single lines was lost (cf. pp. 69, 70, and Fig. 14). Now the characteristic of the clear cut line noticed in the backgrounds of the Florentine nielli is already seen to some extent in several plates of the earliest group (*e.g.* the *Resurrection with the Medici Badge* (Fig. 11) and the *St. Peter Martyr*, B. xiii. 88, 6), but the

[1] A type of niello was practised among the Romans, and also by the Pagan Saxons in England (about the sixth century). A description of the process is given in Theophilus (also called Rugerus), *Diversarum Artium Schedula* (lib. iii. capp. 28, 29, 32, 41), which was probably written at the beginning of the twelfth century. In the preface to lib. i., in referring to the Schedula, he adds *quam si diligentius perscruteris illic invenies quicquid . . . nigelli varietate novit Tuscia*. Dr. Ilg (who edited the Schedula, Vienna, 1871) held that Theophilus was a German monk of Helmershausen. In any case the mention of Tuscany as the chief home of the art of niello is significant, though the reading *Tuscia* has not passed unchallenged.

second factor, the close modelling, does not begin to make itself felt before the engraved work of Finiguerra himself and the beginning of what is called the "Fine" Manner. In the development of this "Fine" Manner the niello technique is of definite moment, though engraving in its beginnings must be regarded as originating from the goldsmith's art in general rather than from this special branch.

To judge from the niello prints in existence (of which scarcely any go back as early as 1450), the idea of taking impressions of nielli on paper would hardly have been the beginning of engraving in Italy; much more probably it was the niellist who took the suggestion from the already existing practice of engravers. A common method for the niello engraver to test his work was to take a sulphur cast of the plate and rub the lines with black, which would give an effect far truer to the original than any impression on paper, as may be seen by several examples of these rare "sulphurs"

FIG. 14.—Peregrino da Cesena (?) Neptune.

which are preserved in the Print Room of the British Museum. It seems that in most instances of early impressions from real nielli the proof was taken from the sulphur; but the sulphur being an exact replica of the plate in form, and the impression being the reverse of the original, whether taken from the plate or from the sulphur, certainty on this point is not always attainable.

Soon the niello-worker felt in his turn the influence of the engraver. Plates quite in the niello manner were done with the express purpose of taking impressions. Sometimes it is extremely difficult to make an absolute line of distinction between the two classes of work; certain signs, however, if present, such as rivet-holes or inscription in reverse, declare for the niello proper, and impressions of these, which were taken merely to show the craftsman the progress of the work, are of course extremely rare. Of the second category, niello-like engravings, the majority issued from the Bolognese school of Francia, of which we reproduce an example by its most prolific exponent, to whose personality we shall recur at

Engravings in the niello manner.

the end of the chapter (Fig. 14). These niello-like engravings may

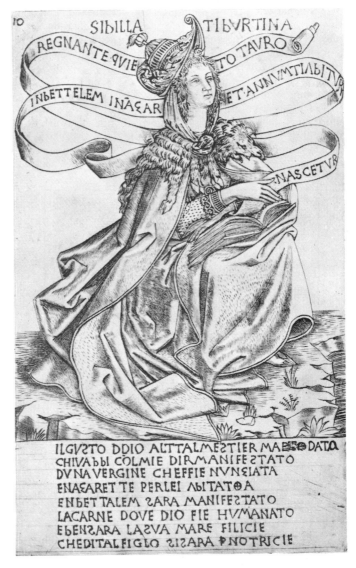

FIG. 15.—Anon. early Florentine Engraver. The Tiburtine Sibyl (in the Fine Manner).

have been produced in many cases for the purpose of providing prints to be used as models for the worker in niello.

Somewhat later than the *Planets*, but almost certainly within five The Finiguerra
to ten years after Finiguerra's death, come the companion series of School.
the *Prophets* and the *Sibyls* in the Fine Manner (see Fig. 15). In
their theatrical costume they seem to be an illustration of some
Sacra Rappresentazione of the "Annunciation," and verses below
each print correspond closely to such a play by Feo Belcari, of which
the first editions, though undated, must go back as early as 1480.[1]

FIG. 16.—Anon. early Florentine Engraver. Design for a Plate or Lid
(from the Otto series).

These, like the prints attributed to Finiguerra, belong to what The two styles
has been called the Fine Manner group. Their engraving is of Florentine
characterised by fine lines laid closely together, and by a consider- engraving :
able use of somewhat irregular cross-hatching, and the result, if not Broad
their aim, is an imitation of the tone of a washed drawing. Another Manners.
completely distinct method, termed the Broad Manner, appeared
in Florentine art about 1470-75, no doubt emanating from a com-
pletely distinct workshop. It is a system composed of simple broad

[1] Alessandro d'Ancona, *Sacre Rappresentazioni dei sec. xiv. xv. e xvi.*, Florence,
1872, vol. i. p. 167. See also E. Mâle, *Gazette*, 1906, p. 89.

lines of parallel shading, after the manner of a pen drawing. The characteristics of the two manners may be well studied by a comparison of the two sets of the *Prophets* and *Sibyls*, the Fine Manner series having been copied with considerable variations in the Broad Manner. The engraver who was responsible for this second version changed the characters of the figures into something far nearer Botticelli's style than the earlier series. As some evidence of the commerce in German prints at this period, it is of interest to note that nine of the *Prophets* and *Sibyls* were adapted from originals by the Master E. S.[1] Then Schongauer's *Pilate* (B. 14) is copied in the Prophet *Daniel*, and his *St. Sebastian* (B. 59) may have suggested

The Fine Manner.

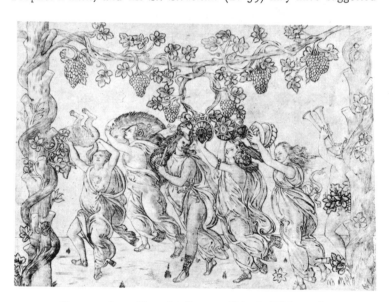

FIG. 17.—Anon. Florentine Engraver (School of Finiguerra).
The Triumph of Bacchus and Ariadne (left half).

The Otto prints.

the Albertina version of the *Chastisement of Cupid*, one of the set of prints called the "Otto" series, from the name of the eighteenth century collector, who possessed twenty-four of the type (now for the most part in the British Museum) (*e.g.* Fig. 16). They are prints of round or oval form, mostly having an escutcheon or a blank space left for inscription, and no doubt intended to decorate the spiceboxes such as the Florentine gallant used to present to his mistress. In one case, that of the *Youth and Girl holding up a Sphere* (B. 17, Paris), probable connexion has been established with an amour of the young Lorenzo de' Medici and Lucretia Donati, which took place

[1] See Lehrs, *Jahrbuch*, xii. 125. For an example of an original plate of E. S. used for an Italian engraving see above, pp. 26, 27.

between about 1465 and 1467.[1] In many of these prints, and in
the beautiful *Bacchus and Ariadne* (see Figs. 17 and 18), we find
the artificialities of Burgundian fashion being discarded in favour of
the simple classical costume ; and there is a grace and harmony in
the design which suggests the growing influence of Botticelli. It
is not at all unlikely that most of the prints in the Fine Manner
which we have mentioned, showing as they frequently do repetitions
of Finiguerra designs, also emanated from the same engraver's studio.
Maso's father, Antonio, who died in 1464, soon after his famous
son, left his sons Francesco and Stefano (who are mentioned in
1457 as working in Venice and Rome respectively), and Maso's

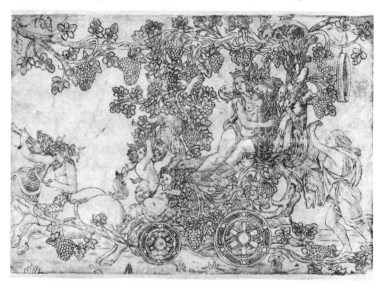

FIG. 18.—Anon. Florentine Engraver (School of Finiguerra).
The Triumph of Bacchus and Ariadne (right half).

son Pierantonio, the heirs of his workshop. Francesco is known to
have been carrying on the same goldsmith's shop in 1466.[2] Almost Engravings
the last prints in the manner of this school, and distinctly inferior in books :
to the preceding in technical power, are the illustrations to Antonio *Monte Sancto di Dio*, 1477 ;
Bettini's *Monte Sancto di Dio*, 1477, and Landino's *Dante* of 1481, Landino's
both of which were published by Nicolas Laurentii. The former *Dante*, 1481.
is one of the earliest instances known where the copper-plates used
for book illustration were printed directly on to the page of text.[3] Of
the *Dante* illustrations, which were engraved after designs by Botticelli,[4]

[1] See A. Warburg, *Riv. d'Arte*, iii. (1905), July. [2] Again in 1498
he is mentioned as renting a goldsmith's shop with Tommaso and Antonio (sons
of his late brother Stefano). Cf. H. P. Horne, *Botticelli*, 1908 (pp. 77-86).
[3] Cf. pp. 30, 33, 65, 70, 96, 119. [4] Either adapted from those at
Berlin and in the Vatican, or more probably based on an earlier series now lost.

and never completed (they embrace the first nineteen cantos of the

Questo e colui chel mondo chiama amore
Amaro chome uedi & uedrai meglio
Quando fia tuo chome nostro signore.

E i nacque docio & di lasciuia humana
Nutrito di pensier dolci & soaui
Facto signor & dio da gente uana.

FIG. 19.—Anon. early Florentine Engraver in the Broad Manner.
The Triumph of Love.

Inferno), only the first two, or at most three, are ever found printed

on the page of text. The others, when they occur, are generally printed on a separate piece of paper and pasted in, an evidence of the difficulties which the printer experienced with the other process. Besides these two publications there is hardly any book of impor- Other engrav- tance illustrated with metal engravings until the end of the next ings in fifteenth century, when the practice was revived with success. Three engrav- century books. ings (two tables of affinity and the *Virgin's Crown with a small Annunciation*) are found in Fra Pacifico di Novara's *Sumula di Pacifica Conscientia*, printed in Milan by Philip de Lavagna in 1479. Another engraving of the *Virgin's Crown* was given in the earliest issues of Savonarola's *Compendio di Revelazione* (Florence, 1495), and these make the sum of copper engravings used for book illustration in Italy during the fifteenth century, with the exception of the maps engraved for the editions of Ptolemy (Rome, 1479, and Bologna, 1482) and Berlinghieri (Florence, about 1481, from the same press as the *Dante*). A few of Marcantonio's engravings were designed for books, but with such occasional exceptions,[1] wood-cut commanded the field of book illustration throughout the first three quarters of the sixteenth century.

Most of the prints in the Broad Manner, notably the two series, The Broad the *Life of the Virgin and of Christ* and the *Triumphs of Petrarch* Manner Group. (see Fig. 19), range themselves near to the influence of Pesellino, Filippo Lippi, and Alessio Baldovinetti. Three large plates— *Moses on Mount Sinai* (P. V. 39, 93), *David and Goliath* (P. V. 39, 94), and the *Adoration of the Magi* (P. V. 40, 96)—are notable examples, while in another of the group, the *Deluge* (B. xiii. 71, 3), the suggestion was undoubtedly taken from Uccello's fresco in S. Maria Novella. The large *Assumption with Rome in the background* (B. xiii. 86, 4), is perhaps as near as any of the Florentine engravings of the time to Botticelli in design, and the *Madonna with St. Michael and St. Helena* (P. V. 108, 33) presents kindred elements of style, somewhat more freely translated.[2]

How far BACCIO BALDINI, who, according to Vasari, worked Baccio Baldini almost wholly after Botticelli's designs, is responsible for any of the anonymous plates we have mentioned is still an unsolved problem. He may have been among those who carried on the tradition of the Finiguerra school in the *Monte Sancto* and *Dante* engravings, but his separate entity as an engraver would incline one to look for him as the representative of the Broad Manner group which, as we have seen, contains examples almost as certainly derived from Botticelli as the Dante prints in the Fine Manner.

The same principle of technique that is found in the Broad Antonio Manner, the imitation of the character of pen drawing, is also seen Pollaiuolo. in the only engraving which is unquestionably by the hand of the painter and goldsmith ANTONIO POLLAIUOLO, the large *Battle of the Nudes* (Fig. 20). In the power of its design and the nervous grip of

[1] See, *e.g.*, Mocetto, p. 65. [2] Cf. Horne, *Botticelli*, 1908, pp 288-91.

its drawing, it is one of the greatest achievements in the engraving of

the fifteenth century. In technical character, with the open parallel
lines interlaid (at a small angle) with lighter lines of shading, it
resembles Mantegna, who may owe something of his style to the

suggestion of the Florentine, though it is dangerous to be dogmatic in regard to the interchange of influence of these contemporaries. Despite the largeness of the line-work, there is still something in its character, *e.g.* the close deep lines of shading of the background casting the whole into relief, which reveals the goldsmith who has worked in niello. Of the nielli which Pollaiuolo must have done it is difficult to speak with any certainty. The style of Finiguerra, who was probably the more prolific craftsman in this medium, is so near to his, that a definite distinction of their work presents considerable difficulty. The *Hercules and the Hydra* (Dut. 338, British Museum) must depend directly on his design, although its close technique shows a certain affinity to the school of Bologna. Of all the Florentine nielli the *Fortitudo* (Dut. 425, Rothschild), which is essentially in the same technical manner as those attributed to Finiguerra, most nearly reflects Pollaiuolo's style, even if it be not by his hand.

An attractive engraver, though scarcely an accomplished crafts- Robetta. man, is CRISTOFANO ROBETTA, about whose personality Vasari tells us nothing except that he belonged to a certain dining society of twelve, called the " Kettle " (of whom Andrea del Sarto was perhaps the most distinguished member) which met at the house of the sculptor G. F. Rustici.[1] He is a typical master of a period of transition, having lost the conviction of the primitive without succeeding to the developed modes of expression. Three of his prints are adaptations from Filippino Lippi (*i.e.* the *Madonna appearing to St. Bernard,* from the picture in the Badia, *Music and Philosophy,* from a grisaille in S. Maria Novella, and the *Adoration* from the Uffizi picture). The variations introduced in the latter, *e.g.* the addition of a graceful group of singing angels, show that he was no servile copyist, but possessed of a real sense for composition. Pollaiuolo provides him with two models in the *Hercules and Antæus* and *Hercules and the Hydra,*[2] while Robetta's facility in adaptation is seen in the fragments of background taken from Dürer, a source of plagiarism which was just beginning to become popular in Italy. Some of his various nude and subject studies, *e.g.* the *Allegory of Envy* (B. 24), may be inspired by Signorelli, but no definite connexion can be traced. How pleasing Robetta can be, when to all appearance original, is well illustrated in his *Allegory of Abundance* (B. 18) and in his *Ceres* (Fig. 21). The irregularity of the scheme of shading, with its unrestful curvature, fails to detract from their charm.

Of later Florentine engravers, who, like Robetta, worked at the

[1] In any case before 1512, which is the date given by Vasari for another society (the " Trowel ") which, in point of time, succeeded the " Kettle."

[2] The small panels in the Uffizi which are in reverse to the prints, were probably the immediate originals. The complete change in the landscape to something perfectly characteristic of Robetta, and other variations in posture, scarcely justify the assumption that they reproduce the lost pictures of the Medici Palace.

Gherardo
miniatore.

end of the fifteenth and the beginning of the sixteenth century, we
know only the miniature painter GHERARDO, and LUCANTONIO DEGLI
UBERTI. The former is little but a name except for his work in
illumination (*e.g.* in the Museo Nazionale, Florence), but he may be
responsible for some of the rough Italian copies after Schongauer

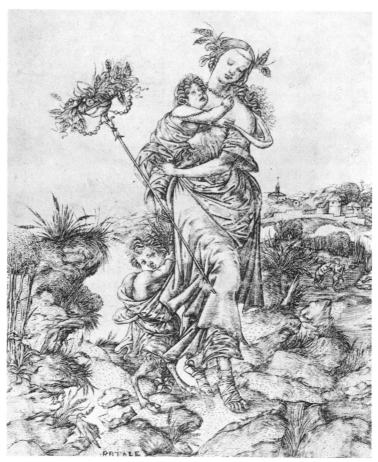

FIG. 21.—Cristoforo Robetta. Ceres.

Lucantonio
degli Uberti.

and other northern originals at this epoch. Lucantonio must
not be confounded with the Lucantonio da Giunta, a Florentine
who was settled as a publisher in Venice, although our engraver also
worked in Venice, and himself turned printer at Verona in 1503-4.
His engravings are roughly and irregularly cut, and have no artistic
merit. Perhaps the most important is a large print after the much

discussed *Last Supper* in St. Onofrio in Florence (P. V. p. 194, Gotha).

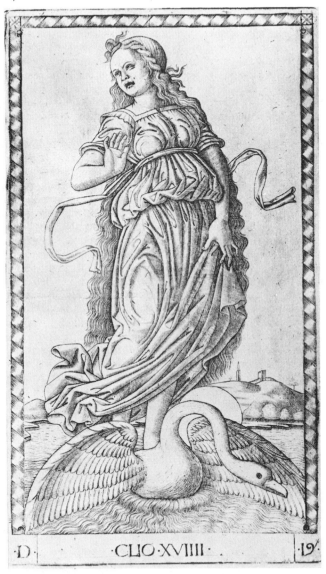

FIG. 22.—Anon. early Italian Engraver.
Clio (from the E series of the so-called "Tarocchi" Cards).

Turning to the north of Italy we are confronted at the outset

The North
Italian set of
instructive
cards
(erroneously
called the
"Tarocchi
cards of
Mantegna").

Two versions :
The E series.
The S series.

with problems of authorship as difficult and obscure as in the case
of the school of Florence. The "Tarocchi cards of Mantegna,"
as they have been called, are no more Tarocchi than they are by
or after Mantegna, but seem to form a sort of instructive game
for youth, if not a mere picture-book of popular designs, the
subjects represented in the fifty cards of five suits comprising the
sorts and conditions of men, Apollo and the Muses, the arts and
sciences, the genii and the virtues, the planets and spheres. There
are two different sets of prints, the one engraved with much greater
precision and finish, in which Nos. I.-X. are lettered E (B. xiii. p. 131,
"Copies"), the other to a large extent in reverse and executed in
a more careless technique, with Nos. I.-X. lettered S (B. xiii. p. 120,
"originals"). There has been much difference of opinion as to
which is the original series, some again thinking that both may go
back independently to the same set of designs. Many elements,
however, point to the "E" series (Bartsch's copies) being the earlier
set, if not the original from which the other was adapted.[1] If the
author of the E series had known S, or S's originals, he would
scarcely have replaced the easy posture of the legs in the *Imperator*
(9) and *Musica* (26) with his own awkward versions. On the other
hand, it would be most natural for the later engraver to correct
such errors of a predecessor. Absurd mistakes such as occur in the
Talia (16), who in the S series bows the viol with her left arm and
fingers with her right, cannot be taken as arguments on one side or
the other, as the earlier engraver would be just as likely to reverse
an original drawing as the copyist an engraving. With all his
clumsiness in detail—*e.g.* the feet in the *Speranza* (39), the figure of
the *Cosmico* (33), the limbs and folds of *Clio* (19)—the S engraver
possesses a freedom and realism in his draughtsmanship which
scarcely supports its priority in face of the precise and archaic manner
of the E series.

 In character of design, in the rounded forms and bulging folds,
the latter series has a close kinship to the Ferrarese school of
Cosimo Tura, and Cossa. There are, at the same time, reminis-
cences of Mantegna, *e.g. The Merchant* (4), while other elements,
(*e.g.* the spelling "Doxe" for Doge and the recurrence of the
lagoons in the background) point to a Venetian production, or at
least a Venetian market. The assumption that the E series is the
work of a Venetian engraver is strongly supported by the correspond-
ence of its technical manner, the clear cutting, and the regular

[1] There are two important pieces of evidence which fix the date of the E series as
before 1468 :—
 (i) Five of the prints are pasted in a MS. (a German translation of *Fior di Virtù*),
which was finished 28th Nov. 1468 (S. Gallen Library, Cod. Vad. 484). The
scribe has written round the prints, and has in some cases let his lines pass over their
margins, proving that they were not inserted later.
 (ii) Miniature copies (of the *Emperor* and *Pope*, and the throne from the *Mars*)
in a MS. of 1467, *Constituzioni dello Studio Bolognese*, in the Archivio di Stato,
Bologna (see Malaguzzi, *Archivio Storico*, vii. p. 16 and tav. 5).

system of shading, with a print so certainly Venetian as the political *Allegory of Pope and Emperor* (Ottley, Facsimiles, 1826, No. 24, cf. P. V. 190, 106).[1] Nevertheless, while placing the engraving in Venice, we would still look to the Ferrarese school for the origin of the designs.

With all his shortcomings, the author of the S series shows a greater feeling for beauty of form, and a truer appreciation for the value of space in composition. This consideration, as well as the affinity of its less regular system of engraving to the prints of the Fine Manner group, lends some support to the suggestion that its author belonged to the Florentine school.

Closely akin to the E series of the cards are two *Fountains of Love* (P. V. 189, 99 and 100) in the British Museum, and the *Death of Orpheus* in Hamburg (P. V. 47, 120), while a *Virgin adoring the Child* (Burlington House, and Trivulzio collection, Milan) seems directly inspired by a drawing in the Uffizi attributed to Marco Zoppo. A few engravings of Ships (*e.g.* P. V. 192, 110, Venetian Brit. Museum) are not far removed in style, and, like the *Allegory* engravings. *of Pope and Emperor*, almost certainly Venetian. Of a somewhat different character is a print of a *Madonna with Saints and Angels*, pasted on the cover of a book printed in 1496, in the Biblioteca Marciana, Venice. It is somewhat earlier than any of the preceding, and is more nearly akin to the school of Bartolommeo and Alvise Vivarini.

A real pack of Tarocchi cards (P. V. p. 127, etc.), which is The Ferrarese complete in the collection of the Conte Sola, Milan (the British school. Museum and the Albertina possessing certain numbers), corresponds much more absolutely than the so-called "Tarocchi" with the style of Cosimo Tura, and may be definitely regarded as Ferrarese. A few other prints quite in the same style are known, *e.g.* a *St. Sebastian* and a *St. Anthony* in the Royal Library at Vienna (P. V. 186, 91, and P. V. 115, 80).

In Florence the engravers, with the exception of Pollaiuolo, Mantegna. have all been artists of second or third rank. The North of Italy, on the other hand, can boast one of her great painters, and, in fact, one of the greatest masters of modern art, *i.e.* ANDREA MANTEGNA, among her earliest engravers. Born at Vicenza in 1431, trained in the classical school of Squarcione at Padua, he settled about 1459 in Mantua, remaining there in the service of its Marquesses until his death in 1506. The character of his engraving is a close imitation of the style of his pen drawings—open parallel lines of shading with lighter lines obliquely laid between them. Possibly the first idea that suggested engraving of this type was the popularity

[1] Probably dating about 1470, and referring to the meeting of Paul II. and Frederick III. which took place just before that date. The engraving described by Bartsch (xiii. 110, 8), bearing the date 1495, is a repetition of the subject, which is also found earlier in several wood-cuts.

of his drawings as designs in other studios, and the profit that would accrue through the multiplication of impressions.

In all, some twenty-five plates have been attributed to Mantegna, but it is very doubtful whether the master himself engraved more than the seven or eight, which so far excel the rest in quality.

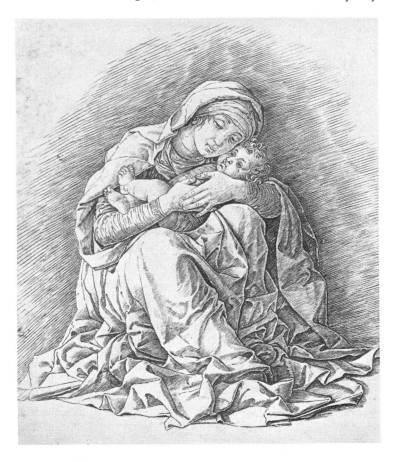

FIG. 23.—Andrea Mantegna. The Virgin and Child.

These plates are the *Virgin and Child* (B. 8, Fig. 23). The two *Bacchanals* (B. 19 and 20), the *Battle of the Tritons and Sea-Gods*[1] (two plates, B. 17 and 18), the *Entombment* (horizontal plate, B. 3), and the *Risen Christ between St. Andrew and St. Longinus* (B. 6). In these the line exhibits all the characteristics of Mantegna's pen-work. The outline is firm and broad, but the

[1] Christened by R. Förster *Envy among the Ichthiophages* (*Jahrb.* xxiii. 205).

cross-lines of shading seem to have been but lightly scratched on the plate, and were consequently worn away in a very few printings, leaving most of the late impressions (which are not uncommon) mere ghosts of the composition in its original state. Generally, too, fine early impressions show the broken line, which possibly implies an undeveloped roller-press and lack of pressure in the printing.

With one possible exception (the *Elephants*, from the *Triumph of Caesar*, B. 12) none of the other plates attributed to the master exhibit any of the nervous power and delicacy of modelling seen in the prints we have mentioned. The *Flagellation* (B. 1) and the *Christ in Limbo* (B. 5) stand in particular contrast to the above in their hard outlines and shading, and crude modelling. They are engraved directly after Mantegna and after designs belonging to the period of the Eremitani frescoes (which were painted some time between 1448 and 1455). The earliest of the undoubted engravings (the *Virgin and Child*) can hardly be earlier than 1470-1480, but even this interval of time can hardly account for the enormous difference in quality, between what must be called the "school" and the "authentic" groups.

The vertical *Entombment* (of which there are two plates; one, perhaps the better, given by Bartsch to G. A. da Brescia) and the *Descent from the Cross* (B. 4) have something more of the technical character of the authentic group, but are too weak to bear comparison, while the *Virgin in the Grotto* (B. 9) and the three plates after drawings for the *Triumph of Caesar*[1] have lately been rejected on the principle that the artist-engraver does not repeat his painted work in engraving.[2] Probably the latter reason is a nicety of feeling which did not occur to the great masters, whose practice created convention, but in any case the *Elephants* is the only plate of the three which possesses any of the best characteristics of Mantegna's engravings, and even this one fails to carry conviction.

From documentary evidence it is known that two engravers, ZOAN ANDREA and SIMONE DI ARDIZONE, were working in Mantua in 1475, and from the alleged hostility of Mantegna, which once went to the length of assaulting the two engravers and leaving them for dead in the street, it seems probable that they were making free use of the master's designs. And the very fact that Mantegna had made offers to Ardizone on his arrival in Mantua, seems to show that the great painter already had the idea of getting his designs engraved, although he may not yet have taken up the graver himself. Both Simone di Ardizone, to whom hitherto no prints have been attributed, and Zoan Andrea, may be responsible for some of the anonymous school engravings. Only a small proportion of the prints signed by the latter (*e.g.* the *Hercules and Deianeira*, B. 9) are in the essentially Mantegnesque manner. Many are copies from Dürer, while

[margin note:] Simone di Ardizone and Zoan Andrea.

[margin note:] Zoan Andrea.

[1] The series of nine large canvases is now in Hampton Court.
[2] Cf. Chapter VI. on Rembrandt, p. 174 and note 1.

Fig. 24.—Zoan Andrea.
Panel of arabesque ornament (part).

others are so near the style of the miniaturist of the Sforza Book of Hours (*e.g.* three[1] of the series of *upright arabesques*, B. 21-32, see Fig. 24), that Zoan Andrea may be assumed to have settled in Milan after leaving Mantua. Moreover, two of his later engravings (a *Virgin and Child*, B. 6,[2] and the *Dragon and the Lion*, B. 20) are undoubtedly after designs by Leonardo da Vinci. In his later works (*e.g.* the *Two Lovers*, P. 43) the engraver has discarded the Mantegnesque system for a much more meagre treatment of line. He must not be confounded with the woodcutter Zoan Andrea Vavassore who was working in Venice as late as 1520.

GIOVANNI ANTONIO DA BRESCIA probably came into connexion with Mantegna later than Zoan Andrea, but he has left more signed engravings than the latter directly after designs by the master, of which the *Hercules and the Lion* (B. 11) and *Hercules and Antaeus* (B. 14) are good examples. Three of his prints bear dates: two copies from Dürer, the *Great Horse* and the *Satyr Family*, belonging respectively to 1505 and 1507, and a large *Flagellation* (P. 29) being dated 1509. In the last he is still working in the Mantegnesque manner, but a suggestion of Pollaiuolo in the figures, and of the Roman school in the architectural setting, suggests that he may have lately arrived in Rome after journeying South through

[1] Cf. below, p. 61, for the attribution of the remaining nine.
[2] After a study for the Madonna Litta.

Florence. A print based on a newly-found statue of *Venus* (P. 42) and a free version of the *Belvedere Torso* (B. 5) are also probably early works of this period, showing the transition to a style which was never more than a most crude assimilation of the Roman engraver's manner. He must have been working here in any case up to 1517, if not considerably later, as his print of *Abram and Melchizedek* (P. 26) is based on one of the Vatican Loggie frescoes (which were painted between 1517 and 1519).

Another engraver of the same local extraction, GIOVANNI MARIA G. M. da DA BRESCIA, a member of the Carmelite Order, who worked at the Brescia. beginning of the sixteenth century (the dates 1502 and 1512 occurring on two of the four prints by his hand), is an utterly poor craftsman, but interesting from one print, the *Triumph of Trajan*, which almost certainly preserves a lost original by Vincenzo Foppa.

NICOLETTO ROSEX (Rossi or Rosa?) of Modena is another North Nicoletto da Italian engraver who in his earlier works came under the influence Modena. of Mantegna's style, though he only directly copied that master's designs in a very few instances, e.g. *Hercules and Antaeus* (after Mantegna [school], B. 16), and *Neptune* (after a figure in Mantegna's *Bacchanal with the Tub*). The *St. Cecilia* (P. 85), the *Victory* (P. 101), and the *Two Nude Children holding a Cross*,[1] are good examples of this early phase. He soon developed the use of cross-hatching, and many prints of a second phase (which may be contemporary with certain other prints still in the Mantegnesque manner) are designed on a darkly-shaded ground somewhat after the conventions of the niellist. One or two small prints in the manner of nielli bear his initials (*e.g.* Galichon, *Gazette*, 2me pér. IX. p. 167, No. 7), but whether he worked as a goldsmith and ever produced nielli proper is quite uncertain. The development of his engraving at this period may have been partly due to Schongauer (from whom he made several copies), but a far greater change seems to have been effected by his study of Dürer (which must have been about 1500, the date of a copy of the *Four Naked Women*). But the change in his manner of shading, and his adoption of a more delicate system of cross-hatching was not all. He developed about the same time a style of composition quite his own among engravers of the time, nearly always surrounding his saint or allegorical figure in a fantastic setting of classical ruin. That Mantegna first inspired him to this treatment we might gather from the large *St. Sebastian* in the British Museum (Chalc. Soc. 1891, No. 29), which seems suggested by some picture, such as the Aigueperse or

[1] B. xiii. 297, 5, as Zoan Andrea, who is more probably the author of Bartsch's copy (i.). The connexion with this engraver suggests that Nicoletto might have learnt his "Mantegnesque" under Zoan Andrea in Milan, a possibility not unsupported by the style or architecture seen in the *Nativity* (P. 70). We would also tentatively suggest that Nicoletto might be the engraver of Bramante's large design of an Interior. The *Vulcan and Cupid* (B. 52), *St. Cecilia* (P. 85), and *St. Sebastian* (Chalc. Soc. 1891, 29) are closely related to it in style of cutting.

Vienna versions of the subject. Then something of the charm of his landscape may have been inspired by the anonymous master I B, whose work we are about to mention. In one case Nicoletto actually reworked a plate by this engraver (*Leda*, P. 9), and replaced the original signature with his own monogram.[1] This late phase of his work seems to follow closely after the Dürer copies, and extends at least until 1512, the date on a *St. Anthony within a Colonnade*.

The *Apelles* (P. 104), borrowed from a figure in Filippino Lippi's fresco of the Triumph of St. Thomas (in S. Maria sopra Minerva), and the engravings of the statues of *Marcus Aurelius* (B. 64) and of the *Apollo Belvedere* (B. 50) suggest the probability of a sojourn in Rome. His plates of arabesque ornament, which form a considerable part of his work, are a mixture of the purely North Italian elements seen in the arabesques of Zoan Andrea, with the style of the Raphael school as seen in the prints of Giovanni Antonio da Brescia and Agostino Veneziano.

I B (with the Bird). An engraver who uses the signature I B (accompanied by the device of a bird [2]) was identified by Zani, perhaps somewhat rashly, with a Giovanni Battista del Porto, to whom Vedriani, in his work on the artists of Modena, devotes a short paragraph.[3] Neither Tiraboschi [4] nor Venturi [5] has been able to find documentary evidence even of the existence of Vedriani's engraver, the only member of the Modenese family cited by Venturi who might be identical being a certain Battista del Porto, who was working as a goldsmith and die-cutter in Modena between 1529 and 1537. It is not impossible that the engraver was working as late as this, but general elements of style, and the print commemorating the monstrous twins born at Rome in 1503, point to the earlier years of the century. His small allegorical figure of *Foresight* (P. 8), with its niello-like technique in the background, suggests a goldsmith's education. Influenced by Mantegna (more particularly in his wood-cuts), and to some extent by Nicoletto da Modena (whom he inspired in his turn), copying and borrowing from Dürer, and showing some characteristics in common with the Bolognese school (to which he has recently been assigned by Dr. Kristeller), it seems rash to dogmatise on the locality of so eclectic a spirit.

[1] For similar practices cf. above W ♃ and Meckenem. Of the early Italian school we may refer to a print of Montagna (*Virgin and Child*, B. 7), which in one state bears the signature of G. A. da Brescia (IOAN. BX), though whether this engraver added it himself seems open to question.

[2] One thinks of Passeri or Uccello as possible surnames, but no artist of either name is known who can be identified with I B.

[3] L. Vedriani, *Raccolta de' pittori scultori et architetti Modonesi.* Modena, 1662 (p. 45, immediately following the article on Nicoletto da Modena). Zani, unfortunately, never published the material which he seems to have possessed in support of his identification (see *Materiali*, p. 134).

[4] G. Tiraboschi, *Notizie de' Pittori,* etc. *di Modena.* Modena, 1786.

[5] A. Venturi, gli Orafi da Porto. *Archivio Storico Italiano,* 1887, p. 205.

Until nearly the end of the century hardly any engravings seem The Milanese School. to have been produced at Milan. There are the three prints already mentioned,[1] which appeared in Fra Pacifico di Novaro's *Sumula di Pacifica Conscientia* of 1479, and a few isolated examples which seem to bear the impress of the school, such as an *Annunciation* (P. V. 67, 61) and a *Crucifixion* (P. v. 68, 65*a*) (both in the Albertina), may certainly be referred to a date prior to 1490. Then about this period follows an interesting group of engravings, which Master of the Sforza Book of Hours (Antonio da Monza?) stands in the closest relation to the Milanese school of illumination, as seen in the *Sforza Book of Hours*[2] and in the Grenville copy of Simonetta's *Historia delle cose facte dallo . . . Francesco Sforza*, Milan, 1490 (both in the British Museum), and in two miniatures[3] in the collection of M. Leopold Goldschmidt in Paris. The prints we refer to include among others a *Virgin and Child with Playing Angels* (B. xiii. 85, 3), a *Pietà* (Albertina), and a little *Allegory on Death* (P. V. 21, 35). Quite near in style again are the large upright arabesques by Zoan Andrea, while the thinner line work and cross-hatching of nine of the same series mark them as by our Milanese Anonimo (B. xiii. 306, 21-32). Another of the prints of the same engraver (B. xiii. 83, 28) reproduces the *Last Supper* of Leonardo da Vinci, which was finished in 1498, so that his activity must extend till quite the last years of the century. Every element of style and every mannerism of this Milanese engraver corresponds so absolutely with that of the Master of the *Sforza Book of Hours* that it seems more than probable that miniaturist and engraver are identical. It is at least rare to find an engraver of the fifteenth century who so completely merges his individuality in the artist, by whose designs he is inspired. The further point, that the author[4] of these illuminations is ANTONIO DA MONZA,[5] of whom there is only one signed miniature (the *Descent of the Holy Spirit*, in the Albertina, Vienna), is supported by good authorities, but scarcely proved by a convincing correspondence in style.

Several engravings have been attributed to LEONARDO himself, and Did Leonardo da Vinci engrave? it is natural to imagine that among his numerous interests he at some time made attempts in this medium. Only one of the prints in question possesses anything of the character of Leonardo's authentic work, i.e. the *Profile Bust of a Young Woman* in the British Museum (P. V. 180, 1). The slipped stroke on the forehead betrays the hand of a tiro in the medium, but the sensitive quality of the outline, and the exquisite significance of the drawing, show

[1] See p. 49.

[2] See G. F. Warner, London, 1894.

[3] Reproduced, Venturi, *L'Arte*, i. p. 154. One of them is signed AN MA.

[4] *I.e.*, the master illuminator. The difference in quality between many of the illuminations points to several assistants working out his designs.

[5] An artist of the name was working in Padua in 1456 (see G. A. Moschini, *Pittura in Padova*, 1826).

a veritable master of style. The other profile bust, a *Young Woman with a Garland of Ivy* (P. V. 180, 2), is much coarser in engraving, and might be the work of the same hand that is responsible for the six patterns of interlaced cord ("*knots*," as Dürer called his wood-cut copies), which also bear the inscription ACADEMIA LEONARDI.[1] The three *Heads of Horses* (B. xiii. 331, 24) might have been done by a Zoan Andrea, or G. A. da Brescia, and the same may be said of the three *Heads of Old Men* (B. "Mantegna," 21-23), which seem to be inspired by some Leonardesque design. The *sheet of studies for the Sforza equestrian monument* (British Museum) shows a far greater freedom of handling, but its draughtsmanship lacks articulation and unity, and marks it as a mere contemporary reproduction of his drawings.[2]

Bramante.

A large engraving of an interior signed *Bramantus fecit in Mlo*[3] is generally accepted as the original work of the great architect, who was working in Milan from before 1477 until 1499. There is no question about the authenticity of the design, which is reminiscent of elements in the sacristy of S. Satiro[4] in Milan, but the engraving seems to be rather the work of a dull but fairly equipped craftsman[5] than the unique attempt of a genius in a strange medium. The use of the word *fecit* is unusual at this epoch in reference to engraving, and it may simply refer to the author of the design.

Jacopo de' Barbari.

The first personality to issue from the cloud of uncertainty which envelops the early history of the art in Venice is the engraver who uses as his signature the "Caduceus," or wand of Mercury, *i.e.* JACOPO DE' BARBARI. Born about 1450 (or somewhat earlier),[6] working as a painter in Venice and the neighbourhood in the latter part of the century, appointed portrait and miniature painter to the Emperor in Augsburg in 1500, painting at Wittenberg and various parts of Saxony in the service of Frederick the Wise between 1503 and 1505, visiting Nuremberg in 1505, if not also at other times, with Joachim I. of Brandenburg at Frankfurt-a-O in 1508, working for Count Philip of Burgundy in his castle at Zuytborch in company with Mabuse, and finally pensioned and dying in the service of the

[1] The inscription, which probably means no more than "academical exercise," has given rise to wild conjectures about a regular teaching Academy under Leonardo's direction in Milan.

[2] Cf. drawings in Windsor ; in particular one reproduced by J. P. Richter, *Literary Remains*, Plate lxv.

[3] Two impressions are known : (i) British Museum (with inscription in ink) ; (ii) in the Casa Perego, Milan (where the inscription is said to be engraved).

[4] Completed some time between 1480 and 1488.

[5] Cf. note 1, p. 59, where Nicoletto da Modena's name has been suggested in connexion.

[6] In the grant of a pension in 1511 he is mentioned as "old and infirm." The double portrait of Luca Pacioli and the artist (signed IACO·BAR·VIGENNIS·P·1495), recently acquired for the Naples Museum, would upset this theory if rightly interpreted as *Jacopo de' Barbari painted in his twentieth year.* . . . Documentary evidence is so strong on the other side that the authorship of this interesting picture must be still regarded as a problem (see Venturi, *L'Arte*, vi. 95 ; Ricci, *Rassegna d'Arte*, iii. 75 ; Gronau, *Rassegna d'Arte*, 1905, p. 28).

Archduchess Margaret, Regent of the Netherlands—these are a
wealth of biographical detail possessed in the case of few other
Italian engravers of the period. In Nuremberg he was known as
Jacob Walch, *i.e.* Jacob the "foreigner"—the Italian, and the
error which long placed him among Northern engravers is easily

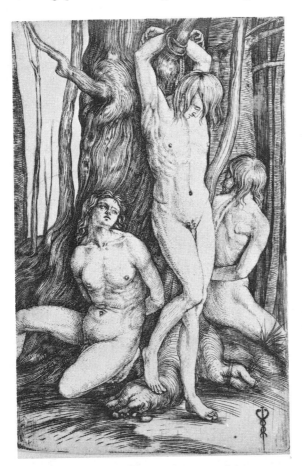

FIG. 25.—Jacopo de' Barbari. The Three Prisoners.

understood. Nevertheless throughout this engraved work (which
contains some thirty numbers) he shows himself essentially Italian
in spirit, owing something to the Vivarini, but thoroughly individual
in his development. Nor was his system of engraving greatly in-
fluenced by Northern models.
 Barbari handles the graver with a light touch, and his line, with
the burr incompletely removed, possesses something of the character

of dry-point. He never developed the regularity of cutting, which
gives engraving its special quality in rendering tonic values, and his
prints possess the appearance of pen drawings transferred to copper.
In his earlier work (to judge from the *Judith*, B. 1, and the *St.
Catherine*, B. 8, with their long sinuous folds, clinging draperies, and
sentimental pose) he follows roughly in the wake of the Mantegna
school in his parallel shading, though an essential difference may
be remarked in the curving lines which follow the contours.
Later he developed a closer system of cross-hatching, which may
have found its inspiration in Dürer,[1] but never approached the
master at all closely. To Barbari in this later phase, of which the
St. Sebastian (P. 27) is perhaps the finest example, Lucas van Leyden
seems to be in some degree indebted. Prints like the *Three
Prisoners* (B. 17, Fig. 25) and the *Apollo and Diana* (B. 14), we
would place midway in his development, probably somewhat before
than after 1500. This, however, is a dangerous point, and touches
another problem of great uncertainty, *i.e.* the order of relationship in
which the *Apollo and Diana* stands to Dürer's print of the same
subject. To us it seems that the most natural explanation is to
assume the priority of Barbari's print, to regard this as one[2] source
of suggestion for Dürer's Apollo drawing in the British Museum
(Lippmann, 233), and for the engraving of about 1505, while admit-
ting that the transformation of the subject leaves great room for very
different speculations.[3]

Mocetto.

Both as craftsman and artist GIROLAMO MOCETTO stands on a
lower plane than Jacopo de' Barbari. His careless method of
shading seems less like the work of a practised engraver than the
occasional attempt of the painter. But even in the latter capacity,
in which he may have acted as assistant to Bellini, his works are
few and poor. According to Vasari he came from Verona, but the
greater part of his work is completely Venetian in character, and
produced in Venice under the influence of Alvise Vivarini, Giovanni
Bellini, and Cima. Some of his prints, probably earlier examples
dating in the last decade of the fifteenth century, are after designs
by Mantegna or his school, *e.g. Judith*, and the *Calumny of Apelles*,
the latter being based on a drawing attributed to Mantegna in the
British Museum. The setting of the *Calumny* in a background
suggested by the Place of SS. Giovanni e Paolo shows that the
engraver was already working in Venice. The *Virgin and Child
enthroned* (B. 4) and the large *Virgin and Child with Saints and
Angels* (P. 10) reflect the style of Alvise Vivarini; the *Baptism of
Christ* is directly inspired by a picture by Giovanni Bellini in
S. Corona, Vicenza, though certain elements may have been sug-

[1] The nearest analogies are seen in Dürer's work about 1500, *e.g.* the nude in the
Rape of Amymone.
[2] The other being the Apollo Belvedere.
[3] For other points of relation to Dürer, cf. Chap. II. pp. 74, 75.

gested by Cima's Baptism in S. Giovanni in Bragora, Venice. In
his lineal manner, and in the angular character of fold and contour
(comparable to the Vicentine school), Mocetto stands in even closer
relationship to Vivarini and Cima than to Bellini.

Some unimportant topographical plates were engraved by Mocetto
to illustrate Ambrogio Leone's *De Nola Opusculum* (Venice, 1514),

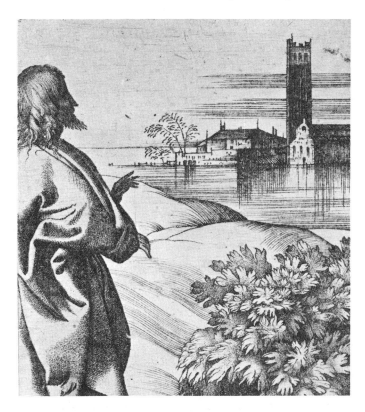

FIG. 26.—Giulio Campagnola. Christ and the Woman of Samaria (part).

but this is the only certain date afforded by his prints of an activity
which is known to have continued until after 1530.

GIULIO CAMPAGNOLA is an interesting artist whose only recog- Giulio
nised monument consists in his engravings, which scarcely amount Campagnola.
to a score in number. According to contemporary accounts he
was a youth of wonderful versatility and promise, and while still
under seventeen reaped much praise for his skill in the various arts
of painter, miniaturist, engraver, and musician, no less than for his
knowledge of Latin, Greek, and Hebrew. One of his prints is a

direct copy from Dürer (the *Penance of St. John Chrysostom*, P.K. 4), and several of his plates show adaptations from Dürer's landscape backgrounds, but the style of his engraving was far less dependent on the German master than that of most of his contemporaries. The inspiration of his art, seen in plates like the *Young Shepherd* (P.K. 8), *Christ and the Woman of Samaria* (P.K. 2, Fig. 26), and the *Astrologer* (P.K. 11), is clearly that of Giorgione, and the special character of his technique, a system of graver flicks so delicate that they approximate to dots made with the point, is directed to rendering the soft gradations of chiaroscuro affected by his model. Two of his prints, *i.e.* the *Young Shepherd* and the *Astrologer*, are known in two states,—the first in pure line, the second with the spaces between the lines filled up with the flick work ; while in others, *e.g. Naked Child with three Cats* (P.K. 7), the *Woman Sleeping* (P.K. 13), and the noble *St. John the Baptist* (P.K. 3), the shading is achieved almost wholly by the most delicate flick work. The latter shows him, like Mocetto in a print of the same composition, borrowing the figure probably from some design by Mantegna, of which the existing versions (*e.g.* Ambrosiana) seem only school copies. One of his plates, the *Shepherds in a Landscape* (P.K. 9), was left unfinished, the foreground and figures being added later by Domenico Campagnola. It is natural to infer that Giulio's activity did not extend long after the latest mention we possess of his existence.[1]

In the special character of his technique, the completion of a skeleton lineal design by close graver flicks, Giulio Campagnola finds his closest imitator in the engraver who uses the signature PP. He has been identified, partly on the basis of the monogram, with MARTINO DA UDINE (called also PELLEGRINO DA S. DANIELE), but the distinctly Ferrarese character of his few prints, *e.g.* the *Pietà* (P. 2), and the *Triumph of the Moon* (P. 4), has still to be explained if this identification be correct.[2]

MARCELLO FOGOLINO, a painter who was working between 1519 and 1548, chiefly in Vicenza, has also signed a few engravings whose flick-work shading takes its suggestion from Giulio Campagnola (*e.g.* the *Nude Woman and Child*, P. 3). Other prints, *e.g.* the *Presentation of the Virgin* (P. 2), are engraved almost wholly in line, but with a softness of tone which seems to indicate the use of the dry-point.

Another small group of engravings,[3] which has been generally assigned to the Milanese school, seems to be nearer in style of

[1] In the will of Aldo Manuzio (Jan. 1515), who charges his executor to get certain cursive type cut by G. C. (see A. Baschet, *Aldo M., Lettres et Documents*, Venice, 1867, p. 47). Another famous artist of the period, who is known to have cut type for Aldo, is Francesco Francia (see A. Panizzi, *Chi era Francesco da Bologna?* London, 1858 and 1873).

[2] Martino worked in Ferrara at various times between 1504 and 1512, but there is no evidence of a transformation of style sufficient to support the hypothesis.

[3] For the attribution to Cesare da Sesto, see Passavant, *Deutsches Kunstbl.* i. 364.

composition to the school of Campagnola, and in technical manner finds its closest analogy in Marcello Fogolino. The *Allegory with*

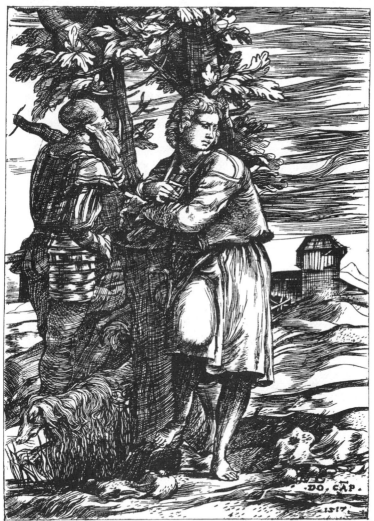

FIG. 27.—Domenico Campagnola. Young Shepherd and aged Warrior.

a Nude and various Animals (attributed by Bartsch to Duvet), the *Beheading of John the Baptist*, and studies of a *Stag* and a *Doe* (P. "G. Campagnola" 16 and 17) form the group in question. The fact that the *Allegory* is based on a drawing by Leonardo (in the

Louvre) seems to be the only real connexion with Milan, while the close analogies, both in technical manner and in the landscape background to Fogolino, the suggestion of Giorgione in the *Beheading of John the Baptist*, and of Campagnola in the two animal studies, seem greatly to favour the assumption that the artist belonged to one of the provinces in the north-eastern corner of Italy.

Domenico Campagnola. The work of DOMENICO CAMPAGNOLA may be mentioned here, though, like several of the engravers just referred to, it falls wholly within the sixteenth century. None of his engravings are dated except in the years 1517-18, but there seems little reason to doubt his identity with the painter who assisted Titian in 1511 and continued working in Padua until after 1563,[1] and to suspect two personalities of the same name. Whether he was a Venetian or a Paduan by birth is not certainly established, but the assumption that he was a pupil and the artistic heir, if not a family connexion,[2] of Giulio Campagnola is strongly supported by his completion of the *Shepherds in a Landscape*, to which we alluded above. He did not, however, follow Giulio's stipple-method, and as an engraver handles the line with a somewhat loose, though picturesque touch. The *Young Shepherd and aged Warrior* (B. 8, Fig. 27) is a delightful plate, with a romantic atmosphere and a method of design which almost anticipate Salvator Rosa.

Benedetto Montagna. Near to the Venetian school is BENEDETTO MONTAGNA of Vicenza, whose work centres in the first three decades of the sixteenth century. His style was formed on that of his father, Bartolommeo Montagna, and prints like the *Sacrifice of Abraham* (B. 1) and the *St. Benedict with four Saints* (B. 10), strong and simple, if somewhat stiff in design, belonging perhaps to the last decade of the fifteenth century, show him in this early phase. His later plates, mostly of allegorical and classical subjects (several taken from Ovid[3]) show him to have possessed the qualities of a graceful illustrator, a delicate technique, and a real sense for the possibilities of the small space he generally chose to use. Like most of his contemporaries in Italy he occasionally copied and borrowed from Dürer (*e.g.* the *Nativity*, P. 35), and may have received from the same source the suggestion for his *Peasants quarrelling* (B. 30), an unusually realistic piece of genre for Italian art of the period.

Francia and the School of Bologna. We have alluded above[4] to the school of niello, which found its inspiration in the studio of the goldsmith and painter, FRANCESCO

[1] See G. A. Moschini, *Pittura in Padova*, 1826 (pp. 61, 70, and 76).

[2] J. Morelli's *Anonimo* refers to paintings in the Palazzo Cornaro, Padua, as by *Domenico Veneziano allevato da Julio Campagnola*, and there seems good reason to regard this artist as D.C. (Ed. Frizzoni, 1884, p. 22).

[3] Several similar designs are found in the cuts in the 1497 Venice edition of the *Metamorphoses*, and it seems probable that Montagna rather than the wood-cutter was the plagiarist. [4] See pp. 42, 43.

RAIBOLINI (FRANCIA). Besides two niello plates in the Bologna gallery, a few prints from nielli, *e.g.* the *Profile Head* (*of a Bentivoglio* ?) Duch. 350 (Brit. Mus.), can certainly be attributed to the master, but it is more than doubtful whether we know any real engravings by his hand.[1]

Among the many anonymous nielli and niello-like prints which ₽ (Peregrino come from his school, there is a group by an engraver who generally da Cesena ?)

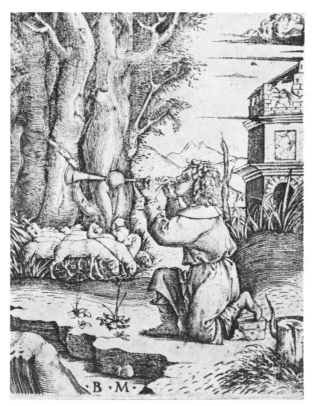

FIG. 28.—Benedetto Montagna. The Shepherd.

uses the signature ₽, less frequently ℭ or O₽DC. A print of the *Resurrection* (Duchesne 122) is inscribed *Opus Peregrini de Ces*,[2] but comparison with indubitably genuine works by the master

[1] Cf. below, Marcantonio, p. 92.

[2] Impressions with this inscription in the British Museum, Berlin, and Paris (Bibl. Nat.). An impression in the collection of Baron Edmond de Rothschild signed *Opus Peregrino* is described by Dutuit as an earlier state. The same composition is seen in a silver plate in the British Museum, which is a far more egregious modern forgery.

(*e.g.* the *Story of Abraham*, D. 9-14, *Mars and Venus*, D. 220, *Orpheus*, D. 255, and *Mucius Scaevola*, D. 263) inclines me to regard the work as an eighteenth or early nineteenth century fabrication, while admitting that the inscription may go back to some authentic source. One of his best engravings in the niello manner, the *Neptune in his Car*, is reproduced (Fig. 14). This sort of print may have been largely used as model composition in goldsmiths' and engravers' studios, and in this instance there are at least two other versions of the subject known,—one a niello even nearer Francia's own manner (Gutekunst sale, Stuttgart, 1899, No. 864), and the other a print which has been attributed to Marcantonio.[1]

· · · · · · · ·

Scarcely any engraving was produced in the North of Europe during the fifteenth century outside Germany, the Netherlands,[2] and Italy.

FRANCE.

In a French translation of Breydenbach's *Travels*, published at Lyons in 1488, there appeared engraved copies of the large woodcuts of the original Mayence edition of 1486, but apart from this, there are only isolated instances of engravings which can be definitely regarded as French. One of these (dating probably about 1460), a *Lion-King* from a set of cards (Dresden),[3] is evidently suggested by the work of the early Master of the Playing Cards. In technical style it is similar to the French wood-cut of the period, with a characteristic meagreness of line.

· · · · · · · ·

SPAIN.

Spain has even less to show than France in engraving during the fifteenth century. Three playing cards in the Berlin Print Room, with *Valenzia* inscribed on medals (with coats of arms) which are supported by the figures, are perhaps the best examples. They are poor productions, and of an even lower order than the work of the Master of the Year 1464, standing in style midway between the work of that master and the early Florentine engravings in the Fine manner. Among certain crude engravings in the National' Library at Madrid, such as the *Beato Carlo de Viana in a Gothic Niche*, and a *Wheel of Fortune*, is a modern impression from an old plate with *Scenes from the Life of Christ and St. Eulalia*, patron saint of Barcelona. The last example, which bears the signature FR. DOMENECH 1488, is the only Spanish print of the period with indication of date and authorship.

[1] See below, p. 91.

[2] From the close connexion of Burgundy and Flanders in the 15th century, we have chosen to classify certain engravers, who might with equal justice be claimed for the honour of France, with the Netherlandish school. Cf. pp. 23, 24.

[3] Lehrs, *Chronik.* ii. 2, 23. Another impression in E. de Rothschild collection, Paris.

CHAPTER II

(About 1495–1550)

AMONG the engravings of the fifteenth century there is much that possesses great interest and charm, but little which can be regarded as the work of artists of supreme genius. Of that little is the work of Mantegna, while in the north Schongauer is almost the only engraver who at all closely approaches the level of a great master, and he is still too trammelled by Gothic conventions to rise to the height of a great personality. The close of the century heralds the The great activity of three engravers, Dürer, Lucas van Leyden, and Marcantonio, triumvirate. in each of whom technical mastery was united to a high measure of artistic genius. The first of these, Albrecht Dürer, can be pronounced almost without qualification as the greatest of all line-engravers—a man who had found in this phase of art a means of expression perfectly at one with his genius. An artist of the most solid conviction and concentration, he is none the less by far the most versatile genius of the triumvirate. Far from being merely the engraver, it is difficult to say whether he excelled most in this field, as a designer for wood-cut, or as a painter, while an inquiring spirit led him, like Leonardo in Italy, to probe many theories that lay about and even beyond his art. Lucas van Leyden is an artist of a frailer calibre than Dürer, and prone to lose himself in imitation of stronger men, each of his great contemporaries in turn dominating his style. Nevertheless he had no lack of original power, and, when most himself, achieved work which fully justifies his place in the trio of the master engravers. In Marcantonio a stronger spirit than Lucas van Leyden's yields itself voluntarily to the interpretation of the ideas of others. He was essentially a specialist; in fact, no work of his in any other medium than engraving[1] is certainly authenticated, though no doubt some of his studies may be hidden

[1] Besides the line-engravings his only authenticated work is a wood-cut of the *Incredulity of Thomas*, which appeared in the *Epistole et Evangeli*, printed by N. and D. dal Gesù, Venice, 1512 (printer's error for 1522?), (see Lippmann, *Jahrb.* i. 270), but he is probably only the author of the design and not the cutter.

in the mass of unattributed, or wrongly attributed, drawings of the Raphael school. Taking Dürer as his model, he simplified and refined until he attained a system which, regarded simply from the technical point of view, is without a rival. But the chief tenour of his work, the reproduction of alien composition, though done in the reverse to a servile spirit, puts him immediately on a different plane from Dürer, and it was the harbinger of the host of servile reproducers who formed the greater part of the line-engravers during the next two centuries.

GERMANY.
Albrecht
Dürer.

ALBRECHT DÜRER was born in Nuremberg in 1471, the son of a goldsmith who had migrated some fifteen years earlier from Hungary. His first education in art must have been in his father's craft, but his real apprenticeship was passed under the painter Michel Wolgemuth, who is perhaps most widely known for his wood-cut illustrations to Hartmann Schedel's *Chronicle of the World* (Nuremberg, 1493). If the early training in his father's shop gave Dürer the required facility in handling the graver, it is certainly to Wolgemuth that he owed the inspiration to design the wood-cuts which form, perhaps, the most powerful achievement of his life. Dürer could hardly have found a master more essentially Gothic in his style than Wolgemuth, whose work, though extending well into the sixteenth century, is characterised throughout by all the stiffness of line and uncouthness of figure which Germany was capable of displaying in the fifteenth century. But though Dürer himself retained till the end some of the limitations of the Gothic tradition, he was from the first evidently struggling towards a more universal ideal of beauty which scarcely a single German artist before his time, with the exception of Schongauer, had in any degree realised. Dürer's earliest enthusiasm not unnaturally centred in the painter of Colmar, and here too he found the model on which he formed his style and system as a line-engraver. Leaving Nuremberg in 1490 for some years of travel and study, he may have come into touch with Schongauer while in the neighbourhood of Basle, but there is evidence that he never met the master face to face. Though long a matter of dispute, an early visit to Venice about 1495 seems now to be almost an established fact, but hitherto no uncontested allusion to it has been found in Dürer's writings.[1] Apart from

[1] It is at least the most natural explanation of the passages *und das Ding, das mir vor eilf Johren so wol hat gefallen, dass gefällt mir itz nüt mehr* in a letter from Dürer to Pirkheimer, dated Venice, 7th Feb. 1506 (see K. Lange, *D's Schriftl. Nachlass*, 1893, p. 22 ; Thausing, *D's Briefe*, 1872, p. 6). An earlier visit seems also to be assumed by C. Scheurl in his *Libellus de laudibus Germanie* (Leipzig, 1508), who refers to Dürer's journey of 1505-7, *cum nuper in Italiam rediisset*. Two other pieces of evidence may be cited : (i) the landscape in the engraving of the *Large Fortune* (B. 77) of about 1502-3 is undoubtedly suggested by Klausen, a little town between Brixen and Botzen on Dürer's route towards Trent *via* the Brenner Pass. See Haendcke, *Chronologie der Landschaften Dürer's*, Strassburg, 1899. (ii) Every characteristic of the early water-colours of the Tyrol points to their production on an earlier journey than that of 1505-7.

these early years of wandering, a second visit to Venice in 1505-1507 (partly undertaken to protest to the Venetian Senate against Marcantonio's imitations of his prints), one or two visits to Wittenberg,[1] and a journey to the Netherlands in 1520-21, of which he has left a diary, the master was working almost entirely in Nuremberg until his death in 1528.

The earliest date found on any of Dürer's engravings is that on the *Four Nude Women* of 1497. He has not yet learnt to render the human form with any subtlety of modelling, and his engraving has hardly attained the solidity of structure seen in the best of Schongauer's prints. But this realistic study of the nude is a fresh factor in German art, and perhaps the only means by which he could surmount the limitations of his predecessors, and escape from the entanglement of ill-placed drapery, which only succeeded in hiding or distorting all the essentials of the human frame. Several other plates, to judge from their very closeness to the older traditions, as well as their undeveloped power of drawing, must certainly precede this work of 1497 by some two years at least. Most elementary of all, both in faulty foreshortening (*e.g.* the child flat against its mother and the squash figure of Joseph behind the bank), and in the abundance of angular folds, is the *Holy Family with the Dragon-fly* (B. 44). *The Offer of Love* (B. 93 ; see frontispiece) and the *St. Jerome* (B. 61) are others of a similar type, still loose in draughtsmanship, and somewhat incoherent in landscape. Quite the noblest of this early group is the *Prodigal Son* (B. 28), where the background of simple sheds and gabled houses offers the young engraver forms which he can perfectly master. The kneeling figure of the Prodigal presents problems which still baffle the artist, though the power of human expression is already wonderfully developed. After the turn of the century there is a remarkable advance both in technical skill and in the comprehension of form. As a display of agility in engraving, in the perfect realisation of the slightest shades, *e.g.* in the surface texture of the helmet, as well as in its harmony and balance as a composition, the *Coat-of-Arms with the Skull* of 1503 (B. 101) is a masterpiece. In the field of formal composition and in brilliance of engraving there is nothing which surpasses it in Dürer's work, if it be not the *Coat-of-Arms with the Cock* of some nine years later. The reality of Dürer's progress in every direction may be estimated by a comparison of the *Adam and Eve* [2] of 1504 (B. 1) with the earlier nude study we have already

[1] In the service of Friedrich the Wise. There is evidence of visits in 1494-95 and in 1503. For art at Friedrich's court see R. Bruck, *Friedrich der Weise als Förderer der Kunst*, Strassburg, 1903. Bruck considers that the earlier visit excludes the early journey to Italy, not, I think, a necessary conclusion. Weisbach (*Der Junge Dürer*) admits the necessity of Bruck's conclusion if his premises are correct, but doubts whether the *Albrecht* in question be really Dürer.

[2] Two trial proof states of this engraving are known (British Museum and Albertina) which are of great value as showing Dürer's method of work. He first lightly engraved the outlines, and then finished piece by piece separately, leaving

referred to. A system of cross-hatching of the most regular and delicate order, seconded by a perfect mastery of clear cutting, now correctly expresses the minutiæ of modelling ; while in the earlier prints an imperfect knowledge of form was combined with an irregular and undeveloped lineal system. Moreover, in his ideal of human form the change is remarkable. From the exaggerated ugliness of the earlier nude he has arrived at a feeling for classical beauty, which can only have come from the study of Italian models, and in this plate it is the influence of Jacopo de' Barbari that

Dürer and Jacopo de' Barbari.

speaks so clearly. This artist, who was in sundry parts of Germany between 1500 and 1508, is known to have been in Nuremberg in 1505, while in 1503 he must have met Dürer at Wittenberg where both were working for the Elector of Saxony. But the assumption of an early journey to Venice, to which we have already referred, places the first meeting of the two engravers probably as far back as 1495.[1] Whether at this early period or not,[2] it must have been at least no later than 1500-1501 that Dürer saw the study of a " man and woman, drawn according to a canon of proportions " (aus der Mass), which he himself admits[3] was the first suggestion to his own studies in the proportion of the human figure. But it was a mere suggestion, as Barbari evinced unwillingness to explain the subject,[4] and Dürer started to develop his own theories on the basis of Vitruvius and his own speculations. He seems to have modified his treatment after his second visit to Italy, possibly through further knowledge gained from Luca Pacioli,[5] whom he may have met in Bologna. The Adam and Eve, in whose style Barbari's influence has already been remarked, is the best example among the engravings of figures constructed according to canon, several original studies[6] being witness of Dürer's development of the subject.

A general connexion of ideas may be noted in several of the prints of Dürer and Barbari, e.g. in their Satyr Families, as well as correspondence in various details (e.g. the head of Neptune in

the completion of the figures to the last. The Hercules (B. 73) is the only other print of which a proof state of similar interest is known (Berlin, Albertina), though slight differences of state have been noted on some seventeen other prints.

[1] See passage quoted in note 1, p. 72. Whether das Ding is Barbari himself or a mere phase of art, such as the Vivarinesque, is a much debated question.

[2] A "proportion" drawing of a reclining woman (closely related to the Amymone of the engraving) in the Albertina is dated 1501. The date 1500 on a standing female figure in the British Museum has been disputed (cf. Justi, Construirte Figuren in der Werken A. D's., Leipzig, 1902.)

[3] In an unpublished sketch in the British Museum for the preface of his Proportionslehre (see Sir W. M. Conway, Literary Remains of A. D., 1889, pp. 165, 253-54 ; K. Lange, D.'s Schriftlicher Nachlass, 1893, p. 340).

[4] No writing on the subject and no " proportion " drawing by Barbari is known, nor do his own engraved figures evince any deep study of such theories.

[5] The author of the Divina Proportione, Venice, 1509 (with wood-cuts after designs by Leonardo). He owed much of his system to Piero della Francesca and Leonardo.

[6] E.g. in the Albertina (Vienna), and Lanna collection (Prague).

Dürer's *Rape of Amymone* [1] with that of the Triton in Barbari's *Triton and Nereid*), but their respective plates of *Apollo and Diana* form the most striking instance of their artistic relation. In describing Barbari's work, we have expressed the opinion that Dürer probably owes to the former the suggestion for his engraving, though the final correspondence in treatment is inconsiderable.

An even more powerful influence than Barbari on the develop- *Dürer and* ment of Dürer's style was that of Mantegna. There are two *Mantegna.* drawings by Dürer in the Albertina (dated 1494), after this engraver's *Battle of the Tritons* and *Bacchanal with Silenus*, and he embodied the same ideals in several of his plates, most evidently perhaps in the *Rape of Amymone* (B. 71), and in the allegory which is generally called the *Hercules* [2] (B. 73), both belonging to about 1500. The latter plate is a most curious medley of plagiarisms: the reclining woman is from Mantegna, the woman with the club is directly copied from an anonymous North Italian engraving of the *Death of Orpheus* (P. V. 47, 120, in Hamburg), while a figure used in the standing *Hercules* (a study for a *Rape of the Sabines*, in the Bonnat collection), seems to be borrowed from some lost drawing by Pollaiuolo. Dürer is as candid and free in his adaptation as Rembrandt, and, in fact, as all the greatest original creators are wont to be. [3]

Very soon after the return from Venice he must have started *The Copper-* the series of sixteen prints which constitute the *Copper-plate Passion.* *plate P.* The *Descent from the Cross* (B. 14), is dated 1507; two plates belong to 1508, one to 1509, the majority to 1512, while last in order (if indeed it strictly belongs to the series at all) is the *Peter and John healing the Cripple*, of 1513. From problems of proportion in designing single figures, Dürer had come to treat proportion in its relation to composition as a whole, and the *Passion* plates form the chief attempt in his engraved work in dealing with many figures in limited space. If some of the earlier examples are lacking in balance, *e.g.* the *Descent from the Cross*, the later plates, in particular the *Christ bearing the Cross* and the *Peter and John*, are wonderful in their concentrated significance, the last, most of all: a darkly shaded background, such as Dürer affected more and more in his later work, and the expression in the two foremost actors thrown into prominence by the light which falls across Peter's shoulder into the face of the cripple, are but two elements which help to induce the concentration of idea which Dürer was the first of Germans to accomplish.

Several isolated compositions, nearly all of the same small dimensions, fall into the same period as the *Passion* series. We may

[1] Also called the *Sea-Monster*.

[2] Other titles are the *Effects of Jealousy*, and the *Great Satyr*.

[3] Before leaving the question of Dürer's copies from Southern originals we may refer to his drawings after the so-called "Tarocchi Cards" (British Museum and Paris; see Dürer Society, 1906).

mention the *Three Genii with Helmet and Shield* (B. 66), where the
putto motive might have been suggested by some Florentine niello
(like that reproduced in Fig. 13), and the two plates of *St. George*,
one of which was reproduced in the frontispiece of the earlier editions
of this history.

If advance in technical power was possible after such achieve-
ments as the *Coat of Arms with the Skull*, it was directed to
simplification rather than further finish. While in the latter and the
Adam and Eve, the lines of shading are almost lost in the subtlety
of the shading, in most of the plates of the *Passion* series the use
of line is economised and individualised (if we may so refer to the
part played by each stroke) in a manner far more in keeping with
the general maxim that the artist should never belie his medium,

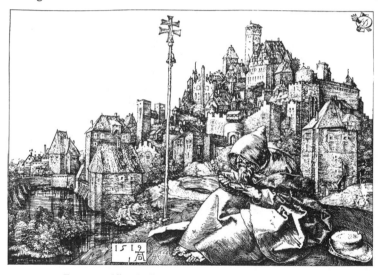

FIG. 29.—Albrecht Dürer. St. Anthony before the Town.

or so handle it as to attain an end which could be better realised
by some other method.

From about the same period Dürer begins a series of simpler
studies, where merely geometrical problems of construction become
completely secondary to that of human expression. Viewed in this
light, the *Adam and Eve*, great as it is, barely exists as a work of
art, while of the little plates of the *Virgin and Child* (there are nine
between 1511 and 1520), one is only more perfect than another.
Most remarkable, perhaps, in beauty of composition and engraving is
the *Virgin by the Town-wall* of 1514 (B. 40), while in "intimate-
ness" of feeling Dürer touches us most nearly in the *Virgin
nursing the Child* of 1519 (B. 36). The introduction of the walls
of his native town which gives so perfect a background to the *Virgin*

and Child (B. 40) seems no less inseparable from the *St. Anthony reading* of 1519 (Fig. 29), so wonderfully is the whole combined. It may be noted here that the town, or the background in this case, though suggested partly by elements of the Burg at Nuremberg, is more particularly taken from a drawing Dürer made of Trent (now in Bremen).

Three of the most ambitious, if not the most successful plates that Dürer produced, fall in the years 1513-14: the *Knight, Death, and the Devil* (B. 98), the *St. Jerome in his Study* (B. 60), and the *Melancholia*. If the beauty of the last is somewhat impaired by its crowded and obscure symbolism, the *Knight, Death, and the Devil*, though less brilliant than the *Melancholia* in engraving, drives home all the more for the directness and force of its intention. With Death staring him in the face, and the Devil ready to catch him if he trips or turns, the Knight rides on with foreboding of danger, yet firm resolve marked in every line of his face, too intent even to cast a glance at the distant city which is his goal. As a draughtsman of animals, which figure in all the three prints, Dürer never escapes a stiffness which is not merely that of convention, but a lack of practice or of the particular aptitude of the realist in representing these most restless of sitters.

Dürer is one of the earliest of all the portrait engravers, the few The portraits before him in Germany who attempted anything in this field (*e.g.* the Master of the Amsterdam Cabinet and W♃B[1]) leaving mere isolated examples of no great value; while in the south, if one excepts an early Florentine profile of a lady[2] and a few heads engraved in the style of Leonardo, there is scarcely anything until the Pietro Aretino of Marcantonio, which was perhaps not done until after the latest of Dürer's portraits. Earliest in date and finest in execution is the smaller *Albrecht of Brandenburg* of 1519 (B. 102), which is reproduced (Fig. 30). In the three larger portraits of 1523-24, the *Albrecht of Brandenburg* in profile (B. 103), *Friedrich the Wise, Elector of Saxony* (B. 104), and *Wilibald Pirkheimer* (B. 106), there is greater breadth of line and a certain monumental power. But, it must be confessed, they are not the work of the born engraver, for despite the wonderful delineation of all the intricacies and undulations of feature, they lack in the expression of real individuality. Even one of the latest, the *Erasmus* of 1526, tells us little of the man himself, though we seem to know every particle of his features; it is first and foremost a composition of still life, of wonderful design and brilliance of technique.[3] If in any

[1] See p. 31. [2] See p. 39.

[3] The plate was based on some drawing taken from the life in the Netherlands, 1520-21. Erasmus's own words in relation to the likeness are cold, courteous, and worth quoting: *si minus respondet effigies mirum non est. Non enim sum is qui fui ante annos quinque* (letter of 30th July, 1526).

of his portrait engravings the decorative factor yields to the expres-

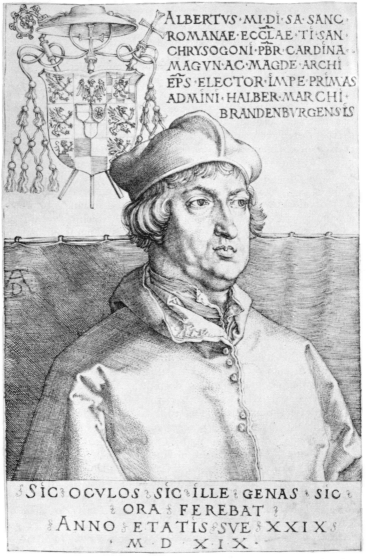

ALBERTVS·MI·DI·SA·SANC
ROMANAE·ECCLAE·TI·SAN·
CHRYSOGONI·PBR·CARDINA·
MAGVN·AC·MAGDE·ARCHI·
EPS·ELECTOR·IMPE·PRIMAS
ADMINI·HALBER·MARCHI·
BRANDENBVRGENSIS

SIC·OCVLOS·SIC·ILLE·GENAS·SIC·
ORA·FEREBAT·
ANNO·ETATIS·SVE·XXIX·
·M·D·XIX·

FIG. 30.—Albrecht Dürer. Portrait of Albrecht of Brandenburg.

sion of personality, it is in the *Melancthon* (1526), which is the simplest of all in its technical structure and secondary ornament.

Besides his line-engravings, Dürer has left us a few dry-points

and etchings. Of the three [1] dry-points two are dated, both in 1512 The dry-
—a *Man of Sorrows* (B. 21) and the magnificent *St. Jerome* (B. 59, points.
Fig. 31). A large *Holy Family* (B. 43), not dated, but certainly
belonging to the same period, is less successful. In the *St. Jerome*
the value of the burr of dry-point is so completely realised that one

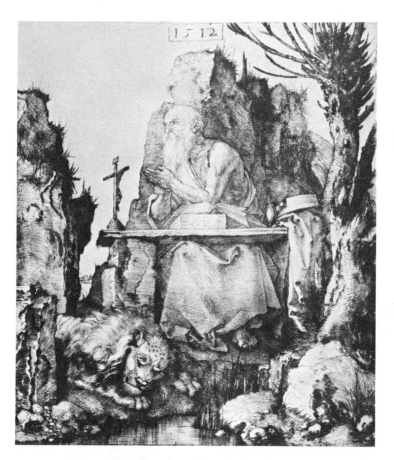

FIG. 31.—Albrecht Dürer. St. Jerome in the Wilderness.

wonders that Dürer did not recur to the method later. The most
practical explanation might be the right one, that the few good
impressions that could be taken would not repay him for his labour,
at a time when a single impression of an engraving was probably
sold for a small price, and before the public had realised the special

[1] There are good reasons to think that the little *St. Veronica* (B. 64), dated 1510
(of which the only impressions are in Dresden and the Albertina), is a later fabrication.

artistic value and the limitations of the new method. After Dürer
we find dry-point practised very little, and never with any apprecia-
tion of its possibilities, until the time of Rembrandt.

The etchings. Dürer was one of the pioneers of the art of etching. A plate by
Urs Graf [1] is dated 1513, *i.e.* two years before any of Dürer's etched
plates ; but this is an interval of small account, and the extraordinary
power of two, at least, of the six plates etched by Dürer immediately
places them in the van of the progress of the art, and indeed in the
foremost rank of all etchings. They all occur between 1515 and
1518. The *Man of Sorrows* of 1515 (B. 22) is hardly successful
as a print, differing too little in its quality from that of penwork ;
but the same year sees the creation of the *Agony in the Garden*
(B. 19), which is among the most wonderful of all his compositions.
In the next year fall the *Angel displaying the Sudarium* (B. 26) and
the *Pluto and Proserpine* (B. 72). Then there is a curious plate
sometimes called the *Man in Despair* (B. 70), which seems to be
little more than a study of various figures and faces, and is perhaps
as early as any of the rest. In his last plate, the *Cannon*, B. 99
(part of which is reproduced, Fig. 42), the line is handled with
much greater vigour, and the biting is completely successful. In
the treatment of landscape it must have done much to give the
particular direction to the early German school of landscape etchers,
to whom we shall refer in our next chapter. All these etchings are
on iron, and all have the rough characteristics arising from the fact
that the material, of less uniform texture than copper, would be
bitten with less regularity. It could hardly be the lack of know-
ledge of a proper mordant for copper which kept Dürer to the use
of iron, though this reason has often been suggested ; far more
probably it was the feeling, shared by some modern artists, that the
very roughness of the metal is more in keeping with the less precise
character of the etched line.

General char- But Dürer's genius was not by nature most adapted to the
acteristics of vagaries of line, by which all the greatest etchers seem to obtain
Dürer's art. significance almost subconsciously. He was above all others the
artist whose every line is laid with conscious thought. He is the
most perfect representative of that factor in the style of the "Old
Master" which stands in such contrast to the less formal elements
of design which are more strictly "modern" in feeling. In his
painting, as well as in his engraving on wood and metal, the part
played by each stroke is so considered, the harmony of each factor
with the whole so absolute, that it would seem impossible to take
away, add, or alter the slightest element without altogether impairing
the effect of the whole composition. Such were the conditions
which, according to the architect Leon Battista Alberti, constituted
" beauty " ; and we may allow at least that they constitute a certain
"formal dignity," which is no small element in the former. Beauty,

[1] See Chap. III. p. 106.

in the secondary sense of "grace" of form and feature, we cannot admit that Dürer often expresses, but he is no whit the smaller artist for the lack of it. Despite all he learnt from Italy, he remained essentially a true German, and a noble type of the national character. He was solid, scientific, conscious in all his creating. Learning his art from masters who were still in the youth of artistic development, his whole work shows a progress towards an ideal which the trammels of Gothic tradition never left him free to attain without a struggle. By the very energy spent in its realisation, his accomplishment is all the more intense in its expression. He recognised the truest limits of the medium in which he worked, never allowed technical virtuosity to have the better of the central aim of significant composition, and established a balanced style which remains the most perfect model of the line-engraver's art.

Before approaching the more immediate school of Dürer, we may just refer to two engravers who owed much to him in their development, but probably found their earliest inspiration like Dürer in Schongauer. Our chief interest in the Swiss artist URS GRAF Urs Graf. centres in his two etchings, one of which is the earliest dated etching known (1513).[1] Besides these he has left little more than half-a-dozen engraved plates (among which are two copies from Schongauer and one after Dürer), but in none of them does he express himself so well as in his wood-cuts. HANS BALDUNG, a German of Hans Baldung. the vicinity of Switzerland, came under similar influences, and, like Urs Graf, was far more prolific as a designer for wood-cuts than as a line-engraver. A genial adaptation of Dürer's treatment of form characterises the style of his few line-engravings (*e.g.* the *Horse and Squire*), as well as his work in other fields.

During the sixteenth century Dürer's influence was paramount in Germany, and found a multitude of imitators and copyists in the Netherlands and in Italy. But in Germany an even more powerful influence was the renaissance of feeling for classical form which began to find so many adherents North of the Alps. Towards the end of the century the Italianisation of German artists and their complete desertion of Dürer's ideal left an art as empty as it was unnatural and affected. But for some two or three decades after Dürer's death a group of artists, who, from the small dimensions of most of their plates have been called the LITTLE MASTERS, managed The Little to steer midway between the two currents, and produced a host of Masters. tiny plates as graceful as they are excellent in engraving.

ALBRECHT ALTDORFER, who was the oldest artist in the group, Albrecht was the least dependent on Dürer in the formation of his style. Altdorfer. He was born in 1480, and most of his life was spent in Regensburg, where he died in 1538. The earliest of his engravings are dated 1506, but a plate like the *Fortune on a Globe with a Genius*, of 1511, still shows him undeveloped in the use of the burin. Archi-

[1] Cf. Ch. III. p. 106.

tect as he was, he may at first have given rather the amateur's attention to painting and engraving. If his technical power is in consequence of secondary merit, the intimate personal touch which he gives to the expression of each small composition secures him almost the highest place as an artist among the Little Masters. His characteristic flat drawing of a child's face is forgotten in the atmosphere of human feeling which distinguishes plates like his large *Virgin and Child* (B. 17). Perhaps his greatest distinction among the Little Masters is his feeling for landscape, and as a landscape etcher he was the inspirer of a large following (*e.g.* Hirschvogel, Lautensack, and Wolf Huber—the latter, however, not an engraver in metal), which from its fountain-head is not inaptly termed the Regensburg school.[1] In pure landscape his work is almost entirely in etching, but none of his contemporaries knew better than he how to give a romantic colour to his subjects by the background of woods and hills. The *Pyramus and Thisbe* (B. 44, Fig. 32) and a *St. Christopher* (B. 19) are good examples, while his power of expression is perhaps at its highest in the *Crucifixion* (B. 8). He may owe something of his style to LUCAS CRANACH the elder (a Bavarian, born in Cronach, near Bayreuth, in 1472), who, in his early paintings, and the one engraving of this period (a *Penance of St. John Chrysostom*), shows just those elements of landscape, steep hills, pines, and larches

FIG. 32.—Albrecht Altdorfer.
Pyramus and Thisbe.

Lucas Cranach.

with their drooping foliage which are the characteristics of the Regensburg school. Cranach's work was far more that of a painter and designer for wood-cuts, and mostly done in Wittenberg, where he settled as painter to the Saxon court about 1504. Except for the *St. John Chrysostom*, Cranach's eight engraved plates consist of portraits : three of *Friedrich the Wise* (of 1509 and 1510, the latter with *John the Constant*, and another undated in which he is adoring St. Bartholomew), three of Luther (1520-21), and a copy of Dürer's *Albrecht of Brandenburg*.

The Behams. The most eminent of the Little Masters as virtuosi of delicate engraving are unquestionably the brothers BARTHEL and HANS SEBALD BEHAM, and GEORG PENCZ. They were all Nuremberg masters and came closely under Dürer's influence, though there is no definite proof that any of them were Dürer's pupils, unless Pencz

[1] Cf. Ch. III. pp. 107, 108.

be the assistant (Knecht) "Jörg," who married the master's maid in 1524. In their early days they formed a trio of freethinkers, and in this period of reformation, when lukewarmness in religious matters was eyed askance, this was enough to cause the banishment from their native city, which occurred in 1525. Apparently the ban did not last long, although the bad feeling may have caused Sebald Beham's later settlement in Frankfurt.

BARTHEL BEHAM, though the younger of the brothers by two years (he was born in 1502), seems to have been the more pre-cocious (his dated work begins in 1520), and in the compara-tively small number of his prints he certainly exhibits a depth of expression quite unknown to his elder brother. His *Cleopatra* of 1524 (B. 12) shows a feeling for classical beauty which is almost unequalled in German engraving of the period, while prints such as the *Mother and Child with a Death's Head* (B. 5), and the *Virgin and Child at the Window* (B. 8) are as full of true sentiment as they are masterly in engraving. Barthel is thought to have visited Italy, and he also worked for some time in Munich for Duke Wilhelm IV. of Bavaria, probably not returning to Nuremberg after the banishment. Barthel Beham.

If Barthel was the more talented artist, HANS SEBALD BEHAM, who was probably of a stronger nature or constitution, and able to give more assiduous practice to his craft, attained to a greater virtuosity in engraving, and left a far more prolific work. On his earlier prints he used a monogram composed of the letters HSP, while later, from about 1531, *i.e.* about the time of his settlement in Frankfurt, he changed the signature to HSB. Whether he came back to Nuremberg for any period before moving to Frankfurt is uncertain ; but he managed to get into difficulties again in that quarter, this time on a charge of appropriating Dürer's unpublished material for the *Proportionslehre*. In his earliest plates (*e.g.* the *Bust of a Girl,* dated 1518) he is a close imitator of Dürer, who was also the immediate inspirer of his etchings, some of which are dated in the years 1519 and 1520. Towards the end of the twenties his technique reached its highest point, and in most of the prints between 1525 and 1540 the lineal system is significant and strong, that of a Marcan-tonio on a tiny scale. The larger *Prodigal Son* of 1538 (Fig. 33) is one of the most perfect examples, while the natural bent of his genius is seen at its best in the sets of genre produced about the same period, *e.g.* the twelve plates to the *Peasants' Festival* of 1537 (Pauli 155-166). In the last ten years of his life his virtuosity even increased, his technique becoming more delicate as it lost some of its vitality. So finely engraved as they were, his plates could not last out many printings, and much of the last part of his life was spent in reworking his own plates as well as those left by his brother, to which he even added his own signature. These reworked plates often belie recogni-tion, and form one of the great difficulties in the study of his work. Hans Sebald Beham.

Unfortunately, he did not return often enough in these later years to his real sphere, that of genre, but played to the public taste in supplying classical pieces which were often adaptations from Italian engravers, if not mere repetitions of his own earlier work. In ornament, however, in which he is one of the great masters, some of his finest plates belong to this last decade.

Georg Pencz.

The fifty years of GEORG PENCZ's life, 1500-1550 exactly cover those of his early boon companions, Barthel and Sebald Beham. Even if he be not Dürer's assistant, as has been suggested, he at least derived his style directly from the master, but nevertheless developed a manner which has distinctly individual character both in draughtsmanship and technique. Somewhat less finished and

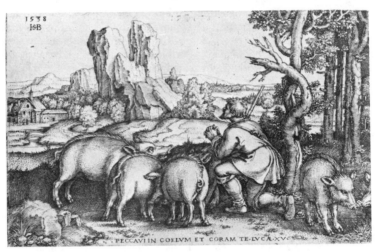

FIG. 33.—Hans Sebald Beham. The Prodigal Son.

less careful of surface texture than the Behams, he generally uses a multitude of dots in helping out the lighter portion of his shading. Nearly all his life was spent in Nuremberg, except for the short term of banishment, and possibly for certain visits to Italy. He succeeded better than most of his contemporaries in combining something of the largeness of classical Italian painters with a style which is still essentially German. Though he did some excellent Bible studies—*e.g.* the *Good Samaritan* (B. 68), and the *Story of Tobit* (B. 13-19), both of 1543—he was most at home with subjects of allegory or antiquity, and in view of the circumstances of his life it is hardly surprising that he engraved not a single plate of the Virgin and Child. Pencz has left a considerable number of portrait paintings, but the plate of *Friedrich the Wise* (of 1543) is apparently his only engraved portrait.

In the same group as the Behams and Pencz is an anonymous engraver who signs his plates with the initials I B, and whose works seem to fall almost entirely within the years 1525 and 1530. He is an excellent engraver, thoroughly imbued with the spirit of Renaissance art, so delightfully shown in his frieze of the *Children's Bacchanal* of 1529, and in many a plate of ornament. In his studies of genre and peasant life he stands near to H. S. Beham, with whom some have attempted to identify him. Quite recently, again, it has been suggested [1] that I B is none other than Georg Pencz, whose name in the Nuremberg vernacular might have been Jörg Bens. It is certainly true that nearly all Pencz's work signed G.P. is later than 1530, and a visit to Italy might have induced him to adopt the Latinised form Georgius Pencius for the basis of his signature. I think reasons of style are not sufficient to clinch either identification, and prefer to consider the problem of his identity as still unsolved.

Is I B to be identified with Georg Pencz?

Outside the Nuremberg circle the most interesting member of the group of Little Masters is HEINRICH ALDE-GREVER, a goldsmith and engraver of Soest in Westphalia, whose activity corresponds in time nearly to that of Pencz (1502-1555). He no doubt came into closer contact with the art of the Netherlands than his Nuremberg contemporaries, and the mannerism of his figure drawing, with its exaggerated length of body and limb, may probably be traced to Italian mannerists, like Pontormo and Rosso, through the medium of Bernaert van Orley, or some such Italianised Fleming.

Aldegrever.

FIG. 34.—Heinrich Aldegrever. Panel of ornament.

He has a curious affection for small shining folds of drapery which are dazzling in brilliance of execution, but damning to the grace and significance of his conceptions (*e.g.* the *Annunciation*, B. 38). He engraved several good portraits, but his real fame rests on his prints of ornament. In this department he was the real professional of the Little Masters (see Fig. 34).

[1] Friedländer, *Repertorium*, xx. 130.

Jacob Binck. Two other names almost complete the group of Little Masters, JACOB BINCK of Cologne (d. about 1569), and HANS BROSAMER, who was working in Erfurt between about 1537 and 1555. The former is an artist of little original power, a large part of his work consisting in copies from the Behams, Marcantonio, and the like. Most interest attaches to his portraits, *e.g.* the *Christian III.* of Denmark,

Hans Brosamer. in whose service he spent part of his life. HANS BROSAMER is an engraver of even smaller technical power. He is an imitator of Barthel and H. S. Beham and their compeers, but the precision of the true Little Masters is already gone.

Virgil Solis. The work of VIRGIL SOLIS of Nuremberg heralds a new epoch in German engraving. He started on the basis of the Little Masters, but developed a much lighter system of engraving which has far more in common with careful etched work of the French ornamentist Ducerceau. He worked at a time when the demand for engravings and etchings for all manner of illustration was enormously increasing. Several hundreds of plates issued with his signature from his workshop, many, without a doubt, the work of assistants. Popular allegories, plates of costume and genre, medallion portraits, and ornaments of all kind, make up a motley array of prints, possessing little artistic value, but of considerable interest to the student of the history of culture. Solis was an etcher as well as engraver, but the precise character of his etched line is still that of the engraver, and seldom exhibits any of the strength of Amman, who represents the same artistic tendencies in the medium of etching.[1]

THE NETHER-LANDS. The artistic pedigree of LUCAS VAN LEYDEN as an engraver is shrouded in far greater mystery than that of Dürer or Marcantonio.

Lucas van Leyden. The son of a painter Huygen Jacobsz, of whom almost nothing is known, a pupil of the painter Cornelis Engelbrechtsz, Lucas Huygensz van Leyden meets us in his fourteenth year (if we may trust the tradition that puts his birth in 1494), all but fully equipped as a master-engraver. We know of no engraver in Leyden before him, and of the few engravers of the fifteenth century whose activities are placed with probability in the Netherlands our knowledge is of the vaguest. But engraving is a cosmopolitan art, and prints of the better-known German masters, such as E. S., Schongauer, and van Meckenem, must have been familiar enough to the young Lucas van Leyden to give a sound basis for his technique, though their style is little reflected in his work. Nearer to him in locality, and seemingly a greater influence on his style, is the engraver I A of Zwolle, whose large clumsy forms are continued, though greatly refined, in some of Lucas's earlier plates (*e.g.* the *Round Passion* of 1509).

The large engraving of *Mahomet and the Monk Sergius* bears the earliest date on any of his works (1508), and he is already an

[1] Cf. Chap. III. p. 109.

accomplished master of a sound technical system. More than this.
Its excellence as a composition wins no small praise from the fact
that Marcantonio did not disdain to appropriate its background
two years later for his rendering of Michelangelo's *Bathers*. Several
other prints show a less developed knowledge of form and a looser
handling of line, and were probably executed even earlier : one might
instance the *Raising of Lazarus* and the *Samson and Delilah*, both
exhibiting the ill-achieved foreshortening which mars much of his
work. A small plate of *Adam and Eve seated* (B. 7) exemplifies the
minuteness of his early method of modelling, for which he soon
substituted a somewhat bolder system in which cross-hatching plays
a secondary part to the use of parallel lines. The development of
his power in composition may be traced through the *St. George*, in
its human and original aspect with the knight comforting the
distressed princess, the *Conversion of St. Paul* (1509), and the
magnificent *Ecce Homo* (1510), to the later *Crucifixion* (1517),
and the *Magdalene returning to the Pleasures of the World* (1519).
Certain figures in the *Ecce Homo* (man, woman, and child in front)
show that he had already assimilated something of the character
of Dürer's work, but these large subject pieces display a genius
quite different from the German master.

The *Round Passion* of 1509 shows another side of his activity. As
the name implies they are circular in form, and the general character
of their composition with the decorative border seems to justify the
assumption that they were intended as designs for windows. They
might be compared in this respect with numerous drawings by
Dirick Vellert for a similar purpose, and with a wood-cut passion
by Jacob Cornelisz (van Oostzaanen), an artist who was directly
influenced by Lucas van Leyden.

In the study of humanity in its most varying moods and in its
simplest dress, Lucas strikes the key-note of his country's art. It
is deplorable that he lacked the strength to resist the current of
classicism and to continue in the vein which makes his early print
of the *Cowherd and Milkmaid* (Fig. 35) so striking an anticipation of
the best Dutch work of the next century, and, as a study of animals,
almost unequalled.

The early *David playing before Saul* (Fig. 36), and the Mabuse-
like *Christ and the Magdalene* of 1519, a work of his most
mature period, well exemplify his peculiar power of expressing
human emotion, linked with a certain deficiency, which he never
wholly escaped, in the rendering of human form.

From about 1520 the stronger style of Dürer begins to quash
the originality of the more yielding nature, and personal contact
with the master must have greatly served to strengthen the influ-
ence. In spite of their excellence, such prints as the *Meeting of
Joachim and Anna* (1520), the *Passion Series* of 1521, the *Lamech
and Cain* and the *Musicians* of 1524 (cf. the fat forms in Dürer's

Dancers of 1514), possess none of the persuasive freshness of the earlier work. Even in technique nothing was really to be gained after such achievements in brilliance of tone as the *Temptation* of 1518.

But the next transformation is more disastrous. Dutch art has never been able to bear the outward idealism of Italian aims, and Lucas van Leyden, like Mabuse and Bernaert van Orley, joined the mass of his contemporaries in yielding to the seductions of the South. From 1528 not only does he completely change his technique to the simpler system of Marcantonio, but entirely declares in favour of a less human and sympathetic treatment of scriptural and

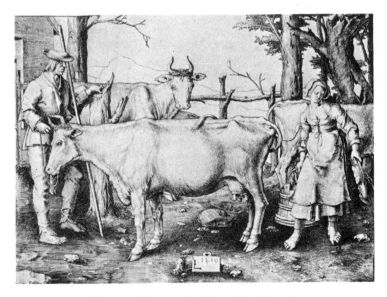

FIG. 35.—Lucas van Leyden. The Milkmaid.

allegorical subjects (*e.g.* the series of the seven *Virtues*). The latest of his productions, the large *Adam and Eve*, and the *Lot and his Daughters* (1530), suffice to show how greatly his individuality suffers beneath this classical bombast.

His etchings Like Dürer, Lucas made a few attempts in etching, and at least succeeded in producing a more delicate line than the Nuremberg master. The *Fool and the Girl* and the *David in Prayer* (1520) are examples in pure etching, while the *Portrait of Maximilian* of the same year shows a successful medley of the two processes, the face being entirely done with the graver, while most of the secondary work is etched.

Lucas van Leyden was not the founder of a school. That even he should have veered round from the front that might have made

one, is witness to the overwhelming tide in the classical direction which for a century successfully hindered the natural development of art in the Netherlands.

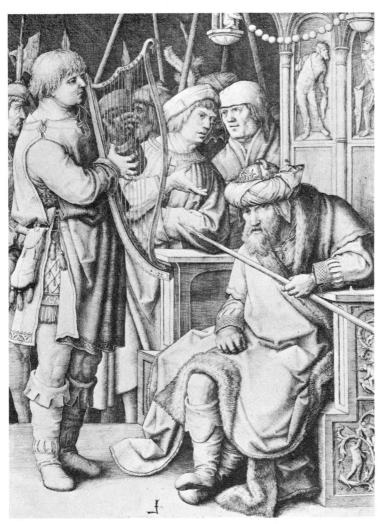

FIG. 36.—Lucas van Leyden. David playing before Saul.

His closest follower was perhaps DIRICK VELLERT of Antwerp. Dirick Vellert. But though an engraver too, his constant use of etching, either alone or in combination with the burin work, justifies his place in the chapter that follows.

Jan Gossaert (Mabuse).

More potent leaders of style in the first half of the century were the painters Quentin Matsys, Jan Gossaert (Mabuse), and Bernaert van Orley. To Mabuse, with whose manner Lucas van Leyden had much in common, have been attributed three engravings (two *Madonnas* signed I M S, one dated 1522, and, with even less certainty, a *Mocking of Christ*, in Paris); and Bernaert van Orley has sometimes been held responsible for a roughly executed etching of 1531, with an epitaph on Margaret of Austria. But these attributions are too precarious, and it is as inspirers of engraving rather than as engravers that these artists are of interest in our study.

Bernaert van Orley.

The Master of the Crayfish.

Closely dependent on the style of Quentin Matsys, and influenced in some degree by Lucas van Leyden (note the long forms in the *Execution of the Baptist*) stands the engraver who uses a CRAYFISH as his signature. The identification with FRANS CRABBE of Mechlin is now generally accepted. He varies the lineal system of his predecessors by a very liberal use of dotted work (*e.g. Death of Lucretia*, B. 23), and also combines with his engraving a delicately etched line. Some of his plates, (*e.g.* the *Execution of John the Baptist*, P. 28) seem entirely composed of bitten work, and the influence of Dirick Vellert's technique is unmistakable. Another engraver working at Mechlin at the same period, hitherto known only by his initials N. H., has recently been identified with NICOLAS HOGENBERG,[1] an artist of Munich origin, whose family was represented by several other engravers in the next generation. His most interesting work (etched on thirty-eight plates (represents the *Entry of Charles V. into Bologna*, 1529.

The Master S.

Under similar influences comes a prolific engraver known only by the initial S. He has been generally called Master S of Brussels, but tradition seems to be the only foundation for this localisation. Some critics regard the Lower Rhine as the more probable centre of his activity. Certain of his plates, executed in the manner of nielli, suggest that we have here to do with a goldsmith, and it may be with a circle of craftsmen in his employ.

Allart Claesz.

ALLART CLAESZ (of Utrecht?)[2] stands as an artist on a somewhat higher plane, and is the chief representative in the Low Countries of the tendency of the German Little Masters. He borrows much from the latter, combining with their manner a much coarser adaptation of the Italian style than is seen in the Behams and Pencz.

Cornelis Matsys.

The influence of the Little Masters is seen also in CORNELIS MATSYS (a son of Quentin Matsys). He betrays a lighter touch than his German models, partly by dint of combining his engraving with the etched line, and his style seems inspired less by the Roman school than by Parmigiano.

Lambert Suavius.

As an engraver of the transition we may just mention in this place LAMBERT SUAVIUS (who worked in Liège about 1540-59), although he belongs more strictly to the group of Italianised

[1] See Bibliography, Friedländer. [2] VTRICH̄ appears on his *Woman with a Dragon*, and VTRICHT on the *Nativity* in Oxford.

Flemings of whom we shall speak in Chapter IV. Suavius still, however, preserves more than most of that group something of the indigenous element of Lucas van Leyden's style, although, like his father-in-law, Lambert Lombard, he was already imbued with the Italian spirit. In his design and engraving he shows more particularly the influence of Jacopo de' Barbari, but he could hardly have met the Venetian, who ended his days in Flanders before 1516. Suavius has just the same tendency as the latter to long and narrow folds continued in parallel curves from top to bottom of his draperies. He is a graceful artist, with considerable power in dealing with light and shade (*e.g.* in the *Entombment*), and is given to few of the exaggerated mannerisms of his contemporaries.

Compared with Albrecht Dürer, Marcantonio is unquestionably a ITALY. genius of a limited scope, if not of a secondary order, but he has none Marcantonio. the less exercised an unparalleled influence, and inspired the largest following of any engraver who has ever lived. Dürer stands as a master who infused the noblest feeling into forms which, in the hands of empty imitators, are in danger of becoming merely expressive of ill-favour. On the other hand, the art of Marcantonio, though lacking the inner power possessed by Dürer, spoke through a medium which retains a certain formal beauty even in feebler hands, and so attracted a host of imitators from one end of Europe to the other.

MARCANTONIO RAIMONDI was born in Bologna about the year 1480, and served his apprenticeship under the famous painter and goldsmith of his native town, Francesco Francia, whom we have already mentioned for his work in niello.[1] He may at first have followed his master's activity, and produced some plates in this method, but there is no certain evidence of the fact. The only prints which show any likeness to the method at all, in respect of the dark shading in the background, *The Three Maries* (D.[2] 54-56) and the *St. Catherine, St. Lucy and St. Barbara* (D. 57-59), even if by his hand, are quite in his later manner; while the *Neptune in his Car* (P. 282), a copy from the niello-like engraving of "Peregrino da Cesena" (Duchesne 214, reproduced, Fig. 14), or from an even better niello print of the same school (reproduced, Gutekunst sale Catalogue, 1899, No. 864), is attributed with even less certainty than the former. The earliest date occurring on any of Marcantonio's prints, is that of 1505 on the *Pyramus and Thisbe.* There are several, however, which must precede this, and one group in particular, where somewhat tentative and elementary drawing is combined with a simple manner of shading, parallel lines in the background being generally formed into an arch of shadow behind the figures. These characteristics are exemplified in the *Youth extracting a Thorn from his Foot* (B. 465),[3] and in the *Woman and Man with an*

[1] See pp. 42, 68. [2] = Delaborde. See Index and Individual Bibliography.
[3] Perhaps copied from a Bolognese niello (Duchesne 316) which, in its turn, is an adaptation of the celebrated bronze in the Capitol Museum at Rome.

Axe Head (B. 380). The latter, especially, shows the inexperienced hand in the pentimento along the outlines of the man's left leg.

Still about the same time, but more ambitious in composition, and nearer to the *Pyramus and Thisbe* in the close and more goldsmith-like shading, should be placed the *Judgment of Paris* (B. 339), the *Allegory with Bologna and its leaning towers in the background* (B. 399), and the *Orpheus* (B. 314), where the same delicate manner is carried to even greater finesse. How far Marcantonio's engraving is definitely due to Francia's teaching it is

Was Francia an engraver ?

impossible to say. Some four engravings have been attributed to the master (*i.e.* a *Baptism of Christ*, a *Virgin enthroned and two saints*, a *St. Catherine and St. Lucy*, and a *Judgment of Paris*, see P. V. p. 201), but they differ hardly at all from the work of the young Marcantonio, and lacking stronger evidence are more safely assigned to the latter. We may mention in passing that the last letter of Marcantonio's usual signature M A F seems to have reference to the name *de' Franci*, which Vasari tells us he acquired, like so many other Italian artists, from his master.

In a somewhat later stage of his development, but still during his Bologna period, Marcantonio makes a far more liberal use of dots, and lays greater, perhaps exaggerated, emphasis on the darker parts of shading, showing in the latter respect a peculiar mannerism in edging his masses of trees with bands of dark foliage. The *Three Cupids Playing* (of 1506), an *Allegory with two female figures* (B. 377), and a *Woman watering a Plant* (B. 383), are typical examples of this phase. As early as 1504 the praises of the young engraver were sung by the Bolognese theologian, jurisconsult, litterateur, and musician, Giovanni Philotheo Achillini, in his *Viridario* (though the book remained unpublished until 1513), and one of the most attractive of Marcantonio's early plates, the *Guitar Player* (B. 469, Fig. 37), is almost certainly a portrait of the artist's panegyrist.

His debt to Dürer.

In the trees and landscape of his compositions he soon began to borrow largely from Dürer, whose work was at this time beginning to be widely known and copied in Italy. Of these copyists Marcantonio was the most prolific and not the most scrupulous in his appropriations. Besides many of Dürer's line engravings, he copied the large wood-cut series the *Life of Mary* on copper, in a manner closely imitating the original, and signed them with the Northern master's signature. This was in 1506, and Dürer, who visited Italy in that year, had this immediate incentive for his bitter complaints to the Venetian Senate of his young rival's action. Happily this sufficed to induce Marcantonio, whose previous offence had no doubt been less his own than that of unscrupulous dealers, to add his own signature to the copies which he subsequently made of Dürer's smaller *Wood-cut Passion*.

It is almost impossible to overestimate the influence of the

Nuremberg master on Marcantonio's development. The latter, however, was always original in his assimilation of another's methods, and though learning much from Dürer in respect of a

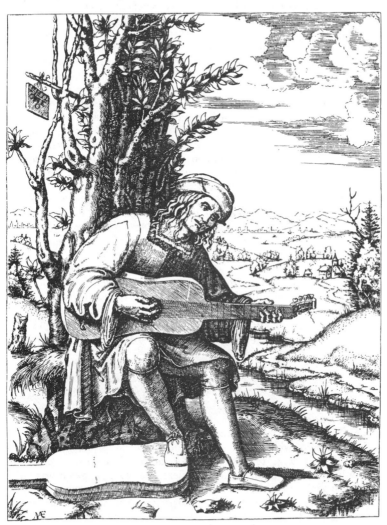

FIG. 37.—Marcantonio Raimondi. Portrait of Philotheo Achillini.

regular method of cross-hatching, he ended by simplifying the same to a system which possesses a strength and character of its own, by no means inferior to the technical style of his Northern rival.

For an uncertain period between 1505 and 1509 Marcantonio

was working in Venice, and in this centre of artistic commerce he no doubt had greater opportunity for seeing Dürer's prints, even if we are not to accept Vasari's story that it was here that he first made their acquaintance. An interesting relic of his sojourn in this city is the print which, at least since the middle of the eighteenth century, has borne the inexplicable title *Raphael's Dream* (B. 359). Giorgione may have inspired this, as he did at least one other print of the period, *i.e.* the *St. Jerome* (B. 102), though the latter is probably more immediately suggested by the style of Giorgione's interpreter, Giulio Campagnola.

Marcantonio left Venice for Rome about 1509-10, visiting Florence on his way, and making drawings from Michelangelo's lost cartoon of the *Bathers*, which he used in an engraving dated in this year.

Adaptations from Lucas van Leyden. His treatment of the subject has an added interest from the compliment he paid to the young Lucas van Leyden (who, if tradition is correct, was still only some sixteen years old) by copying the landscape from the latter's *Mahomet and the Monk Sergius*. He seems to have adapted his background from the same master again in his *Adam and Eve*, another of the prints of the early Roman period. In mitigating the sternness of the Dürer convention the Dutch master's work was certainly not without influence on Marcantonio.[1]

Baldassare Peruzzi's influence. Another mellowing influence in the formation of the engraver's style at the epoch of his arrival in Rome was that of Baldassare Peruzzi, whose drawings in several cases seem to have been the basis for Marcantonio's plates. This is established in the case of the print representing an *Allegory on the Third Punic War* (B. 213) (and so rather the *Triumph of Scipio* than the *Triumph of Titus*, as it has been called), which is based on a drawing by Peruzzi in the Louvre (perhaps a study for a projected continuation of the frescoes in the Capitol Museum, Rome), while there are others, like the *Orpheus and Eurydice* (B. 295), which one has every reason to suppose were inspired by the same master. It has been suggested that the *Death of Lucretia* (B. 192, Fig. 38) is also after Peruzzi, but Vasari was probably justified in his ascription of the design to Raphael, and in his statement that it was this magnificent print which induced the great painter to acquire the co-operation of Marcantonio, which lasted till the death of the former in 1520.

His connexion with Raphael. Of the drawings furnished by Raphael to his engraver very few are authenticated, but these are sufficient to show how much was left to Marcantonio to elaborate and develop, and it is exactly in his wonderful sympathy and power in adaptation that his chief strength lies. A study for the *Pietà* (B. 37) in Oxford, and another for the *Massacre of the Innocents* (B. 18 and 20) in the British Museum (where the original chalk is possibly covered by work of another hand) are almost the only examples beyond dispute.[2]

[1] A copy of L. v. Leyden's *Pilgrims* (B. 149) is also attributed to Marcantonio with plausibility (B. XIV. 462).

[2] See O. Fischel, *Raphael's Zeichnungen*, Strassburg, 1898 (Nos. 100 and 380).

The prints of the first two or three years in Rome are, as a group, perhaps the most charming of all Marcantonio's work, the

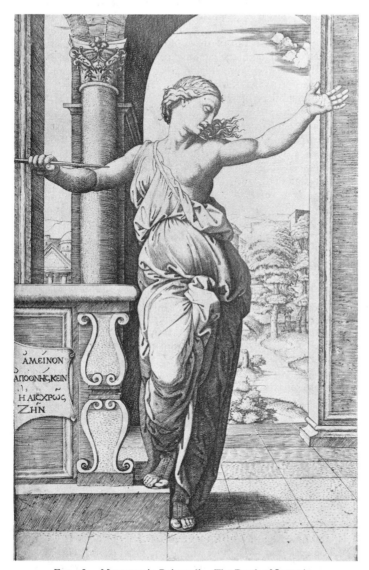

FIG. 38.—Marcantonio Raimondi. The Death of Lucretia.

Death of Dido (B. 187) and the *Poetry* (B. 382) (the latter after the fresco by Raphael in the Camera della Segnatura) being unsurpassed

for grace of design and delicacy of workmanship. Marcantonio's cutting is now perfectly clean, and the tendency to exaggerated depth of tone in the darker portions has quite disappeared. We may probably be right also in placing in this period the two attractive portrait studies (B. 445 and 496) which, with the perpendicular shading and in the method of treating the figure, may have suggested to Parmigiano the etching of *St. Thais* (B. 12, Fig. 44). The second of the two studies is of great interest if tradition is right in calling it a portrait of Raphael.

The same subtlety of shading which has been remarked in the earliest works of the Roman period, added to an even greater power, is seen in large plates like the *Judgment of Paris* (B. 245), *Apollo and the Muses*, and the *Massacre of the Innocents*. Of the last-named there are two versions (B. 18 and 20), one of which (18) is often distinguished by the small fir tree in the right corner, which does not appear in B. 20. There is little difference in artistic value between the two versions, and it is possible that Marcantonio himself repeated the composition. There are several similar repetitions of other compositions, *e.g. Christ lamented by his Mother* (B. 34 and 35). If, as is generally held, Marco da Ravenna (or some other pupil) is responsible in such cases for one of the plates, it is great testimony to the efficacy of the immediate direction of a master like Marcantonio.

Repetitions by the master or school copies?

Finally Marcantonio turns to a far bolder and more open manner of engraving, perhaps gaining in strength, by the simplification of his system of shading, but sometimes sacrificing far more virtue than he gained in his attempt at a summary method. Good examples of this later style are the three prints of the story of *Cupid and Psyche* (B. 342-44), after the Farnesina frescoes, and an allegorical figure of *Strength* (B. 375). A certain number of the prints after Raphael were no doubt executed after the painter's death in 1520; and prints in the later manner, after Raphael and other masters (such as the large *Martyrdom of St. Laurence* after Bandinelli), show a deterioration, which may be partly due to the lack of the personal direction which had meant so much to the engraver. The most attractive part of the work of the later years are the numerous small prints (perhaps inspired by the work of the German Little Masters) which, in certain cases at least, were used for book illustrations (*e.g.* the *Amadeus*, B. 355, for a dialogue of Amadeo Berruti on Friendship, 1517). This and the suppressed illustrations after Giulio Romano to Aretino's Sonetti, which caused Marcantonio's temporary banishment from Rome, are examples of a practice we have noticed in reference to the *Monte Sancto* of 1477,[1] which was not revived with any success till the end of the sixteenth century. The engraver's connexion with Aretino, the notorious blackmailer and satirist, is more worthily represented in the portrait which, if after a picture by

His later engravings.

[1] See p. 47. Cf. also pp. 30, 33, 65, 70, 119.

Titian,[1] can hardly date before the sack of Rome, as Aretino's arrival in Venice and his first relation with Titian did not occur till about 1527. The engraving, which is of great richness of tone, but somewhat stolid portraiture, does not convincingly point to Titian, and Vasari may be right in calling it a study from the life made by Marcantonio while Aretino was in Rome, *i.e.* sometime between 1517 and 1524. At the sack of Rome in 1527, Marcantonio is said to have returned to Bologna, and in 1534 he is spoken of as dead. Apart from this nothing is known, and the last phase of his life is still wrapped in obscurity.

Raphael was the first of the great painters to realise the market value of popularity by pressing an engraver of first rank entirely into his service. His factotum, Baviera, who seems among other things to have mixed the master's paints, turned to printing, and was among the earliest of the profession of printseller, which was to become so lucrative a calling during the course of the century. For the dignity of engraving, it is easy to regret the submission of the art to the mere reproduction of the ideas of others. The introduction of photography and the photo-mechanical processes has completely changed the state of the case, and present conditions have practically ousted the engraver from the possibility of profiting by reproduction. We may rejoice at the change, but it is not for us to lament that, before this change came about, one of the greatest of all engravers was ready to lend his powers to the expression of another's genius. We should rejoice that it was he, and no other, who laid the foundations of tradition in a branch of work for which there was bound to be an increasing demand. *(margin: Reproductive engraving.)*

From the mass of anonymous engravers who must have worked in the school, or directly under Marcantonio's influence, three are known by name and a few more by their monograms alone. Of the former, JACOPO FRANCIA, the son of the great painter and goldsmith Francesco Francia, was probably a fellow-pupil of Marcantonio under his father, but his work nearly all betrays the influence of his more powerful contemporary. The *Death of Lucretia* (B. 4) shows him an artist of graceful talent, but with a characteristic tendency to a fulness of form and feature which lacks the grip of Marcantonio. The assumption that he worked at some time in Rome is probable but quite uncertain, gaining no real support from the fact that some of the later prints which bear his monogram are direct copies from Marcantonio, *e.g.* the *Christ in the House of Simon* of 1530 (P. 8, after B. xiv. 23). *(margin: Jacopo Francia.)*

More certainly in the immediate entourage of Marcantonio, probably an assistant if not a pupil, is MARCO DENTE DA RAVENNA, who generally uses a monogram composed of R and S, and on one of his prints (the large *Laocoon*) has signed in full *M(a)rcus* *(margin: Marco Dente da Ravenna.)*

[1] As is asserted by Hollar in the little etching which may be nothing more than a copy of Marcantonio.

Ravĕnas. Beyond his name and his work, and the probability that his life met a tragic and premature conclusion in the sack of Rome in 1527, nothing is known about the engraver's history. In a certain richness of texture and tone he comes nearest of all the school to the master's technique in engraving, though as a draughts-man his powers are by no means great. His shading, with large flat surfaces of tone, is simple and not unpleasing, but not sufficient to really express the modelling or structure of the human form. One of the best examples of his manner of figure engraving is the *Boxing Match of Entellus and Dares* (B. 195). His prints after sculpture are good, *e.g.* the equestrian statue of *Marcus Aurelius*, and in certain cases (*e.g.* the *Laocoon*) of great interest as showing the sculpture before later restorations.

𝕶.

A somewhat later master who used a very similar monogram 𝕶 (*e.g.* in his *Assembly of Savants*, B. 479) should not be confused with Marco da Ravenna. His work is characterised by a much harder system of line than the latter's.

Agostino
(Veneziano)
de' Musi.

The most prolific of the engravers in the school of Marcantonio, and like Marco da Ravenna, almost certainly one of the master's assistants, is AGOSTINO DE' MUSI (VENEZIANO, as he was called from his birthplace). His practice of not only signing his prints (either with his name in full, or with the initials AV), but also adding the date, gives us ample material for tracing the develop-ment of his work. In his earliest plates we find him copying his compatriots Jacopo de' Barbari and Giulio Campagnola, while the earliest date on any of his works (1514) occurs on a plate of the *Last Supper*, copied from Dürer's larger *Wood-cut Passion.* He seems most of all to have been influenced by Giulio Campagnola, and not only copied, but imitated his work. His *Man with a Flute* (B. 454) is a mere travesty of the former's *Shepherd*, while his *St. Margaret* (B. 119), the *Nude woman reclining asleep* (B. 412), and the *Diogenes* (B. 197) are quite in the same master's manner.

In 1517 he is probably settled in Rome, for the *Christ carrying the Cross* (B. 28), after Raphael, belongs to this year, while a print after Andrea del Sarto, dated 1516 (a *Pietà*), no doubt points to a visit to Florence on his journey South.

Like Marco da Ravenna he repeated a considerable number of the compositions which Marcantonio himself engraved, generally making his copy in reverse. He seldom attains the former engraver's richness of tone, but his draughtsmanship possesses greater clearness and definition in line. In his later prints, many of which are designed by Giulio Romano, he shows an affection for rendering artificial light, *e.g.* the *Nativity* of 1531 (B. 17), and the *Infant Hercules strangling a Snake* of 1532 (B. 315). Another similar effort, representing the sculptor *Bandinelli with his Pupils in his Studio, working by Candle-light*, of 1531 (B. 418), has a special interest on account of its subject. Towards the end of his career

Agostino engraved a few portraits, that of *Hieronymus Alexander*, *Archbishop of Brindisi* (1536), being the best in a sphere in which his achievement is of small merit.

Among the immediate followers of Marcantonio must be mentioned the engraver who signed his plate with the initials B. V., or more generally with a die marked with the letter B alone. Identifications have been suggested with a certain Benedetto Verini, spoken of in tradition as a natural son of the master, and with Tommaso Vincidore, of Bologna, an assistant of Raphael, commonly called Il Bologna,[1] but neither case seems proven. His plates (certain of which bear the dates 1532 and 1533) show little originality of manner, but a close assimilation of Marcantonio's style.

<div style="text-align:right">*The Master with the Die (Benedetto Verini?)*</div>

One other school of engraving, that of Mantua, deserves mention here, as preserving strong individuality, at a time when nearly all the engravers in Italy were dominated by Marcantonio. At the head of the school stands GIOVANNI BATTISTA SCULPTOR (born 1503), but its great master was GIORGIO GHISI, while a son and a daughter of the former, ADAMO and DIANA SCULPTOR, were close imitators of both.

<div style="text-align:right">*The Mantuan school.*
G. B. Sculptor.
Adamo and Diana Sculptor.</div>

Like Marcantonio they were to a large extent reproductive engravers, but were less happy than the Roman master, in having for their model the large emptiness of Giulio Romano, who spent the last years of his life decorating the Palazzo del Tè in Mantua. The peculiar characteristic of their style of engraving is most noticeable in the rich blackness of their shadows, which is partly obtained by a liberal use of dots between the lines, and in certain instances by an admixture of thick etched lines with graver work. These characteristics are already present in Giovanni Battista Sculptor's *Virgin and Child on the Crescent* (B. 4), but they are seen at their best in the works of Giorgio Ghisi, such as the large *Nativity* of 1553-54 after Bronzino. In this emphasis on dark shading, which is well exemplified in the allegorical figure of *Victory* (?) (B. 34, Fig. 39), Ghisi stands nearer to Marcantonio in his Bolognese manner. The strongly emphasised depth of tone is still present in his most monumental achievement, the prints after Michelangelo's *Sixtine Ceiling* and *Last Judgment* (the latter alone being engraved on eleven separate plates), but a greater breadth of line seems in this case to show the influence of Marcantonio's later work.

<div style="text-align:right">*Giorgio Ghisi.*</div>

In the history of the development of engraving Ghisi is of special interest, as forming a link between the South and North in the visit he paid Antwerp in 1550, where several of his plates (*e.g.* the *Last Supper* after Lambert Lombard, and, in its second state of 1554, the *Nativity*, mentioned above) were published by Hieronymus Cock. As we shall see in a later chapter, the printsellers from the Netherlands were soon to do as much to turn Italian engraving into a

[1] Worked in Rome and the Netherlands from before 1520 until about 1537. See Bibliography, A. Fischel.

mere commerce as the Italians from their side debased the natural growth of art in the North.

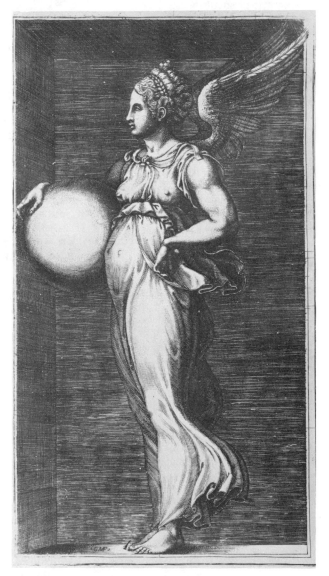

FIG. 39.—Giorgio Ghisi. Fortune.

THE FRENCH
SCHOOL. The French school, which was almost barren in the fifteenth century, produced no great engraver in the succeeding epoch.

Scarcely anything was done until after the second decade of the century, and, not possessing a tradition of their own, the French engravers yielded to the Italian influence even more completely than their Northern neighbours.

Among the earliest who practised the art in France, JEAN DUVET, born at Langres in 1480, evidently formed his style on Italian models, though he is not known to have studied in Italy. Rough copies of Mantegna's horizontal *Entombment* and Marcantonio's *Virgin in the Clouds* are evidences of the direction of his early application. Michelangelo was another of his models, but unhappily for the beauty of his art, he seems, like most of his fellow-countrymen at the time, to have leaned rather to the exaggerated bigness of Michelangelesque forms, as seen in Pontormo and Rosso. He never mastered the elements of drawing, and never got beyond a heavy and overcharged manner of engraving, in which an irregular shading is outlined with thick strokes often carelessly doubled and doubled again to add to their breadth. Nevertheless, as an interpreter, he is not without a certain charm analogous to that of William Blake. He often shows a real power of graceful composition, though he too often mars it with faulty drawing, or overcrowds his space with figures. His greatest work, showing his tendency to mysticism, is the set of illustrations to the *Apocalypse*, from which we reproduce the lower part of the *Angel showing John the River of the Water of Life* (Fig. 40). Here and there he did a plate in a cleaner and more precise technique, *e.g.* the *Body of Christ borne by Soldiers* (dated 1528), but most of his work is in the same heavy manner as the *Apocalypse*. An allegorical plate representing the *Glory of Henri II.* shows him at his strongest. His devotion to allegory may be noted again in the series of plates which are said to refer to the amour of Henry II. and Diana of Poitiers, where the recurrence of the unicorn suggested the name given him by some early iconographers, the " Maître à la Licorne."

The only other early French engraver who did much work on a large scale in imitation of models like Michelangelo, was NICOLAS BEATRIZET of Luneville ; and he almost belongs to the Italian school, working as he did so much of his life in Rome, and assimilating the Italian manner. Apart from the historical interest of a few dull portraits and the value of some engravings of antiquities to the archæologist, his work possesses little importance.

Most of the French engravers of the period followed the Italians, but qualified this influence with a distant imitation of the ideals of the Little Masters of Germany.

The engraver who directly copied most from the Germans is NOEL GARNIER, but his work (dating between about 1520 and 1540) is of little worth.

In JEAN GOURMONT we meet the best representative of the spirit of the Little Masters transplanted to France, and treated

Jean Duvet.

Nicolas Beatrizet.

Noel Garnier.

Jean Gourmont.

with considerable originality. He appears as a printer in Paris as
early as 1506, but his engravings seem to belong to some two
decades later, when he was working in Lyons. In making adapta-
tions from Italian models (*e.g.* from the niello-print of *Three Women
Dancing*, Duch. 287, and from some prints of the *Laocoon*) he knows
well how to set his subject amid the simple renaissance architecture,
with little or no decoration, which characterises his school. His
little *Nativity* (B. 2), a small roundel like so many of these early
French prints, though possessing none of the finesse of the best of

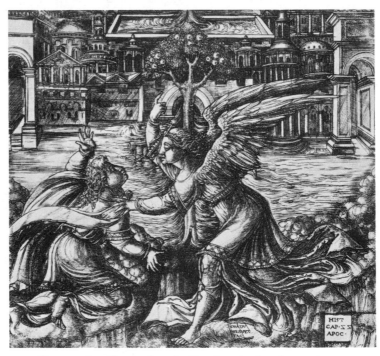

Fig. 40.—Jean Duvet. Part of a Plate from the Apocalypse series.

the German Little Masters, is a good example of the sound and
simple method of shading he adopted. He also engraved a few
portraits somewhat in the manner of Martino Rota.

Claude
Corneille (?)

Another Lyons artist working on similar lines to Gourmont is
the engraver who uses the monogram CC, which almost certainly
indicates some member of the Corneille family, if not a "Claude."
His work has none of the sound technical qualities of the former,
and his draughtsmanship is distinctly inferior. A series of *Portraits
of the Kings of France*, published in 1546 by Balthasar Arnoullet
(*Epitomes des Roys de France*), has at least an historical interest.

To the same school of Lyons belongs also GEORGES REVERDY, Georges "Ce. Reverdinus," as he Latinised his name, to the confusion of all Reverdy. but quite recent iconographers. His early work about 1531 was probably done in Italy, and chiefly shows the influence of the Mantuan school of the Sculptors and Ghisi, from whom he made some copies. Prints like the two *Adorations* (of the Kings and Shepherds), both roundels, have all the characteristics of the Lyons group of engravers, and almost certainly belong to his later period, *i.e.* after his return to France.

By far the greatest achievement of the early French school of ORNAMENT. engraving was in ornament and architectural prints. ÉTIENNE Étienne DELAUNE, who worked in Strassburg and Augsburg as well as Paris, Delaune. is without qualification one of the finest of all ornament engravers. The character of his designs largely issued from the style which

CVM . PRIVILEGIO .. REGIS STEPHANVS . F.

FIG. 41.—Étienne Delaune. Arabesque.

originated in Raphael's decoration of the Vatican Loggie, which with its slender foliage and grotesques stands in such contrast to the bolder scroll ornament, still half Gothic in form, which survived in Germany well into the latter part of the same century. The sinuous lines, the wasp-like forms, show to better advantage in Delaune's extraordinarily fine engraving than as they were painted by Giovanni da Udine in the Vatican.

The other great ornament designer of the early French school, J. Androuet JACQUES ANDROUET DUCERCEAU, may just be mentioned here, Ducerceau. but as he worked almost entirely in etching, he will find his place in the following chapter.

Another engraver of ornament, inferior in power to either of the Pierre preceding, is PIERRE WOEIRIOT. His chief interest for us, how- Woeiriot. ever, lies in the multitude of small portraits which he produced somewhat in the manner of the Wierixes, though, like JEAN RABEL,

possessing none of their microscopic finish. A series of consider-
able historical importance is that of the *Kings of France*, pub-
lished at Cologne in both Latin and French in 1591 (Clement
de Treille's *Austrasiae Reges et Duces*; the French version by
F. Guibaudet).

CHAPTER III

THE BEGINNINGS OF ETCHING AND ITS PROGRESS DURING
THE SIXTEENTH CENTURY

THE genius of etching is the very antithesis of the formality of line-engraving.[1] The needle is drawn through the ground against the slightest resistance, and the artist who uses this process can in consequence command a spontaneity of expression almost equal to that in drawing with the pen or pencil. It is this very lack of convention which gives the method so much closer an affinity with the spirit of modern art, which in a sense begins with Rembrandt, than with the classical tendencies and more rigid systems of the fifteenth and sixteenth centuries. Until the seventeenth century etchings of any importance are only occasional performances, and even in these the specific quality of the etched line is scarcely ever realised.

The process of etching, in its widest signification, was practised by the goldsmith, metal-chaser, and more particularly by the armourer and gunmaker, long before it was used for the production of prints. It is perhaps impossible to date any weapons with etched decoration before the last three decades of the fifteenth century, but instructions for etching on iron are found in a MS. of the earlier part of the century,[2] and there is every reason to suspect that the

[1] With regard to the essential virtue of etching, it is curious to note the development of opinion in the editions of Bosse's *Traicté des manières de graver*. In his own preface of 1645 Bosse assumes that the etcher's aim should be the imitation of the precision of burin work. C. N. Cochin II. in the preface to his revision of Bosse (1745 and later) rightly contests this point of view, arguing for the virtue of a greater freedom of style, and emphasising the important fact that the hard etching-ground, still in general use in Bosse's time, would naturally militate against the flexibility proper to the etcher's art. In fact the "etchers" of the sixteenth and early seventeenth centuries were often more truly "engravers," using the acid as an aid to reinforce the lines already cut or scratched on the plate, with the *échoppe*, graver, or point, through the hard etching-ground. Dietrich Meyer is said to have been the first to have used the soft etching-ground, better described as the "wax-ground" (and not to be confused with soft-ground etching), and to have been followed by his pupil, Matthäus Merian I. Callot is an example of an etcher of the transition period who still generally used the hard-ground (though he had recipes for soft-ground); Rembrandt, on the other hand, the true exponent of the wax-ground, and its adaptability to perfect freedom of draughtsmanship.

[2] By Jehan le Begue, MS. (written about 1431) Bibl. Nat., Paris (see Mrs. Merrifield, *Original Treatises on the Arts of Painting*, London, 1849, vol. i. p. 76). For the whole subject consult in particular E. Harzen, *Archiv* v. 119, and S. R. Koehler, *Zeitschrift*, 2nd ser. ix. 30.

method was known well before the fifteenth century, if not in antiquity.

The practice of taking impressions on paper from etched plates may possibly go back to the last few years of the fifteenth century, but no date can be assigned to any etching earlier than 1513, the

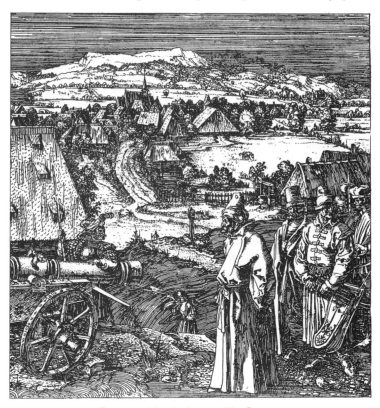

FIG. 42.—Albrecht Dürer. The Cannon.

Urs Graf. year given on URS GRAF'S *Girl bathing her Feet*, of which the only impression known is in Basle. Then there are some five etchings by DÜRER, which we mentioned in the last chapter, dating between 1515 and 1518. The *Gethsemane* and the *Cannon* (Fig. 42) are most powerful works, but Dürer was probably ill content with the coarseness of line attainable on iron, which remained for a considerable time the common material for etching in Germany. The use of iron may have been determined rather by the conventions of an art which was chiefly applied in the armourer's workshop, than from any lack of knowledge of a suitable mordant for copper. The H. S. Beham. etched plates of Dürer's follower, HANS SEBALD BEHAM, amount

to less than twenty in all, and, as in the case of Dürer, are the occasional work of an artist chiefly devoted to line-engraving.[1]

ALBRECHT ALTDORFER, whose memorial etching of the Regensburg Synagogue destroyed by fire in 1519 gives some indication of the date of his work in this medium, was a more successful and prolific etcher than Beham, and is of considerable importance as one of the earliest interpreters of landscape for its own sake. His style in landscape etching is simply the transference to metal of the manner of his pen drawing. The study of the forms of trees and of other things in nature is still in its infancy, but the quaint conventions and the characteristic German curves in the landscapes of this school possess a distinct charm of their own. *Altdorfer and landscape etching.*

One of the landscape etchings of Albrecht Altdorfer's immediate entourage is signed E.A. (British Museum), and is almost certainly the work of a brother, Erhard Altdorfer. An engraving which bears the same initials is dated 1506 (*i.e.* the same year in which *Erhard Altdorfer?*

FIG. 43.—Augustin Hirschvogel. Landscape.

Albrecht's first plates in line were produced), so that it is possible they started their artistic life in close contact. Later, however, Erhard seems to have settled in Mecklenburg, where he is known to have been living as late as 1570. He does not appear to have left many plates ; his chief work is in wood-cut.

Altdorfer's closest followers in landscape are AUGUSTIN HIRSCHVOGEL and HANS SEBALD LAUTENSACK. HIRSCHVOGEL, born in Nuremberg about 1503, and living long in Vienna, was a versatile genius, adding to glass-painting (the profession of his father) the crafts of etching, enamel-painting, and even engineering. His manner of etching landscape was even simpler than that of Altdorfer : he seldom attempts more than a bare outline sketch, perfectly suggestive as an etching should be. LAUTENSACK, some *Hirschvogel.* *Lautensack.*

[1] The greater part are dated in 1519 and 1520, *i.e.* almost immediately after Dürer's attempts (e. g. *St. Jerome writing*, Pauli 63, *Virgin with the Apple*, P. 20, *The Standard-bearer*, P. 205). The date 1540 occurs on another (*Woman and Fool*, P. 149), and about six are undated.

twenty years Hirschvogel's junior, also seems to have migrated from Nuremberg and settled in Vienna a few years before his death in 1563. His landscape etchings are the most important part of his work. In design they are quite similar to Hirschvogel and Altdorfer, but the usual charm of this school of landscape is in Lautensack somewhat marred by the overcrowding of detail, and in the attempt at working more in a painter's manner the value of line is lost. In his portraits he frequently combines etching and engraving (*e.g.* that of his father, the painter, *Paul Lautensack*). Like Lucas van Leyden, he models the face with the graver, adding dress and accessories in etching.

The Hopfers of Augsburg. Daniel Hopfer.

Another interesting group of etchers at this period is that of the Hopfers of Augsburg. DANIEL HOPFER, who was already working in Augsburg in 1493, was certainly one of the first, if not the earliest, of the German artists to practise etching in our sense of the word. He used it, like many another before him, for ornamenting armour and guns, and the majority of his rough etchings were intended as little more than patterns for the goldsmith or sculptor. Of native artistic instinct there seems little in the family. A few of his plates, *e.g.* *Christ and the Adulteress* (B. 7), may be his own invention, but most of his subject prints (such as the *Christ before Pilate*, with its dependence on Mantegna's fresco of St. James in the Eremitani) seem suggested by the designs of others. He shows a strong predilection for the heavily ornamented renaissance forms which were beginning to exert so much influence on the Northern art of this period.

External evidence seems to place at least one of Hopfer's plates well before the first essay of Urs Graf, *i.e.* the portrait which has been identified with *Konrad von der Rosen*, the jester-adviser of Maximilian I. (B. 87).[1] There is another version of the same portrait engraved in North Italy (probably Venice) during the early years of the sixteenth century, which from the inscription undoubtedly served as a portrait of *Gonsalvo of Cordova*, the general of the forces of Ferdinand V. of Castile in Italy (P. V. 191, 109).[2] Now Gonsalvo was serving in Italy between 1494 and 1504, and it is far more probable that the print was issued about 1503-4, when his fame was at its height, than after his fall from favour in 1504, or even as a memorial print on his death in 1515. Although the common practice of the Hopfers would incline one to suspect them of using an Italian original rather than of supplying the Italian with a model, in this case the lack of anything more than a typical resemblance to

[1] In Fugger's MS. *History of Austria* (vol. ii. fol. 311 ; Hofb., Vienna) there is a water-colour portrait of Rosen which is almost certainly copied from Hopfer's print. Fugger was generally trustworthy, so that this is great support to the identification. Rosen also appears in the large wood-cut *Triumph of Maximilian*, as well as in drawings by the elder Holbein in Berlin.

[2] A third version (P. V. 191, 109, copy A) does not touch the question at issue, as it is a mere reversed copy of the P. V. 191, 109. The inscription in this copy, *el gran Capitanio . . . retrato dal vivo*, makes too bold a claim to originality.

Gonsalvo (enough for the hero-worshipping public) is so striking, the whole costume of the sitter so essentially Northern, and the identity with Rosen so plausible, that the reverse seems to be the true position. If this portrait, which is one of Daniel Hopfer's best prints, be accepted then as probably before 1503-4 it may be assumed that not a few of his other prints date at this period of his activity, an inference of considerable importance in the history of etching.

His brothers HIERONYMUS and LAMBERT HOPFER,[1] who worked in the same style, have even less originality than Daniel. Hieronymus was a most prolific copyist, not only from Dürer and the German school, but from Mantegna, Jacopo de' Barbari, Nicoletto da Modena, and many of the early Italian engravers. Lambert Hopfer, and the anonymous etcher who signs with the initials CB accompanied by the device of the little tree, which is used by the three other members of this group, are of even smaller importance. The influence of the great Augsburg painter, HANS BURGKMAIR, is manifest throughout the work of this school, and he is himself probably responsible for one etching, the *Mercury and Venus* (B. vii. 199, 1), of which the British Museum possesses the original iron plate. His son, of the same name, seems to have been joint author with HEINRICH VOGTHERR, the younger, of a series of full-length figures with escutcheons for the arms of Augsburg citizens, which was first published in 1545.

All the etching of the Hopfer family, if not also most of that of Hirschvogel and Lautensack, seems to have been on iron. This metal is bitten more irregularly than copper, with the result that certain parts hold the ink much better than others, causing the somewhat patchy contrasts of dark and light, which characterise and sometimes disfigure the work of the school.

The only etcher of real note who worked in Germany in the second half of the sixteenth century was a Swiss settler in Nuremberg, JOST AMMAN, and he too, like the engraver Virgil Solis, sacrificed much of his talent to merely commercial uses. A large proportion of his production consists of ornament and heraldic prints, title-pages, and miscellaneous book illustration. But, happily, he found more opportunity than Solis for doing artistic work less subject to these secondary aims. His portraits in particular, *e.g.* of Nuremberg worthies such as *Neudörffer, Hans Sachs,* and the goldsmith WENZEL JAMNITZER (of whom one etching is known, an *Arch of Triumph* in Berlin), show him as something more than an ordinary craftsman. So, too, do many less pretentious pieces of genre and simple studies like the *series of animals* (A. 194-211).

The German etchers of the latter part of the sixteenth century may be dismissed in a few words. Their work for the most part

Marginal notes: Hieronymus and Lambert Hopfer. C B (with the Tree). Hans Burgkmair I. and II. Heinrich Vogtherr II. Jost Amman.

[1] It may be mentioned that there are three of the original iron plates of Lambert Hopfer in the British Museum (B. viii. 531, 28-30).

M. Zündt.

served some practical purpose, and possessed little artistic value. Thus MATTHIAS ZÜNDT is chiefly of note for his etchings of ornament intended to serve as patterns to the goldsmiths. A series of *vases*, dated 1551, are probably by his hand. The author of these designs was long known as the MASTER OF THE KRATERO-GRAPHIE, but there seems every reason to discard the awkward anonymity in favour of the identification with Zündt. Besides a few portraits Zündt also etched some views of towns. Witness to the growing popularity of illustrated books of topography and travel are the large Cologne publications of Georg Braun (*Civitates Orbis*

F. Hogenberg.
The de Brys.
M. Merian I.

Terrarum, 1572, etc.), which were illustrated by FRANZ HOGEN-BERG, and the *Collectiones Peregrinationum*, started by the DE BRYS in 1590, and only brought to completion by MATTHÄUS MERIAN, the elder, in 1634. As the better part of this work is not etched, but engraved, it is noticed in more detail in the succeeding chapter.[1]

Sibmacher.

A large heraldic publication by HANS SIBMACHER (Nuremberg, 1605, 1612) and a book of ornament for architect, cabinet-maker,

Dietterlin.

and sculptor by WENDELIN DIETTERLIN, of Strassburg (1593-99), are among the more prominent examples of the practical uses of etching at this period.

.

ITALY.
Francesco
Mazzuoli.

The first attempts at etching in Italy stand in sharp contrast to the rough etching on iron of the early German engravers. FRAN-CESCO MAZZUOLI of Parma (PARMIGIANO), whose earliest etching can scarcely date before 1520, is the first of the Italians to make a regular practice of the art, and there are only one or two Italian plates before his time where the use of acid can be even suspected. The character of his work is typical of the distinction of Italian work in general from the earliest German etchings. The line is thin and scratchy, the shading is irregular, the plates are for the most part lightly bitten. All the characteristics of his swift and summary pen drawings reappear in his prints, with too little significance to be forcible as etching. Nevertheless, with all their mannerism, Mazzuoli's plates possess a graceful charm, and found numerous imitators. The *St. Thais* (B. 4, Fig. 44) is one of the most pleasing of his prints, and in the simple perpendicular shading which he affected there is quite a modern touch. The treatment of this subject may perhaps have been suggested by two small portrait studies by Marcantonio (B. 445 and 496, one of which has been called a portrait of Raphael).

A group of etchings nearly in Mazzuoli's manner, but possessing none of his swift and significant touch, and none of the gradation of colour that the master puts into his line, are signed F. P. The initials are less probably those of the anonymous etcher than of Mazzuoli himself (Francescus Parmesanus), who is without doubt the inspirer of the designs.

[1] See p. 124.

Another follower of Mazzuoli, ANDREA MELDOLLA (SCHIAVONE), was once held in honour as the inventor of the art of etching. If, as seems almost beyond a doubt, he is identical with the painter, the pupil of Titian, he could hardly have started etching till some twenty years later than Mazzuoli. His etchings display all the mannerisms of his model in an exaggerated form, and have little

Andrea
Meldolla
(Schiavone).

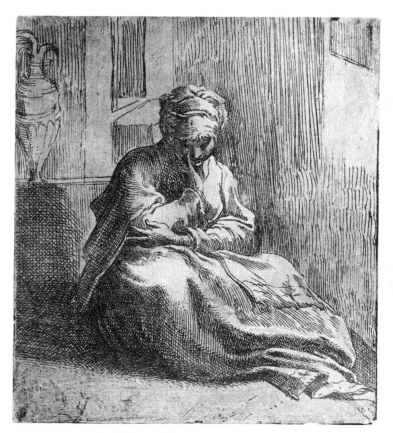

FIG. 44.—Francesco Mazzuoli. Woman seated on the Ground (St. Thais?).

of the excellence of draughtsmanship which Parmigiano possessed. The bad drawing of the hands, with their sharply pointed fingers, immediately distinguishes his work from Mazzuoli's, while the character of his etching is far more scratchy and irregular. He makes considerable use of the dry-point, though not realising the value of the burr to any extent (*e.g. Minerva and the Muses*, B. 79). With all their faults, his plates, like his paintings, possess a certain spontaneity and verve. He not infrequently tinted his impressions,

probably to get effects similar to the chiaroscuro cuts which were so popular at this period.

Meldolla is said to have worked on pewter, but I must admit that comparison with the surface quality of certain English music of the eighteenth century said to be printed from pewter, and with an impression from a pewter plate by William Strang, has led to no

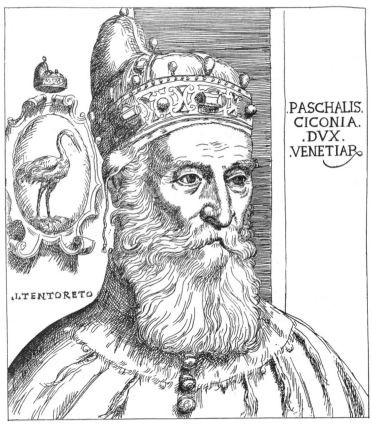

FIG. 45.—Anon. etcher after Tintoretto. Portrait of the Doge
Pasquale Cicogna.

definite conviction.[1] Pewter was so largely used for other things in Italy at the period that the experiment might well have been made in etching, and the softness of the metal would account for the rarity of good impressions.

[1] After an examination of the prints, Mr. Strang, whose occasional use of pewter in etching adds great weight to his opinion, declared against the probability of the tradition, which does not seem to date earlier than Bartsch. Cf. Introduction, p. 3.

A considerable amount of etching was inspired by the work of The Venetian Titian, but it has far less artistic value than the magnificent wood- School. cuts that were being done by Boldrini and others, after designs of the master and of followers, such as Domenico Campagnola. One of the best etchings of the class, the *Landscape with squire and horse* (B. 8, Titian), bears the contemporary inscription *Titianus manu propria,* but it has none of the grip and certainty of draughtsmanship in ground and trees which characterise the master's authentic work. A portrait plate, which has been attributed to Tintoretto, that of the Doge *Pasquale Cicogna* [1] (B. xvi. 105, 1, see Fig. 45), can hardly be more than a school adaptation of some picture by the master, but will serve as an excellent example of the breadth of handling characteristic of this group. All the etchers of the school have a broad touch, but there is nothing which can stand as etching beside Mazzuoli. We may mention a few without quoting from their works : GIOVANNI G. B. Franco. BATTISTA FRANCO, among the first, though a good part of his early B. d'Angeli del work was line-engraving in the spirit of Marcantonio ; then four artists Moro. originally of Verona—BATTISTA D' ANGELI DEL MORO, GIOVANNI G. B. and Giulio BATTISTA and GIULIO FONTANA, and PAOLO FARINATI, and, finally, Fontana. a somewhat more original spirit in JACOPO PALMA the younger of P. Farinati. Venice. J. Palma II.

Nearly all the central Italian work of the century was done in line-engraving. Towards the end of the century, when Marcantonio's influence was lessening, a revival, chiefly due to Agostino Carracci, continued to militate against the progress of etching. The two brothers of the latter, LODOVICO and ANNIBALE CARRACCI, produced Lodovico and a few etchings and dry-points in the last decade of the sixteenth Annibale century and the first of the next : they are the work of hands quite Carracci. unskilled in the art, unimportant, but not without charm. The only artist of any real feeling for the true character of etching was FEDERIGO Baroccio. BAROCCIO (born 1528 in Urbino, working at intervals in Rome, where he died in 1612). Unhappily he has left only some four original etchings, but the large *Annunciation* and the *Virgin and Child in the Clouds* show him the master of a very delicate and individual method. By the liberal use of dotted work both by itself and between the lines, he attains the same effect of soft, misty gradations of tone which characterises his paintings.

.

We have noted in our last chapter that LUCAS VAN LEYDEN, THE NETHER like Dürer, made a few attempts in etching. In date they probably LANDS. belong to 1520 or thereabouts, *i.e.* two years after Dürer's last Lucas van Leyden. etching. It was just the period that Lucas was falling so completely captive to Dürer's style, so that it is almost beyond a doubt that the idea of etching came from the same quarter. In one respect there

[1] There are pictures of Cicogna (Doge, 1585-95) attributed to Tintoretto in Innsbruck, and in the collections of the Marquis of Stafford and Marquis of Bute, but I have not verified any immediate connexion with the print.

is a notable difference. Lucas van Leyden certainly used copper,
and succeeded, in consequence, in obtaining a far more delicate line.
In such studies in pure etching as the *Fool and the Girl* and the
David in Prayer, this refinement is not so marked as in the great
portrait of *Maximilian I.*, where the face is engraved, but the
costume and setting are entirely etched.

Dirick Vellert. In this combination of etching with engraving, Lucas van Leyden
has a follower in an Antwerp artist whose identity has only recently
been established,. DIRICK JACOBSZOON VELLERT[1] ("Dirick van

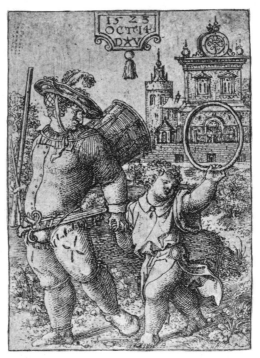

FIG. 46.—Dirick Vellert. Drummer and Boy with a Hoop.

Star" as he had been called, from his signature D✳V). This point
of contact, their close connexion in style, and the fact that Vellert's
earliest etchings are dated in 1522, when Lucas was in Antwerp,
seem to show that Vellert was inspired if not instructed in this sphere
of art by Lucas van Leyden himself. As a designer of glass windows
Vellert had been at work in Antwerp for a decade before he turned

[1] Index and Individual Bibl. (Glück). An attempt has recently been made (Beets,
Oud Holland, 1906) to identify the master ⚲, whose monogram figures on some
prints of ornaments (reading, as if reversed in printing, D I, and not G I as is gener-
ally accepted) with Vellert.

to engraving. Although the design of one of his plates (the *Temptation* of 1523) corresponds to a known study for a glass painting (in the Ducal Museum, Weimar), the type and form are completely altered, and none of his prints absolutely reflects (as the *Round Passion* of Lucas van Leyden seems to have done) his activity in the other field. On the dating of his prints (which fall between 1522 and 1526, one only, *The Flood*, coming later, in 1544) we are curiously well informed, for it was his practice to inscribe the day and month as well as the year on his plates. They are for the most part lightly and precisely etched in the principal lines, and then finished in the finer parts of shading with the graver. Only a smaller number are done in pure etching, *e.g.* the *Drummer and Boy with a Hoop* of 1523 (Fig. 46), and the *Drunken Warrior* of 1525, plates in which the distinctively Flemish character of his work is unalloyed in its broad humour. Except for the *Flood*, his prints are chiefly of small dimensions, and he is strictly one of the Flemish Little Masters. While of modest power and reflecting now Lucas van Leyden, now Matsys, now Bernaert van Orley, plates like the *Christ and the Woman of Samaria* (1523), the little *Virgin and Child with St. Anne*, the *Eve showing Cain the Apple* (1522), and the *St. Luke painting the Madonna* (1526), have a distinctly individual charm of manner.

After Lucas van Leyden and Dirick Vellert there is almost less etching of interest to record during the sixteenth century in the Netherlands than we have found in either Germany or Italy. The MASTER OF THE CRAYFISH cannot, however, be forgotten. The Master of the Crayfish. Influenced by both the preceding artists, his etched plates form a considerable proportion of his work, which we have already noticed in the second chapter.[1] Among Dutch artists JAN Jan Vermeyen. VERMEYEN may be mentioned as one of the earliest to work in the lighter and more open manner of the Italian etchers. At the invitation of Charles V. he settled about 1534 for some time in Spain (where he was nicknamed "El Mayo," *i.e.* long beard), and in his travels no doubt saw more of the work of the etchers of North Italy and of Fontainebleau, to whom his technical style has some resemblance. His plate of *Venus and Cupid* (P. 2) and some portraits (*e.g. Philip of Spain* of 1555) are by no means without talent, and have a certain modernity of touch.

Among the Italianisers of the Netherlands, most preferred to Frans Floris. follow the Marcantonio tradition of line-engraving, though there P. Feddes van were a few, like FRANS FLORIS (DE VRIENDT), PIETER FEDDES VAN Harlingen. HARLINGEN, and BARTOLOMÄUS SPRANGER, who used the other B. Spranger. process. The only certain work of HIERONYMUS COCK himself, Hieronymus the great publisher of Antwerp, who did so much to spread the Cock. commerce of reproductive line-engraving, is in etching (chiefly of

[1] Now identified with Frans Crabbe. Nicolas Hogenberg should also be noted as an etcher. Cf. p. 90.

landscape, between about 1551 and 1563), though he must be responsible for some of the unsigned line-engravings of the school as well.

Pieter Brueghel I.

Far more truly national in character are the few plates of PIETER BRUEGHEL the elder, but they hardly betray the power that produced such masterpieces among Flemish paintings of peasant life as

Jan Brueghel I. the pictures in Vienna. Pieter's son, JAN BRUEGHEL the elder, was, like his father, for some time in Italy, but he too preserved the national characteristics, though he cared more for mythological staffage in his landscape than for the realistic figures of "Peasant" Brueghel, as his father is sometimes called. There are only two or three etchings with his signature, but they have all the curious and delicate quality of his paintings.

Hans Bol.
Paul Bril.

Nearly akin to Jan Brueghel is HANS BOL, with his landscapes crowded with figures, while PAUL BRIL, who passed the greater part of his life in Rome, is perhaps the strongest of this group of landscape etchers. Their work is scarcely ever true to nature, always bizarre in character and meagre in line, yet much of it possesses a certain fairyland charm of its own.

Vinckboons.

The Flemish tradition of Pieter Brueghel the elder was ably carried on at the turn of the century by DAVID VINCKBOONS of Mechlin, who worked chiefly in Amsterdam. One or two of his etchings of genre are exceedingly good, but his work is represented far more fully in the many engravings which were done after his designs.

FRANCE.

Except in the sphere of ornament, we have found that little line-engraving of importance was produced in France during the sixteenth century, and this little was largely an offshoot of Italian art. In etching there is even less to recount. In the front rank is again an artist largely devoted to ornament, the etcher and

Androuet Ducerceau. architect JACQUES ANDROUET DUCERCEAU. Although his manner of etching is wonderfully precise and delicate, it must nevertheless take second rank to the finely engraved work of Delaune, at least in the sphere of small ornament prints. He left, besides, many hundreds of etchings of palaces, gates, bridges, and plans of all sorts, and it is in these contributions to the history of architecture that his real importance lies.

The school of Fontainebleau.

The event of greatest moment to French art in the sixteenth century was the invitation given about 1530 by Francis I. to several Italian painters, under the leadership of Rosso Rossi of Florence and Francesco Primaticcio of Bologna, to take part in the decoration of the Palace of Fontainebleau. The greater part of the frescoes they executed have disappeared, either destroyed by fire or removed in later restoration and rebuilding, so that it is a happy circumstance that so many of the painters of the school left etchings, which were either directly copied from the printed works or

suggested by the studies of the greater masters of their group.
Among the mass of anonymous work, are signed prints by the
Italians ANTONIO FANTUZZI, GUIDO RUGGIERI, and DOMENICO DEL A. Fantuzzi.
BARBIERE, while among native artists etched work is attributed G. Ruggieri.
to GEOFFROY DUMONSTIER, and signed by LÉONARD LIMOSIN, the Domenico del
 Barbiere.
famous enamel painter, and by LÉONARD TIRY of Deventer. As Geoffroy
etching there is nothing of note. The light touch seen in Mazzuoli's Dumonstier.
work reappears, but has lost most of its virtue in combination with Léonard
 Limosin.
the sprawling figures and grandiose compositions of Rosso and Léonard Tiry.
Primaticcio.

One of the few French artists of the period who rises to some- Jean Cousin.
thing of a personality in spite of a close dependence on Michelangelo
is JEAN COUSIN. Painter of pictures and of windows, sculptor, wood-
cutter, and writer on portrait and perspective, he is also generally
regarded as the author of some four or five etchings, two of which,
an *Annunciation* and a *Pietà*, bear the master's name. Somewhat
heavy in their line, which is partly helped out with the graver, their
importance lies chiefly in their attribution and their rarity.

Beyond this there is almost nothing of note to recount. The The
historian of the Huguenot wars may perhaps take a curious interest *Événements*
 Remarquables
in the series of *Événements Remarquables*, executed partly in wood- of Perrissin
cut and partly in the coarsest of etching by JACQUES PERRISSIN and Tortorel.
and JEAN TORTOREL between 1559 and 1570, but the student of
art will miss little if he does not know them.

CHAPTER IV

THE DECLINE OF ORIGINAL ENGRAVING

THE PRINT-SELLERS—THE GREAT REPRODUCTIVE ENGRAVERS OF THE SCHOOL
OF RUBENS—THE FIRST CENTURY OF ENGRAVING IN ENGLAND

(About 1540-1650)

THE middle of the sixteenth century was nowhere a time of great achievement in engraving, and, unhappily for the student, the deficiency in quality was far from being accompanied by a paucity of production. There has never, perhaps, been a period more prolific in prints of all sorts. The traveller—and this was the great era of discoveries—must have his engravings of topography, the annalist his series of portraits, the political agitator his broadsides. Moreover, at this epoch of religious upheaval the value of engravings as a subsidiary to propagandism, was being realised by the religious orders, and illustrations of Scripture stories and small devotional prints were disseminated broadcast. The enormous increase in the demand for engravings greatly changed the conditions of their production. With the prospect of sound business the middle-man of necessity enters, and there gradually grew up the new and soon flourishing profession of print-seller.

The Netherlands, with its great houses of COCK, GALLE, and PASSE, was the home of such enterprise in Europe, and we find members of Dutch and Flemish families the pioneers of their profession all over Europe. DOMINICUS CUSTOS of Antwerp settled in Augsburg; the SADELER family, of Brussels and Antwerp, had members in Prague and Venice, and the Utrecht firm of CRISPIN VAN DE PASSE was represented by some who at various times were settled in Paris, London, and Denmark. Italy was hardly behind in the race, but here, too, enterprise was often in the hands of the foreign settlers. The name of ANTONIO SALAMANCA, which is seen so often on later and bad impressions of the engravings of Marcantonio and his school, is hardly less ubiquitous than that of Cock, while ANTONIO LAFRERY is the publisher of a monument of archæological reproduction, for which classical students will always be grateful.[1]

The print-seller and print-publisher.

Cock.
The Galles.
The Passes.

Custos.
The Sadelers.

Salamanca.

Lafrery.

[1] *Speculum Romanæ Magnificentiæ*, published in its completed form with 118 plates in 1575.

118

One of the chief causes for the need of an intermediary profession was the growing demand for engraved book-illustrations. Hitherto wood-cuts, which can be printed far more conveniently in conjunction with type, had been almost universally used for the purpose of illustration,[1] and the publisher would seldom be without some cutter constantly working in his service. The engraver on metal, on the other hand, has generally a larger field than the woodcutter outside book illustration, and when required for such a purpose, he would naturally preserve a greater independence. An important publishing house, like that of Christophe Plantin at Antwerp, would of course have some engravers, *e.g.* P. VAN DER BORCHT, more or less under its wing, but it would constantly need to go farther afield, as we may gather from the business connexions it had with the engraver print-sellers, HIERONYMUS COCK and PHILIPPE GALLE.

The print-seller of this period has no real counterpart in the print-dealer of to-day. Far more frequently than is now the case, he acquired the original plate, and would be ready to print impressions as they were called for to almost any number, no doubt getting his hack engravers to rework the lines as soon as they were worn, a custom most dangerous to any artist's reputation. It is no misfortune, perhaps, that the identity of the engraver for whom he cared just enough to give a commission is often entirely lost ; for we may generally regard a print inscribed by a name followed by the predicate *excudit*, as executed by some anonymous hand in the publisher's service.

HIERONYMUS COCK probably engraved a considerable number of the plates which appeared anonymously from his own house, but his signature occurs on scarcely any prints except some sets of etchings, Roman ruins and landscapes with scriptural and mythological staffage (1550–51, 1557–58, 1562–63, some probably after P. Brueghel and Mathys Cock). He is of far greater importance as one of the movers in the inter-communication between Italy and Flanders,[2] which was of such disastrous moment to the Northern school. But alongside the innumerable engravings which he published after the paintings of Italianised Flemings like Martin Van Heemskerk, Jan van der Straet (Stradanus), FRANS FLORIS,[3] BARTOLOMAUS SPRANGER,[4] and Otto van Veen, it must be put to his credit that he did not forget the more purely native genius of Pieter Brueghel, the elder. *Hieronymus Cock.*

Cock's most vital influence in the development of the art of engraving was exercised in the person of a pupil, CORNELIS CORT, who migrated to Italy, and about 1571 formed a school of *Cornelis Cort.*

[1] For the few exceptions, see pp. 30, 33, 47, 65, 70, 96.
[2] A definite example may be noted in his publication of work by Giorgio Ghisi, who visited Antwerp about 1550. Cf. p. 99.
[3] Executed a few original etchings.
[4] Etched some six plates.

engraving in Rome. In the use of a more open system of lines, contrasting with the closer hatching of Marcantonio and his followers, Cort was perhaps the pioneer in Italy, and the immediate inspirer of Agostino Carracci.

Goltzius.

Among his own countrymen Cort's breadth of style was best appreciated and developed to its highest pitch by HENDRIK GOLTZIUS, who came under the influence of his school in Rome. Unfortunately, like most of his contemporaries, he suffered from the mannerisms of his models—Spranger, Stradanus, and the host of pseudo-classicists—but he was happier than the majority in his assimilation of some of the true character of classical art. His large *Massacre of the Innocents* (an unfinished plate) reveals some real sympathy for the ideals of Michelangelo. The delight he takes in rendering swelling curves, be they as bombastic as they will, is irresistible. The *Standard-bearer* (B. 125, Fig. 47) is a magnificent example. The pose was evidently a favourite one, for it is repeated in the nude figure of the *Dawn* (1588), a print in his broader manner. He has complete command of the whole gamut of technical expression. His portraits range in character from prints of the most minute hatching,[1] *e.g.* the *Nicquet* (B. 177), to others of the greatest breadth of line-work, well exemplified in a *portrait of himself* (B. 172). There is no little bravado in his telling imitations of the characteristics of other masters, *e.g.* in the *Circumcision* (Dürer manner), the *Adoration* (Lucas v. Leyden), and in the *Passion* series of 1596-98, which is a medley in the styles of both.

Line-engraving and tonic values.

Goltzius was perhaps the first adequately to realise the capabilities of the graver in expressing tone and surface qualities. Much was done by an increased command of the graver in swelling or diminishing the breadth of each individual line in its own length, much again by the intermixture of lines of different thickness, a brilliant surface being often achieved by the alternation of thick and thin, while a calculated variation of the intervals between the lines of shading required to suit the various parts of the design is a third factor of scarcely less importance. Despite the efficacy of these means to render the most varied tone, the yielding folds of cloth, the shimmer of silk, the glister of steel, the whole tendency is a questionable encroachment on the domain of painting, which Dürer, Marcantonio, and the greatest masters of line had, perhaps consciously, avoided. But, for good or for ill, there are few rivals of Goltzius and his pupils, JAN MULLER, JACOB MATHAM, and JAN SAENREDAM, as virtuosi of the burin. Particularly powerful are some large portraits by Jan Muller (*e.g.* the

Jan Muller.
Jacob Matham
Jan Saenredam.

[1] Of these a certain number are strictly silver plaques or medallions (*e.g.* the *Robert Earl of Leicester*, B. 175), from which impressions happen to have been taken (the inscription appearing, of course, in reverse). Simon van de Passe was another engraver who did a good many works of the kind, more particularly of the members of the court of James I. and Charles I. They were mostly on silver, sometimes on gold.

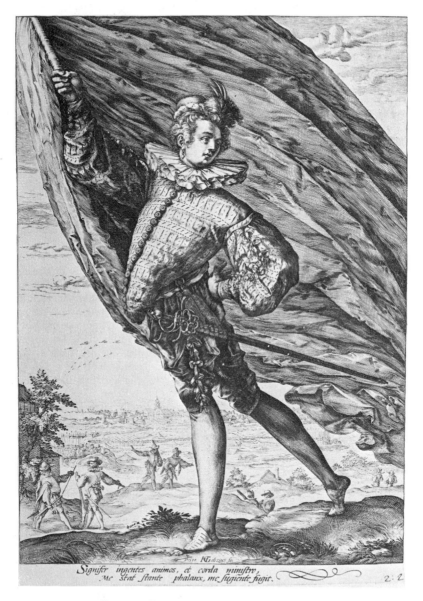

Signifer ingentes animos, et corda ministro,
Me stat stante phalanx, me fugiente fugit.

2 : 2

FIG. 47.—Hendrik Goltzius.　The Standard-bearer.

Archduke Albert, after Rubens), with remarkable backgrounds of dark horizontal shading, interspersed with streaks of light.

Cornelis Bloemaert.

The broad manner of engraving practised in the school of Goltzius was continued in a somewhat mollified form by CORNELIS BLOEMAERT (b. 1603).[1] He followed Mellan in a tendency to a light tonic scheme, and probably owed to the same source his simple method of shading. He worked for some time in Paris (after 1630), afterwards migrating to Italy, where he seems to have passed the

His influence on the French school.

rest of his life. Many French engravers appear to have been his pupils or come under his influence in Rome (*e.g.* Charles Audran, Étienne Baudet, and Étienne Picart), and he holds thereby a more important place in the history than the intrinsic virtue of his work warrants.

In marked contrast to the bold style of Cort and Goltzius is the work of two families of engravers, the WIERIXES and the VAN DE PASSES.

The brothers Wierix.

The productiveness of the three brothers, JAN, JEROME, and ANTHONIE WIERIX, whose activity centred in Antwerp, is enormous. In Alvin's catalogue some 2000 prints are described, and the list might be considerably augmented. The character of the great mass of their work was determined by the Jesuits, who seem at this time to have realised in Flanders more than anywhere else the use of small devotional prints to combat the new principles of the Reformation. Two, at least, of the brothers, Jan and Jerome, are astonishingly skilful masters of the minutest manner of engraving, but as artists their production is comparatively insignificant. In much of their work are reflected paintings of the earlier Flemish masters, such as Patenier and Mabuse, and of contemporaries like Martin de Vos and Stradanus, but to a large extent they engraved their own compositions. Their precocity is remarkable. From their twelfth year Jan and Jerome began to date copies, chiefly after Dürer, proudly recording their age even when they omitted their signature. Jan's copies of Marcantonio's *Venus and Cupid* (æt. 14), of Dürer's *Adam and Eve* (æt. 16), and his later *Melancholia* (1603), and Jerome's plates after Durer, the *St. George*, the *Satyr Family* (æt. 12), and the *St. Jerome in the Study* (æt. 13), are among the best copies after these masters that exist. The brothers are also responsible for a large number of portraits, nearly all executed on a small scale in the delicate manner which Goltzius sometimes affected (see Fig. 48).

The Van de Passe family.

Of special interest from their connexion with English engraving, and hardly less prolific as publishers than the Wierixes, were the numerous engravers of the VAN DE PASSE family. At their head

[1] His father, ABRAHAM BLOEMAERT, engraved little : he left a few plates, landscape and figure etchings in a broad, open style. His designs were etched in a similar manner by his son FREDERIK BLOEMAERT, who also collaborated with the father in his "Drawing Book" (etching plates which were used in certain cases in combination with chiaroscuro wood-blocks, cf. Chapter IX. p. 310).

stands CRISPIN, THE ELDER, whose early activity centres in Cologne, whither he had migrated from Holland not later than 1594. By 1612 he was settled in Utrecht, remaining there till his death in 1637. Of his children, SIMON, MADELEINE, CRISPIN II., and WILLEM followed their father's profession, and there is also a CRISPIN III., who is probably a son of Willem. Simon and Willem

FIG. 48.—Jan Wierix. Unidentified portrait.

worked in England : the former between about 1616 and 1621 (after which date he was appointed royal engraver to Christian IV. of Denmark) ; the latter succeeding him and staying in London till his death, about 1637. Crispin, the younger, represented his father's house in Paris, where he seems to have been settled at least from 1617 to 1627. His position as professor of art in the Maneige. Académie led to his illustration of A. de Pluvinel's *Maneige Royal*,

1623 (later entitled *Instruction du Roi à l'exercice de monter à cheval*), which forms perhaps the best achievement of any member of the family. In some of his earlier work, Crispin, the elder, attempted the broader manner of Goltzius (who, like himself, had been a pupil of D. VOLKERTSZ COORNHAERT), but the bulk of his production, and that of his sons, which included portraits, title-pages, and the most multifarious subject-prints, reflects the same tendency to minuteness of hatching seen in the Wierixes.

The map and topographical engravers.

Gerard Mercator.

Jodocus Hondius.

We may mention a few of the great commercial undertakings of the engravers of the time. First, those of the famous geographers, Abraham Ortelius (*Theatrum Orbis Terrarum*, Antwerp, 1570, whose maps were mostly engraved by FRANZ HOGENBERG),[1] and of GERARD MERCATOR (whose collected works first appeared posthumously in the *Atlas Major* of 1596). Unlike Ortelius, Gerard Mercator was to a great extent his own engraver. His influence was carried into England, and his work supplemented by JODOCUS HONDIUS, who bought the original plates after the edition of 1596.[2] Some of the latest work of the latter was for one of the greatest English atlases of the period : John Speed's *Theatre of the Empire of Great Britain*, of 1611. Then in a field with more artistic scope, the great record of discovery and travel forming the *Collectiones Peregrinationum in Indiam Orientalem et Occidentalem*, holds an important place among the publications of the time. Commenced in 1590 in

The de Brys.

Frankfurt by THEODOR DE BRY, a settler from Liège, and his sons, JOHANN THEODOR and JOHANN ISRAEL, it was only brought to conclusion by MATTHÄUS MERIAN the elder, in 1634. The inspiration of the whole work came from England, where, through Hakluyt's mediation, Theodor de Bry acquired a series of drawings[3] which John White made in Virginia, 1585-1586, on an expedition sent out at Sir Walter Raleigh's expense. It was in England, too, that he obtained the sketches of Florida, made in the Laudonnière expedition, 1563-1565, by Jacques Le Moyne, which formed the second part of the *Collectiones*.

Prints of ornament.

Theodor de Bry is of considerable interest also for his ornament prints. In the excellence and delicacy of their engraving they are no unworthy successors to the work of Aldegrever and the Little Masters. Of course the style of ornament has greatly changed. It is no longer scroll and leaf, but strap-work which forms the basis of the design,—seldom the pure strap-work of the Venetian school, but curiously intermingled with the grotesque figures which formed the feature of the decoration of the Vatican Loggie by Raphael and Giovanni da Udine.[4] De Bry, however, is freer than most of his

[1] Cf. Chap. III. p. 110.
[2] The new supplemented edition appeared in 1606.
[3] Now in British Museum.
[4] The combination seems to have been first fully developed by such designers as Pieter Coeck of Alost (*e.g.* the wood-cuts in C. Scribonius Grapheus, *Spectaculorum in Susceptione Philippi*, Antwerp, 1550).

contemporaries from the convention of strap and grotesque, and developed an individual style [1] which combines the naturalist spirit of early sixteenth-century illumination, in its representation of bird, beast, insect, and flowers of all sorts, with the classical feeling of Delaune,[2] whom he no doubt met in Strassburg, where he was living between 1568 and 1590.

The goldsmith, MICHEL LE BLON (b. 1587) is another Fleming of the period famous for his ornament engravings. The son of a Flemish settler in Frankfurt (CHRISTIAAN LE BLON, the author of the title-page to the 1628 edition of Burton's *Anatomy of Melancholy*) he must have come under the influence of the younger de Brys, though he probably left quite early in the seventeenth century.[3] He settled in Amsterdam, and developed a style of ornament en- Michel Le Blon

FIG. 49.—Michel Le Blon. Design for goldsmith's ornament.

graving, largely white relief on dark ground, graceful and original in design, and of wonderful precision in the cutting.

The soundest elements of the system of engraving which had been developed to such virtuosity by Goltzius, were carried forward with undiminished accomplishment by the school of engravers which gathered round the foremost Flemish painters of this, and, in fact, of all time, Rubens and Van Dyck. The reproductive engravers of the schools of Rubens and Van Dyck.

[1] A good example is the *Emb'emata nobilitati et vulgo scitu digna*, Frankfurt, 1593.

[2] Apparently for a considerable period in Strassburg, from about 1573 or 1576. Like so many of the emigrating French and Flemish artists of the day, he was a Protestant refugee.

[3] A set of his engravings, dated 1610, was published in Rotterdam; another of 1611 has a Dutch title. See C. Dodgson, *Burlington Mag.*, November 1905, for an early set dated 1605-6, probably belonging to the Frankfurt period. His style may have been somewhat indebted to D. Mignot, Corvinian Saur, and Hans Hensel, three German goldsmith engravers who were working in the last decade of the sixteenth century. The last named was working in Nuremberg in 1599, but is said to have settled later in Frankfurt.

The Rubens school.

Like Raphael with the school of Marcantonio in Italy, Rubens was in the closest touch with engravers who devoted themselves to reproducing his works, and his success as a painter enabled him to secure and almost monopolise the best strength in engraving of the time. In certain cases the engraver no doubt worked in the master's studio, and though there is no proof that Rubens,[1] any more than Raphael, himself handled the burin, the care with which he super-vised the production of the plates finds witness in numerous proof impressions which exist with the master's own corrections.[2]

C. Galle I.
Willem
Swanenburg.

CORNELIS GALLE the elder, WILLEM SWANENBURG (a pupil of Saenredam), and several engravers of the school of Goltzius were reproducing paintings of Rubens in the latter part of their careers, but the earliest engravers to owe their artistic training to the master were Soutman, Vorsterman, and Paul Pontius.

Pieter
Soutman.

PIETER SOUTMAN, of Haarlem, was a pupil of Rubens, a painter and a draughtsman who frequently supplied designs after paintings to serve as the immediate basis for the reproductive engravers. He was in Antwerp working after Rubens in 1619 if not earlier ; in 1628 he is noticed as filling the position of court painter to the King of Poland,[3] but was already settled in Haarlem again by 1630. Among the Rubens engravers he has quite a manner of his own, which has less of strength than variety. His lines are thin and in-decisive, sometimes etched, and interspersed with much flick-work,

P. van
Sompelen.
Jacob Louys.
W. de Leeuw.

a style in which he was closely followed by his pupils, PIETER VAN SOMPELEN, JACOB LOUYS, and WILLEM DE LEEUW. Sompelen's por-traits of the *German Emperors* may be taken as typical examples of the group. Large plates, light in tone, generally ovals set in an even more lightly engraved or etched border with somewhat exuberant design of flower, fruit, and putti, are the prominent characteristics.

Vorsterman and Pontius are far more closely linked with the name of Rubens, far more allied to him in the monumental character of their work, than almost any of the school, with the possible ex-ception of the Bolswerts.

Lucas
Vorsterman.

Like Soutman, LUCAS VORSTERMAN entered Rubens's studio to study painting, but was diverted quite early in his career to the practice of engraving. His work, which is well illustrated in such plates as the *Descent from the Cross,* the *Resurrection,* and the *Susannah and the Elders* (of which a part is given in Fig. 50), shows a thorough assimilation of the master's style and a brilliance of technique which never errs in exaggeration. But Vorsterman's connexion with Rubens was short : by the time he was about twenty-seven, *i.e.* in 1622, it seems to have been rudely severed, and, if we are to believe report, not without attempted violence on the part of the enraged pupil, for what reason we know not. Then between 1624 and 1630

[1] See Chapter VI. pp. 164-5, for etchings attributed to him.
[2] *E.g.* in the Bibliothèque Nationale, Paris.
[3] S. Ampsing, *Beschryving van Haarlem*, 1628, p. 372.

we find him working in England, brought thither perhaps by the
persuasion of the great collector, the Earl of Arundel, for whom he
did several drawings and engravings. The enormous difference in
his work after the break with Rubens, shows how much he owed to
the master's direction. Most of his English prints have a certain
surcharge of black shadow, and an unrestful persistence of dot and
flick work, and the sure hand and style did not return to him until

FIG. 50.—Lucas Vosterman. Susannah and the Elders, after Rubens (part).

he came under the guidance of another master, Van Dyck, in his
work for the *Iconography*.

PAUL PONTIUS, Vorsterman's pupil and junior by some eight
years, began to engrave for Rubens in the early 'twenties. His
technique is even bolder than his master's, and he makes less use
of short cross-lines, dots, and flicks, to aid the principal lines of
shading. The noble simplicity and breadth of handling of his style
are well exemplified in his *Assumption* (1624) and the large *March
to Calvary* (1632). As with Vorsterman, some of his best work was
done for Van Dyck.

Paul Pontius.

The Bolswerts. The two brothers BOËTIUS and SCHELTE A BOLSWERT were some years senior to either of the preceding, and though not trained in the school of Rubens, were among the most powerful and prolific of his interpreters. Both are inclined to a somewhat heavy use of line, and often over-emphasise the contrasts of light and shade on their plates. Schelte is of particular interest in landscape, of which he is the most fertile engraver after Rubens. By the use of lines of varying breadth, unaided by intermediate dot-work or cross-hatching, he obtains some extremely powerful results.

The *Icono-graphy* of Van Dyck. Rubens's famous pupil, VAN DYCK, is of scarcely less importance than his master as an inspirer of reproductive engravers. As a portrait etcher he holds a unique position,[1] but he is of particular interest to us in the present chapter for the noble collection of engraved portraits of famous men of his time, which were executed under his direction. For the *Iconography*,[2] as the collection is generally called, he etched eighteen plates, but for the majority of the portraits he merely made drawings in chalk or grisaille.[3] The task of finishing the etchings in line, or engraving the grisailles, fell to several of the same artists already mentioned as working after Rubens. VORSTERMAN, PONTIUS, the BOLSWERTS, and PIETER DE JODE the younger, are the most distinguished. The scheme was probably initiated by Van Dyck soon after his return from Italy to Antwerp in 1626. Whether the whole series, or only portions of the work, had been published before 1645 (when it was issued by Gillis Hendricx) is uncertain. It is more than probable that Martinus van den Enden,[4] whose name appears on the plates before they got into Hendricx's hands, was merely the printer commissioned by Van Dyck to issue the plates separately as the work proceeded.

The editions of Martinus van den Enden and Gillis Hendricx.

From the great legion of reproductive engravers who continued in the direction promoted by Rubens and Van Dyck, there are no others that we care to single out for special mention. The interest of their work centres chiefly in portrait, and their share in the development of the great French school will be followed in the next chapter. But there are two engravers of the early seventeenth

[1] See Chapter VI. pp. 165-8.

[2] The title to Hendricx's edition reads : *Icones Principum Virorum doctorum Pictorum Chalcographorum Statuariorum nec non amatorum pictoriæ artis numero centum ab Antonio van Dyck pictore ad vivum expressæ eiusque sumptibus æri incisæ. Antverpiæ. Gillis Hendricx excudit. Anno* 1645. The "centum" included fifteen of the original etchings (not the *Cornelissen, Triest* or *Waverius*), the eighty engraved plates (the *Iconography* proper), and five other newly engraved plates after Van Dyck. To later editions (*e.g.* Verdussen) many more plates were added.

[3] Some excellent examples of those in chalk are in the collection of the Duke of Devonshire, Chatsworth. Many of the grisailles (of which there is a considerable number in the Alte Pinakotek, Munich) seem to have been made by assistants, or by the engravers themselves after the master's less elaborated studies, to serve as the immediate originals for the prints.

[4] His name appears in the books of the Guild of St. Luke in 1630.

century in Holland who kept clearer than the rest from the overwhelming tide, and produced some individual work of interest, JONAS SUYDERHOEF and CORNELIS VISSCHER, both of Haarlem.

SUYDERHOEF is one of the most expert of all interpreters of the character of a painter's work in line. He is the engraver par excellence of Frans Hals, and in his prints the brilliant brush-work of the master seems to live again. He was a true pupil of Soutman, but quite surpassed his master and any of his master's immediate following in the certainty and significance of his handling. Jonas Suyderhoef.

CORNELIS VISSCHER was a prolific engraver of portrait and all manner of subject. His prints after Ostade and Brouwer, and original works, like the large *Rat-killer*, whose character is suggested by those painters of genre, form his most individual title to fame. His engraving has much of the solidity of the best Rubens engravers, but the frequent intermixture of etching places it in a category of its own. Cornelis Visscher.

.

Engraving in France at the end of the sixteenth and beginning of the seventeenth centuries, can be passed over almost in silence. FRANCE.

In the delicate manner encouraged by the Wierixes, small portraits, title-pages, and illustrations were numerous enough in Paris at the turn of the century, but the best of these were done by two craftsmen who were foreigners by birth, THOMAS DE LEU from Flanders, and LÉONARD GAULTIER of Mayence. BALTHASAR MONCORNET may be mentioned as one of the most prolific print publishers of the period, the number of portraits bearing his address being enormous. Before the middle of the century there were already some reproductive engravers in the larger style of the school of Rubens (*e.g.* JEAN BOULANGER and GILLES ROUSSELET), but the best craftsmen amongst them were chiefly engaged on portrait, and will find their place in the next chapter. The real French school of classical engraving does not start till the second part of the century, and this we reserve for a still later chapter.[1] T. de Leu.
L. Gaultier.

Moncornet.

J. Boulanger
G. Rousselet.

.

Line-engraving in Germany during the early seventeenth century has hardly more claim than that of France to any national feature ; it is little but a poor repetition of Flemish work of the period. The style of the Wierixes finds its followers in such as PETER ISSELBURG of Cologne, and PETER AUBRY of Strassburg, whose second-rate portraits are sufficiently numerous, while an even greater influence was exerted by the Sadelers. GERMANY.

Peter Isselburg.
Peter Aubry.

RAPHAEL SADELER, the elder, had worked for some time in Munich, while his nephew, GILLES SADELER, the best craftsman of the family, was long settled in Prague, doing many prints of portraits, pageants, and the like. The Sadelers.

The most prosperous school centred in Augsburg under the

[1] Chapter VII. pp. 197-8.

Dominicus
Custos.

leadership of DOMINICUS CUSTOS [1] of Antwerp, who married the widow of a goldsmith, Bartholomäus Kilian. His stepsons and

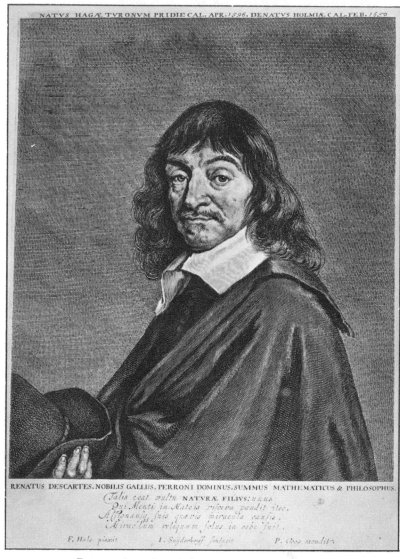

NATVS HAGÆ TVRONVM PRIDIE CAL. APR. 1596. DENATVS HOLMIÆ, CAL. FEB. 1650

RENATUS DESCARTES, NOBILIS GALLUS, PERRONI DOMINUS, SUMMUS MATHEMATICUS & PHILOSOPHUS.

F. Hals pinxit I. Suyderhoef sculpsit P. Goos excudit

FIG. 51.—Jonas Suyderhoef. Portrait of René Descartes.

Lucas and
Wolfgang
Kilian.

pupils, LUCAS and WOLFGANG KILIAN, are members of a numerous

[1] The name of Custos was apparently assumed ; he was a son of the engraver and painter PIETER BALTENS.

family which carried on his tradition, rivalling the de Brys of Frankfurt in the mass of their published portraits. Both the brothers studied in Italy and left a considerable number of engravings after *Philipp and* Italian masters. Wolfgang's sons, PHILIPP and BARTHOLOMÄUS, are *Bartholomäus* chiefly known by their portraits, and the latter, who studied under *Kilian.* F. de Poilly in Paris, was the one member of the family who attained any real distinction in style. He stands in Germany as a representative of the transition from the colourless portraits of Custos and his compeers to the more developed system of tone and modelling which had already reached its height in France in the person of Nanteuil. The growth of the French influence is seen also in the brothers Elias and Johann Hainzelmann of Augsburg, *Elias and* both of whom studied in Paris. Their work is less that of portrait *Johann* than the reproduction of classical subject painting. *Hainzelmann.*

Of other German engravers of the time there is none we care to *Joachim* notice but JOACHIM SANDRART, and he interests us far more as the *Sandrart.* art historian, the author of the *Teutsche Academie der edlen Bau- Bild- und Malerey Künste* (Nuremberg, 1675-79), to which his wide culture, his many travels, his personal acquaintance with so many artists, lend so great an importance. His plates are not numerous (only a few engraved portraits and some classical etchings), but he afforded liberal encouragement to engraving for the illustration of his publications on art in the fields of painting, sculpture, antiquities, and topography.[1]

His nephew, JACOB SANDRART (portraits, etc.), the latter's son, *Jacob* JOHANN JACOB (*e.g.* topographical and architectural etchings and *Sandrart.* engravings), PHILIPP KILIAN (portraits), and RICHARD COLLIN of *J. J. Sandrart.* Antwerp (chiefly statues, in a broad, open style), were his chief *R. Collin.* collaborators in his various works. Another engraver, who did a few prints for his *Teutsche Academie*, J. J. THOURNEYSSER of Basle, is *Thourneysser* notable as a successful imitator of Mellan's treatment of line.

.

The debasement of Italian engraving was already foreshadowed ITALY. when Raphael evinced the commercial sagacity of making a market for reproductions of his works, and turned his factotum, Baviera, to printing, and perhaps print-selling. The essential difference, however, between the character of reproduction here and that of the school of Rubens of a century later must be clearly understood. Marcantonio and his followers seldom had more than a slight study from the master's hand as basis of their engraving : the Flemish engravers more generally worked directly after a picture, with considerable attention to accuracy of detail. It is evident that there was more hope for the display of individuality of interpretation under the former conditions, and while Marcantonio was living, the genius was not lacking.

[1] *E.g. Iconologia Deorum,* 1680 ; *Sculpturæ veteris admiranda,* 1680 ; *Romæ antiquæ et novæ Theatrum,* 1684 ; *Insignium Romæ Templorum prospectus,* 1690 ? *Palatiorum Romanorum . . .* 1694 (all published in Nuremberg).

But we have found no talent in Marcantonio's immediate followers to resist the subduing force of the master painter, and with the ever-increasing demand for his works they became the mere hacks of publishers—of ANTONIO SALAMANCA, DUCHETTI, LAFRERY (two Italianised French emigrants), BARLACCHI, and the like. Above all things let the collector remember that the presence of the address of any of these print-sellers on works of Marcantonio condemns them as late impressions.

Outside Rome there were still a few engravers who preserved something of their individuality, the Ghisi so far above the rest that they have been placed among the master engravers of the previous chapter.

Enea Vico.

ENEA VICO of Parma (fl. 1541-67) was little more than a distant echo of the Roman school, in which he had studied under the engraver print-seller Barlacchi, who published many of his plates. There is much among his prolific work to interest the archæologist— prints of reliefs, statues, gems, vases, and the like—but, except for one or two portraits and a subject such as that of *Bandinelli's Academy* (B. 49), there is little to inspire the artist. A certain meagreness of line, in comparison with the Marcantonio manner, may perhaps be due to the influence of the growing school of lightly bitten etching in the North of Italy.

Jacopo Caraglio.

Another engraver of Parma,[1] somewhat senior to Vico, JACOPO CARAGLIO (born about 1500), was an artist of much more powerful character. He developed a mastery of light and shade which only just fails to attain the brilliance of Giorgio Ghisi. His method, which is characterised by the use of thin lines of clear and close shading, interspersed with short and delicate flick-work, is seen at its best in plates like the *Annunciation* after Titian (B. 3) and the *Diogenes* (B. 61). No doubt the manner of Parmigiano and Primaticcio, which, in comparison with the harder definition of Giulio Romano and of the immediate offspring of Raphael, seems to live in mists of intangible texture, tended to this softening of the decisive lineal style of the school of Marcantonio, in which he probably received his training. He was certainly working in Rome by 1526, if not earlier, and was employed by Baviera, but probably went north at the time of the sack of the city in 1527. After 1539 he served the King of Poland in the varied capacities of medallist,[2] die-cutter, and architect, and died in Cracow in 1565. His engravings may possibly all precede his departure to Poland.

Giulio Bonasone.

With all his softness of tonality in line, GIULIO BONASONE, a Bolognese by birth, kept nearer than either Vico or Caraglio to

[1] He also lived in Verona. He signs both "Parmensis" and "Veronensis."

[2] A medal of Alessandro Pesenti by Caraglio is in the British Museum. He must have done others of Sigismund and his wife Bona Sforza, but they seem to be unidentified.

the Marcantonio tradition. He has an even greater feeling than
Marco da Ravenna for the effect of flat surfaces of simple shading
in single tones ; but the occasional charm of this manner does not
counterbalance his lack of draughtsmanship. His work, which
numbers about 350 plates (some original designs, others after
Michelangelo, Raphael, Parmigiano, and most of the great masters
of the time), seems to have been done entirely in Rome between
about 1531 and 1574.

By the end of the third quarter of the sixteenth century the
average production in Italy had sunk so low that even the pseudo-
classicists of the North availed somewhat to encourage its temporary
revival.

We have already noticed the presence of Cornelis Cort in Rome *Agostino*
from about 1571. Though apparently never Cort's pupil, it seems *Carracci.*
to have been to this master that AGOSTINO CARRACCI owed the
impulse to the open system of line which characterises his engraving.
He recurred to the strong elements of the later manner of Marc-
antonio, adding little but a more constant use of cross-hatching and a
more regular method of flick-work within the interstices of the lines,
and scrupulously avoided striving after the effects of tone and texture,
on which Goltzius (who was one year his junior) laid such emphasis.
The best of Carracci's work is original, but he also reproduced con-
siderably from painters like Correggio, Titian, and Paul Veronese.

FRANCESCO VILLAMENA is the one other engraver to whom we *Francesco*
might compare him. Apparently a pupil of Cort in Rome in the *Villamena.*
early 'eighties, he did not attain to the full breadth of his style until
the beginning of the seventeenth century. His earliest engravings
(the plates in Alonso Ciacono's "Trajan's Column") date in 1576.
Comparison with Agostino Carracci is almost solicited by the fact
that in 1586 both masters reproduced in engraving Correggio's *Holy
Family* (Parma). Carracci is already master of his style ; Villamena
is consciously aiming at the same goal, but still shows the indecision
from which he only emerged, and then only in occasional works,
some twenty years later. When he does emerge, his treatment of
the swelling line is such as may have been a force of real inspiration
to Claude Mellan.

Until the reaction of the last half-century, the influence of *The influence*
Agostino Carracci, both as painter and engraver, as well as that of his *of the Carracci.*
brother Annibale and their cousin Lodovico, remained among the most
vital factors in art history. His immediate influence as an engraver,
in which he had sound, dull followers, such as CHERUBINO ALBERTI *Cherubino*
and FRANCESCO BRIZIO, was far less than might have been expected. *Alberti.*
The trend of development was now all in favour of etching, and it *Francesco Brizio.*
was in this field, through the immediate example of Guido Reni (for
the few etchings of Lodovico and Annibale can be left almost out of
account), that the tradition of the Carracci was most worthily continued.

.

ENGLAND.

It is significant that we turn to our first discussion of engraving in England in a chapter which explicitly deals with a period of decline. There is, in fact, only the scantiest indication of engraving on English soil until nearly a century after the earliest date found on foreign work.[1] Without branding the English of the period as an essentially inartistic people, it must be confessed that their artistic aims were of the practical order. In many branches of the applied arts, especially those used in church ornament and architecture, they were by no means deficient—witness the "opus anglicanum" in embroidery, which was eagerly sought, and is still treasured in many a convent throughout Europe. But in painting, which is generally the predecessor of engraving, England was comparatively barren, and continued to be so until it received the inspiration of foreigners like Mabuse and the younger Holbein.

From what has been said of the state of the art of engraving in the middle of the sixteenth century, it will be seen that the period was by no means an auspicious one for the formation of a new school. The style of the three great master engravers, who had all been dead, roughly speaking, a decade before the first appearance of a copper-plate in England, was almost lost in the sloughs of commercial enterprise and dull reproduction. Nor was it more fortunate that England's geographical position should have rendered Flanders, with its hybrid Italianised art, the source of its earliest education.

The earliest engravers in England foreigners.

We have said that the earliest engraving in England was a century behind the introduction of the art on the continent of Europe. Engraving *in* England, be it observed ; for English engraving can scarcely boast an existence for another half century, nearly all the engravers of this period, and many of the succeeding fifty years, being visitors or Protestant refugees from the Low Countries.

Raynald's *Byrthe of Mankinde.*

Thomas Geminus.

Except for some unimportant anonymous plates in the *Byrthe of Mankinde*, a book on midwifery published by Thomas Raynald in 1540, the earliest prints published in England appeared in an edition of Vesalius' Anatomy by THOMAS GEMINUS, a Flemish[2] surgeon in court employment, in 1545. The engraved title-page, which is inscribed *Compendiosa totius Anatomie delineatio aere*

[1] For a Bruges engraving found in Caxton's first English book, see p. 33. Of another engraving which has been claimed as English work of the early years of the sixteenth century I cannot speak definitely, as I find no earlier or later trace of it than the impression from the original plate, which Joseph Strutt published in his *Dictionary of Engravers* (1785). It consists of a series of devotional verses engraved in Gothic characters. The initial letters contain several figures : these, and a Virgin and Child above, and a kneeling monk below, make up the artistic part of the work. The words *De Syon* in large letters to the right of the monk below, and the direct references to St. Bridget, make it almost certain that it was produced for the large Brigittine convent which existed in Syon House (the present seat of the Duke of Northumberland) until the time of the Reformation. In style it is not unlike second-rate devotional prints of the Low Countries of the beginning of the sixteenth century, and the un-English character of the Gothic lettering, and the fact that so large a proportion of the English prayer-books of the period were printed in Flanders, make it more probable that it is a Flemish importation, and not native work.

[2] He is called *Flander* in an entry in the *Annals* of the Royal College of Physicians,

exarata: per Thomam Geminum, Londini, is clearly cut and in little but outline, and of interest as one of the earliest examples of the mixture of strap-work and grotesque which became so popular all over Europe, especially in the Netherlands,[1] in the latter half of the century. Geminus is probably[2] also responsible for the anatomical plates throughout the work, which had been pirated and, as Vesalius indignantly complained, not too correctly copied from the splendid wood-cuts by Titian's pupil Hans Stephan van Calcar of the original Basle edition (1543).

The edition of 1559 has added interest in the bust of *Elizabeth* which replaced the royal arms on the title-page, the earliest of all the portraits of the Queen produced in England, and perhaps anywhere. The only other recorded works by Geminus are a second and much more ambitious portrait of *Elizabeth*, dating sometime in the 'sixties (the last figure of the date is lost), of which the only impression at present known is in the Storer Granger at Eton, and a little book of ornament engravings (*Morysse and Damashin renewed and encreased very profitable for Goldsmythes and Embroiderars*, by Thomas Geminus, London, 1548), of which the Landesmuseum at Münster in Westphalia possesses a nearly complete impression. Portraits of Queen Elizabeth.

Next in date to Geminus comes the work of an Englishman, JOHN SHUTE, *i.e.* if he was, in fact, more than the designer of the plates in his *First and Chief Groundes of Architecture*, 1563. The other native engravers of the next few years, HUMFRAY COLE, RICHARD LYNE, AUGUSTINE RYTHER,[3] are little more than engravers of maps and topography, a field in which Christopher Saxton,[4] John Norden,[5] and John Speed[6] were the leading surveyors and draughtsmen. When work of some claim to artistic interest was required, the foreigner had still to be sought. John Shute. The chart engravers.

The brothers FRANZ and REMIGIUS HOGENBERG were probably both working in the employ of Archbishop Parker, who is known to have invited foreign craftsmen to assist in the various works in which he was interested (*e.g.* the *Bishops' Bible*, 1568). The work of Franz has already been noted.[7] Remigius did much less, and the The Hogenbergs and Archbishop Parker.

1555. What is meant by the word *Lysiensis*, which he attaches to his name at end of dedication in the *Anatomy*, is obscure. Lys-les-Lannoy (near Lille) has been suggested, while it might imply any town situated on the river Lys.

[1] Cf. p. 124, note 4.

[2] A dogmatic statement even with regard to the title-page is curbed by the vague phrase *per Thomam Geminum*, which might be taken to imply that he commissioned another to do the engraving. But in view of the Storer portrait of Elizabeth signed simply *Thomas II. 156-*, this interpretation is rendered improbable.

[3] Historically famous are his Armada plates, showing the position of the fleets on various days, after drawings by Robert Adams, published in 1589.

[4] *Survey of England*, 1579 (maps engraved by Ryther, R. Hogenberg, and a few other insignificant craftsmen).

[5] Designed a complete *Speculum Britanniæ*, but only published two parts: *Middlesex*, 1593 (en., P. van den Keere), and *Hartfordshire*, 1598 (en., W. Kip).

[6] *Theatre of the Empire of Great Britain*, Sudbury and Humble, 1611 (en., J. Hondius). [7] See pp. 110, 124.

majority of this apparently in England, a small portrait of *Matthew Parker* (1572), two of *Queen Elizabeth*, and some maps and plans for Saxton's *Survey* (1579) being the most important.

Marcus Gheraerts I.

Of historical interest are two pageant prints of the period: that of the *Procession of the Knights of the Garter*, on nine plates, by MARCUS GHERAERTS the elder (1576-78),[1] and the *Funeral Procession of Sir Philip Sidney* by THEODOR DE BRY (1587-88), a large work extending over thirty plates. The important outcome of de Bry's visits to England in 1586-87, 1588-89, has been noticed earlier in the chapter. With JODOCUS HONDIUS, the greatest and last of the chart engravers of this early period, we can take leave of the foreigners who helped most to create the school of engraving in England in the sixteenth century. He seems to have been settled for some ten years in London, chiefly engaged on works of cartography,[2] leaving it finally in 1594 for Amsterdam. His great work for John Speed's *Theatre of the Empire* of 1611, the year before his death, was probably done abroad.

Theodor de Bry.

J. Hondius.

William Rogers.

The first English engraver of any importance, and the most typical of the Elizabethans, is WILLIAM ROGERS. A goldsmith, whose craft is betrayed by prints overloaded with ornament in high relief, he cannot be said to have mastered even the elements of portraiture. Despite the stiffness of delineation, and the emphasis on detail of vein and wrinkle, a plate like his full-length of *Queen Elizabeth*[3] (dating about 1595-1600) is of enormous value for what it tells of Tudor costume, if not of Tudor character. Even more attractive are his two earlier portraits of the Queen, the fantastic *Eliza Triumphans*[4] of 1589 (probably commemorative of the Armada; reproduced Fig. 52), and the *Rosa Electa*,[5] with its charming floral border, of some three or four years later. Of the books he illustrated we may mention Sir William Segar's *Honour Military and Civill*, 1602, the eight portraits (full-length beneath arch) being less redolent of the goldsmith's shop than the rest, and showing considerable dignity of composition. In one instance, that of the portrait of the *Earl of Essex*, Rogers is found borrowing decorative elements and allegorical figures from foreign work (a portrait of Martin de Vos by Gilles Sadeler), but for the most part his work seems original, though the influence of such

[1] Strictly an etching, slightly strengthened with the graver. The only perfect copy known is in the British Museum. Another English work, attributed with certainty to Marcus Gheraerts I., is seen in the etched plates to Jan v. d. Noot's *Theatre* (John Day, London, 1568), published the year in which he settled in England.

[2] *E.g.* with Ryther and de Bry in Wagenaer's *Mariners Mirrour*, 1588 ; separate maps, such as the "Christian Knight" map of the world (1596), and another designed to illustrate the voyages of Drake and Cavendish.

[3] Unique in this state, British Museum ; later cut down to three-quarter length. There is a very similar portrait by Crispin van de Passe (1603), after a drawing by Isaac Oliver, now in Windsor. Perhaps the Rogers and the Oliver drawing both go back to a lost painting.

[4] Two impressions known, Brit. Mus. and Paris. [5] Bodleian, unique impression.

engravers as the Collaerts, de Bruyns, and de Brys is not to be
gainsaid. One of the latest plates that are known from his hand, the
large *Henry VIII. and his progeny*, after Lucas d'Heere [1] (about 1603-

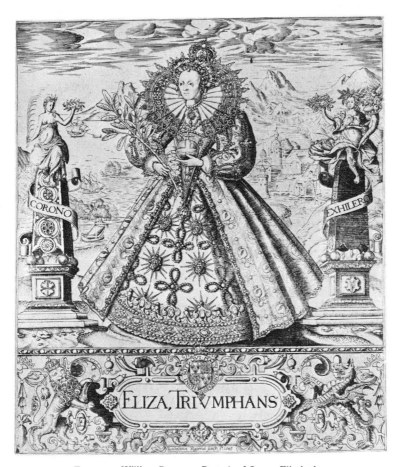

FIG. 52.—William Rogers. Portrait of Queen Elizabeth.

1604) is among the earliest prints to be published by Sudbury and
Humble, whose names figure so frequently on engravings for the
next twenty years. [2] Sudbury and Humble soon had a rival publisher
in Compton Holland [3] (a son of the famous translator Philemon
Holland) and may perhaps have been succeeded by William Peake, [4]
whose name appears on many of the late states of the prints which

The print
publishers :
Sudbury and
Humble.

Compton
Holland.
William Peake,

[1] Picture at Sudeley Castle
[3] From about 1612.

[2] Humble alone, until about 1630.
[4] Cf. Chapter V. p. 152, note 2.

T. Jenner.
J. and T. Hind.
Peter Stent.
J. Overton.

they had issued. In judging prints of the first two decades of the seventeenth century the presence of the addresses of later publishers, such as Thomas Jenner, John and Thomas Hind, Peter Stent, and his successor John Overton, should be taken as implying late impressions.

In the early years of the seventeenth century, line-engraving was coming more and more into use in England for the embellishment of books, and the print-seller must have had a thriving trade in supplying the publishers with the engraved portraits to figure as frontispieces, or by selling the same separately to any comer.

Elstrack.
Delaram.
Hole.

RENOLD ELSTRACK,[1] FRANCIS DELARAM, and WILLIAM HOLE (the first, and probably the second, of Flemish extraction) were the busiest of the engravers of the reign of James I. and the early part of Charles I., who were ready to supply, in their modest but sound manner, any demands the publishers might make.

J. and M. Droeshout.

JOHN and MARTIN DROESHOUT are two more engravers of Flemish extraction who may be mentioned for anything but their excellence. The latter, in particular, has won fame by his portrait of *Shakespeare* which was prefixed to the First Folio, 1623, a dull performance, not deserving Ben Jonson's eulogium, but probably faithful to likeness of feature.

Simon and Willem van de Passe.

Of a similar character to that of Elstrack and Delaram is the production of two members of the Utrecht family of engravers, SIMON[2] and WILLEM VAN DE PASSE. The former (who worked in England certainly between 1615 and 1622) was by far the more prolific, but seldom attained the breadth of such a plate as his brother's equestrian portrait of *George Villiers, Duke of Buckingham* (1625). Willem had taken up residence in London, on Simon's removal to Denmark, and remained there till his death in 1637.

Cecill.
Payne.
Marshall.
Vaughan.
Cross.

For the greater part of the century the unambitious style of these engravers found its imitators, CECILL, PAYNE, and MARSHALL occasionally doing plates of moderate distinction in their class amid a mass of the dullest work, VAUGHAN and CROSS never rising above the lowest level of publisher's hacks. In the embellishment of many of the greatest books of the time, and in portraits of the famous men, the student of literature or history will find much to interest him from Rogers to Cross, but to the single-hearted amateur of engraving the prints of this period will make small appeal.

Van Dyck's influence.
Vorsterman.
Voerst.

The real event of moment during the reign of Charles I. was the visit of Van Dyck and engravers of his school, like LUCAS VORSTERMAN (in England about 1624-30), and ROBERT VAN VOERST

[1] He engraved most of the plates of the *Baziliωlogia . . . the true and lively Effigies of all our English Kings . . .* (printed for H. Holland . . . sold by Comp. Holland, 1618), which may be cited as a standard of much of the smaller portrait work of the period. Delaram and Simon van de Passe also contributed to the collection.

[2] For his silver plaques see note to Goltzius, p. 120.

(about 1628-35), who afforded a real impulse towards a broader style.

Payne was not untouched by the new current, but GEORGE George Glover GLOVER was the first Englishman to show a grain of brilliance in his accomplishment. His larger portrait of *Sir Edward Dering* (1640) shows that he had a true appreciation of the style of Mellan. This artist, who forms as it were a bridge between the styles of the Passes and Faithorne (whom we reserve for the following chapter), fitly closes our account of the first century of English engraving.

CHAPTER V

THE GREAT PORTRAIT ENGRAVERS

(About 1600-1750)

WITH SOME ACCOUNT OF THE PLACE OF PORTRAIT IN THE WHOLE HISTORY
OF ENGRAVING AND ETCHING

As a preface to our study of the French line-engravers of the seventeenth and early eighteenth centuries, who form the central theme of this chapter, we may take the opportunity of summarising the development of portrait during the periods we have passed, and in relation to the other processes with which our history is concerned.

In describing Nanteuil and his school as the *great portrait engravers*, we do not thereby imply that their portraits take a higher position as such than what has been produced in the same field in etching or mezzotint. In fact, the very greatest of all portrait plates are unquestionably to be found among the etchings of Rembrandt and Van Dyck, while the mezzotints of the best English masters of the art stand at least on a level with the production of the French school of line. But Van Dyck's work is not numerous, Rembrandt was as great in other spheres, and so also, though far more consistently devoted to portrait than subject, were the great mezzotint-engravers. The fame of Nanteuil and his following, on the other hand, stands so exclusively on portrait as to justify our title, and a separate treatment of the development of portrait engraving with this school as the central point.

The Fifteenth Century.

In the fifteenth century portrait engraving scarcely exists. An anonymous Florentine profile in Berlin (of about 1450),[1] a few heads and bust portraits of the North Italian schools (some in the neighbourhood of Leonardo), the slightest of studies from the MASTER OF THE AMSTERDAM CABINET, three or four portraits by his follower of the monogram W♯B., and ISRAHEL VAN MECKENEM'S *portrait of himself and his wife Ida*, almost make up the sum of fifteenth-century production.

The Sixteenth Century.

DÜRER is, in fact, the first engraver to devote real effort to this field of art, and both his great contemporaries, LUCAS VAN LEYDEN

[1] *Jahrbuch*, i. p. 11.

and MARCANTONIO, are responsible for one or two portrait plates produced within a few years of Dürer's work. But in spite of their wonderful power as engravers, Dürer, Lucas, and Marcantonio all lack the essential qualities that make for true portrait, and the same must be confessed of all the engraved portraits of the first half of the sixteenth century, represented at its best by BARTHEL BEHAM and ALDEGREVER.

Towards the end of the century, with the revival of the practice of illustrating books with prints from copper-plates, the demand for engraved portraits increased at enormous bounds. But there were few engravers of more than average talent to respond.

In the Netherlands, which was the centre of the publishing The trade at this period, the best work was done by GOLTZIUS, the Netherlands. WIERIXES, and the PASSES, while many of their imitators and rivals, such as the DE BRYS and DOMINICUS CUSTOS, found their opportunity in emigration, starting similar projects abroad.

From the same centre, the Low Countries, issued the chief England. inspiration of the early English schools, where ROGERS in particular held his own alongside the average production of the Continent. Before the middle of the seventeenth century, portrait prints in England are legion : the earlier group modest and well cut, with foreigners like the PASSES as their models, the later group already feeling the broadening influence of the school of Rubens and Van Dyck.

Among the followers of Marcantonio in Italy little was done of Italy. any note in portrait. ENEA VICO of Parma and two Frenchmen of the Roman school, BEATRIZET and NICCOLO DELLA CASA, produced some pretentious plates, but empty of any power of characterisation. The engravers of little portraits are best represented by MARTINO ROTA and OTTAVIO LEONI, the latter of whom is of considerable interest for the use of dotted work in the modelling, which achieves results practically the same as stipple (without the preliminary etching used by the stipple engravers of the eighteenth century).

Except for Beatrizet and della Casa, French portrait in the six- France. teenth century was little but a reflection of the art in the Netherlands. Of her earliest workers, PIERRE WOEIRIOT and JEAN RABEL had a certain distinctiveness of manner in their meagreness of line and tone, but their more accomplished successors of the next generation, with settlers like GAULTIER and THOMAS DE LEU (who lived so long in Paris that their foreign origin may be forgotten), are mere dependants of the Wierixes and other Netherlanders.

While the last embers of the Wierix influence were burning Van Dyck and themselves out in France, Van Dyck was producing the plates which Rembrandt. are perhaps the most perfect models of portrait etching in existence. Except in some of his earlier prints, and the exceptional *Clement de Jonghe*, Rembrandt, Van Dyck's contemporary in Holland, cannot claim similar praise. The Dutchman's manner, the nervous

elaboration of modelling with delicate hatching, which gives us an insight into the depth and complexities of each sitter's character, is even more wonderful in its penetrating genius than the work of Van Dyck ; only it is essentially inimitable, and has perhaps never succeeded except in the hands of the master himself. Van Dyck, on the other hand, has remained the pattern to the best of modern portrait etchers. By the economy of their line, and by concentration on some outstanding feature of face or character, his plates make a far more immediate and direct appeal than the more complex (and possibly thereby more human) studies of Rembrandt.

In spite of the astonishing power of Van Dyck's etchings, we have seen that the public demand was for the more finished work, and it was the elaborated engravings of the *Iconography* [1] that formed the pre-eminent factor in fixing a standard for future engravers of portrait.

FRANCE.
Seventeenth
Century.

But before any of the *Iconography* plates were engraved,[2] there were already two engravers in France whose work heralded the existence of a really national school, MICHEL LASNE of Caen and CLAUDE MELLAN of Abbeville.

Michel Lasne.

Some of the early plates of the former are after Rubens, and it is probable that he was in Antwerp, and perhaps Brussels, between about 1617 and 1620. He was, in fact, one of the first of all the engravers employed by the master, though his work in this connexion is slight. After his return to France he produced a large number of portraits (both original and reproductive), sometimes using an open system of line with little cross-hatching, which he probably owed to Mellan.

Mellan.

CLAUDE MELLAN is some two years Lasne's junior, and a far more notable etcher, with a style which he brought to such perfection that it passes for his own. He seems to have been a pupil of that accomplished master of little portrait, Léonard Gaultier ; but he soon abandoned the miniature style for the bolder and more open manner which appears to have originated in Cort, and to have been continued in the Low Countries by Goltzius, and in Italy by Agostino Carracci and Villamena. If Villamena was the most unequal of these three craftsmen, it is by him that Mellan seems to have been most immediately inspired, if not instructed, when in Rome about 1624. In Rome, too, he must have come under the influence of Simon Vouet (who was settled here about 1624-27), after whom he produced some engravings in the more conventional manner. His boldest and most characteristic work was done after his return to Paris (about 1637), where he lived to the age of ninety. With the development of his style, cross-hatching is entirely discarded in favour of shading with parallels ; variation of tone is

[1] See p. 128.
[2] It is unlikely that any were produced before about 1626, the date of Van Dyck's return to Antwerp from Italy.

achieved by swelling or diminishing the thickness of the principal
lines in their own length, and outline is generally abandoned. The
climax of his mannerism is reached when he shades a whole face
(*e.g.* the *Napkin of St. Veronica*, of 1649) with a continuous spiral,
with the nose for centre ! Quite apart from such mere pranks, the

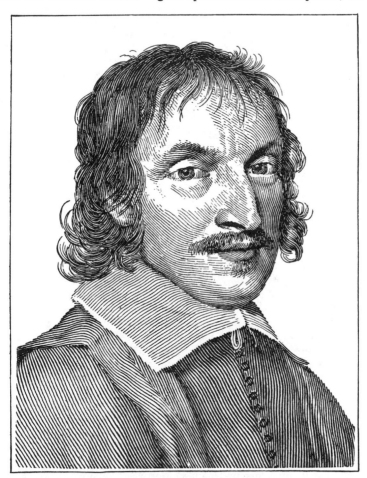

FIG. 53.—Claude Mellan. Portrait of Michel de Marolles (part).

elements of the style, even when unexaggerated, produce an unrestful
surface fatal to the concentration which is the virtue of good portrait.
On the other hand, a similar treatment of line on a smaller scale is
a real virtue with Callot and his many figures.
 The portrait reproduced (Fig. 53) of *Michel de Marolles* (1648)
is a sound example of Mellan's less exaggerated work, and of par-

ticular interest as representing the great connoisseur whose collections form the rich basis of the Cabinet des Estampes in the Bibliothèque Nationale, Paris. Besides portraits, Mellan produced a number of scriptural and other subjects, many of original design, and a set of the statues from the Tuileries (1669-71).

Étienne Picart
François
Spierre.
Mellan's
Italian
imitators :
Faldoni,
Polanzani,
M. Pitteri.

Somewhat in the same direction followed ÉTIENNE PICART and FRANÇOIS SPIERRE (though they did fewer portrait than subject plates) ; but few French portrait engravers perpetuated the characteristic elements of Mellan's style more effectively than the Italians G. A. FALDONI, F. POLANZANI, and MARCO PITTERI of the eighteenth century. Pitteri even outdoes his model in mannerism. His lines are a continued series of alternate thick and thin spots, and the resultant textile-like surface is a curious travesty of the Mellanesque ideal (*e.g. portrait of himself*, after Piazzetta).

Jean Morin.

Mellan's contemporary, JEAN MORIN, is another engraver of the earlier part of the seventeenth century in France, who fills a distinct and distinguished place in our history. He is one of the few French portraitists who stand in nearer relation to Soutman and the Haarlem school than the more rigid school of Vorsterman and Pontius. Like Soutman, van Sompelen, and Suyderhoef (of whom the two latter are among the most interesting of the Dutch portrait engravers), he constantly combines engraving with etched dot and line, and achieves thereby a subtlety of tone of which the *Bentivoglio* after Van Dyck (Fig. 54) is a brilliant example.

Louis Elle.
Claude Le
Febure.

On the border line between engraving and etching, and verging rather to the latter territory, is the work of LOUIS ELLE and CLAUDE LE FEBURE. Elle's production is of similar character to HOLLAR,[1] with a technique too restrained and precise for true etching, and too irregular and unsystematised to be good engraving. CLAUDE LE FEBURE, on the other hand, in his few portraits shows a real appreciation of the character of etching, and his work, though modest, quite bears comparison with Lievens.

Nanteuil.

In ROBERT NANTEUIL we return to a master of pure engraving, and the undisputed head of the French school of portrait. His fame stands on the most solid foundation. We can well believe the testimony of his contemporaries to the excellence of his plates, which to a large extent are from his own drawings,[2] in point of likeness. At its best his work possesses a noble directness of expression and a complete freedom from all the attractive mannerisms by which a spurious reputation is so lightly gained.

In the setting of his portraits he followed the lead of Van Dyck's engravers. For the most part he adopted a simple oval framework resting on an architectural plinth, and produced in this

[1] See Chapter VI. p. 161.
[2] He also did portrait drawings and pastels for their own sake. The best collection of such is in the Louvre.

form his most perfect and balanced portraits, *e.g.* the *Basile Fouquet* (1658), and the *César D'Estrées* of 1660 (Fig. 55). Occasionally the oval is encircled in a wreath tied at the head with ribbons (*e.g.* the *Queen Christina of Sweden* of 1654), while in his latest work

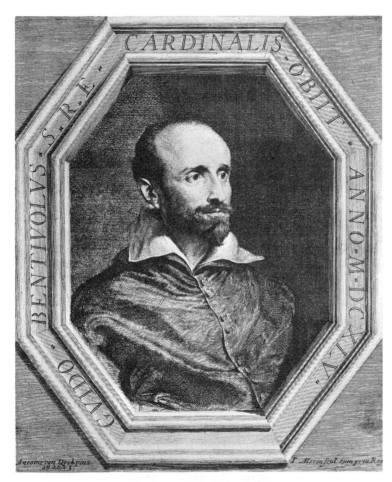

FIG. 54.—Jean Morin. Portrait of Cardinal Bentivoglio, after Van Dyck.

(*i.e.* from about 1670) he tends to disregard the plinth entirely (*e.g. Simon Arnauld de Pomponne* of 1675 and *Guillaume de Lamoignon* of 1676), and not seldom spoils the balance of the print by the undue size of the head in relation to the space to be filled.

On a sound basis of convention, with a fund of real genius to aid him, Nanteuil gradually built up the structure of his style.

His early [1] work (in Paris from about 1648) [2] shows Mellan to have been his model, and his pupillage in Paris under another exponent of the same lineal manner, Abraham Bosse, no doubt strengthened the tendency, which is seen at its best just before he discarded it for good (*e.g.* in the *Louis Hesselin* of 1658). His later development (which is beginning to appear as early as 1654, *e.g.* Queen *Christina*) was an original combination of the strength of the school of Vorstermann and Pontius with the subtlety of Soutman and Suyderhoef. In the delicate modelling of the face in particular he adopted a system of short strokes, carefully and closely laid, which came to form the most distinct element in the French school of portrait.

As portrait engraver to Louis XIV., of whom he has left eleven prints, nearly all the great personages of the court appear in his work, which amounts in all to some 234 numbers (about 216 portraits). The very year of his royal appointment (1659) he rendered a public service to his art in raising the academical status of the engraver. It was at his solicitation that the king passed the edict of St. Jean-de-Luz, elevating engraving from the number of the Industrial Arts to the rank and privileges of one of the " Liberal Arts."

Flemish engravers in France :
M. Tavernier.
Jacob de Bie.
Pieter van Schuppen.
Nicolas Pitau I.

Before the commencement of Nanteuil's activity several Flemish engravers of portrait had been settled in Paris, *e.g.* MELCHIOR TAVERNIER and JACOB DE BIE,[3] but their work was not of the order to have done much in the propagation of the style of the Rubens school in France. PIETER VAN SCHUPPEN [4] (b. 1623 ?) and NICOLAS PITAU the elder (b. 1633 ?) [4] did more in this direction, but they were already the influenced party, forming their style on Nanteuil and the de Poilly.

Gerard Edelinck.

GERARD EDELINCK (b. Antwerp 1640) is the great intermediary force between Flanders and France at this period. He was a pupil of Cornelis Galle in Antwerp, but the development of his style owes more to the instruction of François de Poilly and to the inspiration of Nanteuil after his removal to Paris in 1665. Both FRANÇOIS DE POILLY and his younger brother NICOLAS were clever and prolific craftsmen both in portrait and classical subjects, but they were surpassed in strength by Edelinck, who, with Nanteuil

[1] The date of his birth is much disputed : 1623 has the greatest claim to correctness, but 1625, 1630, even 1618, have been put forward.

[2] Some prints date three or four years earlier, while he was still studying for the iaw in the Jesuit College at Rheims. Nicolas Regnesson of Rheims was his first master in engraving.

[3] His work was chiefly medallic illustration for *La France Métallique*, with the *Vrais Portraits des Rois de France*, Paris, 1634. According to Kramm the second edition (1636) contains a biographical notice which calls him " le maître des plus célèbres graveurs de Rubens." Except for the fact that he undoubtedly had relations with Rubens in 1611, there is nothing in his life or work to support so great a claim. He was a pupil of Adriaen Collaert.

[4] It is doubtful whether either was in Paris before 1655.

and Masson, forms the great triumvirate of the best period of French portrait. Edelinck did less original work than Nanteuil, and largely

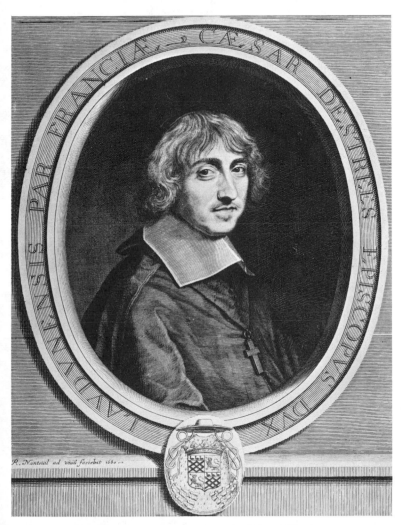

FIG. 55.—Robert Nanteuil. Portrait of César D'Estrées.

reproduced paintings of Le Brun, Philippe de Champaigne, and Rigaud.

Of his portraits one might particularly mention the *Robert Nanteuil* (after the master's own drawing), the *Philippe de Champaigne* (of 1676), the *Dryden* (after Kneller), and *Charles Le Brun*

(after Largillière). Always brilliant and seldom dry in manner, he just fails of that contained and calm forcefulness which makes Nanteuil's work so convincingly great.

He did more subject plates (after the old masters, Lebrun, etc.) than most of the portraitists, but the somewhat overdrawn sentiment of Lebrun (whom he largely reproduced) contributes much to divert the interest of the modern amateur from the sound work of the engraver.

Antoine Masson.

ANTOINE MASSON (b. 1636) is by far the least prolific of the great triumvirate, but in the quality of his work, which is almost entirely portrait, he is the more serious rival of Nanteuil's fame. He started as an armourer, and perhaps never completely escaped a certain metallic stiffness in the handling of detail (*e.g.* the hair). Plates like the *Guillaume de Brisacier* of 1664, and the *Henri d'Harcourt* (both after Mignard), are as brilliant as anything of Nanteuil, but the vigour of the portrait is somewhat lost in the equality of the finish. Absolutely free from a similar reproach, and only slightly removed from Nanteuil at his strongest, are the magnificent prints of *Pierre Dupuis* (1663, after Mignard) and *Olivier Le Fèvre D'Ormesson* (1665).

The Drevets.

On the purely technical side, the next generation of portrait engravers in France, as represented in the Drevet family, by no means fell short of the skill of the great triumvirate. In their command of the graver for the expression of surface texture they show an even greater virtuosity, but with it they lost much of the vigour of their predecessors as portraitists.

In the setting of their figures they followed the painters in introducing greater variety. But where the painter, by his command of colour, escapes the attendant dangers, the engraver who elaborates to the very corners of his plate cannot fail to destroy the concentration of the portrait. How much more significance is possessed by an engraved portrait where subsidiary detail is unelaborated, may be seen by comparing the unfinished state of Cornelis van Dalen's *Charles II.*[1] (Fig. 57), with the later state, with its brilliantly realistic armour which puts even the penetrating visage of Charles into the shade.

Of the DREVETS (PIERRE, his son PIERRE IMBERT, and nephew CLAUDE) Pierre, the father, was by far the most powerful. His portrait of *Rigaud*, whose work he largely reproduced (see Fig. 56), is one of his most vigorous plates, while the *Boileau Despreaux* (of 1706) may be cited as a typical instance of his brilliance in rendering the tonic values of different colours and stuffs. In this latter quality he was even surpassed by his son, PIERRE IMBERT, but amid all the glister of silk and almost tangible softness of the fur in his

[1] The student should examine early states of a work like this (of which the British Museum has several impressions) as an example of the quality of the engraved line before the burr has been scraped away.

Cardinal Dubois (1724), there is a deadness and triviality in the essentials that sounds the knell of true portrait engraving.

FIG. 56.—Pierre Drevet. Portrait of Hyacinthe Rigaud (part).

The development of an exaggerated fineness of technique led

The engravers of miniature portraits : E. Ficquet. P. Savart. J. B. Grateloup.

logically to a corresponding reduction in the size of the plates as a whole, and this, combined with the growing practice of illustration in small books, led to the school of miniature portrait engravers of which ÉTIENNE FICQUET[1] (b. 1719), PIERRE SAVART, and GRATELOUP,[2] were the chief exponents. With them the art of portrait engraving wheeled back, with the added adornment of eighteenth century tastefulness in small things, to the ground which had been trodden by the Wierixes nearly two centuries before.

GERMANY.

Jeremias Falck.

The great French engravers of the best period were not without worthy rivals in other countries. Among the Germans, JEREMIAS FALCK (b. 1609), a pupil of William Hondius, who had settled in Falck's native town of Danzig, was one of the earliest to gain distinction. He probably came immediately under the influence of Nanteuil and the de Poilly in Paris, but he never attained any of their brilliance in execution, preserving some of the breadth of Mellan's style with nothing of its variety. He was a prolific worker, and in a life spent in many places, notably in the service of Queen Christina of Sweden, his portraits cover a wide and interesting field.

Bartholomäus Kilian.

The only other German portrait engraver whom we would refer to again is BARTHOLOMÄUS KILIAN (b. 1630). He had studied under the de Poilly in Paris, and is one of the few German engravers who reflected at all adequately the brilliance of the French school.

NETHER-LANDS.

In the Netherlands, which had led the way in the first half of the seventeenth century with engravers such as Vorsterman, Pontius, and Suyderhoef, the art remained on a higher level than it ever reached in Germany.

Cornelis van Dalen II.

Of the generation contemporary with the greatest French portraitists, one of the most brilliant was CORNELIS VAN DALEN the younger, of Amsterdam. His *Charles II*.[3] after P. Nason (Fig. 57) is perhaps the finest engraving of the king that exists, and one of the most powerful portraits of the time. Two other portraits of English royalties (*Henry, Duke of Gloucester,* and *James, Duke of York*) point to a possible visit to England soon after the Restoration, but there is no certain evidence in the matter. A set of noble engravings after Venetian paintings (the so-called portraits of

[1] His system of engraving is absolutely that of the Drevets almost microscopically reduced. His portraits include many famous men of letters (*e.g.* La Fontaine, Voltaire, Rousseau, Corneille).

[2] His marvellously delicate prints (in all only nine or ten, executed between about 1765 and 1771, *e.g. Dryden* after Kneller, and *J. B. Bossuet* after Rigaud) show curiously mixed methods. The best part of his work seems to be achieved by dotting with the needle, and perhaps with a very fine roulette through the etching ground, strengthening this after biting by dotting with the dry-point and getting some of the high lights by scraping. His grain looks deceivingly like aquatint, so regular is its surface, but I doubt if he used this process. He is said to have engraved on steel plates (see Bibliography), the earliest example of the practice known, if the tradition is correct.

[3] See back, p. 148.

Giorgione, Sebastiano del Piombo, Aretino, and Boccaccio [1]) is also

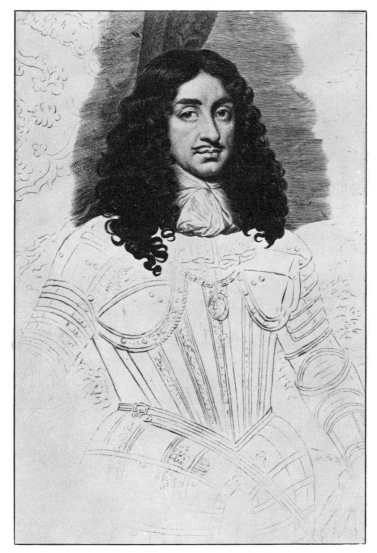

FIG. 57.—Cornelis van Dalen the younger. Portrait of Charles II. (unfinished plate).

probably the work of Van Dalen the younger; but his father of the
same name, who worked in England between 1632 and 1638, occa-

[1] This is the Titian at Hampton Court.

sionally did such capable work (*e.g.* his *Jehan Polyander de Kerckhoven* of 1645) that a dogmatic attribution of the series to the one or the other is dangerous.

Abraham Blooteling

Van Dalen, the younger, produced comparatively little, but his best work is on just as high a level as that of his more famous pupil ABRAHAM BLOOTELING (b. 1640). The latter, however, is of far greater importance for the part he took in the development of mezzotint, so that we need do no more here than mention his por-

Gerard Valck. trait work in line. The same excuse may hold good for GERARD VALCK, apparently Blooteling's pupil, though considerably his senior, who accompanied the latter to England in 1673.

.

ENGLAND William Faithorne.

It is noteworthy how the first great English portrait engraver, WILLIAM FAITHORNE (b. about 1616), who was some years Nanteuil's senior, passed through analogous stages of development. At the beginning of his career, possibly to some extent inspired by Glover,[1] he closely followed the open style of Mellan. His earliest portraits, such as the *Calthorpe* of 1642, are much coarser than the French master's work, but the best in this early manner (*e.g. Sir Thomas Fairfax*), though heavier in line, are scarcely second to Mellan in vigour of presentation.

During the Civil War Faithorne showed his loyalty to the king by serving under Robert Peake,[2] the earliest publisher of his prints, at Basing House. On its capture he was for some time held a prisoner by the Parliament, but continued his activity in engraving, which has left us portraits of both Royalist and Roundhead leaders. Towards the end of the 'forties he obtained leave to emigrate for a while, and his stay in Paris, under the patronage of Michel de Marolles and with the inspiration of Nanteuil, was a momentous event in his life. Nanteuil was still in his Mellanesque period at the time of Faithorne's visit (1649-50), so that Faithorne may have got the real suggestion of his later style several years after his return, *i.e.*, if this took place, as is supposed, as early as 1650-51. The *Sir William Sanderson* (Fig. 58), the author of a book on drawing (*Graphice*, 1658), to which the portrait served as frontispiece, is one of the earlier in the more complex manner, in whose development Faithorne seemed to keep level with Nanteuil rather than to follow his leadership. In the next year come the splendid portraits of *Sir William* and *Lady Paston*, showing him at the height of his power, which was seen at its best in the first decade after the Restoration. Several portraits of *Charles II.*, one of the king's mistress *Barbara Lady Castlemaine* (of 1666), and the *Thomas Killigrew* (prefixed to

[1] See Chapter IV. p. 138.

[2] This Robert (later Sir Robert) Peake, a brother of William, who was also a print-seller, seems to be the son of a Robert Peake, who was serjeant-painter to James I. in 1612. According to Bagford's MS. life (see Brit. Mus., Bagford, *Collectanea Typographica*, Pt. iv. Harl. 5910, fol. 135) the last-named was Faithorne's first master. Cf. p. 137.

the 1664 edition of his plays), are brilliant examples. Faithorne

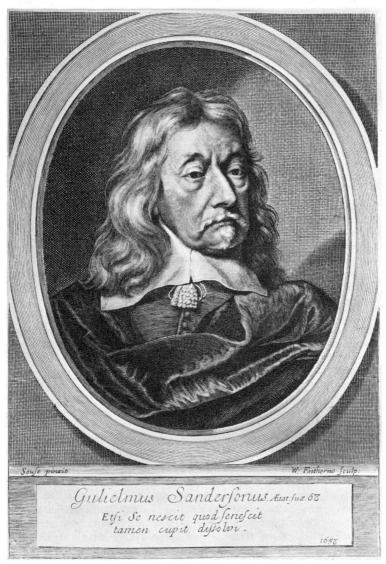

Soufe pinxit W. Faithorne sculp.

Gulielmus Sanderfonus. Ætat: suæ 63
Etsi se nescit quod senescit
tamen cupit dissolvi.

1658

FIG. 58.—William Faithorne. Portrait of William Sanderson.

seldom elaborated the modelling of his faces with the minute flick-
work which gives so subtle a tone to Nanteuil's heads, but his
power as a portraitist is scarcely less convincing. Even in technical

excellence there are few of the great portrait engravers but Nanteuil, whom he does not equal at least in virility. He suffers, however, more than Nanteuil and most of his school if he is to be judged by the hack-work of which he produced not a little. In the latter part of his life in particular, a certain falling off in power of engraving is noticeable, unless we are to regard such portraits as the *Henry Moore* (1675) as partly the work of some pupil.

David Loggan. An immigrant from Danzig,[1] DAVID LOGGAN was a much closer imitator of French models than Faithorne, and he comes, perhaps, nearer to them in his brilliant portrait of *Sir Thomas Isham* (1676) than in many of his other plates, which are very unequal in quality. He holds a far more distinct place in the art of engraving in England for the excellent architectural prints of Oxford and Cambridge Colleges, in the *Oxonia Illustrata* (1675), the *Cantabrigia Illustrata* (1690).

Robert White. With Loggan's pupil ROBERT WHITE, who produced a few sound plates and a multitude of poor ones, we come nearly to the end of English portrait engraving in line. At the beginning of the

George Vertue and Jacob Houbraken.

eighteenth century GEORGE VERTUE [2] was engraving portraits in a similar style to those of the Dutchman, JACOB HOUBRAKEN,[3] with whom he collaborated in Thomas Birch's *Heads of Illustrious Persons of Great Britain* (2 vols. London, 1743-52), but they both showed a smallness of handling which takes all but historical interest from their work.

Line-engraving superseded by mezzotint in popularity.

During the last few decades of the seventeenth century line-engraving in England was gradually yielding place in popularity to mezzotint; and when the mere reproduction of a painting is concerned, it must be confessed that the younger art possesses many qualities in its favour. Robert White himself published, but

George White. William Faithorne II.

apparently never produced mezzotints. The changing fashion is significantly exemplified in his son GEORGE WHITE, and in the younger FAITHORNE, both of whom entirely discarded line-engraving for the new process.

By the latter half of the eighteenth century the engraving of portrait in England was largely in the hands of the mezzotint engravers, though occasional works of almost equal merit were achieved in the lighter art of stipple. The revival of the classical manner of line-engraving led by STRANGE and SHARP in England, by WILLE and SCHMIDT in France and Germany, and by RAPHAEL MORGHEN in Italy resulted in the production of many portraits, but the dull perfection of their system seldom afforded anything but pieces of metallic brilliance which may be disregarded in the history of great portraiture.

[1] He was working in England certainly in 1658, perhaps as early as 1653.

[2] Of greater interest as an antiquary, engraver of antiquities, and as the biographer of English artists.

[3] He engraved the plates to the *Groote Schouburgh der nederlandsche Konstschilders en schilderessen* (1718-21) by his father, Arnold Houbraken.

The eighteenth century is sufficiently barren in portrait etching of any freedom and vigour of execution, and almost the best is to be found in that of JONATHAN RICHARDSON the elder, WORLIDGE, and BENJAMIN WILSON in England. But their etched work is pervaded with the spirit of dilettantism, and it is not until the last century that we meet any renewed conviction in the value of etched portraits as a serious artistic asset to bear comparison with portraits elaborately finished in mezzotint or line. There is a real life in the dry-points of GEDDES, but the great achievement to be recorded starts with the second half of the nineteenth century. On the continent of Europe the most interesting personalities in portrait etching are ALBERT BESNARD and ANDERS ZORN. But in spite of the originality and vigour of their style and the brilliance of their powers of execution, they possess a certain Whistlerian remoteness from human emotion in favour of mere decorative ideals, which militates against the creation of portraits of the first rank. In England there are ALPHONSE LEGROS and WILLIAM STRANG, one of STRANG'S numerous pupils, and an artist of equal technical ability and remarkably versatile powers. Legros's etched portraits are the greatest modern tribute to the noble style initiated by Van Dyck, and one of the chief glories of the art of the nineteenth century.

More completely of the twentieth century is the work of FRANCIS DODD and AUGUSTUS JOHN ; Dodd, the author of many masterly dry-point portraits, and John, of a score of the most sensitive portrait etchings produced in recent times.

CHAPTER VI

THE MASTERS OF ETCHING

VAN DYCK AND REMBRANDT—THEIR IMMEDIATE PREDECESSORS, AND THEIR
FOLLOWING IN THE SEVENTEENTH CENTURY

(About 1590–1700)

THE century, which saw the beginning of etching, was somewhat
barren of work in which the distinctive qualities of the art are
realised. There is a charm in the landscape etchers of the Regens-
burg school, with all their curious affectation, but their style was little
more than pen-drawing reproduced on copper. Nor did Parmi-
giano in his graceful and spontaneous work advance much farther
in the understanding of the qualities of the etched line as distinct
from mere penmanship. But in Meldolla and in the following
of Titian there is a certain large energy and freedom of handling
which show that some, at least, of the elements of good etching had
been grasped more truly in Italy than by the Northern artists.

It was in Italy, moreover, that etching seemed most worthily
represented, whether by native artist or foreign settler, until, with
the third decade of the sixteenth century, the two great masters of
etching suddenly spring into being, full-grown, as it were, from the
head of Zeus, so inexplicable is their genius for the art, when one
considers the slender foundation on which they built. In the two
etchers to whom we refer, Rembrandt and Van Dyck, the present
chapter finds its climax. Meanwhile we will glance at some of
their immediate predecessors in Italy and in France, and at a few
Southern contemporaries who went on their own way, occasionally
imitating, but seldom really influenced by the achievements of the
great Northern masters.

ITALY.

The influence of the Carracci and their academic art tended
rather to the revival of line-engraving than to encourage the less
systematised art of etching. Both Annibale and Lodovico Carracci

Guido Reni.

etched a few plates, but they are quite unimportant.[1] GUIDO RENI,
the most famous of the pupils of the Carracci, formed the real centre

[1] See Chap. III. p. 113.

156

of inspiration for the etchers of the Bolognese school. Forming
his style on Baroccio, in its combination of light line and dot, he
produced many delicately etched plates which not only found many
imitators in Italy, but remained the standard of style among French
etchers for the best part of the century. There is a note of grace-
fulness in his work, and in that of his followers, SIMONE CANTARINI, Simone
and GIOVANNI ANDREA and ELISABETA SIRANI, which fits the some- Cantarini.
what feminine sentiment of their art better than the largeness of an G. A. Sirani.
academic painting. It is the spirit which, at the end of the Sirani.
eighteenth century, in the followers of Angelica Kauffmann and
her peers, found its most apt expression in the superficial charm
of stipple.

Most of the Bolognese painters produced some etchings, and of Guercino.
the occasional executants GUERCINO is perhaps the most brilliant.
But his two or three plates are nothing more than a repetition of
the style of his drawing, with its sweeping line and its characteristic
insistence on local emphasis in colour in the shading.

Another etcher, GIOVANNI FRANCESCO GRIMALDI, may be men- G. F. Grimaldi
tioned as the most prolific interpreter of the landscape of the
Bolognese painters.

The same type of work that characterised the followers of Reni Carlo Maratta.
in Bologna was continued in Rome until the early years of the
eighteenth century by CARLO MARATTA. Here, too, we meet the
style of the pen draughtsman transferred to copper, with no real
appreciation of the latent qualities of the etched line.

The most individually interesting etchers in Italy during the Ribera.
seventeenth century are without a doubt the Neapolitans, JOSÉ DE
RIBERA and SALVATOR ROSA. The former, a Spaniard by birth
("Lo Spagnoletto" he is called), studied in Rome under Caravaggio,[1]
the inspirer of the naturalistic school, from whom as a painter he
no doubt acquired the tendency towards crude colouring and harsh
contrasts of light and shade, to the chiaroscuro, which was so much
more nobly developed by Rembrandt in the north. These less
pleasing qualities do not, however, show in his etchings, which are
done in pure line interspersed with dot work (as in Baroccio), and
exhibit real excellence of draughtsmanship, with a considerably
greater appreciation of tonic values, whether in the higher or lower
gamut, than is shown by his Bolognese contemporaries. The best
of his plates, the *St. Jerome* (1621), the *Flaying of Antæus* (1624),
and most brilliant of all, the *Satyr and Silenus* (1628), were done
by the year in which Rembrandt dated his earliest etching, and
in the twenty years that followed Ribera remained apparently little
affected by the Northern master's work.

Of the versatile talent of SALVATOR ROSA—poet, actor, musician, Salvator Rosa.

[1] A few etchings are attributed to Caravaggio (*e.g. Three Men in Conversation*,
1603), just as bold and rough in manner as those attributed to his best Northern
imitator, GERARD VAN HONTHORST.

painter—we must not expect to find work of academic correctness of draughtsmanship. But with all their carelessness of drawing, his etchings possess a vital energy and an insight into life which gives them irresistible charm and real value. His youthful adventures with the banditti, and a natural sympathy with the rough and ready life of soldier and peasant, were the inspiration for the most numerous type of his etchings, his studies of soldiery and camp life. He produced a considerable number of large mythological and historical compositions, like the *Crucifixion of Polycrates of Samos* (B. 10), and various etchings of the *Philosophers of Antiquity*, but in such ambitious plates his art suffers from the scenic and, sensational tendency characteristic of the South Italian school.

Benedetto
Castiglione.

The most outspoken imitator of Northern etchers in Italy was the Genoese BENEDETTO CASTIGLIONE, who was born the year after Salvator Rosa (1616). Probably Van Dyck's work was the immediate influence that gave the direction to his art, but he could hardly have come into personal touch with the master.[1] In some of his studies of heads Castiglione shows that he knew his Rembrandt, but the technical character of his plates has more real affinity with the attractive but conscience-less scrawl of the looser work of Lievens [2] than with the style of the master.

Of greater interest than any native artists are two French etchers, CALLOT and CLAUDE, who both did much of their work on Italian soil.

Jacques Callot.

JACQUES CALLOT, of Nancy (b. 1592), happily knew his mind better and earlier than his parents, who had intended him for the Church. Twice the boy ran away from home, fired, perhaps, by reports from his friend ISRAEL HENRIET,[3] who was then studying in Rome, and each time he arrived in Italy before being caught. The first time he cast in his lot with a band of gipsies, and so contrived to reach Florence (1604). Here he seems to have aroused the interest and patronage of CANTAGALLINA, but was too impatient to join his friend Henriet to stay in Florence many months. But his arrival in Rome soon led to discovery by some merchants from Nancy, and an enforced return was the result. His second truancy was less successful : he had only just crossed

[1] Van Dyck was in Genoa, with certain intermissions, in the period between 1621-22 and 1625-26.

[2] Cf. *e.g.* the *Resurrection of Lazarus* as interpreted by either etcher.

[3] So according to Meaume, who places Henriet's birth about 1590. If the date of his birth, as given in Bellier and Chavignerie's Dictionary, is correct (1608), the story must be discredited. Henriet settled before 1629 in Paris, and became a prosperous print-seller. On Callot's visit to Paris (1629-30) he seems to have obtained the right of printing and selling impressions from Callot's plates. On Callot's death he must have had or come into possession of a large stock, from which he published impressions for many years, sometimes adding his name in full —generally, however, merely *Israel exc.* on the plate. On his decease in 1661, his nephew, Israel Silvestre, another and far more prolific imitator of Callot, inherited his stock, which also included much of Stefano della Bella.

the Italian border in the neighbourhood of Turin when an elder brother overtook him and turned him back. No parental prejudice could withstand this determination, and he was sent a few years later (1608-9) to study art in Rome.

He may have joined HENRIET and CLAUDE DERUET (another slightly older contemporary from Nancy, who later came under his influence) and studied under ANTONIO TEMPESTA in Rome. At least the particular direction of his art owes something to the multifarious subject-plates of that prolific but poorly-gifted engraver and etcher. Most of his time, however, in Rome (1609-11) seems to have been passed in a sort of working apprenticeship with his fellow-countryman PHILIPPE THOMASSIN. In 1612 he moved to Florence and found more congenial inspiration in the studio of GIULIO PARIGI, an architect of French extraction, and the moderator of Medicean fêtes, to whom he was, perhaps, introduced by his old protector REMIGIO CANTAGALLINA. Both Parigi and Cantagallina were etchers,[1] and the centre of a group of artists who were at once purveyors to the pleasures of the court, and the illustrators of all sorts of ducal and popular festivities and pageants. Callot worked in this sphere until 1621, when he returned to Nancy, and, except for a short interval spent in Paris (1629-30), was settled here until his death in 1635.

His early adventures with the gipsies (whose memory he perpetuated by four plates done some eight years after the event, *i.e.* in 1622), may have sharpened the genius for caricature and grotesque, which always characterised his mode of expression. His plates, mostly small, are very numerous, amounting to some 1000 in all. He treats the widest range of subject, but he is most himself when depicting small figures in all sorts of garbs and poses (as in the *Capricci di varie figure*[2] and the *Fantaisies* of 1634, M. 868-881), in his studies of *Italian Vagabonds* (M. 685-709), and in plates crowded with figures in spirited action, like the *Miseries of War*.[3] His topographical prints with military staffage are among the most important of their type, and of real artistic value. In the history of etching his work is a notable landmark, as it is among the earliest[4] in which the practice of a second (or further repeated) biting was used to any extent. The varied tone of line achieved by this method opens possibilities of

[1] Giulio Parigi etched fewer plates than his son Alfonso.

[2] Meaume, 768-867. There are two sets of fifty plates. In the earlier, which was done in Florence about 1617, and is more prized by collectors, the prints were never numbered. He repeated the subjects in a second set after his return to Nancy in 1623. Impressions from the two sets are often found inaccurately distinguished.

[3] Two sets : *Les petites Misères* (Meaume, 557-563) of 1632 (*see* Fig. 59), and the larger plates, *Les grandes Misères* (Meaume, 564-581) of 1633.

[4] He may have found his suggestion for the practice in the school of Parigi (*e.g.* in Cantagallina's work).

treating atmosphere and distance, which few even of the greatest
etchers have fully realised.

In one other respect the technical character of Callot's plates
demands notice, *i.e.* in the combination of graver work with
etching. Like Mellan [1] in line-engraving, Callot is the special
exponent of the swelling line in etching. In part he achieves his
variation in breadth by holding the échoppe at varying angles as
he opens the ground, but this would be seconded by cutting
through the ground into the copper before biting. Moreover, after
the biting, the lines are frequently strengthened with the graver.
ABRAHAM BOSSE, the author of one of the earliest treatises on the
art of engraving,[2] follows the same ideal in a middle course between
etching and engraving. Bosse used etching to a considerable ex-
tent, but his plates are far more truly in the engraver's manner than

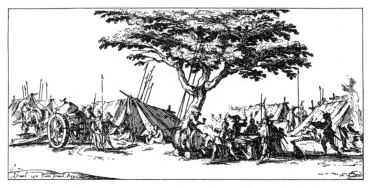

FIG. 59.—Jacques Callot. From the smaller set of the *Miseries of War*.

Callot's. The practice of assimilating an etching to the character
of an engraving was by no means uncommon at the period, and
found its chief representative in the Netherlands in JAN and
ESAIAS VAN DE VELDE. The whole justification for their use of
etching would seem to be the saving of time rather than the suit-
ability of the process.

Stefano della
Bella.

The most individual artist among the imitators of Callot was
STEFANO DELLA BELLA (b. 1610), an Italian, who lived some ten
years of his life in Paris (1640-50). Scriptural subjects, pageants,
topography, hunting scenes, studies of figures and heads, are a few
of the subjects which make up a work which is as numerous as
that of Callot. His style is more essentially that of the etcher,
his delicate line having less regularity, and being seldom strengthened
by the graver. While imitating Callot in his treatment of subject,
he tempers his technique with something of the lighter manner of
the school of Guido Reni.

[1] Who was six years Callot's junior. [2] Paris, **1645.**

Before leaving the group of "Little Etchers," as we might term Wenzel Hollar.
Callot and his following, we cannot omit notice of another, born the
year after Rembrandt and outliving him by some eight years, who
nevertheless seems entirely to have escaped the influences of the
great master. WENZEL HOLLAR (born 1607, in Prague, whence he
was driven in 1627 during the troubles of the Thirty Years' War),
studied in Frankfurt (between 1627 and 1629) under MATTHÄUS
MERIAN the elder, the prolific etcher of topography,[1] who had suc-
ceeded soon after 1623 to the great publishing house of the de Brys.

For a few years (1629-36) Hollar is found in Strassburg and
Cologne. Then Thomas Howard, Earl of Arundel, the famous
collector of works of art and importer of foreign artists, persuaded
him to join him on his embassy to Vienna and return in his employ
to England. Except for eight years passed at Antwerp during the
troubles of the Civil War (1644-52), he spent the rest of his life
in England, and died here in 1677. An artist of modest genius,
the master of an extremely delicate technique, we have to thank his
sane recognition of his own artistic limitations and his unrivalled
industry for a work of over 2500 plates, embracing topography,
architecture,[2] costume, portrait, in fact every conceivable subject of
interest to the student of the seventeenth century, whether he be
artist, antiquary, or historian. His work is almost entirely in pure
etching, but it is etching executed with the close and careful finish
that is more properly the part of the graver. In spite of the
laborious tasks he set himself and was compelled to follow, much of
his miniature landscape work has a wonderful charm, and in prints
of figure and costume like the *Four Seasons* of 1643-44 (Parthey,
606-609), the *Ornatus Muliebris* (P. 1778-1803), the *Aula Veneris*
(P. 1804-1907), and the series of *Muffs* (P. 1945-52), he shows a
command of the needle for the expression of variety of surface value,
which has hardly been surpassed even by Jacquemart.

The second of our Italianised Frenchmen, the famous painter Claude
CLAUDE GELLÉE (LORRAIN), is a very different genius from Callot, Lorrain.
but it was probably from the latter that he received his first impulse
towards etching. The faculty of rendering aerial effect is their
closest point of contact, but one at least of Claude's earlier plates,
the *Campo Vaccino* (of 1636), reflects as well much of Callot's
manner in the treatment of figure.

Claude, who was born of humble parentage at Chamagne on the
Moselle in 1600, seems to have started life as apprentice to a
pastry-cook, and in Rome, whither he had come as a youth, he
apparently profited of these credentials to enter the household of the
landscape painter, Agostino Tassi.[3] But his talent did not fail to

[1] *E.g.* in Martin Zeiler's *Topographia*, Frankfurt, 1642, etc. (in which his sons
Matthäus and Caspar also took part).
[2] *E.g.* Dugdale's *History of St. Paul's*, 1658.
[3] A pupil of Paul Bril.

find its opportunity, and the servant soon became the pupil. With all his genius as a painter of landscape, he never developed that refinement of feeling which sees the greatness in common sights, but was for ever seeking Nature in her larger views and more magnificent moments, whose expression few achieve without theatricality and pose. His etchings, however, which number between forty and fifty, are the least theatrical of his productions,

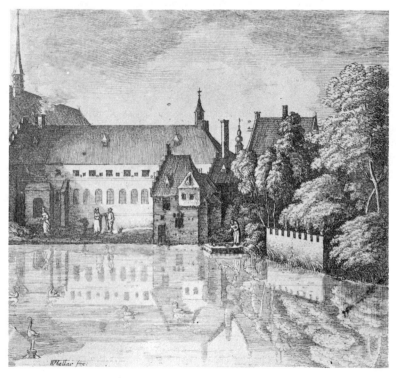

FIG. 60.—Wenzel Hollar. The Abbey of Groenendael (part).

and though by no means the work of a hand practised in the process, possess qualities of rare artistic value. They are even more essentially etcher's etchings than those of Callot with the firm, graver-like touch. Possibly in the delicate character of his etched line and in the irregular mesh of his shading, he may owe something to ADAM ELSHEIMER [1] (a German painter settled in Rome during

[1] *I.e.* if the charming little *landscapes with satyrs and nymphs* (see Nagler, *Monogrammisten*, i. p. 256, Nos. 4-6) are rightly attributed to A.E. Another print, a *Boy with a Horse*, is handled with much greater breadth and more nearly in the manner continued by Pieter van Laer. Probably Elsheimer etched considerably more plates than the few which are attributed, for Joachim von Sandrart (who lived

the first two decades of the seventeenth century), whose influence in the development of chiaroscuro in painting was so much greater than his apparent achievement.

The dates on Claude's plates are limited to two periods of his life—1630-37 and 1651-63. Very probably he had not etched at all before his return to Rome from a visit to Lorraine (between 1625 and 1627), where he may have met Callot.

Several of the etchings are spoilt by bad biting (*e.g.* the *Country Dance*, Duplessis 24), and it is seldom that really well-printed impressions are found. But in spite of these, the imperfections of an amateur in this branch of art, his best plates are incomparable works imbued with a feeling for the romance of rural life seen amid the classic associations of the Campagna. His wonderful power in the expression of atmosphere is seen perhaps at its best in the *Cow-herd* of 1636 (D. 8). By the delicate interlacement of line and subtle use of scraping,[1] one is made to feel the warm mists that are rising at sundown, where the herd is standing knee-deep in the pool. In other plates, such as the *Sunrise* of 1634 (D. 15), Claude treats a more ambitious theme with almost equal success. His least pleasing etchings are those like the *Cattle Drinking*, where the bold and open lines of the drawing show up the faults of figure drawing, which he never lost.

Many of the painters influenced by Claude and Poussin, *e.g.* GASPAR DUGHET and FRANÇOIS MILLET, etched a considerable number of plates, but they are essentially in the manner of the pen-draughtsmen, and have little real distinction as etchings

Nor was the work produced in the school of SIMON VOUET, who himself etched a few plates, of greater interest. MICHEL DORIGNY, one of the several son-in-law-pupils of the master, may be taken as typical of a dull school. His manner of etching is suggested to some extent by the school of Bologna, but lacks the graceful spontaneity of Reni's touch.

Just as the French engravers of the period transformed the character of their work by a liberal mixture of etching, so Dorigny and his followers seemed, on their side, bent on endowing the etched line with a regularity which should more properly belong to the character of line-engraving.

.

In the school of Rubens, where the master's aim was the marketable and magnificent reproduction of his own works,[2] little

Gaspar Dughet. François Millet.

Simon Vouet. Michel Dorigny.

The Rubens School.

from 1629 to 1635 in Rome, and is likely to have had sound basis for his notice in the *Teutsche Academie*) makes more of his etched work than is warranted by what is known. Elsheimer's chief interpreters in etching and engraving are Jan van de Velde and Hendrik Goudt.

[1] Perhaps, as Seymour Haden (*About Etching*) suggested, he may in places have roughened the plate with pumice-stone and scraped out the lines of light (in essentials a rough attempt at mezzotint).

[2] See Chap. IV. pp. 126-8.

encouragement was given to etching. A few etchings are attributed
to RUBENS himself, three with some show of reason, a *St Catherine*

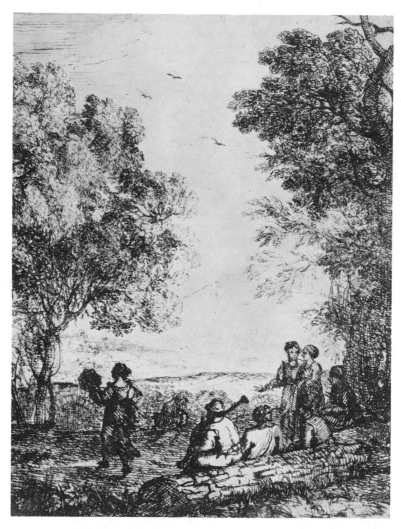

FIG. 61.—Claude Lorrain. Peasants dancing under the Trees (part).

in the Clouds, an *Old Woman and a Boy with Candles*, and a *Bust
of Seneca.*

The first, which is the most powerful work of the three, is signed
in its second state *P. Paul Rubens fecit.* In composition it corre-
sponds to one of the ceiling paintings done by Rubens for the

Jesuits' church at Antwerp in 1620,[1] a fact not entirely favourable to the originality of the etching. In respect of the second,[2] even if there is the etching of the master at the base, it is concealed in the dry elaboration of another hand. The bust of Seneca, which in its early etched state (before Vorsterman's elaboration) is only known to exist in the British Museum, is by no means a brilliant piece of work, but is at least sufficiently near to Rubens's draughtsmanship to render definite rejection unwarranted.[3]

A small number of etchings (some dated 1652) have been attributed to Rubens's younger contemporary, JACOB JORDAENS, but as his name only appears as *inventor*, there is no more certainty than there is honour in the attribution of plates which possess none of the buoyant vigour of his paintings. Jacob Jordaens.

Works of a similar type, combining breadth of style with a light and open manner of etching, are best represented in Rubens's pupil, CORNELIS SCHUT (b. 1597). A somewhat younger pupil, THEODOR VAN THULDEN (b. 1606), followed a similar path, reproducing and imitating the master chiefly in subjects relating to Scripture history and mythology, but he treated his plates with a heavier hand, and not infrequently intermixed graver-work with his etching. Cornelis Schut. Theodor van Thulden.

The landscape of Rubens and the Antwerp school found a modest but unaffected interpreter in LUCAS VAN UDEN (b. 1595), who lived till some three years after the death of Rembrandt, his junior by more than a decade. His timidly etched plates are monotonous, diffuse, and lacking in significance, but they at least deserve honour for their complete freedom from all traces of the fantastic affectation which disfigured such of his predecessors as Hans Bol and Paul Bril. Lucas van Uden.

Quite in Uden's manner, and generally found with the address of Frans van den Wyngaerde (who published many of Uden's prints), are some plates by LODEWYK DE VADDER of Brussels. Unless his plates fall quite in the latest years of his life, it is possible that he rather than Uden was the inspirer.[4] Lodewyk de Vadder.

SIR ANTHONY VAN DYCK (1599-1641) stands out as the solitary great etcher of the school. Portrait etching had scarcely had an existence before his time, and in his work it suddenly appears at the highest point ever reached in the art. As we have seen in our Van Dyck.

[1] No longer in existence. The whole series engraved by J. Punt after drawings by J. de Wit (water-colours in Lord Rendlesham's collection and the Plantin-Moretus Museum, Antwerp, and sanguines in the British Museum).

[2] Based on a picture in Lord Feversham's collection (Rooses, 862). The signature on later state of print merely claims the design for Rubens (*Pet. Paul. Rubenius invenit et excud.*). A contemporary signature with pen on Paris impression, and an old tradition, ascribe the engraving to Pontius.

[3] The original drawing for the etching (after an antique bust in the master's collection) is in the British Museum. I am not at all certain that the old attribution of the etching to Van Dyck has not much in its favour ; what more likely than that the pupil should try his hand in reproducing a drawing of this kind by his master ?

[4] *I.e.* if the dates given in our index are approximately correct. 1605-55 is given as the period of Vadder's life in certain dictionaries, but seems to have less authority.

description of the *Iconography*,[1] Van Dyck's influence seemed, like that of Rubens, entirely directed to the promotion of line-engraving, whether he would or not ; only, for that very collection of portraits, he etched some eighteen of the plates in a manner so fresh and personal, as to be entirely unappreciated by his contemporaries, and to find scarcely an imitator until the nineteenth century. Probably Van Dyck felt as keenly as we do now the greater significance of the pure etching to the elaboration of his engravers. But the public did not see it, and with all his artistic conscience Van Dyck was the artist for success, not struggle. So in the gradual development of his great scheme of a collection of contemporary portraits, the project of etching his plates was probably the earlier idea, which lack of appreciation inclined him to discard in favour of merely supplying the drawing to be reproduced by the line-engraver.

Five of the etchings (*Pieter Brueghel the younger, Erasmus, J. de Momper, J. Snellinx, J. Sustermans*) entirely escaped the engraver's hand, except for rework in the later editions. Six more (*Jan Brueghel, Frans Francken, A. van Noort, P. Pontius, Lucas Vorsterman, J. B. de Wael*) remained unelaborated except for an engraved background which was added for the edition of Gillis Hendricx (1645), if not before. Seven alone were elaborated throughout with the graver. To judge from the extreme rarity of the early etched states, three of these (*A. Cornelissen, Antoine Triest, J. Waverius*[2]) were almost certainly engraved earlier than the rest, and perhaps under Van Dyck's supervision.[3] The remaining four heads (*Van Dyck,*[4] *F. Snyders,*[4] *P. de Vos,*[5] and *W. de Vos*[5]) were not finished until the edition of Gillis Hendricx, the portrait of Van Dyck being used for the title.[6]

Van Dyck's settlement in London in 1632 and his position of court painter to Charles I. has made him seem almost a member of the English school, but the etchings were probably all, or nearly all, done in the six years immediately following his return from Italy to Antwerp in 1626,[7] so that their glory is entirely for Flanders.

[1] See Chap. IV. p. 128.

[2] Engraved respectively by Vorsterman, P. de Jode, and Pontius. These three plates were apparently not published in any of the regular editions of the *Iconography*.

[3] Note, however, a MS. date 1643 on an impression of the first state of the Waverius touched with the brush indicating the completion of the plate (coll. of Baron de Rothschild, Paris ; reproduced, H. W. Singer, *Etchings by Van Dyck*, London, 1905), which counsels caution. Each of the three engraved states had the address of M. van den Enden.

[4] Engraved by J. Neeffs.

[5] Engraved by S. a Bolswert.

[6] The portrait of *Philippe Baron Leroy* does not seem to have ever been issued as part of the *Iconography*. This with two other plates, the *Reed offered to Christ* (*Le Christ au Roseau*) and *Titian and his Daughter*, make the sum of Van Dyck's etching. It may be mentioned that the original plates of the greater part of the *Iconography* were acquired by the Chalcographie du Louvre in 1851, and some impressions have been taken from them since that time.

[7] After leaving Rubens's studio he had spent a few months in England (1621-22) in court employ ; the next three or four years were passed in Italy, chiefly in Genoa.

PETERVS BRVGEL PICTOR

PETRVS BREVGEL

Antonius van Dyck fecit Pictor Ruralium Actionum

FIG. 62.—Sir Anthony van Dyck. Portrait of Pieter Brueghel the younger.

Comparison of Van Dyck with Rembrandt.

His plates stand in marked contrast to most of Rembrandt's portrait work, where so much of the effect depends on close hatching. Van Dyck's choice of open line liberally aided in the modelling of the face with bold dotted work, but with never an attempt at more than suggesting what a painter would elaborate by surface tone and chiaroscuro, seems even more suited to the medium of etching than Rembrandt's subtly modelled figures. We say figures, because it may justly be advanced against the latter that sometimes the intensity of the portrait is lost in the side interest of the setting. Van Dyck carries the principles of suggestion and concentration to their furthest issues, and if the resulting portraits lack some of the complexness that counts for much of the real humanity in Rembrandt's work, they are at least unrivalled in their presentation of the central characteristic which constitutes the whole man in the eyes of the world. The chiaroscuro method presents such difficulties to the etcher and so many chances of failure in the biting, that little less than the astounding technical skill of a Rembrandt is needed to ensure its success. Even from this consideration alone it is by no means astonishing that the modern artist has for the most part preferred to follow in the path of Van Dyck.

HOLLAND.

Even less etching of value had been done in Holland during the sixteenth century than in Flanders, and the few who handled their plates with any freedom of touch (*e.g.* Vermeyen) had little else to recommend their work. It was well into the seventeenth century before the true etcher's style was at all widely realised and developed.

Esaias and Jan van de Velde.

Two of the more interesting names among Dutch etchers during the first quarter of the seventeenth century, ESAIAS and JAN VAN DE VELDE, represent in Holland the technical position held by Bosse in France. Their work is of a most varied description, ranging from Scripture and allegory to landscape and scenes of everyday life. Their figures are largely engraved, but their landscapes, more particularly when they serve as mere backgrounds to a subject, are often in etching stiff enough in treatment, but scarcely touched by the graver.

They were the first of the national school of landscape etching in Holland, finding few real followers in their manner of work, but taking a true lead in their appreciation of the virtue of their own country and its people for the inspiration of their art.

Adriaen van Stalbent.

Pieter Molyn I.

Landscape etching in a similar graver-like manner was being done in Flanders by ADRIAEN VAN STALBENT, while one of the few Dutchmen to work in the same style as the Van de Veldes was PIETER MOLYN the elder, of Haarlem. In the latter, in particular, is manifest the feeling for surfaces of white light, which is an anticipation of the spirit of Tiepolo.

More as an engraver[1] than etcher, Jan van de Velde stands Jan van de
as one of the chief interpreters of the art of Elsheimer. Count Velde and
HENDRIK GOUDT, an amateur of Utrecht, who worked for some Hendrik Goudt as interpreters
time in Rome, and engraved many of Elsheimer's compositions, of Elsheimer.
was probably Van de Velde's immediate inspiration, and in fact
one of the first of Dutchmen to broach the problem of chiaroscuro.

Many of the prints by the Van de Veldes, *e.g.* Jan's series of the
Elements of 1622 (Earth, Air, Fire, Water), reproduce designs by
WILLEM BUYTEWECH, who was, in his turn, another of the more Willem
interesting of Rembrandt's immediate predecessors in etching. Buytewech.
In spite of stiffness and formalism there is considerable spirit
in Buytewech's figure subjects, and a certain decorative element in
his little landscapes strikes a peculiarly modern note.

Another etcher closely contemporary with the Van de Veldes Hercules
and Buytewech, HERCULES SEGHERS (b. about 1590), is far more Seghers.
original in his treatment of landscape, and quite remarkable for the
freedom with which he handles the etched line, but he has not
entirely escaped the mannerisms which characterised the work of
Hans Bol and Paul Bril. Perhaps his tendency towards mountain-
ous foregrounds and the panoramic elements in landscape comes
from this source, but this factor deserved to survive, and formed a
great inspiration to much of the landscape painting in Rembrandt's
school, to Philips Koninck in particular. Rembrandt himself must
have appreciated Seghers's work, for, as we shall notice later, he
turned one of his plates to his own use, leaving the landscape almost
entire as a background for his new subject. With all its charm, his
style of etching is scratchy and lacking in concentration, short curving
strokes being given a somewhat unmeaning and monotonous pre-

[1] As an engraver, too, Jan van de Velde did numerous small portraits in careful
manner, which betrays the influence of Goltzius. In several of these (*e.g. J.
Torrentius*, and that of his father, *Jan van de Velde*, the writing-master) he makes
use of a kind of stipple for modelling the face. The portraits of *Cromwell* and
Christina of Sweden, signed *Velde sculp.*, which have also been attributed to him,
are more probably by a goldsmith and map engraver of the same name who was
working in Haarlem in 1642. The *Christina* is signed *Velde sculp. Stockholmiae*,
and judging from the Queen's age cannot have been engraved before 1650. The
Cromwell bears initials describing him as *P*(*rotector*) *R*(*ei-publicae*), so cannot date
earlier than 1653, the year in which he was given the title. The inscription
Rombout van den Hoeye exc., which appears on both portraits, is that of a printseller
who had a shop in Amsterdam in 1648. The dates seem to put the etcher, Jan van
de Velde, out of account, as he appears to have died soon after 1641. The
Queen Christina is executed chiefly in line and with the roulette, but shows on
the pillar and curtains a rough etched grain analogous to aquatint, as in the oval
border of Sherwin's *Catherine of Braganza*. It has been called a mezzotint, and
as we accept the term in denomination of Siegen's roulette manner, the classification
may be allowed. The basis of the *Cromwell* is also line-engraving ; while the face
is modelled with roulette work and by irregular dotting akin to stipple (as in the
prints of the goldsmith Jan Lutma II). But it is most remarkable for the pure
aquatint background, occurring as it does practically a century before the date usually
given for the introduction of the process. And considering the presence of analogous
bitten grains in the other plates mentioned, and the unity of execution throughout the
plate, there seems no reason to regard the aquatint as a later addition. The only pure
mezzotint bearing Jan van de Velde's name is that of *Dr. John Owen* (C.S. p. 1668),
but this only has his name as printer or publisher, *J. van de Velde exc.*

dominance. With such characteristics it is natural that he achieves the greater effect in smaller plates, such as the *Hilly Landscape with a winding Road* (reproduced, *Jahrbuch*, xxiv. p. 190). As a craftsman he holds a unique position in being one of the first, if not actually the first, to make experiments in the combination of colour with prints from a copper-plate. He never seems to have printed, however, with more than one colour from the plate. He obtained his other tints by hand colouring the paper or the canvas, which he often substituted, either before or after the impression.[1]

The work of the Dutch etchers we have just described falls largely into the decade preceding the beginning of Rembrandt's activity. Belonging to the same time one might mention a few other painters, like PIETER LASTMAN (Rembrandt's master), PIETER DE GREBBER, and LEONARD BRAMER, who have left just a few etchings, but their work in this field is almost negligible, and even then, to a certain degree, perhaps due to the influence of the younger master. Other etchers of landscape, animal subjects, and genre, such as ROGHMAN, PIETER VAN LAER, and SIMON DE VLIEGER, are again so little Rembrandt's senior that their work will best be treated later in conjunction with the younger artists of their own following and style.

If we except Van Dyck, whose etched work can only claim priority by one or two years, it must be confessed that Rembrandt received no great legacy in the conventions of etching, and the attempt to trace the origin of his remarkable comprehension of the varied capabilities of the medium amid the work of his predecessors finds little satisfaction.

Rembrandt.

In the whole history of art Rembrandt stands out as one of the solitary and unapproachable personalities who have struck their own style, and stamped their influence, for good or for bad, on posterity. In his etched work his unique position is realised to even greater advantage than in painting; for in the latter sphere Frans Hals, his senior by a few years, was not far behind in brilliance of brush and incisive delineation. But among contemporary etchers there was no one who combined the same mastery of medium with a tithe of his significance of expression. In fact, no worthy rival in this field can be found before the last century, and then in whom but Whistler? But in the range of his genius Rembrandt still stands alone. Let him handle the most momentous scene from Scripture, a landscape, a piece of genre, the slightest study of still life—all alike are illumined by a power which never fails to pierce to the heart of things.

REMBRANDT HARMENSZ VAN RIJN, born the 15th July 1606,[2] was the son of a well-to-do miller of Leyden, Harmen Gerritsz van Rijn.

[1] For the strict definition of colour-print and Seghers's position, see pp. 305-6.

[2] According to a contemporary authority, Orlers (*Beschrijvinge van Leiden*, 1641, p. 341), he was born on 15th July 1606; but an official entry in relation to his marriage in 1634 gives his age at the time as 26, which inclined his biographer, Vosmaer, to accept 1607 as more likely to be correct. An inscription in the artist's

His first master was Jacob van Swanenburgh, of his own town, under whom he is said to have worked some three years. Later (about 1623-24 ?) he studied under Lastman in Amsterdam, according to Orlers for the short space of six months,—a fact by no means

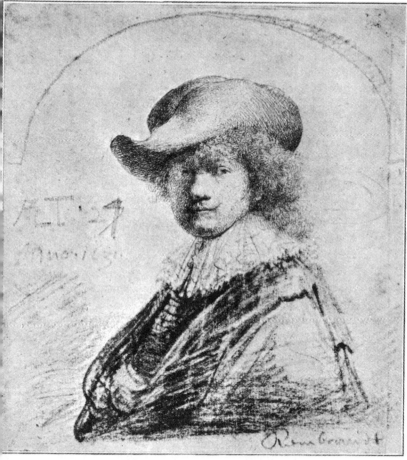

FIG. 63.—Rembrandt. Portrait of himself. Unfinished state, touched by the artist.

improbable in view of the striking independence of Rembrandt as an artist, and of the small trace of outside influences even in his earliest work. At what time Rembrandt actually started practice as a master in Leyden is uncertain, but he was already dating his pictures in 1627, and by 1628 Gerard Dou, who was destined to

own hand, *Aet.* 24 *Anno* 1631, on an impression in the British Museum of the *portrait of himself in a cocked hat* (B. 7, second unfinished state; Fig. 63) is, of course, consistent with either date. Houbraken gives 15th June 1606.

become famous, is known to have been his pupil. It is significant of Rembrandt's individual genius that, in an age when every young artist was supposed to visit Italy, a pupil of the classicist, Lastman, despised the conventional tour, convinced that the true realisation of his own and of his country's art lay in the limited outlook of the Dutch interior, and amid the quiet beauty of uneventful landscape. Throughout his whole work he made a scruple of being content with the types that lay to his hand. He never sought the external ideal of beauty through which the voice that touches humanity often loses its distinctness, appreciating a truth which has placed him at once among the perfect exponents of character and among the most powerful of religious artists, that physical realism is less a hindrance than an aid to the rendering of spiritual significance in art.

Rembrandt's etched work may be profitably considered in three periods, each of which possesses a predominant characteristic. In the first period (1628 - 1639), the pure etched line is the commonest medium, and there is a certain carefulness and even timidity in the draughtsmanship with which the younger artist is wont to belie exuberant passion. By 1640 work with the drypoint, which was beginning to be seen towards the end of the 'thirties, becomes a significant factor in his style, and its use in heightening the effect of light and shade is little by little more adequately realised. Attention to the tone of the whole composition, apart from the mere design, is characteristic of Rembrandt's developing power, though this end is still gained largely by means of close lines of shading. In the third period (from 1651 onwards) there is a remarkable increase in the vigour and breadth of the handling. The lines of shading are more open, the forms less conventional, and the touch truer, more spontaneous and less evidently conscious. Dry-point is now used as much as etching, and chiaroscuro, now of the first moment, though still rendered in some plates by closely hatched shading, is often achieved by a more summary method, which leaves much to the variations obtainable by means of a tint of ink left on the surface of the plate in the printing.

During the last thirty years Rembrandt's collected etchings have passed through the fire of the severest criticism, which has resulted in a far stricter definition between the authentic work of the master and that of pupils or assistants. One of our most distinguished amateurs and etchers, Sir Francis Seymour Haden, led the attack on tradition, and the attempt at a chronological arrangement,[1] which he practically promoted in the 1877 exhibition at the Burlington Fine Arts Club, has no doubt facilitated juster comparison.

Although Bartsch's list (which includes 375 plates) has tradition on its side, it must be remembered that the earliest catalogue, that

The first period.

The second period.

The third period.

[1] Initiated by Vosmaer (1868). The British Museum is still alone among the large collections of Rembrandt in its practical conversion to this principle.

of Gersaint, containing 341 "authentic" numbers, was compiled by
a dealer whose capabilities as an auctioneer meet peculiar praise in
the preface from the publishers Helle and Glomy, both of the same
profession, who themselves made considerable asterisked additions.
Houbraken's collection, which was Gersaint's basis, had all the
authority of direct descent from Rembrandt's friend, Jan Six, but it
is only natural that it should include much unsigned work done
in the master's studio, a certain temptation to the not unbiased
iconographical pioneer.

The catalogues and the question of authenticity.

Middleton, with his 329 plates,[1] is possibly still too generous,
while Legros, the leader of the extreme left in the destructive ranks,
who has left us a paltry 71, seems in his reliance on a personal
feeling for technical excellence to have thrown aside the whole
weight of history.[2] On the principle of admitting all plates which
show any trace of original etching by the master (*i.e.* including those
in which the original work is disfigured by superadded etching, and
those in which the secondary parts are by assistants), we are inclined
to accept some 293 plates, *i.e.* about thirty more than Seidlitz allows
as authentic.

The etchings, whose authenticity has been most debated, are
the rough studies (largely beggar-men and women, and portraits)
executed in or about 1631. The signature on certain of these,
℟ in stiff letters, is quite unlike the lightly written ⒭,[3] which
Rembrandt uses in this early period ; but in spite of this difficulty
which can only be explained in certain instances as the addition of
a later or pupil's hand who reworked and disfigured a plate lightly
etched by the master, I still incline to a somewhat conservative view.

Though executed in an unusually broad and coarse manner (*e.g.*
the *Lazarus Klap*, B. 171), certain of them, such as the *Tobit*
(B. 153), have the real spirit of Rembrandt's best work, and with all
the coarseness of its line, the *Two Beggars Tramping* (B. 154) dis-
plays a sense of motion and a swing quite beyond any of the possible
collaborators of the master. The consideration that one of the
Five Studies of Men's Heads on one plate (B. 366) could not have
escaped rejection, were not the others so characteristically Rem-
brandt's, will help to check the over-confident critic. Rightly esti-
mated, certain of them may be mere trials in technical methods,
which by no means imply a retrogression on the delicate workman-
ship of the earliest dated etchings. The large *portrait of himself*

[1] Dutuit and Rovinski take, roughly, about the same position.

[2] See Gonse, *Gazette des Beaux Arts*, 2e pér. xxxii. 508. For a slightly less
extreme view, which stands in principle for Legros' attitude, admitting about twice
the number, see H. W. Singer, *R.'s Radierungen*, Stuttgart, 1906.

[3] Probably R(embrandt) H(armensz) L(eidensis). After 1632 the use of the mono-
gram is discarded in favour of the signature *Rembran(d)t* (*van Rijn* being added on two
plates, the large *Raising of Lazarus* of about 1631-32, and the *Joseph's Coat brought to
Jacob* of about 1633). The date on the portrait of a *Man in a wide-brimmed Hat
and Ruff* (B. 311), which bears the monogram, has been read by Seidlitz as 1638,
but the old reading of 1630 is probably correct.

(B. 338), the earlier *Peter and John at the Gate of the Temple* (B. 95), and at least one of the *Small Lion Hunts* (B. 116) may reasonably be put in the same category.

The earliest dated etchings to which allusion has just been made are the two small *portraits of his mother* (dated 1628), with which his career as an etcher most aptly opens. The presence of an already accomplished, if timid, technique need not be cause for wonder, for few self-respecting artists would not destroy their merely juvenile efforts. Possibly, however, some of the rough studies which are generally classed as belonging to about 1631, and one youthful *portrait of himself* (B. 27), may precede 1628 though solid evidence is wanting.

Correspond-
ence of certain
of Rembrandt's
etchings with
his pictures.
One of the etchings of his mother of 1628 (the head full-face, B. 352) is very nearly akin to a picture in Mr. Sanderson's collection (Bode 21). If not actually a matter of artistic principle, it is the rarest thing for the true artist to finish a work in more than one medium.[1] It is only fair, however, to note the few cases which at least seem to form notable exceptions. The etching of *Rembrandt's "father" in full face* (B. 304) is in the closest connexion with a picture in Dr. Bredius's coll., the Hague, though of course each may be taken independently from a sketch done at the same sitting. Then the *Diana Bathing* (B. 201) corresponds almost exactly with a picture in M. Warneck's coll., Paris (Bode 47); and the latest of the etched portraits, the *Large Coppenol* (B. 283), is identical, even in size, with a painting in Lord Ashburton's coll. (Bode 456), and it is in the reverse direction, a fact which favours the theory that the picture was the basis for the etching. Two others, the large *Descent from the Cross* of 1633 (B. 81) and the *Good Samaritan* of the same year (B. 90), are also nearly allied and in reverse to paintings in Munich and in the Wallace collection respectively. The two last-named subjects, however, do not need the same excuse that the others demanded, partly because of the further question involved as to how far they are the work of pupils or assistants.

The question of
the collabora-
tion of pupils
or assistants.
Much of the work in the *Good Samaritan* seems too feeble for the master; his expressive touch could hardly have perpetrated the meaningless head at the window. That the chief variation from the picture, *i.e.* the addition of the dog in the foreground, is not in good taste seems to me little argument. There is nothing more characteristic of Rembrandt than the introduction of animals, dogs in particular, in grotesque attitudes in the foreground of some of his most serious scriptural plates, and our English sense of decorum may wrongly bias our judgment. Of the large *Descent from the Cross* there exist two plates: one, of which only three impressions

[1] Cf. Chap. I. (*re* Mantegna), p. 57. The practice of a good modern etcher like Sir Charles Holroyd, who often uses the same composition for both painting and etching, inclines one to take the more practical view. Except where inspiration means almost boundless power of creation and invention, as in the case of Rembrandt, the principle of economy cannot be forgotten.

are known (Amsterdam, Brit. Mus., Paris), so completely fouled in
the biting as to be almost beyond criticism ; the second,[1] though
sound and strong in its technique, betraying, at least in much of
the minor work, a lesser hand than the master's.

Two other large etchings have generally been regarded by recent
criticism as studio productions, the large *Raising of Lazarus* of
about 1631-32 (B. 73), and the *Christ before Pilate* (B. 77), for
which a grisaille in the National Gallery is the original study. The
former plate displays great breadth and freedom of execution, and
apart from the coarse shading and rework in the later states, the
master may well be responsible for the whole. In the early state of
the *Christ before Pilate* (dated 1635, only in Amsterdam and the
Brit. Museum), the central group round Christ is curiously left
white, and it is just this part, added later (the date being changed
to 1636), which is the best work on the plate. No artist would be
likely to proceed in the above manner [2] if the whole of the work
were his own. The most reasonable explanation is that he placed
the design and the plate in some assistant's hands, and then added
the most important figures and harmonised the whole himself. But
who were the assistants or pupils who helped him in the cases we
have mentioned ? Houbraken has left us a vivid picture of Rem-
brandt's "warehouse" full of students in the early days at Amsterdam,
but fails to shed any light on the problem at issue. Bol has been
suggested for the *Good Samaritan*, but against this attribution has
been recently urged,[3] that as his earliest signed and dated etchings
belong to the year 1642, he could not have entered Rembrandt's
studio much before 1640, an inference which is not perfectly con-
vincing. A different hand, with a sturdier but far less sympathetic
and yielding touch, is to be remarked both in the second version
of the *Descent from the Cross* and in the *Christ before Pilate*. Even
if we were rash enough to disregard the traditional account [4] that
Lievens was in England about 1630-34 (and he was already settled
in Antwerp by 1635), there is nothing in the picturesque waviness
of his line-work which would suggest his participation, while in
Van Vliet's signed engravings after Rembrandt's early pictures
(mostly dating between 1631 and 1635) there is just the hard manner
seen in these two studio plates. Vliet was quite probably a pupil
of Rembrandt in Leyden, and possibly an assistant to the master,

[1] The only plate in his work which bears the address of a contemporary print-
seller (Hendrik van Ulenberg, a relative of Rembrandt's wife, an art dealer with
whom the master had dealings before leaving Leyden, and with whom he seems to
have lived on his first arrival in Amsterdam).

[2] Cf. Dürer, Chap. II. p. 73, note 2, remembering that the conventions of the
line-engraver and the etcher are on different planes. But Mr. G. S. Layard rightly
refers me to Meryon's *Stryge* as a corrective. I would add here (1922) that my
opinion tends to conservatism in relation to the *Good Samaritan*, and the large
Descent from the Cross, and *Christ before Pilate*, and I am ready to believe that
Rembrandt was entirely responsible for their etching.

[3] Roever and de Vries, Catalogue of the Picture Gallery, Utrecht.

[4] Given by Houbraken and Walpole. Haden questioned the tradition on the
grounds of the strange lack of work known to have been done in England.

engaged perhaps chiefly in engraving, during the early Amsterdam period,[1] when Rembrandt's success was the greatest reason for reproduction, and the best excuse for the dangerous policy of entrusting a growing reputation to the hands of assistants.

Portraits.

The artist's etchings of himself are very numerous in the years 1630-31. He poses in the most manifold garbs, and in all manner of expressions. Oriental costume and accoutrements always had a fascination for him. One of the finest examples of Rembrandt in such fancy attire is the etching of 1634 (B. 23),[2] where we find him standing in plumed hat, sabre in hand, represented with certain variations from his actual countenance, which mark it as a study rather than a portrait.

Beside the portraits of his mother and himself, there are five heads of 1630 and 1631 (B. 292, 294, 304, 321, 263), as well as a slighter sketch on a sheet of studies (B. 374), which, according to Michel's identification with his father, Harmen Gerritsz van Rijn,[3] reflects his leisure in these early years in the home circle at Leyden. The identification fails, however, to carry absolute conviction, and we incline to regard the sitter as a mere studio model.[4]

Of the happiness of his work in these early years we have proof in the studies of his first wife, Saskia. A small head nearly in profile (B. 347), dated 1634, the year of his marriage, is one of the most charming, exquisitely executed in pure etching. In 1636 and 1637 there are several slighter sketches, and it is possibly Saskia who is taken as the model for the two studies called the *Great* and *Little Jewish Brides* (B. 340, 342), the latter being strictly a *St. Catherine*. Soon, alas! the beginnings of Rembrandt's troubles are heralded by a sketch of *Saskia ill in Bed* (B. 369). The artist's foreboding depicted in the study dated 1639, *Death appearing to a Wedded Couple* (B. 109), was too truly realised. One of the most touching of all his portrait studies, the small *Head of a Sick Woman* (B. 359), is no doubt that of Saskia during her last illness in 1642.

Apart from the studies of himself and of his family, Rembrandt did few portraits in etching in this early period, a contrast to their abundance in his work in oils. The portrait of Saskia's kinsman and guardian, *Jan Sylvius* of 1634 (B. 266), is the earliest, and certainly the least powerful. Comparison with the posthumous portrait of the same sitter (B. 280) will show the advance Rembrandt had made by 1646, how much greater the sympathy and expression he now commands in the delineation of character. The whole figure is alive with the nervous intensity of the preacher. Three of his very finest portraits were executed about the same time as the second portrait of Sylvius, *Ephraim Bonus* (B. 278), *Jan Asselyn* (B. 277) and *Jan Six* (B. 285). In each of these the power of dry-

[1] Cf., however, p. 184, footnote.
[2] First state, three-quarter length, rare: later cut down to a bust in oval.
[3] He died April 27, 1630.
[4] For further criticism, see A. M. Hind, *Burlington Magazine*, March 1906.

point and etching to express the subtlest gradations of tone is realised to the full. Rembrandt, perhaps, never surpassed these master-pieces in the balanced power they exhibit. In the *Clement de Jonghe* of 1651 (B. 272) he essayed a much more open style in pure etch-ing, possibly suggested by Van Dyck's manner; but it is an ex-ception, and henceforward he keeps consistently to the chiaroscuro treatment and the net-work of close line. The *Jan Antonides van der Linden* (B. 264),[1] of 1665, and the *Jacob Haaring* (B. 274, about 1655 ?), warden of the debtors' prison at Amsterdam (a pathetic token of Rembrandt's happy intercourse in the midst of his diffi-culties), have all the balance of the best work of the middle period, while an even added expressiveness and vigour is seen in the *Arnold Tholinx* (B. 284, Fig. 64), the brilliance of the burr in the ex-tremely rare early impressions enforcing a wonderful significance.

Analogous development may be traced in all the multifarious subjects that Rembrandt handles. Apart from the exceptionally broad studies of 1631, his early etchings of genre are executed with an exquisitely delicate needle. The *Blind Fiddler* (B. 138, see Fig. 65) is a charming example: the dog bristles with life, and is less grotesquely curled than usual with Rembrandt. It is a style which culminates in such work as the *Quacksalver* of 1635 (B. 129), while even before that date a bolder manner is appearing, *e.g.* in the *Rat-Killer* of 1632 (B. 121). Subject : genre and scriptural.

Leaving out of account the large studio-plates, his early scriptural subjects show just the same characteristic delicacy of execution. Comparison of the *Christ disputing with the Doctors* of 1630 (B. 66) with his etchings of the same subject of 1652 and 1654 (B. 65 and 64) will serve to emphasise the particular properties of both, periods. In the middle of the 'thirties we see a tendency to greater breadth, through the scriptural series of 1634-35, with their reflection of types used by Rubens, to the large manner of the *Death of the Virgin* of 1639 (B. 99), a work in which dry-point is beginning to be used with effect. At the outset of the second period Rembrandt returned to plates of more modest compass; but how much power is gained by economy and concentration of line may be remarked in the small *Raising of Lazarus* of 1642 (B. 72), one of his most perfect compositions. The slightly later *Entombment* (B. 84) discloses a growing freedom of design, and the intimate force of the artist's sympathy touches here the calmer depths of grief, which appeal to the Northerner so much more truly than the harrowing and theatrical distress of so many Italian entombments.

Meanwhile tone is becoming a factor of increasing import. But in the subject etchings of the middle period (as in his portraits up till the last), it is still achieved by the use of closely hatched lines of shading. The method is well exemplified in the shaded

[1] Now recognised as based on a picture by A. van den Tempel and intended as a frontispiece to Van der Linden's Works, though apparently never published as such. It is the only instance of Rembrandt reproducing another painter's work in his etching.

portions of the unfinished plate of *Rembrandt drawing from a
Model*[1] (B. 192), though these very portions of this interesting
etching may be a pupil's addition to the master's preliminary sketch.
The treatment is still essentially the same in the culminating work

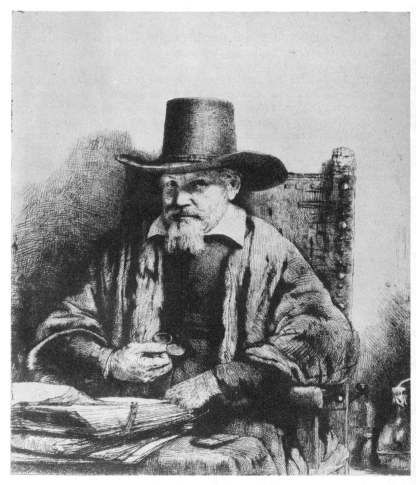

FIG. 64.—Rembrandt. Portrait of Arnold Tholinx.

of the period, if not the crown of his maturest activity, the
Christ with the Sick around Him, receiving little Children (B. 74).[2]

[1] The original drawing for this plate is in the British Museum.
[2] Commonly known as "The Hundred Guilder Print," already its recognised
title early in the eighteenth century, apparently originating in the price it once
realised in an auction (see C. H. de Groot, *Urkunden*, No. 390).

Criticism is almost impertinent in the face of a masterpiece that must make a lasting impression on all who know it. Suffice it to say that it embodies the whole range of Rembrandt's human sympathy, his appreciation of the manifold phases of human character and emotion, from the mother with the child that first elicits the divine help, to the group of curious onlookers lolling and chatting on the left. Of the first state of the plate, before certain cross lines on the ass's neck, only nine impressions are known, and the price, some £1750, which was recently paid for an impression is scarcely an exaggeration of its comparative artistic value. Late in the eight-
eenth century an English amateur, Captain Baillie, acquired the plate and restored it from a debili-tated condition to a degree of likeness to its early state that is no little testimony to his deftness.[1] From the standpoint of etching as an art, it must be confessed that the tendency which has here its embodied ideal has found fewer followers than the phase into which Rembrandt was about to enter. No small praise for the bulk of modern etching is implied in the expression of our belief, that in this latter develop-ment Rembrandt was real-ising more truly than ever the capabilities and limita-tions of the etcher's art. A

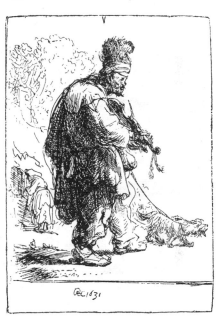

FIG. 65.—Rembrandt. The Blind Fiddler.

few significant lines may often express what would be sacrificed by more. This bolder style is seen in its purest form in the *Christ appearing to his Disciples* of 1650 (B. 89), and with the warmer effect added by dry-point, in the *Christ between his Parents, return-ing from the Temple* of 1654 (B. 60, Fig. 66), where every element of the scene, from the leaping dog to the cattle watering at the stream, lends a vividness to the whole. But it is seldom in this period that the pure line is left to accomplish its own effect, being

[1] Impressions from this resurrected state of the plate are not uncommon. The plate was afterwards divided, and prints taken from the different pieces. One of the best copies of the original work is that of Thomas Worlidge (signed T. W. in the right lower corner).

generally wrapt in a mysterious covering of chiaroscuro, which changes with each impression. Rembrandt has come to realise the wonderful quality and liquid purity of the surface tones which can be gained by leaving ink on the surface of the plate. The method is attended by much uncertainty, and in so far is less satisfactory as an element in etching or engraving; but the variety of effect open to the etcher, who so to speak paints his plate, offers an undeniable fascination to the artist who prints his own plates.

The most magnificent example of these "chiaroscuro" plates is the *Large Crucifixion* ("The Three Crosses") dated 1653 (B. 78), where the introduction of an equestrian figure from a Pisanello medal, one of the most startling changes ever made in the progress

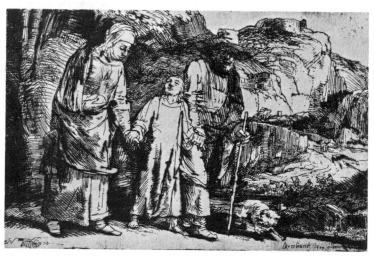

FIG. 66.—Rembrandt. Christ between his Parents, returning from the Temple.

of various states, is a characteristic example of Rembrandt's receptivity and readiness in adapting an alien idea to his own personal expression.[1] Similar to it in execution, apart from the tinting, is its nearly contemporary companion, the *Christ presented to the People* of 1655 (B. 76). The enormous differences of effect to be gained by the mere printing can be seen most pertinently in

[1] For other examples of his power of adaptation note : *Christ driving the Money-Changers from the Temple* (B. 69), figure of Christ from a Dürer cut (B. 23); *The Lion-Hunts* (B. 114-116), suggested by Rubens; the *Oriental Heads* (B. 286-289), after Lievens; *St. Jerome reading* (B. 104), the landscape after Titian or Campagnola; *Virgin and Child with the Cat* (B. 63), adapted from Mantegna's *Virgin and Child*, see Fig. 23; *Abraham entertaining the Angels* (B. 29), based on one of the drawings from Mohammedan-Indian miniatures, which is now in the British Museum; and, finally, the very appropriation of a plate by Seghers (see p. 182).

the various impressions that exist of the *Descent from the Cross by Torchlight* of 1654 (B. 83), and the *Entombment* (B. 86). The rude treatment of form exhibited in these works, embodying a certain primeval simplicity and largeness of emotion, is one of the phases of Rembrandt's style which has most appealed to the modern artist, above all to that school of etching of which Legros has been the leading spirit. This tendency to the grotesque in form contrasts strongly with the assumption that the nude is the best vehicle for the expression of human emotion in art, an assumption to which Rembrandt showed little leaning. Nevertheless, from first to last, he was a consistent, if a somewhat dispassionate, student of the nude : witness in his etchings the true but unpleasing studies of 1631, three other plates of the middle of the 'forties, etched in strong pure line, and, finally, some of his latest prints, and the very last etching that he dated (the *Woman with the Arrow* of 1661, B. 202). One of these, from a far more pleasing model than he had used in the early studies, is reproduced (Fig. 67) ; it discloses his mastery in a sphere he did not affect.

Rembrandt's landscape work, which was almost entirely pro- Landscape. duced during the twelve or thirteen years subsequent to 1640, is by no means numerous, but is in some respects his most fertile artistic legacy. There is some contrast here to the progress of his other work, most of the earlier landscape etchings (1640-45), from the oblong *Cottage and Hay-Barn* (B. 225) and the *Windmill* (233) of 1641 to the *Omval* (B. 209) of 1645, and that master-sketch of *Six's Bridge* (B. 208) being handled in bold open lines with little shading. The *Three Trees* of 1643 (B. 212) is one of the rare examples in which Rembrandt attempted a positive rendering of cloud and atmosphere, a problem in which some modern etchers have been more successful, and it stands apart from his other landscape plates in its fulness of detail and pictorial character. The by-play of the lovers amid the bushes (which also occurs in the *Omval*) is a characteristic touch, and in no sense an indication, as has been suggested, of earlier work on the plate. Rembrandt's keen eye for the living things about him, and his delight in the grotesque, is happily exemplified in the *Hay-Barn and Flock of Sheep* of 1650 (B. 224, Fig. 68), where early impressions full of burr show up a horse kicking on its back in the field. About the same date come a considerable number of other landscape plates, such as the *Canal with an Angler and Two Swans* (B. 235), and the *Canal with a large Boat and Bridge* (B. 236). They are mostly smaller and of closer workmanship than the earlier groups, but have an added richness in the burr from dry-point. The most perfect example of a similar method, somewhat bolder in touch, is the landscape of 1651 that goes by the name of the *Gold-Weigher's Field* (B. 234) (*i.e.* the country seat of the Receiver-general Uytenbogaert, whose portrait Rembrandt

etched in 1639). Of course the traditional identification of this locality, as of several of the other landscapes, is not beyond question. Within two or three years from this date Rembrandt has ceased to do landscape as an end in itself, a fact that no

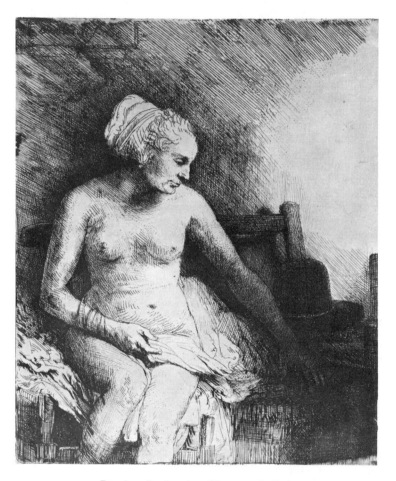

FIG. 67.—Rembrandt. Woman at the Bath.

doubt speaks of his retired life in Amsterdam in these latter years. His latest and broadest manner may be exemplified in the large *Flight into Egypt* of about 1653 (B. 56). The plate has a curious history, having been originally etched by Hercules Seghers with figures representing Tobias and the Angel. In most of the landscape the unique manner of Seghers with the multifarious small

curving lines is still unaltered, but the additions in the clump of
trees to the right are in Rembrandt's strongest style.

Before leaving Rembrandt we would take the opportunity of Quality of
emphasising the differences of value which depend on the quality impression.
or date of an impression. A genuine print from an original plate
may be artistically and marketably worthless, when a good early
impression may be realising its tens of pounds, and a rare early
state its hundreds. A considerable number of the original copper-
plates are still in existence, and in unscrupulous hands are both
a reproach to the master and a danger to the less critical public.
Impressions from a series of eighty-five of the plates—in many
cases much reworked—were published about 1785 by the Paris
engraver and dealer P. F. Basan, and near the middle of the last
century in still worse dilapidation by Michel Bernard. Seventy-nine

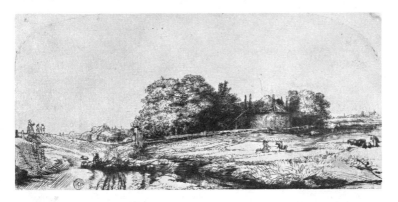

FIG. 68.—Rembrandt. Landscape with a Hay-Barn and Flock of Sheep.

plates of this series recently came to light again in Paris in the old
stock of Bernard's successor. A portfolio of impressions was
issued in 1906 by Alvin-Beaumont and Bernard, but except for
a few of the etchings in open line, which are more amenable to
rework, the result was heartrending. A clear appreciation of
quality must always be one of the aims of the student, but unless
he have facility for constant comparison of impressions, he will
find that certainty of judgment is a slow and sometimes an
expensive acquisition.

Among the etchers who came under Rembrandt's immediate Etchers of
influence, Van Vliet, Lievens, and Bol may be specially noticed, the school of
forming, so to speak, the inner circle of his school. Rembrandt.

J. G. VAN VLIET, though an artist of little merit, is the J. G. van Vliet
closest follower of the master's early manner. Whether he was
a pupil of Rembrandt in Leyden, and, as has been suggested
above, an assistant to the master during the early Amsterdam

period, are matters of mere conjecture, but neither are improbable.[1]
His series of beggars and peasants of 1632 and 1635 are coarse
productions, but they are the nearest assimilation of Rembrandt's
early work possible to this rude imitator. Between 1631 and 1634
Vliet engraved a considerable number of Rembrandt's pictures,
certain of these plates (*e.g. Lot and his Daughters*, B. 1) being of

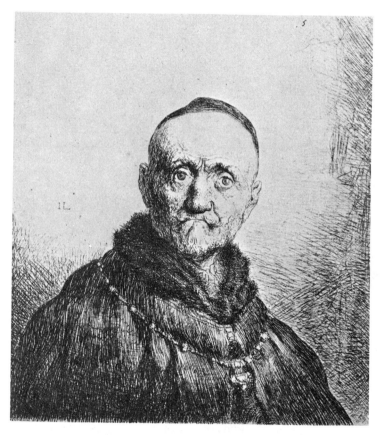

FIG. 69.—Jan Lievens. Portrait Study.

value as the only surviving trace of certain lost works of the master.

Jan Lievens. JAN LIEVENS, who was probably never a pupil, must have come
into contact with Rembrandt before 1631 in Leyden, even if they
did not meet as fellow-students under Lastman in Amsterdam.

[1] For arguments against the latter possibility *see* de Groot, *Repertorium*, xix.
382. The two towns are so closely connected that there is little reason why
Vliet, even if he lived for the most part in Leyden, should not have been in
constant connexion with Rembrandt in Amsterdam.

From 1631 tradition places him for a few years in England—his portrait of *James Gaultier*, a musician at the Court of Charles I., being perhaps an indication of the visit,—and it was here that he seems to have first come under Van Dyck's influence.

In 1635 he settled in Antwerp, and developed a completely Flemish style. A few large portraits which belong to this period,

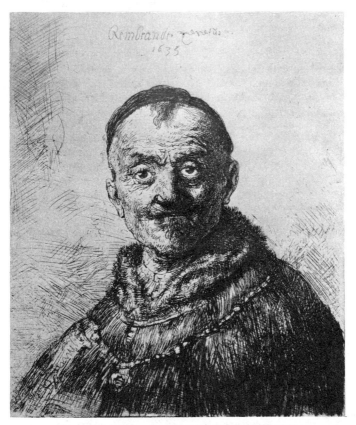

FIG. 70.—Rembrandt. The first "Oriental Head."

e.g. those of the poet *Vondel* and of *Daniel Heinsius*, are excellent works on the Van Dyck model, though with somewhat greater elaboration. They were published by Van den Enden, and are sometimes found inserted in later editions of the *Iconography*. Excluding the portraits, to which he must have devoted more care, the plates of his Flemish period disclose a distinct decline in artistic power, and are too often characterised by clumsy drawing and negligent craftsmanship.

The most interesting and problematical point of Lievens's connexion with Rembrandt is seen in his four portrait studies (B. 21,[1] 20, 18, 26), which correspond in reverse to " Rembrandt's " four *Oriental Heads* of 1635 (B. 286-289). The method of treating the background in both series (especially in the first head, reproduced in Fig. 69) with meaningless wriggling scrawls, is so distinct a characteristic of Lievens that the most reasonable solution seems to be that the " Rembrandt " etchings are school copies of Lievens's plates, retouched by the master's hand, as the inscription *Rembrandt geretuckeert* seems to imply. Only in one case (B. 289) does the conjectured copy surpass the original, and even here the *R* may not be more than a mere studio signature, though it must be confessed that the work is worthy of Rembrandt. In early work, such as the *Raising of Lazarus*, Lievens exhibits a true feeling for Rembrandt's ideals, and considerable technical accomplishment.

Ferdinand Bol. The earliest signed etchings of FERDINAND BOL, who was born at Dordrecht in 1616, are dated 1642, and it is natural to suppose that he had not been Rembrandt's pupil many years previously. The manner he at first adopts is closely formed on Rembrandt's style of the middle of the 'thirties, *e.g.* the *Bust of an Old Man* of 1642 (B. 9) is comparable to Rembrandt's *study of himself with raised sabre* of 1634 (B. 18), while Bol's *Hour of Death* (B. " Rembrandt," 108) has just the same light, sinuous touch as the master's *Death appearing to a Wedded Couple* of 1639, and for his *Sacrifice of Gideon* (B. 2) Bol directly borrows from the figure of the kneeling Tobias in Rembrandt's etching of 1641. Moreover, Bol's assisting hand has with reason been suspected in work of the late 'thirties, such as the portrait of *Uytenbogaert, the Gold-Weigher*, of 1639. Some of Bol's portrait etchings about 1640-55, *e.g.* a *Philosopher meditating*[2] of 1653 (Fig. 71), display a delicate touch and charm of manner,—praise which cannot be meted to much of his later work in oils.

Carel de Moor. Before leaving the school of Rembrandt, we would just refer to a considerably later etcher, CAREL DE MOOR, of Leyden (1656-1738), a pupil of Dou, whose few etched portraits possess a real distinction of manner. Technically, they stand midway between the work of Rembrandt and that of Lievens and Van Dyck. The portrait of *Jan van Goyen* (after Ter Borch) is a good example of his happy combination of delicate etched line with dot and roulette work.

The etchers of genre. In Rembrandt the eye for the real things of life had been tinged with idealism. His constant aim was to make the scenes of Scripture, which touch the whole gamut of human emotion at

[1] After a Rembrandt picture in M. Wasserman's coll., Paris, which Bode (No. 25) calls *R.'s Father*, and dates about 1630.

[2] Etched in reverse after a picture of 1652 in the National Gallery (No. 679).

its deepest, live again in the light of his own experience, setting
them in the surroundings of his own day. The perfect mingling
of these two elements places him among the artists who may be
said to belong to no country, but to the world. The one side of

FIG. 71.—Ferdinand Bol. Philosopher meditating.

his art which is more essentially Dutch than any other, down-
right realism and unaffected truth to nature, is followed up
almost without a single side issue in the school of genre, with
Ostade at its head, which gives us with unfaltering touch a full
picture of the coarse and lusty peasant life in Holland during the

seventeenth century. The other half of the picture—life among the richer classes, which is reflected in the canvases of Ter Borch and Pieter de Hoogh—finds scarcely a representative in etching.

Ostade.

ADRIAEN VAN OSTADE, of Haarlem, was far more a painter than an etcher, but the plates which he has left all show a true appreciation of the character of his medium. It is probable that, like many painters, he set too low a value on his etchings, not troubling to put them much into commerce during his lifetime.[1] This view would at least account for the rarity of early impressions, and it is only in these that their true virtue can be seen, as nearly all the plates have been many times heavily reworked.

His etchings bear dates covering the years 1647-71,[2] but the earliest of these dates shows him already at his strongest. Probably some of the small studies of heads and single figures of peasants and the like may go back several years earlier. The very best of these single figures, the *Man with the Hurdy-Gurdy* (Dutuit 8), is dated 1647. In this, and in most of what we would consider his early work, Ostade bases his style on the delicate manner of Rembrandt's earliest period. Like Rembrandt, he must have felt Callot's influence in his treatment of single figures, though neither master imitated the Frenchman's manner of line.[3]

Ostade seems as much at home in representing scenes in the open street as in his subtly lighted interiors. The *Barn* of 1647 (D. 23) and the *Anglers on a Bridge* (D. 26) are almost the only plates in which the interest does not centre in the figures ; and in the latter he shows a mastery of landscape, an appreciation of distance and light, as true as anything in Ruysdael.

Of his street scenes we may specially mention the *Fiddler and the Boy with a Hurdy-Gurdy* (D. 45) and the *Fête under a Large Tree* (D. 48), where he combines his groups of peasants chatting, drinking, and dancing, before the inn and in the distance, with wonderful skill. On the whole his strongest work is seen in his interiors and smaller family groups. A charming example of the latter class is the *Doll* (D. 16), while he never did stronger line-work than the *Paterfamilias* of 1648 (D. 33), the *Schoolmaster* (D. 17) and *Saying Grace* of 1653 (D. 34, Fig. 72). The last mentioned is characteristic of his manner of strengthening his etched outlines with rather coarse dry-point work.

Two of Ostade's pupils, BEGA and DUSART, followed their master in etching, but neither shared much of his strength either of draughtsmanship or characterisation.

Bega.

CORNELIS BEGA is distinctly the stronger of the two as an

[1] One or two, probably the more popular plates (*e.g. Ostade in his Studio*), are signed in the later reworked states, *A. v. Ostade fecit et excudit.*

[2] The *Doll* (Dutuit 16) may be later in the 'seventies ; the last figure is illegible.

[3] A much closer imitator of Callot's lineal manner in this school of genre is PIETER JANSZ QUAST of Amsterdam.

etcher, but Ostade's vigorous line is changed for a delicate manner of etching which scarcely fits the coarseness of his subjects. He inclines towards square-cut, angular figures, whose peculiarity is emphasised by the clear definition of his light and shade. Nevertheless, a plate like the *Company in a Tavern* (D. 35) shows that

FIG. 72.—Adriaen van Ostade. Saying Grace.

his understanding of chiaroscuro in etching was such as would not put even Goya to shame.

CORNELIS DUSART is hardly so sound a draughtsman as Bega, Dusart. and his deficiencies are more evident in the delicate line of his etchings than in his numerous mezzotints.

In genre painting Ostade had a brilliant but short-lived rival in Brouwer.

ADRIAEN BROUWER of Antwerp (1605-38). It is probable, however, that the few plates which bear his name are not original works, but etched by others after his compositions. In any case, they have little of the vigour or spirit one would expect from the painter.

Teniers the younger.

The same may be said of a large number of the plates with the name or monogram of DAVID TENIERS the younger.[1] There is no reason to doubt the one plate signed *D. Teniers fec.*, *i.e.* the *Festival* (D. 1), where the coarseness, so often remarked, is largely the fault of later rework, without which they are so seldom seen. On the other hand, many of the plates signed *D. Teniers in. et excud.*, or with the monogram alone (a T within a D), are unquestionably etchings by other hands after his work. Some of them, indeed, have other signatures besides the above, clearly indicating another engraver (*e.g. I. L. Krafft F* and an unknown IS[2] occur).

Landscape.

We may return now to the school of landscape, which includes so large a portion of the best work done by Dutchmen, both in Holland and in Italy during the seventeenth century.

Jan van Goyen.

Midway between the sterner manner of the Van de Veldes and of Molyn and the errant line of Ruysdael stand JAN VAN GOYEN[3] with the five or six landscape etchings which bear his name,

Herman Saftleven. Allart van Everdingen.

HERMAN SAFTLEVEN, the draughtsman of the Rhine country, and ALLART VAN EVERDINGEN of Alkmaar. The etchings of Everdingen, chiefly of Norwegian scenery, are among the most charming productions of the time. There is a purity in the line, an economy and significance in the drawing and anatomy of trees and foliage, and a feeling for tonic values, which is a rare combination at this period. A considerable number of his plates (more especially the illustrations to *Reineke Vos*) have received a kind of mezzotint grain on later states, probably added by Everdingen himself. It is an irregular grain which seems to be achieved in places by roughening the surface by something in the nature of a rat-tail file,[4] while in other cases the tone may be due to mere surface etching. Two or three plates—*e.g.* the *Three Monks* (B. 105), a really excellent print—may strictly be regarded as mezzotint.[5]

Roeland Roghman.

Working in a manner less precise than the three preceding etchers, ROELAND ROGHMAN of Amsterdam is a noteworthy forerunner of Ruysdael. Apart from his landscapes, his series of plates illustrating the mail service between Holland and the East Indies

[1] A valuable work of Teniers in connexion with engraving is the *Theatre des Peintures de D.T. . . . auquel sont representés les desseins tracés de sa main et gravés en cuivre par ses soins, sur les originaux Italiens que le ser^me Archiduc a assemblé en son Cabinet de la Cour de Bruxelles.* Brussels, 1660, fol. The engravings were mostly done by J. Troyen, L. Vorsterman II., Van Hoy, Coryn Boel, and T. v. Kessel. The pictures are now for the most part in the Imperial Gallery, Vienna.

[2] D. 33-36.

[3] For some time a pupil of Esaias van de Velde.

[4] Others have suggested that the roulette was used. [5] *Cf.* Chap. IX. p. 267.

has a certain historical interest. His line-work, especially in the drawing of foliage, is sometimes coarsely interspersed with heavy dots ; nevertheless he shows a finer feeling for nature than a more immediate predecessor of Ruysdael, *i.e.* ANTHONIE Anthonie WATERLOO, who was held in such high esteem a century ago. Waterloo.

Though JACOB VAN RUYSDAEL was some twenty years and more Jacob van junior to both Waterloo and Roghman, his influence, at least on Ruysdael. the latter, may have been even greater than the debt he owed to them. He evolved a far finer sense of the delicacy of foliage and the structure of trees, revelling in the dwarfed and knotted oaks that cover the edge of the dunes near his native town of Haarlem, dunes whose serrated edge against the sky was all the inspiration needed for his pictures of mountain scenery.

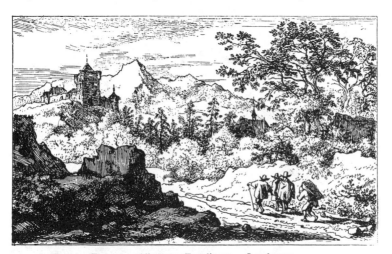

FIG. 73.—Allart van Everdingen. Landscape.

His etched work, which does not reach a dozen numbers, is insignificant in extent beside the endless landscapes that he painted, but happily all his plates are in his least affected style, being for the most part studies of trees. They are remarkable no less for their grasp of masses of light and shade than for truth of line ; but let the student weigh his appreciation by comparing Ruysdael's *Landscape with three large Oaks* of 1649 (Fig. 74), which is the very best of his work, with any landscape etching by Rembrandt between 1640 and 1645. The enormous strength and balance of the latter come out with renewed brilliance in the comparison.

Ruysdael had many contemporary followers, such as NAIWYNX Naiwynx. and VERBOOM, but none who appreciated his special ideals so truly Verboom. as Crome and Théodore Rousseau in the nineteenth century.

In the field of seascapes there are few etchers who display any

Reynier
Zeeman.

real freedom of style beside REYNIER NOOMS (ZEEMAN as he is called). His delicate etchings, which amount to a considerable number, are by no means all above a somewhat dull average level, but they attain from time to time a brilliance in the rendering of sea, sky, and cloud that has been rarely equalled before the nineteenth century.

Besides marines, he did many architectural plates, and his views in Amsterdam and Paris are among the best etchings of their kind, as simply and significantly drawn as Canaletto. One of the Paris plates, the *Ancienne Porte St. Bernard* (D. 62), is reproduced

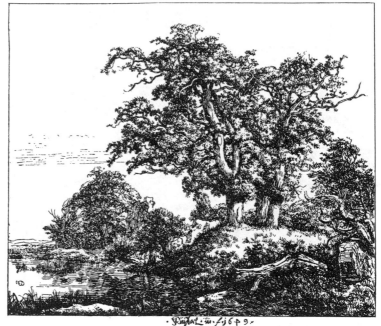

FIG. 74.—Jacob van Ruysdael. The three large Oaks.

(Fig. 75), and will suffice to justify the appreciation of Meryon, who dedicated his Paris set to this "painter of sailors."

Jan van der
Heyden.

Another Dutch artist, who excels in the painting of street scenes, JAN VAN DER HEYDEN, is disappointing as an etcher. As a painter he anticipates Canaletto in his perfect drawing of architectural detail in the clearly defined outline and in the limpid skies, so unusual in the Northern artist, but there is little of the same exquisite power in his somewhat heavy plates. They have a curious interest in their unusual subject, being mostly streets seen in conflagration with fire-engines at work.

SIMON DE VLIEGER, who, as a painter, is best known for his

marine subjects, shows a different side of his talent in his prints. Etchers of
He etched a few landscapes with as free a touch as Ruysdael, but animals.
his chief work in the medium are his studies of animals, which are Simon de
among the earliest etchings of their kind in Dutch art. The hand- Vlieger.
ling of the needle is loose, but his drawing never lacks in life and
energy.

AELBERT CUYP's etched work is very slight, only eight prints (all Aelbert Cuyp.
sketches of cows) being known. His plates are of the smallest
dimensions, and dashed off in the most summary outline, but they
are full of vigour and significance.

PAUL POTTER gave far more attention to etching than Cuyp, Paul Potter.
and his plates are executed with infinitely more pains, but for all
that they can hardly be regarded as of greater artistic value. If his

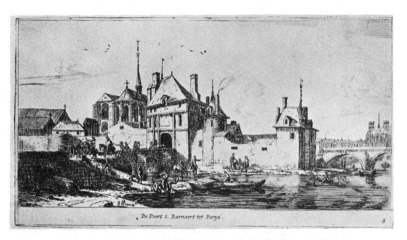

FIG. 75.—Reynier Nooms (Zeeman). Porte St. Bernard, Paris.

animals seem to lack in mobility, and verge on the statuesque, there
are solidity, decision, and truth in his drawing which give him an in-
contestably high position among animal draughtsmen of all schools.
His noble plate of the dappled grey horse set against a background
of a dark sky shows, moreover, a fine feeling for colour in black and
white.

ADRIAEN VAN DE VELDE, of Amsterdam, takes a scarcely lower Adriaen van
place than Potter as an etcher of animals. His touch is lighter, de Velde.
sometimes more sympathetic, but lacks the other's strength.
Though Adriaen is not known to have visited Italy, his art is infused
with the same Southern atmosphere that distinguishes Berchem's
work.

Hardly less important a branch of the school of Dutch animal Dutch etchers
etchers is the group settled in Rome in the first half of the seven- in Italy.
teenth century. PIETER VAN LAER (" Bamboccio," as he was called),

Pieter van
Laer.

no doubt drawn to Rome by the fame of Elsheimer and his school, was with de Vlieger among the pioneers of animal etching. He stands, moreover, at the head of the half-Dutch, half-Italian school of genre, which took the peasant life in the Campagna for its background. In the character of its production the school hovers midway between landscape and genre, seldom giving a really determining emphasis on one side or the other.

The activity of Elsheimer, Claude, and Poussin at Rome in the

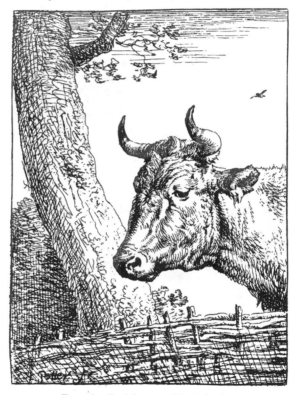

FIG. 76.—Paul Potter. Head of a Cow.

early part of the century drew a host of young painters to the Southern capital. Their special achievement, the development of the expression of light and atmosphere, was followed with considerable success by two Dutch etchers, NICOLAES BERCHEM and JAN BOTH. The work of the former was centred in the peasants of the Campagna and their flocks, while the latter uses these as quite unimportant staffage in his ambitious and idealised landscape compositions.

Nicolaes
Berchem.

BERCHEM studied painting in Holland under Pieter de Grebber and Jan van Goyen, but it is doubtful whether any of his etchings

(of which between fifty and sixty are known [1]) are earlier than his
visit to Italy (which probably fell in the few years immediately
preceding 1649, when he seems to have been back in Holland).
Such plates as the *Shepherd piping, seen from the back* (B. 6), and
the *Bag-piper and the Horseman* (B. 4, sometimes called *le
Diamant*) are good examples of his more delicate etching, prob-
ably the earlier manner, where the subtle gradations of aerial tones
are most skilfully rendered. Somewhat more broadly handled are
plates like the *Shepherd seated piping by a Fountain* of 1652 (B. 8),

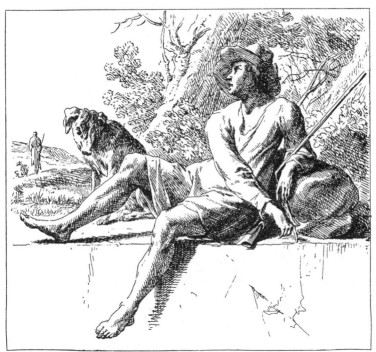

FIG. 77.—Nicolaes Berchem. Title (before letters) to a set of eight prints of animals.

and *Cattle fording a Stream* (B. 9), which show a Tiepolesque
feeling for white light. Most powerful of all in line is the large
print, the *Cow standing in the Water* (B. 1), but his latest [2] manner,
as seen in this plate, is scarcely as pleasing as the first.

JAN BOTH was far more closely influenced by Claude, and in
his few etchings aims even more definitely than Berchem at envelop-
ing the whole landscape in suffused sunshine.

<div style="text-align: right">Jan Both.</div>

[1] Their dates cover the years 1644-1655.
[2] The reading 1680 for the indistinctly engraved date seems corroborated by the
original drawing dated 1679 in the Dutuit collection.

Carel du Jardin.

A pupil of Berchem, CAREL DU JARDIN, was a closer follower of Paul Potter than of his master both in manner and in his choice of subject, which was almost entirely limited to animals in landscape background. The Italian sunlit atmosphere is there, the impress of Berchem, and of his early visit to Italy, but the etchings may all, or nearly all, have been done after his return to Holland. The dates they bear cover the years 1652-1660, and he was certainly back at the Hague by 1656, settling at Amsterdam in 1659. He returned to Italy about 1675, and died in Venice some three years later. Du Jardin is a pleasing etcher, but looser and less convincing in technique than either Potter or Berchem.

The Italianised school of genre. Andries Both. Thomas Wijck.

The spirit of Pieter van Laer on the side of genre was continued to a certain degree in ANDRIES BOTH, the elder brother of the landscape etcher. Like THOMAS WIJCK, whose art also reflects the same influences in Italy, he had assimilated something of the spirit of Ostade and Brouwer, but was completely without their distinction of drawing. Thomas Wijck, who is found painting in London just before the great fire, may in some measure have felt the style of Salvator Rosa and the Neapolitan school of genre.

Breenbergh.

Some of the best elements of the school of Elsheimer and Claude in pure landscape are seen in BARTHOLOMEUS BREENBERGH, who is known to have been in Rome between 1620 and 1627. His master was Paul Bril, from whom he no doubt learnt the same clean and delicately bitten line that is found in Herman Saftleven and Everdingen. His small landscapes, with ruined architecture, chiefly taken from the neighbourhood of Rome, show a fine sense of light and shade, and are masterpieces in their limited way. His one large subject etching, probably a later work, *Joseph selling the Corn in Time of Famine* (printed from two plates), is handled with greater breadth, but hardly possesses sufficient strength of line for its compass.

The decline.

Later in the century the combined influence of Poussin, Claude, and the Carracci became conventionalised in a school of composition which did not make for the true life of landscape art. Etchers like ABRAHAM GENOELS and JAN GLAUBER did solid work with an open etched line, and showed considerable taste. As in the case of Grimaldi, whose influence they must have felt, there is great facility combined with a sad want of natural and spontaneous expression. The art of the Netherlands, whose virtue lay above all in its realism and unaffected truth to nature, did not long survive the mingling with Italian ideals, and a certain superficial effect accomplished by eclecticism soon failed to cover its real decay.

Abraham Genoels. Jan Glauber.

CHAPTER VII

THE LATER DEVELOPMENT AND DECAY OF LINE-ENGRAVING

(From about 1650)

IN the eighteenth century, which forms the centre of this chapter and the next, pure etching and pure engraving are rarer than at any other period in our history. There are times when the combination of the two processes makes definition difficult; but it is seldom that one element is not subservient to the other, and we are still, on the whole, justified in our classification. In the Turner school of "line-engravers" we shall find etching quite the predominant medium, but even here a reason may be found to support the traditional designation. The same excuse will not hold good for the presence of the etcher Chodowiecki, but a section devoted to the subject of book-illustration will serve as apology for his inclusion in the present chapter.

It has been remarked that the etching of Michel Dorigny and the school of Simon Vouet tended, in its character, and, to some extent, in its mixed constitution, to encroach on the domain of line-engraving. On the other side there developed, at the same time, a school of engravers which made use of etching in conjunction with the engraved line, without, however, sacrificing the essential character of line-engraving.

First seen in Holland in PIETER SOUTMAN and his following in Haarlem, the practice was introduced in France by the portraitist JEAN MORIN (d. 1650), while in the field of classical reproduction it found little response before GÉRARD AUDRAN (b. 1640), whose work lies entirely in the latter part of the seventeenth century. In some degree Audran's more immediate predecessor in France, JEAN PESNE (b. 1623), who did both subject plates and portraits (e.g. one of *Poussin*, of whose work he is one of the principal engravers), forms a connecting link between Audran and Jean Morin.

In Audran's plates the etched line stands on its own merit alongside the engraved lines, giving variety to the tone and surface. With etchers like Callot, Jan van de Velde, and Bosse, we have found the etched line to a large extent covered beneath rework

Mixed methods of engraving and etching.

Pieter Soutman. Jean Morin. Gérard Audran. Jean Pesne.

Comparison of Audran's technique with that of Callot,

197

J. van de Velde, Bosse, and C. Bloemaert.

with the graver along the same furrows; and the same may be said of the work of the engraver Cornelis Bloemaert, though here preliminary etching is a much smaller feature. In contradistinction to what might be termed the indissoluble compound of the latter group, Audran's work is a mixture whose parts can easily be separated by the eye.

G. Chasteau.
É. Baudet.
C. Simonneau.

Few of Audran's contemporaries in France followed his mixed style of engraving very closely. GUILLAUME CHASTEAU, ÉTIENNE BAUDET, and CHARLES SIMONNEAU were far more influenced by Cornelis Bloemaert, who had worked in Paris in 1630, and had many French pupils later, when settled in Rome. Theirs is the style of the great engravers of the Rubens school, somewhat simplified in its scheme of shading by the influence of Mellan, and characterised by a tendency to a higher scheme of tone, more in keeping with the lighter grace of the French school of painting.

Lebrun and Vouet inspired a great part of the reproductive engraving of Audran and his contemporaries, but neither formed in any sense a school of engraving as Rubens had done in Antwerp. Almost all the French engravers of the seventeenth century worked as largely after Raphael, the Carracci, Domenichino, and Reni, as after the native painters.

The period of Louis XIV.

The great prosperity of France under Louis XIV., the brilliance of the Court, and a renewed activity in great projects of building and decoration, did much to promote the arts of painting and architecture, and by a side issue largely increased the demand for engraving. Louis XIV., who by his purchase, in 1660, of the collection of the great connoisseur, Michel de Marolles, laid the foundation of the present Cabinet des Estampes in the Bibliothèque Nationale, conceived about 1670 the idea of putting on record, by the medium of engraving, the monuments of his country, his gardens, his palaces and the art treasures they contained, in a collection to be entitled the "Cabinet du Roi." The definite project of a complete record was never accomplished, but the scheme was continued, and survives to the present day in the *Chalcographie du Louvre*, where impressions can still be had from many of the old plates.

Cabinet du Roi.

Chalcographie du Louvre.

La Regia Calcografia, Rome.

A similar institution, *La Regia Calcografia*,[1] was instituted in Rome in 1738 by Pope Clement XII., who purchased the stock of the de' Rossi (a family who had been print-dealers for several generations in Rome) as a nucleus. Its original scope was the same as the Paris Chalcographie, *i.e.* the reproduction of monuments of national art. In the plates of the Piranesi, in particular, it

[1] See Timarchi, *Archivio Storico dell' Arte*, i. 224. Considering the essential aims of both the French and Italian institutions, it is to be regretted that the constitution of each, which seems to be restricted to the commission of engravings or etchings, has not been readjusted in relation to photography and photo-mechanical processes.

can boast a magnificent possession, though it had nothing to do with commissioning their work.[1]

While many of the greater classical engravers of the period, like Edelinck and Audran, were commissioned to reproduce pictures for the Cabinet du Roi, the greater impetus was given, perhaps, to the architect and goldsmith engravers who found encouragement to perpetuate in prints designs of the most multifarious description. *Engravers of ornament and architectural designs.*

JEAN MAROT and his son DANIEL MAROT are among the more distinguished of the architect designers who engraved and etched their own designs, while work by the greatest French architect of the period, Jules Hardouin Mansart, is recorded in the prints of MICHEL HARDOUIN and others. *Jean and Daniel Marot. Michel Hardouin.*

In architectural ornament JEAN LEPAUTRE produced an enormously extensive work, amounting to well over 2000 prints. His plates are largely etched, but ornament etching seldom possesses anything of the genius of its medium, and he finds a natural place in this group. A slightly younger contemporary, JEAN BERAIN, engraved and etched some of his own designs, for the most part based on the style of the Loggie in the Vatican. *Jean Lepautre. Jean Berain.*

The art of the goldsmith is represented in GÉDÉON and GILLES L'ÉGARÉ. The latter was perhaps not an engraver himself, but supplied many drawings to engravers, to L. COSSIN in particular. *Gédéon. L'Égaré. L. Cossin.*

JEAN BAPTISTE MONNOYER, an assistant of Lebrun, and later of Kneller in London, and JEAN VAUQUER of Blois, hold a distinct place for their delicate prints of vases and flowers. *Monnoyer. Jean Vauquer.*

In the Italian school a similar secondary interest attaches to work like that of PIETRO SANTI BARTOLI and his son FRANCESCO BARTOLI, who are among the most prolific of all the engravers after antiquities in Rome. Antique reliefs in particular had always exerted a strong influence on the painters and engravers of the Renaissance. In the sixteenth century one is reminded more especially of the drawings of Polidoro Caldara da Caravaggio;[2] designs of his were etched in the following century by GIOVANNI BATTISTA GALESTRUZZI of Florence (b. 1618). The modern architecture of Rome was represented in the etchings and engravings of GIOVANNI BATTISTA FALDA (1648-91) and ALESSANDRO SPECCHI, while the attractive field of Italian gardens may be studied in the etchings of G. F. VENTURINI of Rome and BERNARDO SGRILLI of Florence. *Pietro Santi and Francesco Bartoli. Galestruzzi. G. B. Falda. A. Specchi. Venturini. Sgrilli.*

The logical development of Audran's system found its real issue in the eighteenth century in the school of engravers inspired by Watteau, Boucher, and Greuze, and by Watteau in particular. The *The Watteau school of engravers.*

[1] Cf. Chapter VIII. pp. 229-32.
[2] A set of some eighty prints of cups and vases has been attributed to Polidoro on the basis of a monogram composed of PCAL (Nagler, *Monogrammisten*, i. 2242). They are probably not even the work of an Italian engraver. In the Catalogue of the Kunstgewerbe Museum, Berlin (1894), it is suggested that they belong to the school of Ducerceau.

The Watteau engravers.

sparkling play of light on costume, which characterises Watteau's *Fêtes galantes*, could only be rendered in its brilliance by the clear lines of engraving, while his landscape and the subtle varieties of tone on every moving form and figure needed the etcher's freer touch to interpret. The whole quality of his work has never been reproduced better than by the engravers who developed Audran's system of combined etching and engraving to its most delicate issue. They perhaps used more etching than engraving, but, for all that, the general character of the resultant work is essentially that of the

Benoît Audran I. Jean Audran.

line-engraver. Nephews of Gérard Audran, BENOÎT AUDRAN the elder and JEAN AUDRAN, contributed largely to the development of the particular style of engraving which marks the school of Watteau. The former seems to have engraved little after Watteau himself, while Jean's work after the master is chiefly contained in the reproduction of his drawings in Jullienne's edition. Another pupil of

Nicolas Henri Tardieu.

Gérard, NICOLAS HENRI TARDIEU, engraved more of Watteau's paintings, and his *Champs Elysées* and the *Embarcation for Cythera* (Goncourt 128 [1]) are among the most successful interpretations of the master's work.

C. N. Cochin I. François Joullain. Laurent Cars. M. Aubert. P. A. Aveline. B. Audran II.

There are many more engravers of the school who worked in just the same spirit with more or less distinction. But their respective work has so few marks of the engraver's personality that we need hardly do more than mention C. N. COCHIN the elder, FRANÇOIS JOULLAIN, LAURENT CARS, MICHEL AUBERT, and PIERRE ALEXANDRE AVELINE as among the most skilful. BENOÎT AUDRAN the younger (a son of Jean) did far more than his father or uncle

Huquier. Moyreau. Crépy. Boucher.

after Watteau. A particular class of Watteau's work, the decorative panels with *scènes galantes* enclosed in dainty framework of scroll ornament, was, for the most part, engraved by J. G. HUQUIER, though a considerable number were also done by JEAN MOYREAU, LOUIS CRÉPY, and FRANÇOIS BOUCHER.

Jean de Jullienne and the reproduction of Watteau.

Watteau's friend, the amateur Jean de Jullienne, did most to encourage the reproduction of the master's work. He had many engravings made after pictures in his own collection, and seems also to have obtained plates which may have been previously published by various dealers, to form a large collected edition of the master's work. This corpus, including two volumes of reproductions of drawings,[2] appears to have been completed about 1734, and issued in 100 copies in four volumes, at an original price of 500 livres.[3]

It is difficult to define exactly what the two larger volumes after

[1] After the picture in the Imperial Palace, Berlin.

[2] Cf. following chapter (p. 248), where one of the etchings by F. Boucher is reproduced (Fig. 92).

[3] See a prospectus in the copy of the work in the Bibl. Nat., Paris. In 1739 an issue of the plates in 4 vols. was announced by the widow of François Chereau, for 250 livres.

the paintings contained, as all the bound copies[1] that are known seem to show variations. Addition of later work, or the separation of the various plates, is to be expected in a work of this kind.

The miscellaneous engravers of the time who worked in much the same manner as the Watteau group are legion. Besides Greuze and Boucher, whose works found almost the same interpreters as Watteau, the Dutch and Flemish painters of the seventeenth century were beginning to find favour in France. *The reproduction of Dutch and Flemish paintings.*

Wouwermans and Wynants found their engravers respectively in JEAN MOYREAU and N. B. F. DEQUEVAUVILLER, while J. P. LEBAS, PIERRE FRANÇOIS BASAN,[2] J. J. ALIAMET, P. AUDOUIN are a few of the miscellaneous reproducers of Dutch work. *J. Moyreau. Dequevauviller Lebas. Basan. J. J. Aliamet. P. Audouin.*

BERNARD LÉPICIÉ, J. J. FLIPART (*e.g.* after Greuze), and JEAN JOSEPH BALECHOU (after the landscapes of Claude Joseph Vernet) may be mentioned as a few of the majority who kept somewhat more to the reproduction of the French school. *B. Lépicié. J. J. Flipart. J. J. Balechou*

The reproduction of classical paintings received an impetus from the popularity of the large gallery works[3] during the eighteenth *The gallery works.*

[1] It may be of use to specify the four bound volumes in the British Museum (of which I. and IV. belonged to John Barnard) :—

(Vol. I.) *L'Œuvre d'Antoine Watteau . . . gravé d'après ses tableaux et desseins originaux par les soins de M. de Jullienne, à Paris. Fixé à cent exemplaires des pres Epreuves.* (Imp. Fol.) Front. (1 pl.) : Prefatory Verses (1 pl.) : and 113 plates : with addresses of the various publishers—F. Chereau, La Veuve Chereau, Gersaint, Duchange, Surugue, Huquier, Jeaurat. Including a series of 12 small plates (*Figures de Modes*) etched by Watteau himself, and other plates numbered in separate series.

(Vols. II. and III.) *Figures de différents caractères de paysages et d'études dessinées d'après nature . . . Tome 1er. Tome 2me.* (fol.). Title, prefatory matter, portrait, and 350 plates, by F. Boucher, J. Audran, B. Audran II., Caylus, and possibly Jullienne and others.

(Vol. IV.) *Œuvre des Estampes gravées d'après les Tableaux et Desseins de feu Antoine Watteau. . . . 4e et dernière volume.* A Paris chez Gersaint. (Imp. Fol.) Front. (1 pl.) and 158 plates. Two of the plates in this volume are dated (E. Jeaurat, *Pierrot content*, 1728, and C. Dupuis, *Leçon d'Amour*, 1734). Publishers' addresses various as in Vol. I. Though the two volumes of *Figures de diff. caractères* are distinct in size and volume-numbering, it seems clear from the preface that they appeared between the first and fourth of the larger folios reproducing the paintings.

[2] One of the most prolific publishers of the period. Cf. Chap. VI. p. 183. Another publisher of the same name, and at once one of the most distinguished collectors, PIERRE JEAN MARIETTE, deserves mention. He came of a stock that had been engraver-printsellers since the middle of the seventeenth century. He reproduced a few drawings in etching, but practised the art very little. His father JEAN (d. 1742, aged 82 ?), and PIERRE MARIETTE (d. 1657), who was probably his great-grandfather, had also been printseller-engravers, the latter marrying the widow of FRANÇOIS LANGLOIS (CIARTRES) and continuing his business (which had published much of della Bella). The majority of their collection was acquired after the death of P. J. M. for the Bibliothèque Nationale (1775-76), but there was also another sale of part of the collection in London (1776). It is remarkable how excellent are most of the impressions bearing the name or monogram of the Mariettes.

[3] We append here for convenience some of the other gallery publications, which occupied so many third-rate engravers at the end of the eighteenth and in the first half of the nineteenth century :—

A. F. Gori, *Museum Florentinum.* Florence, 1731-66 (en. by C. Gregori, P. A. Pazzi, etc.).

century. The *Dresden Gallery* publication (2 vols. 1753 and
1757) and the *Cabinet Brühl* (Dresden, 1754) had given occu-
pation to German, Italian, Dutch, and French engravers, while the
two great French publications, Crozat's *Recueil d'estampes d'après
les plus beaux Tableaux et . . . dessins qui sont en France dans le
Cabinet du Roy, dans celuy du Duc d'Orléans et dans d'autres
Cabinets*, 2 vols. 1729 (sometimes called the "Cabinet Crozat"),
and J. Couché's *Galérie du Palais Royal* (3 vols. 1786-1808;
modern ed. 1858), were even more extensive. As a record of
collections since scattered, the two latter are of great value.

Charles and
Nicolas
Dupuis. In the earlier part of the eighteenth century a less mixed manner
of engraving, more like that of the Drevets and the portraitists,
was represented in CHARLES and NICOLAS DUPUIS. Both did a
few portraits, and Charles some plates after Watteau, but their
chief work was the reproduction of the classical painters. Their
reputation at the time seems to have been greater than their achieve-
ment : both were invited more than once to engrave pictures in
England, and the fame of Nicolas seems to have been considerable
M. S.
Carmona.
P. P. Molés. in Spain. Two of the leading Spanish engravers of the century,
MANUEL SALVADOR CARMONA and PASQUAL PEDRO MOLÉS, poor
enough artists it must be confessed, were his pupils in Paris.
J. B. Palomino. Another somewhat older Spanish engraver, JUAN BERNABÉ PALO-
MINO, deserves mention as the illustrator of the *Museo Pittorico* of
his uncle, the Spanish Vasari, Antonio Palomino de Castro y Velasco
(Madrid, 1715, 1724), and as the first professor of engraving in the
Academy of San Fernando, which was founded in 1752. He produced
a copious work, chiefly of portrait and miscellaneous reproduction.

J. B. P. Lebrun, *Galérie des Peintres Flamands, Hollandais, et Allemands.* 201
planches. Paris, 1792-96.
C. P. Landon, *Annales du Musée et de l'École Moderne des Beaux-Arts*, 42 vols.
Paris, 1801-24 (outline en. by C. Normand, etc.); (cf. C. P. Landon, *Vie et Œuvres
des Peintres les plus célèbres.* Paris, 1803-13).
S. C. Croze-Magnan, *Musée Français, Recueil complet des tableaux qui composent
la collection nationale . . . avec des discours historiques sur la peinture, la sculpture
et la gravure.* Paris, 1803-11.
Caraffe, *Galérie du Musée Napoléon* (Publié par Filhol, graveur). Paris,
1804-28.
R. Gironi, *Pinacoteca di Milano.* Milan, 1812-33 (en. by M. Bisi, G. Gara-
vaglia, etc.).
Reale Galleria di Firenze illustrata (publ. by G. Molini). Florence, 1817-33
(outline en. by P. Lasinio).
C. Haas, *Galérie Impériale . . . à Vienne.* Vienna, 1821-28.
J. Duchesne, *Musée de Peinture et de Sculpture.* Paris, 1829-34 (outline et.
by A. Réveil).
F. Rosaspina, *Pinacoteca . . . in Bologna.* Bologna, 1830 (en. by Rosaspina,
A. Marchi, etc.).
F. Zanotto, *Pinacoteca . . . Veneta.* Venice, 1832 (en. by A. Viviani, etc.).
L. Bardi, *Galleria Pitti.* Florence, 1837-42 (en. by F. Rosaspina, A. Viviani,
etc.).
R. d' Azeglio, *Reale Galleria di Torino*, Turin, 1838-46 (en. by M. Bisi, P.
Lasinio, F. Rosaspina, P. Toschi, etc.).
Galleria dell' Accademia . . . di Firenze. Florence, 1845 (en. by D. Chiossone,
A. Perfetti, etc.)

The attempt to revive pure engraving of the classical style, with *The classical* an alloy of monotony in its new convention which heralded both *Revival.* the decay of the art and an invigorating reaction in the century to follow, is the desert of JEAN GEORGES WILLE, a German engraver, *Jean Georges* who lived from his early youth in Paris. If he introduced any new *Wille.* element into the system of engraving, it is less in its constitution than in the regularity with which cross-hatching is interspersed with flick and dot, in the alternation of thick and thin strokes, in the manifold lighter hatchings over a square pattern of thicker lines. A plate in his broadest style, the *Death of Mark Antony* (1751, after Pompeo Battoni), of which there are four states in the British Museum, may be studied with advantage to show the method of his work. One of the proofs has a special interest in being a gift of the artist to Woollett. In particular it should be remarked that the entire work from beginning to end is pure engraving. Wille did a few landscape and miscellaneous etchings, but in his engravings there is in general little of the preliminary etching which was developed more particularly by the English school. An example of his more finished style, the *Strolling Musicians* after Dietrich (1764), is technically on much the same ground as the *Mark Antony*, but in its closer engraving there is no room for the regular dot work which had occurred in the latter in the triangular interstices. Some of the background, *e.g.* the foliage, is here bitten, but as a rule he leaves etching to such supplementary parts of the composition as the borders (e.g. *La Tricoteuse Hollandaise* after Mieris).

A large portrait like that of the *Conte de Saint Florentin* (1751, after Tocqué) shows him as brilliant with his gold brocade as Pierre Imbert Drevet, but the lack of any real artistic force is even more evident than it had been in the latter. And this was the master of the multitudes of line-engravers of the latter part of the century !

In the unbending regularity and monotonous science of his *Bervic.* work Wille was perhaps surpassed by his pupil CHARLES CLÉMENT BERVIC ("Jean Guillaume" as he is sometimes called from a mistake made at his christening). Bervic is almost without a rival too for the remarkably slow pace at which he worked, producing in his whole life only some fifteen plates.

A slightly older contemporary of Wille who came in his com- *Georg Fried-* pany to Paris in 1736, GEORG FRIEDRICH SCHMIDT, has many *rich Schmidt.* of Wille's faults and a very similar technical method, but he possessed at the same time a far greater portion of the real spirit of the great engravers, especially in portrait. Plates like the *Comte d'Evreux* (1739) and the *Jean Baptiste Silva* (1742), both after Rigaud, already show a hand as skilful as that of Pierre Imbert Drevet (who died in 1739), and far more powerful. There is little wonder that his success in Paris was more

immediate than that of Wille, who was not received into the Academy until 1761.[1] Schmidt was made a member as early as 1744, and the portrait he laid before the Academy on his reception, the *Pierre Mignard* (after Rigaud), shows good reason for the honour conferred. It is a most skilful piece of execution. The painter is seated in his silk robes of office as Director of the Academy of Arts (in which position he had succeeded Lebrun in 1690, the year preceding the date of the picture), but the brilliance of the setting is not allowed to destroy the intensity of the character, which is rendered with a strength which had seldom been seen in French engraving since Masson and Nanteuil. Schmidt's stay in Paris was to be short. In the very year of the Mignard portrait, he was invited back to Berlin as engraver to the Court, and, except for a visit to St. Petersburg in 1757-1762 (undertaken to engrave a portrait of the Empress Elizabeth after Tocqué, and to help in the foundation of a school of engraving), he remained in his native town till his death in 1775.

His work in Berlin between 1744 and 1757 was to a large extent the reproduction of Antoine Pesne, and perhaps the lack of inspiration in his model accounts for the dulness of most of these later engravings in comparison with his Paris prints. After his return from St. Petersburg he turned largely to etching, a medium in which he produced as many plates as in engraving (about 150). He took Rembrandt as his model, but saw him largely through the pictures of his German imitator Dietrich. A few of his etchings are original works, but they are not artist-etchings in the true sense, but produced in much the same manner in which he sought, with considerable success, to reproduce the quality of Rembrandt's paintings.

Sir Robert Strange.

The greatest English classical engraver, SIR ROBERT STRANGE (b. 1721), was only a few years junior to Schmidt and Wille, and even if not an innovator in the matter of preliminary etching, was the first distinguished engraver to turn the practice into a convention. His career was an eventful one.

Apprenticed to Richard Cooper in Edinburgh, he was practising engraving on his own account in that city at the time of the Rebellion of the Young Pretender. He joined the Jacobites, engraved a portrait of Prince Charles, is said to have fought at Culloden, and to have fled after the defeat to France. For some time he studied under Lebas in Paris, returning to England about 1751. His *Cupid* after Vanloo, which was probably done during his stay in France, and the *Magdalene* after Guido Reni (1753),

[1] The plate presented by Wille to the Academy on his reception was the portrait of the *Marquis de Marigny*, after Tocqué. Marigny, a brother of the Marquise de Pompadour, to whom he owed his position, was *Directeur général des Bâtiments, Jardins, Arts, Académies et Manufactures Royales* between 1751 and 1773, and second to the Marquise the most influential patron of the period.

both show the method from which he scarcely deviated in all his later work. He begins with a pure etching of the principal out-lines, and lighter tones of shading, and afterwards changes the character of the greater part of these lines by reworking them with the graver, adding other work with the graver, taking the etched foundation as his guide. In his early production in Edinburgh [1] (*e.g.* portrait of *Dr. Archibald Pitcairn*) there are no signs of this system; he was at that period a somewhat less skilful White or Loggan. Possibly the style of the Watteau engravers suggested his method, but he did far more than merely adapt what others had practised before him. The fundamental distinction between his mixed method and the purer line-engraving of Wille and Schmidt should not be forgotten.

On the accession of George III. in 1760, Strange left England to pass a few years in Italy. Until the last years of his life he was never in favour at Court, and at this particular juncture his refusal to engrave the King's portrait may have advised a temporary retirement. He won great repute abroad, became a member of the Academies at Rome and Florence as well as at Paris, and his prints after the great masters must have exerted a very considerable influence on Italian engravers, like Volpato and his followers. Strange's most powerful and ambitious works were done in England during the last ten years of his life. One may mention in particular the *Charles I., with James Marquis of Hamilton* after Van Dyck (1782), the *Henrietta Maria and two Children*, adapted from Van Dyck (1784), and the *Apotheosis of the Princes Alfred and Octavius* (1786). He stands, as Faithorne had done among the great portraitists, rather for irreproachable soundness and strength, than for any of the qualities of the great artist in engraving.

In brilliance of workmanship he was perhaps surpassed by William Sharp. WILLIAM SHARP. On the purely technical side the latter is one of the most accomplished of all the reproductive line-engravers of the eighteenth century, and in his portraits, in particular, he showed a wonderful power of interpreting his originals. The reproduction of part of an early state (largely in etching) of the *Thomas Howard, Earl of Arundel*, after Van Dyck, placed opposite the same subject as finished with the graver, will show more clearly than words can do, the method of Sharp's work, which is built on essentially the same principles as that of Strange, with a somewhat freer use of dotted work in the earlier stages of the plate (Figs. 78 and 79). Portraits such as the *Richard Hart Davis, John Hunter, Porson* (1810), and *Dr. Raine* (1815) exhibit a command of gradations of tone seldom seen outside mezzotint.

An even more unique position in the development of line- William Woollett. engraving than can be claimed for Strange or Sharp, is held by WILLIAM WOOLLETT, though his large dull plates show how little

[1] Which includes also one mezzotint (portrait of the *Rev. W. Harper*).

can really be achieved by the soundest system of engraving to render the true spirit of landscape. He carried the system of preliminary etching to further issues, often using a second or even a third biting before starting to finish with the graver. He first etches the broadest lines in parallel series of sinuous lines ("worm-lines," they have been called), and for the second biting adds thinner lines between these heavier strokes. To complete the plate, all except the heaviest lines are reworked with the graver, while the

FIG. 78.—William Sharp. Thomas Howard, Earl of Arundel. Unfinished plate (part).

most delicate parts, such as the faces, are entirely left to this instrument. The reproduction of a portion of one of his plates (Fig. 80) will more adequately demonstrate his methods.

Woollett had formed the essentials of his system by 1755, the year in which were published his *Views of Oxford* after John Donowell. It was not, however, until six years later that he produced one of the large plates which have made his name, *i.e.* the *Niobe* after Richard Wilson. Except for the two celebrated battle plates after West (the *Death of Wolfe*, 1776, and the *Battle of La*

Hogue, 1781), most of Woollett's work consists of landscape after Claude and his English imitators, Wilson, George and John Smith of Chichester. Some of his plates were done in collaboration with F. Vivares. FRANÇOIS VIVARES, while his assistant, JOHN BROWNE, and his John Browne. pupil, WILLIAM ELLIS, took part in others. William Ellis.

Besides FRANÇOIS VIVARES, another engraver of French ex- J. B. C. traction, also some years senior to Woollett, J. B. C. CHATELAIN, Chatelain. had done much to direct the English school of landscape along the

FIG. 79.—William Sharp. Thomas Howard, Earl of Arundel.
Finished plate (part).

classical lines, leaving many drawings and prints inspired by the style of Claude. THOMAS MAJOR and JAMES PEAKE come nearer T. Major. to Woollett in the strength of the lineal system of their large land- James Peake. scape plates.

With WILLIAM BYRNE and other engravers working largely after William Byrne Thomas Hearne (who had been an apprentice to Woollett), landscape developed into something little better than topography, and need not concern us until we approach the school of Turner.

.

ITALY.
J. J. Frey.
Joseph
Wagner.

A leading rôle in line-engraving in Italy in the early part of the eighteenth century was taken by two foreign settlers, by JOHANN JACOB FREY (b. 1681, Lucerne) at Rome, and by JOSEPH WAGNER (b. 1706, Munich) in Venice. They were not in any sense pioneers in technique, but continued a sound tradition that varied little from the French work of the seventeenth century, etching being only sparingly used as an aid. The majority of their contemporaries did

FIG. 80.—William Woollett. Judah and Thamar, after Annibale Carracci (part).

A. and F.
Zucchi.

A. M. Zanetti
II.

little more than reproduce classical paintings in prints of small distinction. Many of the pictures in Venice were engraved by ANDREA ZUCCHI,[1] and another member of the same family, FRANCESCO ZUCCHI, took part in the publications of the Dresden Gallery. ANTON MARIA ZANETTI the younger also published many plates after pictures in Venice (1760), and helped his uncle of the same

[1] Chiefly for *Il gran Teatro di Venezia ovvero Raccolta delle principali Vedute e Pitture che in essa se contengono.* Published by D. Lovisa, Venice [1720?]. D. Rossetti was another engraver engaged in this work.

name (who is more celebrated for his revival of chiaroscuro wood-cut) in a work on the antique sculpture of their native city (1740-43). The Florence galleries had similar interpreters in LORENZINI and COSIMO MOGALLI, the famous series of portraits Lorenzini. of painters being mostly engraved by Mogalli's pupil, ANTONIO Mogalli. PAZZI[1] (for A. F. Gori's *Museum Florentinum*, 1731-62). Pazzi.

Wagner's pupils, FRANCESCO BARTOLOZZI and GIOVANNI VOLPATO, Francesco came nearer to the trend of development which we have studied in Bartolozzi. Wille and Strange. Bartolozzi's work in line is among the best of its kind at this period, but his fame is so much more closely linked with the stipple manner, which he largely followed after his removal to England in 1764, that his work will be considered more in detail in this connexion.

After leaving Wagner's studio, Volpato settled in Rome and Giovanni founded a school of engraving, of which he left token in a multitude Volpato. of pupils, and in a book on the Principles of Design (*Principi del Disegno*), with thirty-six plates after antique statues, engraved by himself and Morghen in 1786. In his combination of etching and engraving he may have felt the influence of Sir Robert Strange, who was in high repute at this time in Italy, but he never developed a system of preliminary etching to anything like the method of the English school. His draughtsmanship is often careless and lacking in decision, and his pure graver work is insignificant in consequence. He achieved considerable fame, however, with his series of plates after the frescoes in the Stanze and Loggie of the Vatican.

Volpato's pupil and son-in-law, RAPHAEL MORGHEN, easily sur- Raphael passed his master in technical achievement, but even here his work Morghen. does not bear comparison with Schmidt or Sharp, while his power of expression and interpretation is on a considerably lower plane than theirs. The monotonous regularity of hatching, cross-hatching, dot and flick is rarely relieved by any spark of real life. Possibly for this very reason he personifies more adequately than any other the decadent engraving of the late eighteenth century, and "Morghen-esque" is an epithet full of meaning. His most celebrated print, after Leonardo's *Last Supper*, will suffice to demonstrate at once the elaboration of his style and the lack of real insight into the spirit of his original. As in most work of the school, the varying characteristics of different originals are lost in the engraver's attachment to his conventional method. Morghen sometimes proceeds like Strange with a preliminary etching, but more often, especially in his portraits, uses the dry-point for indicating his outlines as a guide to his work with the graver. Like so many engravers of the time, he frequently finishes the background of his portraits before engraving the face. As professor at the Academy in Florence, Morghen had

[1] Pazzi's own collection of portraits of painters, engraved by himself as a supplement to Gori's *Museum Florentinum* (1765-66), was purchased in 1768 for the Uffizi.

many pupils, who helped to carry on a dull tradition well into the nineteenth century.

Vincenzo Vangelisti.

Among the other Italian engravers, a somewhat older contemporary of Morghen, VINCENZO VANGELISTI exercised considerable influence as head of the school of engraving in Milan. He had studied under Wille in Paris, and with C. A. PORPORATI (a pupil of Beauvarlet) he forms the principal direct link between the French and Italian schools of the time. He also practised to some extent in the stipple manner. Vangelisti was succeeded in his position at Milan by his pupil GIUSEPPE LONGHI, who worked in etching and dry-point as well as with the burin, and was the author of a treatise on engraving.

Porporati.

Longhi.

Outline engraving.

We may mention here the practice of outline engraving, which was so popular at the beginning of the nineteenth century. In Italy it is represented chiefly by CARLO LASINIO and his son GIOVANNI PAOLO LASINIO (the latter executing the plates to the Florence Gallery publication of 1817-33 in this manner), in France by C. NORMAND (e.g. in C. P. Landon's *Annales du Musée*, 1801-24), but in such cases it was merely applied as the most expeditious means of reproducing the composition of a picture. When used for the reproduction of the designs of severe linealists such as John Flaxman (e.g. TOMMASO PIROLI,[1] JAMES PARKER,[2] and WILLIAM BLAKE[3]) and Bonaventura Genelli (e.g. by HERMANN SCHÜTZ), the justification is more essentially artistic.

Luigi Calamatta.

One of the most influential of all the Italian engravers of this period was LUIGI CALAMATTA (b. 1802), who, like Bartolozzi, became the centre of a school abroad. From 1822 he was in Paris, engraving portraits (e.g. *George Sand* and *Paganini*), and subjects more particularly after Ingres. In 1836 he accepted the directorship of the school of engraving in Brussels (later annexed to the Académie Royale des Beaux-Arts). His return to Milan in 1861 was the signal for the dispersal of a school which kept the Morghenesque tradition alive longer in Belgium than in almost any other country.

J. B. Meunier.
A. M. Danse.

Two of Calamatta's pupils, J. B. MEUNIER (who died in 1900) and AUGUSTE MICHEL DANSE (b. 1829) bring us down to the present day.

AUSTRIA AND GERMANY.

The style of Wille and Schmidt was followed most closely in Austria and Germany, by JACOB SCHMUTZER and JOHANN FRIEDRICH BAUSE.

Jacob Schmutzer.

J. F. Bause.

SCHMUTZER of Vienna (b. 1733) was a pupil of Wille in Paris, and combined his master's style with something of the larger manner of the Rubens engravers. BAUSE (b. 1738), an even closer imitator, though not a pupil of Schmidt or Wille, is most noteworthy for his numerous portraits after Anton Graff. He also did work in stipple and aquatint.

[1] *Dante*, 1793, and *Iliad*, 1793. [2] *Odyssey*, 1805.
[3] His plates to *Hesiod*, 1817, are dotted outlines.

Another pupil of Wille, JOHANN GOTTHARD VON MÜLLER of J. G. von
Stuttgart, kept in the majority of his work somewhat nearer the Müller.
manner of the French portrait engravers of the late seventeenth
century, only in his later work yielding sometimes to the more rigid
system of Wille and Morghen. A son whom he survived, FRIEDRICH
WILHELM MÜLLER (1782-1816), gave himself far more completely F. W. Müller.
to the Morghenesque conventions, winning great repute in his day
for one of the most accomplished performances of a monotonous
method, his print after Raphael's *Sistine Madonna*.

We take this opportunity of making passing reference to the very Bank-note
apotheosis of the dull precision and exactness of the Morghenesque, engraving.
which is revealed in bank-note engraving. Jacob Perkins, Asa
Spencer, and Gideon Fairman are the names of three pioneers in
the development of methods which placed the United States in the
first rank of the craft. The steel plate seems to have been brought
into use for this type of work as early as 1810.[1] Unfortunately the
prosperity of the trade in America induced many engravers, who
might have done better work, to enter this narrow field, in which
the only opportunity for the display of artistic feeling was in the
small portraits with which the notes were frequently embellished.
Sound artists like W. S. LENEY,[2] who had been a pupil of P. W.
Tomkins in London, did little but bank-note work after settling in
America, and even two of the most distinguished of American
engravers, JAMES SMILLIE (1807-85) and his son, the etcher, JAMES
D. SMILLIE, did not escape the mill. Machine ruling, which is a
natural method in bank-note work, was very commonly used
by reproductive engravers of all types at the beginning of the
nineteenth century,[3] in particular to obtain a regular tint in the
background.

For the sake of a national memory rather than for its importance The earliest
in our history, we would add that a print of *Increase Mather* by engravers in America.
THOMAS EMMES, dated 1701, seems to be the first portrait and one T. Emmes.
of the earliest plates of any artistic intention engraved in America.
Until the Revolution the engravers, who were generally the local
goldsmiths or silversmiths, ready to accept the few commissions that
offered for artist-engraving, produced little but maps, book-plates,
music, bill-heads, and bank-notes, and their occasional portraits
possess small artistic value. THOMAS JOHNSTON and NATHANIEL T. Johnston.
HURD are two of those whose work dates from the first half of the N. Hurd.
eighteenth century; but from any other consideration they are of
little interest, except perhaps to collectors of book-plates.

PAUL REVERE will always be remembered as a patriot, but his Paul Revere.
crude work in engraving would scarcely deserve mention, were it not
a fair example of the average production of the period. The events
of the Revolution greatly increased the demand for portraits and

[1] Cf. pp. 3, 150 (note 2), 223, 284. [2] Cf. p. 219, note 3.
[3] Cf. Introduction, p. 13; Chap. IX. p. 273 (Unterberger).

historical and subject prints, and the result was a more professional class of copper-plate engravers, whether Englishmen, finding a new field for their enterprise in America, or Americans who could now risk the chances of more special application to their art by study abroad. In the nineteenth century a good deal of small portrait work and illustration was done in line, the best perhaps by ASHER

A. B. Durand. BROWN DURAND, and JOHN and SETH WELLS CHENEY. DAVID
John and Seth EDWIN, CORNELIUS TIEBOUT, and J. B. LONGACRE were among the
Wells Cheney. soundest craftsmen of the first half of the century, but the better part of their portrait work is in stipple. America's real distinction in our history lies rather in etching, of which something will be said in our last chapter.

Later develop- A noteworthy attempt to save the art of line-engraving from a
ment of line- deadening system was made by HENRIQUEL-DUPONT (b. 1797), who
engraving in was Professor of Engraving at the École des Beaux-Arts in Paris
France. from 1863 until his death in 1892. In 1868 he was the prime
Henriquel mover in originating the *Société Française de Gravure*, which did
Dupont. much to encourage the line - engravers by its annual commissions for plates. He discarded the regular convention, and introduced far greater freedom in the handling of his line and in the con-struction of his hatching, freely combining the etched line with

C. F. Gaillard. graver work. His aims were carried even further by CLAUDE FERDINAND GAILLARD (1834-87), who achieved the subtlest gradations of tone by a supremely delicate manner of cutting with the burin, and to some extent by etching. He is still strictly an engraver, though his results are surprisingly near some of Jacquemart's etched work. Some of his original portraits (*e.g.* the Popes *Pius IX.* and *Leo XIII.*) are remarkable technical achieve-ments.

The future of We do not think, however, that it is along the path opened by
line-engraving. Henriquel-Dupont and Gaillard that any real revival of line-engraving will come. The whole essence of their method tends too much to hide the true character of the engraved line, in a tone which might be achieved equally as well, if not better, by some other process.

Pieter Dupont. We look rather to bold work such as that of PIETER DUPONT, who gives his lines a part to play, much as they had in the work of Dürer.

William Then there is a recent departure in technical experiment which
Strang. may do much to open a new vista of possibility before the line-engraver, *i.e.* the use of a burin (or instrument of similar shape), with cutting point turned back, or hooked, so that the tool is no longer pushed, but drawn through the metal. WILLIAM STRANG is, as far as I know, the only artist who has practised this method, and he proved its value by its regular use after about 1908, the date of his portrait of *Sir Charles Holroyd*. The line, which possesses much of the decision and strength of ordinary engraving, can be controlled with even greater freedom than the dry-point, and the

burr being both less powerful and more regular than in the latter process, a greater certainty of result is attainable. As a reproductive art there may be little place for line-engraving, or rather, little opportunity for practical success in face of the photo-mechanical processes ; but there would seem to be a fair field open to the artist who would return to the medium for original work, whether, like Dupont, he keeps to the old road, or with Mr. Strang, broaches new methods whose history is still for the future.

.

In its larger works the eighteenth century is one of the dullest in The history, but no period has shown a greater genius for refinement Illustrators. in the little things of art, and no country has produced artists whose graceful talent was more fitted to miniature creations than France. In engraving this is particularly the case. French art faded beneath the dull weight of the German invasion of Wille and Schmidt, but it found itself in its vignettistes, Augustin de St. Aubin and Moreau le jeune.

In their capacity as illustrators, Moreau and his peers followed François in the wake of FRANÇOIS CHAUVEAU of Paris (1613-76), and of Chauveau. JAN and CASPER LUYKEN of Amsterdam, who are all responsible Jan and Casper for hosts of small and undistinguished plates. Further back still, Luyken. they may trace their pedigree to Callot, though only a small proportion of his plates seems to have been used for what they were so fitted, *i.e.* the embellishment of books.

The greater part of the work of the French illustrators of the eighteenth century was done in etching, but it was seldom that the lines were not worked upon afterwards by the burin, which lent them all the precise character of line-engraving. One of the leaders, indeed, of the school, CLAUDE GILLOT, the master of Watteau, used Claude Gillot. pure etching in the charming plates he did for Houdart De la Motte's *Fables* of 1719. His larger separate plates, however, such as the scenes in the *Life of a Satyr*, are in the usual delicate combination of engraving and etching. More in the manner that B. Picart. formed the convention of the vignettistes to follow are the engravings N. H. Tardieu. in the same book of 1719 by BERNARD PICART and NICOLAS HENRI TARDIEU, the latter largely after Gillot and C. A. Coypel.

An excellent example of somewhat larger illustration than became J. B. Oudry. the rule is seen in the folio edition of La Fontaine's *Fables*, 4 vols. (1755-59), after designs by JEAN BAPTISTE OUDRY (who is also responsible for a few original etchings of still life and genre). Here the engravers are to some extent those known for their work after Watteau, LAURENT CARS, P. A. AVELINE, PIERRE FRANÇOIS TARDIEU, C. N. COCHIN the younger, NICOLAS DUPUIS, and others.

Comparatively little original engraving or etching, like the plates The Draughts- of Gillot, was done in this school of illustration. Draughtsmen like men. Gravelot, Eisen, and Moreau le jeune nearly always put their design in the hands of others to engrave, only very occasionally

acting themselves in the double capacity. It is almost impossible in this connexion not to place the greater emphasis on the draughts- men, although our subject is strictly limited to the engravers. We can only attempt the most summary account of the vast legion of engraver-illustrators who embellished the books of this period, but the subject is simplified if approached from the side of the design, for the illustration of each work is usually in the hands of a single draughtsman.

H. F. Gravelot. One of the earlier of these draughtsmen-engravers, HUBERT FRANÇOIS GRAVELOT (b. 1699), has a particular claim to our interest for the influence he exerted on book illustration in England,[1] where he was settled for the greater part of the twenty years preceding 1754. His work is very copious and, as might be expected, of very variable merit; but his best plates, such as those to J. F. Marmontel's *Contes Moraux*, Paris, 1765 (engraved by LE MIRE, DUCLOS, LONGUEIL, PASQUIER, etc.), are quite among the most excellent of their kind. It is especially in illustrations like these, which reflect the society and manners of the period, that the real value of the French illustrators consists. More often than not their very best work was done for books of the most evanescent interest as literature, while the greater writers of the time, like Voltaire, introduced them to foreign fields or to a glorified past, which they could not interpret without being formal or stilted. Happily the tendency of the illustrator was for the most part in the direction of modern anachronisms, and he seldom had compunction in letting Molière's characters live in an eighteenth century dress.

Against this reflection of contemporary life, which was the natural sequel to Watteau, stands the following of Boucher, with its union of the classical and fantastic elements of art. To the inspira- tion of the latter we may perhaps trace the type of ornament which played so large a part in the embellishment of the books of the P. P. Choffard. time. Vignettes, and culs-de-lampe (head- and tail-pieces), with their medley of curtains and cupids, vases, rose-wreaths, and the rest, became almost a speciality with certain engravers, of whom PIERRE PHILIPPE CHOFFARD was perhaps the most brilliant (*e.g.* in La Fontaine, *Contes*, 1762 ; and Ovid, *Metamorphoses*, Paris, 1767-71).

C. N. Cochin II. C. N. COCHIN the younger and CHARLES EISEN produced many illustrations, the latter being occupied almost exclusively as a draughtsman. Cochin, on the other hand, engraved as much as he designed, and his revision of Bosse's Treatise on Engraving shows the study which he had devoted to his art. He is also responsible for a considerable number of portraits, mostly of the frontispiece size and order, but in this sphere he rarely supplied more than the

[1] Of his English work, note Gay's *Fables*, vol. ii. 1738 (en. by G. J. B. Scotin), Dryden's *Dramatic Works*, 1735, 12°, and Theobald's *Shakespeare*, 2nd ed. 1740, 12⁹ (both en. by G. Van der Gucht), and Richardson's *Pamela*, 1742 (en. by Gravelot after his own designs and those of Hayman).

drawing or preliminary etching. Eisen's plates to C. J. Dorat's Charles Eisen.
Baisers (1770) prove him an impertinent Boucher, dallying, like so
many of the French illustrators of the time, on the border-line of
delicacy, but a graceful artist nevertheless. In the field of con-
temporary life CLÉMENT PIERRE MARILLIER was another fairly C. P. Marillier.
excellent draughtsman and engraver. One might note in particular
the plates he designed for French editions of Richardson's *Sir
Charles Grandison* and *Pamela* (1784), and his illustrations to Le
Sage's *Gil Blas* (1796).

JEAN MICHEL MOREAU (Moreau le jeune, as he is generally Jean Michel Moreau.
called in distinction from his brother, the painter, Louis Gabriel
Moreau) was an artist with the keenest eye for the small superficiali-
ties of society, and judged by his work illustrating contemporary life,

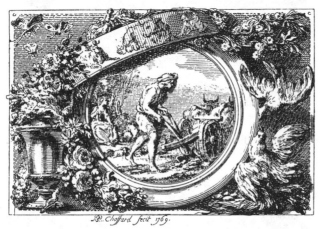

FIG. 81.—P. P. Choffard. Spring. Head-piece to *Les Saisons*, Amsterdam, 1769.

which forms the smaller part of his production, he is the most gifted
illustrator of the school. His plates to the first volume of the
Chansons (1773) of J. B. de Laborde (a valet de chambre of
Marie Antoinette) are of historical importance for the truth with
which they reflect the atmosphere of the Dauphine and her Court.
A more ambitious task, and one of his most successful, was the
illustration of J. J. Rousseau's *Œuvres Complètes*. The best series
of engravings after his designs for this work appeared in the 4to
edition of 1774-83 (in 12 volumes), which was nominally pub-
lished in London,[1] and was the work of NOEL LE MIRE (see Fig.
82), NICOLAS DELAUNAY, J. B. SIMONET, A. J. DUCLOS, P. P.
CHOFFARD, and others. It is a great rarity to find this edition of
Rousseau with its engravings complete ; and the same may be said

[1] Actually, I believe, in Brussels. Like many other books of the time published
with false name of place.

of so many of the illustrated books of the period, which are too

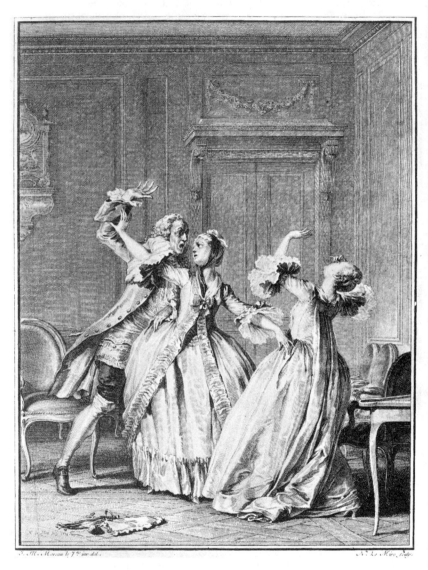

FIG. 82.—Noel Le Mire after J. M. Moreau. The Quarrel (an illustration to
J. J. Rousseau's *Julie*).

often found mutilated of their plates. The same designs were
engraved much less well, and on a smaller scale, in the 8vo editions

of Rousseau (*e.g.* Poinçot, Paris, 38 vols., 1788-93 ; and Didot, Paris, 1801, 20 vols.).

Unfortunately Moreau lived beyond the time to which he belonged by nature. His was too delicate a talent not to yield before the new classicism of Jacques Louis David ; and in the reaction against the outward show of the old society, Moreau found himself the more than commonplace illustrator of J. P. Rabaut Saint-Etienne's *Précis Historique de la Révolution Française* (1792). On this field of stern action he was as nothing compared to JEAN DUPLESSI-BERTAUX, Duplessi-who in his myriad etchings illustrating the period of the Revolution [1] Bertaux. revived something of the spirit of Callot.

One enterprise of Moreau must still be mentioned, *i.e.* the two *Suites d'Estampes pour servir à l'Histoire des Modes et du Costume des Français dans le XVIII^e siècle*, 1776 (1777) and 1783.[2] They form a supplement to a series of prints, issued under a similar title in 1774 (1775), after designs by SIGMUND FREUDENBERGER (a Swiss engraver Sigmund settled in Paris), which they easily surpass in their genius for express- Freuden-ing both letter and spirit of the life of the period. P. A. MARTINI, berger. J. C. BAQUOY, NICOLAS DELAUNAY, and J. B. SIMONET are among the engravers engaged on this work.

From the mass of engravers, some of whom have been already Noel Le Mire. incidentally mentioned in reference to the draughtsmen, we would N. Delaunay. notice in particular NOEL LE MIRE, NICOLAS DELAUNAY, and JOSEPH J. de Longueil. DE LONGUEIL for the excellent preciseness of their work. Another engraver of the school, FRANÇOIS MARIE ISIDORE QUÉVERDO, is F. M. I. most to be remembered for the dainty almanac vignettes of his Quéverdo. design and etching (a large number being finished in engraving by J. DAMBRUN [3]). They are as rare as all such ephemeral illustration on stray sheets tends to become.

Second only in distinction to J. M. Moreau, among the illus- Augustin de trators, stands AUGUSTIN DE ST. AUBIN. His miscellaneous St. Aubin. engravings in books after other masters are very numerous, but his real forte was in the frontispiece portraits, which he executed with a point as delicate as Ficquet or Grateloup.[4]

His elder brother, GABRIEL DE ST. AUBIN, an artist of even Gabriel de St. greater talent, did far less work in book illustration. He etched Aubin. some forty-three plates, but his most remarkable accomplishment consists in his broadly-handled drawings of contemporary life.

The national school of illustration in France did not long survive The decay of the Revolution. The writers of classical drama, like Voltaire, had French illus-tration.

[1] E.g. *Collection complète des Tableaux historiques de la Révolution Française*, Paris, 1798, etc.

[2] Later, the prints of the two series (24 in all), with two from the set by Freuden-berger, were issued with text by Restif de la Bretonne, under the title *Monument du Costume physique et moral . . . ou Tableaux de la Vie.* Neuwied, 1789.

[3] *Étrennes galantes des Promenades et Amusements de Paris*, 1780 (12 pièces en 18°) : *Cris de Paris ; Le Palais-Royal*, etc.

[4] See Chap. VI. p. 150.

always been its bane, but the classical painter Jacques Louis David was its death. We have found the new tendency reflected even in Moreau, while other draughtsmen-illustrators of the first few decades of the nineteenth century, such as A. J. Desenne and Achille Devéria, are even more imbued with the new spirit, and negligible quantities in our history. Among the few illustrations of any distinction at the turn of the century were those engraved after PIERRE PAUL PRUD'HON,[1] by such engravers as B. J. F. ROGER, J. L. COPIA, and the painter's own son JEAN PRUD'HON, in which the more delicate parts of the modelling are often done in stipple. Besides vignettes and the like, the same engravers did numerous larger plates after the master's paintings and designs. Prud'hon himself did the preliminary etching and part of the engraving of a really powerful illustration to P. J. Bernard's *Phrosine et Melidore* (ed. Didot),[2] and a few other etchings of less importance may also be from his hand.

P. P.
Prud'hon.
B. J. F. Roger.
J. L. Copia.
Jean Prud'hon.

• • • • • • • • •

Book illustration in England.

Thomas Stothard.

J. and C. Heath.
James Mitan.
W. and E. Finden.

The English school of illustration in the late eighteenth and early nineteenth century is of far less interest than the French. Through Gravelot it received a certain impulse towards the more delicate manner of design characteristic of the French, but the majority of its engravers in the last quarter of the century were too influenced by the heavier manner of Woollett to attain much refinement in vignette.

Apart from the unique work of William Blake, THOMAS STOTHARD (1755-1834) stands as by far the most gifted and prolific of the English illustrators. He only etched a few plates himself,[3] and his graceful work often suffers greatly through the clumsiness of his reproducers. Robert Smirke, William Hamilton, Richard and Henry Corbould,[4] E. F. Burney, and Richard Westall[5] all designed much for books, but with little of Stothard's charm. Their engravers are many and poor, and most are best passed over in silence. Apart from those who worked in stipple, JAMES and CHARLES HEATH, JAMES MITAN, WILLIAM and EDWARD FINDEN are the best craftsmen of the class.

There is no space to specify the work of these English illus-

[1] *E.g.* in P. J. Bernard, *Œuvres*, ed. Didot, Paris, 1797 (*L'Art d'aimer* and *Phrosine et Melidore*); Lucien Bonaparte, *La Tribu Indienne*, Paris, 1799, and in *Les Amours Pastorales de Daphnis et Chloe* (ed. Didot), 1800.

[2] See previous note. The plate was finished by Roger for the later impressions of the book.

[3] *E.g.* a few plates from drawings by W. Pars of the Parthenon Frieze (published by I. Taylor, 1810, and appearing in James Stuart's *Antiquities of Athens*, vol. iv. 1816). There are also a few small vignettes in the British Museum said to have been intended for some edition of Joseph Ritson's English Songs.

[4] He made drawings for the publication of *Ancient Marbles in the British Museum*, which gave many engravers work for some thirty years (1812-42). He acted in a similar capacity to the Society of Dilettanti in several of its publications of prints and antiquities.

[5] He produced some original etchings (chiefly soft ground), and a few mezzotints.

trators. Much of it is to be found in such publications as Harrison's A few of the
Novelists' Magazine (1780-85), Bell's *British Poets* (1776-83) and illustrated
British Theatre (2nd ed. 1797), Taylor's *Picturesque Beauties of* publications.
Shakespeare (1783-87), Cooke's *Pocket Editions of Select Novels,*
Poets, and *British Classics* (ab. 1796-1803), Manley Wood's edition
of *Shakespeare* (1806), various editions of Rogers' *Poems* ; in period-
icals such as Harrison's *Lady's Poetical Magazine* (1781-82), *Town
and County Magazine* (1769-93), *Universal Magazine* (1747-1814),
the *Lady's Magazine* (1770-1818), *European Magazine* (1782-1826 ;
for portraits in particular), and in the various annuals that are so
common in the second quarter of the nineteenth century (e.g. *The
Keepsake, Friendship's Offering,* and the like).

A great impulse was given to the illustration of history, and of John Boydell
literature in the broader sense, without reference to use in books, by
the engraver-publisher JOHN BOYDELL (1719-1804). He issued
many prints of all kinds—topography,[1] history, and reproduction of
old masters—but his great undertaking was the *Shakespeare Gallery.* The Shake-
Most of the best known painters [2] of the time were commissioned to speare Gallery.
produce pictures, which he had engraved [3] in line and stipple, with
the view of publication in a series. The idea was on foot soon after
1787, but the collected edition of 100 plates did not appear until
1805, published by John Boydell's nephew and successor, JOSIAH
BOYDELL.[4] The result is no more inspiring to us than it was
profitable to its originator (who lost so largely by the scheme as to
be compelled in 1804 to hold a lottery to dispose of his stock of
pictures and drawings), but it stands as a monument of the most
ambitious engraving of the time.

In the midst of the mass of reproductive engraving of the William Blake.
period, WILLIAM BLAKE stands out for an achievement which went
far to restore the dignity of line-engraving as an original art. An
apprentice of James Basire, he went through the drudgery of his
art, and showed himself equal to any of his contemporaries in
illustrations engraved in the conventional manner after Stothard
and others. But these may be forgotten in face of his original
work in line, of which an early plate entitled *Morning* or *Glad
Day* (1780), forty-three plates illustrating Young's *Night Thoughts*

[1] His own work as engraver was chiefly topographical, comprising some 152
views in England and Wales.
[2] Including J. Banks, Barry, Beechey, Josiah Boydell, M. Browne, Downman,
J. Durno, Farington, Fuseli, Graham, Hamilton, Hodges, Hoppner, Kauffmann,
T. Kirk, Northcote, Opie, Rev. W. Peters, Ramberg, Reynolds, J. F. Rigaud,
Romney, West, Westall, Wheatley, Wright (of Derby), Smirke.
[3] By BARTOLOZZI, BURKE, J. CALDWALL, J. COLLYER, EARLOM, G. S. and
J. G. FACIUS, J. FITTLER, GAUGAIN, T. HELLYER, T. KIRK, F. LEGAT, W. S.
LENEY (cf. p. 211), J. B. MICHEL, S. MIDDIMAN, OGBORNE, J. PARKER, C. G.
PLAYTER, T. RYDER, L. SCHIAVONETTI, E. SCRIVEN, W. SHARP, J. P. SIMON,
W. SKELTON, B. SMITH, I. TAYLOR II., R. THEW, CAROLINE WATSON, W. C.
WILSON.
[4] Besides paintings, he produced a few mezzotints (e.g. *C. C. Anslo and a woman*
after Rembrandt, 1781, and two plates after Van Dyck for the *Houghton Gallery*).

(1797), a large print of the *Canterbury Pilgrims* (1810), and the *Illustrations of the Book of Job* (1825) form the most notable part. The *Job* is one of his latest works, and in the beauty and harmony of its design, and in the purity of its cutting, as free from convention as it is unimpeachable in method, it is one of the most remarkable works in the later history of line-engraving. He was engaged about the same time in engraving some larger *designs to Dante*, but only lived to complete seven plates.

Blake's twelve wonderful designs to Robert Blair's *Grave* (1808) were etched by Schiavonetti, who also engraved the artist's portrait after T. Phillips as the frontispiece.

It must be confessed that Blake's work suffers from the obsession of certain ill-formed types of humanity, with the cone-shaped heads, the strongly lined brows, the bull-necks, the exaggerated and often incorrect undulation of muscle. Possibly he may have developed some of these tendencies from the study of bad sixteenth-century prints after Michelangelo, Bandinelli, and Pontormo, and his contemporary Fuseli may have added the rest. It is only in his quite early work that he shows anything of the gentler grace of Stothard. More particularly in his poetical books, which he transferred to metal, text and all, by his strange method of etching in relief,[1] he shows an impassioned harmony which not infrequently verges on discord. His was a genius where human expression was lamed by an unnatural vividness of spiritual vision, and a ray of real truth is continually followed by the mutterings of the incomprehensible.

His colour books strictly fall outside the range of this chapter, but we claim indulgence to avoid dividing the description of his work. It is no wonder that Blake found no publishers for the abstruse mysticism and allegory of his prophetic books, and he was no doubt led by mere circumstance into devising his own means of reproduction, *i.e.* the etching of text and design in relief. The plates were usually printed in one colour (his favourite tones besides black being yellow, blue, and green), the impressions being frequently tinted with water-colour by himself or by his wife. In other instances the impressions show an opaque colouring with a peculiar grain, which seems to have been achieved by a curious method of transfer. He would first paint a card, containing the design indicated in its proper register, in tempera, and then transfer that colour to the monochrome impression by means of rubbing. The reticulated nature of the grain might also have been emphasised by dusting dry colour over the surface of the wet impression. A considerable amount of colour, both in tempera and water-colour, must occasionally have been added with the brush.

The *Songs of Innocence* and *Experience* (1789), and the *Book of Thel* (1789) are among his earliest books of the kind, showing

[1] See Gilchrist, 1880, II. p. 178, for Blake's memoranda on what he calls "woodcut on pewter" (work with graver or *échoppe*), and "woodcut on copper" (relief etching).

something of Stothard's grace, and as yet nothing of the *terribilità*
which pervades his later work. In the books of a few years later,
the *Visions of the Daughter of Albion* (1793), *America, a Prophecy*
(1793), and *Europe, a Prophecy* (1794), he is seen almost at his
best. The *America* in particular (of which the British Museum
copy is printed in black, without tinting) shows the strength of his
design. The colour in the other two is for the most part given by
hand tinting, but separate impressions from the different plates are
also met with, treated in his special method of colour-printing. A
comparison of variant impressions serves to convince us of the falsity
of the latter method, which seldom fails to impair Blake's significance
as a linealist. The *Urizen* (1794) and the *Song of Los* (1795) are

FIG. 83.—William Blake. The Door of Death, from the *America*.

generally found in opaque colour, while in the *Milton, A Poem*
(1804), and in the *Jerusalem* of the same year, he returns to the
simpler method, black line being used in both, only relieved in the
former by delicate transparent tints.

Throughout his work he had made much use of the white line
on a black ground (like Bewick and his followers in woodcut), and
the *Albion adoring Christ on the Cross* from the " Jerusalem " is a
most impressive example.

English illustration found its most typical expression in land- The Turner
scape, under the inspiration of Turner (1775-1851). Here we engravers.
have no longer a second-rate version of a mere cosmopolitan art,
but a school truly indigenous, both in its style and its technical
means. In reality it is not a school of line-engraving at all, as
practically all the work was done by etching, the graver being used

only to a comparatively small degree in giving sharpness to certain details, and occasionally in laying a series of delicate lines to achieve smooth surfaces of equal tone, such as the clear sky. Nor has it the claim of work like that of Bosse to be called engraving, on the ground of the assimilation of its etched line *per se* to the character of an engraved line. On the contrary, analysis of its constitution discloses a wriggling wormlike line which is absolutely opposed to all the reasonable possibilities and conventions of graver work. Nevertheless the general regularity of its system, so close in its work as to be lost in tone, stands in such contrast to the true ideals of the etcher's art, that we would still be content to call its exponents line-engravers rather than etchers.

In its essential nature the system is a natural development from the methods of Woollett, with a much smaller percentage of rework with the graver. The worm-lines are laid closely together with scarcely any cross-hatching, and frequently interlaid with a series of dots, and the variety of tone is achieved to a large extent by numerous bitings.

Turner nearly always supplied his engravers with drawings in water-colour, and it is wonderful how in the monochrome so much of the delicate shades of tone, which depends in the original largely on colour, is preserved. Of course, many instances of contrasting shades, which have no logical place in the engraving, and are only disconcerting, may be pointed out, and Turner's truer instinct as a designer for engraving is seen in his monochrome studies for the *Liber Studiorum*. The care, however, with which the painter supervised and annotated the proofs of his engravers, brought success where an unaided engraver would have certainly failed.

Copper-plate Magazine. Oxford Almanacks. Southern Coast, 1814-26. Views in Sussex, 1819. Hakewill's Picturesque Tour of Italy, 1820. Rivers of France, 1837. Picturesque Views in England and Wales, 1838.

In the earliest prints after Turner, *e.g.* in the *Copper-plate Magazine* (between 1794 and 1798), and in the *Oxford Almanacks* (1799-1811, engraved by JAMES BASIRE), the real genius of the school is scarcely seen. It appears more developed in the *Southern Coast* (1814-26, engraved by W. B. Cooke, etc.), and in the *Views in Sussex* (J. Murray, 1819; engraved by W. B. COOKE), and in full possession of its power over delicate shades of tone in Hakewill's *Picturesque Tour of Italy* (J. Murray, 1820; engraved by G. COOKE, JOHN PYE, etc.). Most typical of all the engravings are perhaps those of the *Rivers of France* (Longmans, 1837) and the *Picturesque Views in England and Wales* (Longmans, 1838), by W. MILLER, R. WALLIS, R. BRANDARD, W. RADCLYFFE,[1] J. T. WILLMORE, J. B. ALLEN, E. GOODALL, and many others. Both series had been published in parts before the dates of the collected editions.

A greater part of the engravings we have mentioned are "illustrations" only in so far as they were issued in book form with a text. It is the text, however, which is more truly the illustration than the

[1] Assisted in the foundation of a School of Art in Birmingham (1814). Radclyffe's pupil, Willmore, and R. Brandard are other members of the Birmingham group.

prints. Turner's work as an illustrator in the stricter signification is important, and some of the most exquisite work of his engravers is seen in his vignettes to Rogers' *Italy* (1830) and *Poems* (1834), and to the *Prose Works of Walter Scott* (Cadell, Edinburgh, 1834-36).

The enormous number of impressions which have been taken from all the plates of this school is chiefly due to the use of steel, which largely took the place of copper between about 1815 and 1860.[1] The introduction of the practice of steel-facing which effectively protects the copper has rendered the use of steel, which of course presents greater resistance to the graver, superfluous even when large editions of a plate are to be printed.

How great a part of the excellent results achieved by the Turner engravers is due to the master's direction may be estimated by comparing the prints of the *Turner Gallery* (60 plates, with text by R. N. Wornum, 1859, etc.) with those done during Turner's lifetime. The engravers are for the most part the same (*e.g.* W. MILLER, J. T. WILLMORE, R. BRANDARD, J. B. ALLEN, J. COUSEN, E. GOODALL), and they show an even greater brilliance in their cutting, but all the subtler gradations of light, which Turner gained by repeated correction on the proofs, are wanting.

.

This chapter cannot end without some description of the work of the famous German illustrator of the eighteenth century, DANIEL CHODOWIECKI. His plates, which amount to over 2000 in number, are almost entirely etched (sometimes strengthened with the drypoint, seldom finished with the graver), but their manner is so essentially modelled on the French illustrators that it is impossible to speak of his work in any other connexion. He produced a large number of plates of all kinds, from landscape to Court pageants, in a freer manner of etching, but these mostly tend towards a lower estimate of the talent of an artist whose fame rests on his small bookillustrations. His charming etching, *Le Cabinet d'un Peintre* (1771), representing the artist in the midst of his family circle, shows the man as he is, the lover of the homely citizen's life, in contrast to the courtly brilliance, which was the true atmosphere of the French illustrators. The one Frenchman whose spirit he most reflected was perhaps Jean Baptiste Chardin. Starting his career as a painter of enamels, he took up etching when he was about thirty (1756-57), backed by almost no academic study. Like Hollar he had a keen eye for the small things, which lend his little plates of costume a wonderful value. Nor did he lack a true power of expression of human feeling when depicting scenes from the phase of society which he knew. Imagination fails him when he tries less realistic themes, and a lack of sound draughtsmanship is evident when he attempts work on a larger scale.

Marginal notes: Rogers' Italy, and Poems. Scott's Prose Works, 1834-36. The use of steel. Chodowiecki.

[1] Cf. above, p. 211, Chap. V. p. 150 (note 2), Chap. IX. p. 284, and Introduction, p. 3.

The pocket almanacs, as popular in Berlin as in Paris at the end of the eighteenth century, in which much of the new literature was published, were happily of a size to need the smallest of illustrations, and it is in these that some of Chodowiecki's best work appeared. He would etch his various illustrations, perhaps a dozen together, on one plate, and impressions from these would be cut up for use in the calendar. It is almost as rare to find these calendars complete with their illustrations as it is to meet with complete impressions from the plate with its various subjects undivided. Most attractive of all

FIG. 84.—Daniel Chodowiecki.
The Marriage, from the *Leben eines Lüderlichen*.

are perhaps the illustrations to Lessing's *Minna von Barnhelm*, which appeared in the *Berliner Genealogischer Calender* for the year 1770 (the earliest of his calendar plates), while the print we reproduce from the *Leben eines Lüderlichen* (Fig. 84) appeared in the same calendar for the year 1774. Gessner's *Idylls* (1773), and Gellert's *Fables* (1775), are other works he illustrated for the same publication.

CHAPTER VIII

ETCHING IN THE EIGHTEENTH AND EARLY NINETEENTH
CENTURIES

THE GREAT ITALIAN ETCHERS—THE ARCHAISERS AND AMATEURS—THE
SATIRISTS—GOYA

THE eighteenth century was a sophisticated age, and unfertile soil for an art which needs above all things natural and forceful expression. It was an age of critics, connoisseurs, and amateurs, which, while encouraging the arts in general, and reproductive engraving in particular, used original etching as its plaything. Great etchers were not absent, the greatest perhaps to be found among the satirists, whose aim seemed one with the spirit of the time in which they lived. But even here artists of first rank, like Goya, are isolated towers in the midst of barren levels, and Italy was alone as a nation to find her school of etching reach its highest development during this period.

At the outset came the Tiepoli who, by the whiteness of their colour scheme, the true note of rococo art, and by the graceful and swinging pose of their groups of figures, contributed fresh elements of life to the art of fresco decoration. But while their achievement is in a truer sense rather a completion of the past ideals of their countrymen, of Veronese above all, we meet, in Canaletto, on the other hand, aims more basically fresh to Italian artists, *i.e.* the seeking of inanimate nature for its own sake, freed from all the side issues of subject or allegory.

GIOVANNI BATTISTA TIEPOLO, whose fame as a painter of G. B. Tiepolo. monumental frescoes brought him to Würzburg (1750-53) and Madrid (from 1762 until his death in 1770), was born in Venice in 1696. As an etcher, he strove first and foremost to render the white scheme of his paintings by means of sparing use of lightly bitten lines, laid with little or no cross-hatching. In his delicate handling of the needle, and to some extent in his treatment of composition, he may have found suggestion in the work of Benedetto Castiglione, but he followed the latter in none of the meaningless scrawl of shading. His etchings, only some fifty in all, are no mere

side-play in his work, but as true an expression of his genius as his paintings. The ten plates of the *Capricci*, from which we reproduce the *Nymph, with Satyr Child and Goats* (Fig. 85), may owe something to Salvator Rosa, but there is a refinement of line and drawing which the latter never attained. More powerful in etching, with less cross-hatching, and a more developed system of tremulous parallel lines broken at regular intervals, are the larger plates of the *Scherzi di Fantasia*,[1] whose character places them even more certainly than the *Capricci* in the Spanish period. These medleys of satyrs and nymphs, gipsies and goats, philosophers and cavaliers,

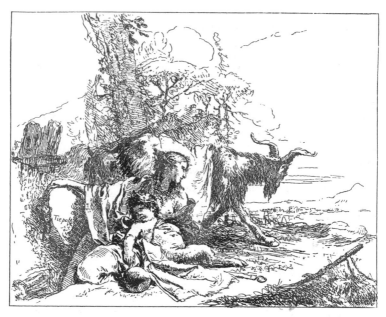

FIG. 85.—Giovanni Battista Tiepolo. Nymph, with Satyr Child and Goats.

snakes and owls, trophies and tombs, are meaningless enough to us in subject, but their balanced composition of triangular build, the lightness of touch and fancy, give a true idea of Tiepolo's genius for decorative combination. Tiepolo's manner of painting finds perhaps its closest translation in the large etching of the *Adoration of the Magi* (after his own picture done for the Convent of S. Aranjuez).

G. D. Tiepolo. GIOVANNI DOMENICO TIEPOLO (b. in Madrid 1726) inherited all his father's ideals but somewhat less of his refinement. His etchings are more numerous than Battista's, and are to a large extent reproductions of the latter's designs and paintings. In his set

[1] There are 24 Nos. in the set published by Domenico, but only 21 seem to be by Battista.

of twenty plates on the Story of the Flight into Egypt (*Idee Pittoresche sopra la Fugga in Egitto*, 1753), he shows however a considerable turn for invention of his own. Earlier he had published another set, 14 plates illustrating the stations of the Cross (*Via Crucis*, 1749). A series of *Character Heads*, which are possibly after Battista's studies [1] (some based on Rembrandt, Leonardo, and other masters), come nearer to Castiglione than anything in the work of father or son. As an etcher Domenico is heavier in his line and shadow than his father, and not infrequently (as with certain of the *Heads*) darkens his tones by leaving ink on the surface of the plate in printing. His darker system conceals a comparatively poor draughtsmanship.

In Venice during the first two decades of the eighteenth century The etchers of arose the school of architectural etchers, which finds its culmination views and in Canaletto. architecture.

MARCO RICCI (b. 1679?), a nephew of Sebastiano Ricci who still Marco Ricci. etched in the older classical manner, was among the earliest of the later Venetians to turn from subject to landscape (of which he left some 20 plates), while a far more prolific etcher of views of Venice is found in LUCA CARLEVARIS, who in his *Fabriche e Vedute di* Luca *Venetia* (104 plates, including title, Venice, 1703) shows a true feeling Carlevaris. for the value of delicate line.

ANTONIO CANALE, Canaletto as he is called, is said to have Canaletto. been a pupil of Carlevaris, and must in any case have owed to him the direction of his art.

A short time spent in Rome (from about 1719) may have brought him into touch with the painter G. P. Panini, who was slightly his senior, but he never yielded much to the influence of his style. Remaining a true Venetian, he always laid far less emphasis on foreground than on effects of distance.

His etchings are few (thirty-one in all), but show the same command of aerial perspective that marks his painting. He uses the simplest system of shading in parallels, giving to his lines a slight but regular sinuosity which suffuses the atmosphere with a sense of misty heat. To the achievement of his aim of expressing buildings in bright sunshine, he sacrifices all idea of rendering the quality of material. His stone never loses its essential character, but in the purely landscape portions of his work the tendency is towards the fusion of varying elements. We imply no blame thereby; the single aim which he pursued has never been attained with more conviction than in these plates. The firm and simple manner in which he shades his solid structures, has much of the virtue which made Meryon so great. A portion of one of his larger prints, the

[1] And in some cases perhaps etched by Battista. The distinction of the work of father and son is not always quite certain. The catalogue in the collected edition by the son (1775) is by no means illuminating. Domenico's younger brother, LORENZO TIEPOLO, also etched some plates after Battista.

Torre di Malghera, which is reproduced (Fig. 86), shows his characteristic style at its strongest.

Canaletto's work won especial appreciation in England, where he is found for a short period of uncertain length after 1746, and a

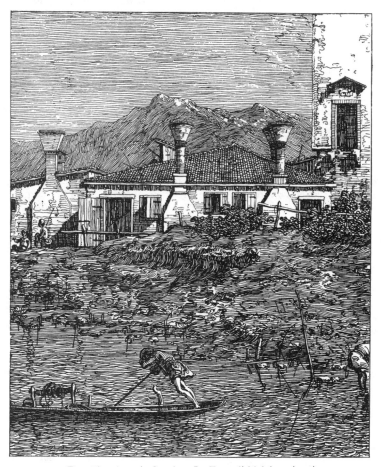

FIG. 86.—Antonio Canale. La Torre di Malghera (part).

graceful acknowledgment of his English connexion is the dedication of the collected edition of his etchings (*Vedute altre prese da i luoghi altre ideate*) to Joseph Smith,[1] the British Consul at Venice (between 1740 and 1760). One of the etchings bears the date 1741, and it is probable that the whole set appeared before Canale's visit to England.

[1] His library was purchased by George III. in 1765, and now forms part of the King's Library in the British Museum.

Canale's nephew and pupil, BERNARDO BELOTTO, who also as- Bernardo
sumed the name of Canaletto, is a close follower of his uncle, adding Belotto.
perhaps in brilliance and precision what he loses in freedom and
freshness of handling. In his etchings, about forty in number, he
follows a more pictorial aim. To balance the large size of his plates
he adopts a heavier and more varied treatment of line, but keeps
largely to the same simple scheme of parallel shading. Only a
small number of his prints are of Italy, which he left early in his
career. Some twenty-three are views of Dresden and the neighbour-
hood (where he was settled for a great part [1] of the period between
1747 and 1768), and a few again are of Warsaw (dated 1770 and
1772), where he ended his days as painter to the King of Poland.

Another great architectural etcher was working at the same time G. B. Piranesi
as Belotto, *i.e.* GIOVANNI BATTISTA PIRANESI, a Venetian who
settled in Rome. Educated as an architect, he devoted himself
almost entirely to engraving the great monuments of Rome of
Antiquity and the Renaissance, achieving a work of enormous
magnitude, a triumph of diligence distinguished by real genius.
The definite archæological aim of his work is evidenced by the
lengthy disquisitions which he added as letterpress to several of his
publications, and by the explanatory text engraved on so many of
his plates ; but he was throughout more artist than antiquarian, and
a strong vein of invention may not recommend him to the stricter
sort of archæologist. The strength of his artistic power may be
appreciated all the more if it is considered that it works in spite of
the letters and numbers of reference, which one might expect to dis-
figure an architectural plate. Of his various publications of pro-
fessedly archæological and topographical purport, the most important
are *Le Antichità Romane*,[2] 4 vols. (1756), *Della magnificenza ed archi-
tettura de' Romani* (1761), and the *Vedute di Roma* (135 plates, in-
cluding title-page and frontispiece, engraved between 1748 and 1778,
with two plates added later by F. Piranesi). Considering the mass
of his work, it is natural that the quality is variable. Occasional
plates in the *Vedute* (e.g. *Ponte Molle, Ponte Salario, Avanzi del Foro
di Nerva*) and in other publications (*e.g.* the *magnifica sostruzione
per render la via Appia piu commoda* in the *Antichità d' Albano*) show
a command of light and of masses of architecture which is of the
most imposing calibre, while other plates, especially those of the more
modern buildings, descend to a more ordinary level of artistic interest.

Like Bernardo Belotto he did the majority of his work on a
large scale, and developed a most powerful manner of etching, which
justifies the " imperial " size of his prints. For his foreground he
uses broad lines, sometimes strengthened with the graver, but never

[1] Visits were also paid in this period to Vienna (1758-60) and Warsaw.
[2] Not to be confused with another set with a similar title, *Antichità Romane de'
Tempi della Republica* (1748). This is a series of smaller oblong plates (of *archi trion-
fali*, etc.), perhaps the most pleasing of all his smaller prints.

deadened thereby in vigour. Like Polanzani (who engraved his portrait[1] in 1750), and the imitators of Callot and Mellan in general, he makes great use of the swelling line, achieving bold contrasts of tone which can only be appreciated at their true value at a distance. His large compositions cannot, in fact, be examined in the hand, and gain immeasurably in force by being hung as pictures. Foreground is everything in his scheme of composition, which he may have owed to some extent to Panini—huge buildings rising to colossal proportions, towering as they do before the spectator in their immediate vicinity.

The staffage of some of Piranesi's dullest subjects with their Callotesque figures discloses an irrepressible instinct for life as well as learning, but the spirit of genius could not but suffer from the drudgery of his toil. Some of his most attractive plates are the fanciful compositions in the *Opere Varie di Architettura*, 1750 (some plates repeated from the *Prima Parte di Architetture* of 1743), while his greatest power is seen when his invention and gloomy fantasy is given the full play which is realised in the sixteen plates of the *Carceri* (1750; see Fig. 87). In the latter series, especially in the early states, his etching is purer, and less artificially varied than in most of his plates, and gains thereby enormously in freshness and vigour. These imaginary constructions with their colossal scaffolding, cranes, wheels, and galleries, with their monstrous contrivances of torture, give scope in the management of masses of light and shade, which has been achieved in equal degree by no other engraver or etcher, except perhaps by Muirhead Bone.

Francesco and Pietro Piranesi. The work and projects of Giovanni Battista, who died in 1778, were continued by his sons, FRANCESCO and PIETRO PIRANESI, aided, it is said, by a daughter, Laura.[2] Francesco is by far the most important of these as an etcher ; but while inheriting the industry and some of the strength of his father, he is altogether inferior in draughtsmanship and artistic feeling.

In 1799 the two brothers removed with their whole stock to Paris, receiving encouragement, if not official support in their establishment, from Napoleon's Government. Between 1800 and 1807[3] they reissued the whole of their father's work with numerous additions of their own, including various series of prints after paintings and drawings by other engravers.[4] The great corpus, amount-

[1] Generally found prefixed to the *Opere varie di Architettura*, 1750.

[2] I have only seen two plates with her signature, and have not included her in the index. Pietro signed some of the plates in the *Antiquités de la grande Grèce* (which first appeared in Paris between 1804 and 1806), but seems to have been mainly occupied as publisher.

[3] Francesco is said to have died in Paris 1810. Pietro seems to have returned to Italy earlier, as he published Piroli's *Bassorelievi antichi di Roma* in Rome, 1808. For contemporary reference to their Paris establishment see *Magasin Encyclopédique*, v. Tom. 5, p. 110 ; Tom. 6, p. 283 ; ix. Tom. 2, p. 238 ; and J. F. C. Blainvillain, *Le Pariséum*, Paris, 1807-8, p. 208.

[4] E.g. *Raccolta di alcuni Disegni del Barbieri* (by Bartolozzi and others, the

ing to twenty-seven[1] large folio volumes, was reprinted by Firmin

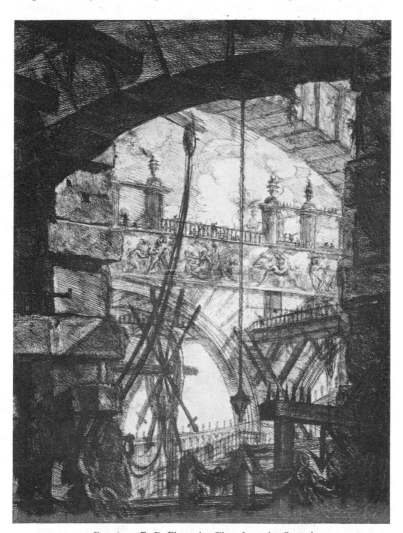

FIG. 87.—G. B. Piranesi. Plate from the *Carceri*.

Didot in Paris between 1835 and 1839. Since that time the original

original series having been issued in 1764) ; Gavin Hamilton's *Schola Italica Picturae* (engravings by D. Cunego, etc., originally published 1773) ; and three series of outline engravings by T. Piroli (who worked very largely in the Piranesi's employ), after paintings in the *Sala Borgia, Villa Lante, Farnesina*, and *Villa Altoviti*, by Raphael, etc.

[1] Sometimes described as twenty-nine ; but the three series by Piroli seemed to have formed one volume, as they do now in the R. Calcografia, Rome.

plates have been acquired by the Regia Calcografia in Rome, and modern impressions of some 1180 plates are still to be purchased. Of course the intrinsic value of these modern impressions is as small as their actual price, but some of the stronger plates are by no means completely bereft of their original virtue.

Luigi Rossini. The mantle of the Piranesi fell on LUIGI ROSSINI, who engraved many large plates of the ancient architecture of Rome (mostly between 1817 and 1824). The greater part of his work appeared in a collected edition in seven imperial folio volumes in 1829. His plates have strength, especially in dealing with masses of dark masonry; but they disclose far less of the powers of imagination that had given G. B. Piranesi's work so much more than a merely archæological or topographical value.

.

Satire. Italy has not produced the greatest caricaturists, but with Leonardo da Vinci she had taken the lead in the art of conscious grotesque in the treatment of feature and form. Gothic art, with its naïve and unconscious grotesque, which persisted so much longer in the North than in the South of Europe, possibly militated against the early development of a true school of satire in Germany or the Netherlands. Amid the mass of broadsides and miscellaneous satirical prints which flooded Europe, particularly the Low Countries, during the seventeenth century, there is scarcely a single work of distinction. Everywhere it is the hack journalist turned designer, and seldom the artist yielding to a natural bent towards travesty and burlesque.

P. L. Ghezzi. In the early eighteenth century it is again an Italian artist who is in the van of the caricaturists, PIER LEONE GHEZZI of Rome (1674-1755). GIUSEPPE MARIA MITELLI of Bologna (1634-1718) may have suggested something of Ghezzi's style in his broad open manner, and bold drawing of large figures, nor was he without something of the sentiment of the satirist in his numerous prints of allegory and daily life. Ghezzi, however, strikes a new note in the outspoken personalities of his satire. The greater part of his caricatures are only preserved in drawings (of which the British Museum possesses two most interesting volumes with manuscript elucidations by the artist), but some are engraved (*e.g.* by MATTHIAS OESTERREICH, *Raccolta di XXIV Caricature*, Dresden, 1750), while a few were etched by Ghezzi himself. They are almost entirely single figures and heads in profile, quite in the Leonardo tradition, not brilliantly incisive, but showing no lack of droll and harmless humour.

English Satire. In the natural development of a school of satirical engraving England stands almost alone. In no other country has the caricaturist been left such complete liberty, and in the eighteenth and early nineteenth centuries social and political satire opened a field which attracted the energies of some of the most talented English

artists of the period. The genius among them, WILLIAM HOGARTH, was something more than a great satirist ; THOMAS ROWLANDSON was scarcely less brilliant, and far more naturally facile, in his limited field ; while JAMES GILLRAY, though on a lower plane than either of the preceding as an artist, holds a very individual place to every student of English politics and history.

In point of a liberal artistic education HOGARTH, who was Hogarth. apprenticed to a silversmith, was the least favoured of the trio. Some study of drawing in the St. Martin's Lane Academy, apparently after the term of his apprenticeship, had given him sufficient facility to undertake work of a more ambitious character, and though in 1720 (the year in which his first trade-card is engraved) he started a shop of his own in his master's craft, he was soon able to turn his back on mere silver-plate and heraldic engraving.

From the very first Hogarth felt his gift and recognised his opportunity in satire. The display of prints on some topic of the day could not but arouse popular attention, and he was happy in finding a great subject in the earliest of his large engravings of the sort, the *South Sea Bubble*, 1721. The plate is for the most part engraved with the burin in the dull manner of the Van der Guchts. The drawing is poor, the composition somewhat confused and obscure ; but in spite of its faults there is a fertility of invention and imagination here that does not belie his best achievement.

In the first print he published on his own account, the *Masquerades and Operas* of 1724, Hogarth found an equally telling subject in a diatribe against foreign favourites in music and on the stage. John Bull, his island and his creation against the World, will always capti-vate the English masses, and the sentiment never flourished more vigorously than in the eighteenth and early nineteenth centuries, reaching its zenith in the prints of Gillray during the war with Napoleon and France. Hogarth is typically English in the didactic nature of his satire. He is essentially a preacher and moralist, but a preacher from the stage of life, with the spirit of the dramatist in the series of scenes with which he often addressed his audience. He is entirely responsible for both design and engraving of three of these "dramas," the *Harlot's Progress* (1733-34), the *Rake's Progress* (about 1735), and, most powerful of all, the *Industry and Idleness* (1747), while another series, the *Marriage à la Mode*[1] (1745), was left to other engravers to reproduce (*i.e.* to. G. SCOTIN, RAVENET,[2] and B. BARON). Meanwhile Hogarth was devoting more time to painting, and in spite of lack of training, his persistent devotion to nature and life developed in him a power which is one of the most refreshing influences in English art of the period. He will always, however, be best known by his prints (which in many

[1] The original pictures are in the National Gallery.
[2] The plates signed respectively R. F. Ravenet and S. Ravenet ; but the R. F. is probably only an engraver's error, both being by S. F. Ravenet the elder.

Hogarth. cases he engraved after his own paintings), and it is here that he could rely most on his early training. Of his large separate prints we might mention in particular the *Southwark Fair* (1733), the *Midnight Modern Conversation* (1733-34, a satire on heavy drinking), and the *Morning, Noon, Night, and Evening* (of 1738, the "Evening" engraved by B. BARON). In another of his best-known designs, the *Roast Beef of Old England, or Calais Gate* (1749), Hogarth was assisted in the engraving by CHARLES MOSLEY, while the engraving of the *March to Finchley* (1750), a record of the year 1745, is entirely by LUKE SULLIVAN.

Besides these larger works Hogarth is responsible for a considerable number of book illustrations, more especially in his early period. He is something of an eclectic in this branch of art, fifteen head-pieces to Beaver's *Roman Military Punishments* (1725) being closely modelled on Callot, while the plates in an edition of Butler's *Hudibras* (printed for D. Browne, 1726) show him merely adapting the anonymous illustrations in an edition published by John Baker (1709-10). Nevertheless the latter series, his most extensive achievement in book illustration, which went through many editions, did much to extend Hogarth's name.

Nearly all Hogarth's larger prints are strictly line-engravings, the foundation alone being laid in etching. Towards the latter part of his career, however, some of his more elaborated compositions were in etching, *e.g.* the two prints of *France and England* or the *Invasion* (1756), and one of his most excellent plates, the *Cock-pit* of 1759, where only a small part is done with the graver.

For several of his important works Hogarth executed small *subscription plates* entirely in etching, and some of these are far more incisive and convincing both in technical quality and in draughtsmanship than the works they represent. The *Laughing Audience* of 1733 (for the "Southwark Fair" and "Rake's Progress"), the *Rehearsal of the Oratorio of Judith*, of the same or following year, for the "Modern Midnight Conversation," and the *Characters and Caricatures* of 1743, for the "Marriage à la Mode," are the most noteworthy of these etched subscription tickets. Hogarth also etched a few portraits in this broader and less elaborated manner, notably the *Lord Lovat* of 1746. In his engraved portraits Hogarth seldom did more than the more important parts, e.g. *Garrick in the Character of Richard III.* (1746, assisted by C. GRIGNION), and *Hogarth painting the Comic Muse* (1749). Many of his portrait paintings or designs were engraved by BERNARD BARON (e.g. *Dr. Thomas Herring*, 1750).

Hogarth was neither a great engraver nor a great etcher. His line-engravings do not possess the soundness of technique and certainty of draughtsmanship required by that art at its highest, and it is only the smaller number of his etchings (such as the *Lord Lovat*) which are done with the freedom of touch, without which an etching has little inherent virtue. But though Hogarth's

achievement is only of secondary importance in the history of engraving and etching as such, he remains an artist whose special gift for dramatic situation and satire gives him a notable place in whatever medium he chose to express his genius.

The genius and achievement of THOMAS ROWLANDSON stands in marked contrast to Hogarth's. Trained in the Academy schools and afterwards studying for two years in Paris, a natural facility of composition was seconded by an unerring draughtsmanship. For a few years after his return from Paris he was exhibiting painting (historical and portrait) in the Academy (1775-81); but his love of irregular living led him to leave a field in which persistent effort was essential, and restrict himself to forms of art which were more compatible with his devotion to the gaming-house and tavern. We cannot imagine Rowlandson other than he is, and perhaps the very irregularity of his life is to be thanked for preserving the caricaturist of first water, where we might have had another portrait painter among so many.[1]

His earliest published caricatures date from 1774, and from the middle of the next decade there was a constant succession throughout his life. Most of his separate prints are good-humoured, if not always discreet, caricature of social life, designed with a full-blooded rotundity of form which with all its coarseness presents a constant charm of curve. He touched politics less than society, except when such a subject as the *Duchesses at the Elections* (1784) gave him a topic that could not but have its purely humorous appeal. Rowlandson seldom did more than the line-etching of these works, most of which were published tinted by hand, sometimes over an aquatint foundation. In the caricatures issued by S. W. Fores of Piccadilly, and by Rudolf Ackermann, these secondary parts are generally added with considerable skill; but we should beware of estimating Rowlandson's artistic power by the later prints published by Tegg of Cheapside, which are most lurid in colour, and often coarse in line and drawing.

The irresponsible Rowlandson was happy in finding a taskmaster like Rudolf Ackermann, a German settler who opened an establishment called the "Repository of the Arts" in the Strand, and who, from 1808 until his death in 1834, was indefatigable in the publication of illustrated books. Much of Rowlandson's work was first produced in his magazines, the *Repository of Arts* (Jan. 1809-28) and the *Poetical Magazine* (May 1809-12), the publisher either supplying the artist from month to month the copy which he was to illustrate, or as it happened in the case of the *Tour of Dr. Syntax*, an even more irresponsible journalist-author, W. Combe, producing each month the verses to illustrate the artist's etchings. Rowlandson is seen in his happiest mood in the *Tour of Dr. Syntax in Search of the Picturesque* (31 plates, 1812, 28 of which had

Rowlandson. (margin note)

Ackermann's publications. (margin note)

[1] He was also a landscape artist of a charming simplicity of style, but his original work in this field was chiefly in water-colour. His *Imitations of Modern Drawings*, issued between 1784 and 1788, include some excellent soft-ground etchings after Gainsborough landscapes.

appeared in the *Poetical Magazine*), with its supplements *Dr. Syntax in Search of Consolation* (24 plates, completed 1820), and *Dr. Syntax in Search of a Wife* (25 plates, 1821).

His other important works for Ackermann with Combe's text are the *Dance of Death* (72 plates, 1816), the *Dance of Life* (26 plates, 1817), and a final good-bye to his congenial collaborator in the *History of Johnny Quae Genus, the little Foundling of the late Dr. Syntax* (1822). In the *Vicar of Wakefield* (24 plates, 1817) he again had a congenial task, while most voluminous of his works are the *Microcosm of London* (completed in 3 vols., 1810; 105 plates

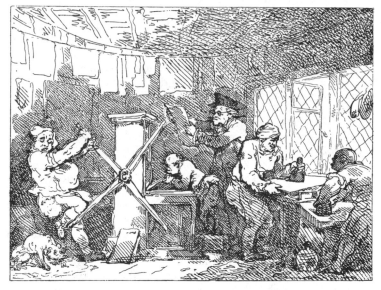

FIG. 88.—Thomas Rowlandson. Copper-plate Printers at Work.

designed in collaboration with Pugin), and the *World in Miniature* (42 vols., between 1821 and 1827; text by F. Shoberl). As in the case of the large caricatures, Rowlandson did nothing in these publications but the pure etching on the plate. These were then aquatinted by one of the many etchers[1] in Ackermann's employ, a proof was coloured by Rowlandson and the published impressions were coloured by hand with this as copy, seldom more than two or three neutral tones being employed in the printing, and probably never more than the one plate.

Gillray. JAMES GILLRAY is a far poorer artist than either Hogarth or Rowlandson, but as political satire of almost incomparable licence his work has a considerable historic value. As a man he was even

[1] *E.g.* J. C. Stadler, J. Bluck, T. Sutherland, and J. Hill.

less responsible than Rowlandson, intemperate habits inducing the imbecility by which the last four years of his life was darkened. Most of his work was issued by Miss Humphrey, the printseller of St. James Street,[1] who also afforded the artist lodging in her house. In his personalities Gillray showed more venom than any of his contemporary caricaturists (*e.g.* his *Alderman Boydell, or a Peep into the Shakespeare Gallery*, 1791), and, with his unbridled criticism of politicians in the stormy time of the French Revolution, it is no wonder that he sometimes provoked more than a passive hostility. Collected editions of impressions from his plates were published after his death, with descriptive text, in 1830 and 1851 (including some 582 numbers).

Among the more prolific of the draughtsmen of social caricature of the latter part of the eighteenth century one might mention H. W. Bunbury and Henry Wigstead, but as original etchers both may be left out of account. Bunbury was reproduced largely by JAMES BRETHERTON, who also published numerous satirical prints, in particular those of JAMES SAYERS[2] (or Sayer, as it is sometimes written). Sayers's etchings are amateurish enough in drawing, but in the political struggle between Fox and Pitt they played no inconsiderable part in the history of the time. *James Bretherton. James Sayers.*

One of the best of the caricaturists of the period was ROBERT DIGHTON. His numerous portrait etchings show delicate draughtsmanship, and an avoidance of excess in caricature, which was rare in his day. Unfortunately the man did not avoid excesses as a dealer and collector, having made a regular practice, between about 1795 and 1806, of deftly abstracting some of the most valuable prints from the portfolios in the British Museum. Happily the majority of these, including many of the Cracherode Rembrandts, were recovered on his detection, all of which may now be recognised by the letter D on a palette, the collector's stamp with which Dighton was brazen enough to decorate his acquisitions. Strange to say his activity did not seem to suffer any interval after this lapse, and both he and his son RICHARD DIGHTON continued their caricatures for several years later. *Robert Dighton. Richard Dighton.*

HENRY ALKEN deserves mention among the social cartoonists as the chief purveyor of sporting prints. His power as a draughtsman is not brilliant, but the very subject of his prints naturally secures their popularity in the English market. Alken himself etched in soft-ground the majority of his plates, which were often *Henry Alken.*

[1] She had also had addresses in the Strand, New and Old Bond Street. William Humphrey, the mezzotint engraver, was also a printseller (addresses 338 Strand, and Gerrard Street) and may have been a connexion.

[2] Not to be confused with a Robert Sayer, who published many caricatures (mostly anonymous, some by ROBERT DIGHTON) in 1792-93, after which he was succeeded by Laurie (the mezzotint engraver) and Whittle. This Robert Sayer was also a publisher of mezzotints, succeeding to P. Overton's stock in 1766.

coloured by hand. His prints were for the most part published by M'Lean of the "Repository of Wit and Humour" (26 Haymarket), as the establishment was christened after the model of Ackermann. One might mention, in particular, *Humorous Specimens of Riding*, 1821, the *Symptoms of being Amused*, 1822, and *A Touch at the Fine Arts*. 1824 (all in soft ground), while in the *National Sports of Great Britain*, 1821 (coloured aquatint), the design alone is by Alken. Another of his more famous books, "Nimrod's" *Life of a Sportsman* (with 32 etchings), was published by Ackermann in 1842.

Before leaving the field of caricature we would mention three more recent artists whose work finds a closer natural affinity with the traditions of the eighteenth century than with etching in its modern phase, *i.e.* CRUIKSHANK, LEECH, and KEENE.

George Cruikshank.

GEORGE CRUIKSHANK (b. 1792) was the son of a caricaturist of the type of Gillray, ISAAC CRUIKSHANK, and even before his twelfth year seems to have embarked on the career of etching in his father's vein. Both he and his elder and less-gifted brother ROBERT CRUIKSHANK [1] (who later did more book illustration of a miscellaneous description) assisted their father in etching and in colouring impressions, and sometimes a satisfactory distinction of their several work is difficult. George Cruikshank, however, developed a power of expression which has left the others completely in the background. He was an enormously prolific worker, some 5265 numbers (about half being etchings, the rest lithographs and woodcuts) being noticed in Reid's Catalogue. He cannot be said to take rank as an etcher. In fact, few of the caricaturists we have mentioned turned to the process for the sake of its special virtue, but regarded it merely as the most practical way of multiplying the designs of their pen or pencil. With all his astounding facility and preciseness of draughtsmanship, he seldom lacks the significant touch of the true artist and humorist. Amid the masses of his work which, as he himself entitled a series of his prints, are for the most part mere *scraps and sketches*, often jumbled together many on one plate, it would be idle to attempt any special citation. His delicate talent for caricature, tinged with a vein of romantic feeling, combined with a high imaginative faculty, produced in art an almost perfect embodiment of what Charles Dickens created in literature.

Phiz."

Another etcher, much influenced by Cruikshank, in whom Dickens lives again, is HABLOT KNIGHT BROWNE, or "Phiz" as he signed himself. His work is too well known to need description.

JOHN LEECH and CHARLES KEENE are of household fame as illustrators of *Punch*. Exponents of the lighter sides of character

[1] *E.g.* 68 aquatints in "Bernard Blackmantle's" (*i.e.* C. M. Westmacott's) *English Spy*, 1825, a regular mine of scandal of life at Eton, Oxford, and London. He worked with George in a similar book, Pierce Egan's *Life in London*, 1821.

and life rather than caricaturists, essentially early Victorian in the John Leech
and Charles
Keene.
harmless and unexceptionable nature of their subjects, they represent
a healthy reaction from the excessive coarseness of eighteenth
century wit. Most of their work was reproduced on wood, but
both etched a considerable number of plates (*e.g.* Leech : *Etchings
and Sketchings*, 1836, and both in *Mr. Punch's Pocket-Book* : Leech,
1844-59 ; Keene, 1865-75).

Keene set little store on the separate plates he etched during
his lifetime, and comparatively few impressions had got abroad
before a recent posthumous issue of twenty-one plates.[1] Most of
his plates (less than fifty, including the *Punch* prints) are single
figures or studies from everyday life, but there are a few landscapes
of exquisite feeling.

.

Apart from Hogarth, Rowlandson, and Gillray the art of etch-
ing in England during the eighteenth century is of little account.
Here and there painters etched a few unimportant plates, while
professional artists and amateurs alike reflected the general lack of
original inspiration by their copies and imitations of the old etchers.

JONATHAN RICHARDSON, the elder (1665-1745), a painter more Jonathan
Richardson I.
interested in his collections and his criticism than in the practice of
his art, etched a few portrait plates which are not without interest.
They are lightly executed with a delicate point, but in a fresh and open
manner of line which has entirely broken with the Hollar tradition.

THOMAS WORLIDGE (1700-66) was a far more prolific etcher, Thomas
Worlidge.
but except for his portraits his work has small artistic value. As a
portrait draughtsman he enjoyed considerable popularity in his day.
He is one of the very few etchers of the period who used dry-point
at all freely, but he possessed neither the boldness of touch nor the
certainty of draughtsmanship, without which the process leads merely
to woolly or unbalanced results. He made numerous copies
from Rembrandt etchings, notably one of the *Hundred Guilder
Print*, which bears his usual signature T.W. He is perhaps most
generally known for the collection of etchings after *Antique Gems*
(182 Nos.), which appeared in parts from about 1754, but was not
published in its entirety until after his death, by his widow in 1768.[2]

Three other English etchers of the eighteenth century whom we Benjamin
Wilson.
would mention were also copyists of Rembrandt, BENJAMIN WILSON.
and two amateurs, Capt. BAILLIE and the Hon. and Rev. RICHARD Richard Byron.
BYRON (a great-uncle of the poet). A few landscape plates by
Wilson and Byron in Rembrandt's manner are clever imitations,
which have not infrequently deceived the collector. Wilson's best
work in etching, as in painting, was in portrait, in which his style
closely resembles Worlidge.

[1] Ed. M. H. Spielmann, 1903. The original copper-plates used in this edition
are now in the British Museum.
[2] Copies are said to have been issued printed on satin.

Captain Baillie. Capt. WILLIAM BAILLIE, an Irishman who had fought at Culloden, and served in various campaigns on the continent of Europe, retiring early to hold an appointment of Commissioner of Stamps, did more etching than either of the preceding. Besides making several copies from Rembrandt etchings (of which the *Goldweigher* and the *Three Trees* are most frequently met with), he achieved fame by his restoration of the original plate of the *Hundred Guilder Print*, which had come into his possession. Impressions from the whole plate as reworked by Capt. Baillie, and from the four pieces into which he afterwards divided it, are by no means uncommon. Most of his work,[1] which numbers over a hundred plates, was done between his retirement from the army (about 1761) and 1787, but one or two of his more dilettantish performances date earlier, *e.g.* a portrait of *Corporal Jones* (? *John Golding*) of 1653. Comparatively little of his work is original, a great part in the crayon and stipple manners reproducing drawings in private collections (in particular that of the Earl of Bute). Considering the lack of early artistic training, and the real excellence of some of his work, especially his crayon engravings and mezzotints, he must have possessed much of Prince Rupert's ingenuity for processes.

The reproduction of drawings. The reproduction of old master drawings by means of etching, aquatint, line, and crayon engraving, was almost as popular in England as in France during the eighteenth century. We take this opportunity of referring in a note to a few works of the kind which are described in various sections of this book.[2]

The landscape etchers. The rise of an indigenous school of landscape painting in England in the second half of the eighteenth century and the beginning of the nineteenth century was the herald of a return to the best traditions of original landscape etching. In the hands of JOHN CROME of Norwich (who did some 44 plates, bearing dates between 1809 and 1813) the accomplishment was modest, and the mere sideplay of a painter, but it is sounder in principle than almost anything that had been produced in Europe for more than a century.[3] He is most at home with the soft-ground process, which so many of the water-colourists of the time used for the plates of their drawing-books.[4] In ordinary etching, his work is inclined to be thin and weak in its line, a fault not improved by poor biting and printing. Nevertheless his natural genius conquers the incompletely mastered medium, and in his landscapes and studies of oaks in particular he is scarcely second to Ruysdael or Rousseau.

The Norwich school : John Crome.

[1] A collected edition was published by Boydell in 1792 ; reissued 1803.

[2] Boucher, Caylus, etc. (p. 248), A. Pond and C. Knapton (p. 311), Earlom (p. 275), Bartolozzi (p. 291), W. W. Ryland and S. Watts in Rogers's *Prints in Imitation of Drawings* (p. 293), Massé, etc. (p. 368).

[3] Gainsborough is a brilliant exception with his few etchings and aquatints. His soft-ground etchings, *e.g.* the *Watering Place*, published after his death by Boydell in 1797, are among the earliest examples of the process.

[4] See Chap. IX. *Aquatint*, p. 303. Cf. also *Crayon*, pp. 288-9.

Crome himself, like many painters, did not much value his etchings, and the first public issue of any number did not occur until after his death (i.e. *Norfolk Picturesque Scenery*, Norwich, 1834; 31 plates).

The second great artist of the Norwich school, JOHN SELL

J. S. Cotman.

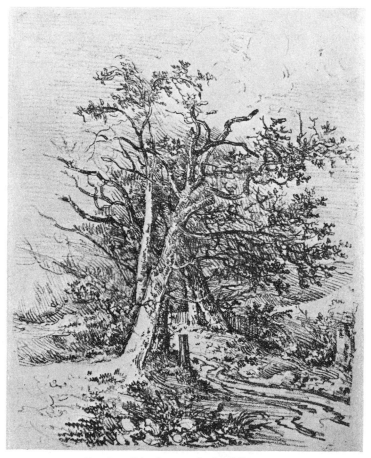

FIG. 89.—John Crome. Study of Trees.

COTMAN, probably did some of his soft-ground studies about the same time that Crome was etching, but they were not published until 1838 in his *Liber Studiorum*. Besides these, Cotman produced a large number of other etchings for various publications[1] of architecture and antiquities, chiefly between 1810 and

[1] E.g. *Architectural Etchings*, 1811; *Antiquities of Norfolk*, 1812-18; *Sepulchral Brasses of Norfolk*, 1814-19; *Specimens of Norman and Gothic Architecture in Norfolk*, 1816-18; Dawson Turner's *Architectural Antiquities of Normandy*, 1822.

1820 ; but though excellent of their kind they seldom rise, like those of his professed model Piranesi, from the category of archaeological illustration into being real works of art.

Perhaps the greatest achievement in soft-ground etching of this period is the series of *Twenty Views in Paris* etched by THOMAS GIRTIN in 1802 (very rare in this state), and completed by F. C. Lewis and others in aquatint.

Girtin.

The work of two Scotchmen (WILKIE and GEDDES) is of particular interest for its revival of dry-point.

Wilkie.

Sir DAVID WILKIE (whose etchings and dry-points, some thirteen in number, are dated between 1819-24) makes good use of the burr in plates like the *Man seated at a Desk*, but his etched work is of small importance in comparison with his painting.

Geddes

With ANDREW GEDDES, on the other hand, etching takes by no means a second place. Next to Raeburn he was one of the most prominent of the Scotch portrait painters in the earlier part of the nineteenth century, and it is chiefly in the field of portrait that he practised etching. The dry-point *Portrait of his Mother* (Fig. 90), which recalls Rembrandt's late work in the richness of its burr, reproduces a painting in the National Gallery of Scotland, and it is possible that Geddes repeated the subjects of his pictures in many of his other portrait plates. His few landscapes are again directly inspired by Rembrandt, and are quite remarkable at the period for their free and vigorous handling. His etchings (about forty in all) bear dates between 1822 and 1826, ten of them being issued by the artist in 1826.

E. T. Daniell.

A considerable number of landscapes in etching and dry-point, much in Geddes' manner, were done by a Norwich amateur, Rev. EDWARD THOMAS DANIELL, who must have enjoyed Crome's teaching in drawing while a boy at the Norwich grammar school. His prints, whose dates cover the years 1824-35, are excellent works, and anticipate far more nearly than anything of Crome or Cotman the modern revival of etching.

D. C. Read.

DAVID CHARLES READ, who passed the best part of his life as a drawing-master in Salisbury, is far more prolific than Daniell as an etcher, but his style is much less sound. His work, which includes some 237 numbers (done between 1826 and 1844) is almost entirely landscape. His interpretation of nature is strikingly unaffected for the time, but his drawing is often somewhat confused and meaningless, the tone being occasionally overloaded with roulette work (*e.g.* the *Stonehenge*). His best plates are the dry-points in which he has refrained from elaboration, but he does not use the medium with the power of either Daniell or Geddes.

J. M. W. Turner.

Among the landscape etchers of the early nineteenth century there still remains the most distinguished artist of all, JOSEPH MALLORD WILLIAM TURNER. His etching, done almost exclusively for his *Liber Studiorum*, dates from about 1807, *i.e.* two years before the earliest date on any plate of Crome, but we have reserved it

for later description, as its style remained almost without influence on the etchers whose work we have just been describing. There is good reason for this ; for his plates, in spite of their excellence, are not, in fact, true etcher's work. Turner merely used the etched

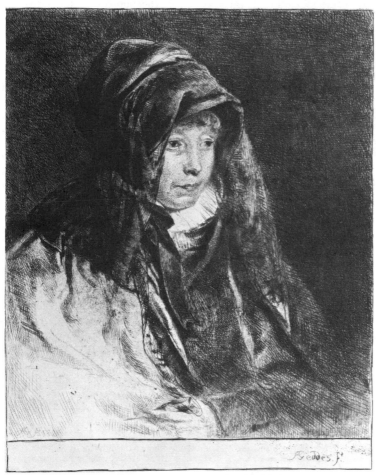

FIG. 90.—Andrew Geddes. Portrait of his Mother.

line as the skeleton, so to speak, of a subject designed to be finished in mezzotint. The *Liber Studiorum* had been projected by Turner in direct rivalry with Claude's *Liber Veritatis*, which Earlom had engraved and published in 1777. Claude's idea had been to safeguard himself against copyists by keeping a record on a small scale of the compositions of his pictures. Turner, on the other hand, aimed

The Liber Studiorum.

at an entirely original work, quite separate from his painting, which was to be a monument of the variety and strength of his genius for landscape composition.[1]

He made the drawings [2] for the most part in sepia,[3] etched the main outlines in vigorous line,[4] and then put the plate in the hands of some mezzotint engraver to finish the subject by the aid of his drawing and under his supervision.

Turner originally intended to include 100 plates in the work, but only 71 were published,[5] some 20 more plates being engraved or partially finished. F. C. LEWIS finished the first plate (R. 43) in aquatint, but this was his only plate, and Turner inclined thenceforward to the use of mezzotint, though aquatint is not infrequently found in combination. The other engravers who contributed were CHARLES TURNER (23 published plates, 1 unpublished), W. SAY (11 published, 2 unpublished), DUNKARTON (5 published plates), G. CLINT (2 published plates), J. C. EASLING (frontispiece, 3 plates alone, and 1 in collaboration with Annis), W. T. ANNIS (1 alone), S. W. REYNOLDS (2 published plates), T. HODGETTS (3 published plates), H. DAWE (4 published, and possibly several of the unpublished plates), T. LUPTON [6] (4 published, and 2 unpublished plates), and finally 10 of the published plates and some of the unpublished were mezzotinted by J. M. W. Turner himself.

One of the most powerful of the plates entirely done by Turner, the *Junction of the Severn and the Wye* (R. 28) is reproduced in its early etched state (showing signs of the mezzotint rocker in places) in Fig. 91. In three instances the etching was done in soft ground, *i.e.* R. 70, 90, and 91, the two latter not being carried beyond this stage. The *Liber* was issued in fourteen parts (each containing five plates) between 1807 and 1819, but was then relinquished for lack of success. Some of the drawings, which were not reproduced at the time, have been recently engraved with

[1] In the words of the prospectus issued in 1807 it was *intended in this publication to attempt a classification of the various styles of landscape, viz. the historic, mountainous, pastoral, marine, and architectural.* The respective styles are indicated in the prints by the capital letters in the centre above, H, Ms or M, P, M, A. EP occurs on several of the more imposing pastoral subjects, and probably means *Elevated Pastoral* (*Epic* and *Elegant* are other suggestions).

[2] The greater part are now in the National Gallery.

[3] Contrast Chap. VII. p. 222.

[4] In certain numbers the inscription only claims the drawing for Turner. The majority are inscribed *drawn and etched by J. M. W. T.*, but even here Seymour Haden and Drake attempt a differentiation between those which they regard as entirely etched (*i.e.* bitten) by the master, and others in which the quality seems to show that he only opened the ground with the etching needle preparatory to biting. It is only natural to suppose that the exact amount done by the master, and the extent of supervision given to his engravers, would vary according to the circumstances of each plate in the course of so arge a work.

[5] *I.e.* Frontispiece and 70 plates (Rawlinson's Catalogue, 1-71). In addition to the unpublished plates (R. 72-91), 8 drawings of other subjects for the work are known, which were not engraved at the time (R. 92-99).

[6] He also engraved facsimiles of 17 of the plates of the *Liber* between 1858 and 1864. Cf. p. 283.

no less power than is seen in the best of those by Turner's contemporaries, by FRANK SHORT. Mr. Short has also made copies of some of the plates, a considerable number being after those which were left unpublished in 1819. It may be added that another of the drawings (*Mill near the Grande Chartreuse*, R. 54) was twice etched by SEYMOUR HADEN (Drake 49 and 50).

The reworking of the plates as they became worn in the printing seems to have been done entirely by Turner himself, and the later impressions preserve a comparatively greater artistic value than they would do in the ordinary course, on that account. It is still, how-

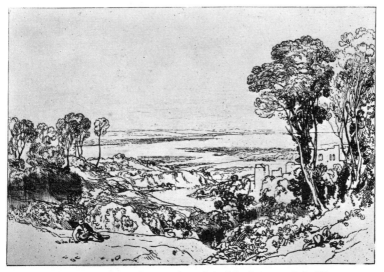

FIG. 91.—J. M. W. Turner. Junction of the Severn and the Wye, from the *Liber Studiorum* (proof state).

ever, the early engraver's proofs, and only the earliest of the published states,[1] which show the delicate mezzotint burr in all its richness.

In the Netherlands the eighteenth century was as barren in THE NETHER-original etching as the preceding period had been rich. Her inspira-LANDS. tion was exhausted with a splendid activity, and her artists were living in the past, copying and imitating with skill, but breaking no new paths, and expressing few fresh ideas. In the latter part of the century HENDRIK KOBELL caught something of the freshness of Hendrik the older masters in his landscapes and marines, while his son JAN Kobell. KOBELL II.,[2] who was working in the first decade of the nineteenth Jan Kobell II.

[1] The states are indicated by a variety of small marks, generally the addition in margin of (*a*) a dot or dots ; (*b*) lines ; (*c*) lines connecting the dots, making in some cases small figures like H or A ; (*d*) dot in circle of letter of classification above, or initial letter of title. These marks generally begin with the second state.

[2] H. and J. K. belonged originally to the same family (of Frankfurt extraction) which produced similar archaising etchers at the same period in Germany.

century, showed himself an apt imitator of Paul Potter in his etchings of animals.

John Chalon.

More exclusively mere imitators are JOHN CHALON, who worked sometime in London and made numerous copies and imitations of Rembrandt and his school, and JOHANNES JANSON of Leyden. The latter, and his sons JOHANNES CHRISTIAN JANSON and PIETER JANSON, produced a considerable number of landscapes with animals, chiefly copied or imitated from A. van de Velde, Carel du Jardin, and the like.

Johannes, Johannes Christian, and Pieter Janson.

L. B. Coclers.

An etcher of greater originality, who used dry-point and soft ground as well as ordinary etching, is LOUIS BERNARD COCLERS. His style is comparable to that of Worlidge, and some of his plates of genre and portrait (*e.g.* one of *Johannes Janson*) are quite excellent and spirited in handling.

GERMANY.

In our chapter on the "Masters of Etching" no word was spoken of German etchers, if we exclude Hollar from this category. Etching played so small a part in Germany during the seventeenth century, that we have reserved allusion to it in introducing the work of the succeeding period.

Jonas Umbach.

JONAS UMBACH (1624-1700) of Augsburg was one of the more independent of the etchers of the time. He produced many small plates of landscape, and of Scripture illustration, but the most charming side of his talent is seen in his *Bacchanals* and other mythological subjects, in which he affects Guido Reni's delicate manner of etching.

J. F. Beich.

JOACHIM FRANZ BEICH is another etcher at the turn of the century who was influenced by work produced in Italy. His landscapes savour of Claude and the school of Poussin at Rome. A more powerful artist, whose inspiration also came from Italy, is

C. B. Rode.

CHRISTIAN BERNHARD RODE (1725-97) of Berlin. His numerous plates, many of large dimensions, illustrating history, Scripture, mythology, and various subjects, show an imitator of Tiepolo, though their diffuseness and lack of grip are more reminiscent of Castiglione.

J. W. Baur.
M. Scheits.

Followers of Northern models were the etchers JOHANN WILHELM BAUR (1600?-1642) and MATHIAS SCHEITS of Hamburg (about 1640-1700), the former closely influenced by Callot, the latter working in the manner of Ostade. Somewhat comparable to Baur is JOHANN ULRICH FRANCK of Augsburg, whose etchings of soldiers are rough, but full of life.

J. U. Franck.

J. H. Roos.

During the latter part of the seventeenth century Germany had a capable representative of animal etching in JOHANN HEINRICH ROOS,[1] who had come under the influence of the Dutch etchers both in Amsterdam and Italy, before settling in Frankfurt. Animal etchers of much more indigenous character are the Augsburg

[1] A Vienna etcher of the same surname, JOSEPH ROOS, etched a few plates of animals in a very similar manner about a hundred years later.

painters GEORG PHILIPP RUGENDAS and his pupil JOHANN ELIAS G. P.
RIDINGER. The former worked as a battle-painter, but the etchings of Rugendas.
both consist largely of animals and hunting scenes. For the sports- J. E.
man and the lover of game they may possess a certain interest, but Ridinger.
their artistic value is a negligible quantity, so dull and lifeless is their
draughtsmanship. Ridinger was a most prolific etcher, and both he
and Rugendas also produced a considerable number of mezzotints.

German etchers in the eighteenth century were for the most
part without individual style, and were content to repeat badly what
had been done greatly by the Dutch the century before. CHRISTIAN
WILHELM ERNST DIETRICH of Dresden was the leader of the C. W. E.
archaisers alike in painting and in etching, and many a picture Dietrich.
produced in his school has long passed under names such as
Rembrandt and Ostade. His etchings are numerous, and, like
those of the line-engraver G. F. Schmidt, are mostly modelled on
Rembrandt.

Of the landscape archaisers and imitators, FRANZ EDMUND F. E.
WEIROTTER is most successful when he keeps to plates of the Weirotter.
small dimensions, to which his delicate and clearly etched line is
fitted. Only a small number of his prints are directly after Dutch
originals ; but almost all his work, though strictly independent in
composition, is reminiscent of the simpler type of Dutch landscape,
such as that of Jan van Goyen and Pieter Molyn.

Berchem finds a prolific imitator of his landscape in FERDINAND Ferdinand and
KOBELL[1] of Mannheim, while the latter's son, WILHELM KOBELL, Wilhelm
followed Berchem and Du Jardin in his plates of animals, which are Kobell.
slight but not without spirit.

A modest, but nevertheless more individual place is held by the Salomon
Zurich amateur and author SALOMON GESSNER. His etchings of Gessner.
idyllic landscape are feeble enough in figure drawing, and scarcely
pleasing in their dotted manner of rendering foliage (like Roghman),
but they possess a genuine atmosphere of their own, which finds its
nearest analogies in the sentiment of Blake, Calvert, and Samuel
Palmer. Almost all his plates were done to illustrate his own
writings, e.g. *Contes Moraux*, Zurich, 1773, *Schriften*, Zurich, 1777-78
(the first volume being the *Contes Moraux*), and numerous other
editions. A considerable number of his small prints were also
published in the *Helvetischen Calendern* of Zurich (between
1780 and 1788).

German and Austrian etching present little more of interest until
the revival of the art in the nineteenth century, and the movement
was felt considerably later here than in France or England. There
is no lack of large, dull landscape work, in a stiff manner, on the
borderland between etching and engraving, *e.g.* that of JACOB
PHILIPP HACKERT and J. L. E. MORGENSTERN, but almost all the
work of the school is best consigned to oblivion.

[1] Cf. above, p. 245, footnote.

Adam von Bartsch.

We cannot leave the German and Austrian etchers without some reference to ADAM VON BARTSCH (1757-1821), who for some years before his death was Director of the Imperial Print Collection at Vienna. As an engraver, he is chiefly known for numerous plates in line, etching, and crayon after prints and drawings by old masters. His real fame, however, rests on his numerous catalogues of engravers, and above all on the great work, *Le Peintre-Graveur*, which appeared in 21 volumes between 1803 and 1821. Despite the absence of scientific criticism and of reference to locality of prints, and many lacunæ which are explained by the limited basis of its material,[1] the work still forms the central foundation of iconography.

FRANCE.

Etching in France during the eighteenth century was to a large degree merely the transference of drawings to copper, in a manner imitating all the peculiar qualities of the pencil, pen, or chalk. We mentioned in the preceding chapter the great publication of Watteau's work by the amateur JEAN DE JULLIENNE.[2] Two of the four volumes of this work (*Figures de différents caractères de paysages et d'études dessinées d'après nature*) were entirely devoted to the reproduction of the master's drawings. Pure etching is seldom used, the bitten line being almost always sharpened and reinforced with the graver. Of the 350 plates, some 125 are the work of the then young FRANÇOIS BOUCHER, while JEAN AUDRAN, BENOÎT AUDRAN II., COUNT CAYLUS, and several others beside JEAN DE JULLIENNE himself, are responsible for the rest.

Jean de Jullienne.

J. Audran.
B. Audrán II.
Count Caylus.

Boucher.

One of Boucher's plates is reproduced (Fig. 92), and shows how excellently he preserved the quality of Watteau's drawing. Jullienne's publication contains the greater part of Boucher's etched work, but there are some fifty or sixty more stray plates of figure and fancy subject.

Antoine Watteau.

ANTOINE WATTEAU himself etched a few figure studies in a similar manner, but they are of slight importance (e.g. *Figures de modes dessinées et gravées à l'eau-forte par A. Watteau et terminées par Thomassin lé fils. Chez Duchange. . . .* Front. and 11 plates, occurring in the Watteau Corpus of the British Museum).

Caylus, and the reproduction of drawings.

In the reproduction of drawings the archaeologist[3] and amateur COUNT CAYLUS was by far the most prolific worker of the time. Some three thousand etchings and engravings after drawings in the Royal and private collections of France are from his hand, and though scarcely true enough in reproduction to satisfy the modern student, they at least form a most valuable record of scattered works. The etchings which he contributed to the *Cabinet Crozat*[4] (1729) are

[1] The collections of Vienna formed its chief groundwork, though Paris and numerous German collections must have also contributed.

[2] See pp. 200-1, and notes.

[3] His great work in this capacity is the *Recueil d'Antiquités*, 7 vols., Paris, 1752-67 (the plates by himself).

[4] Cf. Chap. VII. p. 202.

in many cases combined with tone printed from several wood-blocks in the chiaroscuro method by Nicolas Le Sueur.[1]

Two pupils of the painter Lemoyne, CHARLES NATOIRE and Charles Natoire.

FIG. 92.—François Boucher. Study of a Woman's Head, after Watteau.

CHARLES HUTIN,[2] approach Boucher's light manner most nearly in Charles Hutin.

[1] Cf. Chap. IX. p. 310. A similar combination occurs in the title-page to Caylus's collection of etchings after Leonardo da Vinci (*Recueil de Testes de Caractères et de Charges*, 1730). [2] C. H. settled in Dresden in the latter part of his life.

their etchings of figure and fancy, while an even more exquisite refinement of light and line is seen in the slighter studies of **J. H. Fragonard.** Boucher's pupil JEAN HONORÉ FRAGONARD. Fragonard stands as the chief French representative of the rococo love for white lights, and in his etching follows the aims of Tiepolo, with a reminiscence of Baroccio's system of light line and dot.

The amateurs. Unfortunately the best painters of the time, like Fragonard himself, treated etching more as a plaything than a serious branch of their art. It was the fashion with the artistic society of the **Marquise de Pompadour.** period, set at Court by the MARQUISE DE POMPADOUR, to dabble with the etching needle, and the result was a host of third-rate copyists and archaisers, and the minimum of serious production. The Marquise herself was a pupil of Boucher, and shows considerable talent in her careful etchings of the vignette order, though she may have left a good deal in the hands of her able assistants (e.g. a frontispiece to Corneille's *Rodogune*, etched by the Marquise after a design by Boucher, and retouched by C. N. Cochin).[1]

Vivant Denon. Beside the Marquise de Pompadour and Count Caylus, the most distinguished French amateur etcher of the eighteenth and the early nineteenth centuries was Baron DOMINIQUE VIVANT DENON, who, as General Director of the Paris Museums (until 1815), was entrusted by the Emperor Napoleon with the selection of the works of art which were collected from every conquered territory for the Musée Napoléon. His numerous etchings[2] are for the most part copies and imitations of drawings and etchings of all schools, a large number being based on Rembrandt.

Archaisers. Work of a similar order, including numerous good copies of plates by Rembrandt and other prints of the Dutch school, was done **J. J. de Claussin.** by another amateur, J. J. DE CLAUSSIN, the author of a catalogue of Rembrandt's etchings. Another imitator, but one of considerable **J. P. Norblin.** individuality in his method of expression, is JEAN PIERRE NORBLIN, a pupil of the Dresden Academy, who was settled for some years as Court painter in Warsaw before returning to his native country. The model for his style is the delicate etching of Rembrandt's little *Christ among the Doctors*, of 1630; and he combines an exquisite sense for line with a subtle understanding of the effect of chiaroscuro in plates of miniature dimensions.

Landscape. Of original landscape etching there is little of note at this period **A. Manglard.** in France. ADRIEN MANGLARD (1695-1760), the author of some fifty plates of marines, and of landscape somewhat in the style of Adriaen van der Cabel, is of more interest as master of CLAUDE

[1] Basan published an edition of her plates in 1782. The greater number (fifty-two) are *d'après les pierres gravés de Guay* (etched about 1750).

[2] A few original etchings occur in his great work, *Voyage dans la basse et haute Égypte pendant les campagnes du Général Bonaparte* (Paris, 1802), but the majority of the illustrations are engravings after his drawings. His *Monuments des Arts du Dessin* (Paris, 1829), a noble record of his collection, is entirely illustrated in lithography.

JOSEPH VERNET, the most famous of French painters of marines. Claude Joseph
Vernet himself is of no importance in the field of etching, only a Vernet.
few slight landscapes being attributed to him.

The only French etcher of landscape to be reckoned with during J. J. de
the eighteenth century is JEAN JACQUES DE BOISSIEU of Lyons. Boissieu.
He is one of the very rare French artists who, after studying in
Paris, have rejoined their local school. A certain provincial dull-
ness and a lack of brilliant characteristic in his work cannot be
gainsaid. Most of his somewhat large landscapes are original, but
all have the appearance, which probably does not belie the fact, of
being etched after his own pictures. He was essentially an eclectic
in this branch of art, imitating now Ruysdael, now Du Jardin, now
Claude, after each of whom he also made some etchings. His
most individual work lies in his plates of subject and genre, and
in his studies of heads. In the larger *Cellarers* (1790), and in the
Two Hermits (1797), he shows a powerful sense of chiaroscuro,
using the somewhat unique method of crossing and interlacing his
more heavily etched lines with fine dotted and roulette work, which
adds force to the contrast of light and shade. Less elaborated
than the two we have mentioned in its lineal method is the *School-
master* (1780), but it is quite the most convincing of his subject
plates.

Before leaving the French etchers, we would just mention the J. A. D.
only etching known by the hand of the great classical painter, JEAN Ingres.
AUGUSTE DOMINIQUE INGRES. It is a half-length portrait of
Gabriel Cortois de Pressigny, French Ambassador at Rome, and
later Bishop of Besançon, and is dated 1816 in Rome. In the
rendering of figure and hands it is somewhat stiff, but the etching
of the head shows a simplicity and conviction of draughtsmanship
which form a true anticipation of the best work of Legros.

<p style="text-align:center">.　　.　　.　　.　　.</p>

Only one Spanish etcher has hitherto been noticed, *i.e.* José SPAIN.
de Ribera, and his activity chiefly centred in Naples. In Spain
itself there is little etching of importance during the seventeenth The seven-
century, but what there is possesses a distinct character of its own, teenth century
showing for the most part a system of lineal shading intermingled
with dot, which may to some extent be derived from Ribera. On
the other hand, the Dutch and Flemish influence, which had been
encouraged by the political relations between Spain and the Low
Countries, is unmistakable. The mixed manner of Soutman,
Suyderhoef, and Sompel is adapted by the Spanish etchers to some-
thing of the lighter touch of the school of Reni, while there is an
evident tendency to imitate the hazy softness of Murillo's style. The
two great Spanish painters of the period, Velazquez and Murillo, do
not appear to have left any etchings, nor were their works reproduced
to any extent until the eighteenth century. CLAUDIO COELLO Coello.
(1621-93) is responsible for at least one plate (the title-page to

Augustin de San Ildefonso's *Theologia Mystica Sciencia*, 1683, but the best of the work of the seventeenth century, only enough to throw into relief the barrenness of the period, is that of MATHIAS ARTEAGA (a few portraits and architectural plates), JUAN DE VALDES LEAL (architectural, etc.), JOSÉ GARCIA HIDALGO (*e.g.* illustrations of anatomical proportions in his rare book on Painting, *Principios para estudiar la nobilissima arte de la Pintura*, Madrid, 1691), and JOSÉ MARTINEZ (*e.g.* a good portrait of *Mathias Piedra*, dated 1651).

During the early part of the eighteenth century the style of Michel Dorigny made itself felt in Spain, but it was only in line-engraving that French art exerted any lasting influence in Spain. With the advent of Tiepolo in Madrid in 1762, the Italian school was again in the ascendant.

As belonging to the former category one might mention J. B. CATENARO, who worked about 1700 in a light manner, midway between that of Reni and the French etchers of Dorigny's school, while the style of Tiepolo is already dominant in JOSÉ DE CASTILLO (*e.g.* after Luca Giordano) and in RAMON BAYEU Y SUBIAS. The last named etched a few plates after Ribera and Guercino, but most of his work was either after his own paintings or those of his better-known brother, Francisco Bayeu, who was one of Mengs's chief collaborators in Madrid.

But there is no Spanish etcher from the time of Ribera to the last quarter of the eighteenth century who deserves more than a passing notice. Then in FRANCISCO GOYA we meet one of the great names in the whole history of etching, as it is in that of painting. Like Bayeu, whose sister he married, Goya was inspired by Tiepolo, but except in his early works he owed little but the mere suggestion of his technical system to the Italian. He developed a most striking independence of style, and with it attained to a more typical expression of the sentiment of his country than any other artist, before or since, not excluding Velazquez. He is the most cutting of all satirists, combining an almost animal fancy with a certain demoniacal blackness of malice against convention and authority, which is scarcely surprising in a country which had so long known the Inquisition [1] at its worst. In his later years this phase of his temperament may have been increased by the bitter isolation consequent on almost total deafness.

Goya's plates are almost entirely bitten, dry-point occasionally being used to strengthen the etched lines. He constantly uses the combination of an aquatint grain with his line, and he still stands as

Side notes:
M. Arteaga.
J. de Valdes Leal.
J. Garcia Hidalgo.

J. Martinez.

The eighteenth century.

J. B. Catenaro.

J. de Castillo.
Bayeu y Subias.

Francisco Goya.

[1] A plate with the *Inquisition* as its subject is cited by Piot, *Cab. de l'Amateur*, 1842, and by L. Matheron, Paris, 1858, but no impression is known to recent writers on Goya. The Inquisition seems to have been intent on suppressing the *Caprichos*, which gained immunity by being acquired by the State ; perhaps success attended its efforts in the case of the plate illustrating its own institution.

one of the greatest virtuosi of an art which had only been introduced a few years before his work commenced.[1] Of his earlier etchings only the smaller proportion were aquatinted in their later states. In his later work, on the other hand, it is the rarest thing to find early states before the addition of the aquatint grain. From the studies which exist for several of his plates we see that his work was from the first conceived in light and shade, and to this end he set himself to develop the possibilities of aquatint in expressing the subtlest gradations of tone, no doubt choosing this method rather than mezzotint for the transparent luminosity, through which all his lines might have full play.

Among the earliest of Goya's etchings are the plates after Velazquez (about sixteen in all, e.g. *Philip II.* and *III.* and *their Queens, Aesop*, etc.), dated for the most part in 1778. In these, and in another subject of the same period, the *Street Musician* (Lef. 248 [2]), his line is essentially in the manner of Tiepolo, and in the last-named plate the whole structure of the composition in the form of a triangle follows the same model.

The earliest work in which Goya shows complete independence Caprichos. is the set of *Caprichos*, seventy-two of which were produced between 1793 (94) and 1796 (97). In 1803 the plates, together with 240 impressions of the series (by that time brought up to eighty in number), were acquired by the King for the Calcografia Nacional. It seems very questionable whether there was ever, strictly speaking, an edition of the seventy-two plates in 1796-97, as has till recently been supposed. Probably only separate impressions had got into commerce before 1803, so that the first collected edition may perhaps be regarded as belonging to this date. In 1806 another edition is said to have been made under the direction of the engraver Rafael Esteve, so that the 240 impressions received from Goya were apparently exhausted within the three years. Since that time there have been three fresh editions, in 1856,[3] 1868, and in 1892, issued on a thin Japanese vellum, while the earlier editions had been printed on stouter and more opaque paper. Like every satirist before and since, Goya of course denied all intention of personalities, affirming that he merely chose subjects by which the prejudices, hypocrisies, and impostures consecrated by time might best be stigmatised and turned to ridicule.[4] Without giving him credit for being less human than his brother-satirists, we need not be detained

[1] See Chap. IX. p. 300.

[2] The composition corresponds to one of the cartoons for tapestry which Goya made in his early period.

[3] Without the portrait of Goya, which had been used in the 1855 edition of the *Tauromaquia*. It may be remarked that there are three unpublished plates of *Caprichos*, which were done for the Duchess of Alba, in the National Library, Madrid.

[4] The MS. once in Valentin Carderera's collection; see *Gazette des Beaux-Arts*, xv. p. 240.

by the commentaries of certain of Goya's contemporaries,[1] which

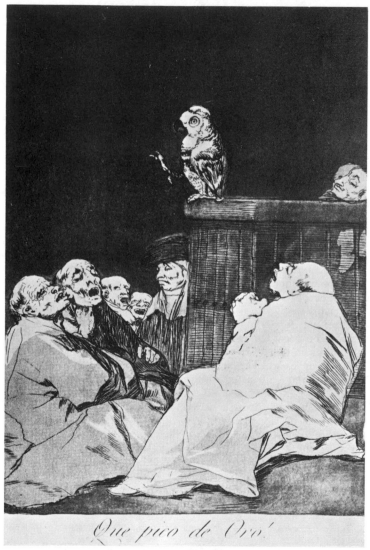

FIG 93.—Francisco Goya. From the *Caprichos* (Plate 53).

have fixed Godoy, Prince de la Paix (*e.g.* Plate 37), Godoy's

[1] See Lefort's Catalogue (1877), and Conde de la Viñaza, Madrid, 1887, p. 134.

surgeon Galinsoya (Plate 40), his painter Carnicero (Plate 41), the Duchess of Alba (Goya's patroness and more than friend), and many other personages of the Court in the pillory. Goya's own commentary[1] unfortunately does little more than adduce further generalities. If there is one butt at which he is never tired of launching his shafts, it is ecclesiasticism.

In the same vein of satire are the eighteen plates of the Proverbios. *Proverbios* (or *Disparates*, "Follies," as Goya called them), which were probably done for the most part between 1810 and 1815, though they were first publicly issued in a series in 1864 (by the Academy of San Fernando). A small number of impressions had been taken from the plates (before the addition of the numbers) by their private owner in 1850.

Later editions, of little artistic value, have been made in 1891 and 1902. Lefort was of opinion that the aquatint of this series was the addition of a later hand. But as he only knew impressions in pure etching of eight of the plates, and considering the similarity in quality in the aquatint to his other work, it is probable that he was mistaken. No commentary on this series is preserved, and for the most part the point of the satire is more obscure than in the *Caprichos*.

Nothing in art reflects with more terrible emphasis the horrors Desastres de of war than the eighty-two plates of Goya's *Desastres de la Guerra*, la Guerra. which were etched at the time of the French occupation (the only three bearing dates belonging to 1810), but not published until 1863. The edition then published by the Academy of San Fernando (of which Goya had been Director) contained eighty plates, the remaining two, which were in Lefort's collection, never having been included. A second edition was issued in 1892 (in which the *Academia de Nobles Artes* of the title-page of the first edition now figures as *Academia de Bellas Artes*), and unfortunately the Calcografia Nacional at Madrid seems still bent on publishing bad impressions from the much worn plates (*e.g.* editions in 1903 and 1906).

Aquatint is a less important factor in the *Desastres* than in any of the other series of Goya's plates, twenty-eight of the plates being in pure etching, sometimes slightly worked with dry-point.

It is a strange situation, this of the intellectual rebel reaching the coveted position of chief painter to the Spanish Court in the

[1] Once in Carderera's collection (now in the Prado, Madrid). Only a French paraphrase of extracts from it has been published (see Lefort's Catalogue). For another, apparently later, commentary by the artist, see Yriarte, *L'Art*, ii. (1877) p. 37. As an example of the Lefort's paraphrase I cite an extract referring to the plate reproduced (Fig. 93) : *Ceci ressemble quelque peu aux réunions académiques. Qui sait si ce perroquet ne parle pas médecine ? Que l'on n'aille pas toutefois l'en croire sur parole. Il y a tel médecin qui quand il parle, parle d'or et lorsqu'il écrit une ordonnance est quelque chose de plus qu'un Hérode. Il discourt admirablement des maladies, mais ne les guérit pas. Enfin, s'il ébaubit son malade, il peuple en revanche les cimetières de cadavres.*

very face of the *Caprichos*, which disclose a man who did not shrink even from the satire of Royalty. But the time of Charles IV. was analogous in its reaction against the severity of the reign that preceded it, to that of Charles II. of England, and the satirist is seldom silenced in a period of moral licence. Goya did not scruple to retain his position at the sacrifice of his loyalty to his king, and on the success of Napoleon's invasion, yielded allegiance to Joseph Bonaparte (1808). On the restoration of 1814, Goya still adroitly kept his seat, and though branded by Ferdinand VII. as worthy of the garrotte, he was none the less allowed to retain the position of Court painter. It was not until some ten years later (1824) that Goya thought fit to solicit the king's consent to retire from Madrid, spending most of the last four years of his life in Bordeaux.

Tauromaquia. The last series of etchings we have to mention is the *Tauromaquia*, thirty-three plates illustrating the Spanish national sport. Here Goya was on safe ground, and himself made a public issue in a small number of impressions about 1815, with the title *Treinta y tres estampas que representan diferentes suertes y actitudes del arte de lidiar los Toros*. In the second edition, published by the Calcografia Nacional in 1855, with the portrait of Goya from the *Caprichos*, the title runs, *Coleccion de las diferentes suertes, etc.* About 1876 they reappeared, with seven additional plates, in a Paris edition (*La Tauromachie, recueil de 40 estampes*, etc. : Loizelet, Paris, n.d.), the first two plates showing rework with the roulette to restore the worn aquatint grain.

The series we have described, with the prints after Velazquez, almost complete Goya's etched work. Some half-dozen separate subjects are of no great importance, and contribute nothing to the formation of an estimate of his genius.

As a satirist he may be misanthropic and bitter, completely lacking in the *bonhomie* which takes all evil taste from the work of so much of the coarsest of English caricature, but in the unflinching courage with which he probes right to the heart of social rottenness he proves himself the true satirist who battles with abuses, not the mere degenerate social historian such as one will meet later in Rops.

In the *Tauromaquia* satire is left on one side, and it is in these plates that Goya's individual genius in the art of composition pure and simple can best be studied. Plates such as No. 16 (*Martincho vuelca un toro en la plaza de Madrid*) show a brilliance in concentration, a command of spacing, an unfailing grasp of the mysterious power of a veil of light and shade, that place them at once among the greatest triumphs of art.

CHAPTER IX

THE term TONE PROCESSES may be fairly applied to denote all those methods of engraving which aim at the achievement of a surface of tone corresponding either to washes of colour, or to the surface texture obtained by chalk, pencil, or similar means. Although engraving, etching, and dry-point do occasionally attempt the same problem, it may be taken as a general principle that they should not aim at hiding the line, which is the essential factor that rules their conventions. The etcher, moreover, will often leave ink on the surface of the plate to add tone to his impressions; but this, of course, is rather an accident than a property of the method. It is, perhaps, no mere coincidence that, just at the time when Rembrandt was beginning to turn to the problems of chiaroscuro in etching (*e.g.* in his *St. Jerome* of 1642), which he realised most wonderfully in the *Descent from the Cross* of 1654, and several other plates of the same period, an amateur living in Amsterdam discovered the process which stands at the head of all the methods of chiaroscuro engraving, that of mezzotint.

The fifteenth and sixteenth centuries had seen little accomplished with the same end in view, except in the form of the "chiaroscuro" cuts, which were printed from several wood-blocks in ink of various shades. There are isolated engravers like GIULIO CAMPAGNOLA and OTTAVIO LEONI, who obtained their delicate modelling by short flicks and dots, in a manner anticipating that of stipple; there are, again, goldsmiths such as the KELLERDALLERS of Dresden, who at the end of the sixteenth and in the early seventeenth century achieved similar ends by the use of punches; but there was no sustained effort along these lines until the invention of mezzotint engraving. Later developments, all working towards similar ends, are the processes of AQUATINT and STIPPLE, while the CRAYON-MANNER may be allowed to come within the field of our definition, as the aim is still the imitation of surface texture, although to some extent limited to the texture of lines of various breadth.

After reviewing the history of each process, we shall conclude

with a summary of the development of colour printing, which has been chiefly applied to these methods.

I. Mezzotint

John Evelyn, who is the first writer to refer to mezzotint, has unfortunately done little but cast a veil of mystery over the early history of the art. The spirit of the courtier is perhaps responsible for the flattery which made him head his notice, *Of the New way of engraving, or Mezzo Tinto, invented and communicated by his Highnesse Prince Rupert,* without a mention in what follows of its real author, Ludwig von Siegen.[1] The notice itself is tantalising in what it conceals. After relating how his Highness had communicated to him the art,[2] *causing the instruments to be expressly fitted to shew me with his own hands, how to manage and conduct them on the plate,* in spite of having obtained the Prince's permission to publish the whole matter, he *did not think it necessary that an art so curious and (as yet) so little vulgar . . . was to be prostituted at so cheap a rate as the mere naked describing of it here would too soon have expos'd it to,* and so chose to leave it *aenigmatical.* Finally, he expresses readiness to demonstrate the entire art to gratify any curious,[3] *if what I am preparing to be reserved in the Archives of the Royal Society concerning it, be not sufficiently instructive.*

Apparently no memorandum of the kind reached the Royal Society : renewed search has at least failed to bring the same to light.[4] But a reference to a similar manuscript, probably the one in question, as being in private hands between 1734 and 1741,[5] which

[1] *Sculptura,* 1662, p. 145. W. Vaillant's portrait of the Prince, inscribed *Prins Robbert, vinder van de Swarte Prent Konst,* may also have something to do with the error, continued by Walpole, which Heinecken (*Idée Générale,* 1771, pp. 208 and 233) was the first to refute. Sandrart, who was in Amsterdam 1637-44 (45), and may have known Siegen personally, knew the true facts of the case, except that he gives 1648 instead of 1642-43 as the date of the *Amelia Elizabeth* (see *Teutsche Academie,* Nuremberg, 1675, Pt. I. p. 101).

Sir CHRISTOPHER WREN is another for whom the honour of the invention has been claimed (see S. Wren, *Parentalia,* 1750, p. 214). In the passage in the *Parentalia* a print of a *Moor's Head* is mentioned as his work. The claim may be merely a mistaken inference from an entry in *Journal of the Royal Society,* Oct. 1, 1662 (quoted by Birch, *Hist. of the R.S.*), but there is no reason why he should not have made essays in the new art, possibly seen in the two *Negro Heads* in the British Museum. Chelsum (p. 15) states that the passage in the *Parentalia* is extracted from preface of Dr. Hooke's *Micrographia.* But I fail to find anything of the sort in either the 1665 or 1667 editions of that book.

[2] Cf. Evelyn's *Diary* for Feb. 21 and March 13, 1661.

[3] One of these " curious " was Pepys, who in his *Diary,* Nov. 5, 1665, notes : *Mr. Evelyn . . . showed me . . . the whole secret of mezzotinto and the manner of it, which is very pretty, and good things done with it.*

[4] See Evelyn's *Sculptura,* ed. C. F. Bell, Oxford, 1906, Introduction to Pt. II. p. vi.

[5] Bayle's *General Dictionary,* Eng. Transl. by Bernard, Birch, and Lockman, 1734-41, vol. v. p. 131 (under EVELYN) :

" We have now in our hands, communicated to us by the very learned Richard

definitely assigns the discovery to von Siegen, proves that Evelyn knew enough of the true facts to render his public account something of a perversion.

Unfortunately the only quotation from this memorandum which has been preserved refers merely to the fact and fable of the invention : the use of tools called the *hatcher* and *style* [1] being the only definite excerpt from his description of the method itself. So, in treating the early development of the process, which is in many respects obscure, we are left almost entirely to a careful examination of the plates themselves.

In our introductory chapter the essentials of the developed process have been described as one in which the engraver works from dark to light, *i.e.* in the exactly opposite course to most engraving and etching. By means of the rocker he first obtains a regular grain on the surface of the plate, which by the virtue of its burr would yield a rich black impression. Then by the aid of scraper and burnisher he removes the burr, and polishes the surface in varying degrees in the parts where he wishes to have his lights.

Now the earliest mezzotinters, Ludwig von Siegen, Prince Rupert, and to some extent their immediate successors, proceeded for the most part in an entirely different manner, working positively from light to dark, leaving those parts of the plate which were to appear white untouched, and so depending on the scraper for occasional correction rather than as an indispensable adjunct in their process. Their chief

Middleton Massey, M.D. and F.R.S., an original MS. written by Mr. Evelyn, and designed for the R.S., and entitled *Prince Rupert's New Way of Engraving, communicated by his Highness to Mr. Evelyn.* In the margin is this note : *This I prepared to be registred in the R.S., but I have not yet given it in, so as it still continues a secret.* In this MS. he first describes the two instruments employed . . . viz. the *Hatcher* and the *Style*, and then proceeds to explain the method of using it. He concludes with the following words : *This invention . . . was the result of chance, and improved by a German soldier, who, espying some scrape on the barrill of his musquet, and being of an ingenious spirit, refined upon it, till it produced the effect you have seene. . . . I have had the honour to be the first of the English to whom it has bin yet communicated . . . but I have esteemed it a thing so curious, that I thought it would be to profane it, before I had first offered it to this illustrious Society. There is another way of engraving by rowelling a plate with an instrument made like that, which our Scriveners and Clearks use to direct their rulers by on parchment ; only the poynts are thicker sett into the rowell. And when the plate is sufficiently freckled with the frequent reciprocation of it upon the polish'd surface as to render the ground dark enough, it is to be abated with the Style, and treated as we have already described. Of this sort I have seen a head of the Queen Christina, grav'd (if I mistake not) as big as the life, but not comparable to the mezzotinto of Prince Rupert so deservedly celebrated by J. Evelyn.*"

The story about the rusted musket barrel, which may be taken for what it is worth, is given with enhanced picturesqueness by Walpole (*Anecdotes*, ed. Dallaway and Wornum, 1862, p. 922), whose account Vertue is stated to have received at second hand from Evelyn.

The portrait of *Queen Christina*, alluded to, is the large plate by Van de Velde (see Chap. VI. p. 169, note).

[1] The *style* is probably the scraper or burnisher. The *hatcher* might be the engine, or even the *rocker*, though the latter is not generally supposed to have been in use before Blooteling.

instrument seems to have been the roulette in various shapes and
sizes, which in the broader barrel form was called the "engine."[1]

FIG. 94.—Ludwig von Siegen.　Portrait of Elizabeth of Bohemia (?).

The obscurity which still shadows the early development of mezzo-

[1] The earliest plate known illustrating the mezzotinter's tools is in Dorman
Newman's *Excellency of the Pen and Pencil*, London, 1688, where the "engine," a
"burnisher," and the "several scrapers" are given.　For a note and reproduction,
see A. Whitman, *Print Collector's Handbook*, 3rd ed. 1903.　Cf. also note 5, p. 258.

tint, and the comparative lack of real artistic interest in the work of its early exponents, will excuse a somewhat technical treatment of the art as it was practised in its first two or three decades.

.

LUDWIG VON SIEGEN, born at Utrecht in 1609, is rightly regarded as the inventor of the art of mezzotint.[1] Part of his early education was in the Rittercollegium at Cassel (1621-26), where he also passed some two or three years at a later period in the service of the Landgravine Amelia Elizabeth, and in particular attendance as Kammerjunker on the young Landgrave William VI. (1639-41).

For some three or four years after 1641 he was settled in Amsterdam, and a few years of retirement from active service spent here, at the time when Rembrandt's fame had reached its zenith, may have been the most momentous influence in his life. He is known to have worked both as a portrait painter and medallist, but up to the present none of his pictures have been identified.

After 1644 his life was passed in a variety of circumstances as a military officer: serving first in the armies of the Bishop of Hildesheim and the Archbishop of Cologne, he is known to have been in the service of the Elector of Mayence before 1654. It was possibly considerably later that he entered the service of the Duke of Wolfenbüttel. The latter end of his life is obscure: we know almost nothing, except that he was still living in 1676.

His earliest dated essay in the art of mezzotint, the portrait of the Landgravine *Amelia Elizabeth*, followed soon after his return from Cassel to Amsterdam. With the print, which he dedicated to the Landgrave, he sent a letter (dated August 1642) in which he definitely claims the invention as his own. After referring to the other methods of engraving, he vaguely describes the new process as one essentially differing from the others in being made up, not of lines, but of dots.[2]

Siegen's dot work was largely achieved by means of the roulette, but he must also have made considerable use of the graver in the stipple manner.

In all only some seven plates by Siegen are known, the *Amelia Elizabeth* (1642, later state 1643), then three large portraits after Honthorst, *Elizabeth of Bohemia* (?),[3] 1643 (Fig. 94), *William II. of*

[1] The glory of his discovery is sufficiently cosmopolitan: his father was German, his mother (the widow of a Dutchman) of Spanish origin.

[2] *Diese arth ist deren keine, wie wohl auch lauter kleine puncktlin und kein einziger strich oder Zugh daran ist, wan es schon an etlichen orthen strichweise scheinet, so ist 's doch all punctirt.*

[3] Laborde was the first to entitle this portrait *Eleonora Gonzaga*, wife of Ferdinand III., an identification condemned by both date and likeness. Seidel's suggestion of the elder *Eleonora Gonzaga*, wife of Ferdinand II., was admittedly a makeshift and no whit more convincing except from point of date. The title given above, found in the catalogue of the Sutherland College, Oxford (1837), and in H. W. Diamond, *Earliest Specimens of Mezzotinto* (1838), has every circumstance in its favour, and is at least plausible (though not unquestionable) on the side of portrait.

Orange and his wife *Henrietta Maria* (1644); ten years later, the Emperor *Ferdinand III.* and the *St. Bruno in a Grotto* (1654); and last of all a *Holy Family*, after An. Carracci, dated 1657. The early work of 1642-44 is certainly the most powerful; possibly it was done more at leisure. Except for the backgrounds of the *William II.* and *his Wife*, which are engraved in line, Siegen's portraits are almost entirely done with the roulette, with occasional aid of the graver or point in dotted work. Though much fainter in tone than the rest, he never showed greater skill in using his instrument than in the *Amelia Elizabeth.*

The *Holy Family* is somewhat distinct from the rest in technical character, showing the work of a roulette of much less regular grain, or even the use of a rough file. In this plate, and in some of the others (e.g. *William II.*), it seems quite possible that some of the peculiar quality may have been attained by biting with acid.

Prince Rupert. PRINCE RUPERT, son of the unfortunate Frederick V. and Elizabeth of Bohemia and a nephew of Charles I., whom he served so brilliantly in the Civil War, passed most of his youth with the exiled family in Holland. Before he was twenty (1638) he had made a few essays in etching (figures and landscape, suggested by Callot, and by Rembrandt's early manner), which possess considerable spirit. Though no longer regarded as the inventor of mezzotint, he did much, both by the encouragement he gave to others and by his own work, to develop the technical possibilities of the process, and he deserves honour for raising a somewhat dull craft into a real art.

It is possible that Rupert learnt the art from Siegen in Germany, but tradition puts the momentous meeting in Brussels in 1654,[1] which is probably correct as being the more unlikely place. The only dates figuring on Prince Rupert's plates, which number about twelve in all, are 1657, 1658, and 1659 (*i.e.* within the period in which he was settled in Germany). Scarcely any of his work seems more tentative than the small *Head of Titian*[2] (British Museum, inscribed *Anno* 1657 *Wien*); but if the date given for his meeting with Siegen be correct, there were probably some earlier essays than this. After settling in England in 1660, he is known to have done the replica of the *Head of the Executioner* as an illustration for Evelyn's *Sculptura*, but it is impossible to say whether other plates belong to this period.

In its essentials, Rupert's work does not differ from von

[1] That it could not have occurred before this date finds witness in a letter known in two copies (Staats-Archiv, Berlin and Dresden), which von Siegen sent from Regensburg (January and February 1654), together with his portrait of Ferdinand III., to various princes through their ambassadors, announcing a large project of Royal portraiture in the method, which he declared was still unknown to any other engraver. The project itself was never carried out.

[2] The same head (corresponding to the picture once in the Uffel Coll., Antwerp, reproduced in Van Dyck's etching *Titian and his Daughter*) was mezzotinted by Jan Thomas, 1661.

Siegen's; it is mostly done with the roulette, working from light to dark, and traces of the use of the scraper can only be noted in occasional instances (*e.g.* in the *Magdalene* of 1659, and the *Portrait of Himself*, Fig. 95).

The appearance of some of his plates, and the reference in Evelyn to the Prince "causing the instruments to be expressly fitted," leads one to conjecture that he occasionally used some contrivance of pole and pivot[1] to attain the long sweeping curve which characterises such plates as the *Great Executioner* (dated Frankfurt, 1658), the *Magdalene* (1659), and the *Bust of an Old Man* (C.S. 4). It is probable that his roulette was formed with a regular series of teeth, although the effect of unbroken lines is attained in the darker parts of the work.

None of Rupert's other plates equal the *Great Executioner* (based on a picture by Ribera in Munich) in brilliance and energy; even the strongly marked curves of the ground fail to spoil the general effect in a work on this large scale. In the *Standard-Bearer* (after Giorgione(?), also of 1658) a good deal of the tone, especially in the face, is attained by irregular dotted work, as well as by the roulette, and some of the outlines (hair, etc.) are added with the graver or dry-point. The *Portrait of Himself* (Fig. 95) is one of the smoothest of all in tone, the roulette grain almost disappearing in the softness of the tone.

Another amateur, THEODOR CASPAR VON FÜRSTENBERG, a Canon of Mayence, must have received his instruction in mezzotint directly from von Siegen, and one of his few plates, the portrait of *Leopold William, Archduke of Austria*, is dated in 1656, *i.e.* a year before the first accredited date on Rupert's work. In this print he followed Siegen in shading the background with engraved lines, and in his method of using the roulette he stands on much the same ground. His *Man of Sorrows*, however, shows a grain more like that of Rupert's *Small Executioner*, and may have been done by means of pole and pivot. In the *Daughter of Herodias* he combines a dry-point outline with the grain. A curious type of aureole, with a sort of spiral of light issuing from the centre, has been sometimes used as an argument to attribute unsigned plates to Fürstenberg, but it is used just as frequently by Jan Thomas.

JAN THOMAS, a painter, born at Ypres in 1617, who had studied under Rubens, did far more powerful work than Fürstenberg. He was master in the Guild of St. Luke at Antwerp in 1639-40, but soon left the Low Countries for Italy and Germany, and by the year 1652 is found settled in Vienna as Court painter to the Emperor.

T. C. von Fürstenberg.

Jan Thomas.

[1] Others have thought that the engine, worked backwards and forwards with the wheel at right angles to the resulting curve, and gradually brought round in a circle from the elbow, would give the same regular sweep. I doubt if the perfect curve could be achieved unless the wheel were rolled in the direction of the curve itself, *i.e.* set at right angles to the pole. The use of a coppersmith's *comb-scraper* (a serrated edge of about 3 inches set in a handle about 2 feet long) is another suggestion.

In 1658 he must have met Rupert at the coronation of Leopold I. at Frankfurt, and his earliest dated plate, *Pro Deo et Patria* (1658), which belongs by subject almost certainly to the immediate time of the coronation, is executed in absolutely the same manner as the Prince's *Great Executioner* of the same place and date. There

FIG. 95.—Prince Rupert. Portrait of Himself.

can scarcely be a doubt as to his instructor. Except for this plate, however, his work, especially the portraits, seems more influenced by the style of von Siegen. But he attained much greater depth of tone than the latter, without any essential advance in technical means, the engine or roulette laying the foundation, and the scraper being still quite sparingly used. Like many of the earlier mezzo-

tinters he combined the etched line, *e.g.* in his *Achilles Disguised* (1659). His *Girl at the Window*, after Dou (1661), and the *Peasants Drinking* of 1664 (after Andreas Both (?)), are quite the most excellent plates which had been produced up to this time, and show a skilful management of light and shade.

Far more a professional mezzotint engraver than Thomas (who W. Vaillant. only produced 12 to 15 plates) is WALLERANT VAILLANT, a Frenchman who studied in Flanders and settled later in Amsterdam. Prince Rupert is said to have divulged the secret to him, and to have used him as an assistant. They probably met at Frankfurt in 1658, at the coronation of Leopold I., where Vaillant is known to have painted a portrait of the Emperor ;[1] and if not before, it was possibly here that Vaillant learnt the art, and not, as has been supposed, after settling in Amsterdam in 1662.[2] Vaillant did several portraits of the Prince, one of them (W. 55) a copy of Rupert's portrait of himself (see Fig. 95), which we have already referred to as bearing an inscription (in its second state) describing the Prince as the inventor of mezzotint. Another, a half-length of *Prince Rupert in Armour* (W. 56), is possibly again one of Vaillant's earliest plates, produced as it is in a rough manner closely resembling Rupert's work.

Vaillant engraved in all over 200 plates, the larger number being subjects after painters of the Dutch and Italian schools, though these are of less interest in themselves than the portraits (of which nearly seventy are catalogued). He probably worked, like his master, chiefly with roulettes, but the regular grain and rich tone of certain of his plates incline one to surmise that the use of the rocker was not unknown to him. There are considerable signs of scraping, but, as a general rule, he does not seem to have started the work by completely grounding the plate.

Wallerant's younger brother, BERNARD VAILLANT, did far less B. Vaillant. work, but a portrait like that of *J. Lingelbach* shows his capability to have been almost as great.

The introduction of the rocker [3] as the grounding tool, whose A. Blooteling. use we have thought might not have been unknown to Wallerant Vaillant, is generally ascribed to ABRAHAM BLOOTELING. Whether he was the first or not to make use of the instrument, now generally

[1] Several studies by Vaillant of the Princes at the Coronation are in Dresden.

[2] *I.e.* at a time when Prince Rupert was in England.

[3] Cf. above, p. 259, note 1. Another quite unknown name is given as the inventor of the instrument in a passage in Rees's edition Chambers's *Cyclopædia*, 1778-88, which we quote in full for the further details it gives of the development in the use of tools, vol. iii. (1781), under MEZZOTINTO. . . . *The Prince had laid his grounds on the plate with a channelled roller; but one Sherwin, about the same time, laid his grounds with a half-round file, which was pressed down with a heavy piece of lead. Both these grounding tools have been laid aside for many years; and a hand tool, resembling a shoemaker's cutting board-knife, with a fine crenelling on the edge, was introduced by one Edial, a smith by trade, who afterwards became a mezzotinto painter.*

used, may never be decided, but at any rate there is a far greater regularity [1] in the ways of his grain than in the best plates of Vaillant, and he was certainly the first to use the scraper systematically to attain a desired brilliance and variety of effect.

Blooteling's earliest work is no doubt in line-engraving (in which he produced about as many plates as in mezzotint), but he must have started mezzotint by 1671, the year in which he dated two small portraits of *Erasmus* and *Frobenius* after Holbein. Vaillant had engraved the same portrait of Erasmus, and also one of Frobenius, and it was probably under his direction that Blooteling did these early mezzotints. He came to England about 1672-73, staying until 1676, and worked in mezzotint for the most part after pictures by Lely. Most splendid of all his plates after Lely is perhaps the large portrait of *James, Duke of Monmouth.*

Gerard Valck.

He had a capable follower in GERARD VALCK, who accompanied him to England, doing numerous mezzotints after Lely. Like Blooteling, he also worked in line-engraving. Another Dutch engraver who felt Blooteling's influence in the development of a

Jan Verkolje.

smoother tone is JAN VERKOLJE. Several of his prints are after Lely and other English masters (*e.g.* the *Duchesse de Mazarin* after Lely, 1680, and the *Duchess of Grafton* after Wissing,[2] dated 1683), and seem to have been issued in England, but there is no evidence that he ever visited the country. Two of his plates are

Nicolaas Verkolje.

dated in 1670. His son NICOLAAS VERKOLJE, whose work belongs almost entirely to the first part of the eighteenth century, even surpasses his father in the smoothness of his technique. He was a fit interpreter of the elaboration and light effects of Dou and Schalcken, but like his models his work is often spiritless and metallic in its finish.

Jan and Paul van Somer.

The brothers JAN and PAUL VAN SOMER stand in technical quality nearer to Wallerant Vaillant than to the Verkoljes. Their artistic power, however, is considerably lower than Vaillant's. JAN, the more prolific mezzotinter, whose plates date from 1668,[3] seems to have worked entirely in Amsterdam, while the younger brother was settled in the latter part of his life (from about 1674 to 1675) in London.

Cornelis Dusart.

CORNELIS DUSART'S etchings have already been noticed, but his mezzotints are both more numerous and better in quality. For the most part they are original studies of peasant life, an agreeable relief in the history of an art which has been too exclusively devoted to reproduction

[1] In Walpole's notice on Luttrell, it is stated that a certain Blois used to lay grounds for Blooteling. In spite of Laborde's assertion to the contrary, I think it likely that this is the ABRAHAM DE BLOIS who did several portraits in mezzotint and line-engraving of personages of Charles II.'s Court (e.g. *Nell Gwynn*, the *Duchesses of Mazarin* and *Portsmouth* in mezzotint, and *Queen Catherine* in line).

[2] On a first state it is described in error as after *P. Lely.*

[3] The *Ferdinand Maximilian of Baden* belongs to this year.

Far more problematical are the few plates by the earlier etcher ALLART VAN EVERDINGEN, to which we have already alluded.[1] We would merely repeat here, that although the majority of his plates to *Reineke Vos*, which have received a ground in the later states, are only on the borderland of mezzotint, there are nevertheless a few plates (*e.g.* the *Three Monks*, B. 105) which are unquestionably executed in this method, *i.e.* if we accept as mezzotint plates on which a burr has been raised by rolling with a rat-tail file or by some other rough process, similar to that achieved by the rocker or roulette. Allart van Everdingen.

Though Evelyn's published notice explained nothing, it is probable that the very mystery which enveloped the process may have encouraged experiment and "set many artists to work," as the author says in his own Diary. Possibly WILLIAM SHERWIN himself, to whom belongs the honour of the earliest mezzotint dated by an Englishman, may have made essays with methods of his own devising before he was instructed by Prince Rupert, to whom his marriage with the grand-niece of the Duke of Albemarle might easily have obtained him introduction. William Sherwin.

The very rough grain of the large plate of *Catherine of Braganza*,[2] which shows a curiously heavy and irregular dotted surface, would incline one to accept the tradition[3] that Sherwin sometimes used some sort of file, pressed heavily on to the plate, to get his ground. Rees describes the method as a "half-round file, pressed down with a piece of lead"; but similar results might be obtained by rolling a rat-tail file by means of a piece of wood. The more delicate parts of the modelling, however, seem to be done by some sort of roulette or engine, as in fact does almost the whole of the companion-plate of *Charles II.* (dated 1669). Though both are dedicated to Prince Rupert, it seems to me quite possible that it was only after these experimental plates that Sherwin put into practice the Prince's regular method of working with the roulette, which he seems to have used in plates such as those of the *Duke* and *Duchess of Albemarle*.

The few mezzotints of FRANCIS PLACE, an amateur engraver whose work is among the earliest produced in England, form a strong contrast in quality to those of Sherwin. They are characterised by a peculiar smoothness of tone, but some, *e.g.* the portrait of *Richard Tompson* the printseller, are by no means lacking in strength. Place was also an etcher, an art in which he may have been instructed by his friend Hollar. Francis Place.

EDWARD LUTTRELL, an Irishman who settled in London, ISAAC BECKETT, and R. WILLIAMS are the most interesting of the E. Luttrell.
I. Beckett.
R. Williams.

[1] Cf. Chap. VI. p. 190.

[2] In technical character, cf. the print of *Queen Christina of Sweden*, by Van de Velde (see Chap. VI. p. 169, note). The grain of the oval border of the *Catherine* seems to have been bitten by acid, and is analogous to aquatint.

[3] See Granger, *Biographical History of England*, 1769, Charles II., Class X., under PRINCE RUPERT, and Rees's edition of Chambers's *Cyclopædia*, MEZZOTINTO, 1781, quoted above, p. 265, note 3.

same generation—Beckett, like so many of the mezzotinters, acting also in the capacity of printseller. Luttrell's *Charles II.* (after Lely) and *Francis Le Piper* show vigorous handling of a rough ground ; but they do not bear comparison with the best of Beckett, who at times could be as brilliant as Blooteling. Beckett's portraits of *Lely* and *Kneller* (after paintings of themselves) deserve special praise for a combination of sensitive modelling and vigour of treatment, which can stand by John Smith's finest work. More often, however, Beckett suffers from a monotonous smoothness, and a lack of modelling which gives a flat appearance to his plates, *e.g.* the bust of *Robert Feilding* after Wissing (C.S. 37). He is particularly skilful in rendering the soft and glossy texture of the wigs of the period. The plates of ROBERT WILLIAMS, which were produced between 1680 and 1704, exhibit some richness of tone, but they lack Beckett's incisive touch.

R. Tompson.
A. Browne.

A considerable number of mezzotints of the last three decades of the seventeenth century bear the names of RICHARD TOMPSON and ALEXANDER BROWNE,[1] but as they are never accompanied by anything but the word *exc*(*udit*),[2] it is doubtful whether they were ever more than the printers and publishers.

William
Faithorne II.

WILLIAM FAITHORNE the younger and GEORGE WHITE (both sons of distinguished line-engravers) represent the change of artistic fashion, by completely giving up line in favour of the new process. Faithorne's real capability is well represented in his portrait of *Charles XII.* of Sweden (after Ehrenstrahl). More usually his work possesses the weakness one might expect, if the tradition of a dissipated life be true.

George White.

GEORGE WHITE, on the other hand (whose work falls mostly in the first quarter of the eighteenth century), is one of the first of the real artists among the mezzotinters. The broad touches of tone which characterise his portraits of *William Dobson* (after Dobson), *Dryden* (after Kneller), and *Pope* (after Kneller), wonderfully reproduce the character of brush work in oil. Sometimes he mixes the etched line with rocked work (a practice we noticed among the earliest mezzotinters), and in certain cases, *e.g.* the *Abel Roper* (Fig. 96), he starts his work with a preliminary skeleton etching. His portrait of *Bishop George Hooper* (after Hill) shows a combina-

[1] The author of the *Ars Pictoria*, 1675, where he wrote a short note on the process, on the *Manner or Way of Mezotinto*, speaking of the *divers shapes of the engin*, without describing them. The year 1669 has been given as the date of the first edition of the *Ars Pictoria*. That of 1675 is described on the title-page as a second edition ; but until I find a copy dated 1669 (which is not in the British Museum, nor mentioned by Hazlitt or Lowndes), I shall be inclined to regard his *Whole Art of Drawing, Painting, Limning and Etching*, published by Peter Stent, 1660 (in which the article on etching exactly corresponds to the *Ars Pictoria*), as the earlier edition alluded to.

[2] Granger (*Biogr. Hist.*, Charles II., Class X., artists), notes a plate of Charles II. signed *A. Browne fecit*, but it is not at present known, and the citation may have been incorrect.

tion of etching in modelling the face which adds remarkably to the expression of character.

FIG. 96.—George White. Portrait of Abel Roper.

JOHN SMITH is nearly twenty years White's senior, and he John Smith. survived the latter by a decade, and in his long life there was room

for large variation in character and quality of work. In fact, his work varies from something by no means above the average level of his contemporaries to occasional masterpieces, which have scarcely been surpassed even by the more famous of the mezzotinters after Reynolds. As always with mezzotints, much of the effect depends on the freshness of the impressions (for the burr is worn with few printings), and one needs to see a superb series of Smith's works, such as the two volumes in the Duke of Devonshire's collection, to fully appreciate his power.

To a large degree the skill of the earlier mezzotint engravers seems less, for no other reason than the inanity of the paintings they reproduced. Closterman, Wissing, Dahl, and Van der Vaart are not inspiring models, and even Lely and Kneller, in their female portraits, seldom avoid an affectation of pose, which drives us for the most part to the portraits of men, to obtain a just appreciation of the mezzotint portraits of the late seventeenth and early eighteenth centuries. A very large proportion of Smith's work is after Kneller, and the *Portrait of the Painter* (C.S. 150) will serve as one of the most brilliant examples. Smith's *Portrait of Himself* (after Kneller [1]), of the engraver *Beckett*, of the composer *Corelli* (after H. Howard), are excellent plates, while the *First Marquess of Annandale* (C.S. 13) and the *First Earl of Seafield* (C.S. 228) (both after Kneller) may be cited as rare instances where the ornamental border enclosing the oval is entirely engraved in line. He also produced a large number of subject plates after Titian, Correggio, Heemskerk, Laroon, and others. John Smith was a printseller as well as engraver, publishing, and sometimes not scrupling to sign, plates by other masters, which he had reworked.

Peter Pelham and mezzotint in America.

We may mention here a slightly younger contemporary of John Smith, PETER PELHAM, for the honour of having introduced mezzotint in America. He migrated and settled in Boston in 1726, and his portrait of the *Rev. Cotton Mather* (of 1727) is probably the first mezzotint produced on American soil. In his more famous stepson, the painter John Singleton Copley, the direction of migration was reversed.

John Faber I.

Of the foreign engravers contemporary with Smith we may mention JOHN FABER the elder, who was born at the Hague, and settled in London about 1690. He was a much weaker artist than any of the English engravers we have cited from Luttrell to Smith; but his work, which comprises such series as the *Founders of Oxford and Cambridge Colleges* (45 plates, commenced 1712),

John Faber II.

possesses considerable historic interest. His son, JOHN FABER the younger, who worked entirely in England, was a more skilful engraver than his father; but in spite of a certain freedom of manner, he produced nothing to equal the best work of John Smith. His plates after Kneller, Vanderbank, and Hudson are very numerous,

[1] The original picture is now in the National Portrait Gallery.

and he is, besides, one of the few mezzotinters born in the seven-
teenth century who lived to reproduce Hudson's more famous pupil
Reynolds. He is best known for his two series after Kneller, the
Kit-Cat Club (48 portraits on 47 plates, issued by a member of the
club, Jacob Tonson, in 1735) and the *Beauties of Hampton Court*
(12 full-length portraits).

JOHN SIMON, a French Protestant refugee, who was settled in John Simon.
London in the first half of the eighteenth century, produced a large
number of mezzotints after Kneller, who is said to have used his
services after falling out with Smith. His best work, such as *Lord
Somers* (after Kneller), and *Sir Charles Wills* (after Dahl), closely
rivals John Smith, but he does not quite reach the latter at his
strongest. He had had predecessors in the art in France, but he
does not seem to have engraved except in line before coming to
England. Besides reproducing Kneller, Dahl, Gibson and the
like, he engraved a considerable number of plates after Mercier,[1] a
follower of Watteau, who was working for many years in England
during the second quarter of the seventeenth century.

Among the earliest of his French predecessors is LOUIS FRANCE.
BERNARD, who worked in Paris during the last two decades of the Louis Bernard
seventeenth century. His plates are curiously rough in surface,
as if grounded with an " engine " of an irregular dotted grain, the
scraper being sparingly used. Besides portraits (after F. de Troy,
etc.), he produced some plates after Rembrandt (*e.g.* an *Adoration
of the Shepherds*), in which his bold style achieved really effective
results.

His contemporaries SÉBASTIEN BARRAS and ANDRÉ BOUYS S. Barras.
mark an advance at least in technical methods, making far more André Bouys.
use of the scraper, and almost certainly laying their grounds with
the rocker. Bouys, whose work extended well into the eighteenth
century, left a few really excellent portraits after his master
François de Troy.

In our notice of the early French masters we have left HENRI Henri Gascar.
GASCAR (b. 1635) to the end, although the plates which bear his
name (chiefly notables of the Court of Charles II., to whom the
Duchess of Portsmouth formed his introduction), were all done in
England about 1670-80.[2] None of them, however, bear further
signature than *H. Gascar pinxit*, and the attribution of the
engraving to him must, without further evidence, be considered as
extremely doubtful. The works with this signature (*e.g.* the
Duchess of Portsmouth, Nell Gwynn and her two sons, and *Mrs.
Middleton*) are all of a rough character not far removed in style
from the work of Prince Rupert.

The German work of the period is of less interest than the GERMANY.
French. Fürstenberg had a few followers in Mayence, *e.g.* JOHANN

[1] Mercier produced a few engravings and etchings, after Watteau and original.
[2] After the latter date Gascar is said to have worked in Italy.

FRIEDRICH VON ELTZ and JODOCUS BICKART, and before the end of the century a numerous school had sprung up in Nuremberg and Augsburg (*e.g.* G. and M. FENNITZER, G. A. WOLFGANG, and CHRISTOPH WEIGEL), but none produced work of any distinction.

.

Mezzotint as the *manière anglaise.* The seventeenth century has shown a far greater number of foreign than English mezzotint engravers, and yet even at that time the art was commonly regarded as the "English manner." Why it should have taken such firm root in England as to almost seem an indigenous art, it is difficult to see. Perhaps Prince Rupert, though doing little himself at this time, may have helped to induce Charles and his painters Lely and Kneller to promote the new art, which in France found a more persistent and, in fact, victorious rival in line-engraving. In any case, England formed the centre of attraction for the best mezzotinters of the period, and it was work such as that of Blooteling which served most to discipline the English engravers in an art that from the beginning of the eighteenth century became their own by virtue of pre-eminent achievement.

The eighteenth and nineteenth centuries. There are few foreign mezzotint engravers in the eighteenth and nineteenth centuries of any distinction, and we would complete our reference to these before approaching the great period of Reynolds in England.

GERMANY AND AUSTRIA. G.P. Rugendas. J. E. Ridinger. G. P. RUGENDAS and his pupil J. E. RIDINGER,[1] exercised a large influence on the mezzotint of the period in Augsburg, but their original work in the process is neither large nor excellent. Nevertheless a few small plates of cavalry fights by the former, and the latter's sporting scenes and portraits, at least stand by themselves in the history of the art.

The Haids of Augsburg. Their work was largely reproduced by members of the Haid family of Augsburg, who produced a large proportion of the German mezzotints of the eighteenth century. JOHANN JACOB HAID (b. 1704), his son JOHANN ELIAS HAID, and JOHANN LORENZ HAID (b. 1702), all did numerous plates, but the only member of the family who ever rises above a very dull average is Lorenz's brother, JOHANN GOTTFRIED HAID (1710-76), who enjoyed the advantage of a visit to England. In the latter part of his life he settled in Vienna, which from the time of Jan Thomas was the best centre of the art on the continent of Europe.

Jacob Männl. Quite early in the seventeenth century JACOB MÄNNL produced some plates after pictures in the Imperial collections at Vienna, but his work is dull, and artistically no advance on that of Jan Thomas.

Johann Jacobé. The real maker of the school at Vienna was JOHANN JACOBÉ, who visited England about 1779-80, where he executed a few excellent plates after Reynolds (e.g. *Mary Monckton, Countess of Cork*, 1779, and *Miss Meyer* as "Hebe," 1780), and after Romney

[1] Cf. p. 247.

(e.g. *William Hayley*, 1779). As professor in the Academie on his return to Vienna he exercised a large influence in spreading the art he had developed, if not acquired, in England.

Three of his pupils, who all settled in Vienna, J. P. PICHLER, FRANZ WRENK, and VINCENZ GEORG KININGER, are technically the most accomplished of the German and Austrian mezzotinters, and carry the art through the first part of the nineteenth century. *J. P. Pichler. F. Wrenk. V. G. Kininger.*

PICHLER was the master of a very smooth manner, but his plates, which are largely subjects after Italian masters, are monotonous, and lacking in vigour. WRENK'S work has virtues and faults similar to Pichler's, and shows less individuality than that of KININGER, who is perhaps the most brilliant of the school.

Before leaving Vienna we would mention another engraver, IGNAZ UNTERBERGER (1748-97), rather for his vices than his virtue. He seems to be one of the earliest engravers in Europe to attempt the imitation of the mezzotint grain by mechanical means, *i.e.* by a complicated interlacement of lines achieved by a ruling machine. Mechanical mezzotint of this kind is found frequently in England in small portraits of the early nineteenth century, but I do not know any earlier instance than that of Unterberger. *Ignaz Unterberger and mechanical mezzotint.*

The second half of the eighteenth century, the great period of English mezzotint, opens with a succession of artists from Dublin. JOHN BROOKS and THOMAS FRYE were both engaged for part of their lives in the management of china factories in London, and in the mezzotint work of the latter, in particular, an unpleasant porcelain-like surface betrays the worker in miniature and enamel. Frye did a series of life-sized portrait heads from his own design, but they are all smooth and dull in tone, and lack vigour in outline and significance in modelling. *The Dublin group. John Brooks. Thomas Frye*

Brooks's chief glory is in his pupils MCARDELL and HOUSTON.

JAMES MCARDELL (b. about 1729) was one of the earliest engravers to work to any considerable extent after Reynolds. Among the thirty-seven plates he produced after this painter one might mention for special praise the *John Leslie, Earl of Rothes*, and *Mrs. Catherine Chambers*, while some of his prints after older masters are no less brilliant. The true character of Lely's female portraiture is seen in McArdell's *Elizabeth Hamilton, Comtesse de Grammont*, far better than in the painter's contemporary engravers, and here, as in the *Lords John and Bernard Stuart* (after Van Dyck), the engraver shows masterful skill in rendering the texture of the costumes. *McArdell.*

RICHARD HOUSTON, at his best, was as good an artist as McArdell, but far less regular and prolific in the practice of his craft. His portrait of *Richard Robinson, Bishop of Kildare*, is a splendid example after Reynolds, and his plates after Rembrandt show almost a genius for interpretation. The character of the Dutch master's brush-work at two periods of his career has seldom *Richard Houston.*

been so magnificently rendered as in Houston's *Syndics* of 1774, and the *Man with a Knife* of 1757 (Bode, Rembrandt, No. 508).

Richard Purcell.

A somewhat younger pupil of Brooks, RICHARD PURCELL, is a far less distinguished member of the Irish group. A large part of his work consists in copies after McArdell, which he did for Robert Sayer, one of the principal publishers of mezzotints at this period.[1]

Two other members of the Irish group, FISHER and DIXON, stand little behind McArdell or Houston in the quality of their

Edward Fisher.

achievement. EDWARD FISHER, in particular, is the master of a powerful style, which anticipates John Jones in its use of broad surfaces of tone. His large bust of *Lord George Seymour* (as a boy) and his *Laurence Sterne* are among the most convincing of all mezzotints after Reynolds, while in the *John Armstrong* (after Reynolds) Fisher shows himself equally successful in rendering delicate tones in the higher gamut of colour. Of the prints after other painters one might mention the *Paul Sandby* (after Cotes), and *Roger Long* (after B. Wilson), the slight turn of expression being most skilfully caught in the latter.

John Dixon.

JOHN DIXON is an able engraver who has enjoyed a greater fame than Fisher, but his work seldom carries the same conviction of power. He not infrequently used the dry-point to finish his plates, *e.g.* on the fur and coat of the second *Duke of Leinster* (after Reynolds). Beside Reynolds, his prints find various models in Gainsborough, Pine, Stubbs, Zoffany and others. He lived till after 1800, but a wealthy marriage had induced him to give up the serious practice of his profession some twenty years earlier.

James Watson.

The last of our Irish group, JAMES WATSON, who was probably a pupil of McArdell, was far more prolific than Fisher or Dixon. He is a skilled craftsman, with a mastery of smooth and delicate tones, but lacks the force of Fisher. For a certain largeness of manner and simplicity of surface, his portrait of *Dr. Johnson* (after Reynolds) is a striking achievement. A very large proportion of his plates are after Reynolds ; one might mention his *Edmund Burke*, the *Lady Scarsdale*, *Caroline, Duchess of Marlborough*, and the *Lady Stanhope*. The last, a large full-length, is among the best of his female portraits, which are inclined to be flat in tone, and wanting in life. In one instance, that of *Mrs. Bunbury* (Goldsmith's " Little Comedy "), after Reynolds, the inevitable vitality of his subject saved the engraver from his common fault.

Before approaching the famous group of English mezzotinters, the breath of whose life was Reynolds, we would mention two of their contemporaries who each hold a somewhat more individual position, WILLIAM PETHER and RICHARD EARLOM. Neither are artists of first-rate skill, but even their imperfection is a relief amid a crowd of masters of technique who possessed so little artistic individuality.

[1] Cf. Chap. VIII. p. 237, note 2.

Like Houston, PETHER did a considerable number of plates William after Rembrandt, but he was too true a disciple of Frye to be a Pether. good interpreter of the master. His *Standard-Bearer* (after Bode, 370), *Rembrandt with Sword and Breastplate* (Bode, 348), and his larger plates of the *Rabbi*, dated 1764 (Bode, 199), are clever, but are too smooth in tone, and lack the grip and verve which Houston rendered so well. He comes nearer to the surface of the original in his plates after Rembrandt's English imitator, Wright of Derby (e.g. *Artists drawing from a Statuette of a Gladiator*, 1769).

EARLOM suffers, like Pether and Frye, from a certain flatness of Richard tone (unpleasantly noticeable in his portrait of *McArdell*), but in his Earlom. subject pieces it is relieved by his practice of combining the etched line with the mezzotint ground. He scraped a considerable number of plates for the *Houghton Gallery*,[1] a large work of some 129 prints published by John Boydell (1787-88), reproducing pictures from the collection of Horace Walpole, Earl of Oxford, which had been acquired by Catherine II. of Russia for the Hermitage in 1779. A landscape after Hobbema, various plates of still life after Snyders, and his *Concert of Birds* after Maria da' Fiori, and the *Flower* and *Fruit Pieces* after Van Huysum and Michelangelo Pace di Campidoglio (all for the *Houghton Gallery*), break the monotony of an art traditionally devoted to portrait. Of his other subjects one might mention the six plates after Hogarth's *Marriage à la Mode* (1796), and the *Life School at the Royal Academy* of 1773 after Zoffany. His most interesting and successful work is undoubtedly the set of 200 plates after Claude's *Liber Veritatis*,[2] which was published in two volumes by Boydell in 1777.[3] Both in its artistic scope and in its technical manner (the combination of etched line with mezzotint tone) it formed the immediate inspiration to Turner's *Liber Studiorum*. Besides the plates after Claude, Earlom produced a considerable number of other prints after drawings (*e.g.* a set of 51 after Cipriani, published by Boydell, 1786-87), in line, etching, and in the crayon manner, and a few portraits in stipple (e.g. *Cipriani* after Rigaud 1789, *Lord Heathfield* after Reynolds 1788).

We are now approaching the great classical group of English The great mezzotinters who were so largely devoted to the reproduction of mezzotinters of Reynolds. They are the contemporaries of many of the engravers the period of whose work has already been described or mentioned, but born for Reynolds. the most part after 1745, while the latter were all born before that date. The best period may perhaps be regarded as the last three decades of the eighteenth and the first ten years of the nineteenth

[1] Valentine Green did most of the other mezzotints in the publication, though Pether, Josiah Boydell, and J. Watson produced a few. Of the line and stipple engravers engaged we may mention John Browne, J. Peake, J. B. Michel, and P. C. Canot.

[2] The original drawings in the collection of the Duke of Devonshire.

[3] A third volume after Claude drawings in the R. P. Knight, Earl Spencer, and other collections, was published between 1802 and 1810 (78 numbers in B.M. copy).

centuries, though until the middle of the latter century there was no lack of powerful work. Some dozen engravers were virtuosi in their craft, but it is striking how dependent they were as artists, and what poor work even the best of them could produce when left to their own devices. As artist and virtuoso combined, John Raphael Smith perhaps holds the first place, which is usurped in the early nineteenth century by his pupil William Ward, and by the latter's brother James Ward.

John Finlayson.

JOHN FINLAYSON (b. 1730) who, besides a few subject plates, engraved a score of portraits after Reynolds, Read, Zoffany, Hone and others, is only on the verge of this group. He is a fair craftsman, but by no means so convincing or vigorous an artist as

Dunkarton.

his contemporary of the Irish group, Edward Fisher. To be done with our second-rate engravers of the great period, we would just allude to ROBERT DUNKARTON, a pupil of Pether, who shows a harsh and unsympathetic manner, only at rare intervals producing anything as good as his *Lord Lifford* after Reynolds.

Valentine Green.

In VALENTINE GREEN we meet one of the most famous of the Reynolds engravers, but one who seldom honestly deserves his great reputation. He can be brilliant on occasion, but even the most brilliant, *e.g.* the *Mrs. Cosway* (after herself) and the *Ozias Humphry* of 1772 (after Romney) are somewhat hard and metallic. His great name rests largely on the full-length portraits of ladies after Reynolds, of which we might instance the *Duchess of Rutland* and the *Georgiana, Duchess of Devonshire*, of 1780, the *Countess of Salisbury* of 1781, and the *Lady Louisa Manners* of 1779, as among the most excellent. All these plates show an imposing solidity of tone, but unhappily a very large number of his full-lengths are empty in character as well as too smooth in tone to be effective on so large a scale. The *Viscountess Townshend* and *Lady Jane Halliday* after Reynolds are sufficiently glaring examples, while excursions into the reproduction of other painters find him scraping such unpardonable plates as the *George Prince of Wales* and *Frederick Duke of York* (after West), the *Earl of Leicester* (after Zincke), and the *Washington* of 1785 after Peale. Nevertheless some of his strongest engravings, *e.g.* the portrait of *Sir Joshua Reynolds* (after himself), and the beautiful plate after Reynolds's *Ladies Waldegrave*, are almost unequalled in the fine quality of their tone.

Of his subject plates after old masters, which are numerous, we have already mentioned the most important, *i.e.* his contribution to the *Houghton Gallery*. He also did some twenty plates from pictures in the *Düsseldorf Gallery*, which now forms part of the Alte Pinakotek at Munich.

Both WILLIAM DICKINSON and THOMAS WATSON, who were for some time associated in a print-publishing business, did finer work than Valentine Green.

THOMAS WATSON, who by the way was no connexion of the Thomas
Irish mezzotinter James Watson, produced in a short life some of Watson.
the most magnificent plates after Reynolds, as well as many after
less well-known painters, such as Gardner and Willison. In a set
of six plates of *Windsor Beauties* of 1779 (e.g. *Elizabeth Wriothesley,
Countess of Northumberland*), he reverts to Lely for his originals.
His *Lady Bampfylde* is one of the most striking of all the full-length
portraits after Reynolds, leaving those of his namesake James Watson
far behind. There is great depth and power in the tone, and a sense
of good draughtsmanship in the details of the figure which Green
often lacked. Of his male portraits after Reynolds his bust of
David Garrick is full of power, and the *Resignation* of 1772 (a
portrait of George White, pavior and artist's model) is a wonderful
study, if not quite free from a certain affectation for brilliant streaks
of light (*e.g.* in the hair). Unfortunately Watson's promise was
larger than his achievement, but even as it is, he is worthiest of all
the mezzotinters before the Wards to stand next to J. R. Smith.
He also left a few plates in stipple (*e.g. Elizabeth Beauclerc* as
" Una," after Reynolds, published 1782).

WILLIAM DICKINSON shows many common characteristics with William
his partner Thomas Watson. In his *Elizabeth Houghton, Lady* Dickinson.
Taylor after Reynolds, a particular resemblance in their styles may
be remarked in the treatment of the foliage, with its scintillating
qualities and its affectation of streaks of light. He is perhaps
seen at his best in his portraits of men, e.g. *Dr. Thomas Percy* after
Reynolds, and the impressive *Sir John Fielding* after Peters. Like
Watson, Dickinson also produced some stipple plates, *e.g.* the
Duchess of Devonshire and Viscountess Duncannon, 1782 (after
A. Kauffmann). The latter part of his life was spent in Paris,
where he died in 1823.

JOHN JONES is particularly successful in rendering the quality John Jones.
of the painter's brush, and Romney with his broad touches of
colour finds him an excellent interpreter. *Mrs. Charlotte Davenport*
(1784) and *Edmund Burke* (1790) are two of his most convincing
plates after that master. Scarcely less effective are his prints of
Miss Kemble and the *Lady Caroline Price* (Fig. 97) after Reynolds,
but his portraits do not always show a real master of drawing, *e.g.*
the poor modelling of the hands and arms in the *Hon. Mrs.
Tollemache* after Reynolds and in the *Duchess of Marlborough* after
Romney. His large landscape, *View from Richmond Hill* after
Reynolds, in which he uses the etched line in combination with
mezzotint, shows how loose is this engraver's grasp of the structure
of things in nature. As a portraitist he forms an exception among
his contemporaries, in engraving far more men than women.

By far the most original talent in the whole group is JOHN John Raphael
RAPHAEL SMITH, a son of the landscape painter Thomas Smith of Smith.
Derby. He was himself by no means negligible as a portrait painter

(e.g. the *George Morland* and *Sir Nathaniel Dance* both engraved
by himself (1805); *Horne Tooke* of 1811 and *William Cobbett* of

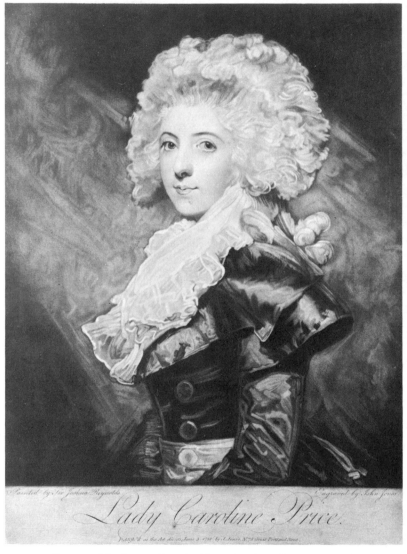

Fig. 97.—John Jones. Portrait of Lady Caroline Price, after Reynolds.

1812 engraved by his pupil William Ward, and *Charles James Fox*
engraved by S. W. Reynolds in 1802). His position as a publisher

of prints and his extreme facility with the brush contributed to render him a popular painter of political portraits.

Another side of his original work was the society genre, in which he showed perhaps no great inspiration, but produced a good many paintings and drawings as well as prints of considerable spirit (*e.g.* a *Lady in Waiting*, 1780). But his original work counts almost for nothing beside his unequalled power in the interpretation of Reynolds, Romney, and Gainsborough. His female portraits after Romney, e.g. *Louisa, Viscountess Stormont*, the *Hon. Mrs. Henrietta North* (1782), *Mrs. Carwardine and Child* of 1781 (see Fig. 98), *Mrs. Robinson* (1781), and *Emma, Lady Hamilton* (1784), are among the most exquisite productions in the whole range of mezzotint.

No less powerful and generally deeper in tone are the plates after Reynolds, *e.g. Richard Robinson*, Archbishop of Armagh, *Lord Richard Cavendish, Giovanni Bacelli* (1783), *Mrs. Payne-Gallwey and her son*, and the *Hon. Mrs. Stanhope*, the last being one of the subtlest of all in its rendering of a soft moonlit atmosphere. In his larger full-length portraits after Reynolds he commands a variety of moods, seldom failing to avoid the flatness of Valentine Green, and the affectation of Thomas Watson. Among the most convincing of all in its broad touches of shading is the *Mrs. Carnac* (1778), while the *Mrs. Musters* (1779), if somewhat less vigorous, has added life in the exquisite variety of its surface.

Two prints after Peters, *Lady Elizabeth Compton* (1780) and the *Hon. Mrs. O'Neill*, may be instanced to show the delicacy of his rendering of the tones in the higher gamut, and the *Hon. Mrs. Bouverie* (after Hoppner) exemplifies the effect which he sometimes gained by a few broad touches with the rocker, after the scraping had been done.

A considerable number of his subject plates were engraved after his friend, George Morland, who later found prolific interpreters in the Wards.

JOHN DEAN inherited a certain command of delicate tones from John Dean his master Valentine Green, but though possessing an attractive lightness of touch, his work is conspicuously lacking in real vitality. A comparison of his *Elizabeth, Countess of Derby* of 1780 (after Romney), with a very similar plate by J. R. Smith after the same painter (*Viscountess Stormont*), will immediately show the gulf between their capabilities. Another of Green's pupils, JAMES James Walker WALKER, developed into a far stronger engraver, quite equalling his master in the balance and solidity of his tone. A wise avoidance of elaboration helps greatly in increasing the effect of his larger portraits, *e.g.* the *John Walter Tempest*, and *Sir Hyde Parker* (1780) after Romney. After 1784 he spent some eighteen years in St. Petersburg as engraver to the Empress Catherine, scraping pictures from the Hermitage Gallery, as well as numerous portraits.

C. H. Hodges. CHARLES HOWARD HODGES, a pupil of J. R. Smith, is another

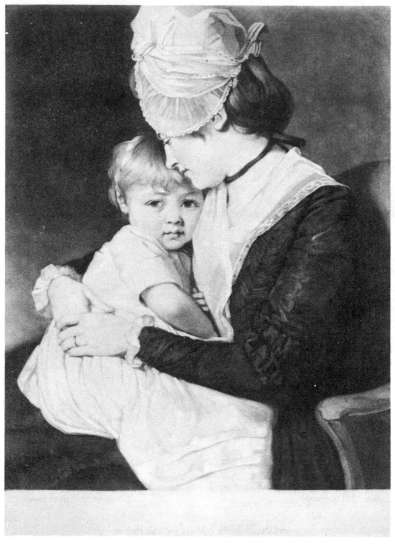

FIG. 98.—John Raphael Smith. Mrs. Carwardine and Child, after Romney.

of the mezzotinters who settled abroad, living at Amsterdam from about 1794 to the time of his death in 1837.

His best work, *e.g. Mrs. Williams-Hope* of 1788, and *Mrs. Sophia Musters* (as "Hebe") after Reynolds, and *William IV.* (as

Duke of Clarence) after Hoppner, possesses the true flavour of the best period. The same can hardly be said of his late work in Amsterdam, but his plate of the *Shipbuilder and his Wife* after Rembrandt (1802), and the full-length of *Rutger Hans Schimmel-penninck* (1806), in which a preliminary etching is used with skill, at least betray no technical decline.

There is a host of other mezzotinters working in the latter half of the eighteenth century, but nearly all are greatly inferior to those whose work has been described. WILLIAM DOUGHTY is a brilliant William exception. His work is exceedingly limited, but what there is Doughty. is extremely powerful; his *Dr. Johnson* (1779), and the *Hon. Augustus Keppel* (1779), after Reynolds, being among the most convincing plates of the period. Of the rest we would just mention JONATHAN SPILSBURY, with his smooth and somewhat J. Spilsbury. lifeless plates after Reynolds and others; JOHN MURPHY, for a J. Murphy. few plates, rather coarse in grain, showing an unpractised hand; JOHN YOUNG, a pupil of J. R. Smith, brilliant, but superficial; J. Young. GUISEPPE MARCHI, an assistant of Reynolds, whom he interpreted G. Marchi. in a few soft-toned mezzotints; GEORGE KEATING, whose *Kemble* G. Keating. *as Richard III.* (after Stuart), and *Georgiana, Duchess of Devonshire* (1787, after Reynolds), show a fine mastery of his craft; HENRY HUDSON, for an attractive full-length of a certain *Mrs. Curtis* H. Hudson. with a large muff on a couch, and GAINSBOROUGH DUPONT, for a Gainsborough considerable number of harsh and amateurish plates after his Dupont. famous uncle Thomas Gainsborough.

In the early part of the nineteenth century the best traditions Nineteenth of the art were most worthily represented in WILLIAM and JAMES century. WARD, GEORGE DAWE, CHARLES TURNER, and SAMUEL WILLIAM REYNOLDS.

WILLIAM WARD, a pupil of J. R. Smith, stands little behind William Ward. his master in the power of his scraping. He will perhaps be remembered most for his plates of landscapes and animals after his brother-in-law, George Morland, which are not infrequently printed in colour. But his portraits alone would give him rank beside the strongest of his predecessors. *Arthur Murphy* (after Dance), *George Morland* (after R. Muller), *James, Earl of Malmesbury* (after Lawrence), *Dr. G. H. Baird* and *Sir David Wilkie* (after Geddes), and the *Misses Marianne and Amelia Frankland* (after Hoppner), show him at his best. In the last of these plates, and in many others, he attained a pleasing variety of surface by a few open strokes with the rocker after the scraping. He was also one of the best of the engravers in stipple.

His younger brother and pupil, JAMES WARD, scarcely holds so James Ward. important a place as an engraver, but his works show an equal talent. His mezzotints were all produced in his early period, the latter part of a life of some ninety years being entirely devoted to painting, for the most part landscape and animal subjects in the

manner of Morland. Besides his plates after that painter, he also scraped a considerable number of his own compositions (*e.g.* the *Poultry Market*, the *Fern Burners*, and the *Lion and Tiger Fighting*).

A few of his portraits, such as the *Miss Frances Vane as "Miranda"* (after Hoppner), are fully as sound as anything by his brother, but many others, e.g. *Henry Erskine* (after Raeburn), and *Juvenile Retirement* (the children of the Hon. John Douglas) after Hoppner, are neither free from affectation in the landscape, nor sound in draughtsmanship. James Ward himself, on abandoning the art of mezzotint in 1817, gave a most representative set of his prints to the British Museum, in some cases including as many as ten proofs in various stages from one plate.

George Dawe.

GEORGE DAWE kept more strictly than the Wards to the old traditions of portraiture. His freedom from the growing practice of preliminary etching, and the powerful simplicity of his deep tones and brilliant lights render him especially effective as an interpreter of Raeburn (e.g. *Viscount Melville, Dr. James Gregory*, and *Charles Hope*). The last ten years of his life were spent at St. Petersburg, painting a large number of portraits for the Emperor.

Charles Turner.

An engraver of a greater compass of subjects is CHARLES TURNER. Like Dawe he is an excellent translator of Raeburn (e.g. *Dr. John Robison, Lord Newton*, and *Sir Walter Scott*), but he produced a greater variety of portraits, engraving after Hoppner, Lawrence, Jackson, Beechey, Shee, and other contemporary painters, after old masters such as Rembrandt and Van Dyck, and also translating into mezzotint certain early English engraved portraits by Elstrack, Passe, and Delaram. The quality of his work is remarkable for the use of aquatint in combination with mezzotint. His large plate of the *Shipwreck* (after J. M. W. Turner) will illustrate this method, the aquatint adding a certain liquid and luminous character to the tone which can never be attained by mezzotint. His lighter use of etching, combined with mezzotint, shows a more artistic feeling than the more regular line seen in the plates of Samuel Reynolds. Plates like the *Lady Louisa Manners* and the *Countess of Cholmondeley* (after Hoppner) exemplify the freedom and dash of his style in this respect, but just fall short of being masterly in draughtsmanship or modelling.

Besides his part in the *Liber Studiorum*, which has already been mentioned,[1] he engraved five plates after Turner for the *River Scenery* or *Rivers of England*[2] (1824-30). He also produced about a score of plates in stipple, largely in the earlier part

[1] See p. 244, where the other mezzotinters who contributed to the work are enumerated.

[2] The other mezzotinters in the *River Scenery* or *Rivers of England* after Turner and Girtin, are T. G. LUPTON, G. H. PHILLIPS, W. SAY, S. W. REYNOLDS, and JOHN BROMLEY. The prints date from 1823 to 1830.

of his career. Two subjects after Singleton, the *Fairing* and the *Savoyard* (both belonging to the year 1800), will suffice to represent his spirited work in a process which he never really mastered

The best part of the work of SAMUEL WILLIAM REYNOLDS was done in the first decade of his activity (about 1794-1804), and his plates in pure mezzotint are comparable in depth and richness of tone to all but the greatest work of J. R. Smith and William Ward. His *Duchess of Bedford* of 1803 after Hoppner is a dignified production, and the *Elizabeth, Marchioness of Exeter*, of the same year, after Lawrence, may be mentioned with even greater praise for the simplicity of the tone surface, both in figure and background. It is the more remarkable, as the shimmering quality of Lawrence's painting seldom failed to lure the engraver to an exaggerated glossiness, tempting him to discard the purer convention of a less imitative texture, which should distinguish the mezzotint engraver from the photographer.

Reynolds very largely uses an etched foundation for his mezzotint, and given a good proof, it is sometimes not ineffective (*e.g.* in his *Countess of Oxford* of 1799, and the *Mrs. Arbuthnot* of 1800 after Hoppner). There is always, however, a dangerous tendency for the etching, if too heavy, to coarsen the effect, and render the tone a mere redundancy. This may be remarked in particular in the etched ground of the *King Leopold* (as *Prince of Saxe-Coburg*) after G. Dawe, while the repose and concentration of the *Lady Hood* (after Lawrence) is marred except on the darkest impressions by the heavy outlines of the dress.

For some time after about 1826 Reynolds was in Paris, and produced numerous subject plates after Géricault (*e.g.* the *Wreck of the Medusa*), Horace Vernet, Delaroche, A. C. H. Haudebourt-Lescot, Dubufe, and other French painters.

During the six years previous to his removal he had been chiefly engaged in producing a series of 357 plates after Reynolds. He was greatly assisted in the work by his pupil (and later assistant) SAMUEL COUSINS, who claimed to have entirely scraped some eighty-four of the plates.

Of other mezzotinters of the first half of the last century we may just mention GEORGE CLINT, an engraver of numerous theatrical groups; HENRY MEYER,[1] faulty in draughtsmanship, but often powerful in tone; THOMAS HODGETTS, and THOMAS GOFF LUPTON. Besides a small part in the *Liber Studiorum*[2] and seventeen facsimiles of the original series published between 1858 and 1864, Lupton also engraved after Turner (mostly dating between 1826 and 1828) the set of *Harbours of England*, which was published with text by John Ruskin in 1856. Some seven plates of the

Marginal notes: S. W. Reynolds. George Clint. Henry Meyer. T. Hodgetts. T. G. Lupton.

[1] He worked largely in stipple.
[2] For full list of mezzotinters in this work, cf. p. 244.

River Scenery (or *Rivers of England*) by Turner and Girtin are also from his hand (1823-27).

William Say. A more important place is held by WILLIAM SAY, one of the most prolific of the later mezzotinters. He produced much work of a second-rate order, but here and there a print like the *Lady Mildmay and Child* after Hoppner (1803), which in its tasteful combination of etching has very similar qualities to some of Charles Turner's plates. He is particularly successful in his busts after Hoppner (e.g. *Rt. Hon. William Windham*, 1803, and *Sir George Beaumont*, 1808) and Beechey (e.g. *John Heaviside*, 1803), knowing well how to use a full tone in the background to give an added emphasis and force to his figure. He not infrequently combines his light etching with delicate touches of roulette work.

The use of the steel plate. The claim put forward by his son,[1] that his smaller portrait of *Queen Caroline* (1820) was the first attempt to use steel plates in mezzotint is a questionable honour.

The rich quality of a mezzotint impression depends largely on the burr caused by the rocker, and, as in the case of work with the dry-point, this is worn down after very few impressions. It naturally follows that the late impressions from mezzotints have an incomparably small value beside the early impressions, and the efforts, not only of the original engravers, but of the later possessors of the plates, to repair the tone by rework, render it a constant difficulty to decide whether certain impressions are from the original plate or from some copy. In most cases it matters little, for the original in a state of dilapidation has no more marketable value and often far less artistic value than a copy.

The new development was an attempt to revive an art already in its decay, by using a metal which would place the mezzotints more on an equality in market rivalry with the more lasting work of the line engravers. For some ten years the use of steel was often paraded in the lettering as an attractive novelty. From about the same time there is a marked deterioration in the depth and richness of mezzotints in general. What proportion of this is due to the harder quality of impressions from steel, and what to the decay of real power in the engraver, it is difficult to decide. It would, perhaps, be the juster estimate to say that the second factor is by far the more important, while the general decline of the school of painting, on which the engravers relied for their models, except in the one field of landscape, should also be reckoned in the account.

Samuel Cousins. In SAMUEL COUSINS the deterioration of the quality is sometimes lamentably evident. Like Turner and Reynolds he uses mixed methods, but his habitual foundation of a sort of mechanical stipple is of the dullest order, and the tone of his mezzotint far too often spoiled by inartistic imitations of the glossy tones of Lawrence

[1] MS. on an impression in the British Museum, which possesses an almost complete collection of his prints (some 335 Nos.). It should be noted that in 1823 T. G. Lupton obtained a medal of the Society of Arts for "engraving in mezzotinto on steel."

and his early Victorian followers. The value of his work may be justly estimated by examination of the stipple proofs and the finished impressions of the *Sir Robert Peel* (after Lawrence), of which the British Museum possesses impressions. In most cases Cousins is probably responsible for the whole work on the plate, but there is one instance where collaboration is acknowledged, *i.e.* the *Robert Burns* of 1830 (after Nasmyth), where the stipple was executed by WILLIAM WALKER.

Cousins stands as one of the most important of the engravers after Landseer, while his reproductions of Leighton, Millais, and James Sant bring us into a generation that has not yet entirely passed from us.

WILLIAM WALKER is on the whole a far better artist. He also William combines stipple with mezzotint, but it is the work of one of the Walker. best stipple-engravers,[1] and of a far less mechanical order than that of Cousins (e.g. *W. E. Gladstone*, after W. Bradley). His mixture of etching is also done with considerable skill, remarkable in the portrait of *James Abercromby* (1835), after Jackson.

JOHN RICHARDSON JACKSON (1819-77) is an engraver of a later J. R. Jackson. generation who has some of Walker's quality. He could be dull in his mixtures of mezzotint, stipple, and etching, combined with no great power of draughtsmanship (e.g. the *Lord Hatherly*), but he also produced a considerable number of sound plates, in particular after J. P. Knight (e.g. *Lieut. Holman*) and George Richmond (e.g. *Earl of Leven* and *Mrs. Hook*). Both Jackson and Walker generally avoided the thin, glossy surface which was the bane of the mezzotint workers in the second two quarters of the century.

A unique position among the mezzotinters is filled by DAVID David Lucas. LUCAS, the interpreter of Constable. The son of a grazier, and working himself on the land till he was twenty, a mere chance discovered his talent to S. W. Reynolds, who made him his apprentice in 1823. Among his earliest dated works are a few portraits (*e.g. Dr. Mayhew* after J. Lonsdale, 1827, and the small plate of the *Duke of Wellington* after Lawrence, 1828), and there are a few others scattered throughout his work, but these and his subject plates are of the very slightest importance beside his landscape.

The mass of his landscape work is after Constable. We may mention a few small but excellent plates after C. Tomkins (*e.g. Dieppe*, 1830), another after Bonington (*Boulogne*, 1836), two of 1834 after Horace Vernet, two large and unsatisfactory reproductions of J. D. Harding (*Corsair's Isle*, 1835, and the *Grand Canal, Venice*, 1838), the *Return to Port Honfleur* after Isabey (1836), and a rare and most powerful plate of *Jerusalem* after David Roberts (1846), and the tale of his work after other painters in this field is almost told. At first Constable took the responsibilities of the reproduction, and it was he and Colnaghi who published in 1833 the *Various Subjects of Landscape*. The 22 plates of this set, including the frontispiece and "vignette," bear

[1] Cf. p. 299.

dates between 1828 and 1832, and show some of the engraver's best work. The *Noon* (1830), *A Summerland* (1831), *Summer Afternoon, Sunshine after a Shower* (1831), may be cited for their brilliant

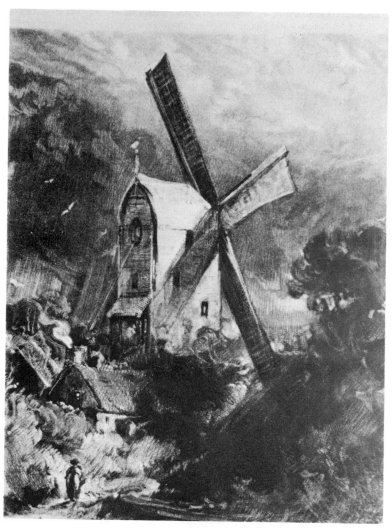

FIG. 99.—David Lucas. Mill near Brighton, after Constable.

and luminous rendering of Constable's atmospheric effects, while others, like the *Glebe Farm* (1832), and the *Water Mill, Dedham, Essex* (1832), exemplify the rougher grain which Lucas used when he had to deal with darker masses of foliage and heavier foregrounds.

The *New Series of Engravings of English Landscape* after Constable (14 numbers), which appeared in 1846, was a venture of the engraver, and was commercially as complete a failure as the former set. Constable's appreciation unhappily brought Lucas no substantial success, and a disappointed life ended miserably in the Fulham Workhouse.

Like his master and most of his contemporaries, Lucas frequently combined etching with mezzotint. The line-work is most in evidence in the *Rainbow* (the larger plate of *Salisbury Cathedral from the Meadows*), of 1837. In this instance the etching was done after the plate was nearly finished in pure mezzotint, and a comparison of the earlier with the finished impressions makes one regret his combination. The mixture of etching is far less emphatic, and the general effect more pleasing, in two other large plates, the *Lock* (1834) and the *Cornfield* (1834), but all these large productions are less perfectly fitted to their medium and size, and less convincing as works of art, than the smaller plates.

The decay of mezzotint as a reproductive art has been largely due to the perfection of photogravure, which serves the student of painting so well by its faithful transcriptions of the quality of painting. There are still, however, a few exponents of the art who are able to show how immeasurably the tone of mezzotint surpasses that of the best of the mechanical processes. We refer in particular to J. B. PRATT, NORMAN HIRST, R. S. CLOUSTON, GERALD ROBINSON, and FRANK SHORT. *J. B. Pratt. Norman Hirst R. S. Clouston G. Robinson. Frank Short.*

Besides his reproductive work after Turner,[1] De Wint, and others, in which he commands a gamut of tone almost unrealised by the earlier mezzotinters, Short has also scraped a considerable number of excellent original landscapes.

The mezzotinters of the past have used their method too little for original expression. Recent work, like that of SEYMOUR HADEN, JOHN FINNIE, and SHORT in England, and of RICHARD KAISER in Germany, makes one hope that an unworked field of real promise may yield a good harvest in the near future. *Haden. Finnie. Kaiser.*

II. THE CRAYON MANNER AND STIPPLE

Three engravers claimed for themselves the honour of discovering the crayon method, JEAN CHARLES FRANÇOIS, GILLES DEMARTEAU, and LOUIS BONNET.[2] François himself stated[3] that he made experiments in the method in 1740, though he did not repeat his essays until 1753. François's work is by no means artistically important, but his own statement, and the fact that in 1757 he attained recognition from the French Royal Academy, *J. C. François.*

[1] Cf. p. 245.
[2] In earlier editions I was not perfectly convinced of his generally accepted identity with the Louis Marin whose name figures on some of his plates (*e.g.* as inventor of printing in gold). But it was assumed by his contemporary, P. F. Basan (*Dictionnaire*, 1789), and I now see no reason for doubting it.
[3] In a letter addressed to Savérien, printed 1760.

and in 1758 a pension from the king with the title of "graveur des dessins du Roi," point to an official acknowledgment of his discovery. His most considerable work consists of the plates which he engraved for Savérien's *Histoire des Philosophes Modernes*, 8 parts (4 vols.), Paris, 1760-69 (with 8 frontispieces and 67 portraits), of which we reproduce the portrait of *Sir Isaac Newton* (Fig. 100). François was a skilful craftsman, addicted to experiments in manifold methods,—one of his portraits, the *François Quesnay*, showing a combination of mezzotint, line, crayon, and aquatint in its various parts.

Demarteau.

GILLES DEMARTEAU, of Liège, who was working in Paris from about 1746, must have taken up the new process very soon after François. His work is very copious, and more important than that of François, realising with greater success the absolute quality of the red chalk drawings which it constantly reproduces. Boucher supplied the greatest number of his originals, but he produced many prints after Cochin, Le Prince, Huet, Eisen, Fragonard, and others. He occasionally worked with two colours, seldom with more.

Louis Bonnet.

Though BONNET's claim to the discovery of the whole method is out of the question,[1] he at least seems to have been the first to imitate the quality of pastel by printing a crayon engraving in various colours, apparently using a plate for each tone. He is one of the few engravers (excepting the artists in chiaroscuro wood-cuts) who have used a white pigment in printing to give a light higher than the tone of the white paper. His pigment seems to have been comparatively permanent in colour.

Bonnet was as prolific as Demarteau in his reproduction of drawings by Boucher, Lagrenée, and the like, but the greater part of his work is of a much more commonplace order. He often descends to imitating a gilt frame to decorate his engraving; in fact, he seems to have taken special pride in the power of compassing these difficult trifles by the art of printing. He also seems to have made experiments in processes like aquatint as early as Le Prince.[2]

Many other engravers during the latter half of the eighteenth century and the early part of the nineteenth did work in the crayon manner, but for the most part they are the same artists who worked in stipple, and their names will be reserved for our summary of that method.

A completely different method, that of soft-ground etching,[3] often effects results which are surprisingly like crayon prints, the aim

[1] 1743 is generally given as the date of his birth, but as it appears from the 1758 edition of Bosse (revised by Cochin) that he had already produced successful plates in the *pastel* manner, Basan's date, 1735, very probably has better authority behind it. Cf. however, A. M. Hind, *Burl. Mag.*, Sept. 1907.

[2] Note, *e.g.*, his title-page and two plates in the 1767 edition of Caylus's *Recueil de Testes de caractère et de charges dessinées par Leonard da Vinci.*

[3] This process appears to have come into use early in the second half of the eighteenth century. As I have not devoted a special section to its history, I add references to the pages on which etchers in soft ground are mentioned, *i.e.* pp. 235, 237, 240, 241, 244, 282, 303, 304, 313, 335, 337, 385, and 386. Thomas Vivares is one of the few artists who often specifically letters his plates *soft-ground etching.*

of both methods being essentially similar. The student will often need care to discriminate between the two; but there is an irregularity and softness in the grain of soft-ground etching that could not be produced by roulettes and other tools of the crayon-

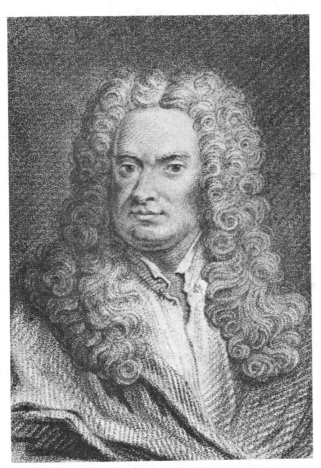

FIG. 100.—J. C. François. Portrait of Sir Isaac Newton.

engraver. Prints after Morland's drawings include many examples in both methods, which are sometimes mixed on the same plate, and offer good opportunity for the comparison. *E.g.* soft-ground etchings by THOMAS VIVARES might be compared with crayon-engravings by JOHN WRIGHT.

In Holland a process standing midway between that of the crayon and stipple manners was practised by J. J. BYLAERT, and

J. J. Bylaert.

described by him in a book published in 1772,[1] the base idea of which is the method of dotting with points ("*poinçons*") of various sizes to obtain the texture, which François achieved largely by the roulette. He refers to having done prints after Van Goyen and Saftleven in this manner. The aim he had in view was still the rendering of the texture of chalk, and I have met no prints of his which could be strictly classed with stipple.

Punch-engraving. The method of engraving entirely by dots,[2] which, in combination with elements of the crayon manner, forms the basis of stipple, can be traced far back in the history of the art of the goldsmith in the *opus interrasile* and *opus punctile* of the Middle Ages.[3] A considerable number of impressions (for the most part comparatively modern) are in existence taken from plates dotted with the punch and hammer, which were originally intended only for ornament in themselves. One might mention an *Annunciation* by Buonincontro da Reggio,[4] belonging to the second part of the fifteenth century, of which there is an impression in the British Museum. At a later date the Dresden goldsmith family of the KELLERDALLER (late sixteenth and early seventeenth centuries) did similar work, not infrequently with the idea of taking impressions. Two distinct classes of this type of work may be observed: (i.) where the dots are used positively to show the blacks (*e.g.* most of the plates of JOHANN KELLERDALLER I. and II., which can therefore be printed with proper effect); (ii.) where the dots represent the whites, so that an impression is merely a negative from a plate designed as an ornament in itself (*e.g.* BUONINCONTRO and DANIEL KELLERDALLER). Work of the former class was done, among others, by FRANZ ASPRUCK and PAUL FLINDT about 1600. Roulette work is also found combined with their punch-engraving, and was probably done for the most part with the *matting-wheel*, which is an old tool of the goldsmiths.

Some of the most successful work with the punch definitely intended for impression are the plates of JAN LUTMA the younger. His portraits of *Himself* (dated 1681), of his *Father* (also a goldsmith),[5] of *Vondel* and *Hooft* show an astonishing command of the method in the delicate shades of tone achieved in the modelling.

To return to the engraver in the narrower sense of the word. We have already noted dotted work in plates of GIULIO CAMPAGNOLA, of the engraver of the monogram ℔, and of MARCELLO FOGOLINO at the beginning of the sixteenth century,[6] and a century later in the work of OTTAVIO LEONI; but this has all been done almost certainly with the ordinary graver, and is thus merely a refinement and

[1] See General Bibliography.

[2] The French term, *manière pointillée*, serves both in the general sense of dotted manner, and in the special signification of stipple.

[3] Cf. Introduction, p. 11. The mediæval processes are described in Theophilus, *Diversarum artium schedula*, ed. Hendrie, 1847, lib. iii. capp. 72, 73.

[4] See Zanetti, Cabinet Cicognara, 1837, p. 142.

[5] The subject of one of Rembrandt's finest etched portraits.

[6] Note also E. Delaune's *History of Genesis* (R. D. 24-59).

concentration of the short flicks so constantly used in conventional line-engraving at almost every period.

Just as the limits of the various processes are often ill defined, so this practice of Campagnola may be regarded as an anticipation of stipple; but in its strict signification, as it has been described in the introduction, stipple is a combination of the processes of etching and engraving, the graver used being specially curved to facilitate the dotting.

At what precise date stipple came into use is uncertain, but in any case it is the follower and not the predecessor of the crayon manner. Nor is it profitable to inquire whether it originated on the Continent or in England. It can, at least, be asserted that England was the first country in which it took root, and the only country in which it ever flourished. A great number of its masters, however, were foreign, very many Italian engravers being attracted to England by the success of one of its first exponents, FRANCESCO BARTOLOZZI. *The introduction of stipple.*

BARTOLOZZI was born in Florence in 1727, and studying under Joseph Wagner at Venice, followed his master at the outset of his career in the practice of line-engraving. On the invitation of Dalton, librarian to George III., he came to England in 1764, where one of his earliest works was *a series of prints after drawings by Guercino.*[1] *Bartolozzi.*

Just before leaving Italy he had been engaged, in collaboration with Giovanni Ottaviani and Giacomo Nevay, on a series of reproduction of Guercino drawings from the collection of T. Jenkins, Joseph Smith, A. M. Zanetti, G. B. Tiepolo, and others, which was published by G. B. Piranesi at Rome in 1764.[2]

Except those after Guercino, the majority of the prints after drawings which Bartolozzi produced in England were in crayon or stipple. In particular may be mentioned the *Imitations of original Drawings by Hans Holbein in the Collection of His Majesty* (published by John Chamberlaine, 1792-1800),[3] and his part in John Chamberlaine's series of prints after miscellaneous drawings in the Royal collection.[4]

[1] Boydell issued these with prints by other engravers under the title *Collection of Prints engraved by Bartolozzi and others, after Guercino and others, from Original Pictures and Drawings in the Collection of His Majesty*, etc. (J. and J. Boydell, *Catalogue*, 1803.) G. Vitalba was among the other engravers.

[2] *Raccolta di alcuni Disegni del Barbieri da Cento detto il Guercino.* The title etched by Piranesi. In the Catalogue of the Piranesi, 1792, the collection is described as containing 28 plates with the frontispiece. This set, with many other prints of the kind (*e.g.* by A. Bartsch after Guercino; by F. Rosaspina after the Carracci, Reni, etc.), was the property of the Piranesi, and appeared again in the large Paris edition of their works (Firmin-Didot, 1835-39).

[3] Including eighty prints by Bartolozzi, three by C. Metz, and one by C. Knight. In 1812 an edition appeared, based on the earlier edition, with smaller plates by various engravers (Knight, Facius, Minasi, Cardon, Cheesman, etc.), only two of Bartolozzi's plates (after miniatures) being repeated.

[4] Which appeared at various times between 1797 and 1811, a collected edition being published in 1812. Bartolozzi contributed the largest number, but it also contains prints by F. C. and G. Lewis, P. W. Tomkins, B. Pastorini, L. Schiavonetti, and others. G. Lewis deserves mention for etchings in T. F. Dibdin's *Tour* (1821).

Prints after
Cipriani and
Angelica
Kauffmann

He found the great opportunity for the practice of the delicate stipple method in the reproduction of drawings by his Florentine friend, G. B. CIPRIANI, who had settled in England for some years before his arrival.

Nor was it less Cipriani's opportunity, for he was negligible as a painter of large canvases, and his drawings only attained real fame

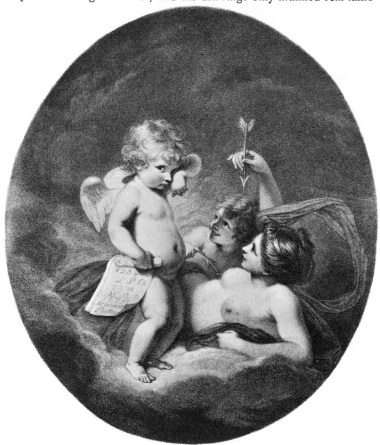

FIG. 101.—Francesco Bartolozzi. Venus chiding Cupid, after Reynolds.

in their reproduction. Another foreign artist of similar talent for slight subjects of graceful fancy, ANGELICA KAUFFMANN, who came to England the year after Bartolozzi, is scarcely less important as an inspirer of stipple, and there are few of the engravers in the method who did not use her designs. Both she and Cipriani left some etchings of fancy subject and portrait, etc., but they are of little interest. Few English draughtsmen hold a place in the history of

stipple at all comparable to these, unless perhaps it be Richard Cosway. At some distance, but still very largely represented in the stipple engravings of the end of the eighteenth and beginning of the nineteenth centuries, are Stothard, Burney, Westall, Hamilton, Wheatley, Bigg, and Singleton.

Besides the very numerous plates of fancy subjects serving manifold ends, from book illustrations to invitation cards and admission tickets, in many of which he may have been assisted by anonymous pupils, Bartolozzi produced a considerable number of prints of a more serious order after Reynolds and many other painters. Of his portraits one might mention in particular *Georgiana, Duchess of Devonshire* (after Lady Diana Beauclerc), *Mrs. Crouch* (after Romney), *Angelica Kauffmann* (1780), *Lord Thurlow* (1782), *Dr. Burney* (1784), *Lady Smyth and her children* (1789), *Countess of Harrington and her family* (1789), *Lord Burghesh* and *Philip Yorke* (as children, both dated 1788) after Reynolds, *Lady Jane Dundas* (after Hoppner), *Kemble as Richard III.* (after Hamilton, 1789-90), *William Pitt* (after Gainsborough Dupont, 1790-91), *Dr. Blair* (after Raeburn, 1802), and the magnificent full-length of *Elizabeth Farren,*[1] of 1791 (after Lawrence).

Bartolozzi's portraits.

In some of the larger plates (*e.g.* those of *Kemble* and *Pitt*, the etched line is largely used in combination with stipple, while in the *Lord Thurlow* the whole of the figure is etched in line, the face alone being dotted.

At his best, *e.g.* in the excellent rendering of Hogarth's *Shrimp Girl*, Bartolozzi shows a remarkable command of the delicate shades of tone, but his reputation as a draughtsman inevitably suffers by the mass of inferior work which issued with his signature from his studio.[2] His success in England was great, but apparently not sufficient for his manner of living, and it may have been monetary difficulties that induced him in 1802 to accept the position of Director of the Academy at Lisbon, where he spent the last thirteen years of his life.

WILLIAM WYNNE RYLAND was probably working in stipple as early as Bartolozzi. After serving an apprenticeship to S. F. Ravenet in England, he spent several years (about 1760) in Paris, where he is said to have studied under Boucher and Lebas. His interest in the crayon manner may have been personally inspired by François or Demarteau. Some of his crayon engravings, published in Charles Rogers's *Collection of Prints in imitation of Drawings*[3] (2 vols. 1778), are dated in 1764, *i.e.* very soon after his return to England.

W. W. Ryland.

[1] This was only finished by Bartolozzi. The etching, the greater part of the work, is by Charles Knight. See Nash, *Mag. of Art*, 1886, p. 143.

[2] As evidence of an assistant's work finished by Bartolozzi, note two oval stipple plates of subjects from the "Vicar of Wakefield" (*Sophia and Olivia* and *Olivia and Sophia with Fortune-teller*), published 1784, signed *F. Bartolozzi correct*d.

[3] The title-page, inscribed *A Century of Prints from Drawings*, is by Bartolozzi. Most of the other prints (in et., en., and cr.) are by SIMON WATTS and J. BASIRE; the latter and CHARLES PHILLIPS (one plate) also used mezzotint.

Impressions
in red.

In his many prints of fancy subjects after Angelica Kauffmann and Cipriani, nearly all of which were printed in red, a particular affectation of this school of engravers, he exhibits a delicacy of tone which even surpasses Bartolozzi himself in smoothness. It is the brilliance of weakness, however, rather than strength, and when left to work out his own designs, he shows himself only a very second-rate artist. Of his work in line-engraving, in which he has none of the strength of Strange, and much of the somewhat finnicking quality of French portrait work of the period, the *Earl of Bute* (1763) and *George III.* after Romney, and the *Queen Charlotte with the Princess Royal* after Cotes (1770), may be mentioned as examples. They may have served to get him the position of engraver to George III., which he held throughout his life. Convicted of a bank-note forgery, his career ended prematurely in 1783 on the gallows, as young William Blake, when taken by his father as a prospective pupil to Ryland, had strangely prophesied.

Thomas Burke.

THOMAS BURKE makes up the trio of Angelica Kauffmann's chief interpreters. He inclines to a rougher surface than Ryland, and in general is more spirited in expression. He was a pupil of John Dixon, and also practised to some extent in mezzotint.

Of Bartolozzi's pupils, Knight, Sherwin, Marcuard, Cheesman, and P. W. Tomkins are most worthy of notice.

Charles
Knight.

CHARLES KNIGHT did a brilliant piece of work in his etching of the *Miss Farren*, mentioned above, but this was probably produced immediately under Bartolozzi's direction, and he shows scarcely anything else of comparable brilliance. One might instance portraits of *William Viscount Barrington* (1794-95), and the *Duchess of York*, 1801 (after Beechey), but they are rather crude in modelling, and lack the delicacy which is the chief distinction of stipple.

J. K. Sherwin.

JOHN KEYSE SHERWIN is one of the few of Bartolozzi's pupils who engraved more in line than in stipple. He did some brilliant work after subjects by the old masters, as well as after contemporary painters, but his original work on copper does not show any great talent.

Marcuard.

R. S. MARCUARD left some excellent work in stipple, one of his most powerful plates being a portrait of *Bartolozzi* after Reynolds (1784).

Thomas
Cheesman.

Bartolozzi had a close follower in THOMAS CHEESMAN, more particularly in his system of combining the etched line with stipple in the darker tones. He did a considerable number of original plates, both fancy subjects and portraits, but few of the latter attain the excellence of his *Lady Hamilton* as the "Spinster" (after Romney). Of his plates after the old masters, a *Venus with Cupid* after Titian [1] may be cited as a good test of the value of stipple in modelling.

In sheer craftsmanship the four engravers just mentioned cannot

[1] Not exactly corresponding to any of the known pictures, though near to one in the Uffizi (catalogue 1905, No. 1108).

rival LUIGI SCHIAVONETTI, a native of Bassano, who came to Eng- L. Schiavon-
land in 1790 to work under Bartolozzi. He is equally brilliant in etti.
stipple, line, or etching, but in all these mediums he produced a
mass of indifferently executed hack work for book illustration and
miscellaneous commercial uses. He shows a wonderfully smooth
and finished technique in his portraits (e.g. *Luigi Marchesi* of 1790,
after Cosway, *Joseph Haydn*, 1792, after Guttenbrunn, and *Lady
Cawdor* after Edridge [1]). His most popular work is undoubtedly
contained in the series of the *Cries of London* after Wheatley
(1793-1797).[2]

PELTRO WILLIAM TOMKINS, another of Bartolozzi's many P. W.
pupils, is most noteworthy for several charming sets of little fancy Tomkins.
subjects of children at play and the like (*e.g.* the *Birth and Triumph
of Cupid, from papers cut by Lady Dashwood*, 1795, and the *Birthday
Gift, or the Joy of a New Doll*, 1796).

His portraits (e.g. *Mrs. Siddons* after Downman) are often of
delicate workmanship, but possess little real vigour.

CHARLES WILKIN is the author of a considerable number of Charles
portraits, combining stipple and etching, much in the manner of Wilkin.
Bartolozzi. Engraved with considerable freedom and spirit are the
ten prints of the *Series of Portraits of Ladies of Rank and Fashion*
which were published in pairs in the years 1797, 1799, 1800, 1802,
and 1803, and probably issued as a set in 1803 (the general wrapper
is not dated). Three of the series are both drawn and engraved by
Wilkin (*Lady Gertrude Villiers, Lady Catherine Howard, Lady
Gertrude Fitzpatrick*), and the rest are after Hoppner (e.g. *Lady
Charlotte Campbell* and the *Duchess of Rutland*). Of his prints
after other masters, the *Lady Cockburn* ("*Cornelia*") *and her
Children* after Reynolds (1791), may be cited as one of the strongest,
but it shows a weakness in modelling, an uncertainty in the use of
lights, and a dulness of surface tone which he seldom surmounts.

CAROLINE WATSON, the daughter of the mezzotint engraver Caroline
James Watson, is the miniaturist in style among the stipple Watson.
engravers. Her surface is of the closest and finest texture (*e.g.*
portraits of *Benjamin West* and *William Woollett*), and suffers from
the excess of its quality, while her design lacks grip and robustness.
She engraved much after Reynolds, and her portrait of the painter
(after himself) is one of her most brilliant plates (1789). She
engraved one plate for the *Shakespeare Gallery*,[3] but subjects on
this scale were too large for her delicate talent. One of her most
vigorous plates, with nothing of her characteristic fault, is the *Miranda*
after Romney (1809).

While speaking of the miniaturist style as represented in

[1] Original drawing in the British Museum.

[2] In which he had N. Schiavonetti, G. Vendramini, A. Cardon, and T. Gaugain
as collaborators.

[3] For other engravers engaged in this work (in stipple and line), cf. Chap. VII.
p. 219.

stipple, we may refer to JOHN CONDÉ and ANTHONY CARDON, who will be remembered specially for their full-length portraits after Cosway. The delicately finished face and the slighter indications of the figure are most excellently rendered by a combination of stipple and the crayon manner.

Anthony Cardon.

ANTHONY CARDON was a native of Brussels, but settled early in London, studying under Schiavonetti. Of his full lengths after Cosway, we may mention the *Mrs. Merry* and *Major-General R. C. Ferguson* (1810), of numerous portraits after Edridge, the *George III.* (1803), the *Hon. John Smyth*, and that of his master *L. Schiavonetti* (1811). He also engraved after his own drawings, *e.g.* a large portrait group of 1801, including the *Marchioness of Donegall, Mrs. and Miss May, and the Earl of Belfast.* A powerful stipple print, after Rembrandt's *Ganymede* (1795), is an exhilarating work amid the constant repetitions of fancy subjects affected by the school. Besides work in stipple and line, which he largely used in small book illustrations, he did a series of prints in etching and aquatint after drawings by Mrs. Cosway (published by Ackermann, 1800).

John Condé.

JOHN CONDÉ is only known to have worked in London, though he is certainly of French or Flemish extraction. He knew even better than Cardon how to render the delicate tone of miniature (*e.g.* his full-lengths of *Mrs. Tickell*, 1791, and *Mrs. Fitzherbert*, 1792, after Cosway), but in vigour of draughtsmanship he is much Cardon's inferior.

Thomas Gaugain.

Two other foreigners whose work centred in London are THOMAS GAUGAIN and JEAN PIERRE SIMON. The former, a native of Abbevile, is a prolific craftsman, and engraved many subjects and portraits after Hamilton, Northcote, Reynolds, Morland, Hoare, and others; but he is a less interesting artist than J. P. Simon.

J. P. Simon.

A rather weak plate, *Psyché Suppliante* (after A. C. Fleury), was published in Paris, but does not help to fix the date of Simon's removal to London, which seems to have been quite early in his life. He is one of the few stipple engravers who had sufficient power to make some success in large subjects, like those of Boydell's *Shakespeare Gallery*, to which he contributed several plates. His print, after Reynolds's *Heads of Angels* (*children of Lord William Gordon*), in the National Gallery (1789), is one of the most attractive of all stippled plates

Of other foreigners who practised stipple in England we would mention the Facius and the Sintzenichs of Germany, and Elias Martin of Stockholm.

G. S. and J. G. Facius.

GEORG SIGMUND and JOHANN GOTTLIEB FACIUS did much work for Boydell, who is said to have invited them to England in 1766. For the most part they worked in common on their plates, which include numerous portraits (e.g. *Prince Octavius*, 1785, after West), and many subjects (*e.g.* after Reynolds's *New College Windows*, and for Boydell's *Shakespeare Gallery*). If their work is dull, and lacking

in draughtsmanship, that of HEINRICH and PETER SINTZENICH shows Heinrich and
an even dryer manner. Heinrich Sintzenich was probably in London Peter Sint-
zenich.
to study under Bartolozzi (ab. 1775-79 ?), but soon returned to settle
in Germany. The little work of Peter that is known seems to have
been done in London about 1789.

ELIAS MARTIN is of no great importance as an artist, but his Elias Martin.
stipple engravings at least have a character of their own. In a series
of fancy subjects and portraits published in 1778, he shows a light
manner of using stipple, indicating dress and accessories with broad
open dot and flick work, whose effect is somewhat reminiscent of a
Watteau drawing.

The best English engraving in crayon and stipple, the work of The mezzo-
artists who have already been referred to in the capacity of mezzo- tinters who
worked in
tinters, remains to be mentioned. The work of EARLOM, CAPT. stipple.
BAILLIE, THOMAS WATSON, and WILLIAM DICKINSON in this field
has already been noticed, and we can limit ourselves here to the great
trio of JOHN JONES, J. R. SMITH, and WILLIAM WARD.

These three engravers realised better than any of the immediate The combina-
imitators of Bartolozzi that the virtue of the smooth and shallow tion of the
crayon manner
surface tones of pure stipple could only be appreciated to advantage and stipple.
when relieved by an unelaborated setting in the lighter manner of
crayon. Stipple tones carried consistently throughout the whole
of a plate tend to monotony. They lack the depth required to give
a powerful reproduction of painting. On the other hand, the crayon
method of representing a chalk drawing is completely satisfying,
and the finished stipple of the principal part of the design (most often
the face of the portrait) serves well to concentrate the effect of the
whole. Cosway had realised this, and some of the engravings by
John Condé, Anthony Cardon, and others after his drawings show
how effective the combination could be. A lighter manner of draw-
ing throughout his portraits, with nothing of Cosway's miniature
handling of the face, is represented by John Downman. Such
prints as Bartolozzi's *Duchess of Devonshire* (1797) and John Jones's
Miss Kemble (1784) show how well his drawings appear in stipple
and crayon, and they possess just that style which characterises the
best original work by Jones, Smith, and Ward.

Of JOHN JONES we would mention in particular two plates after John Jones.
Romney, *Lady Hamilton* (1785), and *Serena* (*Miss Sneyd*, 1790),
as comparable to his *Miss Kemble* in lightness of touch. His
more purely stippled work in the heavier manner, e.g. *Robinetta*
(1787) after Reynolds, is less successful, and shows some of the
faults of drawing and little of the strength of his mezzotints. A
large full length of the *Duke of York*, 1790 (Reynolds), will suffice
to demonstrate the inefficiency of the stipple method to represent
the tone of pictures on a large scale.

JOHN RAPHAEL SMITH did a considerable number of fancy portraits J. R. Smith.
and original subject prints in the methods of stipple and crayon.

Of the fancy portraits we may mention the *Thoughts on a Single*

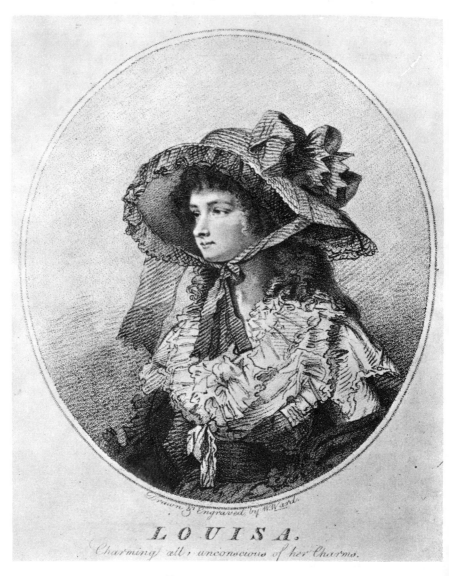

LOUISA.

Charming all, unconscious of her Charms.

FIG. 102—William Ward. Louisa.

Life (1787), and the pair, *Narcissa* and *Flirtilla* (1787), as good examples of the lighter method, while his *Widow* (1791) is at least

a brave attempt at rendering depth of tone by stipple. A portrait of *Miss Hervey* is of some interest, as it shows a curiously rough mixture of aquatint and etching with stipple. Besides original work, there are numerous stippled plates after Morland, e.g. *Delia in Town* and *Delia in the Country* (1788), and the *Tavern Door* (1789).

Both Jones and Smith are surpassed by WILLIAM WARD in the William Ward sphere of stipple and crayon. His original fancy portraits are among the most attractive work that has been produced in the field. The *Louisa* of 1786 (Fig. 102) is perhaps the best of these, but many other charming plates might be mentioned, e.g. *Lucy of Leinster*, *Alinda*, *The Cyprian Votary*, *The Soliloquy* (1787), and the *Musing Charmer* (1787). Like J. R. Smith he did numerous stipple prints after Morland.

A notable recurrence to the heavier manner and a bold attempt William to achieve something of the depth of mezzotint is seen in WILLIAM Walker. WALKER, whom we have already mentioned in our section on mezzotint. It must be confessed that in his particular aim he is a far more powerful artist than Bartolozzi or any of his followers, and he has the advantage of avoiding the affectation of printing in red. His *Lord Brougham and Vaux* (Lawrence), *Lord Lyndhurst* (Ross), and in particular several plates after Raeburn, e.g. *Sir Walter Scott*, show the best that has been done in stipple to render depth of tone while preserving significance of delineation. But despite the technical and artistic excellence of these plates, the principle is wrong, and the renewed attempt merely foreshadowed the decay of an art which only flourished with that lighter spirit of fancy which was heralded in England by Cipriani and Angelica Kauffmann. It has already been noted how the process of stipple was used by William Walker and Samuel Cousins as a mere adjunct to mezzotint, and by the latter and many others it was practised in a mechanical strain that merely offends. With the modern revival of the nobler art of original etching, and the more powerful method of mezzotint, there is no reason to deplore the almost total extinction of the art of stipple.

Allusion has already been made to the colour prints of the Stipple and French crayon and pastel engravers. The majority of the English crayon engrav-ings printed crayon and stipple engravers also constantly printed in colour, but in colour. they probably never followed the method practised by Bonnet and to some extent by Demarteau, of using a plate for each tone. The general practice seems to have been that of painting the plate between each printing with rag stumps (dollies), *à la poupée*, as it is called in French. The lighter kind of crayon and stipple prints, such as those of John Jones and William Ward, are eminently fitted for printing in this manner, but it is rare to find one of the pure stipple plates at all successfully rendered in any delicate scheme of colour.

III. Aquatint

JEAN BAPTISTE LE PRINCE (1734-81) is generally regarded as the inventor of aquatint. He was undoubtedly the first etcher to achieve consistent success in laying the porous ground, but in respect of the discovery it is dangerous to make any more definite assertion than that he was among the earliest to attempt to grain his

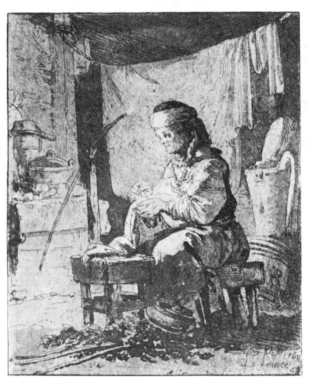

FIG. 103.—J. B. Le Prince. La Ménagère.

plates by means of this process. Stray examples of plates similarly treated may be cited considerably earlier than his time,[1] and among his contemporaries, Ploos van Amstel, Bonnet, and P. G. Floding[2] had used mixed methods on the borderland of aquatint possibly for several years previous to Le Prince's first attempts.

Le Prince obtained his ground by means of the dust-box and fly-wheel (or bellows), a method which is still used as much as any

[1] *E.g.* a portrait of *Cromwell* by Van de Velde (cf. Chap. VI. p. 169, note), parts of Sherwin's *Catherine of Braganza* (see p. 267, footnote 2), and a few plates done in Vienna between 1718 and 1722 by Gerhard Janssen of Utrecht.

[2] Several plates dated 1762, aq. mixed with roulette work, en., et.

other, though the fluid grounds have been found to give a more delicate grain.

His etchings in line date from 1760, but none of his aquatint plates are dated before 1768, and twenty-nine of these were exhibited in the Salon of 1769 with a special, but cryptic, note on the new process.[1] Except for a few rare prints after his master Boucher, all his work is original, a large part reproducing drawings which he had made of landscape and peasant life in Russia, where he seems to have spent several years between 1758 and 1763.

It was his practice to issue his prints in sets of six, e.g. *Divers Habillements des Femmes de Moscovie* (pure etching, 1763-64), *Habillements de Diverses Nations* (pure etching, 1765), 2ᵉ *Suite de Divers Cris de Marchands de Russie* (1765, pure etching), 2ᵉ *Suite d'Habillements de Diverses Nations* (aquatint, 1768), 1ᵉ *Suite de Coiffures dessinées d'après nature* (aquatint, 1768). His aquatint is always combined with a liberal use of line.

One of the earliest imitators of Le Prince's manner is the gifted amateur JEAN CLAUDE RICHARD, ABBÉ DE ST. NON. He did a considerable number of etchings and aquatints in monochrome after Le Prince, Robert, Fragonard, and others. <abbr>L'Abbé de St. Non.</abbr>

Not many years elapsed after Le Prince's discovery, before the new process was applied to printing in colour.

FRANÇOIS JANINET seems to have introduced the practice in France.[2] He used a succession of plates (often seven or eight in number) for the different colours, and considered as true colour impressions, the results he obtained are excellent in their clearness. Like many of his school he frequently strengthened his aquatint ground with the roulette. <abbr>F. Janinet.</abbr>

Janinet's work is almost entirely reproductive,[3] and embraces a multitude of subjects from landscape and genre to portrait. His larger portrait of *Marie Antoinette*, which is of great value in good impressions, is an accomplished technical production, but shows the same triviality of style that has been noted in Bonnet, a framework in imitation of gilt and marble being represented in the engraving. His method of colour was extremely successful in imitating Ostade's water-colours, with their clearly divided tints.

PHILIBERT LOUIS DEBUCOURT is as sound a master of the process of colour-printing as Janinet, and a draughtsman of far more original talent. He keeps far more strictly to pure aquatint than Janinet, seldom combining work with the roulette, and his surfaces of colour gain wonderfully thereby in the transparent quality of their tone. In Society genre he is one of the most distinguished masters, and his *Promenade de la Galerie du Palais Royal* (1787) <abbr>Debucourt.</abbr>

[1] See J. J. Guiffrey, *Collection des Livrets des anciennes Expositions*, Feb. 1870.

[2] One of his small plates, *L'Opérateur*, is inscribed : *gravé à l'imitation du lavis en couleur par F. Janinet, le seul qui ait trouvé cette manière.*

[3] *E.g.* after Boucher, Lavreince, Caresme, Gravelot, St. Quentin, and H. Robert.

and *la Promenade Publique* (1792) are of the greatest interest in their spirited representation of manners in Paris at the time of the Revolution.

Descourtis.
One of Janinet's pupils, CHARLES MELCHIOR DESCOURTIS, stands as an artist on a far lower plane than Debucourt. His colouring is almost as good, but his draughtsmanship is as weak as his sentiment. Six plates after F. J. Schall, illustrating *Paul et Virginie*, and *L'Amant surpris* after the same painter, are good examples of his work.

P. M. Alix.
A. F. Sergent-Marceau.
Of the other French exponents of aquatint, P. M. ALIX and A. F. SERGENT-MARCEAU deserve mention more particularly for their portraits.

Ploos van Amstel.
CORNELIS PLOOS VAN AMSTEL was producing plates somewhat in the nature of aquatint[1] before Le Prince's earliest attempts, but it is difficult to date any of his pure aquatints[2] definitely before 1768. Throughout his work his methods are very mixed, and often elude satisfactory explanation. His aquatint was very largely combined with the use of the roulette, and tone seems sometimes to have been achieved by etched lines so closely laid as to be almost imperceptible except in tone.

In the use of several plates to attain colour impressions he anticipated Janinet, but his methods were far less strictly those of the true colour printer. In spite of a testimonial[3] signed by a committee appointed by the Haarlem *Maatschappy der Weetenschappen* (printed, Amsterdam, 1768), careful examination of his prints seems to show that something was left to hand tinting.

His *Imitations de Dessins.*
Ploos van Amstel was an amateur, and a great collector of drawings, and his various and individual methods were largely devoted to their reproduction. He issued forty-six of his facsimiles in various parts[4] between 1765 and 1787 (the earliest plates being dated 1758), but no further collected edition appeared until two decades after his death, when CHRISTIAN JOSI, who became possessed of his stock, published the *Collection d'Imitations de Dessins* (London, 1821). The hundred plates of this second series included all the original prints (except two after Ostade, which were replaced by two new plates by Josi), others by JURIAAN COOTWYCK (a goldsmith engraver who appears to have made independent experiments in similar methods as early as Ploos himself), crayon engravings by JOHANNES KORNLEIN (who had been Ploos's assistant,

Christian Josi.

J. Cootwyck.

J. Kornlein.

[1] E.g. *Young Man leaning on a Door* after Rembrandt, which is among his prints published in 1765.

[2] E.g. *Judgment of Solomon* after L. v. Leyden.

[3] In relation to his processes of engraving and printing we may quote : *dat hy de Figuuren in zyne Plaaten brengt, nog door en Graveeryzer, nog door en Etsnaald, nog door een Pontsoen, maar alleenlyk door zekere grondvernissen, poeders en vogten ; dat hy de kleuren in zyne Printen geenszins afzet, maar alle, tot haare volkommenheid toe, op eene Pers drukt, en dat niet met waterverf, maar met olieverf. . .*

[4] Each accompanied with some prefatory matter headed *Bericht wegens een Prentwerk volgens de nieuwe Uitfinding van den Heer Cornelis Ploos van Amstel.*

1765-67), and aquatints by BERNAERT SCHREUDER and CORNELIS B. Schreuder.
BROUWER. C. Brouwer.

To these, which were all done before they came into his hands,
Josi added a few engravings of his own, of a certain Di(e)trich,[1] and
of C. C. Lewis, and had the flower pieces after Huysum hand
coloured by a young painter, Jean de Bruin.

In Germany the most interesting etchers in aquatint in the GERMANY.
eighteenth century were JOHANN GOTTLIEB PRESTEL and his wife J. G. Prestel
MARIA CATHARINA PRESTEL. Their aquatints are for the most and M. C.
part of a rough grain, but by no means ineffective. J. G. Prestel Prestel.
produced many prints in etching, aquatint, and in the crayon
manner after drawings in various collections (*e.g.* Paul Praun, 1776?
and G. J. Schmidt, 1779), in which he was also assisted by his
wife. The latter was separated from him in 1786, and afterwards
worked in London.

PAUL SANDBY, the water-colourist, is said to have learnt the ENGLAND.
process from the Hon. Charles Greville, who had purchased the Paul Sandby.
secret from Le Prince.[2] Sandby, however, in an autograph pre-
served in the British Museum[3] describes *a mode of imitating draw-
ings on copper plates discovered by P. Sandby, R.A., in the year* 1776,[4]
to which he gave the name of Aquatinta. He then proceeds to
describe his method of laying the fluid ground (resin dissolved in
spirits of wine), which Le Prince does not seem to have used at all.
In this sense his method was new, and possibly nothing but the
mere suggestion was due to Greville.

A set of twelve *Views in Aquatinta from Drawings in South
Wales* (dedicated to the Hon. Charles Greville and Joseph Banks)
of 1775, seems to have been his first venture in the process, and
it was followed in the succeeding years by three further series of
Welsh views.

Aquatint found a natural response in the English school of Publications of
water-colour, and it was frequently applied both in publications of views and the
views, and in the drawing-books which were popular at this period. books.
Of these we may mention the works of DAVID COX (*Treatise on
Landscape Painting*, 1814[5]), SAMUEL PROUT[6] (e.g. *Rudiments of*

[1] Identity uncertain. He had been working in Amsterdam before 1814, when
he returned to Germany. Having found no other work of this Dietrich or of C. C.
Lewis (unless C. C. is an error of Josi for F. C. or C. G.), I have not included either
in the index.

[2] See *Library of the Fine Arts*, ii. 344 (1831). It now appears that P. P. Burdett
of Liverpool produced a few aquatints between 1771 and 1774, one being dated 1771.
A MS. note of 1817 by Matthew Gregson of Liverpool in the British Museum
(acquired with Burdett's aquatint of "Boys blowing the Bladder" after Wright of
Derby), states that Greville purchased the secret from Burdett, but it is difficult now
to decide which version of the purchase story is true.

[3] MSS. Addenda, 36994, foll. 117, 118 (dating April 1801).

[4] Certainly an error for 1775.

[5] Contains soft-ground etchings by Cox, as well as aquatints by R. Reeve after
his drawings.

[6] Most of his works of this character, published by Ackermann, were executed by

Landscape, 1813), JOHN HASSELL (*Progressive Drawing-Book*, 1820, *The Camera, or Art of Drawing in Water-Colours*, 1823, and numerous aquatint views [1]), and various publications of aquatint views after Rev. William Gilpin (the author of the *Essay on Prints*, 1768), John Varley and others, most of which partook of the nature of books of instruction in the beauties and artistic rendering of landscape. Many of the water-colourists made unimportant essays in aquatint and soft-ground etching, but the medium is seldom treated for its own sake, and only a few such names figure in our index.[2]

Thomas Malton. Landscape work in aquatint of a more ambitious and independent order was done by THOMAS MALTON the younger, and THOMAS and WILLIAM DANIELL. The former, who enjoys some fame as the master of J. M. W. Turner, published two large series of original aquatints, *A Picturesque Tour through the Cities of London and Westminster* (1792-1800) and *Picturesque Views of the City of Oxford* (plates dated 1802-3 and 1810).

Thomas and William Daniell. Of the work of THOMAS DANIELL and his nephew WILLIAM, most interest attaches to their aquatints illustrating life and landscape in India,[3] which they visited together about 1784-94. WILLIAM DANIELL, besides his Indian plates and numerous aquatint views of British scenery,[4] also worked in stipple, and etched a large series of excellent portraits in soft ground after George Dance, produced between 1808 and 1814 (e.g. *J. Flaxman, Benjamin West*, and *Richard Cosway*).

Ackermann and aquatint. J. C. Stadler. J. Bluck. D. and R. Havell. T. Sutherland. J. Hill. F. C. Lewis. We have already referred to Ackermann's method of reproduction by aquatint in speaking of Rowlandson. J. C. STADLER, J. BLUCK, D. and R. HAVELL, T. SUTHERLAND, J. HILL, and F. C. LEWIS were among the more prolific of the craftsmen whom he employed. In general their work was printed from one plate in two or three neutral tones, the chief colouring being added by hand on the impressions. Apart from the work of Pugin and Rowlandson in the *Microcosm*

himself in soft-ground etching (e.g. *Progressive Fragments*, 1817 ; *Views of Ancient Buildings*, 1821, as well as parts of the *Rudiments*, 1813). By 1830 (*e.g.* in Prout's later works), etching was largely superseded by lithography in such books.

[1] *E.g.* in his *Aqua Pictura*, 1813 (after Payne, Francia, Cox, Girtin and others), and in his *Picturesque Rides and Walks round the British Metropolis*, 1817-18 (the plates of the first volume entirely by Hassell ; most of the second volume aquatinted by D. Havell).

[2] The name of J. R. COZENS should, however, be recorded for a fine series of 14 plates in soft-ground (landscape illustrations of the varieties of trees) published in 1789. They are only signed *J. R. Cozens inv^t.*, but are very probably etched by himself. His father, ALEXANDER COZENS, who was drawing-master at Eton, was an etcher, and published 43 remarkable plates illustrating his pamphlet on composition by blots, *A New Method of assisting the Invention in Drawing Original Compositions of Landscape* (1784-85). The *blots* (some of them wonderfully beautiful in themselves) are executed in aquatint, with a fine resin ground. BENJAMIN GREEN, drawing-master at Christ's Hospital, might also be mentioned as the author of several of the earliest drawing-books, with soft-ground etchings dating from 1771.

[3] E.g. *Oriental Scenery* (in 6 vols. ; completed 1808) ; *Picturesque Voyage to India*, 1810.

[4] E.g. *A Voyage round Great Britain*, with text by Richard Ayton, 1814-25.

of London (1810), the most important publications are the *Histories of the Universities of Oxford* (1813) and *Cambridge* (1814) with aquatints after drawings by Pugin, Westall, Mackenzie, Nash and others, and various *Picturesque Tours* (e.g. *The Seine*, 1821, after Pugin and Gendall ; *English Lakes*, 1821, after T. H. Fielding, J. Walton, and Westall ; *River Ganges*, 1824, after Lieut.-Col. Forrest ; *River Thames*, 1828, after Owen and Westall).

F. C. LEWIS may be mentioned in particular for his set of *Imitations of Drawings by Claude in the British Museum* (1837). They do not, however, approach Earlom's *Liber Veritatis* in the strength of their reproduction. Lewis also worked in mezzotint ; and his attractive plates after portrait drawings by Lawrence are in mixed processes in which crayon-engraving and soft-ground etching form the chief elements. F. C. Lewis.

The greatest of all the etchers in aquatint, GOYA, has found a place in the preceding chapter, so that a mere reference to his work in this connexion will suffice. Since his time there have been many others who might be specially mentioned, but the process has been, and is, so promiscuously used by etchers of all descriptions in combination with line, as to render it superfluous to treat of their aquatint work outside the chapter on Modern Etching.

IV. COLOUR-PRINTS

By colour-prints we would imply impressions printed in more than one colour. Impressions in a single colour stand on exactly the same technical grounds, whether they be printed in black, brown, red, or any other tone, and naturally fall outside our definition. Then, again, these single-colour impressions are frequently tinted by hand. These also are excluded from our category ; they might be called coloured prints, but not colour-prints. A definition.

Having established this basis we would divide colour-prints into two main groups— Classification
of colour-
prints.

A. Those in which only one plate is used in the printing.

B. Those in which two or more plates are used.

The second group may be subdivided into

(i.) Impressions in which each colour used in the printing retains its original character unalloyed.

(ii.) Impressions in which the original colours used are intended to combine to form compound tones (*i.e.* in the three-colour process, and its variants).

Finally, we would just mention what is strictly beyond the border-line of our subject—

C. Impressions from metal plates in which the tone or colour is printed from wood-blocks.

A. Colour-Prints in which only one Plate is used

This method implies painting the plate for each impression, so

leaving the artist a perfectly free hand, while the other methods involve restrictions which keep variation from extending beyond certain limits. The very fact of the infinite possible variations renders it essentially an artist's process, but the antithesis to a true

Printing à la Poupée. printer's method. Rag stumps (the " Dolly " or " Poupée ") would be used in conjunction with dabbers of various sizes to fill the plate, and the process would naturally be a lengthy one if delicate divisions of colour were required.

Hercules Seghers. We have already referred to the coloured etchings of HERCULES SEGHERS.[1] They show one of the earliest attempts to give impressions in colour, but they cannot in a strict sense be called colour-prints. The line work is printed in a single colour (often varied in tone), and the other tones seem to have been obtained by tinting the paper (or canvas, which he frequently used instead) by hand, either before or after the impression.

Joannes Teyler. In the latter half of the seventeenth century JOANNES TEYLER took some true colour-impressions from his line-engravings. His work includes subject pieces of varied description, but by far the most effective in the process he uses are his plates of birds and flowers. Collections of his prints, which vary in the examples they contain, are known with a title-page printed in type *Verscheyde Sorte van Miniatuur. Anno* 1693, and engraved title *Opus Typochromaticum*.[2]

Peter Schenck. PETER SCHENCK also printed a few line-engravings (chiefly floral pieces) in the same manner as Teyler, about 1700. In the work of both engravers the colour is wiped from the surface of the plate, and merely remains in the lines.

J. Robert. A few anatomical plates[3] were produced in this manner, half a century later, by a certain J. ROBERT, who is said to have been a pupil of J. C. Le Blon, and to have assisted his master in the mezzotint of some of his Paris plates.[4]

Stipple and crayon prints. The method of printing *à la poupée* has been largely used in stipple and crayon[5] engravings. We do not need here to do more than refer to the section devoted to these processes.[6]

Mezzotints. William and James Ward. J. P. Pichler. F. Wrenk. Then the colour-prints from English mezzotints seem to be exclusively made from a single plate. The practice was most common at the turn of the eighteenth and nineteenth centuries, and then chiefly for subject prints like those of WILLIAM and JAMES WARD after Morland. A few of the foreign mezzotinters, such as J. P. PICHLER and F. WRENK, also occasionally printed in colour.

William Blake. The methods used by WILLIAM BLAKE in his coloured books have already been discussed.[7] Neither of his processes can strictly

[1] Chap. VI. pp. 169-70.

[2] See J. E. T. Graesse, *Trésor de Livres rares et précieux*, Dresden, 1859-69 (in Supplement, 1869). The only set I know with title in type is in the collection of Mr. H. C. Levis. The B. M. series only has the undated engraved title.

[3] In P. Tarin's *Adversaria Anatomica*, Paris, 1750.

[4] *General Bibl.* ii., Gautier de Montdorge, 1756, p. 128.

[5] Cf. Section B (i.) in reference to the French crayon engravers.

[6] Cf. especially pp. 288, 299. [7] See Chap. VII. pp. 220-1.

be called colour-printing. The majority are merely tinted by hand in water-colour, while the prints in opaque colour (*tempera*) are obtained by a method of transfer from a card which partakes more of the nature of painting than printing. He frequently uses the colour so heavily as to almost hide the lineal design. In such cases the resultant impression might be a mere monotype, and all virtue in the combination is lost. Blake often applied this method of transfer quite apart from any etching, achieving a curiously mottled surface which could hardly be attained by direct painting with the brush.

Modern colour-etchings, which for the greater part are printed from single plates, will be discussed in the succeeding chapter.[1] *Modern etchings.*

B. Colour-Prints in which two or more Plates are used

The first division of the second method involves engraving on a separate plate each part of the work which is to be printed in a separate colour. Great care is of course needed in the register, *i.e.* the method of pinning the corners to secure absolute correspondence, when the paper is laid on each plate for its impression. Given the colour of the inks required, this method could be carried out with accurate repetition by the printer without the artist's supervision. It is essentially the true printer's process. *(i.) Impressions in which each colour used in the printing retains its original character unalloyed.*

This method has been chiefly used by the crayon and pastel engravers and the etchers in aquatint, whose work has already been described.[2] In the case of the French crayon engravers it is often difficult to say whether several plates have been used, or only one, inked *à la poupée*, as seems to have been the practice with almost all engravers outside France. *Crayon and pastel prints. Aquatints.*

A certain number of modern etchers (*e.g.* CAMILLE PISSARRO and JEANNIOT) have also used this process.[3] *Modern etchings.*

The three-colour process is based on Newton's theory that the whole gamut of tonic values is composed of three cardinal colours— blue, yellow, and red. *(ii.) The three-colour process and its variants.*

JACOB CHRISTOPH LE BLON seems to have been the first to use the theory in relation to colour-printing, his idea being to split the composition of the various tones of a coloured picture into the terms of the cardinal colours, and, on the basis of this analysis, to make three plates, which by superposition of impression should combine to give the true composite result. The theory was good, but in practice, with the imperfect means at his disposal, Le Blon's work is a lamentable failure. His plates are nearly always marred by garish streaks of disturbing colours which have failed to combine in *J. C. Le Blon*

[1] See pp. 322-3, 331, 338.

[2] Cf. pp. 288, 301-2, 304. It should also be noted that J. C. Rugendas produced a lengthy series of prints after G. P. Rugendas printed from two separate mezzotint plates, one giving the tones in yellow, the second the black shadows with etched outline. Their effect is comparable to chiaroscuro woodcuts.

[3] See Chap. X. pp. 322-4.

the appointed manner. Considering how seldom the three-colour
process-plates of to-day, with all the advantage of modern scientific
methods, attain to any absolute combination of colour, it must be
admitted that Le Blon's boldness and persistence in tackling one of
the most difficult problems in colour-printing constitute some real
success. Le Blon frequently used a fourth plate for his blacks, and
the same discrepancy between theory and practice is generally found
in most modern mechanical applications of the process.

J. C. Le Blon, like his namesake (and relative?) the ornament
engraver, Michel Le Blon, was born in Frankfurt, and settled early in
Amsterdam. Here he seems first to have been engaged mostly in paint-
ing miniature portraits, but before 1711 he was making essays in the
new process, and from that time the varying fortunes of his life were
inevitably bound up with the art of colour-printing. His first great
venture was made in London, where he had settled, in 1720. He was
granted a royal patent for his discovery, and a company was formed
to work the method, with Le Blon as a salaried servant. In spite
of considerable capital, the company had to declare bankrupt some
three years later. It was probably soon after this failure that Le
Blon issued his book *Coloritto*,[1] which purports to explain the process,
but does little more than add to its obscurity. Later, Le Blon
attempted the application of the method in tapestry weaving, but
about 1732 his new company had to face a more disastrous bank-
ruptcy than the former, and Le Blon found it well to retire to
Paris. Here he spent the rest of his days, and here first found a
few followers to continue his attempts.

About fifty plates by Le Blon are known, portraits being rather
less numerous than the subjects after the old masters (largely of the
school of Carracci, Domenichino, and Maratta). Only some three
plates are signed *Le Blon fecit*, and it is very uncertain what definite
part he took in the work. Quite possibly he left the mezzotinting
and etching (for line is often intermixed) for the most part to
others,[2] supplying the three-colour designs and generally superintend-
ing the work himself. Despite the fact that Le Blon's plates were
printed in very large numbers, impressions are very rare in public
museums. No doubt large numbers have been varnished, and pass
as oil-paintings in many English houses. Of his portraits one might
mention as among the most successful the *George I.* (signed *I. C.
Le Blon fec.*), Kneller's *William III.* and *Queen Mary*, those of
Van Dyck and *Rubens* by the painters themselves (the two latter from
pictures in Windsor), *Edmund Spenser*, and *Louis XV.*

[1] Le Blon states in the preface that he was preparing some anatomical plates for
Nathaniel St. André, the king's anatomist, who was appointed to this office in 1723,
but lost the Royal favour after 1726. Perhaps the plates he produced, which are not
identified, are to be found among those usually attributed to the Gautier d'Agotys.

[2] In Paris he is said to have been assisted by P. F. Tardieu and J. Robert.
Gautier de Montdorge (*General Bibl.* ii., 1756, p. 133) refers to work by these
engravers, but I have failed to identify any coloured mezzotint as their work.

In Holland he had a follower in JAN L'ADMIRAL, who signed Jan
a few anatomical plates, produced in a similar method, to illustrate L'Admiral.
books by B. S. Albini and F. Ruysch (published in Leyden, 1736-
1741).[1] L'Admiral was a native of Normandy, and is said to have
been a pupil of Le Blon in London before settling in Amsterdam.

In Paris Le Blon's method found imitators in the various The Gautier
members of the family of GAUTIER D'AGOTY, anatomists, botanists, d'Agoty
and artists, whose work in science is as unsatisfactory and confusing family.
as their production in art. The head of the family, JACQUES FABIEN
GAUTIER D'AGOTY, claimed to have developed his process quite
apart from Le Blon (with whom he worked for a short time about
1738), but was certainly wrong in regarding the use of the fourth
plate for the black as a new discovery of his own. He published
numerous works on anatomy, as much for the plates (which could be
purchased separately) as for the text, and it is difficult to differen-
tiate in many cases between his engraving and that of his sons,[2] of
whom JEAN BAPTISTE ANDRÉ, ARNAUD ÉLOI,[3] and ÉDOUARD[3] seem
to have been his chief collaborators.

His largest work, and one that contains most information in
reference to his methods, is the *Observations sur l'Histoire Naturelle,
sur la Physique et sur la Peinture*[4] (Paris, 1753-57). Besides the
colour mezzotints, a large number of the plates are executed in
etching, some being coloured by hand. The tone is also sometimes
achieved by dotting with the punch[5] or graver, as had occasionally
been done by Le Blon.

Jacques Gautier d'Agoty and his eldest son Jean Baptiste André
started ambitious series of portraits, parts of which appeared with
title-pages in 1770 and 1772 respectively. The earlier, which came
out in 1770, under the son's name alone, was entitled *Galerie Française,
ou Portraits des Hommes et des Femmes Célèbres qui ont paru en France*,
and it is uncertain whether the father took any part in this set.
The later, entitled *Galerie Universelle contenant les Portraits de
Personnes Célèbres de tout Pays*, had both father's and son's names as
engravers on the title-page, the only two livraisons that appeared
being issued in June and August 1772. In the *Galerie Universelle*,
the portraits of *Voltaire, D'Alembert*, and half a dozen others are by

[1] Another important scientific work illustrated by colour-plates in the style of Le
Blon, though more in line than mezzotint, is J. G. Weinmann's *Phythantoza Icono-
graphia*, Augsburg, 1737-45 (Dutch ed., Amsterdam, 1736-48). It contains 1025
large botanical plates by B. Seuter, J. E. Ridinger, and J. J. Haid.

[2] Prof. H. W. Singer's articles in the *Monatshefte* (1917 and 1918), contain
catalogues of the works of the D'Agoty family, and of Lasinio, L'Admiral, and
J. Robert, which help greatly to clarify a very difficult subject.

[3] In the *Cours Complet d'Anatomie . . . expliqué par M. Jadelot*, Nancy, 1773,
A. E. G. d'A., who designed and engraved most of the plates, is called the *second son*.
One of the plates is signed by L. Gautier d'Agoty. Édouard calls himself 2ᵐᵉ *fils* on
the impression of his *St. Francis* of 1780, after Van Dyck, in the Bibliothèque
Nationale, Paris. Perhaps at that time he was the second surviving son.

[4] Title in 1756 and 1757 runs: *Observations périodiques sur la physique, l'histoire
naturelle et les beaux-arts*.

[5] *E.g.* in particular in the *Collection des Plantes*, Paris, 1767.

D'Agoty père, but the greater number in this, as well as perhaps all in the earlier publication (e.g. *Frederick the Great* and *M. de Maupeon*), are by the son, who, in many cases, was also responsible for the original painting. Sets preserved with their title-page are of extreme rarity.

ÉDOUARD GAUTIER D'AGOTY, whose work holds a more individual place than that of Arnaud Éloi, who seems to have kept chiefly to anatomy and natural history, engraved some twelve plates after pictures in the Orléans Gallery (*e.g.* after Titian, Paul Veronese, Correggio, Reni, Lebrun, etc.), as well as a few portraits (*e.g. Madame Dubarry* and *Marie Antoinette*). In the latter part of his life Édouard was settled in Italy, where he at least succeeded in inspiring one follower, the line-engraver and etcher CARLO LASINIO.

Carlo Lasinio. Lasinio produced a portrait of *Édouard d'Agoty* in this manner, some subjects after old masters (e.g. *St. Mark in a Niche* after Fra Bartolommeo), and a series of small engravings of *Portraits of Artists* from the pictures in the Uffizi. There is a copy of these *Ritratti de' Pittori* bound in three volumes, and with a MS. title (with the date and place, *Venice*, 1789), in the Print Room of the British Museum, but I cannot find whether they were ever published as a set.

With Le Blon, the Gautier d'Agotys, and Lasinio the history of the three-colour process in artist engraving is almost ended. The declared aim of the process is truth to the natural tones of colour, but the theory has never been found satisfactory in practice. Engraving is above all things not the art for imitative realism in colour, even though certain decorative colour-effects may sometimes be appropriately rendered by one of the processes described in this chapter. Though occasional instances might be cited during the nineteenth century where engravers and etchers have made partial use of some elements in Le Blon's process of colour combination, it may be stated that the method practically finds no exponents outside the field of photo-mechanical reproduction.

C. Impressions from Metal Plates in which the Tone or Colour is printed from Wood-Blocks.

Engravers, etchers, and mezzotinters have occasionally used the " chiaroscuro "[1] method of getting surface colour by means of several wood-blocks in combination with their plate. HUBERT GOLTZIUS,[2] ABRAHAM and FREDERIK BLOEMAERT were among the earliest to use the engraved and etched line in this combination.[3]

Hubert Goltzius. Abraham and Frederik Bloemaert.

[1] The pure " chiaroscuro " method was chiefly practised in the sixteenth century. Its earliest exponents were probably Germans (*e.g.* Cranach (one print dated 1506), Burgkmair with J. de Negker, and Wechtlin), but the greatest production comes from Italians like Ugo da Carpi, Antonio Fantuzzi da Trento, Giuseppe Nicolo Vicentino, and Andrea Andreani.

[2] In his *Imperatorum Imagines*, Antwerp, 1557 (the wood-blocks cut by Josse Gietleugen).

[3] There is an isolated example (a *Pair of Lovers seated in a Landscape*) by an anonymous artist of Upper Germany, dated 1538 (Gutekunst sale, Stuttgart, 1903, III. Teil, No. 11, with reproduction ; acquired for the Kunsthalle, Hamburg). A single tone block is used in combination with an etched plate, which is reminiscent of the style of Lautensack and Huber.

In the early eighteenth century we may note a considerable number of the etchings and engravings by P. P. A. ROBERT, CAYLUS, and C. N. COCHIN I. for the *Cabinet Crozat* (1729 [1]), where the tone is achieved in chiaroscuro blocks cut by Nicolas and Vincent Le Sueur. The same method was used only a few years later in England by ARTHUR POND and CHARLES KNAPTON in their imitations of drawings from the Richardson and other collections (1734-35).

P. P. A. Robert. Caylus. C. N. Cochin I. Arthur Pond. Charles Knapton.

ELISHA KIRKALL had used the combination with mezzotint plates (in which engraved and etched lines also appear) in a series of twelve prints issued in 1722.

Elisha Kirkall.

In the nineteenth century the combination of copper and wood-blocks was applied by GEORGE BAXTER in a method of printing in oil colours, for which he obtained a patent in 1835. In his use of a succession of wood-blocks for his various tints, he was following in the path of J. B. Jackson and William Savage, who developed the elements of chiaroscuro (which seldom went beyond four tints of a single colour), so as to command a much larger scale of colour. Baxter's variation on these predecessors, not in any sense a discovery, was the use of a copper or steel plate for the lines of the design, sometimes adding a neutral tone on the same plate by means of aquatint or stipple.

George Baxter.

According to his own description of the process,[2] he sometimes used as many as twenty blocks, and even in the simplest colour-prints seldom less than ten. His work, which ranges from 1834 to 1860 (when he retired from business), covers one of the dullest epochs in English painting, and the artistic value of the majority of his reproductions is correspondingly small.

Up to about 1849 he did a considerable amount of book illustration (*e.g.* for Sir N. H. Nicolas's *History of the Orders of Knighthood*, 4 vols., 1841-2), but throughout his life the majority of his work was in separate plates, including royal portraits, views of the Great Exhibition, prints after the old masters, and subjects of the most miscellaneous order. His colour surface is always unpleasant and glossy, and militates against any satisfactory result.

From about 1849 Baxter sold the license of using his patented process to several printers. ABRAHAM LE BLOND was among the first to take advantage of the license, and at a later date reissued impressions[3] from Baxter's original plates and blocks, which he had acquired about 1868.[4] He seems, however, to have profited little from the venture, and his stock was sold in 1888 to Mr. Mockler,[5] and subsequently dispersed by public auction in Birmingham in 1896.

Abraham Le Blond.

[1] See Chap. VII. p. 202 ; Chap. VIII. pp. 248-9.

[2] See Baxter's *Pictorial Album or Cabinet of Paintings*, 1837.

[3] For the most part with the original signature erased.

[4] From Vincent Brooks, the printer, who was in possession of most of the stock between 1860 and 1868. George Baxter, jun., who worked with Brooks, retained some of the plates, and issued impressions on his own account.

[5] Who made a systematic study of the plates and blocks, issued a folio of prints in black from the plates, and in 1895 helped in founding the Baxter Society, which just lived to publish three monthly numbers of a journal.

The eighteenth century a barren period in original etching.

FOR the century and a half that followed the death of Rembrandt, the art of original etching was little practised and less understood. Italy, whose best etching was produced in the eighteenth century, affords the one brilliant exception; elsewhere etchers, who worked in a spirit suited to the medium, stand in noteworthy isolation. By far the greatest bulk of etching during this period was produced in a dry graver-like manner, even when it was not actually combined on the same plate with graver work, a practice which had become the conventional method of the line-engraver from the middle of the eighteenth century.

The revival.

Then at the beginning of the last century, just at the time when line-engraving in reproductive work reached a subtle finesse of technique which almost concealed the use of line,[1] came a reaction in favour of a freer handling, and a revival of original etching along the path of the best tradition; a revival which has added to the art not a few elements which the older etchers had barely realised.

Some of the etchers noted in the eighth chapter may have considerably contributed towards this revival (*e.g.* Turner, Crome, and Geddes), but they were isolated examples who left no real following in this direction. The most notable part in originating the new movement was undoubtedly played by the French landscape etchers, whose work commenced in the third and fourth decades of the century, while its perfection is due even more notably and directly to a few British and American artists, such as Haden and Whistler, whose work received its first impulse from etchers of the French school.

Two artists of the earlier part of the nineteenth century, who as painters and draughtsmen are among the pioneers of modern art, DELACROIX and DECAMPS, do not hold a place of at all comparable importance in their few etchings.

Delacroix.

EUGÈNE DELACROIX is the greatest of modern historical painters, the realist whose whole work was an assault on classicism, a citadel whose storming would have been easier, had not David found an

[1] *E.g.* in the Turner school of engravers.

even greater successor in Ingres. His etchings, opening about 1814 with a *sheet of studies with a profile of Napoleon*, and numbering about twenty in all, are for the most part hasty studies (chiefly of figure subjects), lightly etched after the manner of pen drawing Most modern and convincing is the sketch of a *Nude Woman seen from the back* (about 1833 ; Robaut 463), while his unfinished plate of a *Blacksmith* (R. 459) is an excellent example of his work in aquatint. Delacroix's etched work is scanty in amount and slight in character, but it never belies the energy of passion which makes his smallest work a living force.

ALEXANDRE GABRIEL DECAMPS left about as many plates as *(margin: Decamps.)* Delacroix, and from the technical point of view they are of the greater importance. There is still much of the pen draughtsman in his style of etching, *e.g.* in the *Girl playing a Hurdy-Gurdy*, said to be after a sketch by Jamar (Moreau 7), but other studies of a similar nature, like the *Old Beggar Woman* (M. 10), in which the etching has been strengthened by roulette and dry-point, show that he had realised the quality of true etching.

He excelled in depicting animals and genre, but he also left several quite excellent landscape plates, some being etched in soft-ground (e.g. *Environs de Smyrne*, M. 12). Both Decamps and Delacroix did more work in the then new and popular process of lithography than on copper.

One of the earliest of the landscape painters in France to *(margin: Théodore Rousseau.)* produce etchings with a true appreciation of the value of line and economy of method was THÉODORE ROUSSEAU. To some extent he stands in a similar position to Crome, the advance made consisting in a return to the spirit of the old Dutch etchers, and, like Crome's work, his four etchings of forest landscape (which date between 1836 and 1861) are quite in Ruysdael's manner. With Ruysdael and Crome, too, he is a classic in the representation of the gnarled strength of the oak.

He was among the first of the group of landscape painters (the *(margin: The Barbizon school.)* school of "1830") who made Barbizon, a little village on the verge of the forest of Fontainebleau, the centre of their work. It was from this school that the best landscape etching of the time emanated, Jacque, Daubigny, and Millet accomplishing most in this direction.

Like so many artists of the time, Théodore Rousseau was a painter who did a few etchings rather than the professional etcher : only, in his case, the few plates produced count for much. First of the school to devote himself pre-eminently to etching was CHARLES *(margin: Charles Jacque.)* JACQUE. In fact, he began his artistic career as a vignettiste, doing much careful work in the late 'thirties, which scarcely betrays the power that was to come. His original etchings did not begin to appear until about 1841, and from that time, for several decades, in Paris, and at intervals at Barbizon, he continued a prolific activity.

It was perhaps his early training in vignette that suggested to him the use of roulette work, which he frequently combines with the etched line to attain tone, *e.g.* in the *Cow-herd* (G. 94), and *La bonne Compagnie* (G. 120). The latter plate and many others show how much his feeling was in harmony with that of the early Dutch etchers of genre such as Ostade, whom he frequently copied in his youth. Imbued with the wide sympathy for all types of peasant life which characterises the school, he stands apart from the rest as the special devotee of the swine-herd, a subject which he repeated again and again (*e.g.* G. 153, Fig. 104). At his best—and the necessities of doing hack-work often show him at something much

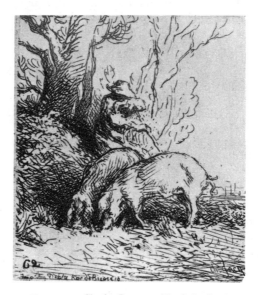

FIG. 104.—Charles Jacque. The Swine-herd.

lower—Jacque is among the great etchers in the significance of his expression as a linealist.

Daubigny.

Among the other etchers of the school C. F. DAUBIGNY is most akin to Jacque in the character of his work, but it is only in a few of his best plates that he commands an equal strength of line (*e.g.* certain examples in the *Cahier d'Eaux-fortes*, published in 1851). He etched at various times between 1838 and 1874.

J. F. Millet.

Far less prolific as an etcher than either Jacque or Daubigny, but in some respects the noblest representative of the best elements of the Barbizon school, is JEAN FRANÇOIS MILLET. He only left twenty plates, and some half-dozen of the earliest of these are the slightest of studies, but the rest are the creations of a conscious power, which places them on a level with his paintings as perfect

expressions of his genius. Like his paintings they are studies of peasant life, full of sympathy for the great elemental forces in nature and life, and pervaded with the sense of power and mystery behind the relation between man and the soil, which encircles the humblest toil with a halo of dignity and romance. His earliest etchings, studies in which the roulette plays considerable part,

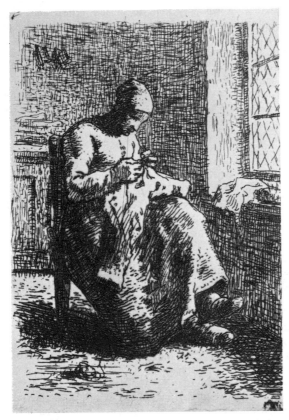

FIG. 105.—J. F. Millet. Woman sewing.

undoubtedly owe their inspiration to Jacque, in whose company Millet left Paris for Barbizon in 1849. Then in the same year to which these first essays belong (1855), follow two or three plates of remarkable completeness as works of art (*e.g.* the *Woman churning* (Delteil 10, Leb. 11) and the *Woman sewing* (Leb. 10, De. 9, Fig. 105). In both strong line-work suffices to realise a fine treatment of light and shade, a problem which is still further developed in the *Two Women sewing by Candlelight* (De. 14). In

his last etchings (and these fall less than ten years after his first attempts) there is a greater breadth of handling and little thought for chiaroscuro, the *Shepherdess knitting* of 1862 (De. 18), where so much more care is given to the quality of the line than in the earlier plates, being followed in 1863 by one of the strongest of all, the *Peasants going to Work* (De. 19).

Camille Corot. CAMILLE COROT, the other great individual genius of the Barbizon school (if we may include in the group one who never worked at all consecutively in the centre of Fontainebleau), also produced some fifteen etchings (between 1845 and 1871). They have all the light shimmering quality of tone seen in his paintings, but as etchings are perhaps of less importance than interest as the occasional studies of a great painter. Similar in appearance to his etchings are the glass-prints to which allusion has been made in the Introduction.[1] The confusion is more easy in the case of Corot than of others of the school who produced works of this type (*e.g.* Millet and Daubigny) on account of the generally delicate character of his etched line.

Paul Huet. In strong contrast to the light studies of Corot stands the work of PAUL HUET, one of the earliest of the modern French landscape painters. Some of his best plates were published in 1835, but though strikingly good, they are rather on the older lines, eminently in the finished painter's manner, and possess few of the broader characteristics which helped most towards the revival of the art of etching.

The discussion of the French masters of landscape and peasant life leads by a natural chain of connexion to the work of an etcher who lived so long in England, and exerted so wide an influence on English art, that he almost seemed to belong to the English school.

Alphonse Legros. ALPHONSE LEGROS, born at Dijon in 1837, disciplined in the humbler paths of a house painter, but of such brilliant promise as to be entrusted at the age of fourteen with the fresco decoration of a church at Lyons, commenced his real study of art at the École des Beaux-Arts in Paris in 1851. His first etchings appeared in 1857, *i.e.* in the year before Whistler's public début as an etcher, and at once announced the presence of a remarkable talent. There is Millet here, with his broad human touch, but it is the spirit of the Barbizon etcher enriched with an even deeper insight into the great factors of life and death and with an added forcefulness of presentation.

Several of Legros' earliest etchings are pictures of Spanish life (e.g. *Les Chantres Espagnols*, M. T. 59), and were the offspring of a visit to Spain about 1860, the first of many to follow. One element at least in the modern art of Spain he assimilated, the tendency towards the grotesque. If Goya in particular is the type

[1] See p. 8.

of this worship of the grotesque in form, we must not forget that it

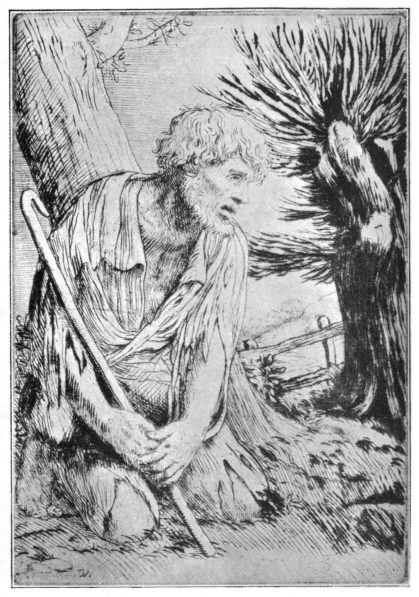

FIG. 106.—Alphonse Legros. The Prodigal Son.

was Rembrandt who in his latest and most magnificent etchings

initiated the spirit, which has found so many adherents among the

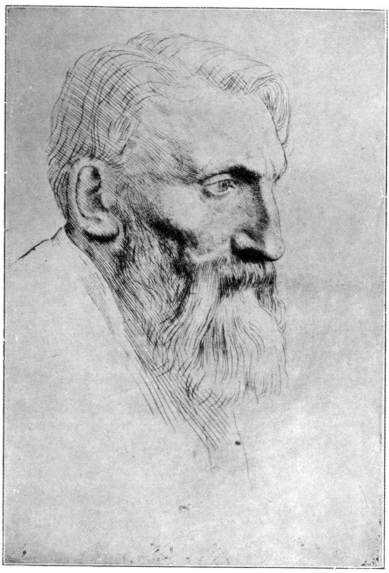

FIG. 107.—Alphonse Legros. Portrait of Auguste Rodin.

greatest of modern etchers. Among the noblest examples of his
power as an etcher of peasant life and of the life of the poor in

general—and he is greater here than in pure landscape—may be mentioned the *Death of the Vagabond*, and various plates representing woodcutters, notably the two allegories of *Death and the Woodcutter*. Nor is Legros less important in the sphere of portrait : the revival of the noble simplicity of Van Dyck's ideal is more the merit of Legros than of any other. The *Auguste Delâtre* (the printer-etcher), the *Cardinal Manning*, and the profile head of *Auguste Rodin* (Fig. 107) are magnificent examples taken from various periods. From 1866 till his death in 1911 Legros had been settled in London, first as master of engraving at South Kensington, then from 1876 to 1894 in the Slade Professorship at University College, a position in which his influence was incalculable. It is sufficient to mention pupils like William Strang and Sir Charles Holroyd, to whose work we shall recur later in this chapter.

If Barbizon was the centre of the revival, Paris formed the inspiration of the work of the greatest of French etchers, CHARLES MERYON. Sadly handicapped in life by the circumstances of his birth—he was the son of an English doctor and a French dancing-girl—his youth was by no means one of poverty, but set in surroundings which must have left the scars on an over-sensitive nature which helped to bring him to the mad-house at Charenton, where he died in 1868. An opening was found for him in the Navy, but he soon left the service to devote himself to art in Paris. His master was Eugène Bléry,[1] a landscape etcher quite of the older school of Boissieu, and Meryon could hardly have found here any of the formative influences on his style. From the dedication of the published set of Paris etchings (Delteil 17-40) to Reynier Zeeman, "painter of sailors," at least one of the forces that directed the character of his work is clear.

Meryon's plates of the sea and ships, etched between 1850 and 1866 (De. 63-74), are taken from early and amateurish drawings made during his voyage to New Zealand (which happened about 1842-46), and are quite unimportant, except as a biographical record ; but it was not here alone that the Dutch etcher of marines could inspire. Zeeman's views of Amsterdam and Paris (of which one is reproduced, Fig. 75)[2] are among the most charming etchings of architecture that exist, and definitely prepared the way for the most remarkable of all of their type, those of Meryon. The *Eaux-fortes sur Paris* were issued in three livraisons between 1852 and 1854, some two years after he had left Bléry's studio, and most of his best plates of Paris, not included in this set, fall within the next two or three years. From 1858 the signs of the affliction which attacked him were already present, and the curious vagaries of imagination which disfigure certain states of some of his etchings (*e.g.* the

(in right margin: Meryon.)

[1] Meryon is known to have etched a portrait of his master, but an impression is still to be found.

[2] Four of Zeeman's plates of the same order were copied by Meryon, De. 9-12.

Tourelle, Rue de l'École de Médecine, De. 41, and *Le Pont au Change,* De. 34) may here find their natural explanation. In his

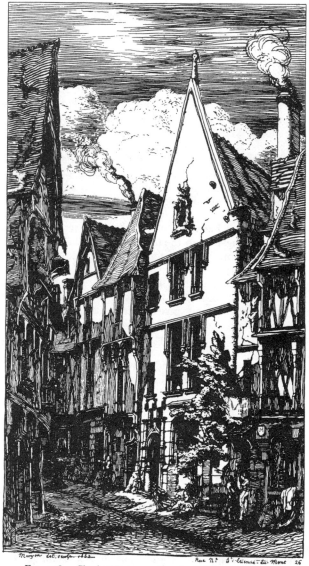

FIG. 108.—Charles Meryon. Rue des Toiles, Bourges.

life he was haunted by suspicions even of his few friends, and the
same spirit is embodied in his plates, where stone walls seem

peopled with lurking eyes. His style, where the line has the highest measure of decision and strength, often tends less to a realistic interpretation of nature than to a decorative convention, which is well exemplified in the *Rue des Toiles, Bourges* (De. 55, Fig. 108). In his finest work, however, the merely decorative element is less prominent, from the forceful simplicity of the *Rue des Mauvais Garçons* (De. 27) to the magnificently elaborated plate *L'Abside de Notre Dame* (De. 38). Perhaps both of these extremes yield in quality to plates like the *St. Étienne du Mont* (De. 30) and *La Morgue* (De. 36), where the powerful contrast of light and shade, which is characteristic of his work, is combined with his incisive draughtsmanship at its best.

A host of artists followed Meryon in etching views of Paris, and happily by 1870 his plates as well as theirs were sought after more for their worth as etchings than as views, for as such Meryon's work had sold during his lifetime, and for the veriest pittance of a price. The etchers of Paris.

MAXIME LALANNE, an artist of considerable talent, who did all that could be attained by technical ability and a good deal more, was among the foremost of the group. His contemporary MARTIAL (ADOLPHE MARTIAL POTÉMONT) is a poorer artist but no less prolific as an etcher. The extreme popularity of etching in the 'sixties and early 'seventies was beginning to yield its fruit, both good and bad. Among other publishers, A. CADART[1] did most to bring third-rate work to the fore in the publications of the *Société des Aqua-fortistes* (1862-67), in *L'Illustration Nouvelle* (1868-73), and in numerous sets of etchings illustrating Paris at the time of the Siege and Commune (Lalanne and Martial being the best producers of the latter). Still, it must be remembered that as well as hack-work, he published much of the greatest engraving of the time, and his deserts are considerable in another direction, *i.e.* in giving an impulse to the younger art in America by founding the " French Etching Club " in New York in 1866. Lalanne.
Martial.
Cadart's publications : Société des Aqua-fortistes
L'Illustration Nouvelle.

Amid all this demand for etched work, a great part was played by the printer-etcher, AUGUSTE DELÂTRE,[2] who for over half a century held a place of honour in his field only rivalled by his English contemporary, FREDERICK GOULDING. The etcher will, of course, generally take many of his early proofs himself, and it goes without saying that the opportunities afforded in the printing to obtain variety in the rendering of light and shade will be used by him with greater freedom than by the intermediary who dare not put too personal a touch into his craft. Nevertheless in plates where the line is the sole and absolute expression of the artist, and it is such work which The printer-etchers.
Auguste Delâtre.
Frederick Goulding.

[1] I have only seen one plate etched by Cadart, and that a poor performance.

[2] He pulled a very large proportion of the impressions of plates by Jacque, Corot, Millet, Daubigny, Meryon, and Bracquemond, as well as numerous prints of Whistler, Haden, Rops, and, in fact, of most of the distinguished etchers of the century. His son, Eugène Delâtre, now continues at his father's press, making a speciality of the etching and printing of colour impressions.

in its inevitableness stands most on its own merits (*e.g.* the latest plates of Whistler), the etcher can hardly attain results to equal those of the professional printer.

Jacquemart.
Bracquemond.　　Quite apart from the other etchers of the period stand JULES JACQUEMART and FÉLIX BRACQUEMOND, many of whose prints have appeared in Cadart's publications and in periodicals like the *Gazette des Beaux-Arts*.　　Their work is for the most part an attempt at producing, in one direction or another, surface texture, a problem which is really more fitted to the genius of line-engraving.　　As virtuosi of the most delicate etching they have remained almost unrivalled, and few etchers have trodden the same road if it be not the brothers

Edward and Maurice Detmold.　　EDWARD and MAURICE DETMOLD, who have produced a few plates (chiefly of birds, etc.) of the most astonishingly fine texture and of real decorative beauty.　　Jacquemart, who was the greater virtuoso of the earlier pair, devoted himself chiefly to the reproduction of works of decorative art, such as vases and gems (*e.g.* for the Louvre, 1865), but he also left a good many plates of flowers and animals.　　The latter field is Bracquemond's special glory ; but beside his etchings of animals, he did some landscapes somewhat in the light spirit of Corot, and, like Jacquemart, did a great deal of reproductive work.

Desboutin.　　Born the year after Meryon, MARCELLIN DESBOUTIN is one of the most gifted artists in dry-point that France has produced.　　His work is almost entirely confined to portrait, and, with sitters like *Zola, Manet, Lepic, Edmond de Goncourt, Jules Claretie*, forms a notable gallery of literary and artistic celebrities throughout the second half of the nineteenth century.

The Impressionists.　　It is hardly to be expected that the Impressionists with their central aim, the realistic rendering of contrasts of colour in the higher gamut and the momentary play of reflected light, would find in etching a medium that would preserve the essential character of their art.

C. Pissarro.　　CAMILLE PISSARRO succeeded, however, in expressing a wonderful atmosphere in his little-known plates.[1]　　His line-work is as thin and sinuous as Corot's, and in his combinations of grey and darker tints, which form a large factor in his scheme, he relies considerably on stopping out and second biting.　　He made liberal use of aquatint, no doubt finding in its regular open grain a certain kinship with the "divisionism," or "pointillism," by which a certain vibrative quality is achieved in the rendering of light and atmosphere. He always aimed at the production of a plate whose tone should be entirely expressed in the bitten work, leaving the smallest margin for variation in the printing.　　In his few colour etchings, which are among the best that have been done of their kind, a similar feeling no doubt led him to choose the more certain method of

[1] They are now (1922) better known than when the above was written. A limited edition of ten of his plates was made in 1907 at the time of an exhibition at Durand Ruel's in Paris.　　In 1920 another limited edition of a further selection of ten plates was issued by the Leicester Galleries in connexion with a memorial exhibition of his works.

using several plates rather than print from one plate *à la poupée.* Most of his etched work, which includes about 114 plates, was produced subsequent to 1879, his earliest plate dating in 1864.

DEGAS is another of the impressionists who produced occasional Degas. etchings, but their value in relation to his other artistic production is less than in the case of Pissarro. The two artists worked together in their first essays, getting technical advice from Bracquemond, and generally enjoying doing exactly what the experienced etcher disadvised.

ÉDOUARD MANET is on the border-line of the same school, but Manet. he is more accurately described as Realist than Impressionist. In his etchings he is for the most part the grotesque linealist, inspired of Goya. A certain aberration of undeniable genius is seen in his plates with even less alloy than in his paintings, where his mastery of colour induces one to overlook perverseness of draughtsmanship. Some of Manet's plates (about fifty in all) date as early as 1861, but none was published before 1874 (when a set of nine appeared), and no comprehensive issue of any considerable number had been made until recently.[1]

Among French etchers of the last quarter of the nineteenth Contemporary and early twentieth century, several distinguished names might be French etchers. noted : J. L. FORAIN, the prolific caricaturist, for a wonderful series of etchings, chiefly subjects drawn from the Bible and Courts of Law, done for the most part between 1908 and 1910, unrivalled since the time of Rembrandt for their sympathy with humanity ; A. T. STEINLEN, another kindred spirit, steeped in the life of Paris, and equally successful in his landscapes ; ALBERT BESNARD for his splendid portraits in the manner adopted by Anders Zorn ; LÉON LHERMITTE for his realistic studies of peasant life ; AUGUSTE LEPÈRE and EUGÈNE BÉJOT, like Lalanne, for etchings of Paris ; EDGAR CHAHINE (an Armenian by birth) for his broad studies of the Paris masses ; and PAUL HELLEU for his brilliant but empty plates (produced with the diamond point) of fashionably dressed ladies ; while to recur to the Olympians one can hardly omit the famous name of the sculptor, AUGUSTE RODIN, who produced a few dry-points in the same swift cursive style as his pen drawings.

From France also come most of the recent essays in etching Colour-printed in colour, an art as capricious and uncertain in its results as etchings. it is dubious in its convention. RICHARD RANFT of Geneva, HENRI GUÉRARD, P. G. JEANNIOT, LOUIS LEGRAND, CAMILLE PISSARRO, J. F. RAFFAELLI, CHARLES COTTET, ALFRED MÜLLER, MANUEL ROBBE, and ALLAN OSTERLIND (of Stockholm) are a few of the etchers who have attempted most in this field. Ranft and Jeanniot represent two methods, the former printing from one plate only, the latter frequently using several plates for the various colours required. The second method, given the knowledge of the required colour for each plate, is a much more absolute and less variable

[1] Thirty plates published by A. Strölin, Paris, 1905.

process, and far the sounder, unless the etcher is content to be the painter of each plate and reprint of each impression.

Raffaelli's work is distinct from that of most of the other colour-etchers, in the avoidance of aquatint and the tone processes; he keeps almost entirely to line, whether in dry-point or etching.

.　　.　　.　　.　　.　　.　　.　　.

We leave the French etchers only to return to French soil as the first real centre of inspiration to two of the master etchers of the century.

Whistler. The former of these, JAMES ABBOTT McNEILL WHISTLER, is the greatest personality in the history of modern etching. Born in the United States, studying and working in Paris and Holland, living for the most part in London, Whistler, with all his cosmopolitanism, remained in sentiment a true American, fostering the ego, as every genius should, but to an extent which seems not infrequently to have overlooked the claims and conditions of society and friendship. It is fitting that from the New World should come almost all the essentially new elements which modern etching has added to the old traditions.

Whistler, the son of a major in the American Army, was born at Lowell, Massachusetts, in 1834, and educated at the Military Academy, West Point College, in view of following his father's profession. For a few years he was in the Government service, and while working for the Coast Survey Department (1854-55) did the two plates whose subsidiary marginal sketches, which, of course, he was going to erase, so shocked his superiors that the unfinished plates were confiscated, and the resignation, which he must have desired, facilitated.

Two years in Paris, under the painter Gleyre, transformed the rebellious young amateur into a master, who at once took a place among the soundest etchers of the time, though he did not at this early period disclose the individual characteristics which place him so apart even among the greater etchers.

His first published series of thirteen plates (the "French set") were printed by Auguste Delâtre in 1858. In the frontispiece, which represents Whistler seated sketching surrounded by a ring of street children, we have a token of the sympathy for young life which lasted throughout all his work. If in comparison with a master like Rembrandt, Whistler seems cold and cynical, here at least he had a fund of genial warmth.

Of the "French set," the *Mère Gérard* (W. 9) is a good example of the close and delicately elaborated shading which he used in his beginnings. The architectural subjects of the same series, in particular the *Liverdun* (W. 4), with its continuation of Meryon's ideal, and the *Street at Saverne: a nocturne* (W. 11), are magnificently simple studies of light and shade.

Recent etchers (*e.g.* D. Y. Cameron) have been far more inclined

to follow him in this phase than in the inimitable development of his later life.

The *Annie seated* (W. 24) is another typical little study of the early period; it is astonishing how near it comes in its technical character to some of Jacque's work (in particular to Jacque's portrait of his little daughter, G. 155).

Besides the "French set," there are three other series which act as landmarks in his development: the "Thames set" (16 etchings, issued 1871), the "Venice set" (12 etchings, Fine Art Society, 1880), and the "Twenty-six Etchings" (Messrs. Dowdeswell, 1886).

The etchings of the "Thames set," done at various times between 1859 (when Whistler settled in Chelsea) and 1871, show Whistler still working along the lines on which Meryon had achieved so much, with a mastery of his medium and a decision of draughtsmanship which are unimpeachable.

The real advance, however, in this period is seen in his drypoints: in portraits such as the *Annie Haden* and the *Axenfeld* (both of 1860), the *Leyland* (W. 93), and in a subject plate like the *Forge* (W. 63), a wonderful study of reflected light. In his figure studies, e.g. *The Boy* (W. 109), *Weary* (W. 83), and the *Model resting* (W. 87), where a few summary lines suffice to present the essential movement of the covered form, Whistler is already mastering the art of omission. Economy of means, and absolute adaptation of these means to the size of his plates, were becoming more and more his ideals. The line-work of his later etchings has been regarded as scratchy and thin,[1] and in certain instances (*e.g.* in the *Turkeys*, W. 165, from the "Twenty-six," Fig. 109) one may remark a certain lack of concentration and significant emphasis. Whistler has, in fact, very little of the peculiar force of Rembrandt which fixes the attention to one predominant emotional element. His genius had little to do with humanity: it expressed itself far more in figure and design in its relation to schemes of tone and colour. If he had predecessors, it is rather in the Tiepoli and those masters of the Rococo, who played mostly in the higher keys, and constantly avoided the strong contrasts which disturb a delightful equanimity with their emphatic demands. No etcher has ever known better than Whistler what can be achieved by the unfilled space. He was immovably convinced in his opinion that only the etcher himself can print his own plate well, and in his wonderful manipulation of the ink on the surface and in his careful choice of old paper (for which he made

[1] For an entertaining selection of contemporary criticism on the "Venice" etchings, see the famous little exhibition catalogue of 1883 (*Etchings and Dry-Points. Venice: second series:* 51 Nos.), which included, beside miscellaneous plates, both the Fine Art Society's set and the "Twenty-six etchings" published by Messrs. Dowdeswell three years later. To understand Whistler's own attitude, much enlightenment and no little entertainment may be gleaned from the master's occasional writings (such as the lecture "Ten o'Clock"), which were collected in the volume entitled *The Gentle Art of making Enemies*, in 1890.

repeated search in Holland and elsewhere) he produced impressions

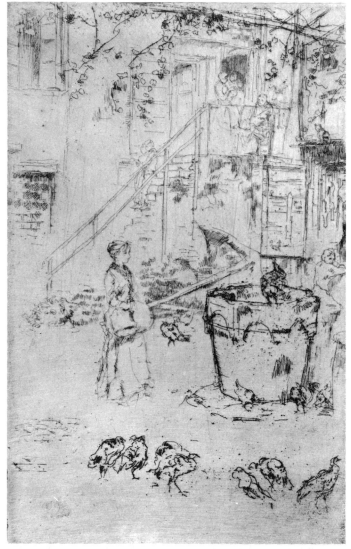

FIG. 109.—J. A. McN. Whistler. Turkeys. (Reproduced by permission of
Messrs. Dowdeswell and Dowdeswells.)

of a luminosity of tone and a quality of surface which are
unequalled.

In dry-points of the middle period like the *Price's Candle Works*
(W. 124) and *Battersea: Dawn* (W. 125) Whistler has all but
realised his most individual expression, but he does not absolutely
come into his own, if we may so put it, until the etchings of the
"Venice set" and the "Twenty-six." Reversing the order of de-
velopment as seen in Rembrandt, he recurs in this last phase to the
pure etching of his early work, divesting his design of all the detail
whose character was a mere continuation of the achievement of
Jacque or Meryon. Plates like the *Mairie, Loches* (W. 259), *Zaandam*
(W. 268), and those of the *Naval Review* series of 1887 (W. 237-
245) are wonderful examples of his latest manner. Surface tone
given by the printing seems to be falling somewhat out of account,
and the nearer the end, the less did the master seem to depend on
anything beyond the pure etched line.

Senior to Whistler by some sixteen years and his predecessor in Seymour
the practice of etching by more than a decade, Sir FRANCIS SEYMOUR Haden.
HADEN, the first President of the Society of Painter-Etchers, is,
beside Legros, the most notable representative of the art in the
nineteenth century. A doctor, distinguished in his profession, his
devotion to the practice of art was of necessity intermittent, but the
character of his work, as accomplished in technique as it is sound
in style, never betrayed the amateur's limitations. A great collector
and connoisseur of Rembrandt's etchings, the pioneer of modern
criticism of that master's work, he stands as an etcher of landscape
for the continuation of old ideals, for soundness of style, rather than
for any striking individuality of manner or method.

He studied medicine for some time at the Sorbonne in Paris,
and at the time when Jacque was producing his earliest plates. It
may well have been this etcher who inspired him to the first efforts
which were made on journeyings in Italy in 1843-44. Impressions
from these plates are as rare as they are unimportant, and they only
give him a nominal priority to Whistler as an etcher. His real work
did not start till about 1858-59, when the young Whistler—his
brother-in-law—was already the really inspiring force.

France, in the person of M. Philippe Burty, was the first to
recognise his power, and it was in Paris[1] that his etchings were
first published. Almost all his plates are of landscape, and in pure
etching or dry-point. The greater part of his etched work was done
before 1880, but after that date he produced a considerable number of
mezzotints, combined sometimes with the etched line, which surpass
almost anything done in the medium during the century, unless it
be work by David Lucas and Frank Short.

He uses line forcibly, but fully : attempting more than Whistler
in the positive expression of aerial problems, and continuing in the
lineal method for which Rembrandt's *Three Trees* is a starting-point.

[1] *Études à l'Eau-forte.* Printed by Delâtre, Paris, 1865-66 (25 etchings, exclusive
of head- and tail-pieces, with text by P. Burty).

Out of my Study Window (1859) is one of the noblest of all achievements in the treatment of cloud in pure line, while the *Shepperton* (1864), which is reproduced (Fig. 110), is a typical example of his simple manner of rendering nature, with one thoroughly characteristic note in the play of shadow on the water, showing the magical effect of his line with all its apparent unconsciousness of aim.

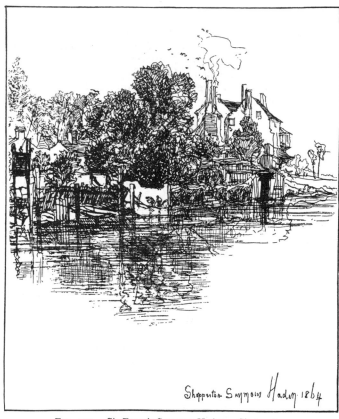

FIG. 110.—Sir Francis Seymour Haden. Shepperton.

Sir J. C. Robinson. Much less prolific, and much more of an amateur in the inequality of his work, Sir JOHN CHARLES ROBINSON etched a few plates (such as the *Nine-Barrow Down* and *Newton Manor*) which in their successful treatment of atmospheric themes stand nearer to Haden's achievement than almost anything of the century.

There are few great English etchers belonging to the same generation as Haden and Robinson. The early Victorian cari-

caturists, Cruikshank, Leech, and Keene, stand apart from the modern school of etching (if we except a few of Keene's plates), and have found a more congenial setting in a previous chapter.[1]

The formation of the "Etching Club" and of the "Junior The Etching Etching Club" in the early years of the last reign showed the Clubs. beginning of a certain revival of interest in the art, but scarcely any of their publications (which included various illustrated works as well as sets of etchings, between the years 1841 and 1879) reveal anything of the true revival of etching. There were RICHARD REDGRAVE, J. C. HORSLEY, and C. W. COPE with their subjects, an occasional MILLAIS and KEENE, the modest landscape of THOMAS CRESWICK in abundance; but except for one or two plates by Haden (*e.g.* Etching Club, 1865) and two rather poor Whistlers (W. 68, 69, *Modern English Poets*, Junior Etching Club, 1862), nothing was published but works of little interest.

Such publications as the *Etcher* (5 vols. 1879-83) and *English Etchings* (1881-91) have crossed the threshold of modern etching, but on the whole they show a much lower level than the similar enterprises of Cadart in Paris.

Two artists of the period of transition who call for individual notice are SAMUEL PALMER (1805-81) and EDWIN EDWARDS.

As an etcher of landscape, the former is an artist of no great Samuel power, but his romantic idealism not unworthily carried on the Palmer. sentiment which inspired much of Blake and all of Calvert.

Like Palmer, EDWARDS betrays a lack of significance and con- Edwin centrated emphasis in his compositions, the line work being generally Edwards confused with overmuch meaningless cross-hatching. Nevertheless, his landscapes possess sincerity of expression, a quality by no means too common in the third quarter of the nineteenth century.

In my first edition I spoke of the dangers of personal feeling encroaching on criticism in writing of one's immediate contemporaries. Equally great are the dangers of prejudice and a decreasing flexibility in appreciating new ideas in estimating the work of artists younger than oneself. But it is just these dangers that render contemporary work so good a field for the exercise of artistic discernment, and it is in drawings and etchings of living artists that the collector of modest means will always find his best opportunity of acquiring original works of permanent and increasing value.

The War has made a clear land-mark in history, and I have taken it as a date beyond which I do not propose to extend this work. So that I am now only adding references to a few etchers whose prints appeared, or only came to my notice, between my first edition and 1914, and revising notes already written in the light of the twelve years that have elapsed.

WILLIAM STRANG and Sir CHARLES HOLROYD were the most

[1] See pp. 238-9.

powerful of the etchers trained in the school of Alphonse Legros. Both etched with the same strong open line, and both preserved the best traditions of their master.

William Strang.
STRANG, less handicapped by official duties, was by far the more prolific, having produced altogether close on seven hundred plates.[1] His power of invention was in nowise second to Legros. If sometimes he carried the latter's characteristic grotesque to questionable limits, he never failed to strike the significant note. Perhaps his greatest distinction was in portrait, where the *Seymour Haden* (1883), *Cosmo Monkhouse* (1892), *R. L. Stevenson* (1893), *Thomas Hardy* (two plates, 1893 and 1894), *Rudyard Kipling* (two plates, 1897 and 1898), and, most splendid of all, those of *Frederick Goulding* and *Emery Walker*, exhibited in the Academy of 1906 (the first year of his associateship), stand without qualification among the noblest classics in the whole history of etching.

Sir Charles Holroyd.
In HOLROYD the rude strength of Legros and Strang appears mellowed by contact with Italian art. His genius has an unforced kinship with the full growth of the renaissance art, which he knows so well. Both his landscapes and his studies of genre (especially those illustrating the convent life at *Monte Oliveto* and *Monte Subasio*) are excellent, but the most individual character of his work shows itself in plates like those of the *Icarus* set, where his feeling for beauty and rhythm of composition is seen at its best.

Frank Short.
As Director of the engraving class at South Kensington, FRANK SHORT represents a distinct tendency from that initiated at the Slade School by Legros. In the certainty of his technique he is perhaps unequalled, and he gives far more encouragement to the calmer study of processes, to the scientific calculations of strength and character of bitings and the like, than ever did Legros, who might retort that any recurrence of technical failure is nothing to the possible loss of freshness and spontaneity. It may be mentioned too that one of the disputed tenets of his school is the practice of steel-facing the plate, which he declares makes no appreciable difference to the quality of the impression.

Excellent in pure etching and in aquatint, Frank Short holds a unique place at the present day for his mezzotints, to which fuller allusion has been made in the preceding chapter.[2]

F. V. Burridge.
Among Short's many pupils, F. V. BURRIDGE should be mentioned for his excellent craftsmanship, and for the influence he has exercised on many young etchers as a teacher at Liverpool and at the Central School of Arts and Crafts in London.

Lee Hankey.
In aquatint and allied processes interesting work has been produced by W. LEE HANKEY. He frequently obtains his grain by means of pressing textiles through the ground.

John.
AUGUSTUS JOHN must be mentioned for a remarkable and varied series of small plates—portraits, studies of the nude, and figure

[1] For his engraved work see pp. 212-13. [2] See p. 287.

subjects—produced for the most part between 1901 and 1906. They are in a sense by-play to his work as a painter, and the medium is sometimes treated with too little respect and taken as a vehicle for a mere off-hand sketch. But when all is said as to the slightness of many of his plates, there remains a considerable number, especially of the portraits, which will live among the most perfect etchings of the time.

FRANCIS DODD is specially noteworthy for his dry-point portraits, though he has also done excellent work in architectural and landscape subjects. Dodd.

We have called Whistler's latest style inimitable. It must, however, be confessed that THÉODORE ROUSSEL, who has been settled for some thirty years in London, has produced work which comes very near to the same mode of expression. FRANK LAING had caught something of the spirit in his early plates, but with nothing of the living reflection seen in the former. More recently Roussel has developed methods of his own in printing aquatint, etching, and dry-point in colours, and in mounting his compositions within passe-partouts printed from separate plates he has achieved some charmingly decorative results, whether the theme be landscape, figure study, or flower.[1] Théodore Roussel.
F. Laing.

The most distinguished of Whistler's followers among English artists is certainly WALTER SICKERT. His early work was strongly influenced by the master, but he has developed an entirely individual style and has been himself the inspirer of a school. He tends too much to sketch on the copper without regard to the special qualities of the medium, but there is vitality in all his work, whether it be in figure, landscape, or architecture. Sickert.

In dry-point Whistler's mantle seems to have fallen in some measure on MORTIMER MENPES, while the earlier "Thames" style has remained the inspiration for a host of etchers. Menpes.

D. Y. CAMERON's art may be traced back to this source, but it possesses a quality of its own, a richness of tone in the treatment of architecture, which is the achievement of great power and individuality. In his later work he has developed a more personal style in his dry-points of mountain and moorland scenery, of an austere beauty and sensitive line. Cameron.

Starting somewhat in the same direction as Cameron, MUIRHEAD BONE has deservedly achieved one of the greatest names in recent etching. Few drawings have been seen to equal his since the time of Rembrandt, and in his studies of scaffold-covered buildings in the breaking or the making, he has followed an individual path, and shown a feeling for the great harmonies of line, which is beyond praise. He works largely in dry-point, a process in which his virtuosity is unrivalled. Bone.

[1] E. g. *Impressions in Colour from original etchings in aquaforte and dry-point, invented, engraved, and printed by Théodore Roussel*, London, 1900.

McBey.

Another Scotch artist, whose work was first exhibited in London in 1911, JAMES McBEY, was immediately recognised as in the first rank of contemporary etchers. He has a magical touch in the use of the needle and dry-point hardly equalled since Whistler, and a power of human expression superadded to his work as a landscape artist.

Gethin.

P. F. GETHIN is another etcher of landscape and architecture whose few plates, done about 1913-14, show a great sense of beauty and real distinction. Unhappily work of great promise was cut short by his early death in France in 1916.

F. L. Griggs.

F. L. GRIGGS stands out among etchers of architecture and landscape for the fine precision of his etched line, and a formal beauty which deserves much praise. This return to the ideals of Hollar is a healthy antidote to much of the most recent etching (or rather " scratching ") on copper.

Axel Haig.

Very different in tendency to all that has been mentioned are the architectural plates of AXEL HAIG, in which the true lineal character of etching plays a second part to pictorial effect. In these days of photographic processes it must be confessed that much work done in this style, and by reproductive etchers who work on the same large scale, is a waste of powers, and a misuse of the special medium.

Brangwyn.
East.

Few would be inclined to agree with Whistler's unqualified condemnation of the large plate,[1] but there are few who would not agree with him "that the space to be covered should always be in proper relation to the means used for covering it." His succeeding proposition " that in etching the means used and instrument employed being the finest possible point, the space to be covered should be small in proportion," cannot stand in face of Rembrandt's *Three Crosses*, and has quite recently been answered in noble fashion by FRANK BRANGWYN and ALFRED EAST in their large plates powerfully etched with a broad point in perfect relation to the size of their compositions. The productions of the former, which only date during the last few years, are remarkable.

.

AMERICA.

Though America's tradition in engraving goes back scarcely more than two centuries, she has already reason to be proud of the part she has taken in its history. Whistler once declared in a court of law that he was born in St. Petersburg, but none the less America may justly claim him as her rightful son. If his achievement puts that of almost all his fellow-countrymen into the shade, it should not be forgotten that some twenty-six years ago (in 1881) the etchings of a then young artist, FRANK DUVENECK, seem to have been taken by two well-known connoisseurs (let him who wishes look at Whistler's *Gentle Art*) as the production of the master himself.

Frank
Duveneck.

[1] See a series of " Propositions " which was issued with the " Twenty-six Etchings " of 1886 (reprinted in the *Gentle Art of making Enemies*).

It is scarcely a matter of wonder that with so startling a power of assimilation, this etcher should not have arrived much further on his own merits.

Among American followers of Whistler, JOSEPH PENNELL, who Pennell. long worked in London, is by far the most clever craftsman, while R. F. BLUM has followed the master's later style with consider- R. F. Blum. able success.

America's veteran etcher is JAMES D. SMILLIE. Son of the line- J. D. Smillie. engraver James Smillie, and born in 1833, he suffered in the earlier part of his career the dull discipline of bank-note engraving, his country's pre-eminence in that craft claiming so many of her artists, and gilding the pathway of drudgery.

From the late 'sixties—to some extent perhaps owing to the efforts of Cadart, the Paris publisher, who in 1866 organised the "French Etching Club" in New York—original etching began to take a more important position in the States. A sign of the new interest in the art was the foundation of the "New York Etching Club" (about 1877), in which Smillie was one of the principal movers. Since that time he has done much sound landscape work both in etching and mezzotint, and holds a high place among living etchers.

Of the etchers of British birth who have settled in America, the Thomas and brothers THOMAS and PETER MORAN are perhaps the best known ; Peter Moran. but it is no mere gallantry that gives the laurels to the wife of the former, Mrs. M. NIMMO MORAN. Her landscape work is among the Mrs. M. best that America has produced, in the strength and significance of Nimmo its line ; its special character is most nearly suggested, perhaps, by Moran. the work of Seymour Haden.

Another lady etcher, ANNA LEA MERRITT, whose work is well Anna Lea known in England, where much of her life has been spent, is Merritt. worthy of note for her few portrait plates.[1]

JULIAN ALDEN WEIR has done some striking and spontaneous J. A. Weir. dry-point studies (especially in portrait), but the irregularity of his work seems to disclose less opportunity of application to etching than one might wish for.

STEPHEN PARRISH has been well known for some years on both Stephen sides of the Atlantic for his landscapes; but a greater name has Parrish. been made by a Canadian artist of a younger generation, D. S. D. S. MACLAUGHLAN, who studied in Boston, worked long in Paris and Maclaughlan. Italy, and is now settled in London. He is one of the few etchers of to-day whose architectural and landscape etchings are comparable in a sense of style with those of Cameron and Bone, betraying the sure touch of the artist of conviction.

[1] *E.g.* one of her husband, the late Henry Merritt, prefixed to his *Art Criticism and Romance* (London, 1879), for which A. L. M. also etched numerous other plates.

HOLLAND.

Remi van
Haanen.

One of the earliest of Dutch etchers of the last century to work with anything of the modern freedom and vigour, which with him was directly inspired by Rembrandt's style, was REMI VAN HAANEN. He was a wanderer who worked in many places—Holland, Frankfurt, St. Petersburg, London, finally settling in Vienna. His etchings, to a large extent landscapes in dry-point (dating for the most part about 1848-50), may lack concentration, but they are intensely alive.

Jongkind.

A much greater artist, but still one who in his few etchings (numbering in all only about twenty-two) is something of a dilettante, is JONGKIND. A pupil of Isabey, he passed much of his life in France, and in landscape painting anticipated in a certain measure the development of the Impressionist school. His etchings (landscapes and marines), slight in aim, and characterised by curious indecisions and vagaries of line, are none the less charming and effective in their light key.

Storm van 's
Gravesande.

CHARLES STORM VAN 'S GRAVESANDE holds by far the highest place among living Dutch etchers. He started as an amateur, but under the inspiration and personal guidance of Rops in Brussels (where he passed a considerable period of his life) he entirely gave up the law for etching, and since 1871 has been a prolific creator in the art. His line-work, whether it be in pure etching or dry-point, is broad and open, and his treatment of simple landscape or sea studies is refreshingly virile.

Josef Israels.

Matthys
Maris.

The etched work of two great painters, JOSEF ISRAELS and MATTHYS MARIS, despite its occasional nature, cannot pass without mention. ISRAEL'S few plates of peasant life, strong in line, powerful in chiaroscuro, rank directly with his paintings in the expression of the depths of human feeling, in which he was so worthy a successor of Rembrandt. The etchings of MATTHYS MARIS, who was long settled in London, are even less numerous. Except for a large print, after Millet's *Sower*, Maris's plates were largely ideal figures of his own creating. His delicate etching, which often rivals the texture of aquatint, clothes them in the evasive and mysterious light which characterises his canvases.

M. A. J.
Bauer.

Some remarkably individual work has been done more recently by M. A. J. BAUER, who draws his subjects almost entirely from life in Turkey and the East. There is a wonderful sweep of line and curve in his large white plates; it is the spirit that Renesse might have developed, had he been more than the amateur he was.

W. Witsen.
W. de Zwart.
Van Angeren.
Jan Veth.
P. Dupont.

WILLEM WITSEN and WILLEM DE ZWART may be mentioned for their landscapes, DERKZEN VAN ANGEREN for his vivid studies of shipping and sea, while the brilliant painter and critic, JAN VETH, has done not a few excellent portraits. PIETER DUPONT, who worked much in Paris, produced some good etchings of figure and landscape, but greater interest attaches to his resumption of the almost discarded graver as the medium for much of his work.[1]

[1] Cf. pp. 212-13.

Belgium, with all her line-engravers of the mid-century, perhaps Belgium. because of the very predominance of that school, has until recently taken less part than Holland in the modern revival of etching. There is, however, one brilliant exception, that of FÉLICIEN ROPS. Félicien Rops An artist of wonderful gifts, a man of avowed licentiousness of temperament, his creation, of such scathing satire, goes so far beyond the normal limits of delicate suggestion, that the majority of his work must still remain a closed book to most amateurs. The magical power of his draughtsmanship only makes one regret the more that his almost exclusive subject was this satire of the demimonde of Paris and Brussels. He excels in dry-point, and is one of the few recent etchers who have used soft-ground etching in any considerable degree.

Active encouragement was given to the art in Belgium by the late Comtesse de MARIE, COMTESSE DE FLANDRE, who was herself an accomplished Flandre. etcher. In 1875 the Princess figured with Rops among the founders of the "Société Internationale des Aquafortistes," and in 1887 was one of the promoters of the still existing "Société d'Aquafortistes Belges."

ARMAND RASSENFOSSE of Liège was, like Storm van 's Gravesande, A. Rassenfosse. diverted from another career by the inspiration of Rops, and guided by that master in his first attempts at etching. Though he only commenced to etch when he was twenty-seven, he has gained distinction for his technical mastery of the various branches of the craft of engraving.

Sound landscape plates have been produced by WYTSMAN, by Wytsman. FRANÇOIS MARÉCHAL of Liège, and by ALBERT BAERTSOEN of F. Maréchal. Ghent, while EUGÈNE LAERMANS' plates of genre are remarkable for A. Baertsoen. a vigorous breadth of handling, which finds its nearest counterpart E. Laermans. in Käthe Kollwitz. But the most original of recent Belgian etchers is perhaps JULES DE BRUYCKER, an artist revelling in subjects of J. de Bruycker. fantastic invention, allegories and street scenes teeming with figures.

In Germany and Austria the eighteenth century manner of GERMANY etching persisted longer than in England or France, and it is only AND AUSTRIA. within the last two decades that a real school of modern etching has come into being.

Before the middle of the century ADRIAN LUDWIG RICHTER A. L. Richter. and MORITZ VON SCHWIND, who were the chief movers in the Moritz von formation of a truly national school of popular illustration, had Schwind. produced some etchings, of considerable charm from their very simplicity of aim. But the same may be said of them as of Cruikshank and Keene, that they are rather stragglers from the eighteenth century than forerunners of the modern spirit. One of the most justly honoured of German graphic artists, ADOLF VON Adolf von MENZEL, started his work with the same modest outlook, and was Menzel greatly influenced by that popular school, but in a long life he spanned the bridge of connexion with the essentially modern. As

a draughtsman, especially of figures and subjects from everyday life, he developed a wonderful power, but he is far better known for the very numerous woodcuts and lithographs after his drawings than for his comparatively few original etchings.

Stauffer-Bern.
Max Klinger.
Two artists, CARL STAUFFER of Berne (or Stauffer-Bern as he is called) and MAX KLINGER, are of peculiar interest for their practice of combining graver work with etching, not, as frequently occurs in seventeenth-century etchings, for emphasising the heavier shading, but in order to achieve the most delicate modelling. They followed the path of Ferdinand Gaillard[1] in handling the graver almost like the dry-point for scratching the lightest lines on the plate, and entirely disassociated their graver work from the dull regularity which had been the conventional mode for so long a period. It cannot be said that in either case the result is altogether satisfactory. When the close shading is carried to its utmost limits, lines lose their meaning, and the same effect might be gained more fittingly by aquatint. Happily, Klinger realised this fact, and some of his finest work is in the combination of a delicate etched outline, which is allowed its perfect play, with an aquatint ground. Klinger's work, which consists of many series of large allegorical and illustrative works (e.g. *Rettungen Ovidischer Opfer, Eva und die Zukunft, Vom Tode, Brahms-phantasie*), must always possess interest as the philosophy of a powerful thinker, even if his technical means do not find favour.

Stauffer's best work is certainly seen in a few plates (more particularly portraits[2]) handled in a broader manner than his wont, which may be less individual examples of his style, but are nevertheless truer in convention. It is noteworthy that both Stauffer and Klinger should have turned latterly more to sculpture. The former unhappily died in the beginning of his achievement in this field; the latter has earned a name second only to that of Rodin, and by his attempt in polychrome sculpture has stepped boldly into the keenest fire of criticism.

Peter Halm.
Meyer-Basel.
In the van of the sound conventions of modern landscape etching in Germany stand PETER HALM and CARL THEODOR MEYER (or Meyer-Basel, as he is called from his birthplace).

J. L. Raab.
William Unger.
The former, following in the path of his master, J. L. RAAB of Munich, and of WILLIAM UNGER of Vienna, has also been prolific in reproduction, while decorative subjects of various types (*e.g.* book-plates) have occupied him as well as portrait and original landscape etching. The large increase of public interest taken in the art is evidenced by the three "Vereine für Original-Radierung," in Berlin, Munich, and Karlsruhe, which have issued yearly portfolios, containing much excellent work, since 1886, 1892, and 1894 respectively.

[1] Cf. p. 212.
[2] E.g. *Menzel* (2 plates, 1885), *P. Halm* and *G. Freytag* (1887).

Of the younger generation, OTTO FISCHER has most ably Otto Fischer.
carried forward the aims of Meyer-Basel, and his art evinces a
strength of style which places him almost at the head of modern Ubbelohde.
German etchers, though OTTO UBBELOHDE, OTTO FIKENTSCHER, Fikentscher.
and INGWER PAULSEN are worthy rivals. Paulsen.

One group of painter-etchers, that of Worpswede, near Bremen, The Worps-
holds a place quite by itself as a sort of modern German Barbizon. wede group.
FRITZ MACKENSEN, OTTO MODERSOHN, FRITZ OVERBECK, and
HANS AM ENDE are all landscape artists of genuine feeling, while
HEINRICH VOGELER follows a more decorative aim, somewhat
influenced by Klinger, in his extremely beautiful etchings. The
flower borders, in which Vogeler so often frames his compositions,
show an exquisite and original feeling.

Two other etchers deserve especial notice : KÄTHE Käthe
KOLLWITZ for her powerful studies of the life of the people, of Kollwitz.
astounding virility of conception and treatment; and HEINRICH Heinrich
WOLFF for his remarkable understanding of the roulette, as a Wolff.
medium of expression in his dashing portrait studies.

Aquatint has found a most successful interpreter, almost a
German classic, in OTTO GAMPERT, who has produced some most Otto Gampert.
effective landscapes. Aiming as he does at imparting tonality even to
his line-work, he frequently uses the soft-ground method of etching.

If any of the numerous German painters who have done Max
occasional etchings should be mentioned, it must be MAX Liebermann.
LIEBERMANN. He has realised to the full the possibilities of
varying grain in soft-ground etching, and has attained by this
medium tone-pictures of remarkable individuality.

Crossing the borders of Germany to Bohemia, a most interesting Emil Orlik.
artist is met in the person of EMIL ORLIK of Prague. The especial
virtue which makes his style, is the appreciation of the decorative
possibilities of simple line and curve, and of flat surfaces of colour.
The likeness of his ideals to those of the arts of China and Japan,
which has been developed by a recent visit to those countries and a
serious study of their methods of engraving, makes one almost
expect the natural expression of his art in woodcut. Nevertheless
his achievement in aquatint and etching is almost equally remarkable.

In Vienna excellent work, both in landscape and in dreams of R. Jettmar.
grim fantasy, is being done by RUDOLF JETTMAR, while FERDINAND F. Schmutzer.
SCHMUTZER has proved himself a most capable artist in his large and
powerful portraits (e.g. *Dr. Joachim*).

.

Art in Scandinavia is still in its youth, but it can boast at least SCANDINAVIA.
one etcher of great individuality, ANDERS ZORN. A Swede by Anders Zorn.
birth, and a student of the Academy at Stockholm, his artistic
inspiration was probably found more in Paris, between which centre
and London and America much of his time was passed. His
initiation in the technique of etching he received from his fellow-

countryman Haig, in London, about 1882, but no pupil could be more unlike his master. He practised a remarkably broad manner of etching, seldom shading in more than open parallel lines, and often leaving the outline to the imagination. Its suggestion is probably due to Besnard, but by constant reiteration of the same characteristic handling Zorn made it recognised as his own. His plates (including nearly 300 numbers, produced since 1882) are nearly all figure subjects, portraits such as the *Ernest Renan* (1892) being among the best. If his prints sometimes just fail to convince, it is perhaps from a certain lack of repose and concentration rising from irregularly placed patches of parallel shading, *e.g.* in the *Artist, with a Model, in his Studio* (1899). Zorn was sculptor and painter as well as etcher, and it may be remarked that he was among the few who have no compunction in repeating the subjects of their pictures in their etchings.

Larsson. CARL LARSSON was another Stockholm etcher who has worked at various periods in Paris. His etched work is somewhat in the nature of a πάρεργον beside his production in water-colour, pastel, and oil, and less than 50 plates were produced between 1875 and 1905. His general tendency was toward the decorative and illustrative side of art, but his etchings were for the most part figure studies and portraits. Only a few plates date before 1888-89, when increased success in other directions and a renewed sojourn in Paris encouraged him to return to the somewhat unremunerative medium of etching. Then in 1895-96 he received further impulse from AXEL TALLBERG,[1] who, as head of the school of etching in the Academy of Arts at Stockholm, exerted considerable influence on Swedish artists. A few mezzotints and soft-ground etchings, and two plates in colour, date about this period.

HAIG, who was born in the Isle of Gothland, has found a place among English etchers, for it was in England that nearly all his life was spent.

Fritz Thaulow. Of Norwegian artists we may just refer to FRITZ THAULOW, who was long settled in Dieppe. His large coloured etchings are as well known as any foreign work in England to-day. Despite their cleverness and occasional success in effect, we must confess to a slight unwillingness to admit the propriety of attempting colour through the medium of etching on the large scale of most of Thaulow's plates.

RUSSIA AND FINLAND. From Russia proper we have hitherto seen nothing that could be acclaimed as a solid addition to European art. Finland has already a landscape school of its own of no little interest. The **Sparre. Edelfelt.** chief inspirer has been Count LOUIS SPARRE, a Swede by birth, but naturalised a Finn, ALBERT EDELFELT, some years his senior, having

[1] Tallberg had resided for a considerable period in England, exhibiting at the Painter-Etchers between 1891 and 1895.

worked chiefly in Paris. Axel Gallén is another interesting artist, Axel Gallén.
while recently some good plates have appeared from the hand of
Hilda Flodin. Hilda Flodin.

.

Perhaps it is the natural order of things that Italy who, if she was Italy.
not in the van of technical development, was at least the greatest
artistic force in the earlier part of our history, should now lag so
painfully in the rear. As a nation of artistic sentiment, Italy is
apparently content with her traditions, and the power of assimilating
living ideals seems crushed by the weight of her past greatness.
Nevertheless, she has been able to show a few etchers of delicate
talent working in a modern spirit, such as Luca Beltrami, widely Luca Beltrami.
known to the student of Milanese art by his numerous writings, and
Ghiberto Borroméo, while in the path of the Impressionists, Borroméo.
Vittore Grubicy has produced landscape etchings of considerable Grubicy.
individuality in the treatment of effects of light. Emmanuele
Brugnoli should be mentioned for his excellent etchings of Venice, Brugnoli.
somewhat in the tradition of Canaletto, and for his influence on
Italian etchers in his capacity as teacher of etching in the Institute
of Fine-Arts, Venice. Vico Vigano is another etcher who, apart Vigano.
from his plates, has done much to encourage the progress of recent
Italian etching in the organisation of exhibitions. C. P. Agazzi Agazzi.
and B. M. Disertori are among the most noteworthy of the younger Disertori.
Italian etchers of landscape and architecture.

.

Mariano Fortuny is the only Spanish artist of the second half Spain.
of the last century whose etching demands attention, and even his Mariano
Fortuny.
plates are of the slightest in comparison with his painting. Rome was
the centre of his activity, but the real making of his art was a visit
to Morocco during the Spanish-Moroccan war of 1860, which he
was officially commissioned to record in his sketch-book. The
white brilliance of the tropical atmosphere found in Fortuny its
natural interpreter, and on a later visit he happily continued his
studies of a people, which formed the subject for most of his
delicately bitten plates.

One of the most striking representatives of the modern school,
Pablo Picasso, is a Spaniard, but his work and influence have Picasso.
centred more in Paris than in his native country. There are several
large dry-point studies of figure and portrait which show him as a
master of sensitive line.

.

This short survey of recent etching may be enough to show that
the present is by no means a period of decline, containing, as it does,
various new factors, both in aims and in modes of expression, which
are far from having realised their full growth. If modern artists
still express themselves more readily in haphazard experiments and
studies, rather than in rounded compositions, engraving and etching

are the fittest vehicles by which more definite thought and conviction in artistic principles can be regained. A great work does not mean a large work, much less a work of technical elaboration in engraving, but it inevitably implies sureness of hand, and concentration and clearness of purpose. In general, the nineteenth and early twentieth centuries have not been distinguished for these latter qualities, and it is only by their presence that the occasional studies, which sometimes offer a more subtle attraction to the connoisseur than the finished work, will possess any lasting value. Engraving and etching have contributed far more than painting during the past hundred years to preserve the artist from mere anarchy, and it is in these fields that one looks for the expression, in which the uncertain streams and tendencies of modern art may crystallize into conviction.

APPENDICES

APPENDIX I

CLASSIFIED LIST OF ENGRAVERS

THE numbers in the *first column* indicate the date by half-centuries. Thus **18.** I = 1700–1750; **15.** 2 = 1450–1500.

The period in which an artist is placed is, with slight qualifications, that within which the greater part of his work falls. An engraver born within the last twenty years of any half-century would naturally be placed in the following period. If his work overlaps in either direction beyond the period indicated in the first column, a note is added to that effect in brackets after his name. In certain cases an engraver may be placed in a period to which he does not strictly belong on the grounds of connexion of style with a particular group.

The *second column* defines the medium used by the engravers in the third and fourth columns.

The *third column* defines the engravers of the fourth column—

 (i.) By the master under whose influence they fall (names in the fourth column being preceded by *cf.* when artistic relation rather than definite influence is implied).

 (ii.) By the characteristic of their group.

 (iii.) By their locality.

(i.), (ii.), and (iii.) may be combined to form a single class, the full stop defining in each case the composite or completed heading.

The headings in the first and second columns hold good until they are superseded by other entries in their own columns; the headings or descriptions in the third column hold good until a full stop occurs in the fourth column. A semicolon divides groups included under a principal heading.

Within each group the order of date (of birth, or of the beginning of production) is as far as possible followed in citing the engravers' names.

An engraver may be given in more than one connexion, sometimes in more than one country. When he is placed in the lists of a country to which he does not belong by birth, his nationality is noted in brackets.

Painters who were not engravers, cited in the third column, are enclosed in square brackets.

ABBREVIATIONS USED IN THE LISTS AND IN THE INDEX

A. = American.
ab. = about.
af. = after.
alleg. = allegorical.
amat. = amateur.
antiq. = antiquities.
aq. = aquatint.
archit. = architectural.
Br. = British.
b. = born.
bef. = before.
B. M. = British Museum.
caric. = caricature.
cf. = compare.
class. = classical (referring largely to the Italian work of the 15th and 16th centuries).
col. = printed in colours.
contr. = contrast.
cop. = copyist (or copied).
cr. = crayon or chalk manner.
D. = Dutch.
d. = died.
Da. = Danish.
en. = line engraving.
esp. = especially.
et. = etching (which may be taken in many cases to include the practice of dry-point).

F. = French.
Fl. = Flemish.
fl. = floruit (flourished).
G. = German.
g. = genre, daily life.
hist. = historical.
I. = Italian.
illustr. = book illustrat -or, -ions.
imit. = imitator (or imitated).
infl. = influence.
l. = landscape.
mezz. = mezzotint.
misc. = miscellaneous.
N. = Norwegian.
orig. = original.
orn = ornament.
p. = portrait.
R. = Russian.
S. = Spanish.
satir. = satirical.
script. = scriptural.
s. = subject.
S. K. = South Kensington (Nat Art Library).
st. = stipple.
Swe. = Swedish.
Swi. = Swiss.

THE COUNTRIES ARE GIVEN IN THE FOLLOWING ORDER:—

1. Germany, Austria-Hungary, and German Switzerland.
2. The Netherlands.
3. Italy.
4. France and French Switzerland.
5. Spain and Portugal.
6. The British Isles.
7. America.
8. Denmark.
9. Sweden and Norway.
10. Russia and Finland.

GERMANY, AUSTRIA-HUNGARY, AND GERMAN SWITZERLAND.

Date.	Medium.	Master, Characteristic, or Locality.	Engravers influenced by the Masters in the previous column, or whose work is characterised or localised by the remarks in the same place.
15. 1, 2	EN	Master of the Playing Cards (Upper Germany).	Master of 1446, Master of the Nuremberg Passion, Master of the St. John the Baptist (*so called from P.* ii. 92, 49), Master of the Banderoles, Master of the Weibemacht, E. S.
15. 2		Misc., Lower Germany.	Master of the Berlin Passion, Master of the St. Erasmus, Master of the Flower Borders, Master of the Dutuit Mount of Olives, Master of the Martyrdom of the Ten Thousand (under which three Masters part of the work formerly attrib. to Master of St. Erasmus has now been divided), FVB (*Franz von Bocholt*?), I. van Meckenem, P. W.
		Martin Schongauer.	L⚹8, B.M, B⚹R, P.M., A.G. (*Albrecht Glockenton*?), b⚹8, I.C.
		Master of the Amsterdam Cabinet.	W⚹B, b⚹8.
		Bavaria and Swabia.	H.W. (*Hans Windsheim*?), Jörg Syrlin,
15. 2, 16. 1			Veit Stoss, M.Z. (*M. Zasinger*?), N. A. Mair.
15. 2		Miscellaneous.	L⚹, W⚹H (*Wolf Hammer*?), Wenzel von Olomucz.
15. 2, 16. 1		Dürer.	L. Krug, H. Schäufelein, L. Cranach, H. Baldung, Urs Graf, H. Leinberger.
		The "Little·Masters."	A. Altdorfer, B. and H. S. Beham, G. Pencz, I.B. (*Georg Pencz*?), G. K. Proger (*orn.*),
16. 1, 2			H. Brosamer, F. Brun,
16. 2			P. Gottlandt (*Roddelstet*), A. Mair (*also* 17. 1).
16. 1, 2		Virgil Solis.	N. Solis, A. Summer, B. Jenichen.
		Lower Germany.	Telman van Wesel, H. Aldegrever, J. Binck.
		Copyists.	H. Ladenspelder, N. Wilborn.
16. 2		Classical.	Melchior Meyer.
16. 2, 17. 1	Punch-EN	Ornament, etc.	J. Kellerdaller I. and II., *cf.* D. Kellerdaller (17. 1), M. Strobel, B. Zan, H. Bang, I.S., P. Flindt, F. Aspruck (*Fl.*), H. C. Laechlin.
	EN, ET	Ornament.	Hornick, Bang, Hensel, Mignot, Saur, Birckenhultz, Hailler, Wechter.
16. 1	ET		Urs Graf.
		Dürer.	H. S. Beham.

Date.	Medium.	Master, Characteristic, or Locality.	Engravers influenced by the Masters in the previous column, or whose work is characterised or localised by the remarks in the same place.
16. 1, 2	ET	A. Altdorfer (chiefly l.).	E. Altdorfer (*also en.*), A. Hirschvogel, H. S. Lautensack.
16. 1		D. Hopfer.	H. and L. Hopfer, C.B., H. Vogtherr II., H. Burgkmair I. and II.
16. 1, 2		Nuremberg.	V. Solis, W. Jamnitzer, J. Amman, L. Strauch.
16. 2		Switzerland.	C. Maurer, A. Stimmer, D. Meyer (*also* **17.** 1).
16. 2	EN, ET	Misc., orn., heraldry, archit., etc.	M. Zündt (= *Master of the Kraterographie of* 1551?) (*orn. and topogr.*), *cf.* P. Opel (*shooting festivals*), W. Dietterlin, J. Guckeisen, H. J. Ebelman, Veit Eck, G. Krammer, A. Eisenhoit (*Rome, antiq.*), H. Sibmacher (*lace*).
	EN + ET	Immigrants from Flanders. (topogr. and misc.).	F. Hogenberg, T., J. I., and J. T. de Bry (*also* **17.** 1).
17. 1	EN	The Sadelers (*Fl.*), the Wierixes (*Fl.*).	P. Isselburg, Jacob v. d. Heyden, P. Aubry.
17. 1, 2		D. Custos (*Fl.*) (Augsburg).	L., W., P., and B. Kilian (*B. K. under French influence*), Melchior and Matthäus Küsell, G. A. and A. Wolfgang (*cf.* J. G. Wolfgang, **18.** 1), C. N. Schurtz, Joachim Sandrart I. (*also et.*) and II., Jacob Sandrart, J. J. Sandrart.
		The de Poillys and the French portrait engravers.	J. Falck, E. and J. Hainzelmann.
17. 1		C. Mellan. Classical.	J. J. Thourneyser (*p. and s.*). M. and J. F. Greuter (*in Rome*), T. Krüger (*Italy*).
17. 2		Ornament.	W. H. v. Bömmel (*grotesque figures of scroll work*).
17. 1	ET	Misc., infl. by Italian school.	G. Pecham, H. Weiner (*af. C. Schwarz, etc.*), A. Griemer, P. Uffenbach.
		Elsheimer.	M. v. Uijtenbroeck (*D.*), C. C. Moeyart (*D.*).
17. 1, 2		Misc., Italian influence.	F. Clein (*cf. Venetian etchers*), J. H. Schönfeld (*cf. Castiglione*), J. O. Harms (*Roman ruins, theatre scenery*), J. Umbach (*cf. Reni school*), B. Zaech.
		Italianising Netherlanders (*e.g.* J. Both).	*Cf.* J. F. Ermels (*Roman ruins*), J. P. Lembke, J. F. Beich (*also* **18.** 1).
		Netherlandish school.	M. Willman (*cf. Rembrandt and Castiglione*), M. Scheits (*cf. Ostade*), J. H. Roos (*animals;*

Date.	Medium.	Master, Characteristic, or Locality.	Engravers influenced by the Masters in the previous column, or whose work is characterised or localised by the remarks in the same place.
17. 1, 2	ET	(*Continued*).	*cf. Joseph Roos*, **18.** 2.), F. Ertinger (*af. Rubens, Lafage, etc.; also topogr. of Brabant*).
		J. W. Baur (infl. by Callot and the Dutch school).	*Cf.* F. Brentel (*Baur's master*), J. U. Franck, Matth. and Melch. Küsell, *cf.* J. S. Küsell.
		M. Merian I.	M. Merian II., C. and M. S. Merian ; *cf.* Jacob v. d. Heyden, *cf.* C. Meyer (*heraldic*), W. Hollar.
17. 1, 2	MEZZ	L. von Siegen.	Prince Rupert, T. C. v. Fürstenberg, J. Thomas (*Fl.*), J. F. v. Eltz, J. J. Kremer (*the two preceding, sch. of Fürstenberg*), J. Bickart (*sch. of Fürstenberg ?*), J. C Dooms (*sch. of Fürstenberg ?*).
		Nuremberg.	A. P. Multz, M. Dichtel, G. and M. Fennitzer, J. A. Boener (*also* **18.** 1).
		Miscellaneous.	J. G. Bodenehr, H. H. Quiter (*D.*), J. F. Leonart (*Fl.*), P. Schenck (*also* **18.** 1 ; *fl. Amsterdam*), B. Block.
17. 2, 18. 1		Augsburg.	G. A. Wolfgang, C. Weigel, E. C. Heiss.
18. 1, 2	EN		B. Seuter (*col. ; also Mezz.* ?)
		Working in Italy. G. F. Schmidt and J. G. Wille.	J. J. Frey, J. Wagner. *Cf.* P. A. Kilian (*e.g. Dresden Gallery work*, 1753 *and* 1757), C. and H. Guttenberg (*cf. also French illustr.*), C. G. Schultze, J. M. Preisler (*later in Copenhagen*), J. G. Preisler (*Copenhagen*), C. W. Weisbrod, G. Camerata (I.),
18. 2, 19. 1			J. M. Schmutzer, I. S. Klauber (*from* 1796 *in St. Petersburg*), *cf.* J. F. Bause, C. F. Stölzel, J. G. v. Müller, C. E. C. Hess (*Düsseldorf Gallery*), C.G. Rasp.
		Landscape.	A. Zingg, W. F. Gmelin (*Rome, etc.*).
18. 1, 2	ET	Animals, hunting scenes, battles, etc.	G. P. and J. C. Rugendas, J. E. Ridinger.
		Misc., under foreign infl., imitators, etc. :— (i.) Chiefly Italian infl.	J. F. Beich (*infl. by Claude; cf. J. Both*), J. A. Thiele (*l.; infl. by Belotto*), M. J. Schmidt (*cf. Castiglione and Tiepolo*) ;
		(ii.) Chiefly Dutch infl.	C. W. E. Dietrich (*imit. Rembrandt, etc.*), J. G. Trautmann (*imit. Rembrandt*), J. A. B. Nothnagel (*imit. Rem-*

Date.	Medium.	Master, Characteristic, or Locality.	Engravers influenced by the Masters in the previous column, or whose work is characterised or localised by the remarks in the same place.
18. 1, 2	ET	(*Continued*).	*brandt*), J. C. Klengel (*cf. Rembrandt*), J. H. Tischbein II., J. H. W. Tischbein (*g., s., and animals; also* **19.** 1), C. L. v. Hagedorn (*l.*), F. E. Weirotter (*l.*), A. Zingg (*l.; also en.*), F. Kobell (*l.*), J. P. and G. A. Hackert (*l.; cf. J. Both*), P. J. Loutherbourg (*l., s., caric.; cf. also Salvator Rosa; fl. chiefly in London*), Joseph Roos (*animals; cf. J. H. Roos*), J. H. Menken (*animals, cf. Berchem; also* **19.** 1), C. v. Vittinghoff (*animals*), W. Kobell (*animals; also* **19.** 1), *cf.* J. F. Morgenstern (**19.** 1, *af. Ruysdael, Roos, Dietrich, etc.*).
18. 2, 19. 1		Misc. landscape.	F. A. Brand, J. L. E. Morgenstern, J. E. Zeissig, J. H. Meyer (*Swiss views; cf. S. Gessner*), A. C. Dies (*country near Rome*), M. v. Molitor, J. G. Schumann (*also in London, with Byrne*), J. C. Reinhart (*country near Rome; also animals*), J. G. v. Dillis (*country near Munich*).
18. 2		Idyllic landscape. Miscellaneous.	S. Gessner, K. W. Kolbe. C. M. Tuscher (*costume and society; cf. C. Troost*), M. Oesterreich (*caric. af. Ghezzi and Internari*), J. H. Tischbein I. (*mythol., hist.*), A. F. Maulbertsch (*s. and g.*), C. B. Rode (*s., cf. Castiglione and Tiepolo*), A. F. Oeser (*s.*), F. Landerer (*character heads*), H. R. Fuessli (*class.*), Angelica Kauffmann (*class., p. and fancy*), J. W. v. Goethe (*a few l. af. A. Thiele, etc., ab.* 1768), C. Gessner (*animals, battle-scenes; also* **19.** 1).
		Reproduction of drawings.	J. G. and M. C. Prestel (*aq.*), Charles, Prince de Ligne, C. M. Metz (*in London; Imitations of drawings in English collections,* 109 *plates,* 1798; *also* **19.** 1), A. Bartsch (*also* **19.** 1), W. Kobell (*aq.*).
18. 2, 19. 1		D. Chodowiecki.	G. and W. Chodowiecki, D. Berger, J. F. Bolt, *cf.* J. W. Meil (*cf. Choffard, and French vignettistes*).

Date.	Medium.	Master, Characteristic, or Locality.	Engravers influenced by the Masters in the previous column, or whose work is characterised or localised by the remarks in the same place.
18. 1, 2	MEZZ	Animals, hunting, battles.	G. P. and J. C. Rugendas, J. E. Ridinger.
		Miscellaneous.	S. and C. F. Blesendorf, B. Vogel (*af. Kupezky*), G. and M. Bodenehr, G. C. and P. A. Kilian, J. L. Haid, J. J. Haid, J. G. Haid (*also in London*), J. E. Haid, H. Sintzenich (*also in London*), J. J. Freidhoff (*also* **19.** 1).
		Vienna.	J. Männl, A. J. v. Prenner, J. Jacobé (*also in London*), J. P. Pichler, I. Unterberger (*mixed mezz.*), J. V. Kauperz, F. Wrenk (*also* **19.** 1), V. G. Kininger (*also* **19.** 1).
18. 1		Colour prints.	J. C. Le Blon (*three-colour process*);
18. 2, **19.** 1			J. P. Pichler, F. Wrenk.
18. 2	ST, CR	Miscellaneous.	J. G. Prestel, M. C. Prestel (*also in London*) (*the two preceding also aq.*), G. S. and J. G. Facius (*both in London*), H. and P. Sintzenich (*both in London*), D. Chodowiecki (*a few plates*),
18. 2, **19.** 1			D. Berger, C. F. Stölzel, C. E. C. Hess, J. K. Felsing, J. J. Freidhoff, F. John, K. H. Pfeiffer.
19. 1	EN	Schmidt tradition.	J. F. W. Müller, M. Müller (Steinla), C. Agricola (*sm. class.*), J. K. Felsing (*topogr.*), S. Amsler (*cartoon and outline manner*),
19. 1, 2			B. Höfel, F. A. Krüger, J. H. and G. J. Felsing, J. Caspar, E. Schäffer, L. Gruner (*sch. of Longhi; outlines, class.*), J. C. Thaeter, H. Schütz (*outlines af. Genelli*), A. Hoffmann, E. Mandel (*sch. of Henriquel - Dupont*), J. v. Keller (*sch. of Desnoyers*), K. Geyer, E. Willmann (*l.*),
19. 2, **20.** 1			J. Sonnenleiter, L. Jacoby, J. Burger, R. Stang, K. Kräutle, G. Eilers, E. Buchel, J. Lindner (*original p. and reprod.*), E. Mohn (*cf. Mandel; infl. by Gaillard*), J. Klaus, A. Krüger.
19. 1	ET	Classical. Landscape, etc.	C. Russ (*also aq.; cf. Flaxman*). J. A. Koch, H. J. Herterich, J. Gauermann, F. A. Dreyer, S. Bendixen, F. Rektorzik, J. C. Erhard, C. F. v.

Date.	Medium.	Master, Characteristic, or Locality.	Engravers influenced by the Masters in the previous column, or whose work is characterised or localised by the remarks in the same place.
19. 1	ET	(*Continued*).	Rumohr, N. Bittner (*stage scenery*),
19. 1, 2			F. v. Lütgendorff (*p.*), G. E. Harzen, L. E. Grimm (*p. studies*), C. Wagner. E. C. Fechner (*p.*), C. E. B. Morgenstern, A. F. Vollmer, J. and J. M. Gensler, L. Gurlitt, A. Achenbach.
		Animals.	J. A. Klein, F. Gauermann, S. Habenschaden.
		Popular illustration.	A. L. Richter, M. v. Schwind, R. Reinick, J. B. W. A. Sonderland, E. Neureuther,
19. 2			W. Busch (*humorous illustr.*).
19. 1, 2		Modern spirit ; for the most part original work :—	
		(i.) Germany, and German Switzerland.	A. Menzel, Frederike O'Connell (*née* Miethe) (*fl. Paris ; p. and reprod.*), A. Brendel (*animals, etc.*),
19. 2, **20.** 1			L. Hartmann (*animals, l.*), H. L. v. Gleichen-Russwurm, H. Thoma, O. Gampert, W. Leibl (*p.*), B. Mannfeld, H. v. Herkomer (*chiefly in England*), W. Rohr (*p., reprod. etc.*), S. L. Wenban (*U.S.A.,*) H. E. v. Berlepsch, M. Liebermann, G. Schönleber, E. Zimmermann (*g.*), P. Halm (*also reprod.*) C. T. Meyer (Meyer-Basel), C. J. Becker-Gundahl, C. Stauffer (Stauffer-Bern) (*partly en.*), M. Klinger (*partly en.*), L. (Graf) Kalckreuth, L. Corinth, H. v. Volkmann, H. v. Heyden (*animals*), E. M. Geyger (*animals, etc.*), A. Welti (*s., alleg.; infl. by Boecklin*), O. Fikentscher, F. Stuck, M. Dasio (*cf. Klinger*), E. Kirchner (*satir.*), W. Leistikow, H. am Ende, F. Mackensen, O. Modersohn, F. Overbeck, H. Vogeler (*the five preceding form the Worpswede group.*), M. Pietschmann, W. Rudinoff, Käthe Kollwitz, O. Ubbelohde, O. Greiner (*infl. by Klinger*), J. Dietz (*alleg.*), E. Nolde, O. Fischer (*also aq.*), O. Graf (*also aq.*), Cecilia Graf (*also aq.*), B. Pankok, F. Boehle (*l , s., etc. ; archaiser*), J. Brockhoff, H. Neumann, R.

Date.	Medium.	Master, Characteristic, or Locality.	Engravers influenced by the Masters in the previous column, or whose work is characterised or localised by the remarks in the same place.
19. 2, 20. 1	ET	(*Continued*).	Müller (*animals, l., etc.*), H. Wolff (*p.*), H. Struck, P. Herrmann, H. Meid, E. Wolfsfeld, A. F. Schinnerer, I. Paulsen, A. Olbricht, M. Behmer, W. Zeising, H. Wilm;
		(ii.) Austria and Bohemia.	R. v. Alt (*also* 19. 1), Hermine Laukota, W. Ziegler (*e.g.* 25 *Originaldrucke in verschiedenen Tiefdrucktechniken,* 1901), A. Roth, H. Seufferheld, H. Jakesch, E. Orlik, F. Hegenbart, R. Jettmar, F. Schmutzer, A. Cossmann, G. v. Kempf, A. Luntz (*fl. Karlsruhe*), C. Myslbek, F. Gold, R. Lux, M. Švabinsky, T. F. Simon;
		(iii.) Hungary.	L. Michalek (*fl. Vienna*), S. Landsinger (*p., e.g. of his master Boecklin*), L. Räuscher, V. Olgyai, A. Aranyossy, A. Székely.
		Reproductive.	H. Bürkner (*also* 19. 1), J. L. Raab, W. Unger, J. Willroider, W. Hecht, W. Krauskopf, K. Koepping, W. Rohr, W. Woernle, P. Halm, A. Krüger, L. Kühn, F. Krostewitz.
19. 1. 2 19. 2, 20. 1	MEZZ		C. Mayer (*sch. of Kininger*), R. Kaiser, B. Pankok.

THE NETHERLANDS

Date.	Medium.	Master, Characteristic, or Locality.	Engravers
15. 1, 2	EN	Working from about 1440.	Master of the Gardens of Love, Master of the Mount of Calvary, Master of the Balaam (*so called from a print in Dresden; see Lehrs, Repert.* xvii. 352), Master of the Death of Mary (*so called from P.* ii. 227, 117, *Berlin, Vienna*).
15. 2		Working from about 1470.	Master of the Boccaccio Illustrations, IAM (with the weaver's shuttle) of Zwolle, W ♻ , Allart du Hameel.
16. 1		Lucas van Leyden.	*Cf.* J. Gossaert (Mabuse), F. Crabbe, N. Hogenberg, L. Suavius (*infl. also by Italians*).
		German "Little Masters."	A. Claesz, C. Matsys, S., *cf. also* D. Vellert (*en and et.*), ⬥ (*read D. I., and identified with Vellert by Beets; orn.*).

Date.	Medium.	Master, Characteristic, or Locality.	Engravers influenced by the Masters in the previous column, or whose work is characterised or localised by the remarks in the same place.
16. 1, 2	EN	Engravers under Italian infl., working largely for the publisher engraver Cock, af. designs by F. Floris, M. v. Heemskerk, J. v. d. Straet, M. de Vos, O. v. Veen, B. Spranger, etc.	A. Collaert (I. and II. ?), H. Collaert I. and II., C. v. Bos, J. Bos ("Belga"), D. V. Coornhaert, C. Cort, F. Huys (*also p.*), P. Huys, Petrus a Merica, P. Galle (*cf. T. Galle and C. Galle I. and II.*, **17**. 1), G. de Jode II., J. v. Stalburch, G. v. Veen (*also* **17**. 1), N. Cloeck, H. Muller (*also* **17**. 1).
16. 2, 17. 1		Engravers and engraver-publishers who settled abroad.	Jan Sadeler I. (*Venice*), Raphael Sadeler I. (*Venice, Munich*), G. Sadeler (*Prague*), M. Gheraerts I. (*London; also et.*), F. Hogenberg (*London and Cologne*), The van de Passes (*various members of the family in London, Paris, Copenhagen*), D. Custos (*Augsburg*), T., J. T., and J. I. de Bry (*Frankfurt*), C. Boel (*London and Madrid*), P. Perret (*Madrid*).
		The Wierixes.	A. and N. de Bruyn, C. v. Mallery; *cf.* T. v. Merlen (**17**. 1, 2).
		Crispin van de Passe and the Wierixes.	Crispin II. and III., S., W., and M. Passe, C. v. Queboren, T. de Leu (*fl. France*).
		Misc. portrait (cf. the Passe and the Wierix).	P. Baltens, H. Liefrink, F. Huys, *contr.* Hubert Goltzius (*et. and chiaroscuro:* "*Imperatorum Imagines*," 1557).
16. 2, 17. 1		Hendrik Goltzius.	J. Saenredam, J. Muller, J. Matham, W. Swanenburg, J. de Gheyn I. and II., B. Dolendo, P. de Jode I., E. v. Panderen, N. Lastmann, *cf. and contr.* A., C., and F. Bloemaert.
		Maps.	G. Mercator, J. Hondius, F. Hogenberg.
		Topography.	G. Hoefnagel, F. Hogenberg, the de Brys.
		Natural History.	J. Hoefnagel (*insects, fruits, and flowers af.* G. Hoefnagel, 1592).
16. 1, 2		Ornament.	C. Bos (*strap and grotesque*), H. Collaert I. and II., M. Gheraerts I. (*e.g. Passion of Christ, in ornamental strapwork setting; also et.*).
16. 1	ET.	Miscellaneous.	L. v. Leyden, Vellert, F. Crabbe, N. Hogenberg, B. v. Orley (?), Vermeyen, Teunissen.

Date.	Medium.	Master, Characteristic, or Locality.	Engravers influenced by the Masters in the previous column, or whose work is characterised or localised by the remarks in the same place.
16. 1, 2	ET	Italian influence, and misc.	F. Floris, M. Gheraerts I. (*s.*, *illustr.*, *etc.* ; *also in England*), P. v. d. Borcht (*script. and g.*),
16. 2, 17. 1			B. Spranger, P. Feddes v. Harlingen (*s. and p.*).
16. 1, 2		Landscape.	L. Gassel, P. Brueghel I., *cf.* J. Brueghel I. (*also* 17. 1), H. Bol, H. Cock,
16. 2, 17. 1			P. Bril, R. Savery, S. de Vries.
17. 1	EN	Misc. portrait, preceding or escaping the infl. of Rubens and Van Dyck.	C. and K. v. Sichem (*and others of the family ?*), W. J. Delff (*af. Mierevelt*), H. Hondius II., J. v. d. Velde, S. Savery (*also misc. reprod.*).
		Rubens and Van Dyck : (i.) Engravers coming under their influence as formed artists.	C. Galle I. and II., J. Muller, J. Matham, W. Swanenburg, E. v. Panderen (*cf. Goltzius school*) ;
		(ii.) Immediate school of Rubens.	P. Soutman, L. Vorsterman (*also* 17. 2), P. Pontius, B. and S. à Bolswert ;
17. 1, 2		(iii.) Miscellaneous.	P. de Jode II., J. Witdoek, M. Robin v. d. Goes, J. Neeffs, L. Vorsterman II. (*also topogr. et. and plates in D. Teniers' "Theatre des Peintures,"* 1660), (*the four preceding, pupils of L. Vorsterman I.*), A. Stock, N. and C. Lauwers, N. Ryckemans, C. Waumans, P. de Bailliu, A. v. d. Does, J. v. Noordt, H. Snyers, C. v. Caukercken, M. Borrekens, J. Suyderhoef (*chiefly af. Hals*), P. v. Sompel, J. Louys, W. P. de Leeuw (*the four preceding, sch. of Soutman ; cf. and contr.* C. Visscher, *a sch. of Soutman who combined en. and et., infl. by Ostade; cf. also* J. *and* L. Visscher), A. Lommelin, P. Clouwet, R. v. Voerst (*also in England*), R. Collin (*"engraver to the King of Spain" ; en. antique statues for publications of Joachim Sandrart*), A. de Jode (*son of Pieter de J. II.*), J. Pitau, F. Ragot (*F.*) ;
		(iv.) Engraver-publishers.	M. v. d. Enden, G. Hendricx, J. Meyssens, F. v. d. Wyngaerde.
		Portrait : (i.) Misc., more or less	F., Gaspar, Gerard and Phili-

Date.	Medium.	Master, Characteristic, or Locality.	Engravers influenced by the Masters in the previous column, or whose work is characterised or localised by the remarks in the same place.
17. 1, 2	EN	under infl. of Van Dyck.	bert Bouttats, A. Clouwet, P. Philippe, R. v. Persyn, A. v. Zylvelt, J. Munnick-huysen, H. Bary, P. Holsteyn II., J. Barra, C. v. Dalen I. and II., A. Blooteling, G. Valck (*also* **18.** 1), L. Visscher, J. Blondeau, P. v. Gunst (*also* **18.** 1);
		(ii.) [Frans Hals.] (iii.) Engravers who later joined the French school.	J. Suyderhoef; M. Tavernier (*cf. his father, G. Tavernier, who had been settled as en.-publ. in Paris from ab.* 1573), J. de Bie (*chiefly af. medals, e.g.* "*la France Metallique,*" 1634), P. v. Schuppen, N. Pitau I. and II., G. and J. Edelinck, C. Vermeulen I.
17. 1		Genre (af. Vinckboons, A. v. d. Venne, etc.).	P. Serwouter, J. v. Londerseel.
17. 1, 2		Miscellaneous.	C. Bloemaert (*fl. Italy*), H. Goudt (*af. Elsheimer*), M. Natalis (*infl. by Poussin and school*), J. v. Troyen, F. v. d. Steen, T. v. Kessel, N. v. Ho(e)y (*the four preceding in D. Teniers' "Theatre des Peintures,*" 1660), C. Le Blon (*illustr.*).
		Colour prints. Ornament.	J. Teyler. M. Le Blon, H. Janssen(s).
	Punch-EN		F. Aspruck (*fl. Augsburg*), J. Lutma II.
	ET	Rubens school: (i.) Largely subject.	J. Jordaens (?), A. v. Diepen-beeck (?), F. Snyders (?), C. Schut, T. v. Thulden, *cf.* R. Eynhoudts; E. Quellin, H. Quellin (*af. A. Quellin's designs, interior of Town Hall, Amsterdam*), G. Seghers, F. v. d. Wyngaerde, W. Panneels (*fl. Germany*), J. Thomas (*also mezz.; fl. Vienna*), W. v. Valckert, L. v. d. Koogen, J. de Bisschop (*also af. B. Breen-bergh*); *cf.* R. v. Orley (*also* **18.** 1); *cf.* J. de Wit (**18.** 1).
		(ii.) Portrait (infl. of Van Dyck).	J. Lievens, P. Fruytiers (*cf. Hollar*), *cf. in technical manner* C. de Moor (*also* **18.** 1).
		(iii.) Landscape.	L. de Vadder, L. v. Uden, I. v. d. Stock, *cf.* F.

Date.	Medium.	Master, Characteristic, or Locality.	Engravers influenced by the Masters in the previous column, or whose work is characterised or localised by the remarks in the same place.
17. I, 2	ET	(*Continued*).	Wouters (*also in England*), *cf.* G. Neyts.
17. I		Immediate predecessors and earlier contemporaries of Rembrandt :	
		(i.) Genre, subject, and misc.	J. B. and C. de Wael, D. Vinckboons, N. J. Visscher (*a few plates in manner of P. Brueghel I.'s paintings, etc.; chiefly worked as publ.*), G. v. Scheyndel (*cf. Callot*), T. Rombouts, J. Bouchorst, P. Lastman, G. Bleker (*cf. animal etchers*), P. de Grebber, W. Buytewech (*s. and l.*), L. Bramer, C. C. Moeyart, *cf.* D. de Bray (**17.** 2), P. Nolpe, C. Mattue, G. Honthorst (*cf. Caravaggio*) ;
	ET + EN	(ii.) Landscape : (*a*) Jan van de Velde,	*Cf.* A. Bloemaert, *cf.* A. v. Stalbent, P. Molyn I., E. v. d. Velde, W. O. Akersloot, R. v. d. Hoecke ;
17. I, 2	ET	(*b*) Misc. (iii.) Elsheimer (*G*).	H. Seghers, W. Buytewech ; M. v. Uijtenbroeck, C. C. Moeyart, W. Basse, *cf.* H. Goudt (*en.*).
		Rembrandt : (i.) Immediate followers.	J. Lievens, J. G. v. Vliet, F. Bol, S., J., and P. Koninck, P. de With, S. v. Hoogstraten, G. v. d. Eeckhout, C. à Renesse, Rodermondt, A. de Haen, H. Heerschop, *cf.* J. Lutma II. (*also punch-en.*), *cf.* P. Angel, *cf.* P. C. Verbeecq, *cf.* J. A. Duck ;
Misc.		(ii.) Imitators, copyists (of later periods).	A. Overlaet, G. F. Schmidt (*G.*), C. W. E. Dietrich (*G.*), F. Novelli (*I.*), Cumano (*I.*), Sardi (*I.*), C. H. Watelet (*F.*), J. P. Norblin (*F.*), A. Marcenay de Ghuy (*F.*), Sauveur Legros (*F.*), D. Vivant Denon (*F.*), J. J. de Claussin (*F.*), L. Flameng (*Fl.*), F. Vivares (*F.; fl. England*), J. Chalon (*D.; in England*), R. Cooper II. (*Br.*), R. Byron (*Br.*), B. Wilson (*Br.*), T. Worlidge (*Br.*), W. Baillie (*Br.*), J. Hazard (*Br.*), J. Bretherton (*Br.*), D. Deuchar (*Br.*),

Date.	Medium.	Master, Characteristic, or Locality.	Engravers influenced by the Masters in the previous column, or whose work is characterised or localised by the remarks in the same place.
Misc.	ET	(*Continued*).	J. E. Beckett (*Br.*), W. J. Smith (*Br.*), Lucy Brightwell (*Br.*).
1, 2		Ostade, Brouwer, D. Teniers II. (genre).	C. Bega, C. Dusart (*also mezz.*), P. Quast (*cf. Callot*), N. v. Haeften, D. Ryckaert III., J. v. Nijpoort; *cf.* M. Sweerts, J. M. Molenaer, T. Wijck, A. Both, Coryn Boel (*af. Teniers; also some class. reprod. for D. Teniers' " Theatre des Peintures,"* 1660), J. L. Krafft (**18**. 1; *af. Teniers*), J. Dassonville (*F.*), M. Scheits (*G.*), *cf.* M. Schoevaerdts, *cf.* Ploos v. Amstel (**18**. 2; *col. af. Ostade, etc.*).
		Landscape: (i.) Early, miscellaneous.	R. Roghman, G. Roghman (*also g.; cf. P. de Hooch*), J. v. Goyen, A.v. Everdingen (*cf. H. Saftleven II.*);
		(ii.) Ruysdael.	*Cf.* A. Waterlo(o), H. Naiwynx (*cf. also H. Saftleven II.*), C. v. Beresteyn, A. Verboom;
		(iii.) H. Saftleven II. (Flemish character).	J. v. Aken, C. Saftleven (*also animals and g.; cf. Callot and Ostade*), J. Almeloveen; *cf.* P. Bout, *cf.* A. F. Boudewyns, *cf.* A. F. Bargas;
		(iv.) Later miscellaneous.	J. Hackaert, V. Lefebre (*af. Titian, D. Campagnola and schcc!*);
		(v.) Architectural.	R. Nooms (Zeeman), Jan v. d. Heyden.
		Marines.	J. Porcellis, R. Nooms (Zeeman), J. v. d. Cappelle, L. Backhuysen, A. Storck, B. Peeters, A. Silo (*also mezz.; fl.* **18**. 1).
		Italianised landscape: (i.) P. van Laer (landscape and genre).	T. Wijck (*cf. also Ostade*), J. Ossenbeeck, *cf.* J. Miele, *cf.* A. F. Bargas;
		(ii.) N. Berchem, J. Both.	*Cf.* F. de Neue, W. de Heusch, A. Both (*cf. also Ostade*), *cf.* H. Verschuring, *cf.* J. Smees (*also* **18**. 1), *cf.* P. Rysbraeck (*sch. of G. Dughet; also* **18**. 1);
		(iii.) Poussin, Claude, and the foreign school at Rome.	W. Nieuwlant, B. Breenberg(h) (*the two preceding sch. of P. Bril*), H. v. Swanevelt, D. v. d. Dyck, A. v. d. Cabel, A. Genoels (*also* **18**. 1), J.

Date.	Medium.	Master, Characteristic, or Locality.	Engravers influenced by the Masters in the previous column, or whose work is characterised or localised by the remarks in the same place.
17. 1, 2	ET	(*Continued*).	Glauber (*also* 18. 1), J. F. v. Bloemen (*also* 18. 1), G. Wouters (*views in Rome*), *cf.* G. de Lairesse, *cf.* G. v. Wittel (Vanvitelli) (*views in Rome ; cf. Canale*), *cf.* M. Natalis (*en.*).
		(iv.) Poelenburgh. Animals :	J. Bronchorst.
		(i.) Flemish.	F. Snyders (?), J. Fyt, P. Boel ;
		(ii.) Dutch :	
		(*a*) P. v. Laer, S. de Vlieger.	P. v. Hillegaert, D. Stoop, J. Jonck Heer ;
		(*b*) Cuyp, Potter, J. Both, Berchem, A. van de Velde.	G. Bleker (*cf. Rembrandt*), A. Begeyn, J. v. d. Hecke, C. du Jardin, J. v. d. Does, J. Le Ducq, M. de Bye, A. Hondius (*also in England*), J. v. d. Meer II., J. H. Roos (*G.*), *cf.* W. J. Troostwyk (19. 1).
		Still life.	A. Flamen (*fishes, birds*), J. v. d. Hecke (*flowers*).
17. 2, 18. 1		Topogr. and Hist. Hist., daily life, and misc. illustr.	Gaspar and Gerard Bouttats. A. Flamen (*also in Paris*), R. de Hooghe, J. and C. Luyken.
17. 1, 2		[P. Wouwerman] battle scenes, etc.	*Cf.* J. Martsen II., W. v. Lande,
17. 2			H. Verschuring,
17. 2, 18. 1			D. Maas, J. v. Huchtenburg, A. F. Boudewyns (*the two preceding after A. F. v. d. Meulen*).
		[Dou and Mieris.	G. Schalcken, C. de Moor (*good p.; cf. Bronchorst and I ievens in technique*).
17. 2	MEZZ	Miscellaneous.	J. Thomas (*fl. Vienna*), W. and B. Vaillant, A. v. Everdingen (?), A. Blooteling (*also in England*), G. Valck (*also in England*), H. H. Quiter (*later in Germany*), J. F. Leonart (*later in Germany*), P. v. Slingelandt, P. Schenck (*G. ; also* 18. 1), J. Van der Vaart (*England ; also* 18. 1), J. v. Somer (*also in England*), P. v. d. Berge, Jan Verkolje,
17. 2, 18. 1			J. v. d. Bruggen (*worked in Paris*), G. Hoedt (*l.*), J. v. Huchtenburg, A. v. Halen, L. Deyster, C. Dusart, J. Gole, A. de Blois (*also in England*?), J. de Later, N. v. Haeften, A. v. Westerhout, N. Verkolje,
18. 1			A. Silo (*shipping*), C. Troost,

Date.	Medium.	Master, Characteristic, or Locality.	Engravers influenced by the Masters in the previous column, or whose work is characterised or localised by the remarks in the same place.
18. 1, 2	MEZZ	(*Continued*).	P. v. Bleeck (*also in England*), J. L'Admiral (*col.; cf. J. C. Le Blon*), A. Schouman, P. Louw (*af. Rembrandt, etc.*), J. Stolker (*af. Rembrandt, etc.*).
18. 1	EN	Miscellaneous (largely class. reproduction).	R. v. Audenaerde (*worked long in Rome; cf. G. Audran*), A. v. Westerhout (*fl. Rome*), T. Verkruys (*reprod. Florence Gallery; cf. Lorenzini*), J. Coelemans,
18. 1, 2			F. Pilsen, J. Houbraken (*chiefly p., e.g. in A. Houbraken's "Groote Schouburgh," 1718-21; with G. Vertue in T. Birch's "Heads of Illustrious Persons of Great Britain," 1743-52*), J. Folkema (*e.g. in Dresden Gallery work, 1753, 1757*), Tanjé, Fokke (*illustr.; also et.*), J. Punt,
18. 2, 19. 1			A. Delfos, J. Kobell I., J. P. de Frey.
18. 1	ET	Miscellaneous.	A. Houbraken (*also 17. 2; s., infl. by Rubens tradition; sculpture, etc.*), I. v.d. Vinne (*l., marines*), I. de Moucheron (*archit., gardens, l.*), J. de Wit (*cf. Rubens school*), J. L. Krafft (*cf. D. Teniers: see also J. L. K.'s " Trésor de Fables," Brussels, 1734*), A. Rademaker (*topogr.*).
18. 1, 2			A. Zeeman (*sm. views*), J. L'Admiral (*p., in van Mander's " Leven der Schilders," ed. J. de Jongh, Amsterdam, 1764*), P. C. La Fargue (*large views*), J. H. Prins (*l. and g.*), H. v. Brussel (*sm. l.; also 19. 1*), L. B. Coclers (*g., p.; also 19. 1*).
18. 2		Archaisers (imitating 17th century etchers, etc.).	J. Chalon (*cf. Rembrandt*), J., J. C., and P. Janson (*l., animals*), C. Bisschop,
18. 2, 19. 1			H. Kobell, J. Kobell II., W. J. v. Troostwyk (*animals*), J. L. de Marne (*l.*), P. J. C. François (*Roman l., and archit.*).
18. 2, 19. 1	ST, CR	Reprod. drawings, etc.	J. J. Bylaert (*reprod. drawings; cf. General Bibliography II., 1772*), J. Cootwyk, T. de Roode, C. Josi (*also London*), L. Claessens (*sch. of Barto-*

Date.	Medium.	Master, Characteristic, or Locality.	Engravers influenced by the Masters in the previous column, or whose work is characterised or localised by the remarks in the same place.
18. 2, 19. 1	ST, CR	(*Continued*).	*lozzi; also en.*)(*cf. also British Isles, st.*), A. Liernur.
18. 2	AQ, CR	Reproduction of drawings.	C. Ploos v. Amstel, B. Schreuder, J. Kornlein,
18. 2, 19. 1	AQ		C. Brouwer ;
19. 1	EN	Dutch : miscellaneous.	C. Apostool (*also in London*). P. Velyn (*illustr.*), J. P. Lange (*illustr., sch. of Velyn*),
19. 1, 2			A. B. B. Taurel (*F., settled in Amsterdam*), J. W. Kaiser,
19. 1, 2, 20. 1			C. E. Taurel, W. Steelink,
19. 2, 20. 1			P. J. Arendzen (*reprod., en + et ; cf. Gaillard*), P. Dupont.
19. 1, 2	ET	Dutch :	
		(i.) Chiefly landscape.	R. v. Haanen, J. B. Jongkind,
19. 2, 20. 1			J. Israels, A. Mauve, J. and M. Maris, C. Storm van 's Gravesande, M. W. v. d. Valk, P. Zilcken, W. Witsen, W. de Zwart, H. J. v. d. Weele, J. Veth (*p.*), M. A. J. Bauer (*Eastern s.*), J. M. Graadt v. Roggen (*also reprod.*), W. O. J. Nieuwenkamp, P. Dupont (*also en.*), J. Toorop, Barbara v. Houten ;
		(ii.) Reproductive.	A. L. Koster, C. L. Dake, H. J. v. d. Weele (*e.g. af. Mauve*), J. M. Graadt v. Roggen.
19. 1	EN	Belgian :	
		(i.) Miscellaneous.	L. A. Claessens (*cf. st.*), H. W. Couwenberg,
19. 1, 2			Erin Corr ;
		(ii.) Calamatta (*I.*).	C. J. Bal, J. B. Meunier, J. Delboète, J. Franck,
19. 1, 2, 20. 1			J. A. Demannez, A. M. Danse, L. Flameng (*also et., Paris*), G. Biot, J. B. Michiels, F. Lauwers, J. Nauwens, L. Lenain.
19. 1, 2	ET	Belgian :	
		(i.) Miscellaneous.	F. T. Faber (*l., cattle, etc.*), E. J. Verboeckhoven (*animals*) ;
		(ii.) Subject, genre, illustration.	H. Leys, Ad. and Alb. Dillens, F. Hillemacher, E. J. C. Hamman, C. F. Bendorp II. (*infl. by Rembrandt*), W. Linnig I. and II., H. de Braekeleer ;
19. 2		(iii.) Social satire.	F. Rops ;
19. 2, 20. 1		(iv.) Portrait and figure studies.	E. Smits, W. Linnig II., F. Khnopff, A. Rassenfosse ;
19. 1, 2		(v.) Landscape.	E. Linnig (*sm. marines*), M. Kuytenbrouwer (*e.g. in V. Joly, " Les Ardennes," 1854*),

Date.	Medium.	Master, Characteristic, or Locality.	Engravers influenced by the Masters in the previous column, or whose work is characterised or localised by the remarks in the same place.
19. 1, 2 **19. 2, 20. 1**	ET	(*Continued*).	W. Roelofs, J. P. F. Lamorinière, H. F. Schaefels (*l., g., sea-fights*), T. Verstraete, H. Cassiers, J. Guiette, G. den Duyts, F. Maréchal, A. Rassenfosse, T. v. Rysselberghe, E. Laermans, H. Meunier, R. Wytsman, A. Baertsoen, H.R.H. Marie, Comtesse de Flandre, J. de Bruycker, J. Ensor, A Derkzen van Angeren, J. C. Portenaar.

ITALY

Date.	Medium.	Master, Characteristic, or Locality.	Engravers influenced by the Masters in the previous column, or whose work is characterised or localised by the remarks in the same place.
15. 1, 2 **15. 2** **15. 2, 16. 1**	EN	Florence.	Master of the Larger Vienna Passion, T. Finiguerra, B. Baldini, A. Pollaiuolo, C. Robetta (**16.** 1), Gherardo miniatore (?), Lucantonio degli Uberti.
		Mantegna.	Z. Andrea, G. A da Brescia, Simone di Ardizone ·(?), N. Rosex (da Modena), *cf. also* Master of **1515** (*B*. **12**, *which gives the name, and at least B*. **10** *and* **13** *are genuine ; others attrib., e.g. B*. **1, 3, 17, 18** *might be* **18***th century imitations*).
		Venice. North Italy, miscellaneous.	G. Mocetto, J. de' Barbari. B. Montagna, G. and D. Campagnola, I·I·CA, ℞℞, M. Fogolino, FN, Master of the Beheading of John the Baptist, N. Rosex, F. A., G. M. da Brescia, Altobello Meloni (?), NA·DAT.
		Milan.	D. Bramante (?), Master of the Sforza Book of Hours (A. da Monza?), Z. Andrea, Leonardo da Vinci (?).
		Bologna, Ferrara.	F. Raibolini (Francia), ℘ (*Peregrino da Cesena?*), IB (with the Bird).
16. 1		Marcantonio Raimondi.	J. Raibolini (Francia), G. A. da Brescia, Marco Dente (da Ravenna), A. de' Musi (Veneziano), Master of the Die, ℞₂
16. 1, 2		Rome ; misc., less immediately under infl. of Marcantonio.	G. B. Franco (*also Venice, infl. of Titian ; also et.*), N. Beatrizet (*F.*), N. della Casa (*F.*),

Date.	Medium.	Master, Characteristic, or Locality.	Engravers influenced by the Masters in the previous column, or whose work is characterised or localised by the remarks in the same place.
16. 1, 2	EN	*(Continued)*.	L. da Udine (*vases ; cf. A. de' Musi*), G. B. Cavalieri (*antiq.*), *cf.* A. Eisenhoit (*G. ; statues*), M. Lucchese, M Cartaro, G. A. (*archit.*).
		Printsellers and engraver-publishers (at Rome, except where otherwise stated).	Baviera, A. Salamanca, C. Duchetti (*F.*), A. Lafrery (*F. ; antiq. : e.g. Speculum Romanæ Magnificentiæ*, 1552, etc.), T. Barlacchi, N. v. Aelst (*Fl.*), M. Lucchese, M. Labacco, P. de Nobilibus, P. P. Palombo, L. and F. Bertelli (*Venice*), N. Nelli (*Venice*).
		Misc. engravers outside Rome, indirectly infl. by Marcantonio.	G. J. Caraglio (*Parma*), E. Vico (*Parma*), G. Bonasone (*Bologna, Rome*), H(HF)E (*Bologna-Ferrara school? infl. of Caraglio in technique, and of Mazzolino in style, with reminiscences of J. de' Barbari*).
		Mantua.	G. B. Sculptor, A. and Diana Sculptor, G. Ghisi.
		Portrait : miscellaneous.	A. de' Musi, N. Beatrizet (*F.*), N. della Casa (*F.*), E. Vico, N. Nelli, M. Rota, A. Caprioli (*e.g. Cento illustri capitani, Rome, 1596*), F. Valesio (*e.g. Brefve cronicque des Roys de France, Venice 1597 ; also misc. s.*), O. Leoni (*also* **17.** 1).
16. 2 **16.** 2, **17.** 1		C. Cort and Agostino Carracci (Rome and Bologna).	R. Guidi (*sch. of Cort*), D. Tibaldi (*sch. of Cort*), O. de Sanctis, A. Caprioli, P. Thomassin (*F., sch. of Cort*), F. Villamena (*sch. of Cort*), C. Alberti, G. A. Maglioli, G. L. Valesio, F. Brizio, Giacomo Franco (*illustr.*), L. Ciamberlano, O. Gatti (*sch. of Ag. Carracci and G. L. Valesio*), C. Cesio (*also* **17.** 2).
16. 1, 2	ET	F. Mazzuoli (Parmigiano). School of Fontainebleau.	A. Meldolla (Schiavone). A. Fantuzzi, D. del Barbiere, G. Ruggieri.
16. 1 **16.** 1, 2		Siena. [Titian, and the Venetian painters.]	D. Beccafumi. G. B. Franco, B. and M. d'Angeli del Moro, G. B. and G. Fontana, P. and O. Farinati, J. Palma II. (*also* **17.** 1), *cf.* C. Sacchi (**17.** 1, 2), *cf.* V. Lefebre (*Fl.*; **17.** 2).

Date.	Medium.	Master, Characteristic, or Locality.	Engravers influenced by the Masters in the previous column, or whose work is characterised or localised by the remarks in the same place.
16. 2	ET	Bologna (infl. of the Venetian school).	B. Passerotti, C. Procaccini, *cf.* B. Passeri (*fl. Rome*), L. and An. Carracci.
16. 2, 17. 1		Baroccio.	V. Salimbeni, F. Vanni, V. Strada, R. Schiaminossi, *cf.* O. Borgiani.
16. 2		Rome.	G. A. Brambilla (*topogr.*, *g.*, *s.*).
16. 2, 17. 1		Guido Reni and the Carracci.	*Cf.* B. Schidone, *cf.* P. Faccini, *cf.* L. Lana (*sch. of Guercino*), S. Cantarini,
17. 1, 2			G. A. and E. Sirani, L. Lolli, G. B. Bolognini I., P. F. Mola (*sch. of Albani*), G. B. Mola (*sch. of Albani*), L. Scaramuzza, D. M. Canuti, F. Torre, L. Pasinelli, G. Rossi I. (*also en., and publ. ?*), G. F. Grimaldi (*l.*), G. Scarselli, G. M. Viani,
17. 2, 18. 1			D. M. Viani, G. M. Rolli, G. G. dal Sole, L. Mattioli, G. M. Crespi.
17. 1		Guercino.	G. Caletti, G. B. Pasqualini.
17. 1, 2		[Domenichino] (Bologna—Naples).	A. Camassei, F. Rosa, F. Cozza, P. and T. del Pò, *cf.* P. Testa (*Rome*).
17. 1		Bologna—Venice.	O. Fialetti,
17. 1, 2			G. Carpioni, G. Diamantini (*also* 18. 1).
		Bologna : misc. s., satir, etc.	A. Mitelli I. and II., G. M. Mitelli.
17. 1		Caravaggio.	B. Capitelli (*infl. also by Elsheimer ?*), G. v. Honthorst (*D.*).
		Ribera (*S.*) (the Neapolitan school).	*Cf.* T. F. de Liagno (*S.*), F. Burani,
17. 1, 2			A Falcone, *cf.* L. Giordano, Salvator Rosa.
16. 2, 17. 1	EN + ET	A. Tempesta.	O. Scarabelli.
17. 1, 2	ET	J. Callot (*F.*).	G. B. Bracelli, G. Pericciuli, S. della Bella, M. Gerardini.
		G. and A. Parigi.	R. Cantagallina, E. Bazzicaluva, *cf.* V. Spada.
17. 1, 2		G. B. Castiglione.	S. Castiglione, A. Travi, G. A. Podesta, 'B. Biscaino, F. Amato, *cf.* G. David (18. 2).
		[Poussin,] Claude.	G. Gimignani, C. Onofri, F. Chiari, *cf.* P. Anesi (18. 1, 2).
17. 2, 18. 1		C. Maratta.	G. Ferroni, A. Procaccini (*also en*).
17. 1, 2		Reprod., misc.	G. B. Vanni (*af. Correggio,* etc.), M. Piccioni, G. Lanfranco (*af. Raphael's Vatican Loggie*),
	EN, ET		S. Badalocchio (*af. Raphael's*

Date.	Medium.	Master, Characteristic, or Locality.	Engravers influenced by the Masters in the previous column, or whose work is characterised or localised by the remarks in the same place.
17. 1, 2	EN, ET	*(Continued)*.	*Loggie, and af. Correggio*), P. Aquila (*af. Lanfranco, etc.*).
	EN	Class., mis	M. and J. F. Greuter (*G.; fl. Rome*), Girolamo de' Rossi I. (*also et.; cf. Reni school*).
		Engraver-publishers.	G. B. de' Rossi (*also* **16.** 2 ?), G. G. de' Rossi, D. de' Rossi (*successor of the preceding; also* **18.** 1 ; *publ. many prints of antiq.*) (*the Rossi stock was purchased to form a nucleus for the Regia Calcografia*, 1738).
17. 2	ET, EN	Architecture, antiquities, gardens, ornament, etc.	G. Maggio (*et.; archit.*), G, B. Mercati (*et. ; archit. ; cf. Silvestre*), G. B. Galestruzzi (*et.; e.g. antique reliefs ; cf. S. della Bella*), P. S. Bartoli (*en. ; antiq.*), F. Bartoli (*antiq.; also* **18.** 1), F. F. Aquila (*also* **18.** 1, *e.g. in P. A. Maffei's Raccolta di Statue*, 1704, *in collaboration with C. Randon, J. B. de Poilly, N. Dorigny, and R. v. Audenaerde*), G. B. Falda (*et.; archit.; cf. Callot*), G. F. Venturini (*et.; gardens*), A. Specchi (*en.; gardens*), *cf.* B. S. Sgrilli (*et.; gardens,* **18.** 1), *cf.* C. Nolli (*en.; Herculaneum, etc.,* **18.** 1, 2).
18. 1. 2	EN	Miscellaneous classical reproduction.	R. v. Audenaerde (*Fl. ; also* **17.** 2 ; *in Rome about 1685-1722; af. Maratta, etc.*), A. v. Westerhout (*Fl.*), J. J. Frey (*Swi.*), J. Wagner (*G.*), G. G. Frezza (*sch. of Westerhout*), Girolamo de' Rossi II., F. F. Aquila (*also af. antiq.*), G. A. Lorenzini (*e.g. Florence Gallery*), C. Mogalli (*Florence Gallery*), T. Verkruys (*D. ; Florence Gallery*), D. Rossetti (*Venice pictures*),A., F., and G. Zucchi (*Venice pictures; A.Z. and D. Rossetti in D. Lovisa's Gran Teatro di Venezia* [1720 ?]), A. M. Zanetti I. and II. (*Venice pictures*), P. Monaco (*Venice pictures*), G. D. Campiglia (*chiefly working as a draughtsman, e.g. in A. F. Gori's Museum Florentinum*, 1731-66, *but sometimes also en.*), A. Pazzi

Date.	Medium.	Master, Characteristic, or Locality.	Engravers influenced by the Masters in the previous column, or whose work is characterised or localised by the remarks in the same place.
18. 1, 2	EN	(*Continued* .	(*in Gori's Museum Florentinum*, *e.g. portraits of painters from the Florence Gallery*), C. Gregori (*sch. of Frey*), A. Capellan (*sch. of Wagner*), P. A. Martini (*e.g. interiors of picture galleries ; also illustr., af. J. M. Moreau, etc.*).
		C. Mellan (*F.*).	G. A. Faldoni, G. M. Pitteri (*e.g. af. Piazzetta, Ribera, Tiepolo*), F. Polanzani, G. Cattini (*sch. of Faldoni ; af. ancient sculpture in Venice, etc.*).
18. 2		J. G. Wille (*G.*) and the French school.	Cf. G. Canale (*fl. Dresden*), V. Vangelisti (*sch. of Wille*),
18. 2, 19. 1			C. A. Porporati (*sch. of Beauvarlet*), C. D. Melini (*sch. of Beauvarlet*), P. M. Vitali, M. Gandolfi (*sch. of Bervic, Sharp, and Bartolozzi*), P. Toschi (*sch. of Bervic ; af. Correggio*).
18. 2		G. Volpato.	P. Campana, F. Cecchini, D. Cunego (*e.g. in Gavin Hamilton, Schola Italica Picturæ, Rome*, 1773), *cf.* F. della Valle.
18. 2, 19. 1		R. Morghen.	Cf. G. Morghen, F. Morghen, T. Piroli (*e.g. Flaxman's Dante and Iliad*), P. Fontana, F. Rosaspina, G. Folo, F. Ambrosi, P. Bonati,
19. 1			Galgano Cipriani, D. Marchetti, C. Caiani, A. Perfetti, A. Viviani, D. Chiossone, I. Pavon, G. Bonaini, A. Marchi, L. Calamatta (*sch. of Marchetti*), P. Mercuri.
		G. Longhi (sch. of Vangelisti ; infl. by Morghen).	P. Anderloni, M. Bisi, G. Garavaglia, S. Jesi.
18. 2, 19. 1	EN + ET	Outline reproductions.	C. Lasinio, G. P. Lasinio (*e.g. Florence Gallery*, 1817-33).
19. 1, 2	EN	Reprod., miscellaneous.	A. Juvara, A. M. Gilli.
18. 1	MEZZ		G. A. Lorenzini (*one plate, af. Titian*), A. Zucchi, G. Baroni,
18. 2, 19. 1			G. Marchi (*assistant of Reynolds*), C. Lasinio (*col. ; cf. J. C. Le Blon and the d'Agotys*).
18. 2, 19. 1	ST, EN	F. Bartolozzi (*fl. London ; cf. British Isles*).	G. Bartolozzi, G. and M. Benedetti, G. Vitalba (*sch. of Wagner*), B. Pastorini, J. A. Minasi, M. Bovi, P. Bettelini, L. and N. Schiavonetti, G.

Date.	Medium.	Master, Characteristic, or Locality.	Engravers influenced by the Masters in the previous column, or whose work is characterised or localised by the remarks in the same place.
18. 2, 19. 1	ST, EN	(Continued).	Vendramini, G. Testolini, C. Lasinio, cf. G. B. Cipriani (et. ; the fourteen preceding worked in London), V. Vangelisti, G. Folo.
18. 1, 2	ET, EN, CR	Reproduction of drawings.	G. Zocchi (e.g. af. Elsheimer), F. Bartolozzi, G. Nevay, G. Ottaviani (London).
18. 2	ET, AQ	Ditto, and miscellaneous.	A. Scacciati, A. Cioci (the two preceding af. Gabbiani, Florence, 1762), B. Bossi (e.g. af. Correggio and Parmigiano),
18. 2, 19. 1			P. Palmieri, F. Rosaspina, L. Ademollo, C. Labruzzi.
	ET	Copyists of old master etchings (Rembrandt, etc.).	Sardi, Cumano, F. Novelli.
18. 1		Class. reprod., etc. ; af. manner of earlier etchers.	S. Ricci (also 17. 2), A. Balestra (also 17. 2), J. Amiconi,
18. 1, 2			C. Carloni (original s.), P. Rotari (af. his master, Balestra).
		G. B. Tiepolo.	G. D., and L. Tiepolo, G. Leonardis (also infl. by Canale).
18. 1		Views of towns ; the immediate predecessors of Canale in Venice.	M. Ricci, L. Carlevaris, G. Baroni, F. Vasconi (the two last in the Gran Teatro di Venezia ovvero Raccolta delle principali Vedute e Pitture che in essa se contengono. Publ. by D. Lovisa, Venice [1720?]).
18. 1, 2		A. Canale (Canaletto).	Cf. G. v. Wittel (Vanvitelli), B. Belotto (Canaletto), M. Marieschi, G. F. Costa (views on the Brenta), G. Zocchi (views of Florence), A. Visentini (en. af. Canale), G. Brustoloni (en. af. Canale).
18. 2		G. B. Piranesi (Roman topogr., antiq., etc.).	Cf. G. Piccini (fl. 1729), cf. G. Vasi (also 18. 1 ; predecessor, and perhaps master of G. B. Piranesi), cf. A. Cioci (e.g. Vallombrosa), F. and P. Piranesi, cf. D. Montagù, P. Anesi (infl. also by Claude school), R. Pozzi, F. Barbazza (af. F. Panini, etc.),
19. 1			cf. L. Rossini.
18. 1		Caricature.	P. L. Ghezzi (cf. en. af. P.L.G. by F. Vasconi and M. Oesterreich).
18. 1, 2		Miscellaneous.	F. Zuccarelli (e.g. af. A. del Sarto ; worked in London), A. Casali (s. ; also in London),

Date.	Medium.	Master, Characteristic, or Locality.	Engravers influenced by the Masters in the previous column, or whose work is characterised or localised by the remarks in the same place.
18. 2	ET	(*Continued*).	B. Bossi (*infl. by F. Boucher*), F. Londonio (*animals in l.; cf. A. v. d. Velde*), D. B. Zilotti (*l.; infl. by Claude tradition; cf. also the Piranesi*), F. Casanova (*battle scenes, and l.; worked in Paris, etc.*).
19. 1			B. Pinelli (*hist., social life at Rome, etc.*), C. E. Liverati (*London, sch. of Reinagle and Briggs; cf. Worlidge and Geddes*).
19. 2		Genre, subject, and landscape.	A. Piccinni, M. Fortuny I. (*S.*), T. Cremona, A. Fontanesi, T. Signorini.
19. 2, **20.** 1		Chiefly landscape and archit.	A. Beccaria, G. Fattori, F. Pastoris, M. Bianchi, G. de Nittis, L. Beltrami, G. Borroméo, C. Chessa (*illustr. and reprod.*), C. Turletti (*illustr. and reprod.*), L. Conconi, G. Miti-Zanetti (*l. and g.*), C. Biseo, G. Kienerk (*dry-point studies*), D. Savardo, V. Grubicy, P. Nomellini, M. Fortuny II., D. Motta (*col. and soft-ground*), G. Marchetti (*col.; fl. Bruges, Paris?*), F. Vitalini (*col.*), E. Brugnoli, V. Guaccimanni (*also aq.*), E. Vegetti, V. Vigano, C. Casanova (*also aq.*), L. Rossi, B. M. Disertori, C. P. Agazzi, F. Arata, E. Bazzaro, L. Bompard, G. B. Galizzi, G. Graziosi (*also aq.*), G. Greppi, U. Martelli, F. Mauroner, V. Stanga, G. Ugonia.

FRANCE AND FRENCH SWITZERLAND

Date.	Medium.	Master, Characteristic, or Locality.	Engravers influenced by the Masters in the previous column, or whose work is characterised or localised by the remarks in the same place.
16. 1	EN	Italian influence : Cf. the "Little Masters" of Germany.	Jean Duvet ; J. Gourmont, C. Corneille (?), G. Reverdy, N. Garnier (*cop. German engravings*).
16. 1, 2		Classical (fl. Rome).	N. Beatrizet, N. della Casa, P. Thomassin (*e.g. antiq. ; also* **17.** 1).
		Classical (cf. school of Fontainebleau). Ornament.	J. Prévost (?), M. Duval, R. Boyvin. E. Delaune, P. Woeiriot, R. Boyvin (*vases, etc.*).
		Portrait.	C. Corneille (?), J. Prévost (?), N. Beatrizet, N. della Casa,
16. 2			M. Duval, J. Rabel,
16. 2, **17.** 1			T. de Leu (*Fl.*), L. Gaultier (*G.*), J. de Fornazeris, P. Sablon, N. and L. Spirinx, J. Granthomme, J. Isac (*Fl.*), R. Boissard, *cf.* B. Moncornet (*chiefly publ.*).
16. 1, 2	ET	Classical.	J. Cousin (*cf. school of Fontainebleau*).
		School of Fontainebleau.	L. Tiry, G. Dumonstier, L. Limosin, A. Fantuzzi (*I.*), D. del Barbiere (*I.*), G. Ruggieri (*I.*).
		Ornament, archit.	J. Androuet Ducerceau, E. Dupérac (*e.g. Vestigi dell' Antichità di Roma*, 1580).
16. 2		Historical.	J. Perrissin, J. Tortorel.
17. 1		J. Callot (the work of his followers largely comprising topography).	F. Collignon, I. Silvestre, N. de Son,
17. 1, 2			*cf.* A. Bosse (*costume, s., etc.*), N. Cochin, S. Leclerc, G., N., and A. Perelle, P. Aveline (*cf. the Perelles ; French Palaces, en.; also* **18.** 1), *cf.* C. Deruet (*a few prints af. Callot, etc.*), *cf.* I. Henriet (*Callot's publ.*), *cf.* G. v. Scheyndel (*D. ?*).
		Claude Gellée. [Poussin.]	H. Mauperché, D. Barrière. G. Dughet. F. Millet, Théodore, G. Focus.
		Miscellaneous (fl. Rome).	F. Perrier (*antiq., statues, etc.*), L. Rouhier (*views*), F. P. Duflos (*views*).
		Baroccio (*I.*), Salimbeni (*I.*).	C. Vignon, J. Bellange.
		G. B. Castiglione (*I.*).	S. Bourdon (*cf. also M. Dorigny*).
17. 1		Simon Vouet.	P. Brebiette, R. Vuibert,

Date.	Medium.	Master, Characteristic, or Locality.	Engravers influenced by the Masters in the previous column, or whose work is characterised or localised by the remarks in the same place.
17, 1, 2	ET		L. de La Hire, N. Chapron, F. Tortebat, M. Dorigny, E. Le Sueur (*only one etching?*), O. Dauphin.
		Miscellaneous (class. reprod., etc.).	J. Stella (*s., g., infl. by Callot*), C. B. Stella (*af. J. Stella*), A. B. Stella (*af. G. Romano, etc.*), Michel Corneille I. and II., J. B. Corneille, N. de La Fage, L. Boullongne I., A. Betou (*af. Primaticcio's Fontainebleau frescoes*), G. Courtois (*af. Tintoretto, etc.*), N. Loir, Noel Coypel, A. Coypel (*also* **18.** 1), P. Parrocel (*also* **18.** 1 ; *af. Subleyras, etc.*).
		Reproduction of drawings.	J. Pesne, J. B. Corneille, M. Corneille II., C. Massé, Jacques Rousseau (*the five preceding etched plates af. drawings by An. Carracci, Titian, Campagnola, etc., in the Jabach collection, about 1666 ; most of Jabach's drawings, which came in many instances from Charles I.'s collection, were purchased by Louis XIV. for the Royal museums in 1672 ; a later edition of 283 plates appeared in 1754*).
		Publisher and etcher.	F. Langlois ("Ciartres") (*succeeded in his business by the P. Mariette, who died in 1657*).
17. 2		Dutch school.	J. Dassonville (*cf. Ostade*), P. Giffart (*af. Potter; also hist.*).
		J. Courtois (battle subjects).	J. and C. Parrocel, *cf.* F. Casanova (*I. ;* **18.** 2).
17. 1, 2	EN	Misc., class. (largely af. Lebrun, Raphael, the Carracci, etc.).	C. Audran, J. Boulanger, G. Rousselet, J. Daret (*also title-pages*), F. Chauveau (*sm. illustrations ; partly et.*), J. Pesne (*en. + et.; cf. G. Audran*), E. Picart (*sch. of G. Rousselet ; some p., infl. by Mellan*), G. Vallet, F. Spierre (*infl. by Mellan*), F. Bignon (*af. Poussin, etc.*), G. Huret (*illustr., infl. by Rubens*).
17, 2			G. Audran (*largely af. Lebrun ; en. + et.*), G. Chasteau, C. and L. Simonneau (*also* **18.** 1), E. Baudet (*also* **18.** 1 ; *af. Poussin, Domenichino, etc.*),

Date.	Medium.	Master, Characteristic, or Locality.	Engravers influenced by the Masters in the previous column, or whose work is characterised or localised by the remarks in the same place.
17. 2, 18. 1			G. Duchange (*note his series illustrating the "crafts"*), J. B. de Poilly (*also antiq.*), L. David (*script. illustr., etc.*).
17. 1, 2	EN + ET	Portrait : (i.) J. Morin.	L. Elle (*cf. Hollar*), *cf.* J. Pesne, C. Le Febure (*cf. J. Lievens*), La Mare - Richart (*also* **18**. 1), M. van Plattenberg (*l., marines, and p.*), N. van Plattenberg, S. Vouillemont (*cf. P. van Sompel and Suyderhoef*) ;
	EN	(ii.) C. Mellan (the broader manner).	*Cf.* M. Lasne, E. Picart (*chiefly s.*), F. Spierre (*chiefly s.*), J. J. Thourneyser (*Swi.*), P. Daret, *cf.* G. A. Faldoni (*I.;* **18**. 1, 2), *cf.* M. Pitteri (*I.;* **18**. 1, 2), *cf.* F. Polanzani (*I.;* **18**. 1, 2) ;
		(iii.) Nanteuil (sch. of N. Regnesson, P. de Champaigne and A. Bosse).	J. Lenfant (*sch. of Mellan*), F. de Poilly (*sch. of C. Bloemaert?*), N. de Poilly, N. Pitau I. (*b. Antwerp*), A. Masson, J. Lubin, N. de Larmessin (the elder), P. Simon, G. Edelinck (*b. Antwerp*), J. Edelinck (*b. Antwerp*), F. Ragot, J. Langlois, A. Trouvain, J. L. Roullet, N. Pitau II.,
18. 1, 2			P., P. I., and C. Drevet, G. E. Petit, E. Desrochers, N. Edelinck, M. Dossier, F. Chereau, *cf.* J. Chereau (*nearer style of J. G. Wille*), J. Daullé.
17. 1, 2 **17. 2, 18. 1**	EN, ET	Ornament : (i.) Architectural.	J. Lepautre, J. Marot, D. Marot (*later in the Hague*), P. Cottart, J. Berain (*style of Vatican Loggie*), J. Dolivar (*S.; af. Berain*), M. Hardouin (*af. J. H. Mansart*) ;
17. 1, 2		(ii.) Miscellaneous.	A. Jacquard (*cf. Delaune*, Gédéon L'Égaré, L. Cossin (*af. Gilles L'Égaré*), N. Loir (*fan-leaves*), A. Loir (*also* **18**. 1), J. B. Monnoyer (*et.; flowers, fruit, etc.; also in London*), J. Vauquer (*vases, flowers, etc.*), P. Bourdon (*cf. M. Le Blon*),
18. 1, 2			J. Bourguet (*cf. P. Bourdon*), J. Saly (*vases*).

Date.	Medium.	Master, Characteristic, or Locality.	Engravers influenced by the Masters in the previous column, or whose work is characterised or localised by the remarks in the same place.
17. 2	MEZZ		H. Gascar (*also in England*), S. Barras, A. Bouys (*also* **18.** 1), L. Bernard. (*See also British Isles.*)
18. 1, 2	ET	A. Watteau, F. Boucher.	*Cf.* C. Gillot (*Watteau's master*), C. Natoire, M. B. Ollivier, J. B. M. Pierre, C. Hutin, F. Hutin (*ancient hist., alleg.*), L. F. De la Rue, P. Lélu (*also some prints of old master drawings; also* **19.** 1), *cf.* J. H. Fragonard.
18. 1		Reprod., af. French and Italian class. painters, etc.	J. Mariette (*also en., and publ.*), C. A. Coypel, P. Subleyras,
18. 1, 2			P. I. Parrocel (*also statues af. Bernini*), C. A. Vanloo, L. J. Le Lorrain,
18. 2, 19. 1			J. M. Vien (*prepares the way to J. L. David's classical revival*), J. J. Lagrenée, J. F. P. Peyron.
18. 1, 2		Landscape.	A. Manglard (*infl. by A. v. d. Cabel; cf. also early Piranesi school*), C. J. Vernet (?) (*a few prints attrib. ; sch. of Manglard*), H. Robert,
18. 2, 19. 1			J. J. de Boissieu, B. A. Dunker (*Swi.; sch. of J. P. Hackert; also Swiss hist.*).
18. 1, 2		Miscellaneous.	J. B. Oudry (*still life and g.*), J. Ducreux (*character heads*).
18. 1	EN	(i.) Chiefly af. Watteau and Greuze (the style of engraving being based on G. Audran).	J. Audran, N. H. Tardieu, N. de Larmessin (the younger) (*also plates in the " Cabinet Crozat,"* 1729), C. N. Cochin I., P. Mercier,
18. 1, 2˙			F. Joullain (*also publ.*), G. J. B. Scotin (*also in England; af. Hogarth, etc.*), L. Cars, B. Audran II., M. Aubert, P. A. Aveline, L. Crépy, J. G. Huquier (*decorative panels*) ;
18. 1		(ii.) Misc., af. Watteau school and classical.	B. Audran I., C. Duflos, J. B. Haussart, N. Edelinck, L. Desplaces, C. Dupuis, P. Simonneau, L. M. Cochin (*née* Hortemels) (*wife of C. N. C. I. ; s., and p.*), F. Hortemels, S. H. Thomassin,
18. 1, 2			L. and P. L. Surugue, J. Moyreau (*af. Wouwerman*), J. B. Massé, N. G. Dupuis (*Dresden gallery, etc.*), B. Lépicié, Bernard Baron (*also in London ; af. Hogarth, etc.*),

Date.	Medium.	Master, Characteristic, or Locality.	Engravers influenced by the Masters in the previous column, or whose work is characterised or localised by the remarks in the same place.
18. 1, 2	EN	(*Continued*).	J. M. and J. E. Liotard (*Swi.*), S. F. Ravenet I. (*also in London ; af. Hogarth, etc.*), S. F. Ravenet II. (*af. Correggio, etc.*), J. P. Lebas (*chiefly af. Dutch*), P. F. Tardieu (*af. Oudry, etc.*), P. Chenu (*af. Dutch, etc.*), J. J. Balechou (*af. C. J. Vernet, etc.*), P. F. Basan (*chiefly worked as publ.*), J. J. and C. J. Flipart (*af. Greuze, Longhi, etc. ; sch. of Wagner in Venice*), J. J. Aliamet (*af. Berchem, C. J. Vernet, etc.*), P. C. Levesque (*af. Boucher, etc.*), L. S. Lempereur (*af. Rubens, etc.*), J. F. and C. F. Beauvarlet, J. C. Levasseur, P. L. Parizeau (*sch. of Wille ; also et., aq.*), N. R. F. Dequevauviller (*af. Wynants, etc.*), P. C. Ingouf (*sch. of J. J. Flipart ; af. Greuze, etc.*), R. Gaillard,
18. 2, 19, 1			L. M. Halbou, F. R. Ingouf (*infl. of Wille*), J. Mathieu, J. B. Patas, M. Blot, R. Delaunay, C. L. Lingée, G. Malbeste (*af. Rembrandt, misc. Dutch, etc.*), J. Couché (*published "Galerie du Palais Royal," 1768-1808, 3 vols. 355 plates*), J. Bouilliard (*joint publ. with preceding of the Gal. du. Pal. Roy.*), A. L. Romanet, J. L. Delignon, P. Trière (*the three preceding en. for the "Palais Royal"*), P. Audouin (*af. Dutch genre, J. Steen, etc.*).
18. 1, 2		Topography.	J. Rigaud (*Palaces, France and England*), C. N. Cochin II. (*French seaports*).
18. 1	EN + ET	The illustrators (largely af. designs by Gravelot,	C. Gillot (*et.*), B. Picart (*also in Amsterdam*),
18. 1, 2		C. N. Cochin II., Eisen, J. M. Moreau, C. Monnet, C. P. Marillier).	P. Soubeyran (*af. Cochin II., etc.*), H. F. Gravelot (*also in England ; chiefly draughtsman*), C. N. Cochin II. (*also topogr.*), J. J. Pasquier, C. Eisen (*chiefly draughtsman*), J. C. Baquoy, N. Le Mire, G. de St. Aubin (*less an illustrator than A. de St. A.*),
18. 2			A. de St. Aubin (*many portraits*), P. P. Choffard (*vig-*

Date.	Medium.	Master, Characteristic, or Locality.	Engravers influenced by the Masters in the previous column, or whose work is characterised or localised by the remarks in the same place.
18. 2	EN + ET	(*Continued*).	*nette ornament*), J. de Longueil, N. Delaunay, E. de Ghendt (*Fl.*), C. P. Marillier, J. F. Rousseau, J. M. Moreau (le jeune), L. J. Masquelier (*also af. Florence gallery, and Swiss pictures*), A. J. Duclos, J. B. Simonet, I. S. Helman, A. Borel (*also aq.*), L. Binet, S. Freudenberger, F. M. I. Quéverdo, J. Dambrun (*almanac prints, af. Quéverdo*),
18. 2, 19. 1			R. Delvaux, N. Ponce.
18. 1, 2		E. Ficquet (miniature portraits for illustration, etc.).	*Cf.* C. N. Cochin II. (*his et. frequently finished with the graver by others*),
18. 2			J. B. Grateloup, P. Savart, A. de St. Aubin, L. J. Cathelin, C. E. Gaucher,
18. 2, 19. 1			G. L. Chrétien, E. Quénedey, C. B. J. F. de St. Memin (*the three preceding used the 'physionotrace,' a mechanism for transferring profile to paper, invented by Chrétien, as a basis for their engraving, which was partly done in aq. See H. Vivarez, Bulletin de la Soc. Archéol.*, "*Le Vieux Papier*," *Lille*, 1906).
18. 1, 2	ET	The Amateurs, archaisers, copyists, etc. : (i.) Largely reprod. of drawings.	B. Picart (*e.g. in his Impostures innocentes, Amsterdam*, 1734), Comte de Caylus, J. de Jullienne, P. P. A. Robert, P. J. Mariette (*collector and publ.*), Comte de St. Morys (*e.g. Disegni originali. . . . incisi ed imitati nell' loro grandezza e collore, London*, 1794), P. Lélu (*also* **19.** 1) ;
		(ii.) Miscellaneous.	Marquise de Pompadour (*vignettes, and af. J. Guay's gems*), Abbé de St. Non (*e.g. af. Fragonard, and antiq. ; olso aq.*) ;
		(iii.) Archaisers, copyists.	C. H. Watelet, A. de Marcenay de Ghuy (*closely hatched drypoint ; s., l., p., imit. Rembrandt*), J. P. Norblin (*imit. Rembrandt, etc.*), Sauveur Legros (*misc., l., p., etc.; cop. Rembrandt, etc.*), J. Duplessi-

Date.	Medium.	Master, Characteristic, or Locality.	Engravers influenced by the Masters in the previous column, or whose work is characterised or localised by the remarks in the same place.
18. 1, 2	ET	(*Continued*).	Bertaux (*infl. by Callot and Chodowiecki ; illustr. of the French Revolution*), D. Vivant Denon (*af. Rembrandt etchings, old master drawings, etc.*), C. Echard (*cf. Potter and Ostade*),
19. 1			J. J. de Claussin (*af. Rembrandt etchings and drawings, etc.*)
18. 1	MEZZ	English influence.	J. Simon (*fl. London ; af. Kneller, Dahl, etc.*).
18. 1, 2		J. C. Le Blon (*G.*) (colour prints).	J. F., J. B. A., A. E., E., L. C., and F. Gautier d'Agoty, J. Robert (?) (*also en. in colours*), P. F. Tardieu (?), G. F. Blondel (*archit., infl. by Piranesi*).
18. 2	ST	Largely influenced by Bartolozzi and his school in England.	G. Vidal, V. M. Picot (*also London*), N. F. Regnault (*also aq.*), L. C. Ruotte (*also London*), J. Boillet, E. and P. J. Challiou, J. L. Julien, L. Legoux (*also London ?*),
19. 1			A. Phelippeaux, J. Godefroy (*sch. of J. P. Simon, London*), Cazenave, G. Maile. (*Cf. also British Isles.*)
18. 1, 2	CR	Monochrome and colour.	J. C. François, G. and G. A. Demarteau, L. Bonnet, S. C. Miger.
18. 2	AQ	Monochrome.	J. B. Le Prince, Abbé de St. Non.
18. 2, **19**. 1	AQ, CR, etc.	F. Janinet (monochrome and colour).	C. M. Descourtis, P. L. Debucourt, L. Le Cœur, A. F. Sergent-Marceau, L. Guyot, P. M. Alix, L. J. Allais (*hist., etc.*), J. A. Allais (*also mixed mezz.*).
18. 2, **19**. 1	EN	J. G. Wille (*G.*).	S. C. Miger, F. Godefroy (*sch. of Lebas*), J. and J. B. R. U. Massard, C. C. Bervic, P. A. Tardieu.
	EN, ST	P. P. Prud'hon.	F. J. E. Beisson, J. L. Copia, B. J. F. Roger (*sch. of Copia*), J. Prud'hon.
19. 1	EN	Miscellaneous, reprod.	A. Girardet (*af. ancient sculpture, etc.*), C. P. J. Normand (*outlines in Landon's " Annales du Musée," 1801-24 ; also in " Recueil de décorations intérieures," 1812*), L. Croutelle (*af. Velazquez*), J. Godefroy (*also st.*), J. Mécou (*p. of Russian Emperors*), E. F. Lignon, P. N. Bergeret (*sch. of J. L. David*),

Date.	Medium.	Master, Characteristic, or Locality.	Engravers influenced by the Masters in the previous column, or whose work is characterised or localised by the remarks in the same place.
19. I	EN	(*Continued*).	A. B. B. Taurel (*sch. of Bervic; af.* 1828 *settled in Amsterdam*), A. Réveil (*et. outlines for publications of Landon, J. Duchesne, Clarac, etc.*).
19. I. 2		Boucher Desnoyers. F. Forster.	F. J. Dequevauviller, A. J. B. M., and A. T. M. Blanchard,
		Henriquel-Dupont.	J. F. Joubert (*also in England*), J. M. St. Eve, A. François, F. E. A. Bridoux, J. M. R. L. Massard (*individual manner, irregular hatching of short lines, nearer et. ; note sm. p. in J. Claretie's " Peintres et sculpteurs contemporains,"* 1882, 1884), G. Lévy, G. N. Bertinot, J. B. Danguin, J. G. Levasseur, J. J. Sulpis (*cf. his son, E. J. Sulpis, who uses more et.*),
19. 2, 20. I			J. P. M. Soumy, E. Rousseaux (*esp. af. Ary Scheffer*), J. A. Annedouche (*also mezz.*), H. J. Dubouchet, C. F. Gaillard (*close shading; lightly engraved lines nearer et.*), C. E. Thibault, A. Didier, A. J. Huot, A. and J. Jacquet (*e.g. af. Meissonier*), E. Gaujean (*en. + et. ; cf. Gaillard; also col.*), J. Patricot. (*Cf. reproductive etchers; the two groups tend to approach each other closely in technique.*)
18. 2, 19. I	ET	Transitional : (i.) Miscellaneous.	Sauveur Legros, J. A. D. Ingres (*p.*), N. T. Charlet ;
19. I			E. Delacroix (*s.*), A. G. Decamps (*s., l.*) ;
		(ii.) Landscape.	B. J. Baron, E. Bléry (*Meryon's master*), A. Calame (*Swi.*), L. H. F. Allemand (*nearer modern l. school*).
19. I, 2		Modern spirit : (*a*) Born before 1840— (i.) Barbizon school.	J. B. C. Corot, T. Rousseau, C. Jacque, J. F. Millet, K. Bodmer (*Swi.*) ;
		(ii.) Miscellaneous landscape.	P. Huet, L. Marvy (soft ground), C. F. Daubigny, L. Gaucherel, A. Appian, L. A. Hervier, J. J. Veyrassat, A. E. Delauney, C. H. Toussaint, L. A. Brunet-Debaisnes (*also reprod.*), A. Taiée ;

Date.	Medium.	Master, Characteristic, or Locality.	Engravers influenced by the Masters in the previous column, or whose work is characterised or localised by the remarks in the same place.
19 1, 2	ET	(iii.) The etchers of Paris.	C. Meryon, M. Lalanne (*also reprod.*), A. Martial Potémont, Gabrielle Niel (*sch. of Meryon*), A. Guillaumin ;
		(iv.) Subject, daily life.	J. L. E. Meissonier (*cf. reprod. etchers*), T. Valério (*g. ; Eastern Europe*), P. A. Jeanron, J. J. Tissot (*script., and misc.*) ;
		(v.) Impressionists.	C. Pissarro, E. Manet (*strictly "Realist"*), H. G. E. Degas, *cf.* Mary Cassatt (*A.*) ;
		(vi.) Miscellaneous.	M. G. Desboutin (*p.*), A. T. Ribot (*g.*), R. Bresdin, C. Chaplin (*fancy s.*), F. Chifflart (*alleg.*), J. de Goncourt (*p., s., etc.*), A. Queyroy (*topogr., and g.*), A. Lançon (*animals, military, and l.*), L. N. Lepic (*alleg., animals, l., etc.*), F. Bracquemond (*also reprod.*), J. Jacquemart (*also reprod.*), A. Legros (*fl. England*) ;
		(vii.) Illustrators.	A. Lalauze, P. Avril ;
19 2, **20.** 1		(viii.) Publishers and printers.	A. Cadart, A. Delâtre ;
		(*b*) Born since 1840— (i.) Miscellaneous.	O. Redon, A. Rodin, A. Renoir, B. Morisot, L. Lhermitte, P. Renouard, A. Forel (*Swi.*), H. Guérard, J. F. Raffaelli, F. Buhot, A. Besnard (*p.*), A. Lepère, H. Paillard, J. L. Forain, P. G. Jeanniot, H. Boutet (*dry-point, studies of figures and heads*), L. M. Boutet de Monvel (*illustr.*), N. Goeneutte, F. Courboin, E. v. Muyden (*Swi. ; fl. Paris ; animals*), T. Roussel (*fl. London*), L. Legrand, A. T. Steinlen, G. Leheutre, E. Béjot, E. Chahine, A. Dauchez, P. Helleu, T. Minartz, C. Houdard, C. Huard, P. M. Roy, L. Delteil, J. P. V. Beurdeley, H. Matisse, P. L. Moreau, B. Naudin, A. Beaufrère, A. Brouet, A. Berton, C. Heyman, J. Frélaut, H. Vergéserrat ;

Date.	Medium.	Master, Characteristic, or Locality.	Engravers influenced by the Masters in the previous column, or whose work is characterised or localised by the remarks in the same place.
19. 2, 20. 1	ET	(ii.) Colour-prints, etc.	H. Guérard, R. Ranft (*orig.*, *and af. J. M. W. Turner*, *etc.*), M. Robbe, J. F. Raffaelli, P. G. Jeanniot, L. Legrand, A. Lepère, C. Houdard, T. Roussel, A. T. Steinlen, C. Cottet, E. De-lâtre, A. Müller (*also p.*), G. Trilleau, J. Villon, C. Maurin, F. Jourdain, B. Boutet de Monvel, A. Brouet (*af. Corot*), A. Lafitte, L. Riche, R. Lorrain, M. Simonnet, G. de Latenay, G. Eychenne (*animal and plant*).
		Reproductive.	J. Laurens, T. N. Chauvel, L. Flameng (*Fl.*; *also en.*), M. Lalanne, F. Bracquemond, J. Jacquemart, B. Damman, J. Carré, E. M. Greux, P. A. Rajon, H. Guérard, E. Boilvin, C. L. Courtry, C. A. Waltner (*sch. of Henriquel-Dupont*); A. Mongin, P. E. Le Rat, L. Monziès (*the three preceding, much af. Meissonier*); E. A. Champollion, F. A. Laguillermie, E. J. Sulpis, A. Mathey-Doret, F. Jazinski (*Polish*).
19. 1, 2	MEZZ	Miscellaneous.	J. P. M. Jazet (*also aq.*), G. Maile (*e.g. af. C. M. Dubufe; also st.*), J. A. Annedouche (*also en.*), H. Guérard (*a few in col.*).

SPAIN AND PORTUGAL

Date.	Medium.	Master, Characteristic, or Locality.	Engravers influenced by the Masters in the previous column, or whose work is characterised or localised by the remarks in the same place.
17. 1	ET	Largely Italian influence: (i.) J. Ribera. (ii.) Miscellaneous.	*Cf.* T. F. de Liagno; V. Carducho (*I.*), F. de Herrera I., P. Angelo (*p.*, *title-pages, etc.*),
17. 1, 2			J. Martinez (*p.*), C. Coello (*title-page*, 1683),
17. 2			M. Arteaga (*archit.*, *p.*), J. de Valdes Leal (*archit.*), L. de Valdes (*also* 18. 1 ; *devotional prints*), J. Garcia Hidalgo (*also* 18. 1 ; *cf. Reni school*).
18. 1, 2		French influence (cf. M. Doriguy, etc.).	J. B. Catenaro (*fl.* 1700?), M. S. Maella (*also* 19. 1), N. Barsanti (*af. L. Giordano*), Juan Barcelon (*af. L. Giordano, etc.*).
		Italian etchers (cf. Tiepolo).	F. Vieira (*infl. by Salvator Rosa*), J. de Castillo (*af. L. Giordano*), R. Bayeu y Subias (*af. Guercino, Ribera, etc.*), A. Carnicero (*e.g. bull-fight ; also* 19. 1).
18. 2, 19. 1	ET, AQ		Francisco Goya.
18. 2	EN	Italian influence. N. G. Dupuis, J. G. Wille, G. F. Schmidt, and the French school.	J. A. S. Carmona. J. B. Palomino (*also* 18. 1 ; *the first professor of engraving in the Academy of S. Fernando, founded* 1752 ; *p. of Kings of Spain*, 1774), J. da S. Carnerio (*Portuguese, p., etc.*), M. S. Carmona (*also* 19. 1 ; *sch. of N. G. Dupuis*), P. P. Molés (*sch. of N. G. Dupuis*), F. Selma (*sch. of M. S. Carmona*), L. F. Noseret.
		R. Morghen, etc.	T. L. Enguidanos, F. Muntaner, J. Ballester, J. de la Cruz, G. Gil (*en.? publ.*), B. Vazquez (*also st., af. Zurbaran, Mor, etc.*),
18. 2, 19. 1			Blas Amettler (*sch. of M. S. Carmona*),
19. 1			M. E. de Sotomayor, G. F. de Queiroz (*sch. of Bartolozzi*), R. Esteve.
19. 2	ET		M. Fortuny I. (*fl. Italy*), R. de Egusquiza (*large p., s., etc.*), C. de Haes (*l.*), Galvan (*p., etc.*),
19. 2, 20. 1			C. Araujo (*reprod. Prado*), B.

Date.	Medium.	Master, Characteristic, or Locality.	Engravers influenced by the Masters in the previous column, or whose work is characterised or localised by the remarks in the same place.
19. 2, 20. 1	ET	(*Continued*).	M. Montaner (*reprod.*), R. de los Rios (*reprod. and orig.*), D. Vierge (*a few plates*), M. Fortuny II. (*fl. Italy?*), P. Picasso.

THE BRITISH ISLES

Date.	Medium.	Master, Characteristic, or Locality.	Engravers influenced, etc.
16. 2	EN	The earliest line-engravers working in England.	Geminus (*Fl.*), Shute (?), F. and R. Hogenberg (*Fl. or G.?*), M. Gheraerts I. (*Fl.; also et.*), T. de Bry (*Fl.*), Rutlinger (*Fl. or G.?*);
		Chart engravers.	H. Cole, R. Lyne, A. Ryther, B. Wright (*also* 17. 1; *in Italy, etc.*).
16. 2, 17. 1		W. Rogers.	R. Elstrack.
		Miscellaneous (p., title-pages, etc).	T. Cockson, L. Johnson, W. Kip (*maps*),
17. 1			F. Delaram, W. Hole.
		Foreigners in England.	S. and W. v. d. Passe (*D.*), J. and M. Droeshout (*Fl.*), Cornelis Boel (*Fl.*), J. Barra (*Fl.*), C. Le Blon (*Fl.*), L. Vorsterman (*Fl.*), R. v. Voerst (*Fl.*), C. v. Dalen I. (*D.*), P. Lombart (*Fl.* or *F.?*).
		Native engravers (p., title-pages, illustr.).	W. Marshall, J. Payne, T. Cecill, G. Glover,
17. 1, 2			R. Vaughan, T. Cross, A. Hertochs (*D. ?*).
		William Faithorne (chiefly portraits).	D. Loggan (*G.*), R. White, *cf.* P. Lombart (*Fl.* or *F.?*), *cf.* A. Blooteling (*D.*), P. Van der Bank (*D. ?*).
17. 2, 18. 1		Small portraits, title-pages, etc.	F. H. Van Hove, M. Burghers (*Oxford Almanacks, etc.*), M., G., and J. Van der Gucht.
		Miscellaneous subjects.	P. Tempest (*e.g. "Cries of London" af. Laroon I.*, 1688).
		Reprod., class., and misc.	Sir N. Dorigny (*F.; af. Raphael cartoons*), S. Gribelin (*F.; af. Raphael cartoons*).
17. 1, 2	ET	W. Hollar (*b. Prague*).	R. Gaywood, D. King (*e.g. in Dugdale's "Monasticon"*), F. Barlow (*e.g. in Mrs. Behn's Æsop*, 1666), T. Dudley (*in* 2nd *ed. of Behn's Æsop*, 1687).
17. 2		Miscellaneous.	J. Evelyn (*l.*), J. Griffier (*animals and insects af. Barlow, etc.; also mezz.*),

Date.	Medium.	Master, Characteristic, or Locality.	Engravers influenced by the Masters in the previous column, or whose work is characterised or localised by the remarks in the same place.
17. 2	ET	(*Continued*).	F. Place (*animals af. Barlow, etc.; also mezz.*) ; M. Laroon I. (*cf. Ostade*),
17. 2, 18. 1			L. Chéron (*F.; reprod., class.; illustr.*).
17. 2		Topography.	W. Lodge (*also p., en.*), J. Kip (*D.; e.g. "Britannia Illustrata,"* 1707-8 ; *Stow's Survey,* 1720 ; *animals af. Barlow ; also* 18. 1). (*For other topogr. prints, cf.* 18. 1, *en.*)
17. 1, 2 17. 2	MEZZ	Ludwig von Siegen (*G.*). Prince Rupert (*G.*) (the engravers following worked largely af. Lely, Kneller, Wissing, Dahl, Closterman).	W. Sherwin, F. Place (*also* 18. 1), E. Luttrell (*also* 18. 1), Sir C. Wren (?), A. Blooteling (*D. ; England,* 1673-76), G. Valck (*D.; also* 18. 1), J. Van der Vaart (*D.; also* 18. 1), P. van Somer (*D.*), H. Gascar (*F.*), A. Browne (*publ.; mezz. ?*), R. Tompson (*publ. ; mezz. ?*), J. and I. Oliver (*work by either father or son ; possibly by both*), I. Beckett (*also* 18. 1), W. Faithorne II. (*also* 18. 1), B. Lens (*also* 18. 1), R. Williams, P. Coombes. R. Robinson, W. Vincent.
18. 1	EN	Antiq., hist., portrait, etc.	G. Vertue (*sch. of M. Van der Gucht ; cf. his p. with J. Houbraken*).
		Topography and archit.	J. Harris, H. Hulsbergh (*e.g. in C. Campbell, " Vitruvius Britannicus,"* 1717),
18. 1, 2			S. Buck, E. Rooker, T. Bowles, J. Tinney (*also mezz.*).
		Landscape.	P. C. Canot (*F.; af. Claude, and Dutch masters*), J. B. C. Chatelain (*F.; infl. by Claude and Poussin*), F. Vivares (*F.*), T. Major (*also p. and s.*),
18. 2			J. Peake, J. Pye I. (*sch. of T. Major*) ;
		W. Woollett (*sch. of Tinney*).	J. Browne, W. Ellis, T. Morris ;
		W. Byrne.	S. Middiman (*also* 19. 1), J. Landseer (*also* 19. 1), *cf.* J. G. Schumann (*G.; worked in London*).
18. 1, 2		W. Hogarth.	G. J. B. Scotin II. (*F.*), Bernard Baron (*F.*), S. F. Ravenet I. (*F.*), L. Sullivan, C. Mosley, *cf.* L. P. Boitard, C. Grignion.
18. 2, 19. 1			T. Cook (" *Hogarth Restored,*" 1806).
		Publisher-engravers.	John and Josiah Boydell.

Date.	Medium.	Master, Characteristic, or Locality.	Engravers influenced by the Masters in the previous column, or whose work is characterised or localised by the remarks in the same place.
18. 1, 2	EN	Calligraphic and misc.	G. Bickham (*author of " Universal Penman "*).
		Portrait.	Richard Cooper I. (*also mezz.*).
18. 1		Classical, miscellaneous, and reproductive.	A. Lawrence (*sch. of Lebas ; certain plates finished by T. Major*),
18. 2			Sir R. Strange (*sch. of R. Cooper*), T. Chambars (*for Boydell, etc.*), F. G. Aliamet (*F.; worked under Strange*),
18. 2, 19. 1			R. Cooper II. (*e.g. af. Rembrandt; also et., and aq.*), T. Holloway (*af. Raphael cartoons*), W. Sharp, A. Smith (*also st. ; misc. illustr.*).
		Subject and historical (for Boydell, etc.).	J. Hall (*e.g. af. West*), J. B. Michel (*F.; also st.*), W. C. Wilson, F. Legat, G. Noble (*e.g. for Bowyer's Hume, 1806*), W. Skelton (*s., and p.; also st.*) ;
18. 2		F. Bartolozzi.	J. K. Sherwin (*also st.*) (*N.B. most of the other st. engravers of the Bartolozzi school also engraved in line*),
18. 2, 19. 1			J. Summerfield, I. Taylor II.
18. 2		Illustration (af. Stothard, Smirke, R. Westall, Burney, Hamilton, R. Corbould, etc.).	A. Walker (*sch. of Tinney*), W. Walker (*l. af. Sandby ; s., etc.*), I. Taylor I.,
18. 2, 19. 1			J. Collyer (*also st.; sch. of A. Walker*), J. Parker (*also st.; partner of W. Blake in 1784*), C. Warren.
		Architectural.	J. Basire I. and II., J. Fittler (*e.g. " Scotia Depicta" ; also marines and misc. illustr.*), J. Le Keux, H. Le Keux (*also misc. illustr.*),
19. 1			G. Cooke (*some prints af. J. M. W. Turner*), J. Coney (*European cathedrals, London views*),
19. 1, 2			J. W. Archer (*e.g. London views*), J. Basire III. (*e.g. for Gough's " English Cathedrals" ; also af. Turner, etc.*).
18. 2		Portrait.	T. Trotter (*af. early English paintings*), J. Caldwall (*also st.; a few l.*), W. Bond (*af. Reynolds*).
18. 2, 19. 1		Animals.	T. Bewick (*only a few plates*).
		Idealistic subjects.	W. Blake (*mixed methods*), E. Calvert (*l.*).
18. 1	ET	Miscellaneous.	P. Tillemans (*Fl.; battle pieces*), P. Casteels (*Fl.; birds and p.*).

Date.	Medium.	Master, Characteristic, or Locality.	Engravers influenced by the Masters in the previous column, or whose work is characteristic or localised by the remarks in the same place.
18. 1	ET	Etching in combination with 'chiaroscuro' blocks.	A. Pond, C. Knapton (*cf.* **17.** 1, *mezz.*, E. *Kirkall, and* **19.** 1, *en.*, *Baxter*).
18. 1, 2		Landscape.	C. F. Zincke (*G.*), G. and J. Smith (*of Chichester*), J. Goupy (*orig., and af. Claude, and S. Rosa*), T. Gainsborough (*also soft ground and aq.*).
		Satirical.	W. Hogarth (*also en.*), T. Patch (*imit. Ghezzi, etc.*),
18. 2, **19.** 1			J. Bretherton (*e.g. af. Bunbury*), J. Sayers, T. Rowlandson, J. Gillray, Robert and Richard Dighton.
18. 1, 2		Miscellaneous (archaisers, copyists, etc.).	J. Richardson I. (*p.*), T. Worlidge (*p., gems, etc.*) (*cf. L. B. Coclers*), B. Wilson (*p., and cop. Rembrandt etchings*), W. Baillie (*l., cop. Rembrandt, etc. ; also cr. and mezz.*),
18. 2			R. Byron (*imit. Rembrandt*), A. and J. R. Cozens (*l.*), B. Green (*e.g. soft ground in drawing-books*), T. Vivares (*e.g. soft ground after Morland*), Edward Edwards (*l.*), S. De Wilde (*also* **19.** 1 ; *p. ; mezz.? see Index, Paul*), J. Hazard (*cop. Rembrandt*), J. Bretherton (*cop. Rembrandt, etc.*; *also satir.*), D. Deuchar (*af. D. and Fl. masters ; cop. Rembrandt, Ostade, etc.*), J. T. Smith (*also* **19.** 1 ; *l., beggars, etc.*).
		Subject.	J. Barry, J. H. Mortimer (*infl. by S. Rosa*),
18. 2, **19.** 1			R. Pollard (*af. Smirke, Wheatley, etc.*), R. Westall (*e.g. s., in soft ground; also mezz.*), J. H. Ramberg (*also plates on proport. of human body*).
18. 1	MEZZ	John Smith (*also* **17.** 2) (largely *af.* Kneller, Wissing, Van der Vaart).	G. White, J. Faber I. (*D.*), J. Faber II., G. Bockman, G. Lumley, J. Simon (*F.*), P. Pelham (*af.* 1726 *in U.S.A.*), F. Kyte, P. van Bleeck (*D.*), W. Robins (*e.g. Founders of Colleges, Oxf. and Camb.*), T. Beard, J. Brooks, T. Frye, A. Miller (*the four preceding worked in Dublin*), T. Ryley, J. Tinney (*also en.*), Richard Cooper I. (*also en.*).

Date.	Medium.	Master, Characteristic, or Locality.	Engravers influenced by the Masters in the previous column, or whose work is characterised or localised by the remarks in the same place.
18. 1	MEZZ	Colour prints.	J. C. Le Blon (*G. ; worked in London and Paris*).
		Mezzotint combined with chiaroscuro blocks, et., and en.	E. Kirkall (*cf. etchers, A. Pond and C. Knapton*).
18. 2		Mostly portrait af. contemporary masters (e.g. Reynolds, Ramsay, Gainsborough, Romney), except where otherwise stated :	
		(i.) The Irish group.	R. Houston (*also af. Rembrandt*), J. McArdell (*also af. Rembrandt and old masters*), E. Fisher, J. Dixon, R. Purcell, James Watson ;
		(ii.) Miscellaneous.	J. Finlayson, P. J. Tassaert (*Fl.*), D. Martin, C. Phillips (*also af. old masters*), W. Pether (*af. Rembrandt, etc.; also* **19.** 1), V. Green, W. Humphrey (*also af. Rembrandt*), P. Dawe (*af. Morland, etc.*), 'J. Johnson (*also en.*), J. Spilsbury (*also s., af. Rembrandt, Murillo, etc.*), T. Watson (*also af. Rembrandt*), R. Earlom (*also l., and s. af. Claude and Dutch, etc.; also* **19.** 1), W. Baillie *also et., and cr.*), R. Dunkarton (*also* **19.** 1), J. Jones, W. Dickinson (*also* **19.** 1 ; *in Paris*), C. Townley, J. Greenwood (*b. in U.S.A.*), S. Okey (*later in U.S.A.*), R. Brookshaw (*also in Paris*), J. Murphy (*also st.; and* **19.** 1 ; *hist. af. Northcote, etc.*), J. Walker (*also in St. Petersburg*), T. Blackmore, S. Paul (De Wilde ?) (*af. Steen and Vanloo*), J. Watts, Elizabeth Judkins, J. Saunders, C. Exshaw (*e.g. af. Vanloo*), W. Doughty, H. Kingsbury (*also st.*), J. Dean, J. R. Smith, R. Laurie (*publ.; also* **19.** 1), J. Young (*also* **19.** 1), G. T. Stubbs (*animals ; also* **19.** 1), T. Park (*also* **19.** 1), H. Hudson (*also af. Rembrandt*), E. Dayes, C. H. Hodges (*also in Amsterdam ; and* **19.** 1), G. Keating (*also st.*), J. Grozer (*also st.*), Gains-

Date.	Medium.	Master, Characteristic, or Locality.	Engravers influenced by the Masters in the previous column, or whose work is characterised or localised by the remarks in the same place.
18. 2	MEZZ	(*Continued*).	borough Dupont (*af. Gainsborough*), Caroline Kirkley, H. Bryer (*publ.*), J. Wright (*also cr.*) ;
		(iii.) Foreigners who worked for some time in England.	J. G. Haid (*G. ; also* 18. 1), J. Jacobé (*G.*), G. Marchi (*I.; assistant of Reynolds*), H. Sintzenich (*G.; more st.*).
19. 1		Largely af. Reynolds, Gainsborough, Hoppner, Morland, Lawrence, Beechey, Northcote (for the most part, portrait).	W. and J. Ward (*also col.*), W. J. Ward, T. Gosse, W. Say (*steel plates*), G. Clint, S. W. Reynolds I. and II. (*the son also* 19. 2), Elizabeth Walker (*née Reynolds*), C. Turner, J. C. Easling, W. T. Annis, William Barnard, T. Hodgetts, W. W. Barney, G. Dawe (*e.g. af. Raeburn ; also in Russia*), H. Meyer, H. Dawe, J. Martin (*large script.*), T. G. Lupton (*e.g. Turner's " Liber " ; also* 19. 2), W. Walker (*e.g. af. Raeburn ; also st.*), J. Linnell (*en. and et. ; also* 19. 2 ; *Sixtine ceiling*), J. C. Bromley, G. R. Ward (*also* 19. 2), J. Bromley, S. Cousins (*mezz. + st. ; also* 19. 2), D. Lucas (*l. af. Constable ; also* 19. 2), J. Lucas (*also* 19. 2), H. Cousins (*also* 19. 2), J. Scott, W. Giller, W. Brett, J. E. Coombs, G. H. Phillips ;
19. 1, 2			W. H. Simmons, G. Zobel, (*mixed mezz. ; af. Landseer, etc.*), J. R. Jackson, J. Faed, C. A. and C. J. Tomkins ;
19. 2, 20. 1		(i.) In old tradition (reprod., and chiefly portrait).	R. Josey, C. W. Campbell, J. D. Miller, R. B. Parkes, J. B. Pratt, J. C. Webb, J. W. Chapman, G. Robinson, H. S. Bridgwater, N. Hirst, R. S. Clouston, T. G. Appleton, E. G. and R. W. Hester, G. Every, (Miss) E. Gulland, (Mrs.) M. Cormack, A. J. Skrimshire ;
		(ii.) Original work (chiefly landscape).	Seymour Haden, J. Knight, J. Finnie, F. Short (*also reprd. af. Turner, etc.*), W. Strang, A. C. Meyer, D. Waterson, W. Hyde.
18. 2	ST, CR	F. Bartolozzi (*I.*) (cf. Italy).	J. Ogborne, W. W. Ryland, R. Earlom (*also* 19. 1 ; *and*

Date.	Medium.	Master, Characteristic, or Locality.	Engravers influenced by the Masters in the previous column, or whose work is characterised or localised by the remarks in the same place.
18. 2	ST, CR	(*Continued*).	*mezz.*), V. Green (*also mezz.*), H. Kingsbury (*also mezz.*), C. Knight (*also* 19. 1), J. Wright (*e.g. cr. after Morland*), T. Watson (*also mezz.*), J. Jones (*also mezz.*), T. Ryder (*also* 19. 1), J. Murphy (*also mezz.*), T. Burke (*also mezz.; and* 19. 1), J. Strutt (*s. af. Stothard; misc. cop. of old prints; en., et.*), C. Wilkin (*p.; also* 19. 1), R. S. Marcuard, J. K. Sherwin (*also en.*), C. White (*also en.*), J. Hopwood I. (*en.; also* 19. 1), J. Chapman (*et., en.; also* 19. 1), W. Nutter, J. R. Smith (*mezz.; also* 19. 1), Anker Smith (*also* 19. 1), J. Collyer (*also en.*), J. Parker (*also en.*), R. Thew (*Boydell's "Shakespeare Gallery," etc.*), F. Haward (*also mezz.*), G. Keating (*also mezz.*), T. Kirk, J. Hogg, C. G. Playter,
18. 2, 19. 1			P. W. Tomkins (*also et.*), T. Cheesman, R. M. Meadows (*Boydell's "Shakespeare Gall.," etc.*), Caroline Watson, W. Ward, J. Godby, W. Holl I. (*p., hist.*), T. Hellyer, T. Nugent,
19. 1			H. Meyer, C. Picart, T. Woolnoth (*p., theatrical, etc.*), B. Smith, Robert Cooper, J. Thomson (*p., etc.*), W. Walker (*p.; also mezz.*), J. Hopwood II. (*p.*),
19. 1, 2			F. Holl (*also en.*), C. H. Jeens, J. Posselwhite.
18. 2		Foreigners who worked chiefly in England (cf. also Italy, Germany, France, Netherlands, Sweden, and Russia).	D. P. Pariset (*F.; sch. of Demarteau*), T. Gaugain (*F.*), L. Sailliar (*F.; for Boydell, af. old masters, et..*),
18. 2, 19. 1			J. P. Simon (*F.*), I. Van den Berghe (*Fl. ?*), J. M. Delatre (*F.; also en. illustr.*), N. Colibert (*F.*), J. and P. Condé (*F. ?*), B. A. Van Assen (*D. ?*), A. Cardon (*Fl.*) M. A. Bourlier (*F.*), C. Josi (*D.; also et., reprod. drawings; publ.*).
18. 2, 19. 1	CR	Reproduction of drawings.	F. Bartolozzi, W. W. Ryland, S. Watts, J. Basire I. (*the four*

Date.	Medium.	Master, Characteristic, or Locality.	Engravers influenced by the Masters in the previous column, or whose work is characterised or localised by the remarks in the same place.
18. 2, 19. 1	CR	(*Continued*).	*preceding in C. Rogers' "Coll. of Prints in Imitation of Drawings,"* 2 *vols.*, 1778), W. Baillie, R. Earlom, F. C. Lewis (*af. Lawrence ; cf. aq.*).
18. 2	AQ		P. P. Burdett,
		P. Sandby (chiefly landscape and views, except where otherwise stated).	R. Cooper II. (*views in Italy*, 1778-79), T. Malton II., Archibald Robertson,
18. 2, 19. 1			T. Daniell, W. Daniell (*also st., and soft-ground et.*), C. Tomkins (*e.g. Isle of Wight*, 1796 ; *British Volunteers*, 1799), R. Dodd (*sea-fights*), R. Pollard (*s.*), J. C. Stadler (*G.*), J. Hassell, C. Apostool (*D.*), E. Scriven (*p. ; also en.*), S. Alken (*l., and sporting*),
19. 1			J. A. Atkinson (*costume*), H. Alken (*sporting ; also soft-ground et.*), T. H. A. Fielding (*also st.*), W. Westall) (*e.g. Yorkshire Caves*, 1818), S. Prout (*also soft-ground et.*), D. and R. Havell, J. Bluck, T. Sutherland, R. Reeve, J. Hill (*later in America*), F. C. Lewis (*e.g. Imit. of Claude Drawings in the B.M.*, 1837), G. R. Lewis.
	EN	Miscellaneous (reprod., hist., etc.).	W. Bromley (*e.g. B. M. Marbles*), W. Holl I. (*more st.*), A. Raimbach (*af. Wilkie, etc.*), J. Burnet (*af. Wilkie, etc. ; also illustr., et., mezz., etc., in his books on art*), J. T. Wedgwood (*hist., p., B. M. Marbles*), J. Romney (*B. M. Marbles ; Ancient Buildings, Chester*), W. H. Worthington (*B. M. Marbles ; af. Stothard, etc.*), C. Rolls (*e.g. in Finden's " Gallery of British Art"*),
19. 1, 2			J. Watt (*s. af. Stothard, Eastlake, etc.*), G. Doo (*also B. M. Marbles*), F. Bacon (*assistant of the Findens*), H. Shenton (*af. Mulready, etc.*), W. Holl II. (*s., af. Frith ; p., and illustr.*), W. B. Scott (*also et. and mezz. af. Blake, etc.*), L. Stocks (*e.g. in Finden's " Gallery"*), E. Smith (*g., and s., e.g. in Finden's*

Date.	Medium	Master, Characteristic, or Locality.	Engravers influenced by the Masters in the previous column, or whose work is characterised or localised by the remarks in the same place.
19. 1, 2	EN	(*Continued*). Sir E. Landseer.	"*Gallery*"), F. Holl (*also st.*), C. W. Sharpe. T. Landseer, R. Graves, B. P. Gibbon (*also mixed mezz.*), C. G. Lewis (*also mixed mezz., and et.*), *cf.* G. Zobel (*mixed mezz.*).
19. 1		Sporting prints, race-horses, etc. Illustrators.	John Scott. J. Heath (*also* **18. 2**; *sch. of J. Collyer ; reworked Hogarth's plates, ed.* 1822), F. Engleheart (*sch. of Collyer ; assistant of Heath*), J. Mitan, C. Armstrong, C. Heath, G. J. Corbould, W. and E. F. Finden (*sch. of J. Mitan ; chiefly l. ; also* "*Royal Gallery of British Art*," 1838-40),
19. 1, 2			J. H. Robinson (*p., etc.*). E. Radclyffe (*also some et., af. D. Cox*).
		Colour-prints (engraving in combination with wood blocks). Landscapes af. J. M. W. Turner, and misc. (largely for book illustration).	G. Baxter (*cf.* **18. 1**, *et., Pond and Knapton*), A. Le Blond (*en.? or only printer?*) W. B. Cooke, J. Pye II., W. Radclyffe (*founded school of engraving in Birmingham*, 1814), R. Wallis, E. Goodall, W. Miller, J. T. Willmore (*Birmingham school*), J. B. Allen, J. Cousen, R. Brandard (*sch. of E. Goodall*), *cf.* J. D. Harding.
19. 2		Book-plates.	C. W. Sherborn (*also p., etc.*), *cf.* A. Robertson (*et.*), *cf.* G. W. Eve (*et., en.*).
19. 1	ET	Landscape (water-colour painters who did occasional etchings, largely in soft ground).	J. Laporte, W. F. Wells (*with Laporte*, 1802, *af. Gainsborough*), F. L. T. Francia, T. Girtin (*views of Paris*, 1802 ; *the aq. by F. C. Lewis, etc.*), J. M. W. Turner (*cf. en.*), W. Delamotte, S. Prout (*archit.*), D. Cox, R. P. Bonington.
		Norwich school (landscape).	J. Crome, J. S. Cotman, G. Vincent (*also combined et. with mezz. ; cf. Turner's* "*Liber*"), J. Stannard, E. T. Daniell.
		Miscellaneous.	G. Cuitt (*archit.*), A. Geddes (*p., l.*), D. Wilkie (*s.*), W. Carpenter (*p.*),

Date.	Medium.	Master, Characteristic, or Locality.	Engravers influenced by the Masters in the previous column, or whose work is characterised or localised by the remarks in the same place.
19. 1, 2	ET	(*Continued*). Imitators, copyists.	D. C. Read (*l.*), G. Hayter (*p., s., etc.; cf. Geddes*). W. J. Smith (*af. Rembrandt*), J. E. Beckett (*af. Rembrandt; also mezz.*), Lucy Brightwell (*af. Rembrandt*).
19. 1 19. 1, 2		Animals.	G. Garrard, R. Hills, Sir J. Stuart (*also military s.*), Sir E. Landseer (*cf.* **19.** 1, 2, *en.*).
		Caricature and humorous illustration.	I. Cruikshank (*also* **18.** 2), G. Cruikshank, I. R. Cruikshank, H. K. Browne ("Phiz"), J. Leech, C. S. Keene (*also l. and s.*).
		Miscellaneous (contributors to the "Etching Clubs," etc.).	R. Redgrave (*s.*), C. W. Cope (*s.*), J. C. Horsley (*s.*), S. Palmer (*l.*), T. Creswick (*l.*), Birket Foster (*l. and s.*), Sir J. E. Millais, W. Holman Hunt (*e.g. in the "Germ,"* 1850).
19. 2, 20. 1		Modern spirit : (i.) Born before 1830.	Sir F. Seymour Haden, Sir J. C. Robinson, Edwin Edwards, J. Finnie ;
		(ii.) J. A. McN. Whistler (*A.*).	J. Pennell (*A.*), M. Menpes, F. Laing, T. Roussel (*F.; also col.*);
		(iii.) A. Legros (*F.*).	W. Strang, Sir C. Holroyd, J. B. Clark ;
		(iv.) Born after 1829— miscellaneous.	D. Law, A. W. Bayes, P. G. Hamerton, A. H. Haig (*Swe.*), A. Evershed, R. C. Goff, E. George, W. H. May, H. R. Robertson (*l., reprod.*), J. P. Heseltine, G. Pilotell (*F.? English portraits*), R. S. Chattock, C. O. Murray (*reprod.*), T. H. McLachlan, W. B. Hole (*some reprod.*), F. and E. Slocombe, A. East, R. W. Macbeth, Arthur Robertson (*s., l., bookplates*), Sir H. v. Herkomer (*G.*), W. L. Wyllie (*seascapes*), G. Clausen, W. Ball, H. Paton, G. W. Rhead (*figures, fancy s., flowers, etc.*), G. W. Eve (*bookplates*), A. Hartley, O. Baker, G. P. Jacomb-Hood (*s., illustr.*), F. Short, H. Fitton, E. W. Charlton, H. Macbeth-Raeburn, F. Marriott, E. M. Synge, E. Wilson, H. Dicksee, H. M. Livens

Date.	Medium.	Master, Characteristic, or Locality.	Engravers influenced by the Masters in the previous column, or whose work is characterised or localised by the remarks in the same place.
19. 2, 20. I	ET	(*Continued*).	(*animals*), G. Gascoyne, W. Monk, F. Newbolt, R. Bryden, D. Y. Cameron, C. J. Watson, S. Lee, F. Brangwyn, A. H. Fisher, H. Schroeder (*aq.*), G. P. Gaskell, C. J. Holmes, H. Percival (*s., decor.*), P. Robertson, F. Burridge, O. Hall, W. Lee Hankey (*aq., and mixed methods*), H. Railton, T. I. Dalgliesh, R. E. J. Bush, P. Thomas, H. B. Van Raalte, W. and B. Sickert, A. E. John, R. Spence (*s.*), W. Rothenstein, M. Bone, F. Dodd (*p.*), L. Taylor (*some reprod.*), D. I. Smart, N. Sparks, J. R. G. Exley (*animals*), E. J. and M. Detmold (*animals, decor., etc.*), E. S. Lumsden, P. Pimlott, M. Hardie, J. Wright, M. Osborne, W. Walker, A. F. Affleck, P. F. Gethin, W. Walcot, A. Bentley, J. McBey, F. L. Griggs, W. P. Robins, A. Howarth, R. Schwabe, F. S. Unwin, H. G. Rushbury, N. Dawson (*soft-ground et.*), C. H. Baskett (*aq.*), E. A. Cole, I. Strang, F. Carter, A. R. Barker, E. Blampied, F. Richards;
		(v.) Lady etchers.	Catherine M. Nicholls, Adeline Illingworth, Constance M. Pott, Minna Bolingbroke, Amelia Bauerlé (*s.*), Susan Crawford, Margaret Kemp-Welch, Mary Sloane, A. Galton, Mary E. Kershaw (*animals, and l.*), Ethel Stewart, Anna Airy (*bird, beast, and flower; decor., col.*), S. Gosse, K. Cameron, H. Frood;
		(vi.) Printer-etcher.	F. Goulding.

AMERICA

(The United States and Canada)

Date.	Medium.	Master, Characteristic, or Locality.	Engravers influenced by the Masters in the previous column, or whose work is characterised or localised by the remarks in the same place.
18. 1, 2	EN	Chiefly topogr., bill-heads, bank - notes, portraits, and bookplates.	T. Emmes, F. Dewing, T. Johnston, N. Hurd,
18. 2, **19.** 1			P. Revere, J. Smither, J. Callender, J. Norman, A. Doolittle, P. Maverick, W. S. Leney (*also st.; b. London, where most of his work was done*), E. Savage, C. B. J. F. de St. Memim (*F.; p., by aid of Physionotrace; cf. Chrétien and Quénedey*), A. Lawson (*b. Scotland*),
19. 1			B. Tanner (*also st.*), D. Edwin (*chiefly st.; b. England*), C. Tiebout (*also st.*), A. Bowen,
19. 1, 2			J. B. Longacre (*also st.*), A. B. Durand, J. and S. W. Cheney, J. Andrews, J. Smillie (*b. Edinburgh*), J. G. Chapman (*en. + et.; cf. Turner school*), H. B. Hall I. (*chiefly st.; b. London, where most of his work was done*), J. Sartain (*b. London*), R. W. Dodson, A. Jones (*b. Liverpool*), A. H. Ritchie (*b. Glasgow*), C. K. Burt,
19. 2, **20.** 1			H. B. Hall II. (*e.g. p., and hist. illustr. Civil War*), W. E. Marshall, E. D. French (*bookplates*).
18. 2, **19.** 1	ST	Portraits, etc.	A. Doolittle, W. Rollinson, W. S. Leney, J. Rubens Smith, R. Field,
19. 1			D. Edwin (*the five preceding b. England*), B. Tanner, C. Tiebout, T. Gimbrede (*b. France*),
19. 1, 2			J. B. Longacre (*e.g. in Nat. Portr. Gall. of distinguished Americans, 1834-39*), E. Wellmore, J. F. E. Prud'homme (*also en.; misc. illustr.*), H. B. Hall I., T. B. Welch (*also mezz., and en.*).
18. 1	MEZZ		P. Pelham (*b. London; in U.S.A. af.* 1726),
18. 2			J. Greenwood (*fl. England*), S. Okey (*b. England; af. ab.* 1771 *in U.S.A. ?*),
18. 2, **19.** 1			C. W. Peale, E. Savage,

Date.	Medium.	Master, Characteristic, or Locality.	Engravers influenced by the Masters in the previous column, or whose work is characterised or localised by the remarks in the same place.
19. 1, 2	MEZZ	(*Continued*).	J. G. Chapman, J. Sartain, T. B. Welch, A. H. Ritchie.
19. 2, 20. 1			J. D. Smillie, I. B. Forrest, D. A. Wehrschmidt.
19. 1	ET	Caricature.	W. Charles (*infl. by Rowlandson ; satir. War of* 1812, *etc.*).
19. 1, 2		Older manner.	S. F. B. Morse (*figure s.; sch. of B. West in London ; the inventor of Morse telegraphic system*), J. G. Chapman, G. L. Brown (*l.*).
19. 2, 20. 1		Modern spirit (for the most part landscape).	J. D. Smillie, J. A. McN. Whistler, J. M. Falconer, Eliza Greatorex, H. Kruseman Van Elten (*b. Holland*), A. F. Bellows, S. Colman, S. J. Ferris (*s.*), J. F. Cole (*af. Jacque*), T. Moran, Mrs. M. N. Moran, P. Moran (*l., and cattle*), (Mrs.) Anna Lea Merritt (*p., illustr., etc.*), Mary Cassatt (*sch. of Degas in Paris*), J. H. Hill (*also aq.; much af. J. M. W. Turner*), R. S. Gifford, S. L. Wenban (*worked in Munich*), F. S. Church, C. H. Miller, H. Farrer, T. C. Farrer, S. Parrish, F. Duveneck, W. M. Chase, J. A. Weir (*p., etc.*), E. H. Garrett, R. C. Coxe, I. M. Gaugengigl, O. H. Bacher, R. F. Blum, J. Pennell (*fl. London*), C. W. Stetson, W. L. Lathrop, C. A. Platt, A. A. Lewis, D. S. Maclaughlan, G. C. Aid, H. A. Webster, C. A. Gagnon, J. O. Nordfeldt (*Swe.*), (Miss) K. Kimball, F. W. Benson, A. B. Davies, S. Gallagher, C. H. White, H. Winslow (*w. London*), F. M. Armington, E. Borein (*cowboys and subjects from Western States*), E. D. Roth (*w. Europe*), C. W. Dahlgreen, C. K. Gleeson, O. J. Schneider (*p.*), E. L. Warner, L. G. Hornby, C. Washburn, J. Marin, G. W. Chandler, J. A. Smith.

DENMARK

Date.	Medium.	Master, Characteristic, or Locality.	Engravers influenced by the Masters in the previous colum, or whose work is characterised or localised by the remarks in the same place.
17. 1	ET	Portrait.	H. Oldelandt (*worked in Holland ; infl. by Rembrandt*).
17. 1, 2 **18.** 1, 2	EN	Portrait and reprod. J. G. Wille (*G.*).	Albert Haelwegh. J. M. Preisler (*G.*), O. H. de Lode,
18. 2. 19. 1			F. L. Bradt, J. G. Preisler, J. F. Clemens (*G.*), J. M. and J. J. G. Haas (*sch. of Delaunay*),
19. 1, 2			C. E. Sonne (*sch. of Toschi*), J. Ballin.
	ET	Miscellaneous.	P. V. C. Kyhn, L. Frölich (*s.*),
19. 2 **19.** 2, **20.** 1			C. H. Bloch, C. Locher (*b. Flensburg ; seascapes, etc.*), P. S. Kroyer (*p.*), Axel Hou (*p.*), H. N. Hansen (*s.*), F. Schwartz (*s.*), E. Krause (*l., archit.*), J. Lübschitz (*l.*), P. Mönsted.

SWEDEN AND NORWAY

Date.	Medium.	Master, Characteristic, or Locality.	Engravers influenced by the Masters in the previous colum, or whose work is characterised or localised by the remarks in the same place.
18. 2	EN	Miscellaneous.	J. Gillberg, P. G. Floding (*cf. French illustr.; also mixed aq.*).
18. 2, **19.** 1	ST, EN, ET		Elias Martin (*st.; in London*), J. F. Martin (*et. views of Stockholm, etc.*).
19. 1	MEZZ AQ ET	Landscape. Portrait.	A. U. and J. B. Berndes. W. M. Carpelan, C. F. Akrel. L. H. Roos.
19. 1, 2		Reproductive.	E. S. Lundgren (*also orig.*), L. Ruben,
19. 2, **20.** 1			R. Haglund (*reprod. pictures in Stockholm ; also orig. l., etc.*), J. Nordhagen (*also orig.*).
		Original work.	A. H. Haig (*fl. England*), A. T. Gellerstedt, R. Norstedt (*l.; also reprod.*), G. v. Rosen (*hist.*), F. Thaulow (*l., col.*), V. O. Peters, C. Larsson, F. Boberg, A. Tallberg (*also in England*), A. Zorn, A. Osterlind (*col.*), E. Munch, O. Willums.

RUSSIA AND FINLAND

Date.	Medium.	Master, Characteristic, or Locality.	Engravers, influenced by the Masters in the previous column, or whose work is characterised or localised by the remarks in the same place.
17. 2, 18. 1	EN		L. Tarasevich.
18. 1		Foreign engravers in Russia.	A. Schoonebeek (*D.*), P. Picart (*b. Amsterdam*), C. A. Wortmann (*G.*).
18. 1, 2		Native engravers.	I. Sokolov, E. Vinogradov, A. Grekov.
18. 2		Native and foreign; chiefly portrait (infl. by the school of G. F. Schmidt and J. G. Wille).	A. Radigues (*F.*), B. L. Henriquez (*F.*), I. S. Klauber (*G.*), I. Vasil'ev, I. Chemesov, D. Gerasimov, A. I. Kolpashnikov, I. A. Bersen'ev (*sch. of Bervic*).
18. 1	MEZZ	Miscellaneous.	A. Zubov (*also et.*), J. Stenglin (*G.*).
18. 2	ST		G. Skorodumov (*sch. of Bartolozzi in London*).
19. 1, 2	EN	Reproductive (portrait and misc.).	N. I. Utkin (*sch. of Klauber*), N. Plakhov, C. L. Tolstoi (*outlines; cf. Lasinio*), F. I. Jordan, A. Oleszczynski (*e.g. Variétés Polonaises, Paris, 1833*), A. Pishtshalkin, K. Y. Athanas'ev,
19. 2			I. P. Pozhalostin.
19. 1	ET	Miscellaneous.	M. Plonski (*sch. of J. P. Norblin; imit. Rembrandt*), I. Shishkin (*l.*), V. A. Bobrov (*reprod., p., s.*),
19. 2, 20. 1			N. S. Massalov (*reprod.*), L. J. Dmitrijev-Kawkaski (*reprod. and orig., s. and p.*), Marie Yakunchikov (*col.; aq.*), I. Lopienski (*l.; reprod.; Poland*), F. Jazinski (*class. reprod., Poland, Paris*), H. R. Glicenstein (*b. Russian Poland*)
19. 1	MEZZ		Selimanov (*sch. of J. Walker, who was in St. Petersburg, 1784-1802*).
19. 2, 20. 1	ET	Finland.	A. Edelfelt, L. Sparre, A. Gallén, Hilda Flodin.

APPENDIX II

GENERAL BIBLIOGRAPHY

PERIODICALS QUOTED IN THE GENERAL AND SPECIAL BIBLIOGRAPHIES,
AND THE ABBREVIATIONS USED FOR THE SAME

Amer. Art Rev. .	The American Art Review. Ed. by S. R. Koehler. Boston, U.S.A., 1880-81.
Annals . .	Annals of the Fine Arts. 5 vols. London, 1817-20.
Archief . .	Archief vor Nederlandsche Kunstgeschiedenis . , . door Fr. D. O. Obreen. Amsterdam, 1877-90.
Archiv . .	Archiv für die zeichnenden Künste . . . herausgegeben von Dr. R. Naumann. Leipzig, 1855-70.
Archivio . .	Archivio Storico dell' Arte. Rome, 1889-97. (Cf. L'Arte.)
Arnold's Library {	The Library of the Fine Arts. 4 vols. London, 1831-32 ; Arnold's Library. 1 vol. London, 1833.
Arnold's Mag. .	Arnold's Magazine. 3 vols. London, 1833-34.
L'Art . . .	L'Art. Paris, 1875-94 ; 1900, etc. (in progress).
Art et Décor. .	Art et Décoration. Paris, 1897, etc. (in progress).
Art et les Artistes	L'Art et les Artistes. Paris, 1905, etc. (in progress).
L' Arte . .	L' Arte (già Archivio Storico dell' Arte). Rome, 1898, etc. (in progress).
Arte en Esp. .	El Arte en España. Madrid, 1862-91.
Art Journal . .	Art Union (later Art) Journal. London, 1839, etc. (in progress).
L'Artiste . .	L'Artiste. Paris, 1831, 1839, etc. (in progress).
Bollettino . .	Bollettino d' Arte del Ministero della P. Istruzione. Rome, 1907, etc. (in progress).
Burl. Mag. . .	The Burlington Magazine for Connoisseurs. London, 1903, etc. (in progress).
Cab. de l'Amat. .	Le Cabinet de l'Amateur; Ed. E. Piot. Paris, 1842-46 ; nouvelle sér., 1861-63.
Chalc. Soc. . .	International Chalcographical Society (Intern. Chalc. Gesellschaft). Berlin, etc., 1886-97.
Chronik . .	Chronik für vervielfältigende Kunst. Vienna, 1888-91.
Cicerone . .	Der Cicerone. Leipzig, 1909, etc. (in progress).
Connoisseur .	The Connoisseur. London, 1901, etc. (in progress).
Deutsch. Kunstbl.	Deutsches Kunstblatt. Leipzig, 1850-54.
F. A. Quarterly .	Fine Arts Quarterly Review. London, 1863-67.
Gall. Naz. Ital. .	Le Gallerie Nazionali Italiane. Notizie e documente. Rome, 5 vols., 1894-1902.
Gazette . .	Gazette des Beaux-Arts. Paris, 1859, etc. (in progress).
Graph. Gesellsch.	Graphische Gesellschaft. Berlin, 1906, etc. (in progress).
Graph. Künste .	Die graphischen Künste. Vienna, 1879, etc. (in progress).
Jahrb. . . .	Jahrbuch der kgl. Preussischen Kunstsammlungen. Berlin, 1880, etc. (in progress).
Jahrb. (Vienna) .	Jahrbuch der kunsthistorischen Sammlungen der allerhöchsten Kaiserhauses. Vienna, 1883, etc. (in progress).

Kunstchronik .	Kunstchronik. Beilage der Zeitschrift für bildende Kunst. Leipzig, 1866, etc. (in progress).
Kunstkronijk .	Kunstkronijk. The Hague, Leyden, 1840, etc.
Mag. of Art .	The Magazine of Art. London, 1878-1905.
Meddelanden .	Meddelanden från Föreningen för Grafisk Konst. Stockholm, 1888, 1892, 1896, 1904.
Mitteil. . .	Mitteilungen der Gesellschaft für vervielfältigende Kunst. Beilage der graphischen Künste. Vienna, 1901, etc. (in progress).
Monatshefte .	Monatshefte für Kunstwissenschaft. Leipzig, 1908, etc. (in progress).
Navorscher . .	De Navorscher. Amsterdam, 1881, etc.
Onze Kunst .	Onze Kunst. Antwerp, Amsterdam, 1902, etc. (in progress). (Also in French as " L'Art flamand et hollandais," and in English.)
Oud Holland .	Oud Holland. Amsterdam, 1882, etc. (in progress).
P. C. Quarterly .	Print-Collector's Quarterly. Boston and New York, 1911-17 ; London, 1921, etc. (in progress).
Portfolio . .	The Portfolio. Ed. P. G. Hamerton. London, 1870-95.
Rassegna . .	Rassegna d' Arte. Milan, 1901, etc. (in progress).
Repert. . .	Repertorium für Kunstwissenschaft. Stuttgart, Berlin, 1876, etc. (in progress).
Rev. de l'Art Anc. et Mod.	Revue de l'Art Ancien et Moderne. Paris, 1897, etc. (in progress).
Rev. Univ. . .	Revue Universelle des Arts, publiée par P. Lacroix. Paris [Brussels], 1855-66.
Riv. d' Arte .	Rivista d' Arte. Florence, 1903, etc. (in progress). Anno I. with title Miscellanea d' Arte).
Sitzungsberichte .	Sitzungsberichte der Kunstgeschichtlichen Gesellschaft. Berlin, 1887-1920.
Studio . . .	The Studio. London, 1893, etc. (in progress).
Vlaemsche School	De Vlaemsche School. Tijdschrift voor Kunsten Letteren en Wetenschappen, uitgegeven door de St. Lucas-gilde. Antwerp, 1855, etc.
Zahn's Jahrb. .	Jahrbücher für Kunstwissenschaft, herausgegeben von Dr. A. von Zahn. Leipzig, 1868-73.
Zeitschrift . .	Zeitschrift für bildende Kunst. Leipzig, 1866, etc. (in progress).

The general bibliography is divided into the following main sections, which are in their turn arranged under sub-headings :—

I. BIBLIOGRAPHIES.

II. PROCESSES, MATERIALS, ETC.

III. DICTIONARIES AND GENERAL HISTORY.

IV. VARIOUS COUNTRIES.

V. VARIOUS SUBJECTS.

VI. COLLECTIONS : A. PUBLIC ; B. PRIVATE.

VII. CATALOGUES OF PRINTS AFTER A FEW OF THE MORE IMPORTANT PAINTERS.

VIII. REPRODUCTIONS.

I. BIBLIOGRAPHIES

MURR, C. G. VON. Bibliothèque de peinture et de gravure. Frankfurt, 1770.

CICOGNARA, L. Catalogo . . . dei libri d' arte. Pisa, 1821. (The collection is now in the Vatican Library.)

WEIGEL, R. Kunstlager Catalog. Leipzig, 1834-66. (Note Uebersicht der aufgeführten Schriften. Abt. xvi., 1845.)

DUCHESNE, J. Catalogue des livres. Paris, 1855.

DUPLESSIS, G. Bibl. de la gravure. Paris, 1862.

Universal Catalogue of Books on Art (Science and Art Dept., S. Kensington). London, 1869-70. (Suppl. 1875.)
Paris, École Nat. des Beaux-Arts. E. Vinet, Catalogue de la Bibliothèque. 1873.
VINET, E. Bibliographie des Beaux-Arts. Paris, 1874, 1877 (incomplete).
Vienna, Akademie der bild. Künste. K. v. Lützow, Katalog der Bibliothek. 1876.
WESSELY, J. E. Anleitung zur Kenntniss und zum Sammeln der Werke des Kunstdruckes. Leipzig, 1876. (See pp. 279-331.)
London, Royal Academy of Arts. H. R. Tedder, Catalogue of Books, 1877. (Suppl. 1901.)
SOMEREN, J. F. van. Bibliographie de la peinture et gravure en Hollande et en Belgique. Amsterdam, 1882.
Berlin, Kgl. Akademie der Künste. E. Dobbert, Katalog der Bibliotek. 1893.
SINGER, H. W., and STRANG, W. Etching, Engraving London, 1897. (Contains an excellent bibliogr. of processes.)
Internationale Bibliographie der Kunstwissenschaft. Ed. A. L. Jellinek and I. Beth. Berlin, 1902-18.
BOURCARD, G. Graveurs et Gravures. Essai de Bibliographie, 1540-1910. Paris, 1910.
LEVIS, H. C. Bibliography of American Books relating to Prints. London, 1910.
Descriptive Bibliography of the most important books in the English language relating to the art and history of Engraving and the collecting of Prints. London, 1912 and 1913.
GIRODIE, A. Bibliographie de la gravure française. Paris, 1913.
SINGER, H. W. Handbuch für Kupferstichsammlungen. Leipzig, 1916. Contains an " Oeuvre-katalog-Bibliographie " with reference to catalogues included in general works such as Bartsch, as well as to monographs.
See also VI. B. (iii.).

II. PROCESSES, MATERIALS, ETC.

PROCESSES AND MATERIALS.

THEOPHILUS (also called Rugerus). Diversarum Artium Schedula [probably written early in the 12th century]. Ed. G. E. Lessing, Brunswick, 1781 ; Escalopier, Paris, 1843 ; R. Hendrie, London, 1847 ; A. Ilg, Vienna, 1871. (Describes *niello*, *opus interrasile*, and *opus punctile*.)
ZONCA, V. Nuovo Teatro di machine et edificii. Padua, 1607 (later editions, 1621 and 1656). Contains description of copper-plate press, with illustrative plate.
BOSSE, A. Traicté des manières de graver. Paris, 1645. Ed. 1701, augmentée de la nouvelle manière dont se sert M. Leclerc. Ed. 1745, revised and enlarged by C. N. Cochin II. Ed. " 1758 " (af. 1769 ?), with further additions describing the Crayon manner, etc. (See A. M. Hind, *Burl. Mag.* Sept. 1907.) (German versions : G. A. Böckler, 1652 ; Nitzsche, 1765 ; J. C. Guetle, 1795. Dutch : Amsterdam, 1662. English: W. Faithorne, 1662. Spanish : Ruida, 1761.)
BROWNE, A. Whole Art of Drawing . . . and Etching. London, 1660.
Ars Pictoria. 2nd ed. London, 1675.
FAITHORNE, W. The Art of Graveing and Etching. London, 1662. (Cf. Bosse, 1645.)
Albert Durer Revived . . . Printed for J. Garrett. London, n.d. (about 1670?) (contains Hollar's directions for an etching ground).
SALMON, William. Polygraphice. London, 1st ed. 1672 (or 1670?) ; 8th ed. 1701.
The Excellency of the Pen and Pencil. Printed for Dorman Newman. London, 1688. (Contains description and plate of early mezzotint tools.)
LE BLON, J. C. Coloritto ; or, the Harmony of Colouring in Painting reduced to mechanical practice under easy precepts and infallible rules (English and French). London, n.d. [between 1723-26 ?].
HAUCKWITZ, J. Graveing and Copper-plate Printing. London, 1732.
BARROW, J. Dictionarium Polygraphicum. London, 1735 (and 1758). (*E.g.* for glass-prints, under heading of *Mezzotint.*)
Sculptura Historico-Technica. (Extracted from Faithorne, etc.) London, 1747.
GAUTIER D'AGOTY, J. Lettre concernant le nouvel art d'imprimer les tableaux avec quatre couleurs. Paris, 1749.
Deux lettres à l'auteur du Mercure. Paris, 1756.
Extrait critique de "l'Art d'imprimer les tableaux." *See* his Observations Périodiques, 1756, p. 240.

GAUTIER DE MONTDORGE, A. L'Art d'imprimer les tableaux. Traité d'après les écrits, les opérations, et les instructions verbales de J. C. Le Blon (French and English). Paris, 1756 (and 1768).

The Handmaid to the Arts. [Ed. by Robert Dossie.] London, 1758 (and 1764). (Vol. ii., Engraving, etc.)

DIDEROT, and D'ALEMBERT. Encyclopédie. Paris (Neuchatel), 1751, etc. (Articles by Watelet and Montdorge under *graver, gravure*, etc., vol. vii. 1757 (1767 ?), and Planches, vol. v. (1767). *Imprimerie en taille-douce*, vol. viii., 1765, and Planches, 1769.)

BONNET, Louis. Le Pastel en gravure inventé et exécuté par L. B. Paris, 1769.

BYLAERT, J. J. Nieuwe Manier om Plaet-tekeningen in 't Koper te brengen. Leyden, 1772. Also French ed., Leyden, 1772 ; German, 1773. (Describes J. C. François' crayon manner, and J. J. B.'s variations.)

STAPART. L'Art de graver au pinceau. Paris, 1773. (German tr., Nuremberg, 1780.)

LE PRINCE, J. B. Découverte du procédé de gravure au lavis. Paris, 1780. (Prospectus.)

Encyclopédie Méthodique. Paris, 1787, etc. (Articles by Levesque and Chereau under *graver*, etc., Beaux-Arts, vol. i. (1788) ; Planches (1805), mostly adapted from those in Diderot.)

TISCHBEIN, J. H. Abhandlung über die Aetzkunst. Cassel, 1790.

GUETLE, J. C. Die Kunst in Kupfer zu stechen. Nuremberg, 1795. (Vol. i. partly a translation from Bosse.)

MILIZIA, Francesco. *See* III., Milizia, 1797.

The Artist's Assistant. Birmingham (and London), 1801. (Also various other editions.)

GREEN, J. H. Complete Aquatinter. London, 1801.

MEYNIER, J. H. Aetzkunst besonders in Crayon und Tuschmanier. Hof, 1804.

HODSON, T., and DOUGALL, J. The Cabinet of the Arts. London, 1805.

ORME, Edward. An Essay on Transparent Prints. London, 1807.

HUBAND, W. Critical and Familiar Notices on the Art of Etching (with prints by the author). Dublin, 1810.

KELLER, K. U. Neue Art den Tusch in Kupfer nachzuahmen. Stuttgart, 1815.

PARTINGTON, C. F. The Engraver's Complete Guide. London, 1825.

LONGHI, G. *See* III., Longhi, 1830.

DELESCHAMPS, P. Mordans, vernis et planches. Paris, 1836.

BARTH, C. Die Kupferstecherei (Pt. I. tr. of Longhi's Calcografia ; Pt. II. practical instructions). Hildburghausen, 1837.

FIELDING, T. H. Art of Engraving. London, 1841 (and 1844).

VALLARDI, F. S. Manuale del raccoglitore e del negoziante di stampe. Milan, 1843.

STANNARD, W. J. The Art Exemplar. A guide to distinguish one species of Print from another. London, n.d. [about 1860]. (Very rare ; copies in the B.M., and in coll. of Mr. H. C. Levis, only the latter showing the author's name.)

POTÉMONT, A. Martial ("Martial"). Lettre sur les éléments de la gravure à l'eau-forte. Paris, 1864. (Printed from four etched plates.)

Nouveau Traité de la gravure à l'eau-forte. Paris, 1873.

LALANNE, M. Gravure à l'eau-forte. Paris, 1866. 2nd ed., 1878. (Engl. tr. with additions, by S. R. Koehler. Boston, U.S.A., 1880.)

BLANC, Charles. Grammaire des arts du dessin. Paris, 1867 (and Gazette XXI.). (Engl. tr., K. N. Doggett. Chicago, 1874.)

HAMERTON, P. G. Etcher's Handbook. London, 1871.

Drawing and Engraving. London, 1892.

LOSTALOT, A. de. Procédés de la gravure. Paris, 1882.

DELÂTRE, A. Eau-forte, pointe-sèche et vernis mou (lettre de Rops sur le vernis mou). Paris, 1887.

SHORT, Frank. The Making of Etchings. London. 1888.

Etchings and Engravings. London, 1911.

HERKOMER, (Sir) Hubert von. Etching and Mezzotint Engraving. London, 1892.

KOEHLER, S. R. Old and Modern Methods of Engraving. Boston, 1894.

VILLON, A. M. Manuel complet du graveur. (Encyclopédie Roret.) Paris, 1894.

SINGER, H. W., and STRANG, W. Etching, Engraving, etc. London, 1897.

ZIEGLER, Walther. Die Techniken des Tiefdruckes. Halle, 1901.
VITALINI, F. L' Incisione su metallo. Rome, 1904. (Introduzione, L' Incisione ai giorni nostri de V. Pica.)
COURBOIN, F. L'Eau-forte. *Art et Décor.* xix. (1906), 129.
NEWBOLT, F. The Art of Printing Etchings. *Studio,* Nov. 1906.
GARIAZZO, P. A. La stampa incisa. Turin, 1907.
ROSENBERG, Marc. Gesch. der Goldschmiedekunst. Niello. Darmstadt, 1907.
STRUCK, Hermann. Die Kunst des Radierens. Berlin, 1908.
PREISSIG, Vojt. Zur Technik der farbigen Radierung und des Farben-Kupferstichs. Leipzig, 1909.
Guide to the Processes and Schools of Engraving. [By A. M. Hind.] London (British Museum), 1914.
HUBBARD, E. H. On making and collecting Etchings. London and Ringwood, 1920.

Reference may be made to works by the following authors :—

J. HASSELL (cr., aq., et., 1811, 1824, 1826), DUCHESNE (1828), A. M. PERROT (1830, 1844, 1865), M. HENRICI (1834), BERTHIAUD (printing, 1837), C. H. SCHMIDT (1838), F. A. W. NETTO (1840), H. ALKEN (et., 1849), A. ASHLEY (et., 1849, 1851), S. E. FULLER (1879), R. S. CHATTOCK (1880), H. R. ROBERTSON (et., 1883), F. ROLLER (et., 1888), H. PATON (et., mezz., 1894 and 1909), A. CURTIS (1902), H. BOUTET (1904), A. SEIBOLD (1909), G. T. PLOWMAN (1914).

THE RESTORATION OF PRINTS.

BONNARDOT, A. Essai sur l'art de restaurer les estampes et les livres. Paris, 1846 and 1858.
SCHALL, J. F. Ausführliche Anleitung zur Restoration vergelbter, fleckiger und beschädigter Kupferstiche. *Archiv,* ix. 109.
BOLAS, T. Restoring and Cleaning of Pictures, Prints, etc. London, 1901.
GUNN, M. J. Print Restoration and Picture Cleaning. London, 1911.
(The amateur should beware of being guided by the scanty literature of a subject, which is only scientifically understood by a few practical restorers.)

PAPER AND WATERMARKS.

BREITKOPF, J. G. I. Versuch den Ursprung der Spielkarten, die Einfuhrung des Linienpapiers . . . zu erforschen. Leipzig, 1784.
JANSEN, H. J. *See* III. Jansen, 1808.
HERRING, R. Paper and Paper-making. London, 1855.
SOTHEBY, S. L. Principia Typographica. London, 1858. (Vol. iii. watermarks.)
VALLET-DE-VIRIVILLE, A. L'histoire du papier. *Gazette,* ii. (1859), iii., iv.
MIDOUX, E., and MATTON, A. Filigranes des papiers employés en France au 14e et 15e siècles. Paris, 1868.
BRIQUET, C. M. Papiers et filigranes des Archives de Gênes 1154-1700. Geneva, 1888.
De la valeur des filigranes . . . comme moyen de déterminer l'âge de documents. Geneva, 1892.
Les Filigranes. Dictionnaire historique des marques de papier . . . jusqu'en 1600. 4 vols. Paris, London, etc., 1907.
MARMOL, F. del. Dictionnaire des filigranes. Namur, 1900.
BLANCHET, A. Essai sur l'histoire du papier. Paris, 1901.

III. DICTIONARIES AND GENERAL HISTORY

BOSSE, A. Sentimens sur la distinction des diverses manières de peinture, dessein, et graveure. Paris, 1649.
EVELYN, J. Sculptura. London, 1662 (2nd ed. 1755; reprint. Oxford, 1906). (Contains the earliest published note on mezzotint, giving Prince Rupert as the inventor.)
MAROLLES, Michel de. Livre des peintres et graveurs. Paris (ab. 1677).

BALDINUCCI, F. Cominciamento e progresso dell' arte dell' intagliare in rame. Florence, 1686 (ed. 2ª . . . annotazioni di D. M. Manni, 1767).

LE COMTE, Florent. Cabinet de singularitez. Paris, 1699, 1700.

ORLANDI, P. A. Abecedario pittorico. Bologna, 1719 (*cf.* Mariette, 1851). Origine e progressi della stampa. Bologna, 1722.

Repertorium sculptile-typicum. (Collection of marks and cyphers, from Orlandi.) London, 1730.

Sculptura Historico-Technica, or the History and Art of Ingraving . . . extracted from Baldinucci, Florent Le Comte, Faithorne, Abecedario pittorico, etc. (Containing the Repertorium Sculp.-typ.) London, 1747.

HUMBERT, A. von. Origine de la gravure. Berlin, 1752.

MARCENAY de GHUY, A. de. Idée de la gravure. Paris, 1764.

BASAN, P. F. Dictionnaire des graveurs. Paris, 1767 (including catalogues of Jordaens, C. Visscher, and Rubens). (2nd ed. 1789 contains numerous prints from old original plates in Basan's possession ; ed. 1809, with preface by P. P. Choffard).

GILPIN, W. Essay on Prints. 1768 (4th ed. 1792).

HEINECKEN, C. H. von. Nachrichten von Künstlern und Kunstsachen. 2 vols. Leipzig, 1768-69. (Vol. i. contains Vasari's life of Marcantonio, annotated ; and list of engravings af. Michelangelo ; vol. ii., list of engravings af. Raphael.)

Idée générale d'une collection d'estampes. Leipzig and Vienna, 1771.

Dictionnaire des artistes dont nous avons des estampes. 4 vols. (Incomplete, A–Diz.) Leipzig, 1778-90.

Neue Nachrichten. Leipzig, 1786. (Contains Entwurf einer Kupferstichgeschichte.)

A Chronological Series of Engravers. Cambridge, 1770.

FUESSLI, J. C. Verzeichniss der vornehmsten Kupferstecher. Zurich, 1771.

GORI GANDELLINI, G. Notizie degli intagliatori. 3 vols. Siena, 1771. (2nd ed. by L. de Angelis. 15 vols. Siena, 1808-16.)

MURR, C. G. von. Journal zur Kunstgeschichte. Nuremberg, 1775, etc. (Part II., 1776, contains "Geschichte der Kupferstechkunst bis auf die Zeiten A. Dürer's.") Beyträge zu der Geschichte der ältesten Kupferstiche. Augsburg, 1804.

FUESSLI, J. R. (completed by H. H. Fuessli). Allgem. Künstlerlexicon. Zurich, 1779-1824 (earlier editions of parts, 1763, 1767-77, etc.).

STRUTT, J. Dictionary of Engravers. London, 1785-86.

HUBER, M. Notices générales des graveurs. Dresden, 1787.

HUBER, M., ROST, C. C. H., and MARTINI, C. G. Manuel des curieux et des amateurs d'art. 9 vols. Zurich, 1797-1808 (German ed., Zurich, 1796-1808).

WATELET, C. H., and LEVESQUE, P. C. Dictionnaire. 5 vols. Paris, 1792.

MILIZIA, F. Della incisione delle stampe. Bassano, 1797 (tratto dal suo "Dizionario delle Belle Arti").

FUESSLI, H. R. Verzeichniss der besten . . . Kupferstiche. Zurich, 1798-1806.

ZANI, P. Materiali per servire alla storia dell' origine e de' progressi dell' incisione. Parma, 1802.

Enciclopedia metodica delle Belle Arti. 28 vols. Parma, 1817-24. (Part I. contains a very extensive dictionary of engravers' names, with the briefest biographical details ; Part II. consists of a subject index, covering Old and New Testaments.) Zani's MS. continuation of the *Enciclopedia* is in the Parma Library, MS. 3618.

BARTSCH, Adam. Le Peintre-graveur. 21 vols. Vienna, 1803-21. (Suppl. par R. Weigel, Leipzig, 1843 ; Zusätze von J. Heller, Nuremberg, 1854.) Reprint, in 18 vols., Würzburg, 1920.

Anleitung zur Kupferstichkunde. Vienna, 1821. (Note in Part II. list of "betrügliche Copieen," tr. and augmented by C. Le Blanc, Paris, 1849).

BAVEREL, J. P., and MALPEZ. Notice sur les graveurs. Besançon, 1807-8.

DAVID, Emeric. Notice historique sur la gravure. Paris, 1808. (Also in the "Musée Français," vol. iii.)

JANSEN, II. Essai sur l'origine de la gravure . . . suivi de recherches sur l'origine du papier, etc. Paris, 1808.

BRYAN, Michael. Dictionary of Painters and Engravers. London, 1816. (Ed. Stanley, 1849, etc.; R. E. Graves and W. Armstrong, 1886-89, and 1898 ; G. C. Williamson, 1903-5.)

OTTLEY, W. Y. Inquiry into the Origin and Early History of Engraving. London, 1816. Notices of Engravers. London, 1831 (covering A–Baldung, in dictionary form).

DIBDIN, T. F. Bibliographical Decameron. London, 1817.
Antiquarian . . . Tour. London, 1821.
Catalogo dei più celebri intagliatori in legno e in rame. Milan (presso P. e G. Vallardi), 1821.
JOUBERT, J. E. Manuel de l'amateur d'estampes. Paris, 1821.
MUSSEAU, J. C. L. Manuel des amateurs. Paris, 1821.
HELLER, J. Praktisches Handbuch für Kupferstichsammler. Bamberg, 1823-25. (2ᵗᵉ Aufl. Leipzig, 1850; cf. Andresen, 1870; Wessely, 1885).
DODD, Thomas. Connoisseur's Repertory, or a Biographical History of Painters, Engravers, etc. 6 vols. London [1824].
QUANDT, J. G. von. Entwurf zu einer Geschichte der Kupferstechkunst. Leipzig, 1826.
LONGHI, G. Calcografia. Milan, 1830 (for German translation, see II., Barth, 1837).
TICOZZI, S. Dizionario degli architetti, sculptori, pittori, intagliatori. 2 vols. Milan, 1830-33.
CICOGNARA, L. Memorie spettanti alla storia della calcografia. Prato, 1831.
DUCHESNE, J. Voyage d'un iconophile. Paris, 1834.
NAGLER, G. K. Allgemeines Künstler-Lexicon. 22 vols. Munich, 1835-52. (The most extensive of all the dictionaries of engravers; of great value for the notices on the less generally known artists.)
Die Monogrammisten. 5 vols. Munich, 1858-79.
ZANETTI, A. Le premier siècle de la calcographie (ou Catalogue raisonné des estampes du Cabinet Cicognara). Venice, 1837.
MABERLEY, J. The Print Collector. London, 1844. (Another ed. by R. Hoe, containing part of Fielding's Treatise on Engraving. New York, 1880.)
Printsellers' Association. An Alphabetical List of Engravings declared at the Office of the P.A., London. Vol. i. 1847-91, London, 1892; vol. ii. 1892-93, London, 1894. Index of Painters and Engravers to vols. i. and ii., 1894.
PASSAVANT, J. D. Zur Kunde der ältesten Kupferstecher. Deutsch. Kunstbl. I. (1850).
PASSAVANT, J. D. Le Peintre-graveur. 6 vols. Leipzig, 1860-64. (Supplements Bartsch, on 15th and 16th century engravers.)
LISCH, G. C. F. Messingschnitt and Kupferstich des Mittelalters. Deutsch. Kunstbl. II. 21. III. 366.
MARIETTE, P. J. Abecedario (based on Orlandi). See P. de Chennevières, Archives de l'art français. Paris, 1851-60.
SOTZMANN, J. D. F. Einige Aufklärungen und Berichtigungen über den Inhalt alter Kupferstiche. Deutsch. Kunstbl. II. (1851) 294, 302.
RENOUVIER, J. Types et manières des maîtres graveurs. Montpellier, 1853-56.
LE BLANC, C. Manuel de l'amateur d'estampes. 4 vols. Paris, 1854-89.
EVANS, A. E. and Sons. Fine Art Circular and Print Collector's Manual. Catalogue of nearly 6000 Etchings and Engravings. On sale. 403 Strand. With an Appendix consisting of a Catalogue raisonnée of nearly 400 prints unknown to Bartsch. London. (The 1st part n. d. ; the Appendix with separate title and pagination, 1857.)
SCHUCHARDT, C. Gebührt die Ehre der Erfindung des Papierabdrucks von gravirten Metallplatten den Deutschen oder den Italienern? Archiv, iv. (1858), 47.
HARZEN, E. Über die Erfindung der Ätzkunst. Archiv, v. 119.
OTTLEY, H. Dictionary of Recent and Living Painters and Engravers. London, 1866.
GAY, Jules. Iconographie des estampes à sujets galants. Geneva, 1868.
HAMERTON, P. G. Etching and Etchers. London, 1868. (3rd ed. 1880.)
The Graphic Arts. London, 1882.
DUPLESSIS, G. Merveilles de la gravure. Paris, 1869. (Engl. tr., London, 1871; Spanish tr., Paris, 1873.)
Histoire de la gravure. Paris, 1880.
Coup d'œil sur l'histoire de la gravure. Catalogue de l'Exposition Retrospective. Paris, 1881.
ANDRESEN, A. Verzeichnis der Kunstfreunde welche auf Kupfer radirt und gestochen . . . haben. Archiv, ix. (1863) 34. (Nachtrag, von D. Gwinner, Archiv, x. 315.)
Handbuch für Kupferstichsammler (auf Grundlage der 2ᵗᵉⁿ Aufl. von Heller) (vol. ii. ed. by J. E. Wessely). Leipzig, 1870-73. (Cf. Wessely, 1885.)

400 GENERAL BIBLIOGRAPHY

MEYER, Julius. Allgemeines Künstlerlexicon. 3 vols. Leipzig, 1872-85. (Incomplete : A–BEZ.)

ROSE, J. A. Collection Illustrative of the History and Practice of Etching. (Catalogues of Exhibitions, Liverpool, 1874, Birmingham, 1874, Southampton, 1875.)

WILLSHIRE, W. H. Introduction to the Collection and Study of Ancient Prints. London, 1874. 2nd ed., revised and enlarged, 1877.

BAKER, W. S. Origin and Antiquity of Engraving. Boston, 1875.

WESSELY, J. E. Anleitung zur Kenntniss und zum Sammeln der Werke des Kunstdruckes. Leipzig, 1876.

Supplemente zu den Handbüchern des Kupferstichkunde. *Repert.*, 1881, pp 120, 127.

Engänzungsheft zu Andresen-Wessely's Handbuch (1870-73). Leipzig, 1885.

CLEMENT, C. E., and HUTTON, L. Artists of the nineteenth century. Boston and London, 1879.

HADEN, F. Seymour. About Etching. London (Fine Art. Soc.), 1879.

The Relative Claims of Etching and Engraving to Rank as Fine Arts. London (Society of Arts), 1883.

The Art of the Painter-Etcher. First and second presidential addresses, Roy. Soc. Painter-Etchers. London, 1890-91.

APELL, Aloys. Handbuch für Kupferstichsammler (oder Lexicon der vorzüglichsten Stecher des XIXten Jahrhunderts). Leipzig, 1880.

PORTALIS, R., and BERALDI, H. Les Graveurs du 18e siècle. Paris, 1880-82.

DUTUIT, E. Manuel de l'amateur d'estampes. Paris, 1881-88.

DELABORDE, H. La Gravure. Paris [1882] (Engl. tr., 1886).

FRANTZ, A. Geschichte des Kupferstichs. Magdeburg, 1883.

LASCHITZER, S. Wie soll man Kupferstiche und Holzschnittkataloge verfassen? *Mitteil. des Instituts für Österreich. Geschichtsforschung*, v. 565 (Innsbruck, 1884).

BERALDI, H. Les Graveurs du 19e siècle. 12 vols. Paris, 1885-92.

Propos de bibliophile. Gravure, lithographie, reliure. Paris, 1901.

KOEHLER, S. R. Etching. London, New York, 1885.

Über die Erfindung der Ätzkunst. *Zeitschrift*, 2nd ser. ix. 30.

MÜNTZ, E. Histoire de l'art pendant la Renaissance. Paris, 1889.

RUSKIN, J. Ariadne Florentina. Six lectures on wood and metal engraving, delivered 1872. London, 1890 (and 1907).

LÜTZOW, K. von. Der Kupferstich der Gegenwart in Europa. Vienna, 1891.

GRAUL, R. Die Radierung der Gegenwart in Europa und Nord-America. Vienna, 1892.

LIPPMAN, F. Über die künstlerische und kunstgeschichtliche Bedeutung der Abdrucksgattungen von Kupferstichen. *Sitzungsberichte*, 1891, v. 21-24. (*Cf. Chronik*, iv. 41.)

Der Kupferstich. Berlin, 1893. (3te Aufl. 1905 ; Engl. tr. M. Hardie, 1907).

CHAPIN, W. O. Masters and Masterpieces of Engraving. New York, 1894.

MÜLLER, H. A., and SINGER, H. W. Allgemeines Künstler-Lexicon. Frankfurt, 1895-1901 (Nachträge, 1906).

SINGER, H. W. Geschichte des Kupferstichs. Magdeburg, Leipzig, 1895.

Der Kupferstich. Bielefeld and Leipzig, 1904.

Die moderne Graphik. Leipzig, 1914 (2nd ed. 1920).

TALLBERG, Axel. Modern Etsningskont. *Meddelanden* III (1896), 64.

WEDMORE, F. Fine prints. London, 1896 (and 1905).

WHITMAN, A. Print-Collector's Handbook. London, 1901 (3rd ed. 1903). (6th ed., M. C. Salaman, 1912.)

Modern Etching and Engraving. *Studio*, Summer Number. London, 1902.

BOURCARD, G. A travers cinq siècles de gravures. Paris, 1903.

KRISTELLER, P. Kupferstich und Holtzschnitt in vier Jahrhunderten. Berlin, 1905.

DELTEIL, Loys. Le Peintre-graveur illustré, 19e et 20e siècles. (Vol. i., J. F. Millet, T. Rousseau, J. Dupré, Jongkind ; vol. ii., Meryon ; iii., Ingres and Delacroix ; iv., Zorn ; v., Corot ; vi., Rude, Carpeaux, Barye, Rodin ; vii., Huet ; ix., Dégas.) Paris, 1906, etc. (in progress).

Manuel de l'amateur d'estampes du 18e siècle. Paris, 1910.

THIEME, U., and BECKER, F. Allgemeines Lexikon der bildender Künstler. Leipzig, 1907, etc. (in progress).

HAYDEN, A. Chats on Old Prints. London, 1908.

ROSENTHAL, L. La Gravure. Paris, 1908.
WEITENKAMPF, F. How to appreciate Prints. New York, 1908.
HIND, A. M. Engravings and their States. *Burl. Mag.* xv. (1909) 25, 27. (*Cf.* xv. 120, 187.)
 Arrangement of Print Collections. *Burl. Mag.* xix. (1911), 204.
LOGA, V. von. Ordnung und Katalogisierung eines Kupferstichkabinetts. Berlin (Kgl. Museum), 1910.
WEIXLGÄRTNER, A. Ungedruckte Stiche. Vienna Jahrb. xxix. (1911), Heft 4.
RICHTER, Emil H. Prints, their Technique and History. Boston (U.S.A.), 1914.
SALAMAN, M. C. The Great Etchers from Rembrandt to Whistler. *Studio*, Winter Number. London, 1913-14.
 The Charm of the Etcher's Art. *Studio.* London, 1920.
Associazione Italiana Acquefortisti e Incisori. Espozione, Londra, 1916. Sessanta Tavole e Xilografie originali. Milan, 1916.
CARRINGTON, F. Engravers and Etchers. The Scammon Lectures. Chicago, 1917.
SIMPSON, T. Modern Etchings and their Collectors. London, 1919.
PENNELL, J. Etchers and Etching. London, 1920.

IV. VARIOUS COUNTRIES

AMERICA.
 BAKER, W. S. American Engravers. Philadelphia, 1876.
 KOEHLER, S. R. American Etchers. *Amer. Art. Rev.*, 1880-81.
 Original Etchings by American Artists. New York [1884].
 BOSTON, Museum of Fine Arts. Catalogues of Exhibitions: American Etchings (1881); Women Etchers of America (1887); Early Engravers in America (1904-5).
 HITCHCOCK, J. R. W. Etching in America. New York, 1886.
 VAN RENSSELAER, M. G. (Mrs. S.), and KEPPEL, F. American Etchers. New York, 1886.
 PAINE, N. Remarks on the Early American Engravings . . . in the Library of the American Antiquarian Soc. (1640-92). *Proceedings of the A. A. Soc.* xvii. part 3.
 STAUFFER, D. McN. American Engravers upon Copper and Steel. 2 vols. Grolier Club, New York, 1907.
 Grolier Club, New York. Catalogue of an Exhib. of early American engraving (1727-1850). 1908.
 WEITENKAMPF, F. American Graphic Art. New York, 1912.
 ILLUSTRATED CATALOGUE OF ETCHINGS BY AMERICAN ARTISTS, with biographical sketches by H. H. Tolerton. Chicago (A. Roullier's Art Galleries), 1913.
 YEAR BOOK OF AMERICAN ETCHING, with introd. by F. Watson. Illustrated with 100 reproductions of etchings shown at the Annual Exhib. of the Assoc. of American Etchers. London, 1914.

AUSTRIA.
 KUZMANY, K. M. Jüngere österreichische Graphiker. *Graph. Künste*, xxx. 63, 91.

BOHEMIA.
 DLABACZ, G. J. Allgemeines . . . Künstler-Lexikon für Böhmen. Prague, 1815.
 DOLENSKÝ, A. Die Entwickelung der graphischen Künste in den Böhm. Ländern. Führer, Museum des Königr. Böhmens. Prague [1910?].

BRITISH ISLES.
 WALPOLE, Horace. Catalogue of Engravers who have been born or resided in England. Strawberry Hill, 1763 (later editions, 1765, 1782, 1786, and 1794; also incorporated in later editions of the "Anecdotes." The first three editions were not given a volume number in relation to the "Anecdotes," but from "Directions to the Binder" were evidently regarded as belonging to the same work).
 Anecdotes of Painting in England. 4 vols. Strawberry Hill, 1762-71. (2nd ed., 1765-71; 3rd ed. in 5 vols., the fifth being the "Catalogue of Engravers"; 4th, 1786; ed. J. Dallaway, 1826-28; ed. J. Dallaway and R. Wornum, 1849.)
 GRANGER, J. Biographical History of England. London, 1769-74. (*See* Class X., Artists.)
 PASQUIN, Anthony. Professors of Painting, etc., in Ireland [London, 1796].
 Memoirs of the Royal Academicians. London, 1796.

THE BRITISH SCHOOL OF ENGRAVING. *Arnold's Library*, iii. (1832) 379, iv. 1, 67.
SANDBY, W. History of the Royal Academy of Arts, with biogr. Notices of the Members. London, 1862.
REDGRAVE, S. Dictionary of Artists of the English School. London, 1874. (Revised ed., 1878.)
FAGAN, L. Engraving in England, illustrated by 100 facsimiles. 3 vols. London, 1893.
WEDMORE, F. Etching in England. London, 1895.
LINDSAY, James Ludovic (Earl Crawford). English Broadsides, 1505-1897. Aberdeen, 1898.
Grolier Club, New York. Exhibition Catalogue . . . of Engraved Titles . . . publ. in England during the 16th and 17th centuries, 1898.
VAUGHAN, W. E. Autobiographica, with a gossip on the lost art of printing in colours and notices of the most important engravers . . . illustrated from engravings by J. R. Smith, C. White, and W. Bond. 1900.
CUST, L. Foreign Artists in London, 1560-1660. (Vol. vii. of the *Proceedings of the Huguenot Society of London*, 1903.)
GILBEY, Sir Walter. The Royal Academy and Engravers. *The Times*, April 15, 1903.
COLVIN, S. Early Engraving and Engravers in England (1545-1695). (With a list of works of engravers, 1545-1650, by A. M. Hind ; also separately printed.) London, 1905.
GOSSE, E. W. British Portrait-Painters and Engravers of the 18th Century. Paris, 1905.
COXHEAD, A. C. Thomas Stothard. London, 1906.
SALAMAN, M. C. The Old Engravers of England. London, 1906.
HIND, A. M. Bartolozzi and other stipple Engravers working in England. Great Engravers. London, 1912.
See also Dictionary of National Biography (1885-1901) ; MSS. of George Vertue (largely but not fully incorporated in Walpole's Anecdotes) ; MSS. of Thomas Dodd (the two preceding in the B.M.) ; V. Colour-prints, Hardie, 1906 ; V. Portraits, British ; VI. A., London, Victoria and Albert Museum.

DENMARK.

WEILBACH, P. Dansk Konstnerlexikon. Copenhagen, 1877-78.
BRICKA, G. F. Dansk Biografisk Lexikon. Copenhagen, 1887-1905.
KROHN, F. C. Samlinger til en beskrivende Fortegnelse over Danske Kobberstik, Raderinger m.m. I. Copenhagen, 1889.

FRANCE.

CHOFFARD, P. P. Notice historique sur la gravure en France. Paris, 1804 (also in Basan's Dictionnaire, ed. 1809).
ROBERT-DUMESNIL, A. P. F. Le peintre-graveur français. Paris, 1835-71. (Continué par P. de Baudicour. Paris, 1861.)
BONNARDOT, A. La gravure en France. Paris, 1849.
DUPLESSIS, G. La gravure en France. Paris, 1861.
La gravure de portrait en France. Paris, 1875.
HAMERTON, P. G. Modern Etching in France. *F. A. Quarterly*, ii. (1864), 69.
BREBAN, Corrad de. Les graveurs troyens. Troyes, 1868.
GONCOURT, E. and J. de. Les vignettistes (Gravelot, Cochin, Eisen, Moreau). Paris, 1868.
L'art du 18ᵉ siècle. Paris, 1873-74 (3ᵉ éd. 1880-82).
GUIFFREY, J. J. Collections des livrets des anciennes expositions depuis 1673 jusqu'en 1800. Paris, 1869-73.
BOCHER, E. Les gravures françaises du 18ᵉ siècle. 6 vols. Paris, 1875-82.
DIDOT, A. F. Les graveurs de portraits en France. Catalogue de la Coll. de A. F. D. Paris, 1875, 1877.
CHAVIGNERIE, E. B. de la, and AUVRAY, L. Dictionnaire général. Paris, 1882, 1885 (Suppl. 1897).
PINSET, R., and D'AURIAC, J. Histoire du portrait. Paris, 1884.
BOURCARD, G. Les estampes du 18ᵉ siècle. École française. Paris, 1885.
Dessins, gouaches, estampes . . . du 18ᵉ siècle. Paris, 1893.

CHESNEAU, E. École française. Les estampes en couleurs du 18e siècle. Paris, 1885-89 (portfolio of reproductions).
DELIGNIÈRES, E. Recherches sur les graveurs d'Abbeville. Paris, n.d. (1886?).
Les graveurs Abbevillois. Amiens, n.d. (1889?).
JACQUOT, A. Les Graveurs lorrains. Paris, 1889.
LEHRS, M. Ein französischer Kupferstich des XV. Jahrhunderts. *Chronik*, ii. (1889) 2.
HERBET, F. Les graveurs de l'école de Fontainebleau. *Annales de la Soc. du Gatinais*. Fontainebleau, 1896-1902.
RONDOT, N. Graveurs d'estampes sur cuivre à Lyon au 17e siècle. 1896.
MOUREY, G. Coloured Etching in France. *Studio*, xxii. 3, 94.
DILKE (Lady). French Engravers of the 18th Century. London, 1902.
BOUCHOT, H. Einige Inkunabeln des Kupferstiches aus dem Gebiete von Douai. *Zeitschrift*, 2nd ser. xv. (1904), 58.
NEVILL, R. French Prints of the 18th Century. London, 1908.
HOMAIS, R. L'Évolution de l'estampe française au 19e siècle. Rouen, 1909.
LAWRENCE, H. W., and DIGHTON, B. L. French Line Engravers of the late 18th Century. London, 1910.
BLUM, A. Rapports des miniaturistes français du xve siècle avec les premiers artistes graveurs. *Revue de l'Art Chrétien*, 1911, No. 5.
HIND, A. M. Watteau, Boucher, and the French Engravers and Etchers of the earlier 18th Century. Great Engravers. London, 1911.
Fragonard, Moreau le Jeune, and French Engravers of the later 18th Century. Great Engravers. London, 1913.
MODEL, J., and SPRINGER, J. Der französische Farbenstich des XVIII. Jahrhunderts. Stuttgart, 1912. (50 colour plates.)
COURBOIN, F. L'Estampe française. Bibl. de l'art du 18e siècle. Brussels and Paris, 1914.
DUPORTAL, Jeanne. Études sur les livres à figures édites en France de 1601 à 1660. Paris, 1914.

GERMANY.

BECKER, C. Missalien des ehemaligen Hochstifts Würzburg. *Archiv*, ii. (1856), 184 (re-engravings printed in books of the 15th century).
ANDRESEN, A. Der deutsche Peintre-graveur. 5 vols. Leipzig, 1864-78.
Die deutschen Maler-Radirer des 19. Jahrhunderts. 5 vols. Leipzig, 1878. (Nachträge ed. Pückler-Limpurg, *Mitteil.* 1907, p. 39.)
STIASSNY, Robert. Die Kleinmeister und die italienische Kunst. *Chronik*, iii. 18, etc.
LÜTZOW, C. v. Geschichte des deutschen Kupferstiches. Berlin, 1891.
WINKLER, A. Die Gefäss- und Punzenstecher der deutschen Hochrenaissance. *Jahrb.* xiii. (1892), 93.
RÓZYCKI, K. v. Die Kupferstecher Danzigs. Danzig, 1893.
KUTSCHMANN, T. Geschichte der deutschen Illustration. Goslar, 1900, etc.
SCHIEFLER, G. Verzeichnis des graphischen Werks neuerer Hamburgischer Künstler bis 1904. Hamburg, 1905.
STEINACKER, K. Die graph. Künste in Braunschweig und Wolfenbüttel während der letzten drei Jahrhunderte. *Braunschweig. Jahrb.* 1906.
WUSTMANN, G. Der Leipziker Kupferstich im 16. 17. und 18. Jahrhundert. Leipzig, 1907.
SINGER, H. W. Die Kleinmeister. Bielefeld and Leipzig, 1908.
PAULI, G. Inkunabeln der deutschen und niederländischen Radierung. *Graph. Gesellsch.*, Berlin, 1908.
DODGSON, C. Notes on Early German Etchings. *Burl. Mag.* xv. 174.
VOSS, H. Aus der Umgebung A. Altdorfers und W. Hubers. Ein Beitrag zur Kenntnis der Donau-stil Graphik. *Mitteil.* 1909, pp. 52, 73.
WALDMANN, E. Die Nürnberger Kleinmeister. Leipzig, 1911.

GERMANY, FRANCE, AND THE NETHERLANDS.

LEHRS, M. Die ältesten deutschen Spielkarten. Dresden, 1885.
Repert. ix. (1886) 2, xii. 21 (re-engravings printed in books of the 15th century).

Deutsche und niederländ. Kupferstiche des 15. Jahrh. in kleineren Sammlungen. *Repert.* 1888-94.
Geschichte und kritischer Katalog des deutschen, niederländischen und französischen Kupferstiches im 15. Jahrhundert. Vienna, 1908 (in progress).
Model-Kopien nach frühen Kupferstichen. *Kunstchronik*, April 11, 1919.
Beiträge zum Werk des primitiven Kupferstiches. *Jahrb.* 1920, p. 189.
SCHMIDT, W. Zur "altkölnischen" Kupferstichschule. *Chronik*, iii. 59.
GEISBERG, M. Beiträge. *Repert.* xxii. 188.
Die Anfänge des deutschen Kupferstiches und der Meister E.S. Leipzig [1909].
SPRINGER, J. Gothic Alphabets. *Chalc. Soc.*, 1897.
BENZIGER, —. Unbekannte Kupferstiche des 15. Jahrh. in der Stadtbibl. zu Bern. *Monatshefte*, v. (1912) 230.
BODE, W., and VOLBACH, W. F. Die gotische Model. *Jahrb.* 1918.
VOLBACH, W. F. Über die Beziehungen der gotischen Model zu den frühen Kupferstichen. *Kunstchronik*, 21st March 1919.
ZIMMERMANN, H. Rheinischer Tonmodel und frühe Kupferstiche. *Kunstchronik*, 21st March 1919.
See also VI. A. London, B. M., Willshire, and Nuremberg.

GERMANY, THE NETHERLANDS, AND ITALY.

LEHRS, M. Italienische Copien nach deutschen Kupferstichen des 15. Jahrhund. *Jahrb.* xii. (1891), 125.
Copie tedesche d' incisioni in rame italiane eseguite nel secolo 15. *Archivio* vi. (1893), 102.
HIND, A. M. Italienische Stiche des 15. Jahrhunderts nach nordischen Originalen. *Mitteil.* 1908, p. 1.

ITALY.

MALVASIA, C. C. Felsina Pittrice. Vite de' pittori bolognesi. Bologna, 1678 (pp. 63-131, Di Marcantonio et altri intagliatori bolognesi).
CUMBERLAND, G. Essay on . . . collecting the Works of the Ancient Engravers of the Italian School, accompanied by a Critical Catalogue. London, 1827.
ARCO, Carlo d'. Di cinque valenti incisori mantovani (the Sculptor family, G. Ghisi and A. Andreani). Mantua. 1840.
RUMOHR, C. F. von. Untersuchung der Gründe für die Annahme dass Maso di Finiguerra Erfinder . . . Leipzig, 1841.
PALGRAVE, F. T. Essay on the First Century of Italian Engraving (appended to 3rd English ed. of Kugler's Handbook of Painting. London, 1855).
CERROTI, F. Memorie per servire alla storia della incisione compilata nella descrizione e dichiarazione delle stampe . . . nella biblioteca Corsiniana. Rome, 1858.
GALICHON, E. Giuoco di Tarocchi. *Gazette*, ix. 143.
De quelques estampes . . . attribuées à Césare da Sesto. *Gazette*, xviii. 546.
DUPLESSIS, G. Mémoires sur 45 estampes de la collection Otto. *Mémoires des Antiquaires de France*, ser. iv. vol. vi. (1873), 215.
De quelques estampes de l'ancienne école milanaise. *Rev. Univ.* xv. 145.
CAMPORI, G. Gli intagliatori di stampe e gli estensi. *Atti e Mem. delle R.R. Dep. di st. p. per le prov. dell' Em.* vii. parte 2ª, p. 70.
KOLLOFF, E. *See* Baldini in Meyer's Künstler-Lexicon, 2te Band, 1878 (*see* III.).
DELABORDE, H. Gravure en Italie avant Marcantoine. Paris, 1882.
REID, G. W. Italian Engravers of the 15th Century reproduced. London, 1884.
FISHER, R. Introduction to a Catalogue of the Early Italian Prints in the British Museum. London, 1886.
LIPPMANN, F., and STRZYGOWSKI, J. Die Handzeichnungen zu Dante. Berlin, 1887.
GUBERNATIS, A. de. Dizionario degli artisti ital. recenti. Florence, 1889.
KRISTELLER, P. Una incisione in rame sconosciuta del secolo xv. *Archivio* v. (1892), 364.

Origine dell' incisione in Italia. *Archivio* vi. (1893), 391.
Italienische Niellodrucke und der Kupferstich. *Jahrb.* xv. 94.
Der venezianische Kupferstich im 15. Jahrhundert. *Mitteil.* 1907, p. 1.
Florentinische Zierstücke in Kupferstich aus dem XV. Jahrhundert. *Graph.*
 Gesellsch. Berlin, 1909.
Die Tarocchi. *Graph. Gesellsch.* Berlin, 1910.
Die lombardische Graphik der Renaissance. Berlin, 1913.
BADIA, Jodoco del. La Bottega di Alessandro di Francesco Rosselli merciaio e
 stampatore. *Miscellanea Fiorentina*, ii., No. 14, p. 24 (Florence, July 1894).
LIPPMANN, F. The Planets. *Chalc. Soc.*, 1895.
COLVIN, S. Florentine Picture Chronicle. London, 1898.
MASSÉNA, V. (Duc de Rivoli, Prince d'Essling), and MÜNTZ, E. Pétrarque et son
 influence sur les artistes. Paris, 1902.
WARBURG, A. (*Re* Otto prints, etc.) *Sitzungsberichte.* Berlin, Feb. 1905.
Delle "Imprese Amorose" (Otto prints, etc.) *Riv. d' Arte*, iii. (1905), July.
MÂLE, E. Une Influence des mystères sur l'art italien du 15e siècle. *Gazette*,
 1906, p. 89.
MESNIL, J. Over enkele vijftiend' eeuwsche gravuren. *Onze Kunst.* Nov. 1906.
VESME, A. de. Peintre-graveur italien (suite à Bartsch). Milan, 1906.
OZZOLA, L. Gli editori di stampe a Roma nei sec. xvi e xvii. *Repert.* xxxiii.
 400.
HIND, A. M. Manteque and the Italian Pre-Raphaelite Engravers. Great
 Engravers. London, 1911.
VOSS, H. Kompositionen des F. Salviati in der ital. Graphik des XVI. Jahrh.
 Mitteil. 1912, p. 30.
See also VI. A. London, British Museum, Hind.

THE NETHERLANDS.

KERRICH, Thomas. Catalogue of the Prints after Heemskerck. Cambridge, 1829.
IMMERZEEL, J. Levens en Werke der . . . Kunstschilders. Amsterdam, 1842-43.
 (*Cf.* Kramm, 1857.)
STAPPAERTS, J. Gravure dans les Pays-Bas. 1852.
ALVIN, L. Commencements de la gravure aux Pays Bas. Brussels, 1857.
KRAMM, C. Levens en Werke. (Supplement to Immerzeel.) Amsterdam,
 1857-63.
RENOUVIER, J. Gravure dans les Pays-Bas (15e siècle). Brussels, 1860.
KELLEN, J. P. van der. Peintre-graveur hollandais et flamand. Utrecht, 1866.
 (Incomplete : only one volume appeared.)
HYMANS, H. Les Images populaires flamandes au 16e siècle. Liége, 1869.
 Une page de l'histoire de la gravure anversoise au 16e siècle. Lecture faite à
 l'Acad. d'archéologie de Belgique. Feb. 6, 1887.
 Der belgische Kupferstich nach Rubens bis zum Ende des XVIII. Jahrhunderts.
 Chronik, ii. 33.
HIPPERT, T., and LINNIG, J. Peintre-graveur . . . du 19e siècle. 3 vols.
 Brussels, 1874-79.
DUTUIT, E. Manuel de l'amateur. Vols. iv.-vi. Paris, 1881-85 (*cf.* III., Dutuit,
 1881).
TER BRUGGEN, E. Histoire métallique et histoire de la gravure d'Anvers.
 Antwerp, 1875.
BINYON, L. Dutch Etchers of the Seventeenth Century. London, 1895.
ZILCKEN, P. Moderne Hollandsche Etsers. Amsterdam, 1897.
WURZBACH, A. von. Niederländisches Künstler-Lexikon. Vienna and Leipzig,
 1906-1911.
LINNIG, B. La Gravure en Belgique, ou notices biographiques sur les graveurs
 . . . jusqu'à la fin du 18e siècle. Antwerp, 1912.
BURCHARD, L. Die holländischen Radierer vor Rembrandt. Berlin, 1917.
BRADLEY, W. A. Dutch Landscape Etchers of the Seventeenth Century. Oxford,
 1919.

PORTUGAL.

RACZYNSKI, A. Dictionnaire historico-artistique de Portugal. Paris, 1847.

RUSSIA AND FINLAND.

ROVINSKI, D. Histoire de l'iconographie en Russie. 1856.
Russian Engravers and their Works, 1564-1758. Moscow, 1870.
Materials for Russian Iconography. St. Petersburg, 1884-91.
Review of Iconography in Russia to the End of the Eighteenth Century. 1903.
HASSELBLATT, J. Der Kupferstich in Russland während der 17. und 18.
Jahrhunderte. *Chronik*, iv. (1891), 60.
TIKKANEN, J. J. Die Kunst in Finland. *Graph. Künste*, xxix. 29.
VERESCHAGIN, V. A. (Material for the Bibliography of Russian illustrated books.)
St. Petersburg, 1908.

SPAIN.

PALOMINO DE CASTRO Y VELASCO, A. El museo pictorico (including the Vidas de
los pintores . . . españoles). Madrid, 1715, 24. (Tr. of the Vidas : Engl.,
London, 1739 ; German, Dresden, 1781.)
BERMUDEZ, J. A. C. Diccionario histórico de los mas ilustres profesores de las
Bellas Artes en España. 6 vols. Madrid, 1800. (Supplement by Conde de
la Viñaza, Madrid, 1894.)
ZAHN, A. von. Ein spanischer Kupferstich des 15. Jahrhunderts. *Archiv*, x.
278.
ROSSELL Y TORRES, I. Estampa Española d. s. 15. *Museo Español de Antique-*
tados, ii. (1873), 445.
Diccionario Enciclopedico Hispano-Americano de Literatura, Ciencias y Artes.
25 vols. Barcelona, 1887-99.

SWEDEN AND NORWAY.

UPMARK, G. Stockholm, National Museum. Grafiska Utställingen. Katalog,
1889.
Moderne graphische Kunst in Skandinavien. Die Radierer. *Chronik* iii. 25.
LAMM, G. Smärre bidrag till en beskrifvande katalog öfver Svenska gravörers
arbeten. *Meddelanden* II. (1892), 41.
Nordisk Familjebok. Stockholm.
Svenskt Porträttgalleri. Vol. xx. Architekter . . . Målare, Tecknare, Grafiker . . .
(by John Kruse). Stockholm, 1901.

SWITZERLAND.

BRUN, C. Schweizerisches Künstler-Lexikon. Frauenfeld, 1905-17.

V. VARIOUS SUBJECTS

AQUATINT.

PRIDEAUX, S. T. Aquatint Engraving. London, 1909.
HIND, A. M. Notes on the History of Soft-ground Etching and Aquatint. *P.C.*
Quarterly, Dec. 1921.

BOOK ILLUSTRATION.

COHEN, H. Livres à gravures du 18ᵉ siècle. Paris, 1870 (6th ed. 1912).
LACROIX, P. Iconographie moliéresque. Nice, Turin, 1872 (and Paris, 1876).
LACROIX, P. Bibl. et iconographie de Restif de la Bretonne. Paris, 1875.
SIEURIN, J. Manuel de l'amateur d'illustrations. Paris, 1875.
BRIVOIS, J. Bibliographie des ouvrages illustrés du 19ᵉ siècle. Paris, 1883.
BOUCHOT, H. Livres à vignettes, 15ᵉ-19ᵉ siècles. Paris, 1891.
ASHBEE, H. S. An Iconography of Don Quixote. London, 1894 (also *Bibl. Soc.*
Transactions, 1893).
VOLKMANN, L. Iconografia Dantesca. Leipzig, 1897.
LEWINE, J. Bibliography of Eighteenth Century Art and Illustrated Books.
London, 1898.
KITTON, F. G. Dickens and his Illustrators. London, 1899.
See also IV. France, Duportal, 1914 ; Germany, Kutschmann, 1900 ; Italy,
Masséna, 1902.

BOOK-PLATES.

POULET-MALASSIS, A. Les ex-libris français. Paris, 1874.
WARREN, (Hon.) J. L. Guide to the Study. London, 1880. (Index by F. J. Thairlwall, Plymouth, 1894.)
FRANKS, A. W. English dated Book-plates. London, 1887.
WARNECKE, F. Die deutschen Bücherzeichen. Berlin, 1890.
 Rare Book-plates of the Fifteenth and Sixteenth Centuries. London, 1893.
 Ex-Libris der 15. und 16. Jahrhunderte. Berlin, 1894.
BOUCHOT, H. Les ex-libris. Paris, 1891.
Ex-Libris Zeitschrift (Ex-Libris-Verein, Berlin). Görlitz, 1891, etc.
Ex-Libris Journal. London (A. and C. Black), 1892, etc. (in progress).
FINCHAM, H. W., and BROWN, J. R. Bibliography of Book-plates. *Ex-Libris Journal*, i. 91, 116, 126.
CASTLE, Egerton. English Book-plates. London, 1893.
VICARS, A. Book-plates. Plymouth, 1893.
Archives de la Société française de collectionneurs d'ex-libris. 6 vols. Paris, 1894-99.
HAMILTON, W. French Book-plates. London, 1894.
 Dated Book-plates. London, 1895.
ALLEN, C. D. American Book-plates. London, 1895.
HEINEMANN, O. von. Sammlung Wolfenbüttel. Berlin, 1895.
LABOUCHÈRE, Norna. Ladies' Book-plates. London, 1895.
SEYLER, G. A. Illustriertes Handbuch der Ex-Libris-Kunde. Berlin, 1895.
[BURGER, K.] Ex-Libris-Sammlung des Börsen-Vereins der deutschen Buchhändler. Leipzig, 1897.
FINCHAM, H. W. Artists and Engravers of British and American Book-plates. London, 1897.
HARDY, W. J. Book-plates. London, 1897.
SLATER, J. H. Book-plates and their Value, London, 1898.
LEININGEN-WESTERBURG, K. E. (Graf) zu. German Book-plates. Engl. tr. London, 1901.
BERTARELLI, A., and PRIOR, D. H. Ex-libris italiani. Milan, 1902.
LINNIG, B. Bibliothèques et ex-libris d'amateurs belges. Paris, 1906.
See also VI. A. London, B.M., Howe, 1903.

COLLECTORS' MARKS.

FAGAN, Louis. Collectors' Marks. London, 1883. (Reprint with Supplements, by M. I. D. Einstein and M. A. Goldstein, St. Louis, 1918.)
LUGT, Frits. Les Marques de collections. Dessins-estampes. Amsterdam, 1921.

COLOUR-PRINTS.

PORTALIS, R. La Gravure en couleurs. *Gazette*, 2ᵉ pér. xxxviii. (1888), 441, 3ᵉ pér. i. 29, 196, 322, iii. 118.
Vienna, Museum für Kunst und Industrie. Ausstellungs-Katalog, 1892.
FRANKAU, Julia. Eighteenth-Century Colour-Prints. London, 1900 (and 1907).
PLEHN, A. J. Wie die farbige Graphik ihre Grenzen festsetzt. *Mitteil.* 1902, pp. 29-53.
HARDIE, M. English Coloured Books. London, 1906.
BURCH, R. M. Colour-printing and Colour-printers. London, 1911.
See also Sections II., III., and IV., *passim*.

EMBLEMS OF SAINTS.

HUSENBETH, F. C. Emblems of Saints. London, 1850.
WESSELY, J. E. Iconographie Gottes und der Heiligen. Leipzig, 1874.

FANS AND FAN-LEAVES.

BLONDEL, S. . Histoire des éventails. Paris, 1875.
BOUCHOT, H. L'Histoire par les éventails populaires, 1719-1804. *Les Lettres et les Arts*, Jan. and July 1888.

SCHREIBER, (Lady) C. Fans and Fan-leaves collected and described by C. S. 2 vols. London, 1888.
CUST, L. Catalogue of the Collection . . . presented to the British Museum by Lady C. Schreiber. London, 1893.

HISTORICAL PRINTS.

MULLER. F. Nederlandsche Historieplaten. Amsterdam, 1863-82.
DOZY, C. M. Nalezing op F. Muller's Cat. van Ned. Historieplaten. *Archief*, vii. 1.
DRUGULIN, W. Historical Atlas. Leipzig, 1867.
British Museum. Catalogue of Prints and Drawings illustrating English History (from Julius Cæsar to James II.) [1882 ; unrevised and unpublished ; a few bound copies in the B. M.].
DAYOT, A. Napoléon raconté par l'image. Paris, 1895.
STOLK, A. van. Katalog der Historie, Spot en Zinneprenten betrekkelijk de Geschiedenis van Nederland. Amsterdam (F. Muller), 1895, etc.
WHEELER, H. F. B. and BROADLEY, A. M. Napoleon and the Invasion of England. London, 1907.
See also under Portraits, and VI. Paris, Bibl. Nat. (Coll. Hennin, 1877 ; Coll. Clairambault, 1887 ; Coll. de Vinck, 1909).

MEZZOTINT.

CHELSUM, J. History of Mezzotinto. Winchester, 1786.
DIAMOND, H. W. Earliest Specimens of Mezzotinto Engraving. London, 1838 (*Archaeologia*, xxvii. p. 405).
LABORDE, Léon de. Gravure en manière noire. Paris, 1839.
CHALONER-SMITH, J. British Mezzotinto Portraits. 4 vols. London, 1878-83.
Burlington Fine Arts Club. Catalogues to Exhibitions, 1881 (Introd. by J. Marshall), and 1902.
WHITMAN, A. Masters of Mezzotint. London, 1898.
DAVENPORT, C. Mezzotints. London, 1904.
British Museum. Exhibition, 1905 (Guide).
HIND, A. M. J. R. Smith and the Great Mezzotinters of the time of Reynolds. Great Engravers. London, 1911.
LEISCHING, J. Schabkunst. Ihre Technik und Geschichte in ihren Hauptwerken. Vienna (1913 ?).

MILITARY.

NEVILL, R. British Military Prints (Connoisseur Special Number). London, 1909.
CROOKSHANK, C. de W. Prints of British Military Operations. London, 1921.
See also sale catalogues of T. H. Parker, 12A Berkeley Street, London, W.

MONOGRAMS.

CHRIST, J. F. Anzeige . . . der Monogrammatum. Leipzig, 1747. (French tr., G. Sellius. Paris, 1750.)
BRULLIOT, F. Dictionnaire des monogrammes. Munich, 1817 (enlarged ed., 1832-34).
Table générale des monogrammes. Munich, 1820.
STELLWAG, J. C. Monogrammenlexicon. Frankfurt, 1830.
HELLER, J. Monogrammen-Lexikon. Bamberg, 1831.
DUPLESSIS, G., and BOUCHOT, H. Dictionnaire des marques et monogrammes de graveurs. Paris, 1886.
RICHTER, P. F. Nachträge zu Monogrammen-Lexicis. *Chronik*, iii. 52, 68.
RIS-PAQUOT, O. E. Dictionnaire des monogrammes. Paris, 1893.

NIELLI.

DUCHESNE, J. Essai sur les nielles. Paris, 1826.
CICOGNARA, L. Dell' origine dei nielli. Venice, 1827. (*See also* III. Cicognara, Memorie, 1831, Pt. I.)
ALVIN, L. Nielles de la Bibliothèque Royale de Belgique. Brussels, 1857.
REID, G. W. Salamanca Collection (reproductions). London, 1869.
MILANESI, G. Les Nielles de Finiguerra et de Dei. *L'Art*, xxxii. 221 ; xxxvi. 66.
DUTUIT, E. Manuel de l'amateur. Tome I. 2e partie (Nielles), ed. G. Pawlowski. Paris, 1888 (*cf.* III. Dutuit, 1881).
KRISTELLER, P. Die italienischen Niellodrucke und der Kupferstich. *Jahrb.* xv (1894), 94.
Bologna, Pinacoteca. P. Kristeller, Nielli del Francia. *Gall. Naz. Ital.* iii. (1897), 186.
MALAGUZZI-VALERI, F. L'Oreficeria reggiana. *Rassegna*, x. 163.
FERRI, P. N. I Nielli della Marucelliana di Firenze. *Bollettino*, vi. (1912), 231.

ORNAMENT ENGRAVINGS.

The Ornamentist, with Essay by W. B. Scott. London, 1845.
REYNARD, O. Catalogue d'ornements des 15e-18e siècles du cabinet de M. R. (Administration de l'Alliance des Arts). Paris, 1846.
Recueil d'ornements des anciens maîtres du 15e au 18e siècle. Paris, 1859. (Ditto, with text by G. Duplessis. Paris, 1873.)
MARSHALL, Julian. Engravers of Ornament. London, 1869.
DESTAILLEUR, H. Recueil d'estampes relatives à l'ornementation des appartements aux 16e, 17e, et 18e siècles. 2 vols. Paris, 1871.
Vienna, Österr. Museum für Kunst und Industrie. Ornamentstichsammlung. F. Schestag, Illustrirter Katalog, 1871 (supplements by F. Ritter, 1889 and 1919).
WESSELY, J. E. Das Ornament und die Kunstindustrie auf dem Gebiete des Kunstdruckes. Berlin, 1877-78.
GUILMARD, D. Les Maîtres ornemanistes. Paris, 1880-81.
AMAND-DURAND. Livres à dentelles et dessins d'ornements reprod. et publ. par A. D. sous la direction de E. Bocher. Paris, 1882-83.
LICHTWARK, A. Ornamentstich der deutschen Frührenaissance. Berlin, 1888.
VON UBISCH. Über Kataloge für Ornamentstichsammlungen. *Chronik*, i. 68.
Berlin, Kunstgewerbe Museum. Ornamentstichsammlung. Catalog, Leipzig, 1894.
ROSENTHAL, L. Catalog LXIX. (ornements). Munich.
BRINCKMANN, A. Die praktische Bedeutung der Ornamentstiche für die deutsche Frührenaissance. Strassburg, 1907.
HYMANS, H. Catalogue des Est. d'Ornement de la Bibl. Roy. de Belgique. 1907.
JESSEN, P. Der Ornamentstich. Berlin, 1920.

PLAYING CARDS.

SINGER, S. W. Researches in the History of Playing Cards. London, 1816.
Jeux de cartes tarots et de cartes numérales du 14e au 18e siècle. *Société des Bibliophiles Français*. Paris, 1844.
CHATTO, W. A. Facts and Speculations on the Origin of Playing Cards. London, 1848.
TAYLOR, E. S. History of Playing Cards. London, 1865.
MERLIN, R. Origine des cartes à jouer. Paris, 1869.
HORR, Norton T. Bibliography. Cleveland, U.S.A., 1892.
SCHREIBER, (Lady) C. Playing Cards. 3 vols. London, 1892-95.
D'ALLEMAGNE, H. R. Les Cartes à jouer du 14e au 20e siècle. Paris, 1906.
VAN RENSSELAER (Mrs. John King). Prophetical, Educational, and Playing Cards. Philadelphia (1912).
See also III. Cicognara, Memorie, 1831, Pt. II. ; IV. Germany and the Netherlands, Lehrs, 1885 ; VI. A., London, B. M., 1901.

Portraits.

(i.) British.

Ames, Joseph. Catalogue of English Heads. London, 1748.
Granger, J. Biographical History of England. London, 1769-74 (5th ed. 1824). (Continuation by Mark Noble, 1806.)
Thane, John. British Autography: a collection of facsimiles of the handwriting of royal and illustrious personages, with their authentic portraits. 3 vols. [1788-93?] (248 plates). The original plates bought by E. Daniell in 1838 and reprinted with supplement of 27 additional portraits, 1839 (Lowndes).
Richardson, W. Portraits illustrating Granger. London, 1792-99.
Bromley, H. Catalogue of Engraved British Portraits. London, 1793.
Harding, S. and E. Biographical Mirrour, comprising a series of English Portraits. 3 vols. 1795, 1798 [and 1802?]. Also supplementary plates, without text, dated 1810-14.
Flindall, J. M. Amateur's Pocket Companion, or a description of scarce and valuable British Portraits. London, 1813.
Caulfield, J. Calcographiana. London, 1814. Remarkable Persons, 1819-20.
Woodburn, S. Catalogue of a splendid and capital collection of Engraved British Portraits. London, 1815. W.'s Gallery of Rare Portraits (from original plates and facsimiles). 2 vols. London, 1816.
Rodd, T. and H. Collection of Portraits to illustrate Granger. London, 1820.
Lodge, E. Portraits of Illustrious Personages of Great Britain engraved from authentic Pictures. 4 vols. London, 1821-34. (Other editions. 12 vols. 1835; 8 vols. 1849-50; 5 vols. 1854.)
Evans, Edward. Catalogue. Great Queen Street, London [about 1830].
Evans, A. E., and Son. Catalogue. 403 Strand, London [about 1853].
Tiffin, W. F. Mezzotinto Portraits. Salisbury, 1883.
Grolier Club. Effigies of the most famous English writers from Chaucer to Johnson. Catalogue. New York, 1891.
Daniell, W. V. Catalogue. London, 1900.
Levis, H. C. Baziliωlogia. Notes on a rare series of Engraved English Royal Portraits from William the Conqueror to James I., published in 1618. Grolier Club. New York, 1913.
 Notes on the early Engraved Royal Portraits issued in various series from 1521 to the end of the 18th century. London, 1917.
 See IV. British Isles, Gosse, 1905; V. Mezzotint, Chaloner-Smith, 1878; VI. A., London, B.M., O'Donoghue, 1908; Oxford, Bodleian, 1837.

(ii.) Dutch and Flemish.

Muller, Frederik. Various Catalogues. Amsterdam, 1853, etc.
Szwykowski, I. von. Historische Skizze über die frühesten Sammelwerke altniederländischer Maler-Portraits bei Hieronimus Cock und H. Hondius. Archiv, 1856, p. 13.
Someren, J. F. van. Catalogus van gegraveerde Portretten van Nederlanders. Amsterdam, 1881-91.

(iii.) French.

Lelong, P. Bibliothèque historique de la France. Vol. iv. Paris, 1809.
Lieutaud, S. Listes de Portraits. Paris, 1844, 46, 54, etc.
Granges de Surgères, de, and Bourcard, G. Les Françaises du 18e siècle. Portraits gravés. Paris, 1887.
Granges de Surgères, de. Iconographie bretonne. Paris, 1888-89.
 See also IV. France, Duplessis 1875, Didot 1875.

(iv.) German.

Panzer, E. W. Nürnbergischer Portraite. Nuremberg, 1790, 1801.
Heitzmann, J. Portraits-Catalog. Munich, 1858.

(v.) RUSSIAN.

ROVINSKI, D. (Catalogue of Russian engraved portraits.) St. Petersburg, 1872.
VASII.'CHIKOV, A. A. Liste alphabétique de portraits russes. St. Petersburg, 1875.
MOROSOV, A. V. [Catalogue of his collection of engraved Russian Portraits, with 483 plates.] 4 vols. Moscow, 1912-13 (German edition, Leipzig).

(vi.) SPANISH.

BARCÍA, A. M. de. Catálogo de los retratos de personages españoles en la sección de estampas de la Biblioteca Nacional. Madrid, 1901.

(vii.) GENERAL.

DRUGULIN, W. E. (Catalogues.) Leipzig, 1854, 1860-61.
PUIBUSQUE, A. de. Catalogue des gravures historiques composant la coll. de feu Mdme. A. de P. renfermant les portraits de souverains. Paris, 1866.
TIFFIN, W. F. Gossip about Portraits, principally engraved Portraits. London, 1866.
ROSE, J. A. Catalogue of Collection of Engraved Portraits (Exhib. 1872, Guildhall Library). London, 1874. (Also further selection with Introd. by G. Goodwin, 1894.)
SEIDLITZ, W. von. Allgemeines historisches Porträtwerk. Munich, 1885-90.
HARVEY, Francis. Various Catalogues. London.
AVEGNAC-LAVIGNE, C. L'Histoire moderne par la gravure, ou catalogue raisonné des portraits historiques. Paris, 1878.
JANKU, J. B. Die Porträtstiche des Robert Boissard, der beiden J. T. de Bry, und der Anteil von C. Galle I. an dem boissard'schen Sammelwerke. *Repert.*, VII. 416.
AMERICAN LIBRARY ASSOC. Portrait Index. Ed. W. C. Lane and N. E. Browne. Index to portraits contained in Printed Books and Periodicals. Washington, 1906.
SUMNER, CHARLES. Best Portraits in Engraving. New York (Keppel).
See VI. A., London, V. and A. Museum, 1895 ; Paris, Duplessis, 1896 ; VIII. Stirling-Maxwell, 1872.

(viii.) CLASSES and INDIVIDUALS.

PRINTERS (J. T. Bodel-Nyenhuis, Leyden, 1836-68) ; MILTON (J. F. Marsh, 1860 ; G. C. Williamson, 1908) ; SHAKESPEARE (J. O. Halliwell-Phillipps, 1868) ; WASHINGTON (W. S. Baker, 1880 ; H. L. Carson, Sale Catalogue, Philadelphia, 1904 ; Whelen Sale Catalogue, by S. V. Henkels, Philadelphia, 1909) ; MARIE ANTOINETTE (Lord R. Gower, Paris, 1883) ; VOLTAIRE (G. Desnoiresterres, Paris, 1879) ; WOMEN (A. Ungherini, Turin and Paris, 1892, 1900, 1905) ; QUEEN ELIZABETH (F. M. O'Donoghue, 1894) ; NAPOLEON I. (A. Dayot, Paris, 1895) ; LINCOLN (Exhib. Catalogue, Grolier Club, N.Y., 1899).

SALES AND SALE-PRICES. *See* VI. B.

SATIRICAL PRINTS.

FLEURY, J. (" Champfleury "). L'Imagerie populaire. Paris, 1869.
Caricature sous la République, etc. Paris, 1874.
La Caricature au moyen âge et sous la renaissance. Paris, 1876.
La Caricature moderne. Paris, n. d.
BUSS, R. W. English Graphic Satire. London, 1874 (for private circulation).
PASTON, G. Social caricature in the 18th century. London, 1905.
BLUM, André. L'Estampe satirique et la caricature en France au 18e siècle. *Gazette* 4e pér. iii. 379, iv. 69, 108, 243. 275, 403, 449.
See VI. A. London, B. M., Stephens, 1870.

SOFT-GROUND ETCHING.

HIND, A. M. Notes on the History of Soft-Ground Etching and Aquatint. *P. C. Quarterly*, Dec. 1921.

SPORTING PRINTS.

SLATER, J. H. Illustrated Sporting Books. London, 1899.
PEEK, Hedley. Old Sporting Prints. *Badminton Mag.* i. (1895), 92, 219, 305;
 ii. 258, 545; iii. 321; iv. 298; v. 95.
NEVILL, R. Old Sporting Prints. Connoisseur extra number. London, 1908.

SUPPRESSED PRINTS.

LAYARD, G. S. Suppressed Plates, Wood-engravings, etc. London, 1908.

TOPOGRAPHY.

(i.) BRITISH ISLES: R. Gough, British Topography, London, 1780; J. Nichols
 and R. Gough, Bibliotheca Topographica Britanniae, London, 1780-1800
 (10 vols. and Appendix, 1815); W. Upcott, Bibliographical account of the
 principal works relating to English Topography, London, 1818; J. P.
 Anderson, the Book of British Topography, London, 1881 (B. M. Topo-
 graphical Books); W. V. Daniell and F. J. Nield, Manual of British Topo-
 graphy (dealer's catalogue), London, 1909.
(ii.) LONDON: J. G. Crace, Catalogue of Coll. of F. Crace (now in the British
 Museum). London, 1878.
(iii.) ROME: F. Hermanin, Catalogo delle incisioni con vedute romane (Gabinetto
 delle Stampe, Roma). *Gall. Naz. Ital.*, III. iii., IV. iii.
(iv.) GENERAL. *See* F. Muller's Catalogues, Amsterdam.

VI. COLLECTIONS

A. PUBLIC

AMSTERDAM. **Rijks Museum.**

KLINKHAMER, H. A. Les estampes indécrites du Musée d'A. Supplément au
 10e vol. de Bartsch. Brussels, 1857 (from the *Rev. Univ.*).
KAISER, J. W. Curiosités du Musée d'A. Facsimile d'estampes de maîtres . . .
 du 15e siècle. Utrecht, Leipzig, Paris [1866].
BOLAND, J. A. Choix d'estampes rares de maîtres . . . du 15e siècle. Amster-
 dam, 1883 (same plates as in J. W. Kaiser, 1866, and additions).

BERLIN. **Kupferstichkabinett.**

Die neuere Kunst in kgl. K. zu B. Eine Anleitung zur Benutzung der Sammlung.
 Berlin, 1909.

BOLOGNA. **Pinacotea.**

Raccolta d' incisioni. *Gall. Naz. Ital.* II. (1896), 162.

BRESLAU. **Schlesisches Museum.**

Kupferstichsammlung. Lehrs, *Jahrb.* iii. 210.

BRUNSWICK. **Museum.**

VASEL, A. Sammlung graphischer Kunstblätter. Wolfenbüttel, 1903.

BUDAPEST. **Museum für bildenden Künste.**

TÉREY, G. von. Verzeichnis der Kupferstichsammlung. Budapest, 1911.

BUFFALO. **Fine Arts Academy. Allbright Art Gallery.**

CHAPMAN, W. D. Collection of Prints. Illustrated Catalogue. Buffalo, 1905.

COLLECTIONS

CAMBRIDGE (U.S.A.). **Harvard College.**

Gray Collection of Engravings. Catalogue by L. Thies, 1869.

COPENHAGEN.

RUMOHR, C. F. von, and THIELE, J. M. Geschichte der Kupferstichsammlung.
Leipzig, 1835.
BLOCH, E. Kgl. Kopperstiksammling, 1881.

DRESDEN. **Kupferstichkabinett.**

FRENZEL, J. G. A. Überblick der Kupferstiche in der kgl. Kupferstichgallerie.
Dresden, 1838.
Kupferstichsammlung Friedrich August II. Leipzig, 1854.
SINGER, H. W. Unika und Seltenheiten im Kupferstichk. zu Dresden. Leipzig,
.1911 (50 reproductions).
LEHRS, M. Zur Geschichte der Dresdner Kupferstichkabinetts. *Mitteil. der
Sächsischen Kunstsamml.* III (1912).

Kupferstichsammlung Friedrich August II.

Catalogue. Leipzig, 1854.

FLORENCE. **Uffizi.**

FERRI, N. Catalogo delle stampe e disegni esposti. 1881.

GOTHA. **Herzogliche Kupferstichsammlung.**

SCHNEIDER, J. H. *Deutsch. Kunstbl.* IV. 214, 221.

GRAZ. **Landes Kupferstichsammlung.**

WIBIRAL, F. Die Landeskupferstichsammlung. Graz, 1911.

HAMBURG. **Kunsthalle.**

MAYER, C. Die Harzen-Commeter'sche Kupferstich- und Handzeichungsammlung.
Archiv, XVI. 88.
Kupferstichsammlung. Catalog, 1878.

LEYDEN.

OVERVOORDE, J. C. Catalogus van de Prentverzameling der Gemeente L.
Leyden, 1907.

LONDON. **British Museum.**

STEPHENS, F. G. Political and Personal Satires. 1870-1883.
FAGAN, L. Handbook. 1876.
WILLSHIRE, W. H. Catalogue of Early Prints. German and Flemish schools.
1879-83.
Reproductions of Prints. Parts i.-xiv. (1882-1905) (and in progress).
COLVIN, S. Guide to an Historical Collection of Prints. 1890.
HIND, A. M., ed. S. COLVIN. Catalogue of Early Italian Engravings, 2 vols., 1910.
Index of Artists. Dutch, Flemish, and German schools, 1893 ; French schools,
1896.
O'DONOGHUE, F. M. Schreiber Collection of Playing Cards. 1901.
O'DONOGHUE, F. M., and HAKE, H. M. Catalogue of British Engraved Portraits,
5 vols., 1908-1922 (in progress).
HOWE, E. R. Gambier. Franks Collection of Book-plates. 1903-4.
See also V. Fans, Cust, 1893 ; Historical, 1882 ; Mezzotint, 1905.

Victoria and Albert Museum.

Dyce Collection Catalogue. 1874.
Catalogue of Engraved Portraits in the National Art Library. 1895.
British Engraving and Etching. Exhibition Catalogue. 1903.
HARDIE, M. Catalogues of Modern Etchings. Foreign Schools, 1903 ; British
and American Schools, 1906.

LYONS.

ROLLE, F. Bibliothèque du Palais des Arts. Catalogue des estampes. Lyons, 1854.

MADRID. **Biblioteca Nacional.**

ROSSEL Y TORRES, I. Sala de estampas. Noticia del plan general . . . y breve
catalogo. 1873.

Calcografia Nacional.

Catalogo de las majores estampas que se hallan de venta en la C. de la Imprenta
Nacional. Madrid, 1857.

MUNICH. **Alte Pinakotek,** Graphische Sammlung.

BRULLIOT, R. Copies photographiques des plus rares gravures. 1854.
SCHMIDT, W. Die Inkunabeln des Kupferstiches im kgl. Kabinet zu M. 1887.
PALLMANN, H. Die graphische Sammlung zu M., 1758-1908. Munich, 1908.
GRÄFF, W. Die Neuordnung der graph. Samml. in M. *Museumskunde.* VI.
(1910) Heft 1.

NANTES. **Musée Dobrée.**

Loys Delteil. Catalogue des gravures. [1906].

NEW YORK. **Public Library.**

Handbook of the S.P. Avery Coll. of Prints and Old Books. New York, 1901.

NUREMBERG. **Germanisches Museum.**

LEHRS, M. Katalog der . . . deutschen Kupferstiche des 15. Jahrhunderts. 1887.

OXFORD. **Bodleian.**

Sutherland Collection. Catalogue. London, 1837. (Largely English portraits.)

PARIS. **Bibliothèque de l'Arsenal.**

SCHÉFER, G. Catalogue des estampes, dessins et cartes. Paris, 1894, etc.

Bibliothèque Nationale.

DUCHESNE, J. Notice des estampes exposées, etc. Various editions, 1819, 1823,
1837, 1841, 1855.
Observations sur les catalogues de la collection. 1847.
DELABORDE, H. Le Département des estampes. 1875.
DUPLESSIS, G. Collection Hennin (d'estampes relatives à l'histoire de France).
1877-84.
Catalogue de la collection des portraits . . . continué par G. Riat. 1896, etc.
(in progress).
FLANDRIN, A. Inventaire des pièces dessinées ou gravées relatives à l'histoire de
France conservées au dép. des manuscrits dans la coll. Clairambault. Paris,
1887.
BOUCHOT, H. Le Cabinet des estampes. 1895.
COURBOIN, F. Catalogue sommaire des gravures . . . composant la réserve.
2 vols. Paris, 1900-1.
Inventaire des dessins, photographies et gravures relatifs à l'histoire générale de
l'art, légués au dép. des estampes de la B. N. par A. Armand. Paris, 1895.
Miniatures . . . estampes à couleurs françaises et anglaises, 1750-1815. Catalogue.
Exposition, 1906.
COLLECTION DE VINCK. Un Siècle d'histoire de France par l'estampe, 1770-1871.
Inventaire analytique par F. L. Bruel, J. Lavan, M. Aubert, and M. Roux.
Paris, 1909, etc. (in progress).

Louvre.

VILLOT, F. Catalogue des planches gravées composant le fonds de la calcographie. Paris, 1851 (1860, 1881, and 1901).

PAVIA. **Museo Municipale** (Coll. Malaspina).

Catalogo . . . di stampe. 5 vols. Milan, 1824.

ROME. **R. Calcografia.**

Indice delle stampe. 1768.
Catalogo. 1823, 1842, etc.
DIDOT, F. Catalogue. Paris, 1841.
TIMARCHI, I. *Archivio*, i. 224.

Galleria Nazionale.

Gabinetto delle stampe. See *Gall. Naz. Ital.* ii. (1896), 139.
See also IV. Italy, Cerroti, 1858.

VIENNA. **Hofbibliotek.**

BARTSCH, F. von. Kupferstichsammlung der k.k. Hofbibl. in Wien. 1854.
GUGENBAUER. Der graphische Schmuck der Mondseer Codices. *Mitteil.* 1912, p. 73.

WASHINGTON. **Library of Congress.**

PARSONS, A. J. Catalog of the Gardiner Greene Hubbard Coll. of Engravings. 1905.

MISCELLANEOUS.

DUCHESNE, J. Voyage d'un iconophile. Revue des principaux cabinets d'estampes . . . d'Allemagne, de Hollande, et d'Angleterre. Paris, 1834.

B. PRIVATE

(i.) VARIOUS CATALOGUES.

BEHAIM, Paul. Verzeichniss allerley Kunst von alten . . . Meistern in Kupfer und Holtz an Tag gegeben, collegirt . . . durch P. B. juniorem, 1618 (MS. in Berlin, Kupferstichkabinet ; *see* J. E. Wesseley, *Repert.* vi. 54).
MAROLLES, M. de. Catalogues. Paris, 1666 and 1672 (the collection described in the earlier catalogue now in the Bibl. Nat.).
DURAZZO, Jacopo. *See* B. Benincasa, Descrizione della raccolta . . . del Conte J. D. Parma, 1784.
FRAUENHOLZ. Verzeichniss. Nuremberg, 1793-95.
PRAUN, Paul de. *See* C. G. v. Murr, Nuremberg, 1797.
DENON, D. VIVANT. *See* J. Duchesne, Paris, 1826.
WILSON, T. London, 1828.
CICOGNARA, L. *See* III., Zanetti, 1837.
QUANDT, J. G. VON. Verzeichniss. Leipzig, 1853.
MARSHALL, Julian. *See* G. W. Reid, Catalogue, 1864.
MORRISON, Alfred. 1868.
ROSE, J. A. *See* III., Rose, 1874, and V., Portraits, General, 1874.
DIDOT, A. F. Paris, 1875, 1877 (*cf.* IV., France, 1875.)
FISHER, Richard. 1879.
BERALDI, H. Paris, 1884 and 1892.
BERWICK Y DE ALBA, Duque de. *See* A. M. de Barcia y Pavón, Madrid, 1890.
Lanna Collection, Prague. *See* H. W. Singer, 1895.

(ii.) List of a Few Important Sale Catalogues.

(A great number published by the auctioneers and dealers : Sotheby, Wilkinson, and Hodge, London ; Christie, Manson, and Woods, London ; R. Weigel, Leipzig, 1834-66 ; C. G. Boerner, Leipzig ; H. G. Gutekunst, Stuttgart ; Amsler und Ruthardt, Berlin ; F. Muller & Co., and R. W. P. de Vries, Amsterdam.

Quentin de Lorangère (Paris, 1744), A. de Burgy (The Hague, 1755 ; for Rembrandt), M. Folkes (London, 1756), P. J. Mariette (Paris, 1775 ; London, 1776), Gulston (London, 1786), J. Barnard (London, 1787 and 1798), Brandes (Leipzig, 1793, 1794), Earl of Bute (London, 1794, 1801), P. Wouters (Brussels, 1797), P. F. Basan (Paris, 1798), Sir W. Musgrave (London, 1798, 1799, 1800), Ploos van Amstel (Amsterdam, 1800, 1810), W. Y. Ottley (various ; London, 1801-38), G. Winckler (M. Huber and J. G. Stimmel, Leipzig, 1801-10), Alibert (Paris, 1803), Paignon-Dijonval (Paris, 1810), Regnault de Lalande (Paris, 1810), Delabere (London, 1811), R. Morse (London, 1816), T. Lloyd (various ; London, 1817-43), Rigal (Paris, 1817), J. Towneley (London, 1818), E. Durand (Paris, 1819, 1821), W. Esdaile (various ; London, 1819-40), Sir Mark Masterman Sykes (London, 1824), Vivant Denon (Paris, 1826), Maurice de Fries (Vienna, 1824, 1828), Revil (Paris, 1830, 1838, 1839), Comtesse d'Einsiedel (Dresden, 1833, 1834), Buckingham (London, 1834), Robert Dumesnil (various ; Paris, 1835-62 ; London, 1836), Sternberg-Manderscheid (Dresden, 1836, 1842), Rev. H. Wellesley (various ; London, 1833-66), L. Cicognara (Vienna, 1839 ; for detailed catalogue see III., Zanetti, 1837), C. v. Hulthem (Ghent, 1846 ; the coll. bought for the Bibl. Roy., Brussels), C. F. L. F. v. Rumohr (Dresden, 1846), Verstolk v. Soelen (Amsterdam, 1847, 1851), E. P. Otto (Leipzig, 1852), P. Visscher (Paris, 1852), H. Weber (Leipzig, 1855), A. Brentano (Frankfurt, 1870), J. Durazzo (Stuttgart, 1872, 1873), Hugh Howard (London, 1873-74), E. Galichon (Paris, 1875), J. A. Rose (London, 1876, etc.), A. F. Didot (Paris, 1877, 1879), W. E. Drugulin (Leipzig, 1879), E. Piot (Paris, 1890), R. Fisher (London, 1892), L. Angiolini (Stuttgart, 1895), H. Destrailleur (Paris, 1895), Goncourt (Paris, 1897), A. Straeter (Stuttgart, 1898), Waldburg-Wolfegg (Stuttgart, 1902), J. V. Novak and A. Artaria (Stuttgart, 1904), A. Barrion (Paris, 1904), H. Grisebach (Stuttgart, 1905), Sir W. Lawson (London, 1907-8), Mrs. Alfred Morrison (London, 1907-8), Marsden Perry (Stuttgart, 1908), Sir John C. Day (London, 1909), Lanna (Stuttgart, 1909-10), H. S. Theobald (Stuttgart, 1910), J. Sagert (Berlin, 1910), J. von Elischer (Leipzig, 1911), J. E. Taylor (London, 1912), A. von Wurzbach (Vienna, 1912), J. Dollfus (Paris, 1912), Rev. Dr. John Gott (London, 1913), A. C. Norman (London, 1914), Lord Northwick (London, 1914, 1918), Sir Walter Gilbey (London, 1915), Dr. C. D. Ginsburg (London, 1915), Earl of Pembroke (London, 1917), T. J. Barratt (London, 1917), C. Fairfax Murray (London, 1917), E. Degas (Paris, 1918), Lady Lucas (London, 1918-19), V. Mayer (Berlin, 1919), Earl Spencer (London, 1919), C. L. Lewes (London, 1919), A. Beurdeley (Paris, 1920), Davidsohn (Leipzig, 1920), J. P. Heseltine (London, 1920), Lawson Thompson (London, 1920).

(iii.) Bibliographies of Sale and Other Catalogues and Books on Sale Prices.

Defer, P. Catalogue général des ventes publiques de tableaux et d'estampes depuis 1737 jusqu'à nos jours. Paris, 1865-68. (Incomplete. Engravers covered alphabetically up to *Byrne*.)
Willigen, A. v. d. Naamlyst van Nederlandsche Kunst-catalogi van af 1731-1861. Haarlem, 1873.
Duplessis, G. Les Ventes, 1611-1800. Paris, 1874.
London, National Art Library. List of Catalogues of Collections, etc. ; also Sale Catalogues. 1888 (a few copies printed, but not published).
Redford, G. Art Sales, 1628-1888. London, 1888 (chiefly picture sales).
Dauze, P. Index biblio-iconographique (Répertoire des ventes publiques cata-loguées). Paris, 1894-98.
Soullié, L. Les Ventes au 19ᵉ siècle. 1896.

ROBERTS, W. Memorials of Christie's. London, 1897.
SLATER, J. H. Engravings and their Value. London, 1891 (3rd ed. 1900). Sale
 Prices of 1896-7. London, 1897-8. Art Sales of 1901-2. London, 1902-3.
The Connoisseur. Monthly Supplement. 1901-3.
MIREUR, H. Dictionnaire des ventes, 18ᵉ et 19ᵉ siècles. 1901-2 (2 vols., A–D only,
 continued by C. de Vincenti, 1912, etc.).
Pictures and their Value (1905-6). Eltham (Turner and Robinson), 1906.
Art Prices Current (Record of Prices at Christie's and Sotheby's, 1907-14). 8 vols.
 London, 1908-14.
BOURCARD, G. La Côte des estampes. Ventes, 1900-1912. Paris, 1912.
DELTEIL, L. Annuaire des ventes d'estampes. Paris, 1912, etc.
Print Prices Current. London, 1918, etc. (Vol. I. ed. E. H. Courville and F. L.
 Wilder ; vol. II. F. L. and E. L. Wilder.)
MONOD, L. Prix des estampes. Paris, 1920, etc. (in progress).

VII. CATALOGUES OF PRINTS AFTER A FEW OF THE MORE IMPORTANT PAINTERS, WHO ARE NOT INCLUDED IN THE INDEX AS ENGRAVERS

BAUDOUIN, P. A.

BOCHER, E. Paris, 1875.

BUONARROTI, Michelangelo.

PASSERINI, L. La bibliografia di M. B. e gli incisori delle sue opere. Florence,
 1875. *See also* III., Heinecken, 1768.

CHARDIN, J. B. S.

BOCHER, E. Paris, 1876.

COSWAY, Richard.

DANIELL, F. B. Catalogue raisonné of the Engraved Works. London, 1890.

GAINSBOROUGH, Thomas.

HORNE, H. P. Engraved Portraits and Fancy Subjects by T. G., and G. Romney.
 London, 1891.
ARMSTRONG, (Sir) W. T. G. London, 1898.

LANCRET, Nicolas.

BOCHER, E. Paris, 1877.

LAVREINCE, Nicolas.

BOCHER, E. Paris, 1875.

LAWRENCE, (Sir) Thomas.

GOWER (Lord), Ronald Sutherland. London, 1903 (with Catalogue of exhibited
 and engraved work by Algernon Graves).

MORLAND, George.

WILLIAMSON, G. C. G. M. London, 1904.
DAWE, G. Life of G. M., with introduction by J. J. Foster, and appendix of
 engravings after G. M. London, 1904.
BAILY, J. T. Herbert. G. M. *Connoisseur* Special Number. London, 1906.

MURILLO, B. E.

See Velazquez.

POUSSIN, Nicolas.

ANDRESEN, A. Die chalcographischen Nachbildungen der Gemälde und Zeich-nungen des N.P. *Archiv*, ix. 237.

RAEBURN, (Sir) Henry.

ARMSTRONG, (Sir) W. London, 1901 (Catalogue by J. L. Caw).

REYNOLDS, (Sir) Joshua.

HAMILTON, E. The Engraved Work of Sir J. R. London, 1874.
GRAVES, A., and CRONIN, W. V. Works of Sir J. R. 4 vols. London, 1899-1901.

ROMNEY, George.

WARD, H., and ROBERTS, W. London, 1904.
See also Gainsborough.

SANTI, Raffaello.

TAURISCUS EUBOEUS (*i.e.* W. von Lepel). Catalogue des estampes gravées d'après R. Frankfurt, 1819.
PASSAVANT, J. D. R. Leipzig, Pt. II. (1839), and Pt. III. (1858). (French ed. 1860.)
RULAND, C. The Works of R. in Windsor Castle. 1865.
See also III., Heinecken, 1768-69.

VECELLIO, Tiziano.

Catalogo delle incisioni . . . tratte dalle opere di T. ed esistenti nella collezione . . . di G. B. Cadorin in Venezia. [Venice, 1876.]

VELAZQUEZ, Diego de Silva y.

STIRLING-MAXWELL, (Sir) W. Essay towards a Catalogue of Prints from the works of V. and Murillo. London, 1873.
CURTIS, C. B. V. and Murillo. Descriptive and Historical Catalogue. London, 1883.

VIII. REPRODUCTIONS

OTTLEY, W. Y. Collection of 129 Facsimiles of scarce . . . Prints of the Early Masters of the Italian, German, and Flemish Schools. London, 1826 (and 1828).
AMAND-DURAND. Eaux-fortes et gravures des maîtres anciens . . . Notes par G. Duplessis. 10 vols. Paris, 1872-78.
STIRLING-MAXWELL, (Sir) W. Examples of the engraved portraiture of the 16th century. Privately printed. London, Edinburgh, 1872.
HIRTH, G. Kulturgeschichtliches Bilderbuch. 5 vols. Munich, 1882.
Les Grands Illustrateurs, 1500-1800. 6 vols. Munich, 1888-91.
Internationale Chalcographische Gesellschaft (also publ. in French and English). Berlin, Paris, London, etc. 1886-97.
Kupferstiche und Holzschnitte alter Meister in Nachbildungen herausgegeben von der Direction der Reichsdruckerei unter Mitwirkung. . . von F. Lippmann. Berlin, 1889-1900. (Engl. ed. 10 vols. Quaritch, London.)

Das Kupferstichkabinet. Berlin, 1897, etc. (Engl. ed. : the Print Gallery, Grevel, London, 1897-98).
The Dürer Society. Notes by C. Dodgson and S. Montagu Peartree. London, 1898-1908.
Graphische Gesellschaft. Berlin, 1906, etc. (in progress).
Autotype Company (various reproductions), London.
DIEDERICH, Eugen. Deutsches Leben der Vergangenheit in Bildern. Atlas mit 1760 Nachbildungen alter Kupfer- und Holzschnitte aus dem 15ten–18ten Jahrhundert. Mit Einleitung von H. Kienzle. Jena, 1908.
HIND, A. M. Great Engravers. London (Heinemann), 1910, etc.
See IV., France, Chesneau, 1885 ; Model and Springer, 1912 ; British Isles, Fagan, 1893 ; V., Portraits, Thane, 1788 ; Richardson, 1792 ; Woodburn, 1816 ; Rodd, 1820 ; VI. A., Amsterdam ; London, B.M. ; Munich ; Dresden.

APPENDIX III

INDEX OF ENGRAVERS AND INDIVIDUAL BIBLIOGRAPHY

THE index is divided into the following sections :—

 I. ENGRAVERS WHOSE NAMES ARE KNOWN.

 II. ENGRAVERS KNOWN BY THEIR MONOGRAMS, INITIALS, ETC.

 III. ENGRAVERS KNOWN BY THEIR MARKS.

 IV. ENGRAVERS KNOWN BY THEIR DATES.

 V. ENGRAVERS KNOWN BY THE SUBJECT OR LOCALITY OF THEIR PRINCIPAL WORKS.

In each entry the first page quoted gives the passage most directly dealing with the engraver's work. Secondary quotations do not include every passing allusion, but only such references as form a real supplement to the principal passage. The index covers the classified list as well as the historical portion of the book, and also includes writings by engravers in the general bibliography.

Van and *de* are only taken as initials in the case of anglicized foreigners. On the other hand *le* and *la* almost invariably stand as initials. Absolute strictness, however, sometimes yields to convention.

I. ENGRAVERS WHOSE NAMES ARE KNOWN

PAGE

FINNIE, John. Mezz., et. Scotland, London, Liverpool. 1829-1906 . 287, 383, 387
Memorial Exhibition Catalogue, Liverpool, 1907.
FISCHER, Otto. Et. Dresden. b. 1870 337, 350
Singer, *Graph. Künste*, xxiv. 72 ; *Studio*, 1905, p. 44 ; *Original und Repro-duktion*, Leipzig, 1909, Heft 2.
FISHER, Alfred Hugh. Et. London. b. 1867 388
FISHER, Edward. Mezz. Ireland, London. 1730-ab. 1785 . . 274, 382
FITTLER, James. En. London. 1758-1835 . . . 219, 380
FITTON, Hedley. Et. London, Haslemere. b. 1859 387
Illustrated Catalogue, London·(Dunthorne), 1911.
FLAMEN, Albert. Et. Netherlands, Paris. fl. 1648-64 . . . 357
FLAMENG, Léopold. Et., en. Brussels, Paris. 1831-1911 . . 355, 359, 376
Hamerton, *Portfolio*, iii. 1 ; Havard, *Rev. de l'Art Anc. et Mod.* xiv. 451, xv. 29.
FLANDRE, Marie, Comtesse de. *See* Marie.
FLINDT, Paul. Goldsmith, punch-en. Nuremberg. fl. 1590-1620 . 290, 345
Recueil de 33 Pièces, Paris (Rouveyre), n.d.
FLIPART, Charles Joseph. En. Paris, Venice, Madrid. 1721-93 . . 371
FLIPART, Jean Jacques. En. Paris. 1719-82 201, 371
Sale Catalogue, 1782.
FLODIN, Hilda. Et. Finland. Contemp. 339, 392
FLODING, Per Gustaf. En., et., aq. Stockholm, Paris. 1731-91 . 300, 391
C. U. Palm, *Meddelanden*, iii. (1896), p. 6.
FLORIS (DE VRIENDT), Frans. Et. Antwerp. ab. 1517-70 . 115, 119, 353, 352
FOCUS, Georges. Et. Paris. 1641-1708 367
FOGOLINO, Marcello. En. Vicenza, Pordenone, Trent. fl. ab. 1519-48 66, 290, 360
FOKKE, Simon. En., et. Amsterdam. 1712-84 . . . 358
FOLKEMA, Jacob. En. Amsterdam. 1692-1767 358
FOLO, Giovanni. En., st. Bassano, Rome. 1764-1836 . . 364, 365
Catalogo, Rome (single sheet, n.d.).
FONTANA, Giovanni Battista. Et. Verona, Venice. ab. 1525-89 . 113, 361
FONTANA, Giulio. Et. Verona, Venice. fl. ab. 1570 . . 113, 361
FONTANA, Pietro. En. Bassano, Rome. 1762-1837 . . . 364
FONTANESI, Antonio. Et. Italy. fl. 19.2 366
FORAIN, Jean Louis. Et. Rheims, Paris. b. 1853 . . . 323, 375
Lehrs, *Graph. Künste*, xxxiv. 9 ; M. Guérin, Paris, 1912 ; Dodgson, *P.C. Quarterly*, April 1921.
FOREL, Alexis. Et. Switzerland. Contemp. . . . 375
FORNAZERIS (FOURNIER ?), Jacques de. En. Turin ? Lyons, Paris. fl. 1590-1622 367
FORREST, Ion B. Mezz., st. U.S.A. b. 1837 (Scotland), d. 1870 . . 390
FORSTER, François. En. Locle, Paris. 1790-1872 . . . 374
FORTUNY, Mariano I. Et. Spain, Rome, Paris. 1836-74 . . 339, 366, 377
Davillier, Paris, 1875 ; C. Yriarte, Paris, 1885.
FORTUNY, Mariano II. Et. Venice ? Contemp. . . . 366, 378
FOSTER, Myles Birket. Et. London, Witley, Weybridge. 1825-99 . . 387
H. M. Cundall, London, 1906.
FRAGONARD, Jean Honoré. Et. Grasse, Paris. 1732-1806 . . 250, 288, 370
R. Portalis, Paris, 1889 ; Tornézy, F., and Bergeret, Paris, 1895.
FRANCIA, Francesco and Jacopo. *See* Raibolini.
FRANCIA, François Louis Thomas. Et. Calais, London. 1772-1839 . . 386
FRANCK, Johann Ulrich. Et. Augsburg. 1603-80 . . . 246, 346
FRANCK, Joseph. Brussels. 1825-83 359
FRANCO, Giacomo En. Venice, Bologna ? b. 1566 . . . 361
FRANCO, Giovanni Battista ("Il Semolei"). En., et. Udine, Venice, Rome, Florence, Urbino. 1498 ?-1561 113, 360, 361
FRANÇOIS, Alphonse. En. Paris. 1811-88 . . . 374
FRANÇOIS, Jean Charles. Cr. Nancy, Lyons, Paris. 1717-69 . 287, 293, 373
See Registres de l'Acad. Roy. de Peint., Paris, 26 Mar. and 26 Nov. 1757 ; Lettre à M. Savérien, Paris, 1760 (both in S. K.).
FRANÇOIS, Pierre Josef Célestin. Et. Namur, Italy, etc. 1759-1851 . . 358
FREIDHOFF, Johann Joseph. Mezz., st. Berlin. 1768-1818 . . 349
FRÉLAUT, Jean. Et. France. Contemp. 375

KABEL—LA FAGE 451

II. ENGRAVERS KNOWN BY THEIR MONOGRAMS, INITIALS, ETC.

III. ENGRAVERS KNOWN BY THEIR MARKS

IV. ENGRAVERS KNOWN BY THEIR DATES

1446, Master of the Year. En. Upper Rhine? . . . 20, 21, 345

1462, Master of the Year ("Master of the Holy Trinity"). En. Upper Germany 23, 345

1464, Master of the Year. *See* Index V. (Banderoles).

1466 (1467), Master of the Year. *See* Index II. (E.S.).

1480, Master of the Year. *See* Index V. (Amsterdam Cabinet).

1515, Master of the Year. En. Northern Italy, Rome? . . . 360
Kristeller, *Amtl. Berichte*, Berlin, xxx. 60.

1551, Master of the Year. *See* Index I. (Zündt).

V. ENGRAVERS KNOWN BY THE SUBJECT OR LOCALITY OF THEIR PRINCIPAL WORKS

AMSTERDAM CABINET, Master of the (Master of the Year 1480, Master of the Hausbuch). En. Middle Rhine. fl. ab. 1480 . . . 30, 140, 345
E. Dutuit, Manuel de l'Amateur, vol. v. 132 ; A. Essenwein, Mittelalterliches Hausbuch, Frankfurt, 1887 ; C. Hachmeister, Der Meister des A. C. und A. Dürer, Berlin, 1897 ; M. Lehrs, *Chalc. Soc.* 1894, *Repert.* xv. 111, *Jahrb.* xx. 173 ; Friedländer, *Repert.* xvii. 270 ; Valentiner, *Jahrb.* xxiv. 291 ; Bossert, *Repert.* xxxii. 333 ; Naumann, *Repert.* xxxiii. 293 ; Glaser, *Monatshefte für Kunstwiss.* iii. 145 ; Storck, *Monatsh.* iii. 243, 285, and *Burl. Mag.* xviii. 184 ; Geisberg, *Cicerone*, i. 245 ; Baer, *Monatsh.* iii. 408. *See* General Bibl. VI., A. Amsterdam (Kaiser, and Boland) ; Weizsäcker, *Jahrb.* xxxiii. 79 ; Leonhardt and Bossert, *Zeitschrift*, 2nd ser. xxiii. 131, 191, 239, and *Monatshefte*, vi. 76 ; Baer, *Monatshefte*, vi. 447 ; H. T. Bossert and W. F. Storck, Mittelalterliches Hausbuch, Leipzig, 1912.

BALAAM, Master of the. En. Burgundy or Netherlands? fl. ab. 1445 . 351
BANDEROLES, Master of the (formerly also called Master of the Year 1464). En. Upper Germany? Holland? fl. ab. 1455-70 23, 345
Dehio, Munich, 1881 ; M. Lehrs, Dresden, 1886, *Chronik*, i. 3, *Archivio Storico*, i. 444 ; Hymans, *Gazette*, 2e pér. xxxv. 446 ; Lippmann, *Jahrb.* vii. 73 ; C. Dodgson, Grotesque Alphabet, B.M., London, 1899.
BEHEADING OF JOHN THE BAPTIST, Master of the. En. North Italy. fl. ab. 1500 67, 360
Galichon, *Gazette*, xviii. 546.
BERLIN PASSION, Master of the (=the father of I. van Meckenem ?). En. Lower Rhine (Bocholt?) fl. ab. 1450-65 34, 345
Lehrs, *Jahrb.* xxi. 135 ; M. Geisberg, Strassburg, 1903 and 1905.
BOCCACCIO ILLUSTRATIONS, Master of the. En. Bruges. fl. 1476 . 32, 351
D. Laing, Facsimiles, Edinburgh, 1878 ; Colvin, *L'Art*, xiii. 149, 180 ; Lehrs, *Jahrb.* xxiii. 124 ; Geisberg, *Cicerone*, i. 245.

DEATH OF MARY, Master of the. En. Burgundy or Netherlands? fl. ab. 1445 23, 351
DUTUIT MOUNT OF OLIVES, Master of the. En. Lower Rhine. fl. ab. 1450-70 345

FLOWER BORDERS, Master of the. En. Lower Rhine. fl. ab. 1450-70 . 345

GARDENS OF LOVE, Master of the. En. Burgundy or Netherlands? fl. ab. 1448
23, 41, 351
M. Lehrs, Dresden, 1893.

A CATALOG OF SELECTED
DOVER BOOKS
IN ALL FIELDS OF INTEREST

A CATALOG OF SELECTED DOVER
BOOKS IN ALL FIELDS OF INTEREST

DRAWINGS OF REMBRANDT, edited by Seymour Slive. Updated Lippmann, Hofstede de Groot edition, with definitive scholarly apparatus. All portraits, biblical sketches, landscapes, nudes. Oriental figures, classical studies, together with selection of work by followers. 550 illustrations. Total of 630pp. 9⅜ × 12¼.
21485-0, 21486-9 Pa., Two-vol. set $29.90

GHOST AND HORROR STORIES OF AMBROSE BIERCE, Ambrose Bierce. 24 tales vividly imagined, strangely prophetic, and decades ahead of their time in technical skill: "The Damned Thing," "An Inhabitant of Carcosa," "The Eyes of the Panther," "Moxon's Master," and 20 more. 199pp. 5⅜ × 8½. 20767-6 Pa. $3.95

ETHICAL WRITINGS OF MAIMONIDES, Maimonides. Most significant ethical works of great medieval sage, newly translated for utmost precision, readability. Laws Concerning Character Traits, Eight Chapters, more. 192pp. 5⅜ × 8½.
24522-5 Pa. $4.50

THE EXPLORATION OF THE COLORADO RIVER AND ITS CANYONS, J. W. Powell. Full text of Powell's 1,000-mile expedition down the fabled Colorado in 1869. Superb account of terrain, geology, vegetation, Indians, famine, mutiny, treacherous rapids, mighty canyons, during exploration of last unknown part of continental U.S. 400pp. 5⅜ × 8½. 20094-9 Pa. $7.95

HISTORY OF PHILOSOPHY, Julián Marías. Clearest one-volume history on the market. Every major philosopher and dozens of others, to Existentialism and later. 505pp. 5⅜ × 8½. 21739-6 Pa. $9.95

ALL ABOUT LIGHTNING, Martin A. Uman. Highly readable non-technical survey of nature and causes of lightning, thunderstorms, ball lightning, St. Elmo's Fire, much more. Illustrated. 192pp. 5⅜ × 8½. 25237-X Pa. $5.95

SAILING ALONE AROUND THE WORLD, Captain Joshua Slocum. First man to sail around the world, alone, in small boat. One of great feats of seamanship told in delightful manner. 67 illustrations. 294pp. 5⅜ × 8½. 20326-3 Pa. $4.95

LETTERS AND NOTES ON THE MANNERS, CUSTOMS AND CONDITIONS OF THE NORTH AMERICAN INDIANS, George Catlin. Classic account of life among Plains Indians: ceremonies, hunt, warfare, etc. 312 plates. 572pp. of text. 6⅛ × 9¼. 22118-0, 22119-9, Pa. Two-vol. set $17.90

ALASKA: The Harriman Expedition, 1899, John Burroughs, John Muir, et al. Informative, engrossing accounts of two-month, 9,000-mile expedition. Native peoples, wildlife, forests, geography, salmon industry, glaciers, more. Profusely illustrated. 240 black-and-white line drawings. 124 black-and-white photographs. 3 maps. Index. 576pp. 5⅜ × 8½. 25109-8 Pa. $11.95

AMERICAN CLIPPER SHIPS: 1833–1858, Octavius T. Howe & Frederick C. Matthews. Fully-illustrated, encyclopedic review of 352 clipper ships from the period of America's greatest maritime supremacy. Introduction. 109 halftones. 5 black-and-white line illustrations. Index. Total of 928pp. 5⅜ × 8½.
25115-2, 25116-0 Pa., Two-vol. set $17.90

TOWARDS A NEW ARCHITECTURE, Le Corbusier. Pioneering manifesto by great architect, near legendary founder of "International School." Technical and aesthetic theories, views on industry, economics, relation of form to function, "mass-production spirit," much more. Profusely illustrated. Unabridged translation of 13th French edition. Introduction by Frederick Etchells. 320pp. 6⅛ × 9¼. (Available in U.S. only)
25023-7 Pa. $8.95

THE BOOK OF KELLS, edited by Blanche Cirker. Inexpensive collection of 32 full-color, full-page plates from the greatest illuminated manuscript of the Middle Ages, painstakingly reproduced from rare facsimile edition. Publisher's Note. Captions. 32pp. 9⅜ × 12¼.
24345-1 Pa. $4.95

BEST SCIENCE FICTION STORIES OF H. G. WELLS, H. G. Wells. Full novel *The Invisible Man*, plus 17 short stories: "The Crystal Egg," "Aepyornis Island," "The Strange Orchid," etc. 303pp. 5⅜ × 8½. (Available in U.S. only)
21531-8 Pa. $6.95

AMERICAN SAILING SHIPS: Their Plans and History, Charles G. Davis. Photos, construction details of schooners, frigates, clippers, other sailcraft of 18th to early 20th centuries—plus entertaining discourse on design, rigging, nautical lore, much more. 137 black-and-white illustrations. 240pp. 6⅛ × 9¼.
24658-2 Pa. $6.95

ENTERTAINING MATHEMATICAL PUZZLES, Martin Gardner. Selection of author's favorite conundrums involving arithmetic, money, speed, etc., with lively commentary. Complete solutions. 112pp. 5⅜ × 8½.
25211-6 Pa. $2.95

THE WILL TO BELIEVE, HUMAN IMMORTALITY, William James. Two books bound together. Effect of irrational on logical, and arguments for human immortality. 402pp. 5⅜ × 8½.
20291-7 Pa. $7.95

THE HAUNTED MONASTERY and THE CHINESE MAZE MURDERS, Robert Van Gulik. 2 full novels by Van Gulik continue adventures of Judge Dee and his companions. An evil Taoist monastery, seemingly supernatural events; overgrown topiary maze that hides strange crimes. Set in 7th-century China. 27 illustrations. 328pp. 5⅜ × 8½.
23502-5 Pa. $6.95

CELEBRATED CASES OF JUDGE DEE (DEE GOONG AN), translated by Robert Van Gulik. Authentic 18th-century Chinese detective novel; Dee and associates solve three interlocked cases. Led to Van Gulik's own stories with same characters. Extensive introduction. 9 illustrations. 237pp. 5⅜ × 8½.
23337-5 Pa. $4.95

Prices subject to change without notice.
Available at your book dealer or write for free catalog to Dept. GI, Dover Publications, Inc., 31 East 2nd St., Mineola, N.Y. 11501. Dover publishes more than 175 books each year on science, elementary and advanced mathematics, biology, music, art, literary history, social sciences and other areas.